British Art in the 20th Century

This is the second volume to appear in conjunction with the series of exhibitions of twentieth-century art organized by the Royal Academy of Arts, London.

Already published:

German Art in the 20th Century: Painting and Sculpture 1905-1985
Edited by Christos M. Joachimides, Norman Rosenthal and Wieland Schmied, 1985

British Art

in the 20th Century

The Modern Movement

Edited by
Susan Compton

With contributions by
Dawn Ades, Andrew Causey, Judith Collins, Susan Compton,
Richard Cork, Frederick Gore, Charles Harrison,
Robert Rosenblum, Norman Rosenthal and Caroline Tisdall

Prestel-Verlag, Munich

First published on the occasion of the exhibition
'British Art in the 20th Century: The Modern Movement'
Royal Academy of Arts, London, 15 January - 5 April 1987

Cover illustration: Edward Wadsworth, *North Sea*, 1928 (detail, Cat. 132)

Distribution of the hardcover edition in the United Kingdom, Ireland and
the Commonwealth (except Canada) by Lund Humphries Publishers Ltd,
124 Wigmore Street, London W1H 9FE

Distribution of the hardcover edition in the USA and Canada by
te Neues Publishing Company, 15 East 76 Street, New York, N.Y. 10021

Typesetting by Fertigsatz GmbH, Munich, using
'Janson Antiqua' by D. Stempel & Co., Frankfurt am Main
Offset Lithography by Karl Dörfel, Munich
Printed by Karl Wenschow Franzis-Druck GmbH, Munich
Bound by Passavia GmbH, Passau

Printed in Germany

ISBN 3 7913 0798 3

Contents

Foreword

'British Art in the 20th Century' is the second in the series of exhibitions at the Royal Academy in which we look back on those achievements in painting and sculpture that have shaped the course of art in our century. It follows upon the success of 'German Art in the 20th Century', which gave an exciting view of another modern movement with its own national characteristics.

In these exhibitions we have rejected the encyclopaedic approach, which some might regard as fairer: this is as much a matter of deliberate policy as of any limitations of space. There could, however, be no harder task for us than to select from the rich diversity of art in our own country an exhibition which is necessarily limited to a relatively small number of representative artists who have been influential in the furtherance of the modern movement. The work of some seventy artists has thus been selected to give a cogent historical view of British art in the twentieth century both in these pages and in the Galleries. The exhibition traces the development of Modernism in Britain from the Post-Impressionist exhibitions held in London in 1910 and 1912 and ends with the work of artists of the post-war generation whose international reputation is now established.

The Selection Committee was headed by Andrew Causey, Senior Lecturer in History of Art at Manchester University, and comprised Frederick Gore RA, Chairman of our Exhibitions Committee, and Norman Rosenthal, Exhibitions Secretary at the Royal Academy, together with Richard Cork and Dawn Ades, who are well known for their writings on art. All have given generously of their time and knowledge, as has Susan Compton, who has acted not only as editor of this catalogue but also as co-ordinator of the exhibition. The exhibition is divided into sections for which the selectors have written introductions in the catalogue, though the exhibits were selected by consensus of the Committee.

We have been most fortunate in having, as sole sponsors, The British Petroleum Company plc, who have afforded us the financial guarantees without which we could not have proceeded, and have helped us with the promotion of the exhibition from the earliest stage in its planning.

The Royal Academy is, as always, particularly grateful to the museums and private collectors who have so generously responded to our requests for the loan of works of art of prime importance. It would be wrong for me to conclude without thanking the artists themselves for their help and forbearance – both those included in the exhibition and the many others, no less important, whose work lies outside its scope.

ROGER DE GREY
President, Royal Academy of Arts

Acknowledgments

Thanks are owed to the following individuals, in addition to the lenders and to all those public and private collectors who were kind enough to show the selectors their collections of British twentieth-century art at the initial stages of this exhibition, who contributed in many different ways to the organization of the exhibition and to the preparation of the catalogue:

Judy Adam
John Bernasconi
Valerie Beston
Monica Bohm-Duchen
Alan Bowness
J. Carter Brown
Judith Collins
Desmond Corcoran
Raymond Danowski
Joanna Drew
Margaret Drummond
Barbara Duce
Karen Faure-Walker
Michael Foster
Anne Garrould

Luke Gertler
Mark Glazebrook
Janet Green
Alex Gregory-Hood
Brian Hercules
Isobel Johnstone
Annely Juda
Alice Kadel
J. Kasmin
James Kirkman
Marie-Louise Laband
Graham Langton
Krystyna Matyjaszkiewicz
Bernard Meadows
Richard Morphet

Michelle O'Malley
Anthony d'Offay
Geoffrey Parton
Lady Anne Ritchie
John Roberts
Peter Rumley
Charles and Doris Saatchi
Mr & Mrs Walter Schwab
Sarah Shott
Mary Taubman
Robin Vousden
Kay Walia
Angela Weight
Geoffrey Wilson
Muriel Wilson

Frederick Gore

Introduction

The development of an artistic tradition is pragmatic. Theory is important but practice is more important. Succession in the history of art lies in the handing on by one painter to another of working methods, for adoption, absorption or rejection. The strongest theoretical tendency guiding the formative years of modern art was the growing sense that painting and sculpture speak for themselves – that the full and proper use of shapes, lines and colours has meaning in itself without literary or metaphorical interpretation.

In Britain, complementary to or even contradicting this bias towards abstraction, there is an equally strong desire to reflect the habits and thoughts and dreams of society. This is certainly related to the empiricist strain in British philosophy, novels, poetry and painting leading back to the eighteenth century, to Bentham, Blake, Reynolds, Smollett, Hogarth, Stubbs, Swift, Defoe. Traditionally there has been a concern for society at all levels and a relish for popular life in town and countryside, viewed with humour and moral fervour. But in the early years of this century, the purification of art from a cluttered nineteenth century was as necessary as to voice the new age, and to make objects which would have the same simplicity, expressiveness and authority as those works which speak suddenly to the present from the past. The primitive was immeasurably attractive.

In Paris the generation of Matisse, Braque and Derain could take their lead from the heroic figures of Post-Impressionism – Van Gogh, Gauguin and Cézanne. They too had legitimate descent from Corot, Courbet, Delacroix and Goya through the Impressionists. In Britain, by contrast, after Constable and Turner there were no great masters to follow and, as the influence of the Pre-Raphaelites faded, no firm direction. In spite of Whistler and apart from Sickert, the Impressionists of the New English Art Club had formed a wavering and diluted stream. The Slade generation turned again to France for a stable practice with firm historical roots. For those who gradually gathered in Fitzroy Street from 1905 this was effected by Sickert's connection with Degas, and by Lucien Pissarro's relationship with his father Camille and also with Seurat, Signac and the Neo-Impressionist circle.

It was indeed a modern practice: the crisis of Impressionism had been produced by the violence that Degas had done to a conventional view of the human body (it echoes on through the century in the work of Sickert, Stanley Spencer and Lucian Freud) and also by the abstract code with which Seurat and Signac had separated the representation of what is seen from pure perception. From both sources, together with the basis for sound practice, came a measure of eccentricity and extremism (not discouraged by Sickert and later to be seen in the work of Lewis, Bomberg, Spencer, Bacon, Auerbach). At the same time the fascination with human society and that passion for techniques and thoroughness of execution already present in British art were reinforced.

This provision held good from 1906 until 1910. There are many hints in their work that London painters knew of the Fauve and Cézannesque tendencies in Paris. It was, however, from 1910 – the year of Roger Fry's first Post-Impressionist Exhibition – that influences from Gauguin, Van Gogh and even Matisse and Cubism were swiftly absorbed. The understanding of Cézanne came more slowly. In 1911, buoyed by a sense of optimism generated by younger artists in their group but despairing of the New English Art Club, the Fitzroy Street circle founded their own exhibiting society, the Camden Town Group. With their work this account of the Modern Movement begins. Recruits fresh from Paris, including Wyndham Lewis,

had joined the group and the very next year a public demonstration of the new art occurred when, at Frida Strindberg's invitation, Spencer Gore raised a team with Lewis and Charles Ginner to decorate her cabaret, the Cave of the Golden Calf. It is recorded here by the preparatory designs, for, alas, the Cabaret Theatre Club and its decorations vanished long ago.

Also in 1912 came Fry's Second Post-Impressionist Exhibition, with advanced art from Britain and Russia as well as France, including large displays of work by both Matisse and Picasso. In July 1913 Fry opened the Omega Workshops, hoping doubtless that British designs might exert a special influence within Post-Impressionism as the British Arts and Crafts Movement had done on the whole of Europe at the time of Art Nouveau. The screens by Vanessa Bell (Cat. 25) and Duncan Grant (Cat. 27) belong to this moment. The Workshops both entranced a wide public and provided work for a generation of young artists. These included Lewis, who horrified Bloomsbury by his ingratitude when he quarrelled with Fry and left to found the Rebel Art Centre and to fly the banner of Vorticism. Soon London was regaled with works like his own *The Crowd* (Cat. 40) and David Bomberg's *In the Hold* (Cat. 50), and sculptures by Jacob Epstein and Henri Gaudier. 1913-15 were years of full-blooded modernism.

During the 1914-18 War many artists served in the trenches and many became Official War Artists. Lewis, William Roberts, Edward Wadsworth, Christopher Nevinson and Paul Nash were impelled by bitter experiences towards a descriptive realism. But it was precisely these artists who retained the expressive economy and the unconventional eye of Modernism whose work went beyond bare description to reveal the alienating horror of modern war. So many artists were driven to consider the fate of man and his environment that, although the tendency was still towards Modernism, it moved away from abstraction. Lewis treated figures satirically but there remained in his work a leaning towards abstraction. Yet after the war other Vorticists, Wadsworth and Roberts, moved in the opposite direction, as did Bomberg. Even the light-hearted and highly original abstractions of Vanessa Bell and Duncan Grant at the time of Omega were forgotten, except in the decorative arts.

There was still, however, a feeling that a Modern Movement needed to be securely founded, and characteristic and influential painters of the Twenties and early Thirties took both a modern French and an Old Master and treated them with equal respect. Thus Matthew Smith gave unaffected devotion to Matisse and to Rubens, Gertler to Renoir and then to Cézanne and also to the Quattrocento artists and Dürer. Roberts, too, combined Cubist and early Italian sources. The recourse of these artists to French painting was in search of tradition as much as revolution.

Stanley Spencer, the very British successor of Blake and the Pre-Raphaelites, in one aspect of his work is shown unself-consciously adopting the primitive eye of a child (*The Dustman or The Lovers*, Cat. 106), in another as the Slade draughtsman whose virtuosity equals the Old Masters (*The Sisters*, Cat. 105). His work is as timeless as it is fully of now: we may not all be awaiting the Second Coming but we do live in dread of the atomic apocalypse. If a doubting stranger should ask for a British painter to be named who stands incontrovertibly with the great masters of modern art, Stanley Spencer is surely one.

Paul Nash, whose early affections were given to the English watercolourists, became the poet of landscape in contemporary terms. Also, with discretion, he successively drew on Continental Cubism, Constructivism and Surrealism. An effective influence on Sutherland (who followed a similar route from Samuel Palmer to Surrealism) as well as on a number of important modern painters in watercolour, Nash, together with his brother John, virtually founded a school and, by his association with Moore and Nicholson, infused an element of landscape into the new abstract movement.

This movement towards abstraction became evident from 1930 when Paul Nash gathered artists into the short-lived Unit One group (1933-4). It had at its centre Ben Nicholson and Henry Moore – through whom the mainstream of the European art movements was rejoined – and included Barbara Hepworth and Edward Wads-

worth. Nicholson, Moore, Hepworth and John Piper were also members of the Seven and Five Society (1919-35), which included a number of distinguished figurative artists – David Jones, a poet and watercolourist in the mystical English tradition, Frances Hodgkins, Christopher Wood and Cedric Morris. The last two found their way by Paris to Cornwall, where Wood was closely associated with Nicholson. Together they are said to have discovered Alfred Wallis, the naïf painter whose conviction also delighted later Cornish artists. The thread of child-like primitivism that runs from the much loved early watercolours of the young Nash brothers to the present day has encouraged the theory that formal training is dangerous. This viewpoint has provided a counterbalance to the almost obsessive technical investigations and thoroughness of many British artists.

Three main tendencies dominated Modernist art in the years leading up to the Second World War. One, towards Constructivism, was encouraged by the presence of a number of European artists (Arp, Gabo, Moholy-Nagy, Ozenfant and even for a while Mondrian); the second was towards Surrealism, which became the popular avant-garde. Both of these overlapped in Unit One, but just before the war, largely at Roland Penrose's instigation, London was plunged into a year of Surrealist manifestations. Artists who embraced unadulterated Surrealism lacked intellectual depth but Moore, Nash, and others who had joined the movement earlier and did not take the theory literally, made wonderful use of what had become common property.

The third, and on the surface most markedly effective tendency, was a return to the mood of the early London Group with a re-examination of the Impressionist origins of British Modernism in Sickert and Cézanne. This is shown in the section devoted to late Sickert and the Euston Road School (Cat. 156-167). The mood of the Euston Road artists led by Coldstream, Pasmore and Claude Rogers was stiffened by political issues: 'Mass Observation', sympathy for hunger marches and the resistance to fascism in the Spanish Civil War. The timing of this movement (formed 1937), the conviction of its followers and their concern for the future of painting prevented any suspicion that it was retrograde. For Pasmore, and Kenneth Martin later, it proved a characteristic English moment of retrospection before moving by stages towards and finally plunging into Constructivism.

What we see in the first half of the exhibition, then, is the work of those early masters of a Modern Movement to which they gave both stability and momentum. They were not cautious. In countries where issues have been extreme and dangers great, art is extreme and the critical evaluations of art intense. In a way which is not overtly political, when extreme issues have emerged in society, British art has also been extreme. The work resulting from the First World War is an obvious example. Sex is another. In Britain throughout the century it has been treated in 'modern' terms, more frankly but with a complicated subtlety which does not exist in German or French art.

Sickert's penetrating sympathy for the character of his Venetian women from the street, and the bitter taste of the sex war which he inserted into the amiable carnality of Camden Town, compare favourably with the caustic symbolic stereotypes of German iconography – the harlots, actresses and society women – or with their suggestions of free love in the open air. Just as extreme, but much more concerned with the individual moment of truth, are Spencer's confrontations with the woman within whose naked presence his whole existence suddenly revolved (Cat. 104). It is the measure of their instinct for the things that have concerned, worried and upset the lives of everyone that artists automatically joined with D. H. Lawrence in the polemics of this aspect of social revolution. Thus Epstein's extremist utterances in stone and bronze deifying the forces of life oppose the weary repetition of 'birth and copulation and death' by T. S. Eliot's 'Sweeney Agonistes'. The opposition to Epstein was usually violent and attempts were made to destroy his work. In the postwar years, Lord Arran may have introduced the Bill which emancipated homosexuals but the climate which has made homosexuality acceptable has been created by Bacon and Hockney. British figurative art, by tradition pragmatic and realistic, has been deeply concerned with society and its values.

After the Second World War an unprecedented enthusiasm for the arts was supported by an improved infrastructure from public and individual effort (for example, the Arts Council and the Institute of Contemporary Arts). An agglomeration of Modernist movements and individual activities set the stage for the public enjoyment and international recognition given to British art in the Fifties and Sixties.

On the one hand, there was a rich and complex field of figurative work. There was the Cubist revival of the Forties (Colquhoun, MacBryde) leading to the romantic post-Cubism of Craxton, Vaughan, Minton, Ceri Richards. Then in the early Fifties came the Social Realism ('Kitchen Sink') of Bratby, Jack Smith, Middleditch, whose forceful drawing, both realistic and expressionist, gave an edge to their movement, lacking in its French equivalent. Bacon, Auerbach, Kossoff and Freud took up their extreme and uncompromising positions on the edge of these movements.

On the other hand, Pasmore's declaration for abstract art in 1948 defined a permanent direction for the post-war avant-garde. The examples of Hepworth and Nicholson were followed by the growing group of painters in Cornwall whose abstracts were redolent of the landscape and the sea. Links with the European avant-garde were renewed by Roger Hilton, whose wry linear abstractions and figurations were related to experiments in Tachisme and automatic techniques taken over from Surrealism. Peter Lanyon owed more to the freedom that he shared with artists in New York, where he early achieved a considerable reputation with his abstracted sea- and cliff-scapes, viewed from the vantage point of a glider. British art was deprived by his early death following a gliding accident.

In the field of sculpture, the influence of Moore temporarily strengthened a modified figuration in the 1950s. The reaction to it came from Anthony Caro, who with his final abandonment of partial figuration in the early Sixties led sculpture more deeply into abstraction and towards a dominant position. It captured ground which had formerly belonged only to still-life painting or landscape – space, colour, linear rhythms and floating planes.

A further strand in figurative art had developed late in the 1940s. Meetings at the ICA, founded by Roland Penrose, fostered a residual Surrealism and a conscious will to form an avant-garde. An urge to extend the media of fine art resulted in a rash of photomontage throughout London. Such factors as the new interest in the collages of Max Ernst and the social consciousness of the Euston Road, led Richard Hamilton and Eduardo Paolozzi to exploit material from popular imagery in collage. Hamilton outlined the programme: 'Popular (designed for a mass audience); Transient (short-term solution); Expendable (easily forgotten); Low-cost; Mass produced; Young (aimed at youth); Witty; Sexy; Gimmicky; Glamorous; Big Business.'

Surrealism had vastly enlarged the subject-matter of art, adding to 'nature' (the exterior world of appearances and their reality) the interior world of dreams, the unconscious mind – the new universe of Freud and Jung – together with the mythic cognition of tribal people, children and ancient literature. Pop Art now added an even vaster world from common experience, the vernacular world of everyday communication at different social levels by any media, old or new. Underlying Pop Art was the truth (almost always ignored) that the Fine Arts only exist as small buckets which dip occasionally into the vast well of visual imagery and visual codes. These now ranged from the practical world of maps and plans to comic strips, press photos and movies, without which words would be meaningless, machines could not be built, physics comprehended or human beings socialized. Like Surrealism, Pop Art was not a movement of formal invention but of content. Any style could be raided respectably. The artist was given a totally new freedom. It became the art form of the 'Swinging Sixties'.

In contrast but contemporary with Pop Art, the Tate Gallery exhibitions of abstract art from the United States (1956 and 1959) and the advent of North American art in quantity in London, originals as well as in print, reinforced both hard-edge and free-form abstraction. The ruthlessness by which American painters had stripped away the last figurative elements and reduced abstraction to the simplest

terms, the way they had learnt from the masters of the European diaspora – substituting the signs of their own urban background – the sheer quantity of their output and the scale of the work stimulated Alan Davie and roused the younger artists who contributed to 'Situation', as well as the wider public.

The most immediate and effective influence from American painting was Jackson Pollock. His working methods as well as his canvases reinforced earlier experiments here in free abstraction, and breaking with the geometric models of de Stijl and the Bauhaus also offered artists a new freedom. His Abstract Expressionism has a satisfyingly logical philosophic background. Any accidental marks left by the activity of the body include the unconscious and constitute a paradigm of external reality, of which body and unconscious mind are a part – a rational explanation of the way things sometimes just seem to happen right (which every artist experiences). The consequent Abstract Expressionist movement in Britain has been very coherent. Its leading figures include John Hoyland and Gillian Ayres, and so far it has lasted continuously for thirty years. It has also been a liberating influence on the techniques and freedom to express themselves of painters of all kinds.

In the wake of American colour painting British sculpture took on a new freedom; indeed in many ways sculpture has shown the most forceful and consistent development in post-war Britain. The seeds were sown by the pragmatic belief of the pre-war sculptor from Epstein to Moore that the form should grow out of the nature of the material – the stone or wood – and, nurtured by the later example of Moore's organized production, followed his instinct for form and poetic reference. So in Britain existing modernist forms were not imitated (the weakness of Zadkine or Gonzales in relation to Cubism) and new forms were discovered in the Sixties by extending Constructivist principles to expressive and emotive purposes. The work of Caro and King, here representing the New Generation sculpture, has a primal psychological unity which is fully expressive without the overtones of historical reference which are not entirely lacking in Moore (where they are much to the point).

It was these three wholly radical developments, the new figuration (Pop Art), Abstract Expressionism and the New Generation Sculpture, which made the Sixties and Seventies times of extraordinary inventiveness. However, in spite of the accommodation between various kinds of abstraction and Pop Art which seem to share a movement encapsulating the mood of the Sixties, there was a growing feeling among artists that the predigested images of Pop were becoming almost too familiar. Influential American critics were exclusively supporting forms of abstraction and once more (as in the wake of Cubism) the only viable alternative seemed to be an absolutely straight confrontation with nature and its translation into the physical substance of paint. The British Social Realists' capacity to do just that had been a casualty to the great wave of enthusiasm for abstraction in 1960. American photographic realism had likewise failed to confront nature; instead it foundered in the boredom of rubber flesh and cardboard backdrops, or the equally unrealistic sunset and celluloid vastness of Photo-Realism.

Where these attempts failed, Bacon, Auerbach, Freud and Kossoff succeeded each in his own way, and places of honour have been given to them in the exhibition: to Frank Auerbach and Lucian Freud for the way in which they have persisted, and the obstinacy with which they studied the act of perception and its translation into paint, Freud with an intense visual contact, Auerbach by mercilessly reappraising the experience of his subject-matter.

But let there be no mistake that by the 1960s, in the face of Pollock, Rothko, de Kooning or Gottlieb, there was no possible choice which would have allowed Matisse or Bonnard to be followed; the students of London had completely forgotten Picasso. Derivations from any of the three would have appeared hopelessly decorative. The idea that nature could be hotted up by artistic devices was in doubt, the whole splendid French box of tricks had been thrown out, and a great sigh of relief had gone up from studios all over the world that Picasso's spell had been broken.

Indeed, the theories of Charles Biederman taken up by the Constructivists challenged the right to paint at all. On top of that there was the misinterpretation of

Gombrich's theories. Although, scientific to a fault, he was the first to recognize the art of painting as a language of signs rather than an imitation of appearances, he also employed the unfortunate word 'illusion' to describe the naturalism in particular of Constable. The word went round the studios that even abstract art, dependent on spatial relationships, was illusionistic. All painting was illusionistic, therefore painting was dead. Leon Kossoff – metaphorically of course – stood alone in the life-room hurling paint at the enemies of painting.

When the possibility of an extreme realism was in the air Francis Bacon above all held his own, providing a new realism and a good deal more. Tom Hayman has written: 'Novel to post-war painting was the illusionistic emphasis; qualities of glitter and speed, familiar in photography, were appropriated again to painting' and quoting Bacon '. . . to bring the figurative thing up on to the nervous system more violently and more poignantly'.

The increasing respect in which the work of Bacon, Auerbach, Freud and Kossoff is held by artists of different persuasions marks the return of interest to a form of painting in which the dualism of meaning in terms of paint, and meaning in terms of life, is resolved. The work of all four is very physical in apprehension; each work is an arena in which both moral and aesthetic conflict has taken place. But whatever the wider European influences, strands lead back to Sickert, Bomberg and Matthew Smith. Expressionism held within the limits of a powerful realism is certainly part of British tradition.

Equally true to the times has been the invention of alternative media – the movement away from the conventions of painting and sculpture. From the beginning Modernism implied a breakdown of accepted categories, a spread into unfilled spaces between the recognized arts, an appropriation by Fine Art of new media and wholesale occupation of unmodernized areas within the recognized art forms. This allowed sculpture in the Seventies to spread into other areas, especially since theatre, music, dance and painting had earlier in the century shed themselves puritanically of unnecessary exuberance from the past.

Gilbert & George and Bruce McLean represent Performance Art and then the return to more permanent forms of expression; Richard Long the translation of sculpture into landscape and the absorption of landscape into sculpture contingent to both Conceptual and Performance Art. At the time when lesser artists burnt holes in their canvases and rolled paint-laden bicycle tyres or nudes upon them, John Latham was pointedly burning books in front of the British Museum. Mark Boyle, Stuart Brisley, Art & Language, Victor Burgin, all represent the inventions which followed the impulse to carry sculpture into totally new directions. With these unconventional alternatives British art has obtained a reputation and influence throughout the world which is scarcely realized, appreciated or enjoyed at home.

In conclusion, there is a thread of continuity throughout the exhibition, for all these movements have much in common. There are similarities between the brisk 'Mod' images of Pop Art and New Generation sculpture; between Auerbach's handling of paint and Abstract Expressionism; between Stanley Spencer's portraits and early heads by Lucian Freud. There is Freud's affection for Gwen John and John Hoyland's for Matthew Smith. Running through much of the art is the ubiquitous and effective ghost of Surrealism and the long arm of Sickert.

In British Art there are very many interrelationships and signs of continuity through the years, very many complementary oppositions and symptoms of a common ground well laid. There is a wide spread of modern ideas among painters who are much less directly in touch with the modern movement, and a consciousness of what is fine over a wide field. There are very many good artists, very little commercial rubbish. Painters in this country have an acute awareness of what each other is doing. Indeed, there are so many links that there seems to be a coherence in British art in the twentieth century which suggests a single overall movement (*una religio in rituum varietate*) and one which is durable.

Andrew Causey

Formalism and the Figurative Tradition in British Painting

The beginnings of a modern movement in British twentieth-century painting go back to the two Post-Impressionist exhibitions of 1910 and 1912 organized by Roger Fry. In effect they challenged British artists to remake an art that was both rudderless and demoralized: the Victorian preoccupation with realism of subject was to give way to an understanding of form and structure in painting through the example of Cézanne and the Old Masters. The enfeebled state of British painting at the turn of the century is beyond question, as is the need that existed for an informed intellect like Fry's to initiate a return to order. That Fry's ideas have dominated much of the thought about art in the subsequent three quarters of a century covered by this exhibition marks the degree to which British taste responded to him. But if his insistence on the primacy of form over subject was a necessary corrective, it also imposed serious limitations.

The visual arts in Britain have very long traditions influenced by poetry, literature and the theatre, social habits and religion, politics, propaganda, satire and ideas about property and work. This complexity is a caution against the formalist notion expressed by Fry's protégé Clive Bell that 'the representative element in a work of art may or may not be harmful. Always it is irrelevant.'[1] There are many strands in British art, and the unlikelihood of them all being broken at the same time is grounds to treat formalism historically, as a strategy for the renewal of art at a particular moment of weakness. Now that the influence of formalism on thinking about art is no longer dominant, it is easier to question past values while tracing the development of resistance to it, noting where and how this occurred.

Many of the artists who fit most readily into this formalist framework, such as Ben Nicholson and at times Paul Nash, have tended to be middle-class, British by birth, and have found it easy to accommodate to well-established traditions of British taste such as a love of Italy and respect for the leadership of France in recent art – two of the foundations on which Roger Fry's ideas were based. However, Britain has always also needed and welcomed foreign talent and this has never been more true than in the twentieth century. In the early years of the century alone a major contribution was made by Jewish refugees from eastern Europe, especially David Bomberg and Mark Gertler, who are not easy to fit into any orthodoxy, and they certainly resisted formalism. Other painters of partly foreign parentage, such as Walter Sickert and Percy Wyndham Lewis, different though they were from one another, shared a mistrust of theory. A few artists, Stanley Spencer and Edward Burra among them, combined natural talent of a very high order with a detachment from theoretical foundations and were able to remain independent of the mainstream, sustained by a passionate creative energy.

More than anything else the arrival of Surrealism in the Thirties and the belief that creativity was a basic and universal aspect of life cast doubt on the restrictive basis of Fry's formalism. In company with the social changes triggered by the Second World War, Surrealism created a climate in which younger artists who did not accept conventional cultural starting points – Hamilton, Paolozzi and the Independent Group at the Institute of Contemporary Arts – were no longer overawed by the authority of Fry and Bell. Their art was something different but it could not be marginalized – that is to say accepted, even praised, but treated as a curiosity – as Spencer's and Burra's had been.

If one thing is common to the artists considered here it is an interest in human life in the modern, urban world. While formalism has tended to concern itself with still-

1. Clive Bell, *Art*, London, 1914, p. 20.

life and landscape and their development into abstraction, the resistance to it has shown itself through confidence in the expressive weight of the human figure.

Late nineteenth-century British painting had offended Fry on the grounds of excessive individualism and a preoccupation with the direct recording of everyday life. Writing in 1905, however, he claimed to recognize among English painters a new sense of order, a 'new reverence to the art of the past', the conviction that 'there are definite things to be learned, a positive knowledge to be acquired and handed on from master to pupil: that there are problems in art the solution of which requires the persistent application of intelligence rather than the improvisation of genius'.[2] Appropriately, since Fry was in effect calling for a true academicism for modern times, he was writing in a new introduction to Reynolds's *Discourses*. Like Reynolds, he made it clear that his advice was directed at practising painters, and the precepts of Reynolds that he stressed were general effect and the avoidance of detail that would interfere with it; the subordination or sacrifice of parts, however elegant or expressive in themselves, to the effects of the whole; balance between variety and unity, in which unity was to be the controlling partner. Reynolds had disapproved of the 'demands made on art by the untrained appetites of the public' and Fry felt it presented an even graver problem in his own day than it had in Reynolds's own. 'The social and intellectual emancipation of the lower middle classes and their demand for crude sensational effects, for vivid appeals to a lazy curiosity, and love of novelty, have become imperious.'[3] In 'Art and Life' (1917) Fry described the modern movement as entering spheres increasingly remote from ordinary men in whom the aesthetic emotion was weakly developed. As art got purer its appeal would get less.[4]

Duncan Grant and Vanessa Bell, the leading painters with Fry in the Bloomsbury Group, were adventurous in the sense that research into abstraction in 1914-15 placed them in the forefront of European experiment. But their commitment remained tentative, perhaps because the deepest concern of their art was with friends, familiar places and the group. As they approached abstraction from the direction of still-life, they abandoned recognizable objects with obvious reluctance. The most impressive Bloomsbury painting is about people: Bell's *A Conversation* (Cat. 23) is sharply observed, with a touch of satirical humour, and her *Portrait of Iris Tree* (Cat. 22) is warm and unabashed with none of the stilted formality of Edwardian portraiture. These artists' conversation pieces have a relaxed and sunny atmosphere, and a decorative charm related to Matisse and Bonnard (Fig. 1). They are an offshoot of Modernism at a stage when it was still reconcilable with English eighteenth-century painting, where Bloomsbury art of the Twenties also has roots. Such work does not have the formal purity Fry was interested in, or truly come to terms with Cézanne. If it had, the course of modern art in Britain between the wars would have been smoother. Artists like Nash and Nicholson, who were respectful of Fry's ideas, had to learn about Cézanne bit by bit for themselves.

Different concepts of Modernism had become apparent when Futurism burst on London in 1912 in an exhibition at the Sackville Gallery, celebrating modernity, the city, and the sensations and vitality of the contemporary urban experience. Fry found that, like much nineteenth-century painting, Futurism was too much a direct representation of life,[5] and with German Expressionism it was omitted from his Second Post-Impressionist Exhibition a few months later.

By contrast, Sickert showed a perceptive interest in Futurism, although he belonged to the generation of Degas and the Impressionists, and as a painter had little in common with Futurism. He saw that here was something from which the British had much to learn.[6] Sickert had lived in France and was friendly with French painters of modern life: in his own painting the subjects are often caught in the middle of actions, there is a sense of time passing, of people having just done something and being about to do something else. It is a narrative art, and Virginia Woolf was right to point out that Sickert was a kind of novelist.[7] Later in life, when he often based pictures on ready-made images – photographs and newspaper illustrations – his compositions seem like frames frozen from a sequence. His portrait of King Edward VIII descending from his carriage (Cat. 159) captures the nervousness

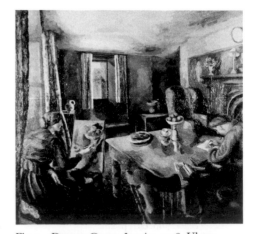

Fig. 1 Duncan Grant, *Interior*, 1918. Ulster Museum, Belfast

Fig. 2 Walter Richard Sickert, *Miss Earhart's Arrival*, 1932. Tate Gallery, London

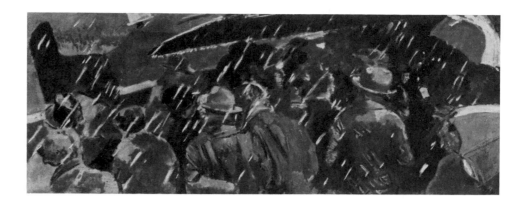

of the moment of transition from a private situation to a public one, the metamorphosis being clear in the expression on the King's face. Sickert's interest in arrivals – moments of tension and poignancy between past and future – has been pointed out,[8] and it is his appreciation of the emotional intensity of particular points in time that makes his art very real in human terms (Fig. 2).

Sickert stressed the importance of tradition for the contemporary painter as Fry had done. But Sickert pointed less to the acknowledged mainstream of art than to any artist or draughtsman in whom he could see reflected his own ambivalent feeling for human existence: the satirical line from Hogarth to Cruikshank, the earthiness of Rowlandson, the socially perceptive creations of the *Punch* draughtsmen, the mannered theatricality of life in Rococo painting. He even continued to admire Victorian painters of crowds like Frith (Fig. 6, p. 95), when the anti-Victorian reaction, dominant everywhere in the Twenties, had rejected them. Sickert saw life as hard and gritty as well as glamorous, and had a strain of melancholy that recognized and acknowledged people's weaknesses, which he revealed without censure. He made extraordinarily wide personal friendships, as Osbert Sitwell pointed out,[9] with painters, jockeys, music-hall comedians, statesmen, washerwomen and fishwives. He was too interested in human life in all its aspects to follow Reynolds in putting unity before variety, or indeed to think in these terms at all. His pluralist and undogmatic approach was very different from Fry's evolutionary concept of art entering a state of increasing refinement and purity.

The Post-Impressionism of Sickert and his colleagues Gore and Gilman in the Camden Town Group represented a vigorous and authentic response to life. In style, though, it was not radical enough to present the challenge to Fry's ideas that came from Wyndham Lewis's Vorticism. Between leaving the Slade School and settling in London in 1909 Lewis led a peripatetic life in Europe, sharing a bohemian existence in Paris with his idol Augustus John, joining in the life of Breton seafaring and gipsy communities, discovering El Greco and Goya while living in Spain, and staying for a time in Germany at the moment when ideas were turning in the direction that was to lead to Expressionism. That Futurism appealed to Lewis in 1912 is shown by *Kermesse* (see Cat. 36), his great bacchic painting – now lost – for Madame Strindberg's Cave of the Golden Calf Cabaret Theatre Club. As an art of great vitality it attracted Lewis but, like Fry, he found its narrative character, its immediate realization of experience, passé, too reminiscent of Impressionism. Clive Bell complimented Lewis on *Kermesse* while regretting that 'the enemy that dogs him is an excessive taste for life. He is inclined to modify his forms in the interests of drama and psychology to the detriment of pure design.'[10]

Lewis apparently took notice of such criticism because in his Vorticist work of the next few years he succeeded in communicating the vitality of the contemporary world metaphorically rather than literally in designs that do not describe the appearance of machines but are like the essence of machines: energy is implied by the way forms are held in control by a tight matrix of hard, angular lines. That human figures are often discernible in these paintings, embedded in the abstract structure, is no contradiction, for to Lewis modern man was himself like a machine, invigor-

2. Sir Joshua Reynolds, *Discourses delivered to the Students of the Royal Academy*, with an introduction and notes by Roger Fry, London, 1905, p. xxi.
3. Ibid., p. 347.
4. 'Art and Life', lecture given to the Fabian Society, 1917, reprinted in *Vision and Design* [1920], Harmondsworth, Middx, 1961, p. 21.
5. Ibid., p. 20.
6. 'The Futurist "Devil among the Tailors"', *English Review*, April 1912, reprinted in Osbert Sitwell, ed., *A Free House! Or the Artist as Craftsman. Being the Complete Writings of Walter Richard Sickert*, London, 1947, pp. 108 ff.
7. Virginia Woolf, *Walter Sickert. A Conversation*, London, 1934, reprinted in Virginia Woolf, *Collected Essays*, vol. 2, London, 1966, pp. 233 ff.
8. Richard Morphet in *The Late Sickert*, exhibition catalogue, London, Arts Council, 1972.
9. *A Free House!*, op. cit., p. xliii.
10. *The Nation*, October 1913, reprinted in Clive Bell, *Pot-Boilers*, London, 1918, p. 182.

ated by some massive energy that must be contained within a hard shell, the external form through which he looks out on to the world. Lewis found the art of Fry's circle too sensuous, too humanist and too detached from the contemporary world. For him, Fry's status as a historian of the Italian Renaissance was a disqualification from understanding the needs of modern art since his key traditions were those of Greece and Rome, which Lewis did not find rigorous enough for the twentieth century. Like Fry he appealed to tradition for authority, and chose, also, to consider himself a Classicist. But Lewis's Classicism was harder and more primitive, its inspiration being the taut, linear and frontal art of Byzantium and ancient Egypt, whose sharp, anti-humanist character made them, to him, more in keeping with the new machine age.

It is hard at first sight to see how a painter who could claim in his artistic manifesto in the periodical *Blast* (1914; Fig. 3) that 'the artist of the modern move-ment is a savage'[11] could also claim to be Classical. In an effort to distance himself from the Mediterranean tradition Lewis called Fry's Classicism Latin. He himself was searching for a more vigorous and specifically Northern art and his concept of Classicism relates to Nietzsche's belief in the importance of the Dionysiac, the energy hidden behind the Apollonian mask of Classical art. Lewis was careful to dissociate himself from Nietzsche when he fell from favour with the coming of the war, but the relationship was fundamental: Lewis's sympathy with German ideas was crucial to Vorticism and separates him from Fry. There is an immediacy of expression in Vorticism, a feeling of the artist directly representing the vitality of the modern world; the art is not the product of long contemplation apart from the cares of life, but arises straight out of it.

In *Kermesse* and the Futurist-influenced works of 1912, and again with his Tyros, the menacing and slightly comic figures of 1920-1 (Cat. 115), Lewis expressed the 'insidious volcanic chaos' in which, he said, 'any great Northern art should partake'. The clash of order and anarchy intrigued him. Humour he described as 'a phenome-non caused by the sudden pouring of culture into barbary... Intelligence electrified by naivety... Chaos invading concept'.[12] It is interesting to find Lewis joining Sickert in admiration of the earthy and anarchic humour of Rowlandson, and their mutual friend Osbert Sitwell proposing to Diaghilev the employment of Lewis to design an English ballet in the style of Rowlandson. Lewis was probably alone among British artists in having the sense of anarchy to have initiated what England badly needed to counteract the tameness of Bloomsbury art: a Dada movement, such as emerged a little haltingly and without issue in the Sitwells' collaboration with William Walton on *Façade* (1923). But Lewis's sense of burlesque was more than balanced by his strong respect for authority which was later to draw him towards Fascism. The government's scheme by which he and others became Official War Artists strengthened Lewis's conservative instincts. The discipline of war and the possibility of individual distinction within a rigid system met with his deliberate response: his major war commission, *A Battery Shelled* (Cat. 70), shows a respect for order and military virtue very different from the dashing commitment to death and glory of the great Romantic masterpieces of war.

Lewis's only equal among contemporary painters was Bomberg, who remained by choice formally outside the Vorticist group, though he shared many of its interests. Bomberg wanted to refashion in contemporary style traditional subjects which he personally identified with, such as religious themes and scenes from East End life. There are parallels with Stanley Spencer in Bomberg's interest in biblical and local life subjects, though for all the richness of emotion in Spencer's Neo-Primitivism, he lacked Bomberg's determination to face the modern movement squarely. While for the Vorticist Lewis, distancing art from the details of everyday life was essential, Bomberg's paintings *In the Hold* (Cat. 50) and *The Mud Bath* (Cat. 49) are direct responses to reality despite their degree of abstraction. Like Sickert and his own later pupils Auerbach and Kossoff, all of them painters of the London scene, Bomberg was a realist. While Lewis brought to his painting considerable powers of abstract thought, the uniqueness of Bomberg's *The Mud Bath* – a great painting of its time by

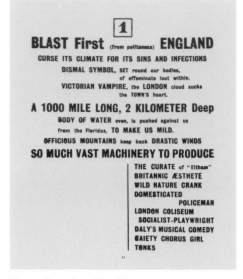

Fig. 3 Page from *Blast No. 1*, 1914

European not just British standards – lies in its capacity to surprise the viewer with new experiences at each encounter. Although Bomberg worked it out by means of sketches and designs like an Old Master, *The Mud Bath* conforms to no conventions of design; even in the final canvas the stick- and block-like shapes of swimmers in the water and round the edge of the bath seem freshly observed, and the sheer variety of the forms and the ways they interact mirror the exhilaration of the scene.

One of Lewis's targets in *Blast* was the British 'idée fixe of class, producing the most intense snobbery in the world'.[13] Lewis himself was an individualist, exclusive in the sense that he believed in the privileged position of the intellectual and society's duty to support him, but he was not a snob. Contemptuous of cliques, he saw Bloomsbury as a group privileged by birth more than talent, and was repelled. In reality, Bloomsbury was by no means a closed coterie and made approaches at different times and with different results to artists such as Spencer, Roberts and Gertler; it was nearer to being a real community than were the Lewis-dominated Vorticists. Mark Gertler's career, however, illustrates the tensions of being an outsider in the Bloomsbury group. Gertler knew that his art had a depth and substance that Fry's Bloomsbury could not match when he wrote in 1913: 'If God will help me put into my work that passion, that inspiration, that profundity of soul that I *know* I possess, I will triumph over those learned Cambridge youths'[14] and 'I don't want to be abstract and cater for a few hyper-intellectual maniacs. Besides I was born a working man. I haven't had a grand education and I don't understand all this abstract intellectual nonsense.'[15]

Gertler's early art seems modern not because it is Post-Impressionist but because it is hieratic, primitive and intense (see Cat. 75). In the course of the war the expression of energy in his work became more direct as he turned to subjects like boxers, wrestlers, dancers and divers, and there is a legacy of Futurism in his now lost painting of swing boats at a fair on Hampstead Heath. Working in a state of extreme nervous tension ('I have never felt quite like it before. I live in a constant state of over-excitement, so much do my work and conception thrill me'),[16] Gertler painted a second fairground scene, *The Merry-Go-Round* (Cat. 74). A brilliant evocation of the terror provoked by an automaton, sustained on its own power and beyond human control, the image resembles a machine of war and is at the same time a metaphor for the war as a whole. The intensity of the oranges and blues, colours unlike those that are found in most British painting of the period (although there are parallels with Lewis), and the hallucinatory effect of the rotatory movement, have been absorbed from the fairground machine and recast into a massive presence that is dreamlike but intensely real. The doll-like human figures are as wooden and incapable of controlling their own destinies as the horses they ride. They have something of the obstinate mindlessness of toy Kellies, which when pushed over always bob up again. They gape, open-mouthed – with, as far as one can judge from their expressions, exhilaration more than fear – so much are they caught up in and identified with a machine beyond their control.

D. H. Lawrence saw *The Merry-Go-Round* as a death cry of such potency that only a Jewish artist could have painted it,[17] because – in spite of the universal devastation of the war – only the Jews had experienced the degree of suffering that could make such a creation possible. Lawrence's reaction to his friend's work was personal and instinctive but arose out of the bond of understanding that he felt with Gertler as an artist of lower-class origin facing what he saw as a bloodless and effete culture. Like Gertler he responded to the primal and primitive, the immediate expression of emotion and anguish. Gertler's friend Sylvia Lynd wrote that this painting 'had much in common with the folk painting that can be seen on such things as merry-go-rounds and barrel organs and barges and cigar boxes'[18]. Augustus John had stimulated an interest among British artists in subjects like gipsies and costerwomen (Fig. 4), but what for him was largely a bohemian affectation for colourful types outside the normal run of society touched a deeper chord in Gertler. According to Sylvia Lynd, 'The gipsy gaudiness and vehemence were part of [Gertler's] instinctive nature, not a deliberate taste'.[19]

11. *Blast No. 1*, June 1914, p. 33.
12. Ibid., p. 38.
13. Ibid., p. 32.
14. Letter to Edward March, October 1913, in Noel Carrington, ed., *Mark Gertler. Selected Letters*, London, 1965, p. 57.
15. Letter to Dora Carrington, December 1913, in Noel Carrington, op. cit., p. 59.
16. Letter to William Rothenstein, 3 April 1916, in Noel Carrington, op. cit., p. 110.
17. D. H. Lawrence to Gertler, 9 October 1916, in Aldous Huxley, ed., *The Letters of D. H. Lawrence*, London, [1933] 1934, pp. 368-9.
18. Sylvia Lynd, 'Mark Gertler', in Noel Carrington, op. cit., p. 250.
19. Ibid.

Fig. 4　Augustus John, *Lyric Fantasy – The Blue Lake*, 1910-11. Tate Gallery, London

Gertler saw in traditional popular arts – the folk pottery, articulated wooden dolls and colourful fabrics and blankets that crop up again and again in his paintings – the expression of vigour badly needed by the modern tradition of high art. Gertler's figures and nudes in the Twenties have a rich sensuality, his pictures are embellished with unashamedly glamorous detail, there is an instinctive love of finery and display, richer than anything in Sickert's music-hall pictures but similar to some of the excesses of style and fashion in the slightly later watercolours of Edward Burra. Modernism and tradition came together most successfully in Gertler, and though it was surely deference to Bloomsbury taste that caused him to make his late work somewhat less exuberant, it is greatly to the credit of Fry that he welcomed warmly an artist so foreign to his declared ideas ('except for Gertler we are fearfully tasteful', he wrote to Vanessa Bell in 1918[20]).

A painter himself (Fig. 5) and sensitive to the multiplicity of choices facing the contemporary artist, Fry can sometimes be seen finding ways out of the straitjacket of theory to make room for art that he liked. Bell had a more severe mind and it was he, in *Since Cézanne* (1922), who used the Parthenon, Raphael and Derain as his exemplars in marking out a possible Classical aesthetic for the Twenties. However, the main direction of taste in Britain after the war turned out to be conservative rather than in any strict sense Classical; it seemed best served by a revival of the landscape tradition, and Bell's ideas were not fully realized in painting. The prevailing conservatism nevertheless accepted a powerful formalist insistence on structure and design. 'It's design that matters not subject,' Gertler wrote in 1924, retreating from his earlier position. 'The less subject the better. The artist of today expresses himself no longer by religion, romance or literary illustration but purely by design.'[21] Nash discussed his own work in similar terms[22] and these artists were by no means alone. Despite the achievement of painters like Spencer and Roberts, at no time more than in the Twenties did the constraints of taste and the confinement of art criticism within a formalist framework so limit art.

The slowness of the British response to Surrealism, surprising for a nation so strong in imaginative poetry and literature, can be partly ascribed to Bloomsbury – such a subjective and psychological art offended its Classical and Renaissance tenets – although the puritanical character of British taste was more deeply rooted than this and its persistence was a legacy still of Ruskin. In Britain in the Twenties the word primitive was more likely to refer to the Italian primitive painters, whose work was never more popular with British artists, than to the artefacts of primitive peoples, as was more common elsewhere in Europe. Fry responded perceptively to African art, but from a formal point of view; he was impressed by the sculptural qualities of African carving, but neither he nor anyone else (excepting Lewis, Epstein and Moore) saw anything in the richer, more colourful and narrative arts of the South Seas, the Pacific North-West and the Eskimos – the kinds of primitive art that stimulated the Surrealist imagination. Between the wars even Moore used primitive

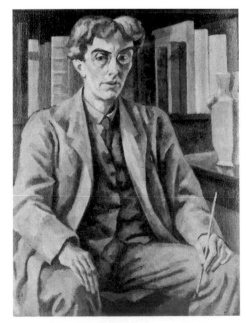

Fig. 5　Roger Fry, *Self-Portrait*, 1918. King's College, Cambridge

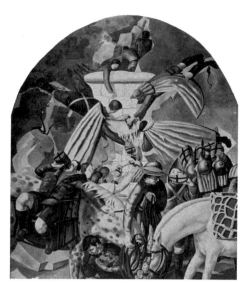

Fig. 6 Stanley Spencer, *Convoy of Wounded Men Filling Water-Bottles at a Stream*, 1932. South wall, Sandham Memorial Chapel, Burghclere

influences in his sculpture in a measured, cautious way, notwithstanding the drawings he made over the same period. It is a virtue of his work that he was not impulsive and his art, like that of Nash and Nicholson, progressed logically and steadily over many years. Fry's insistence on formal values established the framework for avant-garde British art between the wars; even if it held artists back from the highest flights of the imagination, it nevertheless provided a grounding for solid progress in the basic disciplines of Modernism.

To remain free of formalist orthodoxy needed the independence and effort of will evident in Roberts, Spencer and Burra. Roberts was acutely sensitive to issues of social class and his paintings of the Twenties are dedicated to everyday people, who are seen scrubbing and sweeping, queuing for buses, reading newspapers in public parks, relaxing in cafés and dance halls, and engaging in popular leisure pursuits like cycling and boxing. Although Roberts seems completely serious in his comments, an element of caricature enters his work, exaggerated facial features sometimes recalling Lewis's Tyros. The surprise tends to be in the drawing rather than the designs, and the compositions have the sense of being modern urban conversation pieces, counterparts – or parodies, even – of the leisured rural prototypes from the eighteenth century which seem to be echoed in Bloomsbury painting in the Twenties.

Stanley Spencer's passionate need to make his life and fantasies into art overrode any theoretical interest he might have developed in pictorial language. Odd as it may seem now, Bell chose him for inclusion in the Second Post-Impressionist Exhibition on the basis of a brilliant student performance at the Slade which left a vestigial Frenchness in his painting. But Spencer remained resolutely his own man. Obsessed with linear outline and narrative detail, he never turned his back on the Victorian values so alien to Modernists of his generation, although the sheer intensity of his vision has no real parallel in the more controlled expression of Victorian art, excepting perhaps that of the Pre-Raphaelites. The vision of Blake and the passion of Fuseli support Spencer's art. His extraordinary and ingeniously worked out concept of a brotherhood of man pursuing God's purpose on earth emerged in his paintings of the First World War in the Sandham Memorial Chapel at Burghclere (Fig. 6); it reappears in the early Thirties in the series of pictures that bring together scenes of his native village of Cookham with incidents from the New Testament, and occurs yet again in the Port Glasgow shipbuilding series from the Second World War (Cat. 107). No other painter saw the First World War as a source of anything but deep anguish and pessimism. Spencer's attempt to build an unorthodox Christian cosmology for the modern world recalls Blake, while his naive optimism for human brotherhood belongs more to Whitman, whose visionary socialism had a massive impact during Spencer's youth.

The self-protective armour against the modern world, which is partly what Spencer's fantasies were, nevertheless had chinks. The extreme nervous intensity of the early painting *The Centurion's Servant* (Cat. 102), and the budding adolescent sexuality which the picture seems to express, speak for a nervous horror that looks ahead to the work of Francis Bacon. Spencer was a slow emotional developer, and his fantasies of boyish community in the Burghclere paintings mask repressions that had surfaced by the mid-Thirties: by then in grave marital difficulties that he had no capacity to resolve, Spencer – who had not painted nudes before, despite the upsurge of interest in the subject caused by the Classical orientation of the Twenties – suddenly made a series of harsh and tormented nude portraits of his second wife, two of them including himself naked as well (Cat. 104). No privacy is permitted in these pictures, which are painted as if under floodlights. They have been compared with the paintings of the *Neue Sachlichkeit* in Germany,[23] but they are more bitter and confrontational than the stylish double nude portraits of Christian Schad, for example, in Germany, or Edward Hopper's voyeuristic canvases in the United States.

Burra too retained the detail and draughtsmanship of a past age, resuscitating without apology those traditions of illustration, satire and caricature from Hogarth through Gillray to Cruikshank that Sickert commended. In some ways, however, Burra was Spencer's opposite. Where Spencer's constructive vision led him to con-

20. Quoted by John Woodeson in *Mark Gertler*, London, 1972, p. 251.

21. Letter to Dora Carrington, in Noel Carrington, op. cit., p. 211.

22. See Paul Nash to Gordon Bottomley, 22 April 1925, in Claud Colleer Abott and Anthony Bertram, eds, *Poet and Painter. Being the Correspondence between Gordon Bottomley and Paul Nash*, Oxford, 1955, p. 184.

23. By J. T. Soby in *Contemporary Painters*, New York, 1948, p. 129.

centrate on work as a subject, the more sceptical Burra concentrated on leisure. By no means naive like Spencer, Burra took a knowing look at contemporary society and viewed it with amusement and some contempt. He revelled in fashion and had a sharp eye for physique and gesture. His favourite subjects were clubs and music halls, dominated by style and artifice, and the shadier cosmopolitan areas of the cities among the streetwise pimps and traders, where he found panache and authenticity in contrast to the languor and pretence of the beau monde.

Burra experimented with collage and adapted montage effects learned from Dada and the cinema, in order to create emphases and dislocations in his designs, to challenge logic and give life to his fantasies (Fig. 7). He was more open to the use of new media such as collage than most British artists of the period, and tended also to unorthodox interests in the past, as for instance in *The Three Fates* (Cat. 126). While the taste of Bloomsbury and many other artists between the wars was for the early Renaissance and styles that have the clarity and purity associated with early stages of aesthetic developments, Burra's stylish and decorative paintings share the ambiguities and distortions of Mannerism and the decorative and diffuse character of the Rococo, forms of expression that usually come in the declining phases of artistic cycles.

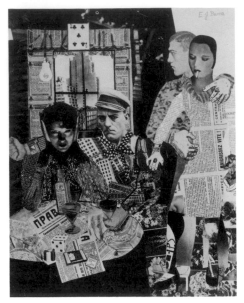

Fig. 7 Edward Burra, *Composition*, 1930. Private collection

Burra's name was often coupled with Beardsley's, and he was vulnerable to the kind of attack that Fry, in his most Ruskinian mood, launched at Beardsley, describing the natural draughtsman's talent as vitiated by 'moral perversity that actually prevented him being a great designer'.[24] Like Beardsley, Burra implicitly rejected Ruskin's belief in art as an instrument of moral improvement, and his work is an example of the 'delight in the forms of the burlesque' which Ruskin disliked, and which, as the pessimistic, even misanthropic Burra would have agreed, 'are connected in some degree with the foulness of evil'.[25]

The first serious challenges to Fry in print – aside from the earlier jibes of Lewis in *Blast* – came in Herbert Read's obituaries of him in 1934.[26] Read, who was then beginning to be interested in Marxism and in art as a reflection of the whole of society, regarded Fry's high valuation of taste and refinement as divorced from the new order of twentieth-century life: 'Faced with the machine, mass production and universal education, Fry could only retreat into the private world of his own sensibility.' Read also took issue with Fry's confinement of art to expressing the fully developed consciousness, because a role as mirror of the instinctive life was thus denied it. He instanced Picasso and the Surrealists as evidence that the concerns of art had shifted from the cultivated sensibility exemplified by Bloomsbury to the instinctive. Fry, he pointed out, had been out of sympathy both with Surrealism ('he was enormously interested in the psychology of art but hated anything in the nature of psychological art') and also with Germany ('he had the greatest difficulty appreciating German art of any period...he simply loathed the more recent developments of Expressionism').

The consolidation of Surrealism in the late Thirties, together with the dispersal of German culture through Europe under Nazi pressure, led to an artistic climate in Britain quite different from that of the cool, French-dominated Post-Impressionist Twenties, as there came into being an art that was emotionally more intense than anything in Britain since Vorticism. For a brief moment Read had been a Vorticist-influenced painter and an admirer of Lewis, and had declared an early allegiance to Nietzsche. He laid heavy stress, especially in his *Contemporary British Art* (1951), on Expressionism.[27] For Read this was neither a style nor the property of a single period but a recurrent Northern trait, a form of art that gives primacy to the artist's emotional reactions, an art concerned not with beauty but with tragedy, neurosis and sentiment. Read proposed a broad definition for Expressionism, to include most art that did not relate to the School of Paris. He regarded it as the characteristic style of the Jews, and included Burra and Spencer within the category. He pointed out that there had existed a tendency on the part of critics – Fry's attitude to Spencer could be cited as typical – to set this kind of art apart, not to condemn it but to identify it as a separate issue apart from the mainstream. Read was attracted, as

Lewis had been, to the idea of a vital Northern art with which to challenge the contemporary supremacy of Latin culture, which he also associated with Fry. It is no surprise to find Lewis himself making something of a comeback in the Forties, less as a painter than as a writer, speaking up for such artists as Bomberg, Burra and Bacon.[28]

Sutherland in his metamorphic Surrealism of the late Thirties recovered the intensity of colour characteristic of Vorticism but absent from the post-war art of Bloomsbury and its successors. In these strange compositions sudden changes are precipitated: tiny fleeing figures are on the point of being swallowed up by the earth; vegetable to animal transformations are implied by prickly root and plant forms. In Nash's paintings of the same time the dry paint surfaces and low-keyed colouring of the Unit One period give way to the grander conceptions and more expansive colours of the late landscapes. Nash's vision of men as subject to the cycles of seasons and tides and the rising and setting of sun and moon gives his work breadth and distinction even if it is less immediately arresting than Sutherland's. Nash was more of the eighteenth century, Sutherland a full-blooded Romantic. An older artist, and nearer to Fry in age, Nash retained an allegiance to Fry that the younger generation did not feel.

By 1950 Nash was dead, and Sutherland's painting was losing its hallucinatory intensity. Painting in England was in the same uncertain state as when Sickert returned from Dieppe in 1905. The graphic qualities of 1940s Neo-Romanticism bear comparison with the strength of British illustration in the 1890s. Sickert's reaction to the enfeebled state of painting (admittedly he saw Whistler as the culprit more than the illustrators) was his reinvigoration of figure painting through impasto. This has parallels in the Fifties in the painting of Bacon and the younger Auerbach and Kossoff. At the same time there was the forging of links between the fine and other arts pursued by the Independent Group at the Institute of Contemporary Arts, which was ultimately to develop into Pop Art. Yet another course was towards abstraction under the leadership of Nicholson, who painted several of his most commanding pictures at the beginning of the Fifties. Though the half century was a moment of new beginnings, the kind of formalism that Fry had proposed was far from dead. Indeed, the very weaknesses that Neo-Romanticism exposed justified the kind of rigorous diagnosis and treatment that Fry had carried out earlier and which Patrick Heron now pursued. In the Sixties his influence was supplemented by Clement Greenberg's theories of Formalist Modernism which spread from the United States. However, there was a crucial intervention between Fry's period and recent decades, namely Surrealism, staking claims for the unfettered creative imagination. Though contested – notably in the Sixties by 'Situation' artists – these claims have ultimately proved unassailable.

Although British Surrealism was itself quite a modest affair, Surrealism has been of immense importance as a stimulus to later artists from Bacon through Paolozzi to Kitaj, and to younger artists (especially sculptors) today. This is especially clear in the work of Francis Bacon. Historically Bacon has been decisive in bringing figure painting back to the centre of artistic activity. He has adapted the Surrealist use of 'chance' in painting as a trigger of emotional release, and shown how chance, used in this way, can express energy, even violence, in the human figure without recourse to the traditional outline drawing used by Spencer and Burra.

Bacon insists that painting is a record of fact, a report that returns an image to the viewer, and in this sense he is a realist.[29] He wants to avoid being an illustrator or communicating meaning through narrative rather than paint marks. He conceives of the abstract brushmark laid on the canvas as a stimulus, as something that unlocks the imagination, encouraging the development of other marks and gradually leading him back to an image of the sitter. The resulting image will reverberate more poignantly on the nervous system than an imitative drawn outline would. This approach separates Bacon from his figurative predecessors (Sickert partially excepted) and establishes a new set of possibilities for figure painting that has not yet been fully explored.

24. Roger Fry, 'Aubrey Beardsley's Drawings', in *The Athenaeum*, 1904, reprinted in *Vision and Design*, op. cit., p. 188.
25. Quoted by Herbert Read in 'Reflections on English Art', *Burlington Magazine*, November 1933.
26. The obituaries appeared in *The Spectator* and *The Listener*, and a composite of the two in Herbert Read, *A Coat of Many Colours*, London, 1947, pp. 282-91.
27. H. Read, *Contemporary British Art*, Harmondsworth, Middx, 1951; see especially pp. 18-20 for the ideas referred to here.
28. See Walter Michel and C. J. Fox, eds, *Wyndham Lewis on Art. Collected Writings 1913-1956*, London, 1969, pp. 393-4.
29. See David Sylvester, *Interviews with Francis Bacon*, enlarged edition, London, 1980, p. 60. This book has been drawn upon further below; see especially pp. 8 and 58.

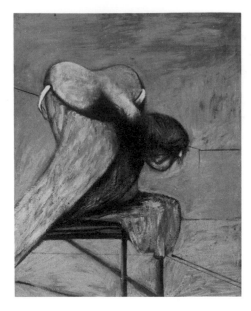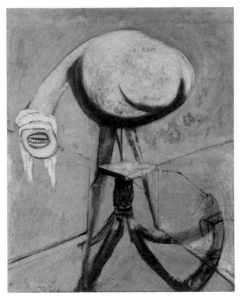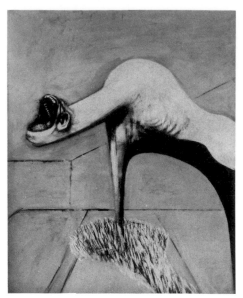

Much of Bacon's art, from the earliest work through the 1944 *Three Studies for Figures at the Base of a Crucifixion* (Fig. 8) to many later portraits and figures, owes a debt to Picasso's figure painting of around 1930, from which, Bacon has said, artists still have much to learn. These are extreme works even by Picasso's standards, in which the figures are not simply opened up, as in Cubism, and, as it were, peered into; they are bodies without outsides, with no skin or shell to mediate between the viewer and the expression of an intense, almost animal, vitality. Bacon was able to relate to Picasso more directly than Sutherland did because his reaction to human presence and vitality was, like Picassos's, immediate and unequivocal, while Sutherland's was through metaphor amplified by the evocation of mood. Although Bacon's work around 1950 is more figurative than the *Three Studies*, the theme has not really changed. The aggressive centrality of the mouth in Bacon's Popes and animal heads is another way of showing energy compressed, with the screaming mouth as a concentration of the muscular power of the body into a single organ. The paintings have the directness and clarity which Bacon has always looked for without sacrifice of power. Increasingly Bacon's subjects have been taken from life; they are figures in rooms or occasionally in the street; they eat, drink, read newspapers and make love, and, vital but unidealized, they resemble Sickert's subjects in a more agitated world.

The most surprising sidelight on British critical appreciation in the Forties and Fifties was the neglect of Bomberg. Read's identification of a vein of Expressionism in British art, his admiration for Lewis and Vorticism, and his recognition of Britain's special debt to Jewish artists, did not extend to an interest in Bomberg. The Expressionism Read defined was a linear rather than painterly art, and the British eye had trouble adjusting to Bomberg's landscapes and portraits with their swathes and patches of rich, glowing colour. An art in which drawing and painting were not two separate activities but one and the same thing had found no place in British art since Turner.

Just as the power of *The Mud Bath* stemmed from its truth to life, so the later works, though quite different in style, are mirrors of experience. The shifting planes and viewpoints in the landscapes suggest the artist exploring the motif, studying it from one point and then another. 'It is as if the painter, in contemplating the landscape out there, had felt he was feeling his way over it with his hands and feet and knees,' David Sylvester has written. 'It is as if the contact was so close that the painter had gone beyond being in the landscape and become the landscape.'[30] Bomberg was here opening up possibilities for the immediate translation of experience into paint in a way that had not been explored in Britain this century and was developed further and on a grander scale by Peter Lanyon from the mid-Fifties.

Fig. 8 Francis Bacon, *Three Studies for Figures at the Base of a Crucifixion*, 1944. Tate Gallery, London

30. David Sylvester, Introduction to *David Bomberg 1890-1957*, exhibition catalogue, Marlborough New London Gallery, March 1964.
31. Unpublished ms. quoted by Richard Morphet in introduction to *The Hard Won Image*, exhibition catalogue, London, Tate Gallery, 1984, p. 45.
32. P. Heron, *The Changing Forms of Art*, London, 1955, p. 81.
33. Ibid., p. ix.

A comparison with Ivon Hitchens, who came in the Forties to share Bomberg's unusual painterliness, illustrates the uniqueness of Bomberg's position at that time. Hitchens's paintings of tangled undergrowth, light filtering through branches and dark woodland rides, combine a personal response to nature with a search for structure and underlying form. Hitchens liked to gather and organize his forms, while for Bomberg sensations were enough; there was no urge to idealize whether in landscape or figure painting.

Bomberg has been linked in the tradition of painterly Expressionism with two of his pupils, Frank Auerbach and Leon Kossoff. Auerbach's concern, expressed in interviews, to escape from illustration resembles Bacon's. His and Kossoff's response to illustrative Neo-Romanticism and later to descriptive 'Kitchen Sink' realism was to use impasto to grasp as fully as possible the character of a subject, its substance, weight and potential for movement. But bracketing Kossoff with Auerbach has its dangers, because Kossoff's painting, especially since 1970, has acquired an entirely individual expressive character. His portraits are often very large and seem even larger than they are because the contours of the figures tend to push up against the edges of the canvas. Apparently less worried than Auerbach at the risk of being regarded as an illustrator, Kossoff introduces powerful facial expression and moodiness with a furrowed brow, sad, staring eyes, the melancholy tilt of a head and big, clasped hands. Using thick, blunt lines he creates figures who are commanding presences but can at the same time seem nervous and insecure. Helen Lessore has characterized them sensitively as having 'a total absence of idealizing in the classic sense The idealizing is in the character of moral qualities, above all endurance; the figures, more often than not, are ungainly women . . . and are often, one feels, a heroic spirit almost bursting out of its inadequate and hampering body, and the heads are tilted not in elegance but weariness.'[31] The painting in Kossoff's portraits is more raw than Auerbach's, while in his urban landscapes and swimming-bath scenes it often has a fragmented and scattered look which makes it hard for the eye to bring the paintings into focus or unity. No painter today is more determined to eliminate the elegance of Frenchified taste.

Painters with either Surrealist or Expressionist leanings had little appeal for Patrick Heron, whose formalist vocabulary used in his writings from the late Forties resembles in many respects that of Fry, and Heron's ideas, like Fry's, were logical in the conditions of their times. Heron effectively promoted much that was best in British art in the Fifties, seeing painting – rather as Fry did – divided between the heroes of the great Classical tradition such as Poussin, Cézanne and Braque, and others like Memling and Brueghel, Blake and Sutherland, in whom pictorial integrity was compromised by concentration on particulars and lack of a binding harmony. Heron's holding Picasso's 'protean invention' and 'unfailing drama'[32] in lower esteem than the painting of Braque suggests the same negative response to Expressionism as Fry's; he also put a low valuation on Surrealism. Summarizing his position in 1955, Heron wrote: 'Form is content now, so analysis of form . . . has become the chief critical function of the day. . . . Personally I believe that formal criticism is still in its infancy.'[33]

Heron's formalist ideas are reflected in the painting of the artists centred on St Ives whom he wrote about. But the unity of St Ives painting as a body of work exploring the borderland between nature and abstraction can be too readily assumed. Peter Lanyon fits uneasily into Heron's pattern. The passion and dynamism of his mature painting has more in it of the 'protean invention' of Picasso than of Braque. Lanyon's reworking of personal experience of nature in the studio was a cumulative and constructive process, in which information from the senses was built into each layer and corner of paint, rather than a gestural or expressive one (Fig. 9). But Lanyon's openness to American Abstract Expressionism sustained the vitality of his painting and enabled him to break away from Nicholson's art which had been the springboard for St Ives painting in 1950 but ended the decade as a constraint.

Although Heron prepared the ground for the British reception of ideas from the United States from the late Fifties, the tendency in the more extreme form of

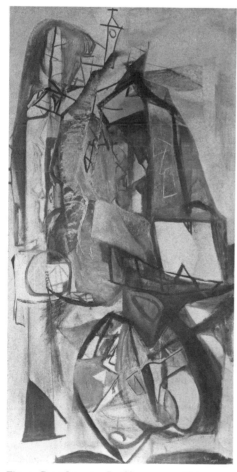

Fig. 9 Peter Lanyon, *Porthleven*, 1951. Tate Gallery, London

American Modernist thinking to separate art from life completely was foreign to Heron's thinking. To make the work of art an object in its own right, equivalent to, but separate from, objects in life, was indeed a concept that met with considerable resistance in Britain, where there was a sense that art and life were not distinct in this way. Moore's search in the Thirties for a middle course between the abstract and the figurative seems characteristically British, and even the Sixties work of Caro had ideas originating in the figure and landscape flowing through it.

St Ives painting is proof of the tenacious grip of landscape or nature, at least in its widest sense, on British painting. Surrealism in this country had been the same; it was less successful with urban themes or, in painting at least, with the figure. The virtual absence of Dada helps to account for the lack of adventure with new media, like collage, which were ideal means of reflecting the fragmented, discontinuous, multi-layered character of the modern urban world. Burra's work was the obvious exception, but his collages of around 1930 (Fig. 7) were unknown to artists like Paolozzi and Hamilton, who were to establish a new urban art for the post-war years, and it was largely in Paris that Paolozzi, the post-war pioneer in collage (Fig. 10), discovered what Surrealism had made of the medium.

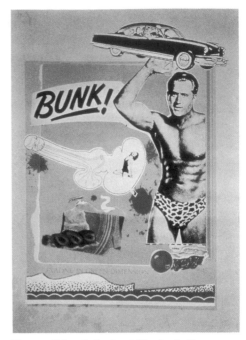

Fig. 10 Eduardo Paolozzi, 'Evadne in Green Dimension', from *Bunk*, 1952. Victoria and Albert Museum, London

The return to full employment with the war, the beginnings of the welfare state, consumerism and increasing prosperity that followed it, and the coming together of contemporary architecture, design and the arts with other aspects of life in the Festival of Britain of 1951 (Fig. 11), all, in effect, helped to call into question the leading role of landscape in British art since 1918 and to challenge the image of the isolated artist fostered by the Neo-Romantic movement of the Forties. Landscape continued to be central to painting in St Ives in the Fifties. But more and more the need was obvious for an art that would move away from the generous spaces of the countryside, which had served a regenerative purpose after the First World War, to the changing social environment, which was inevitably more urban.

From 1952 the Independent Group centred on the Institute of Contemporary Arts in London, which included Hamilton and Paolozzi, the critic Lawrence Alloway and the art historian and critic Reyner Banham, began to open up in discussion themes connected with the impact of contemporary technology and the popular media. One outcome was the photographic exhibition 'Parallel of Art and Life' (1953), the very title of which marked the rejection of the distinction which formalist theory and much of inter-war art stood for. Alloway developed a non-hierarchical theory of visual expression in which the traditional pyramid with fine art firmly at the top was abandoned, and popular graphics and cinema, for example, became the equals of painting and sculpture. Art was no longer thought of in terms of rigid formal concepts or specific styles.

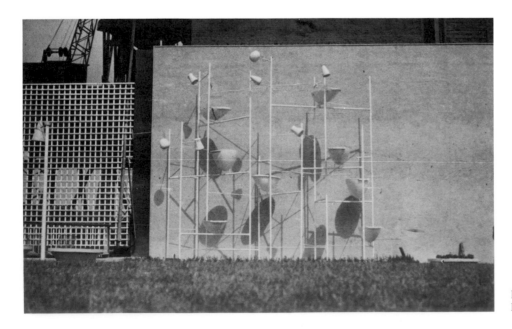

Fig. 11 Eduardo Paolozzi, *Fountain*. Festival of Britain, 1951

Fig. 12 Richard Hamilton, *Aah!*, 1962.
Hessisches Landesmuseum, Darmstadt

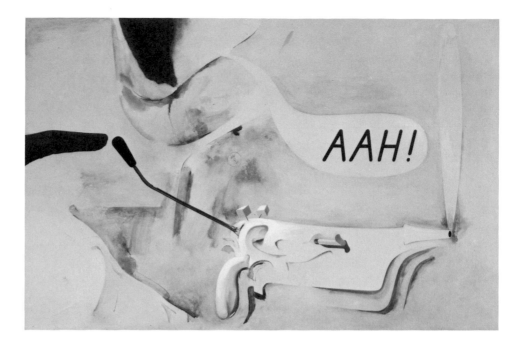

34. Richard Hamilton, 'Art and Design', lecture
 at a National Union of Teachers conference,
 October 1960, on the theme 'Popular Culture
 and Personal Responsibility', in Richard
 Hamilton, *Collected Words 1953-1982*, Lon-
 don, n. d., p. 151.

Hamilton is a subtle and urbane artist, looking at social habits and styles and the
contemporary myths that have grown up around them, as well as the visual
languages, especially of advertising, through which they are presented. His art has
dealt with the accessible worlds of leisure and consumerism, but not on a truly
popular level. Hamilton has for the most part treated graphics and popular cinema
not as equals of fine art but as subjects for fine art to study and comment on. He
recognized the rejuvenating potential of popular culture: 'Popular art, as distinct
from fine art, art created by the people, anonymously, crudely and with a healthy
vigour, does not exist today. Its present day equivalent, pop art, is now a consumer
product absorbed by the total population but created for it by the mass entertain-
ment machine The results are highly personalized and sophisticated, but also
have a healthy vigour.'[34] Hamilton's wit and irony, visual puns and punning titles
attain a high level of sophistication. His reduction of a sexy model to nothing but a
collage of her lips and the skeleton of her bra, or the play of images that conjures up
Michelangelo's *Creation of Adam* from the Sistine Chapel while actually showing a
driver's finger touch a gear lever (Fig. 12), introduces complex levels of reference that
tease and excite in a way that only an artist thoroughly versed in Dada and Surreal-
ism – and especially the irony of Duchamp – could attempt.

Hamilton's insight into contemporary visual culture is matched by a wide-ranging
knowledge of twentieth-century art as a whole. The Independent Group paid more
serious attention to Dada than anyone in Britain before and brought Futurism back
to the centre of the stage for the first time since 1914. The puritanical bent of British
taste was condemned – both Fry and Lewis came under attack at different times –
and this made possible a fresh evaluation of the urban, dynamic and sensuous
character of Futurism. Banham's book *Theory and Design in the First Machine Age*
(1960) argued that modern architecture was rooted in symbol and fantasy as well as
function and that the Futurist dream of an ideal machine age was an underlying link
connecting the different manifestations of Modernism. Hamilton's individualist,
colourful and fragmented art is also about dreams and fantasies. His own interest in
Futurism went back to the early Fifties, emerging most clearly in the exhibition
'Man, Machine and Motion' which he put on with Lawrence Gowing at the Institute
of Contemporary Arts in 1955, on the theme of the ways the machine has extended
man's powers and stimulated technological dreams.

Hamilton was also drawn to the glamour of modern life. Styles and fashions are
reviewed in his work by an eye as satirical at times as Burra's. In works such as *Just
what is it that makes today's homes so different, so appealing?* (Fig. 13) he uses the same
weird juxtaposition of images as Burra (who would particularly have liked the por-

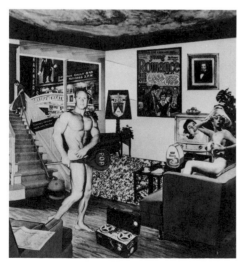

Fig. 13 Richard Hamilton, *Just what is it that
makes today's homes so different, so appealing?*, 1956.
Kunsthalle, Tübingen

trait of Ruskin looking down from the walls of Hamilton's ideal home), as well as his Mannerist changes of scale. Hamilton rejected any fixed norms of design or type forms; he greeted with withering dismissal Lewis Mumford's argument for the defence of Bauhaus design that once the right form for a type of artefact had been achieved, the artefact should keep that form for a generation or even a thousand years, changing only in response to radical social or technical advance. Design, said Mumford, 'should not be subject to the self-indulgent caprices of men', to which Hamilton replied scathingly, condemning Mumford's 'cold expression of the death wish' and thanking God for self-indulgent human caprices.[35]

Looking from a different viewpoint, figurative painters like Hockney and Kitaj have seen Modernism as a necessary part of their inheritance – even if in recent work they have largely transcended it. Hockney believes that the battle for modern art that started with Fry's Post-Impressionist exhibitions has been won, that the complexity and richness of the Modern Movement are such that any artist should be able to find a personal synthesis within it, and that to ignore such a wealth of ideas is foolish self-limitation.[36] Observation may provide the basic material for his art, but poetry, photography and numerous kinds of graphic work, as well as other artists' paintings – especially abstract ones – have all been grist to Hockney's mill. Like Hamilton he is interested not just in life as lived, but also in the popular conceptions and myths surrounding it, in the way we expect things to be or think we know they are. The swimming pools, lawns and sprinklers, cardboard architecture and modern outdoor sculpture in Hockney's disturbingly passive California paintings are neatly poised between fiction or dream and reality. Who except the artist can say what was true to life and what came from a real-estate brochure? The unity of style in these paintings conceals more completely than in Hamilton's art, or indeed than in the ironical play on styles in Hockney's own earlier canvases (for instance, Cat. 260), the seams where art and life meet.

With Kitaj, on the other hand, the seams remain and – at least until his recent work – his paintings have retained a collage-like effect; the treatment of themes has been disjunctive, filmic in its shifts of scale and emphasis, and often dreamlike (see Cat. 258). His pictures are also like collages in the sense that layers of pictorial allusion – sometimes amplified by verbal statements by the artist – build up meaning for the viewer, stimulate the imagination but never close off speculation by speaking too plainly. Kitaj chooses subjects that are emotionally intense and intellectually complex and often relate to life on the periphery of normal society: visionary Socialists, anarchists, exiles, political victims, prostitutes and mobsters. The multiple focus of Kitaj's collage-like technique suits the world of fragments he exposes, his picture of a world with many active nuclei but lacking the linking mechanisms that would harness and synthesize the various energies. His art makes contact with the splintered character of Dada and has connections with Surrealism, too, both on account of the juxtaposition of disparate elements and through Kitaj's interest in the arcane world of alchemy and Renaissance humanism shared with later manifestations of the movement.

Though neither Kitaj's literary-intellectual art nor Hockney's autobiographical painting altogether match up to the common understanding of Pop Art, both belonged to the group that emerged from the Royal College of Art in the early Sixties and has become known as the second generation of Pop artists (after Hamilton and Paolozzi). Even if different aspects of Hamilton's earlier definition of Pop – as urban, sexy, witty, glamorous and reliant on non-fine arts – apply to each member of the group, there was no single common aim. City life has not engaged artists' attention so fully since 1914, but to treat Pop Art simply as a reflection of swinging London of the Sixties would be to miss its subtlety and variety.

Like Hockney's contemporary Tea paintings, suggested by a packet of Typhoo in the artist's studio, Allen Jones chose to paint buses because they were a regular part of his life when he was travelling into London daily from the suburbs (Cat. 259). The subtlety of both groups of paintings lies in the manipulation of images through use of shaped canvas. Jones's rhomboid infers movement not by means of the repeated

35. Ibid.
36. *David Hockney by David Hockney*, ed. Nikos Stangos, London, 1976, pp. 128-9.

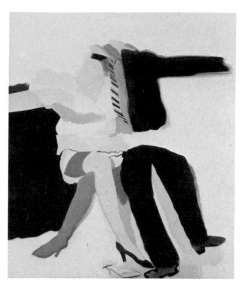

Fig. 14 Allen Jones, *Man Woman*, 1963. Tate Gallery, London

images of Futurism but through a single still image on a canvas shaped to suggest forward thrust; movement is also indicated through the wheels attached on separate canvases and the cloudy out-of-focus effects of parts of the picture.

Jones's subsequent paintings centred on the male and female figure: they dance, coalesce, become androgynes; melded together their heads become a parachute, and the female body – legs, stockings and suspenders – undergoes a bizarre transformation into a war medal. There is great resource in the way the artist joins images and takes them apart, turns them upside down to alter meaning, and conducts the viewer through a startling range of Surrealist-type metamorphoses. As with Hockney's play on images and styles the viewer is actively drawn in rather than remaining a passive spectator, because the pictures are like puzzles presenting shapes to be decoded. Butting up against areas of precise definition, gaps, blurs and unfinished areas suggest ambiguities and leave room for the viewer's imagined solutions. Jones has explained in interviews an interest in the sensual world and the balance of male and female qualities gained from reading Nietzsche and Jung among others. These ideas are obviously starting-off points but there is no pedantry; engagement with historical or intellectual notions is balanced by ironical detachment (Fig. 14).

Patrick Caulfield in his *Portrait of Juan Gris* (Cat. 264) is also preoccupied with languages of art and the enigmas created by confronting opposing ones. A motionless image of the Cubist painter is presented on a blank yellow ground between stick-like shapes related to Gris's own work in the Twenties. Apart from the stick shapes there is nothing in Caulfield's painting reminiscent of Gris's, and even they are mere references since they do not function formally as they would in a Cubist painting. There is a wilfulness in the clash of conventions presented here, a determination to challenge assumptions which has something in common with Picasso's reflections on truth and falsehood in his Artist and Model variants, in which the artist is seen observing a model but scribbling abstractions on his drawing board. Like the naive painter, which he is not, Caulfield recognizes the power of stillness to keep images in an 'art' context so that they do not become too life-like.

Aestheticism was important in Pop Art, which communicated obliquely, its characteristic device being irony. Polemics were rarely the Pop artists' domain, as they have been that of Gilbert & George. Gilbert & George's photo-pieces still speak to some extent in coded messages; these artists too use ironical – and in their bitterer moments, sardonic – humour. But compared with Pop artists they communicate directly and with a power of expression matched among living painters only by Bacon. Parallels do exist with Pop, in the billboard scale, sharply defined images and, recently, the bright even lurid colouring. Like Pop artists Gilbert & George are concerned with glamour, but behind the glitter there is sickness. The optimism of the Sixties has given way to corruption and malaise. They have readily tackled a number of the great subjects of art – religion, violence, eroticism and death – which they express through contemporary images of repression and racialism, militarism, perversion and drunkenness. Even the sweeter side of life manifested in flowers and gardens is marred by a sickly overripeness. There is glamour in Royalty in the postal sculptures, as there is also in military uniforms and the jackboot. Gilbert & George's working-class heroes stand on the borders of innocence and menace, there is nostalgia in their art for a primal virtue, but their engagement is with a dark world – a world, indeed, that grows increasingly threatening in recent close-up studies of body openings that lose nothing of their grossness by association with fruits and flowers. The sequence of the titles they have chosen for their exhibitions, from 'Dark Shadows' (1964) to 'Bloody Life' (1975) and 'Modern Fears' (1980), speaks for their attitudes.

The sardonic humour in Gilbert & George's work has clear parallels with that in Burra's. But it acts for them much less than for Burra as a means of release from the terrors of the world. This is because their expression is so direct; their work may be eccentric, but it has a certain plainness with clear simple drawing, well-spaced forms presented frontally and whole. In Old Master terms they might be regarded as Baroque artists (their religious concerns mingled with common reality recall

Caravaggio) rather than Mannerists with quirky and wilful ambiguities of drawing and space. The grids dividing their photo-pieces are rooted in minimalism, and despite the imagery and colour, there is a classic purity in their art.

Recently Hockney, Kitaj and a few others have rejected the notion of progress in art, which is at the heart of Modernist belief, and the accompanying idea of the avant-garde as a leadership group. They have laid stress not on the importance of specific artistic traditions, as Modernism has, but on the freedom of the artist to use the whole of art, and indeed life, as a sourcebook. It is a role parallel to that played by Sickert earlier in the century and has helped bring narrative figure painting back to the centre of the stage where Sickert wanted it to be. The revaluation of subject painting represents a kind of victory for the opponents of formalism. But the very freedom from constraints about how a picture should be made opens the door to that excessive individualism of which Fry complained.

At the beginning of this essay I noted the influence of aspects of public and personal life, and of other arts such as literature and poetry, that have contributed to the richness and variety of British painting. These beneficial elements, if pursued too single-mindedly, can also allow an artist to forget that painting is a particular profession, different from any other and possessing its own ground rules which are the framework within which a painter exercises self-criticism. The decline of talent brought about by this lack of periodic self-criticism, by the artist's failure to test himself against the standards of his profession, makes the corrective contribution of a theorist such as Fry so salutory.

Richard Cork

The Emancipation of Modern British Sculpture

During the course of the twentieth century British sculpture has played a conspicuously vigorous, inventive and challenging role. Not only did it produce, in Henry Moore, the most outstanding British artist of his time; it also ensured that sculpture need no longer be regarded as inferior or constricted in comparison with painting. There have been several periods in the present century when the work made by sculptors appeared just as vital as contemporary developments in painting. Indeed, it could even be claimed that sculpture often took the lead in questioning and extending the accepted limits of visual art. Time and again, sculptors have claimed for themselves the right to overthrow prevailing shibboleths of the period, thereby opening up the activity called 'art' to a far broader range of expressive possibilities than had hitherto been permitted.

Sculpture became the vehicle for Epstein to explore sexuality, procreation and the relationship between youth and old age with a frankness which provoked an opprobrium he defied to the very end of his career. It awakened, with the help of London's great ethnographic collections, an awareness of cultures far beyond the narrow European boundaries from which sculptors in this country had formerly drawn their exclusive inspiration. It became the means whereby Hepworth proved that a woman could become an artist of the first order in a world overshadowed, to a stifling extent, by male practitioners. It was instrumental in stimulating, at the end of the 1960s and beyond, a debate about alternative materials, strategies and social territories which is still very alive today. And it attracted the energies in the 1980s of an emergent generation of sculptors whose work invariably seems more impressive, in Britain at least, than the 'new painting' practised by so many of their contemporaries. Sculpture at present demands and deserves just as much attention as any other form of art, and its youngest exponents are undoubtedly stimulated by the realization that a long and remarkable line of men and women have emancipated British sculpture and made it a force of considerable international significance over the last eighty years or more.

The temptation to offer a crude contrast between these achievements and the sculpture made in Britain during the previous century should be resisted. In recent years art-historical attention has been focused on neglected aspects of Victorian sculpture.[1] It has been established that the legacy inherited by the leading sculptors of the new century was by no means as negligible as some Modernist partisans once claimed. In particular, the so-called New Sculpture movement was responsible for generating throughout the last quarter of the nineteenth century an ambitious attitude which revolutionized sculptors' relationship with architecture, the public monument and the whole notion of a unique art object. Mass production, as well as the Symbolists' involvement with states of mind rather than grandiose allegory, contributed to a new sense of widening purpose and optimism in sculpture. By 1900, the status of the sculptor had been transformed markedly enough for one writer to declare at the time that 'a radical change has come over British Sculpture – a change so revolutionary that it has given a new direction to the aims and ambitions of the artist and raised the British school to a height unhoped for, or at least wholly unexpected, thirty years ago'.[2] Any assessment of the contribution made by Epstein, Gaudier-Brzeska and Gill to the revitalizing of early twentieth-century sculpture should take the achievements of the previous generation into proper account.

Nevertheless, there is no doubt that the young Epstein's arrival in 1905 coincided with the disintegration of the ideals fostered by Bates, Drury, Frampton, Gilbert,

1. S. Beattie, *The New Sculpture*, New Haven and London, 1983; R. Dorment, *Alfred Gilbert*, New Haven and London, 1985; the catalogue of the 'Alfred Gilbert Sculptor and Goldsmith' exhibition, Royal Academy, London, March-June 1986 (with other contributions by T. Bidwell, C. Gere, M. Girouard and D. James); and B. Read, *Victorian Sculpture*, New Haven and London, 1982.
2. M. Spielmann, *British Sculpture and Sculptors of Today*, London, 1901, quoted by B. Read, 'Classical and Decorative Sculpture', in *British Sculpture in the Twentieth Century*, eds. S. Nairne and N. Serota, London, 1981, p. 39.

Thornycroft and the rest. In most cases their finest work was over, and Susan Beattie has argued that 'the four years from 1898 to 1901 may be shown, with unnerving ease, to have contained not only the greatest achievements of the New Sculpture movement but the forces and events which contributed most insidiously to its decline'.[3] When Epstein received the momentous commission to make eighteen over-life-size figures for the British Medical Association's headquarters in The Strand, he would have felt justifiably impatient with the standards of public sculpture represented by the Queen Victoria Memorial (Fig. 1). Commenced in 1901 as an integral part of the new approach to Buckingham Palace, Thomas Brock's vast monument was at once pretentious, derivative and flaccid. The *Architectural Review* was waspishly prophetic when it warned, in 1910, that 'though the piling together of tons of marble and bronze may...perpetuate the memory of a sovereign or states-man, it may also, in the eyes of posterity, be regarded as a mausoleum for the reputation of the sculptor'.[4] Epstein wanted nothing to do with such vacuous imperial pomposities. Imbued with the liberating spirit of Whitman's *Leaves of Grass* – an enthusiasm felicitously shared by the architect of the BMA building[5] – the American immigrant set about creating a sequence of what he described as 'noble and heroic forms to express in sculpture the great primal facts of man and woman'.[6]

The stylistic influences at work in these figures came from an awkward blend of Classical, Renaissance and Rodinesque sources,[7] but the ensemble as a whole provided refreshing imaginative relief after the orotund banalities of the Queen Victoria Memorial. Even in this most public of contexts, overlooking one of the busiest streets in the metropolis, Epstein was able to give his *Maternity* (Fig. 2) a sense of tender privacy which reveals a profound understanding of the relationship binding the mother to her child. Although her milk-laden breast is exposed in all its fullness, no hint of deliberate provocation mars this absorbed figure. Like all the other carvings on the façade, she is characterized by a stillness and dignity which should have precluded any accusations of immorality. But the furore that erupted in 1908 centred quite specifically on the hapless *Maternity* herself. Although an impressive range of artists, critics and curators rallied to Epstein's defence – including F. W. Pomeroy ARA, a representative of the New Sculpture generation[8] – the scandal had a damaging effect on Epstein's prospects as a maker of large-scale public carvings. With the right kind of daring and enlightened patronage, Epstein could have established modern sculpture as a major presence in our cities. However, timid official disapproval of his expressive frankness prevailed instead, leading Ezra Pound to lament in 1915 that 'there is no power to set Epstein...where his work would be so prominent that people, and even British architects, would be forced to think about form'.[9]

Lacking the opportunities to establish his sculpture in urban spaces, Epstein planned at one stage to create a vast temple of carvings in a Sussex field.[10] He collaborated on the project with his close friend Eric Gill, who was now emerging as another sculptor dedicated to radical renewal. The training Gill received as a youth in lettering, architectural draughtsmanship and monumental masonry helped to equip him for the task of making these 'colossal figures together (as a contribution to the world), a sort of twentieth-century Stonehenge'.[11] But his apprenticeship does not account for Gill's willingness to share Epstein's desire to revolutionize the making of sculpture. In 1908 Gill had been quick to defend the beleaguered British Medical Association carvings on the grounds that they promised 'to rescue sculpture from the grave to which ignorance and indifference had consigned it'.[12] He was fully in sympathy with Epstein's growing insistence on the importance of carving direct, retaining manual responsibility for every blow of the chisel and allowing the intrinsic character of the stone to affect the fundamental identity of the sculpture. 'Stone carving properly speaking isn't just doing things in stone or turning things into stone, a sort of petrifying process,' he maintained later; 'stone carving is conceiving things in stone and conceiving them as made by carving. They are not only born but conceived in stone; they are stone in their innermost being as well as their outermost existence.'[13]

Fig. 1 Thomas Brock, *Queen Victoria Memorial*, 1901-11; marble and bronze. Buckingham Palace, London

3. S. Beattie, *The New Sculpture*, op. cit., p. 231.
4. *Architectural Review*, vol. 28, 1910, p. 152.
5. In a memoir dated 3 December 1940, preserved in the archives of Adams, Holden & Pearson, London, the architect Charles Holden described how Epstein was able 'in a very few days...to lay down a programme as wide in scope as Whitman, which was in fact exactly what I was hoping to find in him'.
6. J. Epstein, 'The Artist's Description Of His Work', *British Medical Journal*, 4 July 1908.
7. For a detailed examination of Epstein's sources in the BMA scheme, see R. Cork, *Art Beyond The Gallery in Early 20th-Century England*, New Haven and London, 1985, pp. 36-51.
8. Pomeroy declared that 'there is nothing indecent or gross about them' in a supportive letter to the *British Medical Journal*, 4 July 1908.
9. E. Pound, *Gaudier-Brzeska. A Memoir*, London, 1916, Marvell Press 1960, p. 101.
10. The site chosen was a six-acre plot of land bordering on Asheham House in Sussex.
11. E. Gill to W. Rothenstein, 25 September 1910, *Letters of Eric Gill*, ed. W. Shewring, London, 1947, p. 33.
12. E. Gill, letter to the editor, 21 June 1908, published in the *British Medical Journal*, 4 July 1908.
13. E. Gill, *Autobiography*, London, 1940, p. 161.

Fig. 2 Jacob Epstein, *Maternity*, 1908, detail (before mutilation); Portland stone. BMA headquarters, The Strand, London

Fig. 3 Jacob Epstein, *One of the Hundred Pillars of the Secret Temple*, c. 1910; pencil. Anthony d'Offay Gallery, London

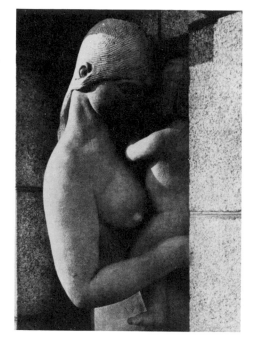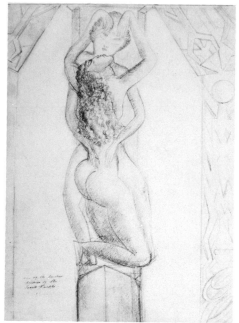

Although their 'Stonehenge' project came to nothing, the surviving work which may be associated with it suggests that this profane temple would have been primarily dedicated to the theme of multi-racial erotic gratification. Epstein's drawing, *One of the Hundred Pillars of the Secret Temple* (Fig. 3), is almost as direct in its celebration of sexual pleasure as Gill's extraordinary *Ecstasy* (Cat. 91), which boldly represents the moment of copulation itself. Both men were determined to emancipate such subjects from the puritanism, hypocrisy and prurience of British society's attitudes towards the delights of the flesh, and their audacity was courageous indeed. But no less innovative was their adherence to the inspiration of cultures which lay far outside the approved Hellenic and Renaissance models. Epstein haunted the British Museum, where he found himself becoming particularly excited by 'the Egyptian rooms and the vast and wonderful collections from Polynesia and Africa'.[14] For his part, Gill was more enthusiastic about medieval carvings on the one hand and Indian art on the other. In 1911 he declared: 'the best route to Heaven is via Elephanta, and Elura [sic] and Ajanta'.[15] Indian art's uninhibited emphasis on sensual delight excited Gill as much as the fusion of sculpture and architecture to be found in Indian temples.

Epstein's status as an outsider, a New York Jew, enabled him to view Britain from the impatient vantage point of a foreign invader. Although he became a British subject and made London his lifelong home, he always remained at a certain remove from the culture of his adopted country. This sense of critical distance made it easier for him to identify the weaknesses of British sculpture and offer a powerful alternative of his own. By 1912 he had become known as 'a Sculptor in Revolt, who is in deadly conflict with the ideas of current sculpture',[16] and so it was inevitable that he should be sought out by another rebellious young sculptor from abroad. Sharing the same dissatisfaction with the established British order, Gaudier-Brzeska was quick to contact Epstein after moving from France to London in 1911. Epstein's *Tomb of Oscar Wilde*, commissioned for the Père Lachaise cemetery in Paris, was still unfinished, and Gaudier's sketch of the carving suggests that he was vastly impressed by it. He evidently needed little encouragement to pursue the path of exploration already pioneered by Epstein and Gill. Sympathizing with their profound respect for certain unorthodox aspects of tradition, he came to England with an open-minded willingness to range far beyond his youthful admiration for Rodin. He also delighted in displaying a bravura ability to execute work in an almost bewildering variety of styles, veering within a few energetic months from the coolness of an overtly classical *Torso* to the extravagance of a garishly painted and gilded *Ornamental Mask*, which may well be an exotic tribute to the elaborate painted plaster columns made by Epstein for the Cave of the Golden Calf (see Cat. 34).[17]

14. J. Epstein, *Let There Be Sculpture. The Autobiography of Jacob Epstein*, London, Readers Union edn, 1942, p. 32.
15. E. Gill to W. Rothenstein, 1911, *Letters*, op. cit., p. 36.
16. *Pall Mall Gazette*, 6 June 1912.
17. Epstein's decorations for the Cave of the Golden Calf are lost, but he surrounded 'two massive iron pillars' supporting the Cave's ceiling with 'a very elaborate decoration which I painted in brilliant colours' (J. Epstein, *Let There Be Sculpture*, op. cit., p. 116). Gaudier's *Ornamental Mask* and *Female Torso 1* are both reproduced, as plates 4 and 29, in R. Cole, *Burning to Speak. The Life and Art of Henri Gaudier-Brzeska*, Oxford, 1978.

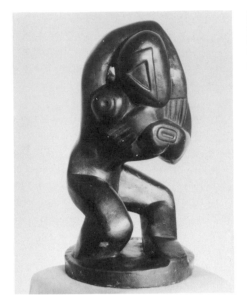 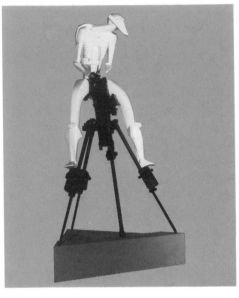

Fig. 4 Henri Gaudier-Brzeska, *Red Stone Dancer*, *c.* 1913; red Mansfield stone. Tate Gallery, London

Fig. 5 Jacob Epstein, *Rock Drill* (original state), 1913-5, reconstruction 1974; plaster and ready-made drill. City of Birmingham Museums and Art Gallery

Gaudier was only nineteen when he settled in London, and much of his early work has the high-spirited eclecticism of a young man testing himself against as diverse an array of cultures as possible. In one letter he described how 'a short visit to the British Museum' had inspired him to dart, with prodigious swiftness, from room to room taking 'particular notice of all the primitive statues, negro, yellow, red and white races, Gothic and Greek'.[18] But Gaudier was equally alert to contemporary developments, showing in his vigorously modelled *Bust of Horace Brodzky* (Tate Gallery) an awareness of the *Heads of Jeannette* series which Matisse had displayed in Fry's Second Post-Impressionist Exhibition of 1912-13. The incipient Cubist angularity of the Brodzky bust also suggests an interest in Picasso's *Head of a Woman* of 1909-10, and Brodzky himself recalled a meeting between Brancusi and an admiring Gaudier at the 1913 Allied Artists' Salon, where the younger man decided that Brancusi was a 'fine fellow'.[19]

The work Brancusi contributed to that exhibition, *Sleeping Muse II*, may well have helped Gaudier to develop one of his most outstanding carvings: *Red Stone Dancer* (Fig. 4). The ovoid head bears a distinct resemblance to Brancusi's bronze, yet Gaudier has stamped it with a very different vitality by placing a provocative triangle on its otherwise unadorned surface. Geometry is likewise asserted on the right breast, which bears a circle and thereby announces in an almost programmatic manner Gaudier's increasing affiliation with the emergent Vorticist group. In comparison with work by Wyndham Lewis or any other member of the Rebel Art Centre, Gaudier's involvement with mechanistic abstraction is only very partial in his *Red Stone Dancer* – throughout the rest of the figure he revels in the ability to give geometry organic life. He takes extraordinary liberties with anatomical propriety, twisting and pulling the dancer's limbs with an exhilarating sense of vitality. Before long, however, he was stiffening the masses of his sculpture. Taking as a springboard the monumental Easter Island carving *Hoa-Haka-Nana-Ia*, which he would surely have admired in the British Museum, Gaudier produced an imposing marble head of Ezra Pound (Cat. 58) which boldly departed from any attempt to achieve a mimetic likeness. By now he was prepared to declare that the new sculpture 'has no relation to classic Greek, but . . . is continuing the tradition of the barbaric peoples of the earth (for whom we have sympathy and admiration)'.[20]

With a thirst for versatile formal experiment which makes Gill appear positively cautious, Gaudier spent a great deal of time in the remaining months of his life exploring the possibilities of a 'barbaric' sculpture. He embodied a mechanistic concern in *Bird Swallowing Fish* (Cat. 61), which turns a predatory act of nature into a cold and menacing struggle between martial aggressors. In its uncanny foreshadowing of the stalemate suffered by opposing forces in the First World War, *Bird Swallowing Fish* can be said to possess the power of unconscious prophecy: although

18. H. Gaudier to S. Brzeska, 28 November 1912.
19. H. Brodzky, *Henri Gaudier-Brzeska 1891-1915*, London, 1933, p. 94.
20. H. Gaudier-Brzeska, letter to *The Egoist*, 16 March 1914.
21. Modigliani's elongated *Head* (Tate Gallery) was displayed at the Whitechapel Art Gallery's 'Twentieth Century Art. A Review of Modern Movements' in the summer of 1914.
22. Epstein even planned at one stage to set the drill in motion: 'I had thought of attaching pneumatic power to my rock drill . . . thus completing every potentiality of form and movement in one single work.' (*Let There Be Sculpture*, op. cit., p. 70.) *Rock Drill* was first exhibited in the London Group show, March 1915.
23. *Torso in Metal from the 'Rock Drill'* was displayed in the fourth London Group exhibition, summer 1916.
24. The catalogue of the exhibition, *Charles Sargeant Jagger War and Peace Sculpture*, ed. A. Compton, London, 1985, contains illuminating essays by J. Glaves-Smith, J. Stevens Curl and the editor.

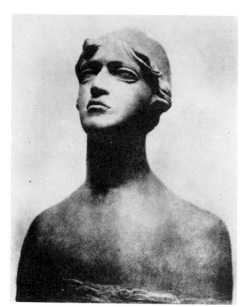

Fig. 6 Jacob Epstein, *Bust of Lady Drogheda,*
c. 1914; bronze. Lost

the bird attempts to consume its smaller prey, the fish seems quite capable of choking the bird. Yet it would be wrong to suggest that Gaudier's short career culminated solely in such disturbing work. The refined *Birds Erect* (Cat. 60) exemplifies an altogether more tender and organic order of feeling, while his late carving of a *Seated Woman* (Cat. 59) is reminiscent of both Maillol and Modigliani[21] in its search for distilled sensual serenity.

Gaudier was only twenty-three when he met his tragically premature death in the trenches, and the sheer diversity of the work he left behind resists the historian's attempts to place him exclusively within a single stylistic camp. Although steadier and less prolific, Epstein likewise confounds neat classification. Even in 1913-15, at the most experimental phase of his long life, extreme simplification did not satisfy the powerful urge he felt to pursue a far more figurative involvement with portraiture in, for example, the lost *Bust of Lady Drogheda* (Fig. 6). But his most ambitious and thoroughly meditated work of this period, *Rock Drill*, certainly belongs within the orbit of the Vorticist movement. Indeed, the different stages of this fascinating sculpture at once summarize the concerns of the *Blast* group and anticipate their demise.

The first stage of the project, defined in an extended sequence of forceful drawings, proposes a view of the modern machine age wholly compatible with the Vorticist manifestos (Fig. 4, p. 92). The driller bestrides his machine with superhuman confidence, wielding the phallic power of the drill in order to help construct the challenging new order of twentieth-century society. By the time Epstein decided to combine a man-made plaster figure of the driller with a ready-made machine, purchased second-hand,[22] this virile confidence had given way to a more haunted vision (Fig. 5). Now that an embryo nestles within the driller's body, he seems oppressed by the responsibility involved in handling such an aggressive instrument; although his body has taken on many of the attributes of the machine he controls, this armoured man looks vulnerable as well as defensive. Pathos takes over entirely in the final version of the sculpture, *Torso in metal from The Rock Drill* (Cat. 57), which Epstein completed after he had discarded the drill. Deprived of his rearing machine, and suffering from severely dismembered arms, this visor-headed presence is more like a victim than a triumphant exemplar of industrial prowess. Epstein first displayed this anxious *Torso* in 1916,[23] when the war had already claimed an appalling number of lives and threatened to continue for an indefinite period. Unavoidably aware of this obscenity, he gave his haunted bronze the fearful and amputated identity of a wounded soldier returning in dejection from the Front.

The consecutive stages of *Rock Drill* make this complex sculpture a pivotal work. They represent the dramatic culmination of all the intensive pre-war experimentation, and at the same time anticipate the crises which the war's cataclysmic horrors were bound to engender. The first heady phase of sculptural innovation and vitality was over, with Gaudier dead, Epstein developing a more naturalistic preoccupation with portraiture, and Gill carving a sombre sequence of *Stations of the Cross* for Westminster Cathedral which paralleled in religious terms the agony suffered by the troops in the trenches. Gill's epic carvings, profoundly indebted to medieval sculpture, foreshadow the sombre mood of the war memorials commissioned by so many bereaved cities, towns and villages after the Armistice. The calamitous numbers of British dead demanded commemoration on the grand scale, and sculptors found employment in abundance while the demand for memorials lasted.

The quantity and size of these monuments should not disguise their essential dullness. But Charles Sargeant Jagger, whose work has recently been reassessed in an excellent exhibition at the Imperial War Museum,[24] provided a memorable corrective to all the triumphant monuments when his masterpiece, the Royal Artillery Memorial (Fig. 7, p. 96), was finally unveiled in October 1925. Jagger's defiant refusal to indulge in heroic rhetoric gives the monument an unforced directness which seems appropriate, concise and genuinely elegiac.

In the same year and only a short distance away, Epstein's memorial, *Rima*, was installed in Hyde Park. Although its impassioned yet mystical sexuality provoked

widespread condemnation, Epstein was determined to remain unswayed by the abuse he suffered. Such carvings enabled him to pursue his pre-war interest in expressive distortion, and the massive groups he went on to execute for the headquarters of the Underground Railway (now London Transport) made a resolute contribution to the flagging tradition of architectural sculpture. On the whole, however, Epstein concentrated on a prolific succession of portrait busts during the inter-war period, many of which did little to develop his earlier achievements. With Gaudier dead and no one willing to revive the spirit of Vorticism, there was a distinct hiatus. A belated homage to the movement was paid by Arnold Auerbach, whose macabre *Vorticist Head* (Fig. 7) shows an obsession with the machine age to which British sculpture would only return when Paolozzi became involved with harsh, robot-like images in the 1950s (see Cat. 224). Another link with the pre-war avant-garde was provided by Lawrence Atkinson, a former Vorticist who concentrated on severe, near-abstract carvings before his death in 1931. However, almost all his sculpture has been lost, a fate poignantly at one with the lonely position he occupied at the time.[25]

Atkinson's dogged consistency must have been regarded with incredulity by all those men and women who thrived on hopping from one 'ism' to another in the post-war years. In 1986 the Fine Art Society's pioneering survey of these sculptors of the period[26] resurrected many whose reputations had been submerged by the rise of another avant-garde generation in the 1930s. The exhibition certainly proved that British sculpture between the wars was far more complex in its variety and scope than a partisan critic like Herbert Read wanted to maintain.[27] Bent on promoting his own favourites, Read claimed in 1933 that sculpture 'has been a moribund art in England for 400 years',[28] thereby discounting the undoubted vitality of pre-war work by Epstein, Gaudier and Gill as well as the best Victorian achievements. It was a blatant act of propagandist distortion and even failed to take proper account of the remarkable work Frank Dobson had been making since 1918. His early sculpture, ranging from the sensuous tenderness of *Pigeon Boy* (Cat. 98) to the shining brass rigidity of his portrait of Osbert Sitwell (Cat. 97), represents the early 1920s at its most vital and compelling. Dobson also managed, in collaboration with H. S. Goodhart-Rendel, to bring about a successful fusion of architecture and relief sculpture on the façade of the Hay's Wharf offices in London.

Nevertheless, by the time Dobson had completed the faience decoration for Hay's Wharf his most imaginative days were over. Read's championship of Hepworth and Moore may have unfairly suggested that no other English sculpture of the period was worthy of consideration but he was right to believe in their exceptional promise. And if Read failed to acknowledge the importance of the previous generation, Moore was himself ready in later life to explain how grateful he was to pre-war precedents. 'When I came to London as a raw provincial student,' he explained, 'I read things like *Blast* and what I liked was to find somebody in opposition to the Bloomsbury people, who had a stranglehold on everything.... Gaudier's writings and sculpture meant an enormous amount as well – they, and *Blast*, were a confirmation to me as a young person that everything was possible, that there were men in England full of vitality and life.'[29] One of those men established a paternal relationship with Moore. Impressed by the young sculptor's work, Epstein asked him round to the studio, wrote an enthusiastic foreword to the catalogue of Moore's second one-man show, and probably helped Moore obtain the important commission for a huge carving of *West Wind* on the façade of the headquarters of the Underground Railway. So far as Moore understood it, 'Epstein had introduced to this country the idea of carving direct'[30] – a principle which remained enormously influential on Moore himself as long as he adhered to the related concept of 'truth to materials'. Coincidentally, the drawings Epstein had chosen to illustrate in *Blast* both centred on pregnancy and birth – themes which Moore explored in early carvings like the 1925 *Mother and Child* (Cat. 192). He did not, of course, need Epstein's example to help him single out a subject which would prove obsessively central to his own imagination throughout his career. But the fact that Epstein had explored intimately related concerns,

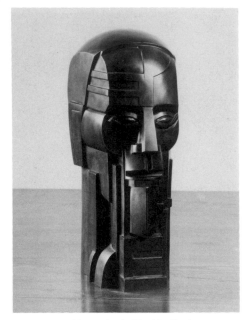

Fig. 7 Arnold Auerbach, *Vorticist Head*, c. 1920-30; bronze. Fine Art Society, London

25. Most of the surviving photographs of Atkinson's lost sculpture are reproduced in H. Shipp, *The New Art. A Study of the Principles of Non-Representational Art and their Application in the Work of Lawrence Atkinson*, London, 1922.

26. The exhibition 'Sculpture In Britain Between The Wars', with a catalogue by B. Read and P. Skipwith, was held at the Fine Art Society, June-August 1986.

27. As Skipwith pointed out (ibid., p. 3): 'There is a degree of historic and poetic justice in having one of Herbert Read's sons reinstating many of the sculptors who were, in their lifetimes, almost totally eclipsed by the power of his father's propaganda on behalf of Henry Moore and Barbara Hepworth.'

28. H. Read, 'Goodbye to Silk Hat Sculpture', *Daily Mail*, 24 July 1933.

29. H. Moore, conversation with the author, 23 October 1972, quoted in R. Cork, *Vorticism and Abstract Art in the First Machine Age*, vol. 2, *Synthesis and Decline*, London, 1976, p. 551.

30. H. Moore, conversation with R. Cork, 26 May 1981.

31. H. Hosmer, quoted by Josephine Withers, 'Artistic Women and Women Artists', *Art Journal*, XXV, 1976, p. 334.

32. H. Gaudier, 'Vortex. Gaudier Brzeska', *Blast No. 1*, London, 1914, p. 156.

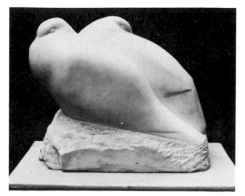

Fig. 8 Barbara Hepworth, *Doves (group)*, 1927;
Parian marble. Manchester City Art Gallery

both in the *Blast* drawings and two superb flenite carvings of pregnant figures
(Cat. 56), might well have fortified Moore's resolve to explore his wholly individual
fascination with maternity.

Judging by Hepworth's early marble carving of *Doves* (Fig. 8), she was likewise
indebted to the precedents established by Epstein in the pre-war period. Her aware-
ness of his sequence of serenely simplified marble *Doves* (Cat. 55), either preparing
for or actively engaged in copulation, cannot be doubted. Themes of womb-like
enclosure and growth permeate Hepworth's work, albeit in a less explicit manner
than Epstein employed. She would surely have appreciated his readiness to place
such subjects at the heart of his work, for Hepworth always stayed very close to her
most personal experience. It took considerable courage on her part to do so, for the
whole notion of a woman making sculpture from her own vision of life must have
seemed almost heretical in a profession traditionally peopled by men. Working in
Rome in the middle of the nineteenth century, the American sculptor Harriet
Hosmer warned a girl art student: 'Learn to be laughed at, and learn it as quickly as
you can.'[31] But Hosmer was bent on executing a version of the Barberini sleeping
faun, whereas the unapologetic Hepworth based her work on a womanly apprehen-
sion of the world. In this respect, she was as much of an 'outsider' as Epstein and
Gaudier had been at the beginning of the century.

However, Hepworth did come from a middle-class family. Her father was
County Surveyor to the West Riding, and she therefore grew up with a perception
of Yorkshire life very removed from Moore, whose father was a Castleford mining
engineer with an active interest in Socialism and Trade Unionism. The difference in
their background and gender may help to account for the fact that, while Hepworth
felt close to archaic Greek and Cycladic sculpture, Moore was attracted to a harsher
and more 'barbaric' vitality. In the 1920s he dismissed the significance of Hellenic
and Renaissance art with as much arrogance as Gaudier, who had announced in *Blast*
that 'the fair Greek' was 'derivative' and his 'feeling for form secondary', while the
vortex 'gave forth SOLID EXCREMENTS in the quattro e cinquo [sic] cento'.[32] Moore
would not have expressed his discontent with quite such hot-headed virulence and
he subsequently revised his opinion of Renaissance art, but his youthful rebuttal of
the hallowed Classical tradition was, for a while at least, uncompromising. Drawn
instead to African woodcarvings and pre-Columbian sculpture, he hewed figures as
monolithic as the rocks of the Yorkshire landscape. The most impressive of his early
carvings, like the great Leeds *Reclining Figure* (Fig. 9) of 1929, equate body and

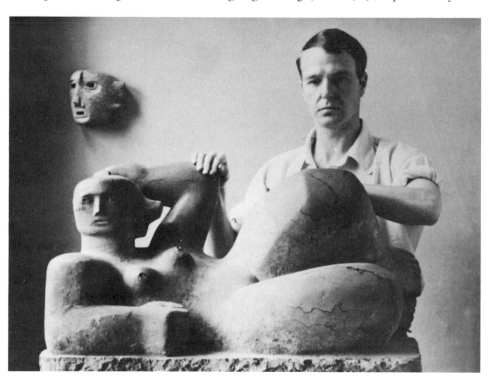

Fig. 9 Henry Moore with his *Reclining Figure*,
1929; brown Hornton stone. Now in Leeds City
Art Gallery

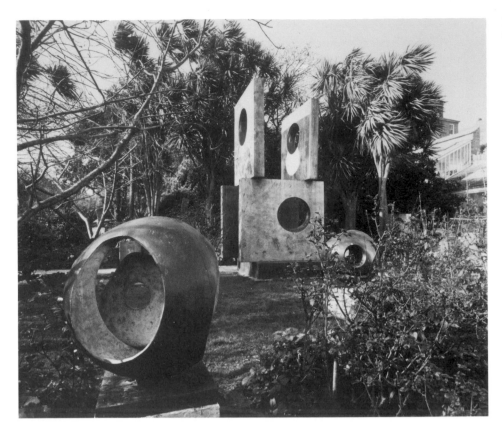

Fig. 10 Barbara Hepworth, Sculpture garden at
St Ives

terrain with resounding finality. Hills, valleys, caves and cliffs are evoked in the dip
and swell of her massive body. This fusion of human and geological forms became
even more overt during the 1930s, when Moore made a habit of working out of doors
and undertook a commission from Serge Chermayeff to make a *Recumbent Figure* for
the grounds of the architect's own house. Here, in the Sussex countryside, Moore
'became aware of the necessity of giving outdoor sculpture a far-seeing gaze', for he
later described how 'my figure looked out across a great sweep of the Downs, and
her gaze gathered in the horizon'.[33]

Hepworth was likewise conscious of her relationship with the Yorkshire landscape
she had known since childhood. As a means of combating 'the horror of the
approaching slump' she would 'imagine stone "images" rising out of the ground,
which would pinpoint the spiritual triumph of man and at the same time give the
sensuous, evocative and biologically necessary fetish for survival'.[34] She pursued this
affirmative vision of sculpture throughout her life, emphasizing the values of
growth, nurture and humanity's integration with the land (Fig. 10). Her desire to
attain this unity between figures and the earth they occupy was reinforced by the
experience of 'the remarkable pagan landscape which lies between St Ives, Penzance
and Land's End'.[35] In a setting that was to remain her home until the end of her life,
she concentrated with even more intensity than before on her own rapport with the
primal Cornish countryside. In many areas this landscape seems remarkably
unchanged since the prehistoric period when standing stones were erected there.
Hepworth wanted to create her own equivalent to those stones, basing the work she
made on an acute empathy with the rocks and sea around her. 'For a few years I
became the object,' she wrote afterwards. 'I was the figure in the landscape and
every sculpture contained to a greater or lesser degree the ever-changing forms and
contours embodying my own response to a given position in that landscape.'[36]

Although her sculptures were as radically simplified as the ancient standing stones
she admired, Hepworth did not ape prehistory. On the contrary: the work she
produced was fully attuned to the modern movement, and both she and Moore
identified themselves with developments in international abstraction during the
1930s. How far they ever went towards *total* abstraction is open to question. Even
the most ostensibly purist of Hepworth's works, like the *Conicoid, Sphere and Hollow II*

33. H. Moore, 'Sculpture in the open air. A talk
by Henry Moore on his sculpture and its plac-
ing in open-air sites', London, 1955, reprinted
in *Henry Moore on Sculpture*, ed. Philip James,
London, 1968, p. 99. *Recumbent Figure* now
belongs to the Tate Gallery.

34. B. Hepworth, *Drawings from a Sculptor's Land-
scape*, with an introduction by A. Bowness,
London, 1966, p. 10.

35. H. Read, *Barbara Hepworth Carvings and Draw-
ings*, London, 1952, p. 4.

36. Ibid.

37. H. Moore, 'The Sculptor Speaks', *The Listener*,
18 August 1937.

38. N. Gabo, 'The Constructive Idea in Art',
Circle, London, 1937, p. 7.

39. H. Moore, ibid., p. 118.

40. A. Caro, interview with R. Cork for BBC
Radio 3, 1985.

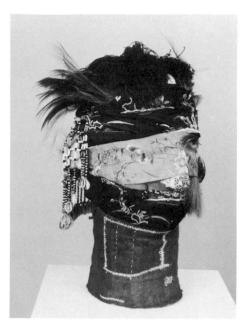

Fig. 11 Eileen Agar, *The Angel of Anarchy (2nd version)*, 1940; plaster cast covered in mixed materials. Tate Gallery, London

Cat. 148) of 1937 or *Wood and Strings* (Cat. 150) of 1944, still depend for their initial inspiration on her passionate apprehension of the natural world. The same is true of Moore's far bonier and more eruptive work, which contrasts with the smoothed-out poise of Hepworth's vision and is sometimes prepared to explore very disturbing areas of feeling. That is why he was more ready than she to associate himself with the Surrealists, although his presence in the International Surrealist Exhibition at the New Burlington Galleries in 1936 did not mean that he fully committed himself to the movement. Moore was never as thoroughgoing in his enthusiasm for Surrealism as Eileen Agar (Fig. 11), Paul Nash or Roland Penrose. Nash made some marvellously intuitive and poetic sculptures out of deceptively mundane found objects like branches, shells, a toy boat and even wooden glove stretchers, the last of which became transformed into a mysterious *Forest* (Fig. 12).

Only a year after the New Burlington exhibition Moore declared that 'all good art has contained both abstract and surrealist elements',[37] thereby helping to account for his contribution to *Circle*, the 'International Survey of Constructive Art' in 1937. Hepworth was also included in this publication, organized in large part by the Russian Constructivist Naum Gabo who had emigrated to England from Paris the year before. He was doubtless encouraged in his efforts by the fact that both Moore and Hepworth had already participated in an 'Abstract and Concrete' exhibition, which numbered Gabo among foreign artists as distinguished as Calder, Giacometti, Léger, Miró, Moholy-Nagy and Mondrian. Now he wanted the British sculptors to become allied with Constructivism, a utopian attempt to synthesize painting, sculpture, design and architecture in an idealistic renovation of 'the whole of our culture'.[38] Once again, Moore's work could only be described as partially involved with such a movement, but during this period his interest in international avant-garde activities was as alert as Hepworth's. Not since 1912, when Epstein established fruitful relationships with Brancusi and Modigliani in Paris, had British sculptors been so closely connected with Continental developments.

The optimism of *Circle*, where Moore made clear his dislike of 'the idea that contemporary art is an escape from life',[39] contrasts with the rapidly increasing political turmoil of Europe at the time when it was published. When war came, the utopian future which Gabo had outlined in *Circle* with his fellow editors Ben Nicholson and Leslie Martin seemed impossible to obtain. The colony of avant-garde artists in London, which had included Mondrian for a couple of years, dispersed. Hepworth went to St Ives, where the energy she devoted to bringing up her children, running a nursery school and a market garden enabled her only to make small works in plaster at night. Moore likewise retreated to a Hertfordshire farmhouse near Much Hadham, although his work as a War Artist ensured that his output did not diminish. Indeed, the series of 'Shelter' drawings (Cat. 191, 202, 203) meant that he extended himself as an artist, discovering in the sleeping forms a stoical endurance which won a new audience for his work when war art exhibitions were staged throughout the country. And around the same time his old mentor Epstein reached a moment of outstanding intensity in the monumental *Jacob and the Angel* (Cat. 101), which proved that in carving at least he could still invest the figurative sculpture tradition with a formidable charge of heightened sexual and spiritual feeling.

Epstein was unable greatly to extend his reputation in the international sphere, whereas Moore held his first American one-man show in 1943 at the Buchholz Gallery in New York. Three years later a retrospective survey of his work at the Museum of Modern Art confirmed his stature in America and set Moore on course to achieve in the post-war era a renown without precedent in British sculpture. When he won the International Prize for Sculpture at the Venice Biennale in 1948, Moore demonstrated both to his contemporaries and succeeding generations in Britain that it was indeed possible to win respect for sculpture far beyond insular confines. Anthony Caro, who established an outstanding reputation for himself in later decades, explained recently that 'Henry Moore's success . . . has given an example to a lot of English sculptors, to feel they don't have to be provincial'.[40] The importance of Moore's achievement for the future confidence of sculpture in Britain

Fig. 12 Paul Nash, *Forest, c.* 1937; wood relief. Leeds City Art Galleries

can scarcely be exaggerated, and Hepworth's international acclaim in her later years provided an inspiration for women who might otherwise have felt down-hearted about their chances of attaining proper recognition for their work. But it should also be remembered that Moore in turn declared that 'the sculptors who followed Epstein in this country would have been more insulted than they have been had the popular fury not partially spent itself on him, and had not the folly of that fury been revealed'.[41]

Although Moore himself came in for a considerable amount of derision in the press when he exhibited a gaunt reclining figure (Fig. 1, p. 89) at the Festival of Britain in 1951, the event as a whole was a landmark in modern sculpture's relations with a wider public. Established sculptors like Epstein and Hepworth were commissioned to provide work for the cluttered but lively South Bank site, along with members of the emergent generation who included Reg Butler, Lynn Chadwick and Eduardo Paolozzi. The entire event, a genuinely popular celebration conceived by a Labour government anxious to stimulate national optimism after the long and debilitating years of war, was an uneven yet heartening demonstration of the country's faith in the capacity of art to enliven post-war urban spaces. The spirited generosity of the Festival's attitude towards artists is in marked contrast with the subsequent failure to employ them with sufficient imagination and flair in the monolithic development of Britain's new towns. Sculpture, which could have played a vital part in the humanizing of these bleak spaces, was either dumped unceremoniously down in alien precincts or excluded altogether from the architects' increasingly brutalist blueprints. The site of the Festival now contains an extensive complex of major buildings devoted to theatre, art, film and music,[42] although the barren, windswept area today amounts to a distressing betrayal of the verve with which the Festival attempted, for all too brief a period, to let art play an enlivening role in the world beyond the gallery.

The sculpture produced by the new generation in the 1950s was by no means all affirmative. Unlike the optimism of Hepworth, whose sculpture garden at St Ives (Fig. 10) brought about a wonderfully unforced union between nature and the artefacts she placed there, the prevailing mood was spiky, etiolated and full of foreboding. The economic austerity of the post-war years bred in art a similar austerity, of form and feeling alike. It replaced Moore's emphasis on mountainous bulk with a partiality for attenuation and fragility which reaches an extreme in Paolozzi's *The Cage* (Fig. 13), where solidity has given way to near-transparency. He had already befriended Giacometti during a stay in Paris, and much of the work produced by young British sculptors of this period chimes with the existentialist anxiety evident in contemporary European art. Moore had foreshadowed this development in a work like *The Helmet* of 1940, which conveys with menacing authority the grim defensiveness of a nation at war. Moreover, he had taken on Bernard Meadows, a sculptor of the generation to establish itself in the post-war period, as an assistant as early as 1939. Meadows, the first of several prominent sculptors to start their careers by helping Moore make his work, was more keenly involved with sinister and predatory animal imagery than his mentor (Fig. 14). And Moore certainly did not dwell on privation with the single-mindedness of the eight young sculptors who shared the British pavilion at the 1952 Venice Biennale. Once again, they gained for their country widespread acknowledgment that sculpture in Britain was now worthy of the closest attention: Alfred Barr, of the Museum of Modern Art in New York, reported that 'it seemed to many foreigners the most distinguished national showing of the Biennale'.[43] When a year later Reg Butler won the international competition for a *Monument to the Unknown Political Prisoner* (Fig. 15), it seemed as if Moore might well be followed by a generation equally capable of ensuring that British sculpture remained a vital and influential force in post-war art.

The hope was not completely fulfilled. With one or two remarkable exceptions, the young sculptors who had distinguished themselves at the Biennale failed to sustain the high level of interest their early work commanded. Part of the reason may

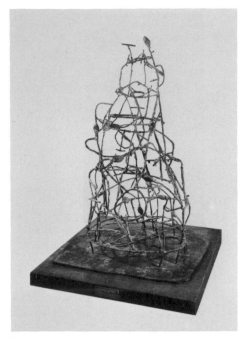

Fig. 13 Eduardo Paolozzi, *The Cage*, 1951; bronze. Arts Council of Great Britain

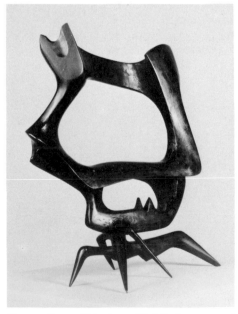

Fig. 14 Bernard Meadows, *Black Crab*, 1952; bronze. Tate Gallery, London

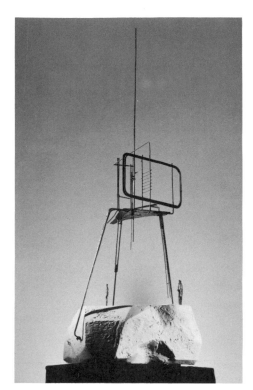

Fig. 15 Reg Butler, *Working Model for the Monument to the Unknown Political Prisoner*, 1955-6; bronze, metal and plaster. Tate Gallery, London

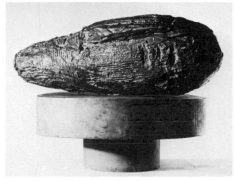

Fig. 16 William Turnbull, *Head*, 1955; bronze. Arts Council of Great Britain

41. H. Moore, obituary tribute to J. Epstein, *The Sunday Times*, 23 August 1959, reprinted in *Henry Moore on Sculpture*, op. cit., p. 194.
42. Apart from the Royal Festival Hall, all the structures specially erected for the Festival of Britain were dismantled by the incoming Conservative government.
43. *The Manchester Guardian*, 3 September 1952.
44. H. Gaudier-Brzeska, letter to *The Egoist*, 16 March 1914.
45. E. Paolozzi, conversation with R. Cork, BBC Radio 3, March 1984.

be that they depended to an unusual extent on technical innovation rather than an enduring vision of the world. Neither Butler nor Chadwick underwent any formal training in sculpture: both of them had previously studied architecture, and Butler had even worked as a blacksmith. Their detachment from more academic thinking and procedures doubtless helped them to adopt techniques which many art college teachers would have regarded as near-heretical. Cutting and forging metal, they succeeded in taking their cue from this material and shaping a body of work startlingly at variance with the sculpture Moore had made so ubiquitous. Linear rather than massive, and often anthropomorphic enough to bestow human characteristics on forms primarily suggestive of animals or plants, their work was instantly identifiable as a novel phenomenon. But like so many other makers of novelties in twentieth-century art, they were unable to move beyond technical ingenuity and develop a language of supple, lasting value. Strikingly of its period, early sculpture by Butler and Chadwick did not lead on to work which transcended the historical moment when they had first won an intoxicating amount of international admiration.

The sculptors of that generation whose work has worn best did not need to rely on technique in order to gain attention. Kenneth Armitage, whose *People in a Wind* (Cat. 218) was one of the most impressive exhibits at the 1952 Biennale, was more conventional in his methods than Butler and Chadwick. He is a gentler and more humanist artist than either of them, and less concerned to present an overtly anxious vision. *People in a Wind* may have to struggle against a formidable buffeting, but its figures remain sturdy and intact in comparison with the altogether more spindly forms created by Butler. Even when Armitage made the bronze *Figure Lying on its Side (No. 5)* (Cat. 219), the vertiginous implications of the woman's vulnerable pose and her truncated legs did not rob her torso of its substance. An even greater sense of compact solidity characterizes William Turnbull's contemporary work. Taking his cue above all from Brancusi, whom he met in 1948, Turnbull used stacked forms of quietly differentiated materials to explore a mythical world. His *Head* (Fig. 16) rests on its plinth like a sacrificial offering and evokes a primitive world where such images would have been charged with the aura of the 'barbaric peoples of the earth'[44] whom Gaudier had extolled nearly half a century before.

Paolozzi, who studied at the Slade with Turnbull, had been fascinated by African carvings ever since his student days at Oxford, when he took time off from studying the approved models of Western art at the Ashmolean and drew African heads in the Pitt-Rivers Museum. His interest in so-called 'primitivism' was only one of a positive cornucopia of sources with which the young Paolozzi fed his impish and capacious imagination. Attracted at once by Picasso, Duchamp, Surrealism, Dada and a whole host of other avant-garde achievements, he developed a far more subversive attitude to art than either his tutors or most of his fellow students could countenance. As the son of an Italian immigrant ice-cream maker in Edinburgh, he was almost as much of an 'outsider' as Epstein and Gaudier had been. More than a decade before Pop Art became an established movement marketed by dealers and validated by critics, Paolozzi was fascinated by the printed ephemera of his period. He had been able in his father's shop to amass a formidable collection of cigarette cards from customers' gifts. 'We were supposed to be poor, but I always thought we were rich because we had such an incredible amount of free material,' he recalled. 'Everything came in big packets, which meant that there was always plenty of material around . . . and in the culture I came from nothing was thrown away.'[45]

Such an upbringing gave Paolozzi an innate respect for the hoarding principle, and to this day he draws inspiration from the comics, novelties, magazines, toys and cheap novelettes collected over the years with magpie insatiability. This defiantly 'anti-fine art' stance, combined with an appetite for cinema, kitsch and the fantasy of America at its most glittering, made him an active participant in the ICA meetings which culminated in the formation of the Independent Group. The influential lecture he gave there in 1952, assaulting the audience with a proliferation of images from magazines shown on an epidiascope, reinforced a new determination among artists to treat pulp imagery with seriousness (Fig. 10, p. 26).

In his most outstanding sculptures of the 1950s, Paolozzi managed to fuse his interest in primitivism with a *mêlée* of found objects from the industrialized society around him (Cat. 223). Using a combination of plaster, wax and metal-casting, he was able to press into plaster an unpredictable range of ready-made objects scavenged from the post-war urban world. Although the constituents he employed were 'lowly' and even debased in the eyes of the art establishment, the paradox was that Paolozzi invested them with a haunting grandeur. A full-length bronze like *The Philosopher* (Cat. 224) may be built up from 'vulgar' components but this bizarre mixture of discarded machine parts, toys and the innards of radios and gramophones takes on a kind of shattered dignity. The fact that a standing figure has been fashioned from such material implies that Paolozzi saw humanity as a beleaguered species, overtaken to an alarming extent by the detritus of mid-twentieth-century life.

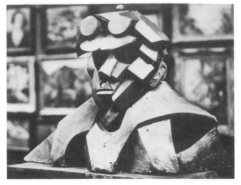

Fig. 17 Christopher Nevinson, *Automobilist or Machine Slave, c.* 1914-15. Whereabouts unknown

Although the strain of robust and debunking humour in his work should never be underestimated, *The Philosopher* still sounds a melancholy note. It represents an involvement with the machine age which British sculpture had neglected since the days of Arnold Auerbach's *Vorticist Head* (Fig. 7). Superficially, at least, Paolozzi's work can also be related to the Futurist enthusiasms of Nevinson, who in 1915 had made his metallic *Automobilist* (Fig. 17) into a menacing embodiment of a world dominated by the speeding car.[46] But the differences between them are immensely significant. Forty years later, the machine age has exhausted the figures who inhabit it. Battered and threatened with imminent malfunction, Paolozzi's robots symbolize a world still unable to recover from the devastating effects of a second world war. Britain's strength had been sapped more grievously than the politicians cared to admit, and the preponderance of broken and bandaged heads in Paolozzi's work during the 1950s indicates that he sensed a terrible weariness beneath the superficial boom of consumerism. Indeed, the title he gave to one group of full-length bronzes, *St Sebastian*, carries a tragic undertow of martyrdom reminiscent of Epstein's final wounded version of *Rock Drill* (Cat. 57).

Paolozzi was not the only sculptor to be obsessed by the aftermath of war. Turnbull's *War Goddess* (Cat. 222) implied that woman's image had become defiled by aggressive instincts, while George Fullard assembled broken furniture and scrap metal into sculptures which linked children's war-games and toys with the annihilation he had himself witnessed as a front-line Lancer in the 1940s. Severely wounded at the Battle of Cassino, he afterwards turned the 'Death or Glory' symbol of his own army cap badge into the ironic title of a powerful assemblage which served as a memorial to the futility and waste of military conflict (Fig. 18). During the same period Elisabeth Frink, who followed Hepworth in proving that a woman could establish herself with a national reputation as a sculptor, produced her most

Fig. 18 George Fullard, *Death or Glory*, 1963-4; wood. Tate Gallery, London

Fig. 19 Elisabeth Frink, *Spinning Man II*, 1960; bronze. Collection Elisabeth Frink

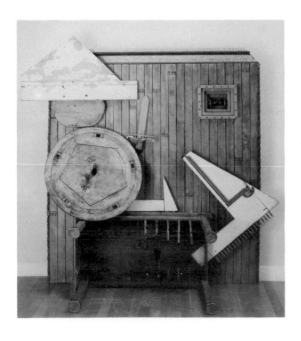

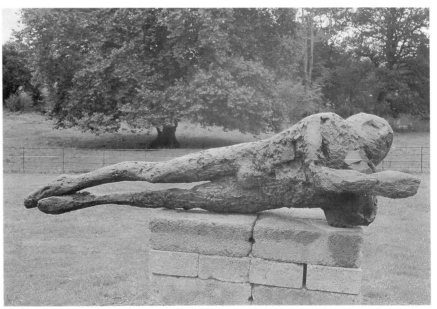

Fig. 20 Michael Sandle, *A Twentieth Century Memorial*, 1971-8; bronze and painted wooden base. Fischer Fine Art, London

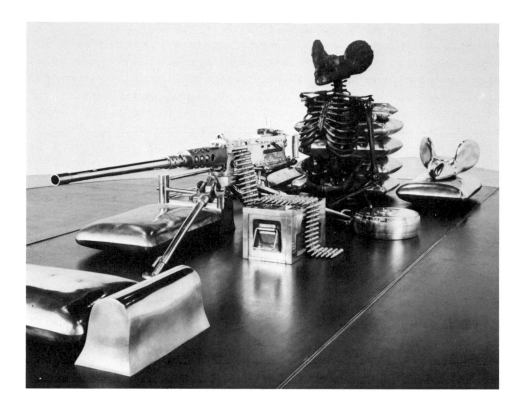

poignant images of suffering and death (Fig. 19). Frink's response to the theme is essentially elegiac. But in later years British sculpture's preoccupation with the destructive horror of war received its most chilling expression in Michael Sandle's *A Twentieth Century Memorial* (Fig. 20), where a skeletal figure of Mickey Mouse mans a gleaming machine gun and prepares to kill.

At the same time that Fullard was developing Picasso's assemblage techniques and Frink adhered to a more traditional use of bronze, Anthony Caro began moving towards a radically abstract alternative which would transform British sculpture during the 1960s. In view of the poise and inventive confidence he went on to display, his earlier difficulty in discovering a personal voice seems strange. Caro was thirty-six when he made his first abstract steel sculpture, and had previously spent several years working in a figurative vein. During that time he shared with Turnbull and Paolozzi an involvement with 'primitive' art. In *Woman Waking Up* (Cat. 220) he distorts forms with a wilfulness reminiscent of the earliest prehistoric sculpture.[47] It suggests that he had an interest in the outspoken expressive figures of de Kooning and Dubuffet. The link with contemporary American art would prove prophetic when Caro arrived at his maturity, but for the moment his bulbous bronzes seemed inhibited by the example of Moore. Like Meadows before him, and Phillip King subsequently, Caro worked as Moore's assistant for a couple of years in the early 1950s. The experience must have offered a refreshing contrast to his student experience at the Royal Academy Schools, where the visiting teachers were dominated by the unadventurous Charles Wheeler. Moore then saw himself in adamant opposition to the Royal Academy's cantankerous disapproval of the modern movement; and Caro, who as a schoolboy had actually worked in Wheeler's studio, was stimulated by Moore's insistence on a far wider view of present and past sculpture than anything Burlington House then had to offer.

All the same, Caro only defined his singularity by separating himself very decisively from the tradition Moore embodied. He afterwards described Moore as 'the last sculptor of the Renaissance',[48] and the remark is a measure of how far he aligns himself with a quite different order. Unlike any previous British sculptor, he was liberated by first-hand contact with American art. During his first trip to the United States in 1959 he was greatly impressed by abstract painters like Kenneth Noland and Jules Olitski. Their work helped him to realize how important a role colour could play in his own sculpture, and the critic Clement Greenberg encouraged him

46. Nevinson exhibited his *Automobilist*, now lost, at the February 1915 Friday Club exhibition at the Alpine Club Gallery.

47. Lynne Cooke, in 'New Abstract Sculpture and its Sources', *British Sculpture In The Twentieth Century*, op. cit., p. 171, cites the Venus of Willendorf as a precedent for *Woman Waking Up*.

48. A. Caro, notes for a lecture, late 1970s; unpublished ms quoted by T. Hilton, 'On Caro's Later Work', in *Anthony Caro Sculpture 1969-84*, catalogue of the exhibition held at the Serpentine Gallery, London, April-May 1984, p. 60.

to explore new ways of making metal sculpture. Of all modern British sculptors Caro remains the most alive to the influence of painting.

In the States he also found a sculptor whose example provided him with the fundamental catalyst he needed: David Smith. Although it would be a mistake to imagine that Caro's post-1960 work bears no relation to Moore's preoccupation with bodily experience, the truth is that he found his most enduring inspiration at Bolton Landing rather than Much Hadham. Without in any way aping Smith's achievement, Caro from then on saw himself in the tradition of welded sculpture which Smith had done so much to distinguish. After the American died, Caro purchased the many tons of scrap metal which Smith had been using for his sculpture at Bolton Landing. Within a year he had, moreover, executed an outright *Homage to David Smith* (Fig. 21). Although it cannot be counted among Caro's most impressive work, and suffers from a self-conscious stiffness which may well arise from the formality of the tribute, this *Homage* is proud to identify itself with Smith in the knowledge that it does not reflect an excessive indebtedness. On the contrary: even *Twenty-Four Hours* (Tate Gallery), which dramatically announced Caro's Damascan conversion to abstraction and welded metal in 1960, does not seem at all overshadowed by Smith's example. It now looks dry and dogmatic in comparison with the uninhibited exuberance of Caro's later work, but at the time he probably needed to make a dour, uncompromising assertion of his new-found priorities. The break with his previous work was a drastic one, and he wanted to ensure that there could be no mistaking the seriousness of his intentions.

Even so, the prime quality of the sculpture that he went on to make lay in its high-spirited *élan* and sense of release. No longer bound by the need to represent the human figure, to cast in bronze and to display the outcome on a plinth, Caro transmitted this fresh confidence into his work with infectious zest. Assembling materials which declared their machine-age origins even more frankly than those used by Paolozzi, he developed an art that escaped entirely from the anxiety and introspection of the 1950s. Although Caro's determination to pursue a new way of working may well have been aided by the unconventional techniques pioneered in the immediate post-war period by Butler and Chadwick, there was nothing overtly troubled or vulnerable about the sculpture he now produced. Even a work as austere in its components as *Early One Morning* (Fig. 22) is lyrical in essence, while *Month of May* positively shouts out its *joie-de-vivre* with an expansive flourish.

Nothing quite like them, either in material, colour or degree of abstraction, had been seen in British sculpture before. Dispensing with plinths and invading the viewer's space, by using the floor as his arena, he established a freer and more open relationship between object and onlooker. Engaging rather than aggressive, Caro's work exuded a sense of optimism. In this respect, it was fully attuned to a decade when the nation – for a while at least – aimed at regarding the resources of technology in a more positive light.

49. P. King, notes (n. d.) quoted by Robert Kudielka, 'Phillip King's Sculpture', essay in the catalogue *Phillip King* for an exhibition held at the Hayward Gallery, London, April–May 1981, p. 8.

Fig. 21 Anthony Caro, *Homage to David Smith*, 1966; steel painted orange. Private Collection

Fig. 22 Anthony Caro, *Early One Morning*, 1962; steel painted red. Tate Gallery, London

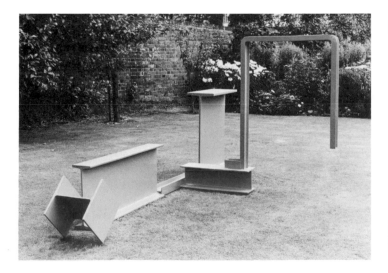

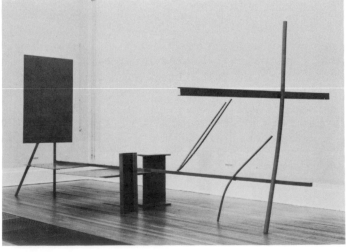

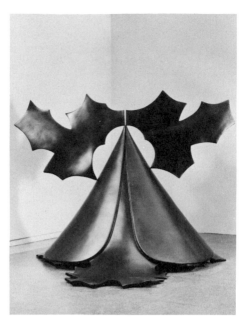

Fig. 23 Phillip King, *Genghis Khan*, 1963; fibreglass and plastic with steel support. Tate Gallery, London

The panache and fertility of Caro's sculpture, carried out with total assurance by a man who had once been so hesitant, rapidly won him an international audience. In America, where he benefited from the critical support and friendship of Clement Greenberg, Caro gained for British sculpture a response which had previously been granted to Moore alone. In London his influence was more direct and profound, especially through his role at St Martin's School of Art, where he had been teaching part-time since 1953. Here a large and lively group of young sculptors established an assertive new identity for themselves. Phillip King was the most substantial of them, a decade younger than Caro and like him having graduated from Cambridge (in languages rather than engineering) before he took up sculpture. Unlike Caro, though, King had spent most of his childhood in Tunisia, an experience which may help to account for the distinctly exotic strain running through his work. Islamic architecture left him with an abiding memory of how 'big domes, rounded forms, sit very squarely'.[49] Both in the scale and palpability of their masses, many of King's larger sculptures possess an architectural presence. But alongside this partiality for imposing, block-like forms, best seen in large-scale works like *Call* (Cat. 269), a vein of almost operatic extravagance animates his work. *Genghis Khan* (Fig. 23) is especially extrovert, contrasting the severe containment of the cone not only with the rippling fluidity of the seepage beneath but also with the flaring outburst of the 'antler' forms above.

Even his most severely organized works, which show King's awareness of American Minimalism at the time of its greatest potency, have a theatricality which distinguishes his work from the deliberate plain statement of Andre or Judd. The effervescence and playfulness may not be as evident in King's later work as they were in his early sculpture, but the apparent starkness of a structure as massive as *Sculpture '71* (Fig. 24) contains a sly comment on all those 'New Generation' works of the 1960s which encouraged the spectator to step inside, inhabit their space and explore them from within. For *Sculpture '71* rebuffs any attempt to investigate its mysterious centre: the rust-coloured mesh enclosing the inner space excites a curiosity which is frustrated by the sequence of steel components surrounding the core like sentinels.

The inherent strangeness and inscrutability of his sculpture mark King out from his more excitable contemporaries, helping to ensure that his work possesses a lasting grandeur. Although much of the sculpture executed by other members of the St Martin's School has worn less well, William Tucker's work was from the outset characterized by a bracing sense of intellectual stringency which saves it from the often relentless frivolity of other sculptors associated with the St Martin's circle (Fig. 25). From the perspective of the Eighties, Caro and King are the two sculptors who stand out from the group for their supple ability to use the abstraction of the 1960s as a starting-point from which to enrich their initial ideas. They have refused to stand still, and Caro in particular thrives on a refusal to remain content with the reiteration of an approach whenever it threatens to become exhausted. His work is

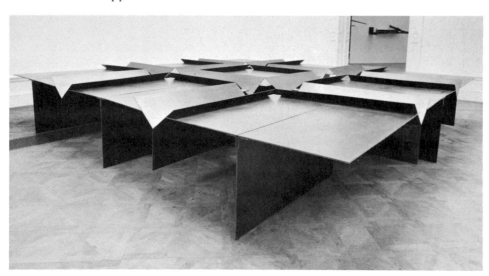

Fig. 24 Phillip King, *Sculpture '71*, 1971; steel. Juda Rowan Gallery, London

still extending itself in fruitful and unpredictable abundance. But the precepts advocated by his disciples became so rigid and intolerant that they were bound to provoke within St Martin's a reaction with far-reaching consequences for the future development of sculpture.

Under the enlightened atmosphere created by Frank Martin, this singular art school became a remarkable focal point for alternative developments even as it continued to support the approach defined at the Whitechapel Art Gallery's 'New Generation' exhibition of 1965. However, even at the moment of the New Generation's greatest success, reservations were being expressed about the shallowness of its concerns.[50] And doubts of a different kind were harboured by many artists associated with St Martin's in the latter half of the decade, who took issue with what they saw as an unnecessarily narrow idea of sculpture's potential identity.

The most senior among them was John Latham, an elusive yet influential figure notorious for the ceremonial burning of book towers – which he described as 'reverse order sculptures'[51] or Skoob Towers – outside institutions like the British Museum in the early 1960s. The spectacle caused shock and deep offence, as Latham intended it to. But rather than exploiting destruction as an end in itself, or mounting a specific attack on literature, the smoking towers signified his belief that society had to rid itself of a compartmentalized way of thinking. Books, which often divide knowledge up into branches or categories, and reflect the increasingly specialized character of our culture, were chosen as an apt target. By reducing them to ashes or to a cluster of fluttering pages in large wall-reliefs (Cat. 281), Latham hoped to direct attention towards his concept of a time-based art. Skoob Towers were a succinct method of asserting, through an object with obvious sculptural associations, that there is no reason why artists should restrict themselves to a medium as exclusive as 'sculpture' any longer. Separating art activity into pigeon-holes of that kind was, in Latham's view, one more symptom of the specialization that he still finds so blinkered. He used the conventions of painting, sculpture and drawing to affirm the importance of 'event structures' which lie beyond space-based objects. That is why the Artist Placement Group,[52] an organization which since 1966 has employed his ideas as a springboard for placing artists temporarily within industrial companies and government departments, stressed that the production of traditional art objects should not be viewed as the goal.

Such a profoundly subversive attitude was bound to cause friction at St Martin's, and in the same year that APG was founded Latham provoked a head-on confrontation with the College authorities. Conscious no doubt of the veneration with which Greenberg's writings were regarded by the sculpture staff, he withdrew a copy of *Art and Culture* from St Martin's library and organized an event at his home called 'STILL & CHEW'. The guests, who included many artists, students and critics opposed to Greenbergian formalism, were each invited to take a page from *Art and Culture* and chew it. The masticated paper was then immersed in acid, converted to a form of sugar and neutralized by adding sodium bicarbonate. Afterwards, 'an Alien Culture', a yeast, was introduced, and 'several months went by with the solution bubbling gently'.[53] The outcome was inevitable. Latham returned his distillation to the College library, enclosed in a glass container with an explanatory label attached. The next day he received a letter from the Principal regretting that Latham would not be asked to do any more teaching there.

The whole work, which was subsequently assembled in a leather case *à la* Duchamp[54] and purchased by the Museum of Modern Art in New York, aimed at asserting a view which encompasses the totality of events rather than dealing with the world in isolated, disconnected fragments. Latham's attitude received sympathetic support from Barry Flanagan, who had arrived at St Martin's as a student in 1964 and was involved in both 'STILL & CHEW' and the founding of APG. Like Latham, he wanted to get away from a literary vantage point and assert instead 'the basic operative drive in men to think, structure and organise their existence in a visual way'.[55] To that end, after making some quirky additive metal sculptures in which he bent their lengths into precarious and unpredictable forms, Flanagan

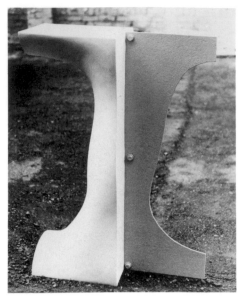

Fig. 25 William Tucker, *Margin I*, 1962; iron and plastic. Tate Gallery, London

50. B. Robertson, 'Preface' to *The New Generation: 1965*, the catalogue of an exhibition at the Whitechapel Art Gallery, London, March-April 1965, p. 10.

51. 'Where does the collision happen?', John Latham in conversation with C. Harrison, *Studio International*, May 1968, p. 261.

52. For a concise summary of APG's first decade see John A. Walker, 'APG: The Individual and the Organisation', *Studio International*, March/April 1976, pp. 162-4.

53. J. Latham, 'Art and Culture', statement dated August 1967 in the catalogue *John Latham* for an exhibition held at the Lisson Gallery, London, November-December 1970, p. 8.

54. Duchamp was given an 'Almost Complete' retrospective exhibition at the Tate Gallery in the same year.

55. B. Flanagan, 'A Literary Work', *Studio International*, July/August 1969, p. 4.

56. B. Flanagan, 'A Letter and some submissions', *Silâns*, no. 6, January 1965, pp. 2-3.

57. 'My work is not urban, nor is it romantic': R. Long, *Five, six, pick up sticks, seven, eight, lay them straight*, Anthony d'Offay Gallery, London, September 1980.

58. Ibid.

59. Ibid.

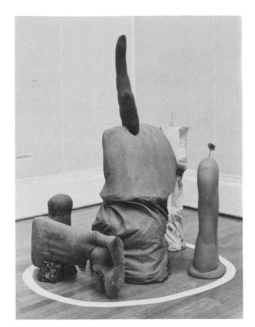

Fig. 26 Barry Flanagan, *aaing j gni aa*, 1965;
mixed media. Tate Gallery, London

began to test the properties of more malleable materials. *aaing j gni aa* (Fig. 26) is composed of an assortment of bulging organic presences, defiantly at odds with the machine-like simplification of so much New Generation sculpture. The pre-sewn shapes such as *Plant I* (Cat. 288), filled with plaster and often inverted after the hardening was complete, have an unclassifiable identity partially dependent on a self-forming process beyond Flanagan's control.

In subsequent works he explored materials even further removed from the metal and fibreglass of the Caro school, pouring and scooping sand, stuffing sacks with polystyrene, laying lengths of rope across an entire gallery floor and using light as a medium by letting it fall across an installation of objects. Sometimes quizzical and always contemplative, Flanagan's early work offers a deceptively informal alternative to the gleaming, ordered finality of New Generation sculpture. 'Am I deluded,' he wrote in a 1963 letter to Caro, '. . . or is it that in these times positive human assertion, directed in the channels that be, leads up to the clouds, perhaps a mushroom cloud? Is it that the only useful thing a sculptor can do, being a three-dimensional thinker and therefore one hopes a responsible thinker, is to assert himself twice as hard in a negative way. . .?'[56] Flanagan's awareness of that 'mushroom cloud' made him prefer a quietly poetic vision, which proposes a gentler order of feeling than the technological brashness of New Generation work. It points to an almost ecological conscience, and links up with Latham's condemnation of short-term profiteering at the expense of preserving long-term natural resources.

No one understood the importance of honouring the innate identity of nature more than Richard Long, who arrived at St Martin's in 1966. From the outset his work was opposed to the essentially urban art of the New Generation sculptors, with their industrial materials and indoor locations. Long preferred to deal with the natural world in the most direct way possible, moving outdoors and taking both his inspiration and his materials from the countryside itself. Unlike other artists who have made the land into the principal arena for their work, he does not presume to impose anything alien on the earth he travels across. The sticks and stones used in his open-air pieces are found on site by an artist who sees his work as practical, simple and vigorous rather than as a romantic interpretation of nature.[57] In *A Line Made by Walking, England, 1967* (Fig. 27), Long did not even pick up any of the materials available in the field: he walked across it instead, treading the grass until a straight track was clearly visible in the photograph he then took of the work.

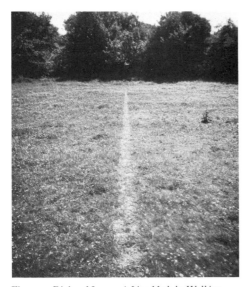

Fig. 27 Richard Long, *A Line Made by Walking,
England, 1967*; photograph. Tate Gallery, London

Circles and lines are the hallmark of Long's art, and they convey in a very clear, single-minded way his preoccupation with movement, distance and time. Rather than responding to the land from a fixed viewpoint, as a more traditional landscape artist would, he prefers to convey the immensity and duration of his experience. Maps, upon which he draws with the utmost economy, are enlisted to help him transmit the totality of a walk. So are words, which refer very concisely to the objects and natural features he passes, intermingled more recently with references to his own state of mind. Long is a very lucid and consistent artist, who knows precisely how to photograph the work he makes in remote locations so that the affinity between sculpture and location appears as harmonious as possible (see Cat. 301). Their fusion is often so complete that his work honours the natural world with a satisfying sense of inevitability. 'My outdoor sculptures are places,' he wrote, stressing the indivisibility of the work and its setting. 'The material and the idea are of the place; sculpture and place are one and the same.'[58] His art seems as wedded to the land it occupies as the prehistoric stone circles found in so many areas of the British countryside. Long achieves the remarkable feat of drawing inspiration from the most ancient sculptural forms and at the same time contributing to adventurous notions about sculpture in his own period. He has defined his art, with a typical lack of pretension, as 'the laying down of modern ideas in the only practical places to take them'.[59]

Although a profound understanding of and respect for the land remain the essential touchstones of Long's work, he responds with equal sensitivity to the galleries where his exhibitions are held. The transition from the inaccessible and often awe-

some stretches of country to the relative intimacy of a museum or dealer's space ought, in theory, to create difficulties. After all, his art arises so directly from the land he traverses that a loss of intensity could easily result in a gallery context. But Long knows exactly how to handle an exhibition arena with a spare limpidity which evokes the compelling vastness and isolation of the locales he explores. His large floor-pieces retain a sense of epic immensity intact (Cat. 300). Displayed either on their own or with photographic pieces on the wall, they succeed in making sculpture a vehicle for his affirmative vision of humanity's dependence on a sustaining relationship with nature.

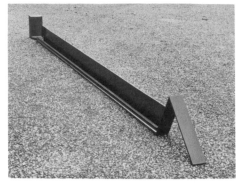

Fig. 28 Anthony Caro, *Strip*, 1965; aluminium and steel painted red. Private Collection

However distinct Long's work may appear from that of sculptors of earlier generations, it does have points of contact with both Moore and Caro. His veneration of the stones, pebbles, slates and other materials found in the landscape recalls Moore's deep respect for the wind- and sea-eroded bones, shells and rocks which he took home to his studio from walks in the country. Moreover, despite Long's undoubted divergence from the idea of sculpture which Caro put forward, both men have been crucially stimulated by the decision to dispense with the plinth and let their work establish a new rapport with the ground it rests on. In Long's case, of course, the old distinction between sculpture and ground has been replaced by a new synthesis, so that walkers coming across his work in the countryside might well regard it as a natural phenomenon rather than art. But Andrew Causey was right to point out the 'ground-hugging' inclinations of Caro's *Strip* (Fig. 28), and to argue that 'the horizontality and articulation of parts in many of Caro's sculptures between 1960 and 1967 suggest analogies with the physical feel of lying and even the undulations of landscape'.[60]

Bruce McLean, another member of the extraordinary generation who trained at St Martin's during the 1960s, also became intrigued by the possibilities of working directly with materials found out of doors. A far more satirical and subversive personality than the retiring Long, who prefers not to incorporate his own physical presence in photographs of land subjects, McLean confined himself to more accessible locations when working with elements as transient as ice, mud and bricks. He never undertook lonely journeys in remote areas of the world, and made a point of using ordinary settings which would match the temporary nature of the work he carried out. He went on, logically enough, to explore the possibilities of sculpture as performance. As if to defy the whole materialist convention of producing an object

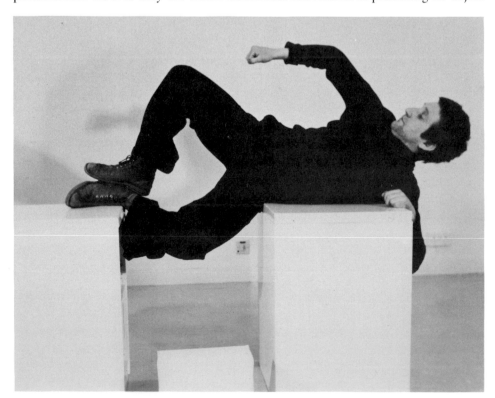

Fig. 29 Bruce McLean, *Pose Work for Plinths I*, 1971; photograph. Tate Gallery, London

which would be marketed by dealers, McLean turned his own body into a sculpture. Moore, whose ever-burgeoning reputation now loomed like a colossus over British sculptors of every generation, became a target as McLean posed irreverently for a *Fallen Warrior* piece near a stretch of rubbish-strewn water. The mock-heroic positions he assumed in *Pose Work for Plinths* (see Fig. 29) likewise referred to Moore's post-war obsession with endless permutations on the reclining figure theme, although the absurdity of McLean's contorted attempts to cling to the plinth also commented on the floor-based debate conducted with increasing dogmatism at St Martin's.

Much of McLean's early work derives its energy from his determination to view art doctrines of many kinds with a jaundiced Glaswegian eye. The style-obsessed manoeuvrings of avant-garde fashion became a particular butt for his caustic attacks. His performances with the Nice Style Pose Band (which began at Maidstone College of Art in 1971 on a bill with The Kinks) were preoccupied with the idea of style as a straitjacket imprisoning everyone held in its thrall (Fig. 1, p. 84). At the same time, in collaboration with the dealer Robert Self, McLean continued to assail the commercial prison of the art market, which many young artists tried to undermine or evade at that period. In a one-man show called 'Objects No Concepts', where plinths of different heights and sizes were topped with glossy magazine photographs of consumer desirables, McLean installed himself in the gallery like an inmate of a cell. His 'job' was to make drawings with prodigious speed, and he attempted to thwart this production-line view of art by crumpling up the results and throwing them on the floor. But Self, his partner in the performance, played the dealer's role to perfection by retrieving the drawings and restoring them to smoothed-out saleability with the help of a steam-iron.[61]

A sample of these rescued sheets was included in each copy of the catalogue McLean issued when he held a one-day 'retrospective' at the Tate Gallery in 1972. The traditional format of a retrospective was flouted not only by the duration of the event but also by McLean's decision to make the catalogue into the principal exhibit. He laid a thousand copies on the floor, using the freedom of post-plinth sculpture in a spirit which Caro would hardly have approved, and invited each visitor to help 'destroy' the show by picking up a catalogue. 'King for a Day' was the typically wry title McLean chose for the exhibition, and the last of the thousand works listed in the catalogue began with the words: 'Goodbye sculpture, art pieces – things/works/stuff/everything piece.'[62]

Despite this premature farewell, McLean has subsequently proved one of the most durable artists to emerge from St Martin's. So have Gilbert & George, who were even more determined to place themselves and their daily experiences at the very centre of their work. They called themselves 'Living Sculptures', and blurred the distinction between art and life so successfully that everything – even the most apparently mundane incident – could be regarded as legitimate sculptural material. The act of staring out at a fall of snow from their Fournier Street window became a sculpture, which Gilbert & George recorded by means of a combined drawing and text sent out to critics, curators and fellow artists in 1969. They called it *Postal Sculpture*, and around the same period they pushed the territorial limits of the activity termed 'sculpture' as far as they would conceivably stretch. Meeting sculptures, singing sculptures, meal sculptures, lecture sculptures, standing sculptures, magazine sculptures, posing sculptures and postcard sculptures – all these variations on the sculptural theme were conducted between 1969 and 1972. The contrast between the audacity of their ideas and the studied politeness of their presentation undoubtedly contributed to the work's effectiveness. With an old-fashioned sense of etiquette, the inseparable pair proposed that 'sculpture' was anything they wanted it to be. Their assertions were seasoned with wit, as if to signify that they knew exactly how outrageous their project had become. But beneath all the mannered behaviour, Gilbert & George's work has always been rooted in a clear and indeed passionate desire to remain true to their own experience. 'Being living sculptures is our life blood, our destiny, our romance, our disaster, our light and life,' they wrote in a 'booklet' called *A Day in the Life of George & Gilbert, the sculptors.* 'As day breaks over us, we rise into

60. A. Causey, 'Space and Time in British Land Art', *Studio International*, March/April 1977, p. 123.
61. The exhibition was held at the Situation Gallery, London, in November 1971.
62. B. McLean, 'List of Works' in *Bruce McLean Retrospective*, Tate Gallery, London, 11 March 1972.

our vacuum and the cold morning light filters dustily through the window. We step into the responsibility-suits of our art. We put on our shoes for the coming walk.... Nothing can touch us or take us out of ourselves. It is a continuous sculpture.'⁶³

The clothes Gilbert & George chose for their 'responsibility-suits' were an integral part of the 'living sculpture' they embodied. Formal, correct, genteel and yet somewhat ill-fitting, these instantly identifiable jackets and trousers signified their awareness of being alone and apart. While the youth culture of the period encouraged everyone to dress with the least amount of convention, Gilbert & George stuck obstinately to an out-of-date uniform which seemed closer to the period of Flanagan and Allan's music-hall song *Underneath the Arches*. The mime they enacted to this song, with bronzed faces, walking stick and gloves, became the best known of their performances and the most demanding (Fig. 30). It needed awesome control to sustain these sessions, which could last up to eight hours, but Gilbert & George's apparent propensity to 'dream our dreams away'⁶⁴ like the tramps in *Underneath the Arches* should never be mistaken for vagueness or indolence. Although they stand apart, and remain intensely conscious of their singularity in a world which views their appearance as anachronistic, the indefatigable duo are motivated by a consistent and energetic desire to share their private vision with as large an audience as possible.⁶⁵ 'Art For All' was the name prefacing their address in the early *Postal Sculptures*, and over the past decade they have succeeded in gaining widespread international attention for work which continues to retain the 'living sculptors' at its centre.

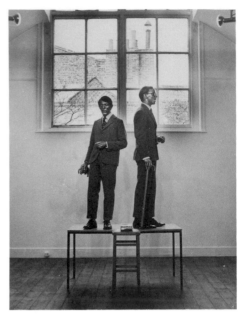

Fig. 30 Gilbert & George, *Singing Sculpture*, 1969. At Nigel Greenwood Gallery, London, 1970

Now that they concentrate on large and increasingly elaborate photo-pieces (for example, Cat. 302-305), however, Gilbert & George no longer seem so interested in twisting the term 'sculpture' in such a prodigious variety of directions. Their photo-pieces relate to painting as much as they do to sculpture, and it now appears less necessary to place them in relation to a sculptural tradition. In this respect alone, they can be linked with their St Martin's contemporary John Hilliard, who made transitory and site-specific sculptures in the late 1960s before growing more and more fascinated by the possibilities inherent in photography itself. Even an early work like *765 paper balls* was made specifically to be photographed, in the knowledge that the camera would provide the only lasting record of its presence. Fascinated by the photograph's ability, through reproduction in art magazines, to 'stand in' for the original work, Hilliard went on to devote himself wholly to an examination of the camera as a device for the shaping of images, often in very deceptive ways (Fig. 31). He always makes us aware of the mysterious sea-changes 'reality' can undergo when subjected to shifts of speed or focus, and the term 'sculpture' has long since ceased to be a major issue in Hilliard's increasingly large-scale and sumptuous photographic work.

The camera has also assumed ever-greater importance in the art of Hamish Fulton, another student at St Martin's during the second half of the 1960s. Having begun, like Long, with a wholehearted commitment to the exploration of time,

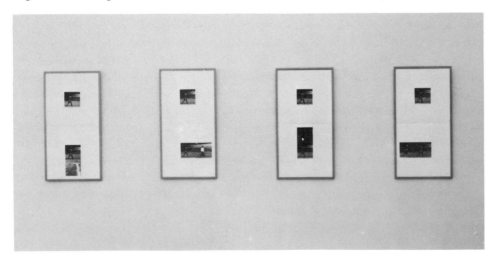

Fig. 31 John Hilliard, *Across the Park*, 1972; four photographs. Tate Gallery, London

Fig. 32 Hamish Fulton, *Moonset and Sunrise*, 1969-71; four photographs. Arts Council of Great Britain

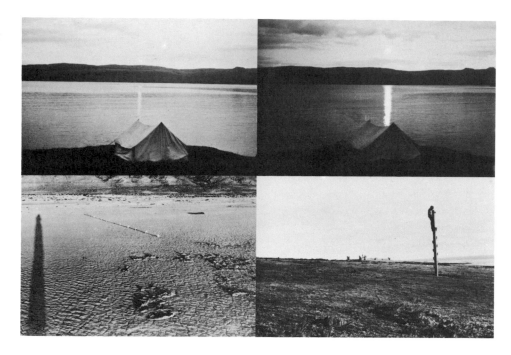

distance and the sanctity of nature (Fig. 32), he subsequently decided to refine the experience by dispensing with any alterations to the landscape. The photograph, with attendant caption, therefore came to stand for Fulton's journey in the remote regions he favours, and he feels no need to follow Long's example by making floor sculptures in galleries as well.

Photography and performance were among the principal directions uncovered by the widening of sculptural parameters in the early 1970s. Stuart Brisley proved a particularly powerful exponent of performance, often in a naked state and always involved with suffering and degradation. But the gruelling rituals he forced his body to endure usually pointed away from the artist himself, and made his viewers aware of a more general condition experienced by humanity at large. When Brisley subjects himself to ordeals which most of us would go a long way to avoid, we realize that he acts as an uncomfortable reminder of how vulnerable our civilized behaviour in Western society really is. He manages to embody aspects of life which we spend most of our time trying to forget. It is as if he wants to reduce himself, albeit temporarily, to the level of life suffered by the victims of famine or oppression elsewhere in the world. Only thus, he implies, can someone with his material advantages ever really know what profound privation must be like. The entire performance is not carried out for his benefit alone. It is a carefully stage-managed event, and our participation as viewers is usually a crucial part of the process. Without an audience Brisley finds it difficult to continue. He feeds off the possibility that his often harrowing portrayals of humanity in travail might arouse compassion and, perhaps, a greater understanding of what it really means to be alive.

With hindsight, we can now see that the broadening of sculpture's scope to encompass activities as diverse as land art, performance and photographic experimentation had reached its zenith by the mid-1970s. After that, artists either pursued these new developments without nominating them as 'sculpture' any more or discovered ways of returning to the three-dimensional object armed with the freedoms which had been claimed during the previous decade. In 1974 Bernard Meadows invited me to deliver the Lethaby Lectures on sculpture at the Royal College of Art, where he taught with admirable open-mindedness in a department that produced a succession of notably independent young sculptors.[66] I called the lectures 'Sculpture Now: Dissolution or Redefinition?', and accompanied them with an international exhibition which included Flanagan, Fulton, Gilbert & George and Long among the British contributors.[67] The final lecture came to the conclusion that 'true dissolution could therefore never be a conceivable reality', since sculpture now required a 'redefining process' which would enable it gradually to 'become "respon-

63. Gilbert & George, *A Day in the Life of George & Gilbert, the sculptors*, autumn 1971, 'Art For All', 12 Fournier St, London, pp. 3-5.

64. Gilbert & George, *A Guide to the Singing Sculpture*, London, 1970.

65. In an interview with Mark Francis, published to coincide with their exhibition at the Whitechapel Art Gallery, Gilbert & George explained that 'popularity is all very well inasmuch as it can be popular but we wouldn't like to do popular things, we wouldn't want to become popular novelists, or illustrators or something. We want as many people to see our work for what it is.'

66. Tony Cragg, Richard Deacon and Alison Wilding studied at the Royal College of Art in the 1970s.

67. The exhibition, likewise called 'Sculpture Now: Dissolution or Redefinition?', was held at the Royal College of Art in November 1974.

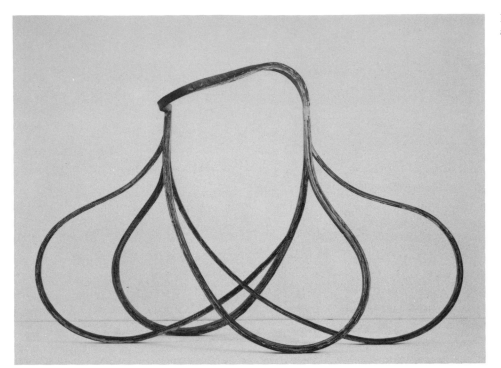

Fig. 33 Richard Deacon, *For Those who have Ears,
no. 2*, 1983; wood. Tate Gallery, London

sible" in the fullest sense of the word, composed of works which further a growing comprehension of sculpture's potential within art and society rather than within a fragmented battlefield full of petty rivals pretending that their enemies simply do not exist'.[68]

It was a large hope to harbour, but since those lectures were delivered sculpture has indeed undergone a 'redefinition' more gratifying and sustained than anything I dared to expect in 1974. Many of the animosities between different kinds of sculptural practitioner have mellowed in the past decade, and from the threatened 'dissolution' an impressive new range of work has been created by sculptors who emerged in the late 1970s and beyond. Their achievements lie outside the scope of the present exhibition, but the work of men and women like Kate Blacker, Helen Chadwick, Stephen Cox, Tony Cragg, Richard Deacon, Anthony Gormley, Shirazeh Houshiary, Anish Kapoor, David Mach, Dhruva Mistry, Alison Wilding and Bill Woodrow offers a heartening demonstration of sculpture's capacity to redefine itself. While affirming the three-dimensional object once again, many younger sculptors have clearly benefited from the liberating example of their forerunners (Fig. 33).

New British sculpture in the 1980s has displayed such questioning vigour and imaginative resourcefulness, in its strategies and materials alike, that it remains at the very forefront of art in this country. Indeed, the sculptural venture has grown into a remarkably supple, stimulating and audacious activity over the decades since Thomas Brock erected his stolid Victoria Memorial at the beginning of the century (Fig. 1). But the prominent metropolitan site occupied by Brock's monument is also a reminder that contemporary sculpture has yet to find patronage capable of enabling it to fulfil a truly public role, far outside the confining boundaries of the gallery. Until this vital challenge is met with sufficient flair and certitude by everyone in our society who could commission such work, the emancipation of modern British sculpture will remain tantalizingly incomplete.

68. The Lethaby Lectures were subsequently issued in cassette form as an *Audio Arts Supplement*, 1975.

Charles Harrison

Critical Theories and the Practice of Art

In an 'Essay in Aesthetics' first published in 1909[1] Roger Fry deliberated, as an established art historian and an emerging critic, upon 'the nature of the graphic arts'. He sought an explanation for 'our feelings about them' which would be free from the kinds of confusion engendered by 'any theory of mere imitation'. The aim was significant of its moment. At one level Fry was exploring the implications of an enthusiasm for French painting since Manet – and particularly for the work of Cézanne – as this bore upon an educated appreciation of the qualities of earlier art. At a perhaps deeper level, he was attempting to articulate a sense of value in the experience of art as part of a critique of utilitarian forms of evaluation. His two interrelated conclusions were that art is 'the expression of the imaginative life' in contradistinction to 'actual life', and that 'we may . . . dispense once and for all with the idea of likeness to nature, of correctness or incorrectness as a test'. In implicitly identifying 'likeness' or descriptiveness with unimaginativeness, Fry was associating himself with the 'progressive' side in that contest between traditionalists and moderns which, in France, had already been decided in favour of the latter.

This was not simply a matter of competition between different concepts of competence in the production of art – between the academics who supposedly assessed 'likeness to nature' and the moderns who assessed 'strength of expression' – though in the establishment of Modernism as the dominant high culture of art the revision of priorities for judgments of competence was certainly a necessary process. Fry was adding his voice to a more urgent debate about the representational character of art. In France since soon after the mid-nineteenth century a divergent 'modern' art had furnished objects of interest and self-identification for the 'enlightened bourgeois detached from the official beliefs of his class'.[2] The art of Manet and of the Impressionists and their successors had also, in a sense, been a *product* of the avant-garde constituency which that detachment defined. The existence of a similar advanced constituency was a necessary condition for the successful implantation of modern art in Britain. Though some ground was established with the Aesthetic Movement of the 1890s, the full self-recognition of a cultured, non-commercial, non-aristocratic elite was achieved in its engagement with Modernist culture in the ten or so years immediately preceding the First World War. If we can talk of a Modernist *period* in English art we must be referring at some level to an era during which this social section has determined the representational character of high culture.[3]

The aesthetic ground of the supporters of modern art was most boldly staked out by Roger Fry's friend and colleague Clive Bell. 'To appreciate fully a work of art,' Bell wrote in 1914,[4] 'we require nothing but sensibility. To those that can hear, Art speaks for itself.' And later, 'Art is not to be learned; at any rate it is not to be taught. All that the drawing-master can teach is the craft of imitation.' Bell made clear that the tendency to match the forms of art against the appearance of things in the world was to be regarded as a symptom of 'defective sensibility'. For the members of the constituency in question loyalty to the cause of modern art went hand in hand with their concern at what they saw as a major threat to culture and civilization: the threat posed by those motivated by 'material' or 'commercial' interests; those for whom nothing was of value 'in and for itself'; those who, when they looked at a work of art, looked 'through' its form in search of that which it betokened or resembled; those unable to distinguish between 'disinterested contemplation' and the 'emotions of life'.[5] That a supposedly innate (contemplative) sensibility contrasted favourably with acquired (instrumental) knowledge and skill was

1. 'An Essay in Aesthetics', *New Quarterly*, 1909. Republished in R. Fry, *Vision and Design*, London, 1920.
2. The phrase is Meyer Schapiro's. He was discussing the 'urban idylls' of early Impressionism, which 'reflect in the very choice of subjects and in the new aesthetic devices the conception of art as solely a field of individual enjoyment, without reference to ideas and motives', and which '. . . presuppose the cultivation of these pleasures as the highest field of freedom for an enlightened bourgeois detached from the official beliefs of his class' (M. Schapiro, 'The Nature of Abstract Art', *Marxist Quarterly*, vol. 1, No. 1, 1937). The idea that works of art have a 'moral aspect' attributable in such terms, and that this aspect is open to historical and sociological forms of inquiry and explanation, is one for which the advocates of a supposedly 'New Art History' are generally indebted to the Marxist critics and art historians of the 1930s.
3. For a more developed argument along these lines see *Art-Language*, vol. 5, No. 3 ('Blue Poles'), March 1985.
4. C. Bell, *Art*, London, 1914.
5. The terms are Fry's; op. cit., n. 1.

perhaps the most telling of all assumptions by which the adherents of the 'New Movement' were characterized.[6]

Bell's and Fry's was a 'Traditional Modernism'. They saw all works of art as identified and united by the form of experience they enabled, and the works of the modern artists they admired as characterized by universal or 'classic' qualities. For Bell, the (tautological) property 'significant form' was 'common to Sta. Sophia and the windows at Chartres, Mexican sculpture, a Persian bowl, Chinese carpets, Giotto's frescoes at Padua, and the masterpieces of Poussin, Piero della Francesca, and Cézanne'.[7] Cézanne's work and career were taken as exemplary both of the experience offered by art and of the practical integrity required of the modern artist. No other artist's work, they believed, was so thoroughly purged of those 'associated ideas' by means of which 'Romantic' art played upon the 'sensations of ordinary life' (thus pandering to debased taste and compromising the purity of aesthetic experience). 'In so far as one man can be said to inspire a whole age,' Bell wrote, 'Cézanne inspires the contemporary movement.'[8]

Claims for the universality and disinterestedness of personal preferences are rightly treated with some scepticism. The naturalization of contingent taste and sensibility has been a well-observed tactic of Modernist criticism.[9] We may also note the tendency to idealize artists as beings with creative powers but with no basic needs or desires, the tendency dogmatically to proclaim the autonomy and disinterestedness of aesthetic production and also of aesthetic experience, the tendency to fail to perceive or to acknowledge the persuasive or admonitory power of evaluative statements,[10] the tendency to attribute aesthetic identity to artefacts in flagrant disregard for the relativities of history, social function and so on. It was in Bell's writing that these characteristics appeared in their baldest form. Though he was emphatic about the disinterestedness of the aesthetic disposition, Fry was not otherwise inclined dogmatically to prise art loose from its historical conditions. It was in its crudest and most coherent form, however, that the earlier work of both writers was absorbed into the artistic culture of Britain. In its most full-bloodedly Modernist aspect their theory dominated English criticism throughout the 1920s[11] and even to this day much of it remains current in forms of artistic chat. Many of the attitudes they represented were shared not only by those artists like Vanessa Bell and Duncan Grant who were of their immediate circle, and by those like Ivon Hitchens and Henry Moore who read and were impressed by their writings, but even by artists such as Paul Nash and Ben Nicholson who saw themselves as positively antagonistic to the society of Bloomsbury.

It is clear that Moore, for example, used Fry's *Vision and Design* not simply as a guide to what to look at in 'the whole of the world's art', but also as a guide to *how* to look at it.[12] In particular, Moore derived from Fry the means to identify supposedly universal qualities and virtues in 'the common world-language of form'.[13] 'Once you'd read Fry,' he recalled in 1961, 'the whole thing was there. I went to the British Museum on Wednesday and Sunday afternoons and saw what I wanted to see.'[14] The 'whole thing' was that set of preferences, regulative concepts and practical prescriptions which, for the purposes of a career in sculpture, went to compose a Modernist disposition and a Modernist practice. This was an important matter. Artists such as Moore were still presented with a choice of identifications. They needed to know how to go about the business of being a *modern* artist and of making that commitment count in practice. One clear requirement was a rejection of the Greco-Roman tradition and of its recapitulations during the Renaissance and after.[15] The antique tradition was for a while entirely compromised by its various associations with literary mythology and by the generally illustrative and narrative tendencies it was seen to encourage. The loose category of the 'primitive' was set up as a contrasting model of virtue and of formal vigour.[16] In 1920, when Nicholson was finally ready to make his decision in favour of the modern, he set to work quite deliberately against his own traditional competences, cultivating instead that superficially disingenuous combination of delicacy and hamfistedness of touch and colouring which characterized the English 'Post-Impressionists'. On visits to Paris in the

6. 'With the new indifference to representation we have become much less interested in skill and not at all interested in knowledge' (R. Fry, 'Art and Life', in *Vision and Design*, 1920, based on notes of a lecture given to the Fabian Society in 1917). For an extended discussion of the implications of this position see 'Introduction: Modernism, Explanation and Knowledge', in C. Harrison and F. Orton, eds, *Modernism, Criticism, Realism; alternative contexts for art*, London and New York, 1984.

7. Bell, op. cit., n. 4.

8. Ibid.

9. See, for instance, M. Baldwin, C. Harrison and M. Ramsden, 'Art History, Art Criticism and Explanation', in F. Frascina, ed., *Pollock and After: the critical debate*, London and New York, 1985; Art & Language, 'Abstract Expression' and 'Author and Producer revisited', in Harrison and Orton, op. cit., n. 6.

10. On the nature of this failure and of its historical prevalence see Alasdair MacIntyre's discussion of Emotivism in his *After Virtue: a study in moral theory*, Notre Dame, Indiana, 1981.

11. *Vision and Design* remained in print throughout the 1920s and new editions were published in 1928 and 1937. Bell's *Art* was in its ninth printing in 1929. His collected essays, *Since Cézanne*, achieved four printings within six years of publication in 1922.

12. According to his own testimony, Moore came on a copy 'by chance' while a student in Leeds in 1922. In particular, Fry made the all-important link for Moore between a commitment to the modern and an interest in the 'primitive'. On Moore's own account, 'That really was the beginning'. (From a statement in *Partisan Review*, March–April 1947.)

13. The phrase is Moore's, from a talk on 'Primitive Art', published in *The Listener*, 24 August 1941.

14. Moore, in John and Vera Russell, 'Conversations with Henry Moore', *The Sunday Times*, 17 and 24 December 1961.

15. This rejection was given emphatic expression as late as 1932 in a chapter on 'The Greek Prejudice' in R. H. Wilenski, *The Meaning of Modern Sculpture*, London.

16. 'Most people who care much about art find that of the work that moves them most the greater part is what scholars call "Primitive".' C. Bell, op. cit., n. 4.

early 1920s he looked at what he could find of the work of Picasso, Braque and Matisse, but also at the Italian (pre-Renaissance) Primitives in the Louvre, at African sculpture, and at the works of the 'naive' painter Douanier Rousseau – at just that range of art, in fact, that was written about and approved by Fry and Bell. Even Nash, whose attachment to the literary and figurative legacy of the Pre-Raphaelites might well have countered the dogma of 'significant form', could write to a close friend in 1925, 'I have still a certain amount of the literary stuff in my aesthetic system! But once one has begun to find the plastic values all other considerations seem irrelevant.'[17]

It was in such terms and by such concepts that the mainstream practice of modern art was defined and entrenched in England during the first quarter of the century. There were competing currents, each also connected to earlier continental precedents, but none that flowed strongly after the First World War. For instance, the work of Sickert and of his younger associates in the Camden Town Group, notably Gore and Gilman, briefly extended the history and practical repertoire of that concern for a 'Painting of Modern Life' which Baudelaire had articulated in the mid-nineteenth century.[18] Interest in the possibility of a kind of contemporary realism had long served as a counter to the developing autonomy theses of Modernist theory, furnishing alternative forms of interpretation and evaluation of modern painting's technical resources. In the 1920s, however, 'realism' was a deeply unpopular and unfashionable requirement. Gilman alone might have demonstrated that realist interests were not necessarily incompatible with Modernist practice, but he was dead by then.

In 1914, the polemic of Vorticism and the critical and theoretical writings of T. E. Hulme converged upon a kind of 'Radical Modernism' which furnished a further brief counter to the 'Traditional Modernism' of Bloomsbury. Where the latter stressed the continuity of all aesthetic experience and the universal qualities of all aesthetic form, the 'Radical Modernists' believed that the experience of modern art should be a qualitatively 'modern' experience, an experience redolent of and specific to the modern world. '. . . the new art differs not in degree but in kind from the art we are accustomed to,' Hulme wrote in 1914, 'and . . . there is a danger that the understanding of the new may be hindered by a way of looking on art which is only appropriate to the art that preceded it.'[19] What he offered by way of prescription, however, was a recipe for merely cutaneous Modernism: submission to a kind of stylistic Zeitgeist. 'It is not a question of dealing with machinery in the spirit, and with the methods of existing art, but the creation of a new art having an organisation, and governed by principles, which are exemplified unintentionally, as it were, in machinery.'[20]

The art of the Vorticists, and specifically of Wyndham Lewis, was energetic and interesting. It was also provincial in so far as it fulfilled Hulme's requirements. Though the evidence (of Picasso's and Matisse's work, for example) showed that cosmopolitan Modernist art was practically feasible by reference to the figurative furniture of private occasions or the idiosyncratic symbolism of personal obsessions, the much propagandized modernization of art by reference to the iconography or machinery of the 'modern world' seems very rarely to have resulted in better than second-rate art. This is perhaps because the 'modern world', so vivid a notion in the later nineteenth century, has rarely since then been better than a journalistic fiction or administrative slogan. The enthusiasms of those who have attempted to capture its ephemeral quality, artists and would-be theorists alike, have all too often been rendered embarrassing by the ironies of history.[21] As Lewis acknowledged in retrospect, 'The brave new world was a mirage – a snare and a delusion.'[22]

With the dominant interpretation of the Modern Movement already formed in terms of 'significant form' and 'classic spirit', it is not surprising that English critical attention in the 1920s and early 1930s should have been directed at what R. H. Wilenski called 'the Cubist-Classical Renaissance',[23] at the expense of any informed interest in the Dada and Surrealist avant-gardes. In *The Modern Movement in Art*, first published in 1927, Wilenski claimed that the artists of this movement

17. Letter to Gordon Bottomley, 22 April 1925. Published in C. Abbott and A. Bertram, eds, *Poet and Painter*, London, 1955.

18. See, for example, 'The Salon of 1846: on the Heroism of Modern Life', and 'The Painter of Modern Life' (first published 1863), in F. Frascina and C. Harrison, eds, *Modern Art and Modernism: a critical anthology*, London and New York, 1982.

19. 'Modern Art and its Philosophy', lecture of January 1914, printed in T. E. Hulme (H. Read, ed.), *Speculations: Essays on Humanism and the Philosophy of Art*, London, 1924.

20. Ibid.

21. For a later example, see Reyner Banham's 'Introduction 2' to the catalogue of 'This is Tomorrow', an exhibition held at the Whitechapel Art Gallery in 1956. For all the vaunted crossing of cultural barriers for which the exhibition has been remembered, in the year of the Suez debacle and the invasion of Hungary the 'Tomorrow' canvassed was at best an *artistic* prospect.

22. 'The Skeleton in the Cupboard Speaks', in *Wyndham Lewis the Artist from Blast to Burlington House*, London, 1939.

23. In R. H. Wilenski, *The Modern Movement in Art*, London, 1927; new and revised edition 1935.

'serve the idea of architecture as typical art . . . for the modern artist's creed, like the creed of all classical artists, postulates a concept in the artist's mind of a formal order or architecture in the universe'. Though Wilenski posited an 'intrinsic value' in the successful work of art, as an explicit counter to Bell's notion that works of art were identified and validated as such by the emotional experience of the sensitive observer, the general tendency of his writing followed that seemingly inexorable preoccupation with 'underlying structures', with 'essential qualities' and, above all, with 'purity' which connects early English writing on Cézanne to theories of abstract art in the 1930s[24] and both, subsequently, to the rationales of a born-again Constructivism in the early 1950s.[25]

Wilenski saw Paul Nash as 'the leading artist of the modern movement in this country' and as one 'advancing towards abstract Cubism'.[26] This was an understandable assessment given the conditions in which it was made. Nash himself certainly came to identify the prospects for the modern movement in England with the possibility of 'a more practical, sympathetic alliance between architect, painter, sculptor and decorator'.[27] It was this conviction which led him to organize the small English avant-garde into a group known as Unit One. Announcing the formation of the group in July 1933, Nash defined 'the contemporary spirit' in terms of 'the adventure, the research, the pursuit in modern life'.[28] In fact, for all Nash's determined – if somewhat vague – identification with what he felt ought to be the case, it was not in his own work but in Nicholson's that the Post-Cubist, Purist and neo-Constructivist aspects of the European Modern Movement were to find their closest echo. Nicholson's white reliefs of the mid-1930s constitute the paradigm English contribution to that movement during the period between the wars. To say this is not, however, to accord the same work unquestionable status in a review of *Modernist* art – or a Modernist review of art. It is arguable that the practical unification of art, architecture and design – as propagandized, for example, by the 1937 publication *Circle*,[29] which Nicholson helped to edit – represented a deformation of Modernism, the critical tendency of which is to oppose design's inescapably utilitarian functions and values. 'The Modern Movement' and 'Modernism' are mutually implicated but not synonymous concepts.

By the early 1930s the critical discourse of Modernism in England had become once more cosmopolitanized – and thus to a large extent updated. There were various factors in this, among them Nash's writing in *The Listener* and the *Weekend Review*, Nicholson's and Barbara Hepworth's contacts with the Paris-based Association Abstraction-Création, and the emergence of Herbert Read as a new advocate for the international Modern Movement and interpreter of its attendant theory. Read was neither an original nor a very sophisticated critic, but a considerable amount of Continental material was recycled in his published writings to the benefit of a native audience. Previous English writers on modern art had tended to look no further than Paris. Read's book *Art and Industry*, published in 1934, owed much to the publications of the German Bauhaus and was prefaced by acknowledgments to Walter Gropius and László Moholy-Nagy. While acting as spokesman for the small English avant-garde, and particularly as defender of abstract art, he also prepared some ground for appreciation of Expressionist and Surrealist forms of art by drawing attention to those symbolic and subjective functions of representation which had been relatively neglected in previous English critical theory. In *Art Now* he offered a way of thinking about artistic form which contrasted strongly with Bell's. 'The thing formed – and this is the key to the whole of the modern development in art – can be subjective as well as objective – can be the emergent sensibility of the artist himself.'[30]

Abstraction was the *cause célèbre* of the early and mid-1930s. The journal *Axis* was launched in January 1935 as 'a Quarterly Review of "Abstract" Painting and Sculpture' along the lines of *Abstraction-Création* and an international 'Abstract and Concrete' exhibition was held under the journal's sponsorship the following year.[31] Critical controversies which attended upon the development of abstract art in England were for the most part legacies of the Modern Movement's more considerable

24. See n. 29.
25. In 1953, the painter Adrian Heath, a close associate of Victor Pasmore, published a small book *Abstract Painting; its origin and meaning*, London. His survey opened with Cézanne: 'Classical, or geometrical abstraction . . .', he wrote, 'descends through the Cubists from Cézanne.' The tendency noted in late-late-Constructivism's historiographical self-image, though long accorded the virtual status of a natural law, was established in terms of a surprisingly *superficial* 'underlying structure'.
26. Wilenski, op. cit., n. 23.
27. P. Nash, 'The Artist in the House', *The Listener*, 16 March 1932.
28. P. Nash, 'Unit One', *The Listener*, 5 July 1933.
29. J. L. Martin, B. Nicholson and N. Gabo, eds, *Circle: International Survey of Constructive Art*, London, 1937.
30. H. Read, *Art Now*, London, 1933.
31. 'Abstract and Concrete' was organized by Nicolete Gray and shown in Oxford, Liverpool, London (Lefevre Gallery) and Cambridge between February and June 1936.

32. See P. Nash, 'For, But Not With', in *Axis No. 1*, January 1935.

33. See H. Read, 'What is Revolutionary Art?', in B. Rea, ed., *Five on Revolutionary Art*, London, 1935; edited reprint in Frascina and Harrison, op. cit., n. 18.

34. B. Hepworth, Statement in *Circle*, op. cit., n. 29.

35. On the mutual implication of the two forms of explanation thus caricatured see Baldwin, Harrison and Ramsden, op. cit., n. 9, and Art & Language, 'Author and Producer revisited', loc. cit., n. 9.

36. A. Blunt, 'From Bloomsbury to Marxism', *Studio International*, November 1973.

37. B. Rea, ed., op. cit., n. 33.

38. The term was introduced into art criticism by Eric Newton; see his 'The Centre Party in Contemporary Painting', *The Listener*, 29 May 1934. The sense of his designation is suggested by his assessment of Stanley Spencer as 'perhaps the only artist in England today who can be called a genius without any fear that posterity will laugh at the judgement'.

39. *Axis No. 7*, in autumn 1936, included the article 'England's Climate', by Geoffrey Grigson and John Piper. Piper's contribution included the reproving truism that 'any Constable, any Blake, any Turner has something an abstract or a surrealist painting cannot have'. *Axis No. 8* appeared late in 1937. The leading article, by Piper, was on the aerial photography of pre-historic sites.

encounters with European history. Was the construction of works of art a model for, or a mere reflection of processes of social (re)construction? Was abstract art merely a means to effect improvement in the appearance of man-made things, as Nash seemed to conclude,[32] or was it, as Read claimed,[33] a practical pointer to the 'art of the new classless society'? Was it to be seen as a critical distillation of the faculty of design, or as philosophy without words but with universal application – 'a thought', in Hepworth's words, 'which gives the same life, the same expansion, the same universal freedom to everyone'?[34] It has to be said that consideration of these issues was largely restricted to discussion of the relative merits of artistic styles, in comparative ignorance of the historical themes which those styles had initially expressed. This was part of the price paid in Britain for a relatively untroubled commitment to the autonomy of art, and for the resulting prevalence among Modernist artists and their typical sympathizers of a nonchalant attitude towards recent and contemporary history.

In the history of modern art, the more evidently idealist forms of practice have tended to be countered by if not actually to generate claims for some species of realism. To say that the basic mechanisms of this relationship are political – as they must be – is not simply to identify, say, idealism with Capitalism, and realism with Socialism (though there are those who would have it that way). It is rather to note that the mutual necessity which binds the one to the other – and which requires, for instance, that an utterance of 'He did it for the money' be countered with an utterance of 'He did it from inner necessity' and vice versa[35] – is of the same species as the mutual necessity which binds Capitalism to its *representation* of Socialism and Socialism to its *representation* of Capital.

The 'realist' discourse of the 1930s was associated with the Artists International Association, a collection of artists, designers and writers which swelled from amateur-Stalinist origins in 1933 to become a broad-front anti-fascist organization with a wide range of liberal support. Over the turn of the years 1933–4, 'revolutionary' entered the vocabulary of art criticism as a term of unqualified approval. Anthony Blunt has described how '... quite suddenly, in the autumn term of 1933, Marxism hit Cambridge', and how, as a consequence, 'Art for art's sake, Pure Form, went by the board totally', to be replaced by a kind of historical materialism.[36] There were of course those, refugees from Hitler's Germany for the most part, who had been familiar with the relevant theories before 1933. One of them, Francis Klingender, combined an education in art history with a party-line commitment to Socialist Realism. His contribution to an AIA symposium on 'Revolutionary Art' promised 'a new style – utilising all technical achievements of modern art – that will be able to express the basic content of the proletarian struggle in a fully convincing manner, appealing to the workers'.[37] Though Klingender was by no means an isolated figure, and though there were a few artists who shared his aspirations, this hopeful *mélange* of Constructivist, Stalinist and Brechtian slogans was cut adrift from all possibility of practical fulfilment in the England of the mid-1930s.

From then until the mid-1950s there was more common ground than either would have wished to acknowledge between the would-be Realist left and the 'Centre Party' in English art and criticism.[38] Typical representatives of the latter were those educated gentry accustomed to some guardianship over and spokesmanship for English art and letters who, while they assumed their own commitment to the progressive in culture, baulked at the combination of cosmopolitanism and professionalism which characterized the career of the ambitious modern artist, and who, while they might demur at the 'literary' and 'illustrative' content of the academic, saw undomesticated abstract art and Surrealism alike as implants potentially injurious to the native romantic sensibility. Full-blooded Modernism was clearly threatening to them. By marginalizing those specifically British themes and interests which they were accustomed to notice, it promised to displace them and their competences from the central position they had traditionally enjoyed. The Romantic Revival, already in hand in 1936–7 and noticeable, for instance, as a change in the editorial policy of *Axis*,[39] was significant of a retrenchment in British culture. As has been

written of another time and place, 'The respectability of culture was what was sought rather than its substance.'[40] (It should be said that Nash's landscapes of the early 1940s, if they are properly called 'Romantic', stand above the level at which these strictures apply.)

The war greatly encouraged cultural isolationism and conservatism and effectively ensured for the Centre Party a position of pre-eminent authority in criticism and in the administration of art. The critical theory of the middle ground *was* effectively its cultural policy, implicitly spelled out, for example, in Robin Ironside's report *Painting since 1939*, a survey of *British* painting written for the British Council and published in London in 1947. 'The best British painting,' Ironside declared, 'relies, for its final justification, upon an amateur stimulus.' This amateur virtue, as exemplified in the art of the Romantics, was clearly contrasted with what Modernist theory had identified as the professional commitment. 'The idea of an exclusive and all-sufficing beauty in plastic values still persists; but its practical application, which never produced outstanding results, is now increasingly neglected and, with few exceptions, fruitlessly attempted. That the idea should survive as part of a culture so ill-conditioned to uncompromising theories is due . . . more perhaps than to anything else, to the far-reaching influence of the teachings of Roger Fry.'

Ironside rightly for his purposes singled out the prime case of 'doctrinaire abstractionism': 'The barrenness that Nicholson has cultivated has no pictorial interest.' The vacant laurels were accorded to those who had proved themselves in war and communication. '. . . the specialised qualities of Moore and Sutherland were made vivid to a large public when they were seen to be the sign of emotions that had been generally experienced.' It was upon those younger neo-Romantic artists who were in sympathy with Moore and Sutherland (Ironside mentioned Craxton, Minton, Richards, Freud, Vaughan, Bacon, Colquhoun and MacBryde) 'that we must found any forecast of future directions', there being at the time 'no likelihood of the alternative of a reaction towards abstraction'.[41]

Four years earlier Klingender had published a pamphlet *Marxism and Modern Art*, subtitled 'An Approach to Social Realism'.[42] It included a critique of 'Roger Fry's Formalism' and of the notion of the autonomy of aesthetic values, a forthright condemnation of abstract art which pointed directly at Nicholson, a backward glance to a moment of authentically English art, and a celebration of 'the blitz paintings of 1940–1' as demonstrations of the artists' capacity to give 'imaginative form' to the experience of 'the people'. Whatever may have been the arguments between the Communist left and the liberal centre, they were clearly at one in their opposition to the cosmopolitan theory, profession and occasional practice of Modernism.

The opposition from the centre has persisted to this day in the urbane voices of numerous littérateurs, self-appointed guardians of the 'constant' or 'underlying' values of (British) art. On the left the longing for a 'relevant', 'comprehensible', 'realist' art has remained alive – or half alive – as the necessary obverse of the coin of Modernist specialization, surfacing among certain factions in the Euston Road School in the late Thirties,[43] in the littered tenements and kitchen tables of the so-called 'Forgotten Fifties',[44] by which decade Klingender's anti-Modernist mantle had passed to John Berger, and again in the agonizings over 'Art for Society'[45] in the 1970s. Modernist art is not conceivably popular; indeed, if there is substance to my earlier speculations about the nature of its constituency, the evading of popularity is one of its necessary functions.[46] It has been a persistent problem for those critics concerned at one and the same time for art and for democracy that this conclusion is not automatically enabling of the production of authentic culture. Whatever may or may not be the virtues of an unmitigatedly Modernist or abstract art, it is clear that fixations with the *effectiveness* of art as communication have always in the modern period had reactionary consequences. It is likely that at some level they have also had reactionary causes. (If works of art may be thought of as texts, the opacity of these texts needs to be acknowledged. Such acknowledgment follows from acceptance of what does happen to be art's practical character. Those who hold on to a self-

40. C. Greenberg, 'The Late Thirties in New York', in Greenberg, *Art and Culture*, Boston, 1961. Greenberg was distinguishing between 'Eighth Street' in the late 1930s and early 1940s and 'Tenth Street' in the 1950s, when 'Eighth Street's original effort to overcome provincialism was continued in a way that served only to reconfirm it'.

41. Contrast the less bureaucratic account offered by Lawrence Alloway in 1954. 'The romantic accent of the later AXIS grew thicker in the war, both among the official war-artists (Sutherland, Nash, Piper) and among the new generation (Vaughan, Craxton, Minton). Both the loyal men and the dreamy boys developed an imagery of landscape which implied a kind of dark, meditative patriotism. The sceptred isle became an armoured womb.' (From Alloway's introduction to *Nine Abstract Artists; their work and theory*, London, 1954.) During the modern period, professionalism in the English criticism of modern art has required the cultivation of distance from the semi-official valuations of British artistic culture.

42. F. Klingender, *Marxism and Modern Art*, Marxism Today Series, London, 1943.

43. See, for example, Graham Bell's pamphlet *The Artist and his Public*, London, 1939.

44. The exhibition 'The Forgotten Fifties' was conceived at the Graves Art Gallery, Sheffield, and shown there and in Norwich, Coventry and London during 1984. In his preface to the catalogue, the Director, Julian Spalding, asserted that 'Realism was the key word at the time'. The supposed timeliness of the exhibition was due, according to Spalding, to the fact that a new 'revival of figurative expressionism' in the 1980s had restored the currency of 'the style of painting of which Bratby was the most publicly famous exponent, a style which was truly international in flavour and which cross-fertilized the long tradition of English realism [sic] with contemporary developments in Europe'. This 'style' was apparently 'superseded' before its time by 'another international style, American Abstract Expressionism, which swept the whole of Western Europe in the latter part of the decade and grafted itself [!] successfully on to our developing tradition of abstract art'. This sorry *mélange* of historical and critical confusions typifies the desperate attempts of British art management to identify the ground it happens to occupy at the moment as centre stage front in the drama of culture and history.

45. 'Art for Society' was the title of an exhibition at the Whitechapel Art Gallery in May 1978. 'Art for Whom?' at the Serpentine Gallery continued the agonizing over art's (un)popularity.

46. On this question see C. Greenberg, 'Avant-Garde and Kitsch', *Partisan Review*, vol. VI, No. 5, fall 1939; reprinted in C. Greenberg, *Art and Culture*, op. cit., n. 40, and in Frascina, op. cit., n. 9. For the contemporary context of debate with which Greenberg was engaging, see *Aesthetics and Politics; debates between Bloch, Lukács, Brecht, Benjamin, Adorno*, London, 1977.

mystified sense of art's 'spiritual' authenticity misperceive and misrepresent this practical character. Their search for transparent, communicable meaning can in the end uncover only the trivial, the dogmatic or the absurd.)

Though such senior European artists as Picasso, Braque, Matisse and Léger continued through the Forties to work in figurative modes, the feasibility of abstract art, and its possible status as the mainstream modern practice, remained one of the central issues for serious and professional criticism for the ten years after the war. The prevailing British style of that decade was one of 'nature-romanticism',[47] qualified by the neurotic humanism for which Bacon stood as token, but with hindsight it is clear that the critical development of Modernist art in that decade was characterized by a painterly abstraction. Introducing the work of *Nine Abstract Artists*[48] in 1954, Lawrence Alloway was concerned to connect the new British work with pre-war abstract painting and construction. He also made clear, however, that no feasible non-figurative art could now be defended in terms of 'the platonic drift of abstract aesthetics', the belief that 'geometry is the means to a high world'. In the most interesting new British painting of the time there was, in Alloway's words, 'a stylistic gamut from expressionistic action painting to a kind of sensual impressionism without things'. A relatively coherent body of British abstract and semi-abstract art had its actual or spiritual home in St Ives, where Nicholson and Hepworth had been since 1939, and where a community of Modernist interest had been sustained during the war.

Patrick Heron's painting of the later 1950s, some of it done in St Ives, falls in the centre of Alloway's 'stylistic gamut'. From 1945 to 1955 Heron wrote regularly on modern European art, addressing himself particularly to the established Modernist masters and to the continuation of a tradition in post-war France and England.[49] From 1955 to 1958 he contributed to the American magazine *Arts*, testifying to the enthusiastic reception of recent American painting in England. In terms of their respective critical positions and loyalties during the 1950s and after, Heron and Alloway could be seen as heirs of the two principal tendencies which defined the critical and aesthetic theory of modern art in the first half of the century. According to the tendency which Heron represented, art proceeds through a concentration upon and intensification of its own means. Its standards and references are derived from other art and from those 'purely visual' experiences of the natural world which are topicalized as aesthetic. The value of art lies largely in its autonomous expressive qualities and in its independence from the contingencies of social life.

According to the second tendency, to which Alloway's criticism can be related, it is in its *engagement* with social life – and with what is distinctively 'modern' in the imagery of that life – that the meaning of art is to be found. Though Alloway's writing about abstract art was distinguished by a rare professional commitment to the modern, his interests as a critic were more typically expressed in his involvement with the Independent Group, whose meetings at the Institute of Contemporary Arts were the conversational circumstances out of which British Pop Art developed. According to his own account, the members 'assumed an anthropological definition of culture, in which all types of human activity were the object of aesthetic judgement and attention'.[50] 'The new role of the fine arts,' Alloway wrote in 1958, 'is to be one of the possible forms of communication in an expanding framework that also includes the mass arts.'[51] As noted earlier, the idea that art's role changes or should change significantly in response to technological and other developments runs counter to the 'Traditional Modernist' tendency which Heron was continuing.

Sooner or later in any serious work, it has seemed during the Modernist period, the interests of descriptive detail will give way to the necessity of manipulation of formal effects. There is always the danger, however, that this manipulation will become empty – and the notion of decorative autonomy which sustains it merely bureaucratic – if the insistence of some actual cultural materials is not somehow experienced as a determinant upon representational activity. A commitment to technical autonomy (for example, a belief in 'pure painting') has often in the history of modern art been productively balanced by interest in the antecedent representa-

47. The term is Alloway's, loc. cit., n. 41.
48. See n. 41. The nine were Adams, Frost, Heath, Hill, Hilton, Kenneth and Mary Martin, Pasmore and Scott. As Alloway made clear, neither the publication nor the selection was his initiative, though he was prepared to say that 'it does . . . represent a fair proportion of the best artists'.
49. His essays of 1945–55 were collected in the volume *The Changing Forms of Art*, London, 1955.
50. L. Alloway, 'The Development of British Pop', in L. Lippard, *Pop Art*, London, 1966.
51. L. Alloway, 'The Arts and the Mass Media', *Architectural Design*, February 1958. According to Alloway's own testimony (see n. 50), the article was written as an argument against the 'anti-populist' thesis of Greenberg's 'Avant-Garde and Kitsch' (see n. 46).

tional materials of a social world (for example, the imagery of publicity).[52] The value of Modernist concepts of autonomy has had constantly to be tested against the contingent. That said, the practical attempt to modernize art by reference to the iconography of post-war consumership generally failed to generate art of real substance. In British art in the twentieth century, forms of conceptualization of 'modern life' have tended to be either 'spiritual' and a-historical or journalistic and superficial. It was the *distribution* of culture, not its production, which most fascinated the typical adherents of British Pop Art.

The impact of American painting in the late 1950s and early 1960s was comparable in many ways to the impact of French Modernism in the few years before the First World War. That it constituted a powerful demonstration of the continuing coherence of the Modernist tradition was in part an effect of the dominance of American criticism in the Modernist tradition – which in turn was a consequence of the relative theoretical adequacy of that criticism. Fry's interpretation of the significance of Cézanne had strongly affected the ways in which Cézanne's work was practically interpreted and absorbed in England. In the wake of the 'American Invasion'[53] the dominant representation of Abstract Expressionism, and particularly of the work of Jackson Pollock, was that furnished by the American critic Clement Greenberg. The power of Greenberg's account derived not simply from the cogency and relevance of his descriptions but also from its complex derivation in those urgent debates on art and politics, realism, avant-gardism and popularity which were conducted largely by German expatriates and American Trotskyites during the later Thirties.[54] The intellectual character of British criticism over a long period has been variously marked and impaired by pseudo-fastidious innocence of the issues raised in these debates or by loutish dogmatization or moralizing simplification of the various positions represented. Greenberg's superficially improbable achievement was to recover what was coherent in the Modernist tradition and in its concept of autonomy and to reformulate it in terms of a theory of artistic development as practical self-criticism. His collected essays, published in 1961 under the title *Art and Culture*, provided for the interested readers of the 1960s and 1970s a set of relatively consistent critical concepts tied to a set of strong valuations of modern art, much as Fry's *Vision and Design* had done for the readers of the 1920s and 1930s.

The new, transatlantic phase of Modernism entailed a new sense of 'ethical commitment'.[55] Pollock's work became a model of integrity, as Cézanne's had been earlier. Self-criticism in practice became associated with 'openness' of procedure, both in the production of large-scale abstract paintings – which tended to be conceived of not as representations, but as 'events in their own right'[56] – and, more significantly, in the kind of abstract, constructed sculpture which Anthony Caro began producing in 1960. English artists and critics came late to the feast, however, as they had done half a century earlier. Those younger English artists who had learned the language of 'Post-Impressionism' in the 1920s were faced in the early Thirties with the need to come to terms with the very different work which had been produced in Paris since the war. During the later 1950s and 1960s the professional culture of British art was accommodated to transferral of the authority of metropolitan Modernism from Paris to New York. By the later 1960s, however, that authority was already insecure, intellectually if not institutionally. This was in large part a consequence of a failure of self-criticism, the principal symptom of which was a tendency for the aesthetic protocols of Modernist criticism to become the more prescriptive as cultural success attended upon Modernist art.

In the various 'alternative' avant-gardes of the late 1960s and early 1970s the virtue of dissent from Modernist theory and Modernist practice tended to be assumed, more or less automatically. Once the avant-garde has come to occupy the foreground of high culture, however, 'dissent' can come to seem merely habitual. Alternative models of theoretical and practical integrity were not generally forthcoming or, in so far as they were lifted wholesale from other fields of specialization, were not often convincingly applied to the culture of modern art. It was in the more rigorous forms of Conceptual Art, and in the deeply unpopular theory associated with them, that

52. On this issue see T. Crow, 'Modernism and Mass Culture in the Visual Arts', in Frascina, op. cit., n. 9.

53. The term is taken from A. Bowness, 'The American Invasion and the British Response', *Studio International*, June 1977.

54. See n. 46. Journals of particular relevance were *Das Wort*, published in Moscow with regular contributions from German expatriates, and *Partisan Review*, published in New York.

55. See Roger Coleman's catalogue introduction to the exhibition 'Situation', RBA Galleries, London, 1960.

56. See Coleman, loc. cit., n. 55: 'Each painting results from a fresh experience, not from the form of the preceding painting or as a development of it . . . Despite the fact that the painting is "about something" it is not a representation but an event . . .'.

57. In this connection the exemplary – and indeed effectively determining – role has been played by Art & Language and by the journal *Art-Language* (first published May 1969).

58. C. Greenberg, 'Modernist Painting', *Arts Year-book*, 4, 1961; reprinted in Frascina and Harrison, op. cit., n. 18.

the complex character of Modernism was engaged to some actual critical purpose.[57] The achievement of Conceptual Art was to find new grounds of anomaly and irony, qualities which had been essential to the oppositional character of early Modernist art, and thus to its distinctive virtue in contrast with a normal culture. The task for art remains one of recovering and holding the critical initiative. Another way to express this might be to say that it has become a matter of priority for the practice of art that it should find the means to embody a critique of criticism.

For some years now the idea of 'Post-Modernism' has been working like yeast in art and criticism. Whether or not there is any firm 'naturalistic' basis for the designation, its expanding currency clearly testifies to a widespread desire that the division it implies should somehow be real; that not only a certain tendency in art but a whole cultural and historical epoch should be brought to a close and thus, perhaps, be seen as discontinuous with our own. It seems an appropriate moment at which to remember a stricture of Traditional Modernist criticism. 'Nothing could be further from the authentic art of our time than the idea of a rupture of continuity. Art is, among many other things, continuity.'[58] This was never a prescription for conservatism.

The critical and aesthetic theory of Modernism has provided a persistent counter to the reductive tendencies of two contrasted but mutually complementary schemas. The first is that reduction characteristic of crude Historical Materialism, according to which all productive activity is seen as explicable, in the last instance, in terms of the need for subsistence. Aesthetic production is not a contradiction of this form of explanation, but rather its most interesting anomaly. The power of the Historical Materialist thesis should never be underestimated, particularly given the tendency of modern artistic culture to dogmatize 'spiritual' causes and to idealize artists as beings unprompted by basic needs. This tendency is produced as a necessary *mis*representation of the second typical form of reduction: that reduction of all actual and potential value to market value which Marx saw as an inexorable function of Capitalism. Within and between these forms of reduction, explanation and misrepresentation, we seek to constitute meaning and value in culture. It should not be assumed that the vaunted overthrow of Modernism is or promises a libertarian end. At least historically, in Britain, the supposed artistic inception of Post-Modernism has coincided with just that form of political culture which the likes of Fry were most concerned to keep at bay: a culture of 'cash limits' and 'value-for-money'.

Richard Cork

Machine Age, Apocalypse and Pastoral

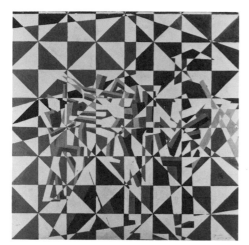

Fig. 1 David Bomberg, *Ju-Jitsu*, c. 1913. Tate Gallery, London

In a revealing yet long-overlooked interview published by *The Jewish Chronicle* in 1914, David Bomberg asserted with youthful confidence that 'the new life should find its expression in a new art, which has been stimulated by new perceptions. I want to translate the life of a great city, its motion, its machinery, into an art that shall not be photographic, but expressive.'[1] For Bomberg, the 'great city' was London, and in his major paintings of the period he charged themes drawn from his East End childhood with a hard, militant vehemence. The rigour of his impoverished early life was conveyed in an uncompromising manner: angular, clear-cut and filled with menacingly sharp edges. But alongside this vision of incessant belligerence, which dramatically reflects the struggle Bomberg himself experienced in Whitechapel as the son of a Polish immigrant, his prodigious canvases transmit a sense of exuberance. *The Mud Bath* (Cat. 49), which took as its starting point the agile recreation and curative massage on offer at the Russian Vapour Baths in Brick Lane,[2] presented figures purged of all excrescences and reborn in a stripped-down, streamlined amalgam of humanity and the machine.

Bomberg responded to the fierce dynamism of his urban world, and in that respect he was indebted to the Futurists' enthusiasm for the transforming power of modern mechanical existence. His 1914 interview appeared under the heading 'A Jewish Futurist', and he laughingly told his interlocutor that 'Futurism is in accordance with Jewish law, for its art resembles nothing in heaven above, the earth beneath, nor the waters under the earth'. Such levity was not intended to hide the undeniable fact that Bomberg, in paintings like *Ju-Jitsu* (Fig. 1), had achieved a remarkable fusion of his inherited Jewish culture and the revolutionary imperatives of the international avant-garde. Marinetti's full-blooded involvement with the new machine age had been a crucial factor in shaping the young painter's attitudes, and for a while at least he was content to accept the Futurist label. But he still wanted to stress that 'where I part company from the leaders of the Futurist movement is in this wholesale condemnation of old art. Art must proceed by evolution. We must build our new art life of today upon the ruins of the dead art life of yesterday.'[3] Hence *The Mud Bath*'s leanings towards a Florentine apprehension of monumental form, which derived above all from his passionate admiration for Michelangelo's *The Entombment*.[4]

Although Bomberg always rejected Wyndham Lewis's pressing invitations to become a fully fledged member of the Vorticist group,[5] his respect for vital aspects of tradition was shared by the artists who did contribute to *Blast* magazine. Lewis may have declared that 'Buonarotti is my Bête Noir',[6] but he venerated certain masters as much as Bomberg. 'The vorticist has not this curious tic for destroying past glories,'[7] wrote Ezra Pound in a credo-like article on the movement which he had christened at the beginning of 1914. Pound insisted that 'we do not desire to cut ourselves off from the past',[8] and the pages of *Blast* likewise reflected his unwillingness to support the hysterical fervour with which Marinetti had lauded the machine age. In the magazine's opening manifesto, Lewis argued that British artists were bound to be more detached about the mechanized world than 'the Latins', for Britain had itself done so much to initiate the Industrial Revolution. How could the Vorticists echo Marinetti's 'Futuristic gush' over the speed of an automobile when they knew that 'machinery, trains, steam-ships, all that distinguishes externally our time, came far more from here than anywhere else'?[9]

The Vorticists' art was characterized by its refusal to indulge in blurred, rhapsodic celebrations of the machine age. Lewis's work in particular is marked by an

1. David Bomberg, interview with *The Jewish Chronicle*, 8 May 1914.
2. A notice outside the Russian Vapour Baths used to inform visitors that they could obtain the 'Best Massage in London: Invaluable Relief for Rheumatism, Gout, Sciatica, Neuritis, Lumbago, and Allied Complaints. Keep fit and well by regular visits.' (Quoted by A. B. Levy, *East End Story*, London, 1951, p. 26.)
3. *The Jewish Chronicle*, 8 May 1914.
4. See Alice Mayes, 'The Young Bomberg, 1914–1925', unpublished memoir, 1972, Tate Gallery Archives, pp. 2–3.
5. Bomberg never allowed his work to be illustrated in the published issues of *Blast*, and he only participated in the 1915 Vorticist Exhibition on condition that his work was included in a non-partisan section entitled 'Those Invited to Show'.
6. Wyndham Lewis, 'The London Group 1915 (March)', *Blast No. 2*, London, 1915, p. 77.
7. Ezra Pound, 'Vorticism', *The Fortnightly Review*, 1 September 1914.
8. Ezra Pound, 'Wyndham Lewis', *The Egoist*, 15 June 1914.
9. Wyndham Lewis, *Blast No. 1*, London, 1914, pp. 41, 39.

intelligent awareness of the disquieting harshness afflicting modern urban life. Both his surviving Vorticist canvases, *Workshop* (Cat. 39) and *The Crowd* (Cat. 40), emphasize the prison-like structure of the twentieth-century city, its ability to make all the inhabitants look minuscule and anonymous when reduced to a dehumanized form. In this respect, he distanced himself from the unqualified rapture with which the Futurists regarded mechanized civilization. Describing 'the great modern city' as an 'up-to-date and iron Jungle', he maintained that 'its vulgarity is the sort of torture and flagellation that becomes the austere creator'.[10] Lewis understood the more discordant aspects of the machine-age metropolis very well, and they give his paintings a deliberately jarring, almost venomous air.

All the same, he was ambivalent in his attitude to the 'factories, new and vaster buildings, bridges and works'[11] which *Blast* placed high among the principal subject-matter fit for the new art. Despite Lewis's insistence that the Vorticists 'should be the great enemies of Romance',[12] both he and his allies undoubtedly savoured the dynamism of the world which they set out to place at the very centre of their art (Fig. 2). *Workshop* takes part of its cue from *Blast*'s ringing description of Britain as an 'industrial island machine, pyramidal workshop',[13] and the same magazine went out of its way to bless the nation's maritime prowess, not only in 'the great PORTS' but also throughout 'the PINK EARTH-BALL' where British ships 'switchback on Blue, Green and Red SEAS'.[14]

Wadsworth was the most ardent admirer of dockland areas and the voyages they initiated. His Vorticist work is permeated by the sharp, cutting forms of vessels moored in harbour. The 'RESTLESS MACHINES'[15] which built and serviced the ships played a prominent role in paintings invariably executed from an aerial vantage point. The lost *Cape of Good Hope* (Fig. 3)[16] looked down on the port from above, enabling Wadsworth to escape from literal depiction and employ instead a diagrammatic metaphor. It looked stern, purposeful and above all as streamlined as the machines themselves. The excitement behind such an image was heartfelt enough: Lewis recalled many years later that Wadsworth, who was the son of a Yorkshire worsted spinning magnate and studied engineering at Munich, 'had machinery in his blood'.[17] But it was channelled through a form-language so clean, hard and structural that Futurist bravado was replaced by an altogether more severe order of feeling.

Looking down from the sky facilitated this new way of seeing. Just as aerial photographs stimulated Malevich in his search for a Suprematist interpretation of the modern world, so Wadsworth must have been inspired by the kind of illustrations published by *Flight* magazine, the 'First Aero Weekly in the World'. Taken by cameras fixed to the bottom of the machine, they revealed a fascinating new vision

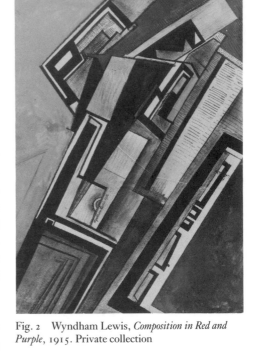

Fig. 2 Wyndham Lewis, *Composition in Red and Purple*, 1915. Private collection

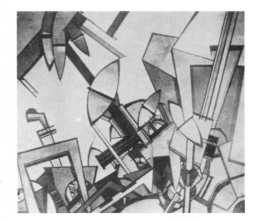

Fig. 3 Edward Wadsworth, *Cape of Good Hope*, 1914. Lost

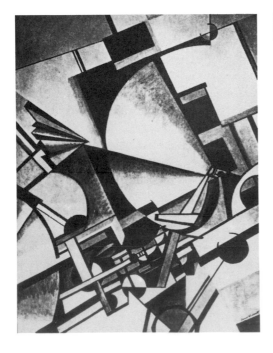

Fig. 4 Edward Wadsworth, *A Short Flight*, 1914. Lost

Fig. 5 Two aerial views from *Flight* magazine, 11 December 1914

10. Wyndham Lewis, 'The God of Sport and Blood', *Blast No. 2*, op. cit., p. 9.

11. Wyndham Lewis, *Blast No. 1*, op. cit., p. 40.

12. Ibid., p. 41.

13. Ibid., pp. 23–4.

14. Ibid., p. 22.

15. Ibid., p. 23.

16. *Cape of Good Hope* now exists only as an illustration in *Blast No. 1*, op. cit., plate i.

17. Wyndham Lewis, 'Edward Wadsworth: 1889–1949', *The Listener*, 30 June 1949.

18. *A Short Flight* now exists only as an illustration in *Blast No. 1*, op. cit., plate ii.

19. Lt-Col. F. H. Sykes, 'Further Developments of Military Aviation', *Flight*, 14 February 1914.

20. Barbara von Bethmann-Hollweg, interview with the author.

21. Frederick Gore and Richard Shone, catalogue of *Spencer Frederick Gore 1878–1914*, an exhibition held at the Anthony d'Offay Gallery, London, February–March 1983, entry no. 21.

22. Ezra Pound, 'Affirmations. IV. Analysis of this Decade', *The New Age*, 11 February 1915.

23. C. R. W. Nevinson, *Paint and Prejudice*, London, 1937, p. 7.

24. Ezra Pound, 'Vortex. Pound', *Blast No. 1*, op. cit., pp. 153, 154.

which marshalled landscapes and urban areas alike into a near-abstract pattern of schematic forms. Wadsworth paid explicit homage to the source of his aerial pictures in a painting called *A Short Flight* (Fig. 4),[18] where the components of the aeroplane were fused with glimpses of the ground below. The merging is carried out with such confidence that it remains difficult to distinguish between close-up machinery and distant terrain. But the entire picture testifies very clearly to the visual possibilities opened up by this extraordinary invention, which *Flight* proudly described as 'the science of aerial photography' (Fig. 5).[19]

Whether Wadsworth actually went up in a plane at this time is open to question: his daughter thought that 'he *might* have had a trial flight during the '14–'18 War'.[20] But *Blast* made a point of blessing the heroic exploits of several pioneer aviators, including the intrepid Gustav Hamel who gave King George V a 'command performance' of loop-the-loops at Windsor and eventually vanished during a Channel flight in 1914. Other artists found themselves drawn to the spectacle of aeroplanes in motion, too. During the summer of 1912 Spencer Gore, his wife and several painter-friends got up at dawn for an expedition to the Hendon Flying Meeting, where they all had a flight in a Blériot monoplane. Although their adventure did not persuade members of the Camden Town Group to follow Wadsworth's example and base a whole body of work on an aerial vision of the world, Gore did execute a swiftly handled canvas of the scene at Hendon (Fig. 6). He contrasted the heavy bulk of the earthbound figures with the agile delicacy of the plane above, savouring a freedom which must have intoxicated those brave enough to clamber into the machine and take off. The spirit of the occasion was summed up when Harold Gilman, who went for a spin in a German pilot's plane, came down 'with a frightful bump'[21] to the cheers of the assembled company.

The sheer enjoyment which machines could engender in the pre-war period should not be forgotten. Pound was right to emphasize in 1915 that the pleasure his generation took in machinery was primarily an instinctive response, not an arcane theoretical indulgence cultivated only by avant-garde artists with a vested interest in changing people's perceptions of twentieth-century existence.

> We all know the small boy's delight in machines [he wrote]. It is a natural delight in a beauty that had not been pointed out by professional aesthetes. I remember young men with no care for aesthetics who certainly would not know what the devil this article was about, I remember them examining machinery catalogues, to my intense bewilderment, commenting on machines that certainly they would never own and that could never by any flight of fancy be of the least use to them. This enjoyment of machinery is just as natural and just as significant a phase of this age as was the Renaissance 'enjoyment of nature for its own sake', and not merely as an illustration of dogmatic ideas.[22]

Pound's argument squares with the memories of Nevinson, the Futurists' only English disciple, who recalled that in his school days at Uppingham 'I had very little interest in the classics, but was enthralled by modern mechanics, and above all by the internal-combustion engine'.[23] Even Pound himself overcame his early 'bewilderment' to such an extent that he made the machine age an integral part of his thinking about Vorticism. In *Blast No. 1* he defined the vortex as 'the point of maximum energy', and went on to maintain that it 'represents, in mechanics, the greatest efficiency'. Far from seeing this mechanistic metaphor in purely functional terms, he equated it with the 'primary form' which ensured that art produced 'the most highly energised statement'. Such concentrated vitality was in Pound's view the essence of all the work he admired most intensely, and he insisted that 'VORTICISM is art before it has spread itself into a state of flaccidity, of elaboration, of secondary applications'.[24]

Pound was, nevertheless, right to point out that an involvement with the machine age was not restricted to the Vorticists alone. As Gore's expedition to Hendon had indicated, British artists of many different persuasions found themselves irresistibly attracted to the heady exhilaration offered by new forms of mechanized transport. They promised, at one and the same time, a release from earthbound constraints in the sky and a rasping sense of power in the urban centres where traffic was at its most boisterous. Today, when we have become so disillusioned with the frenetic clangour of metropolitan life, the whole notion of defining its bustle and dissonance

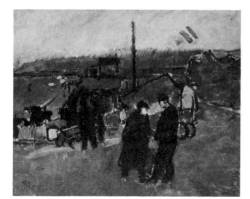

Fig. 6 Spencer Gore, *Flying at Hendon*, 1912. Private Collection

may seem hard to understand. But in 1912, when Charles Ginner decided to make Piccadilly Circus the subject of one of his most elaborate and densely considered paintings (Cat. 18), the transformation of the modern city offered a compelling challenge to artists who were prepared to incorporate its implications in their work.

To a certain extent, of course, Ginner's decision to tackle such a theme in 1912 must have been fired by the Futurists. After Marinetti came over to London in March for the first exhibition of Futurist painting ever to be shown in Britain, he extolled the virtues of the metropolis. 'Why, London itself is a Futurist city!' he declared in an ecstatic interview with the *Evening News*, praising the 'coloured electric lights that flash advertisements in the night', the 'enormous glaring posters' and 'brilliant hued motor buses'.[25] His excitement cannot have been wholly lost on Ginner, who soon afterwards wrenched himself away from the quintessential preoccupations of Camden Town painting and devoted a sizeable canvas to defining life at the very heart of the metropolis. All the same, Ginner distanced himself further from the pictorial language of Futurism than either Bomberg or the Vorticists. Spurning simultaneity, multiple motion and 'lines of force', he opts instead for a calmer and more representational approach which stresses the solidity of the objects in view. Everything is painted with a dogged firmness which precludes the sensation of speed altogether. *Piccadilly Circus* appears to be clogged with traffic rather than vibrating with Marinettian horsepower, and the vehicles Ginner includes are given the same slab-like stillness as the buildings behind them. Having worked in an architect's office at an earlier stage in his career, he constructs his picture from blocks of pigment like a bricklayer patiently assembling a wall.

Yet despite his stubborn desire to remain independent of Futurism, Ginner still produces a 'modern' interpretation of a place associated above all with the nineteenth century. The most ornate of Piccadilly buildings are rigorously excluded from his canvas. So, too, is Sir Alfred Gilbert's *Eros*, the sculpture which to this day gives the Circus its prevailing character. Only the steps leading up to the statue can be glimpsed here, as if Ginner wanted to remove the past as defiantly as *Blast*'s first issue two years later, when its manifesto proclaimed that 'we do not want the GLOOMY VICTORIAN CIRCUS in Piccadilly's Circus. IT IS PICCADILLY'S CIRCUS!'[26] Ginner was, admittedly, prepared to allow the traditional figure of a flower-seller a prominent place in the centre of his composition. But her wicker basket and vulnerable blooms are used as a foil to emphasize the mechanistic character of the transport surrounding her. Hemmed in by their huge wheels and brightly painted bodywork, the flower-seller looks anachronistic and defensive as she huddles in her thick embroidered shawl. As if to hammer home the rapidly changing identity of metropolitan life, Ginner allows the word 'NEW' to stand out among the clamorous music-hall advertisements on the side of the Clapham-bound bus. The large capital letters shout their innovative meaning like a loud-hailer in a Circus where, until recently, horse-drawn vehicles had predominated. In 1909 there had been almost three times as many horse-drawn cabs as motorized ones, but now the position was already reversed.[27] The taxi barging its way so brusquely into the foreground of Ginner's canvas is an inescapable harbinger of the future, and it occupies the road with a certitude which seems to make the female pedestrian avert her gaze from its boorish presence.

No such inhibition affects the full-lipped young woman whose face is so prominent in Stanley Cursiter's *The Sensation of Crossing the Street – the West End, Edinburgh* (Fig. 7). Although surrounded by a maelstrom of rush-hour traffic, jostling passers-by and frowning police, she retains her composure and appears to thrive on the urban din. She is, indeed, the exemplar of an optimistic attitude towards the modern city. Stimulated rather than confused by the bustle around her, she wears a keen-eyed expression which matches the enthusiasm Cursiter himself felt for the Futurist cause. Even in Scotland, where Cubist-related movements found scant support, one painter was sufficiently excited by Marinettian ideas to transfer them wholesale to the very heart of Edinburgh. Cursiter had, in fact, been instrumental in borrowing a number of works from Roger Fry's Second Post-Impressionist Exhibition in London

25. *Evening News*, 4 March 1912.

26. *Blast No. 1*, op. cit., p. 19.

27. For a detailed examination of the types of bus and cab painted by Ginner in *Piccadilly Circus*, see *The Tate Gallery 1980–82. Illustrated Catalogue of Acquisitions*, London, 1984, pp. 100–101.

28. See William Hardie, *Scottish Painting 1837–1939*, London, 1976, p. 93.

29. Boccioni's great canvas, now in the Museum of Modern Art, New York, is commonly known as *The City Rises*.

30. *Daily Sketch*, 18 October 1913. The *Sketch* was ridiculing the Post-Impressionist and Futurist Exhibition at the Doré Galleries, London, where Nevinson's exhibits included *Waiting for the Robert E. Lee* and *The Departure of the Train de Luxe*.

31. *The Non-Stop*, exhibited in the first London Group show of March 1914, and since lost, was described in detail by Frank Rutter, *Some Contemporary Artists*, London, 1922, p. 194.

32. *Tum-Tiddly-Um-Tum-Pom-Pom* is lost, but a photograph of Nevinson standing beside the enormous canvas was reproduced by the *Western Mail*, 15 May 1914.

33. It was published in the *Observer* on 7 June 1914, and subsequently in *The Times* and the *Daily Mail*.

34. C. R. W. Nevinson, *Paint and Prejudice*, op. cit., p. 74.

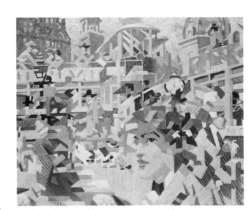

Fig. 7 Stanley Cursiter, *The Sensation of Crossing the Street – the West End, Edinburgh*, 1913. Mr and Mrs William Hardie Collection, Glasgow

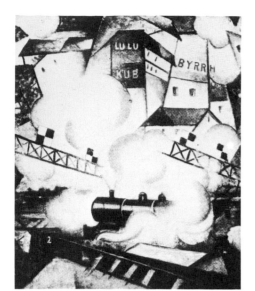

Fig. 8 Christopher Nevinson, *The Departure of the Train de Luxe, c.* 1913. Lost

for a show at the Society of Scottish Artists in 1913.[28] It caused a predictable furore, but Cursiter himself was more directly impressed by Severini's fragmented and elegantly organized visions of city life. The precision with which the Scottish artist constructs this cool yet cacophonous painting of Edinburgh on the move echoes Severini's simultaneity with uncanny faithfulness. The Athenian dignity of Scotland's capital has been transformed, with astonishing zeal, into a *mêlée* of Futurist ideas at their most crisply discordant.

The unlikely metamorphosis was short-lived. No sooner had Cursiter given his full commitment to Futurism than he discarded it again, and down in London his English counterpart Nevinson only remained a wholehearted Marinettian follower for a couple of years. Even though Nevinson's interest in the Futurists was first stirred by their London exhibition of March 1912, and then fortified by personal contact with them in Paris later that year, he did not exhibit full-blown Futurist pictures until the following January. *The Rising City*, which he displayed in that month at the Friday Club show, was presumably an overt act of homage to the masterpiece which Boccioni had exhibited in London under precisely the same title.[29] But Nevinson's picture has since been lost, and only from the later months of 1913 do reproductions survive of his Futurist paintings. Even then, he followed Severini's example by concentrating on Parisian subjects like *The Departure of the Train de Luxe* (Fig. 8), where the engine itself is partially obscured by the expansive smoke it generates. The British press felt free to mock such works with shameless irreverence: under the headline 'You Wouldn't Think These Were Paintings, Would You?', the *Daily Sketch* announced that 'in order to show that it doesn't matter, we have used one of these photographs sideways and the other two upside down'.[30]

But London had to wait until 1914 before Nevinson turned his controversial attention to metropolitan life. With the curiosity of a journalist investigating the city in all its available layers, he set about painting the distinct experiences it offered. Below ground, the dynamism of the Tube system was extolled in *The Non-Stop*, a circular picture of a carriage interior where travellers interpenetrated with advertisements, strap-hangers and the kaleidoscopic vibration of the train itself.[31] Above ground level, the combined assault of hoardings, street lights, traffic and hurtling pedestrians filled his picture of *The Strand* (Fig. 9) with exclamatory movement. While up on Hampstead Heath, a bank holiday avalanche of grinning faces, Union Jacks and real confetti scattered in the pigment was given the ebullient title *Tum-Tiddly-Um-Tum-Pom-Pom*,[32] as if to applaud the way London's green spaces were being overwhelmed by the brash vigour of the twentieth-century crowd.

Nevinson's preoccupation with the machine-age city reached its climax when he collaborated with Marinetti on the publication of a Futurist Manifesto called 'Vital English Art' in June 1914.[33] They roared loudly enough in their boyish enthusiasm, crying 'HURRAH for motors! HURRAH for speed!'. But even as they called on English artists to strengthen their work with 'a recuperative optimism, a fearless desire of adventure, a heroic instinct of discovery, a worship of strength and a physical and moral courage', Nevinson's wholehearted affiliation with Futurism was about to end. From the instant that hostilities commenced in the autumn of 1914, he threw himself into the conflict and became an ambulance driver with the Red Cross. Although ill-health prevented him from enlisting as a soldier, his work among the dead and dying ensured that he saw 'sights so revolting that man seldom conceives them in his mind . . . we could only help, and ignore shrieks, pus, gangrene and the disembowelled'.[34] He looks somewhat dazed standing beside his ambulance for a photograph which concentrates on the machine rather than the man who drove it (Fig. 10). But Nevinson dedicated a copy of the picture to Marinetti, as if in earnest of his continuing commitment to the Futurist cause, and after being sent home as an invalid he reaffirmed his former loyalties in an interview with the *Daily Express*. 'This war will be a violent incentive to Futurism,' he claimed, 'for we believe there is no beauty except in strife, and no masterpiece without aggressiveness.'

After uttering these dubious slogans, though, he went on to explain how his first attempts at war painting had been inspired by rather less stirring sentiments. 'I have

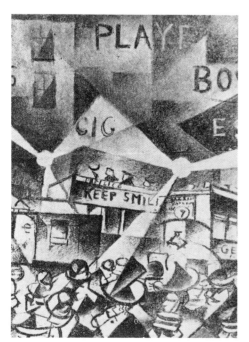

Fig. 9 Christopher Nevinson, *The Strand, c.* 1914. Lost

tried to express the emotion produced by the apparent ugliness and dullness of modern warfare,' he maintained. 'Our Futurist technique is the only possible medium to express the crudeness, violence and brutality of the emotions seen and felt on the present battlefields of Europe.'[35] The words Nevinson chose in this interview to convey the harrowing experiences he had undergone in France no longer chime with the opinions expressed by Marinetti.

Apart from welcoming the war as a patriotic crusade, the Futurist leader saw it as an opportunity to sweep away the 'passéist' world even more drastically than the Italian movement had previously advocated in its belligerent manifestos. Nevinson, by contrast, was already struggling to reconcile the martial ardency of Marinetti with his traumatic new experiences at the Front. He tried to do so by using qualified phrases like 'apparent ugliness', but the paintings he exhibited in March 1915 revealed none of the glory Marinetti found when contemplating warfare.

The most powerful canvas Nevinson displayed, *Returning to the Trenches* (Fig. 11), has no intention of presenting the conflict as a triumphant affair which would cleanse Europe of its impurities. The Futurists' influence can still be detected, most notably in the 'lines of force' which accentuate the surging, relentless motion of the marching column. But there is nothing heroic or indomitable about these gaunt and anonymous men, whose bodies are caught up in a merciless activity over which they have no control. If there is something mechanical about their movements, it should not be confused with the prowess Marinetti cherished in the combustion engine. These men seem trapped within the straitjacket imposed on them, not only by their angular uniforms and burdensome equipment, but also by the orders they obey. They return to the trenches merely because an officer has told the entire brigade to move in that direction. It is a wearisome ritual, and all the figures caught up in the grinding process have been robbed of any individuality they may once have possessed.

Modern war had itself become a machine of the most cruelly dehumanizing kind. Nevinson realized it, and although the bleakness of *Returning to the Trenches* made a nonsense of his lingering Futurist loyalties, he could not prevent himself from painting the conflict in all its harsh futility. As a result he produced his finest work, as honest as it was outspoken about the reality of life at the Front. Lewis recognized the bravery with which Nevinson had conveyed his disillusion. It coincided with the views expressed in the second issue of *Blast*, where Lewis asserted that 'as to Desirability, nobody but Marinetti, the Kaiser, and professional soldiers WANT War'.[36] Although many of the Vorticists fought in France, none of them had any thirst for bloodshed, and Lewis went out of his way to praise *Returning to the Trenches* for 'a

Fig. 10 Christopher Nevinson as an ambulance driver, *c.* 1914. This photograph was dedicated to Marinetti.

35. *Daily Express*, 25 February 1914.
36. Wyndham Lewis, 'A Super-Krupp – Or War's End', *Blast No. 2*, op. cit., p. 14.
37. Wyndham Lewis, 'The London Group 1915 (March)', *Blast No. 2*, op. cit., p. 77.
38. Ibid., p. 25.
39. Alice Mayes, 'The Young Bomberg', op. cit., p. 22.
40. The climax of T. E. Hulme's support for Bomberg came with the publication of his long and thoughtful review of Bomberg's first one-man show at the Chenil Gallery, London: 'Modern Art. IV. – Mr David Bomberg's Show', *The New Age*, 9 July 1914.
41. T. E. Hulme, 'Modern Art and its Philosophy', *Speculations. Essays on Humanism and the Philosophy of Art*, ed. Herbert Read, London, 1924, pp. 73–109.
42. David Bomberg, Foreword to the catalogue *Works by David Bomberg*, an exhibition held at the Chenil Gallery, London, July 1914.
43. *Evening News*, 23 April 1915.
44. William Roberts to Sarah Kramer, 11 November 1917, published in William Roberts, *Memories of the War to End War 1914–18*, London [1974], p. 42.

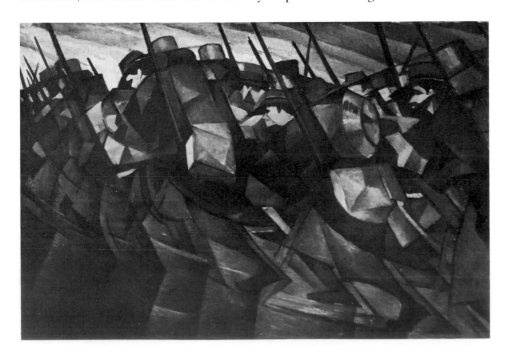

Fig. 11 Christopher Nevinson, *Returning to the Trenches*, 1914–15. National Gallery of Canada, Ottawa

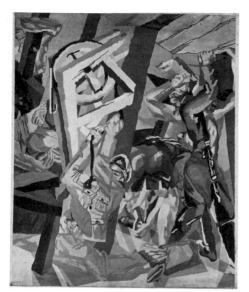

Fig. 12 David Bomberg, *Sappers at Work: A Canadian Tunnelling Company* (first version), 1918-19. Tate Gallery, London

hurried and harassed melancholy and chilliness that is well seen'.[37] He also reported, in the summer of 1915, that Nevinson had now decided to take a stand against one crucial aspect of Marinetti's precepts. Without making any attempt to disguise his satisfaction at such a development, Lewis wrote that Nevinson's first action 'de retour du Front . . . has been to write to the compact Milanese volcano that he no longer shares, that he REPUDIATES, all his [Marinetti's] utterances on the subject of War, to which he formerly subscribed. Marinetti's solitary English disciple has discovered that War is not Magnifique, or that Marinetti's Guerre is not la Guerre. Tant Mieux.'[38]

No one had more cause to share this opinion of the conflict than Bomberg. Having enlisted in the Royal Engineers and undergone hellish experiences at the Front, he became acutely conscious of the machine's unlimited capacity for devastation. The First World War was an industrial conflict, dominated by the terrifying power of inventions like the rapid-fire machine-gun. Bomberg's harrowing period in the trenches, which at one stage drove him to administer a self-inflicted wound,[39] ensured that his former buoyancy gave way to chronic restlessness and doubt. Prolonged exposure to the carnage caused by machine-age weapons at the Front shattered his earlier involvement with the energy of modern urban life. The forms he had explored in pre-war canvases like *In the Hold* (Cat. 50) now seemed inadequate to deal with his altered consciousness. Mechanistic imagery, which had once been associated in his mind with radical construction, became inextricably linked with the horror of destruction. Quite apart from the indiscriminate slaughter of his regimental comrades, he suffered the loss of several people who were close to him: his brother, his boyhood friend the poet Isaac Rosenberg, and the critic T. E. Hulme, who had done so much to support Bomberg's work in 1914.[40]

With hindsight, Hulme's death takes on a particularly poignant significance. The man who had once advocated a 'clear-cut and mechanical' art, which demonstrated its 'admiration for the hard clean surface of a piston rod', was blown to pieces by a large shell at Nieuwpoort. It was an ironic fate for a critic fascinated by the possibilities of a new art 'having an organisation, and governed by principles, which are at present exemplified unintentionally, as it were, in machinery'.[41] The escalating technology of war, with its unprecedented ability to destroy, terminated his life in a second. And along with it went any remaining belief in the constructive inspiration of the machine age. Such a notion looked irrevocably naive in the light of the apocalypse at the Front, and in his painting *Sappers at Work* (Fig. 12) Bomberg turned away from the schematic, near-abstract language he had earlier employed to develop his bracing vision of 'the steel city'.[42]

So did one of his greatest friends, William Roberts. Having suffered almost as grievously in the trenches as Bomberg, he revealed the full extent of his despair in a series of frank letters to his future wife Sarah. Before enlisting for the Front, Roberts had executed a drawing for the St George's Day issue of the *Evening News* (Fig. 13).[43] It is a forbidding image, where he insists on transposing the hallowed national legend of St George and the dragon to a resolutely twentieth-century context. Enmeshed in block-like forms which evoke the architecture of the modern city, St George attacks his opponent with cool, impersonal efficiency. The whole operation is conducted with as much geometric clarity as Hulme could have wished, and the victorious saint has been transformed into an automaton thoroughly at home in the mechanistic jungle of contemporary life. Roberts's years in France were gruelling enough to distance him from such a vision for ever. 'One whose existence is so absolutely monotonous, repetition always, every day lived to order; the only excitement being to dodge and duck for your bloody miserable life,' he told Sarah, 'finds it almost impossible to transport his imagination into the intricasies [sic] and complexities of town living.'[44] Roberts now felt wholly removed from the urban experiences which had informed his pre-war work, and the grotesque alternative reality of the trenches moved him to an anger far more despairing than anything he had felt before. 'I am feeling very bitter against life altogether just at present,' he confessed in 1917. 'But there is one thing I curse above all others in this world, and that's "open

Fig. 13 William Roberts, *St George and the Dragon*, 1915. Lost

warfare". I could strafe it, as "Fritz" never did strafe Ypres, and if you saw that place you would understand the full extent of my hate.'[45]

The strength of feeling expressed in this letter goes a long way towards accounting for the intensity of the massive canvas Roberts then proceeded to execute for the Canadian War Memorials Fund. The degree of representation he employed was, certainly, affected by the terms of the commission, which warned that 'Cubist work is inadmissible for the purpose'.[46] But the demands of official war painting do not wholly explain why *The First German Gas Attack at Ypres* (Fig. 14) is so dramatically at odds with *St George and the Dragon*. Only three years separate these works, and yet the difference is spectacular. The steely reserve of the Vorticist drawing, which insists that the battling protagonist cannot be dissociated from his mechanistic environment, has given way to an altogether more outspoken vision. Human figures now dominate Roberts's painting in the most unequivocal manner, and the emotions they convey could hardly be more exclamatory. Although he had never witnessed cloud gas warfare of that kind, Roberts invests the composition with an uninhibited urgency. The choking forms of the French troops, retreating in panic from the evil vapours beyond, cascade down the canvas with fear in every flailing limb. They collide with the more purposeful bodies of the Canadian gunners, who struggle to train their battery on the advancing German infantry, and Roberts trenchantly defines the chaotic tangle of twisting, jerking and lurching bodies involved in the confusion. He imposes an elaborately orchestrated order on the turbulent scene, organizing his complex design with great theatrical finesse. But this coherence is not achieved at the expense of a direct and disturbing presentation of war's horror. Roberts manages to transmit many of the feelings he had himself experienced in the conflict, and the painting does not betray the sense of overwhelming fury and disgust that he had already described in his letters from the Front. No wonder the young Kenneth Clark was moved by *The First German Gas Attack* when he saw it displayed in the Canadian War Artists' exhibition. Himself an aspirant painter at the time, Clark discovered that the huge canvases by both Roberts and Lewis were 'an eye-opener to me, and I immediately tried to imitate them. In fact . . . I might have been a follower of Wyndham Lewis (although he would certainly have rejected me).'[47]

45. William Roberts to Sarah Kramer, 7 December 1917, ibid., p. 45.
46. Captain Harold Watkins to William Roberts, 28 December 1917, ibid., p. 24.
47. Kenneth Clark, *Another Part of the Wood*, London, 1974, p. 77. The Lewis canvas Clark admired was called *A Canadian Gun Pit* (1918).

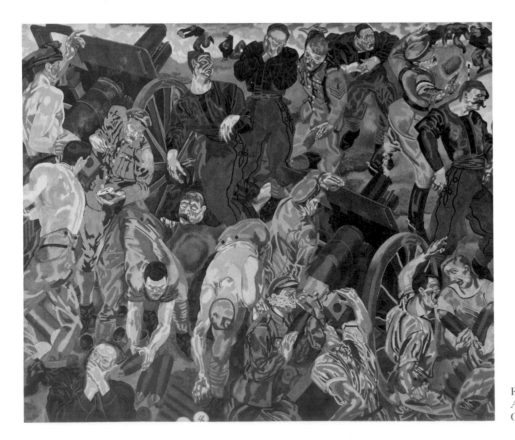

Fig. 14 William Roberts, *The First German Gas Attack at Ypres*, 1918. National Gallery of Canada, Ottawa

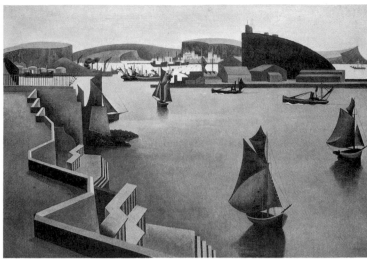

Fig. 15 Christopher Nevinson, *An English Landscape*, 1923. Formerly in the collection of General Sir Ian Hamilton

Fig. 16 Edward Wadsworth, *The Cattewater, Plymouth Sound*, 1923. Private Collection

48. C. R. W. Nevinson, interview with the *New York Times*, 25 May 1919.
49. C. R. W. Nevinson quoted by Malcolm C. Salaman in 'The Art of C. R. W. Nevinson', *The Studio*, December 1919.
50. David Bomberg to Siegfried Giedion, 27 July 1953, collection of the artist's family.
51. *An English Landscape* is reproduced as Plate 29 in Osbert Sitwell, *C. R. W. Nevinson*, London, 1925, when its owner was General Sir Ian Hamilton.
52. *The Cattewater, Plymouth Sound* received understandably high praise when first exhibited at the Leicester Galleries, London, in March 1923.

None of the artists who had been so profoundly altered by their experiences at the Front wanted to continue painting the war for long. Nevinson summed up the prevailing mood when he told the *New York Times*, in a thoughtful interview which revealed just how far he had changed since his Futurist days, that 'the effect of war has been to create among artists an extraordinary longing to get static again. Having been dynamic since 1912, they are now utterly tired of chaos. Having lived among scrap heaps, having seen miles of destruction day by day, month after month, year after year, they are longing for a complete change. We artists are sick of destruction in art.'[48] So far as Nevinson was concerned, he associated this move away from aggression with a rejection of the avant-garde language he had explored with such hot-headed zeal in the pre-war period. 'The immediate need of the art of today,' he told *The Studio* in 1919, 'is a Cézanne, a reactionary, to lead art back to the academic traditions of the Old Masters, and save contemporary art from abstraction.'[49] His call was echoed by other artists recoiling from their former involvement with machine-age innovation. Many painters who had once advocated aesthetic insurrection were now pausing, taking stock and wondering whether they should return to more traditional ways of seeing. The waste and tragic nullity of the war years bred among them a profound mistrust of militant extremism. There was a widespread longing for order, and in 1919 Bomberg turned down an invitation to join the De Stijl group at Leyden. 'This I felt could only lead again to the Blank Page,' he recalled later. 'I declined the Leyden invitation – I had found I could more surely develop on the lines of Cézanne's rediscovery that the world was round and there was a way out through the sunlight – this I have followed and matured in ever since.'[50]

The 1920s was a quiet decade for all the former rebels, a time of retrenchment when the need to concentrate on placid subjects was matched by an equally strong desire to depict the observed world with greater exactitude and directness. In 1923 Nevinson painted *An English Landscape* (Fig. 15),[51] which showed how far he had travelled from the days when the bustling metropolis was his exclusive theme. Now he cherishes the kind of pacific rural haven which would have attracted his most vituperative insults in the Futurist period, and the style which he chooses to elaborate this pastoral already approaches the banality which mars so much of his later work. Wadsworth, painting *The Cattewater, Plymouth Sound* (Fig. 16)[52] in the very same year, achieves a far more impressive synthesis between his former language and the new representational urge. His sense of pictorial structure and economy is still as acute as it was in the Vorticist period, but he no longer needs to paint industrial ports from a dizzying aerial vantage. Now the harbour is unruffled by the 'RESTLESS MACHINES' of *Blast*'s ideal dockland. Wadsworth ensures that the biggest ships are relegated to a distant area of the composition, leaving most of the space for the limpid forms of sailing boats to float gracefully on a quiescent sea.

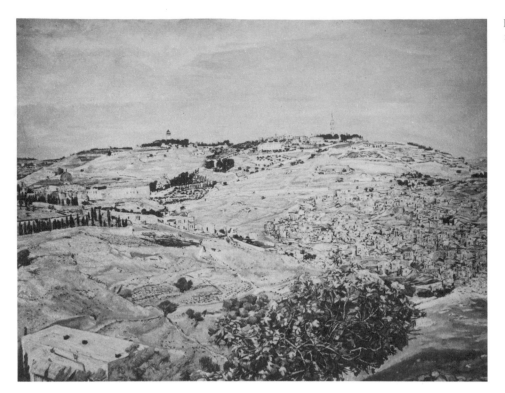

Fig. 17 David Bomberg, *The Mount of Olives*, 1923. Destroyed

But Bomberg took the desire for a new relationship with nature to its greatest extreme, deciding in the year that Nevinson and Wadsworth painted their hushed canvases to settle in Palestine. Here, studying the landscape with a meticulous precision quite astonishing in a man who had achieved such bare simplification a decade before, he painted the blazing white light on *The Mount of Olives* (Fig. 17)[53] and thereby announced a lifelong commitment to landscape at its most primal and inviolate. The paintings he went on to execute later, most memorably in Spain and Cyprus, were far more impassioned and freely expressive than the tight, painstaking panoramas he painted in Jerusalem. But this devoted canvas, with its careful deployment of 'gesso-like white impasto',[54] represents the starting point for his subsequent belief that the artist should attempt to redeem the world from the dehumanization of technological advance. Emphasizing the importance of combating the alienation so alarmingly evident in post-war society, he argued that salvation could be found by rooting his work in an avid involvement with nature.

His conviction that art could counteract the impersonality of modern life has, if anything, grown in pertinence since Bomberg first advocated it. Now more than ever, we share his concern about the alarming consequences of technological 'progress' in a world vulnerable above all to the threat of nuclear apocalypse. Seen in this context, Bomberg's evolution as an artist takes on a special fascination today. Having been so magnificently stimulated by the machine age in his youth, and then experienced its horrific consequences during the First World War, he was well placed to develop an art that offered a heartening corrective to dehumanization. At the age of sixty-two, he argued that 'whether the paintings or sculptures of the future are carried out in ferro-concrete, plastic, steel, wire, hydrogen, cosmic rays or helium, and oil paint, stone, bronze, superseded as anachronisms, it is reality that man is yet subject to gravitational forces and still dependent on sustenance from nature and a spiritual consciousness, an individual with individual characteristics to remain so for aeons of time'.[55]

53. *The Mount of Olives* was destroyed when its owner's residence in Cyprus was burned down in 1930. On the back of the surviving photograph, in the collection of the artist's family, Bomberg wrote that its dimensions were 28 × 36 inches.
54. P. G. Konody, the *Observer*, 12 February 1928.
55. David Bomberg, Foreword to the catalogue of *Exhibition of Drawings and Paintings by the Borough Bottega and L. Marr and D. Scott*, held at the Berkeley Galleries, London, November-December 1953.

Dawn Ades

Figure and Place: A Context for Five Post-War Artists

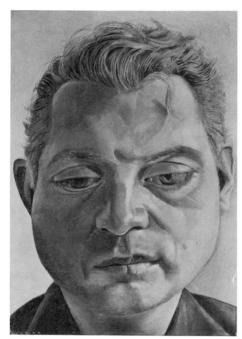

Fig. 1 Lucian Freud, *Francis Bacon*, 1952.
Tate Gallery, London

Francis Bacon, Lucian Freud, Frank Auerbach, Leon Kossoff and Michael Andrews do not form a group with a clear identity: their work is disparate and has few stylistic affinities, though they are among the artists loosely referred to as the 'School of London'. They are, however, linked by personal and professional threads, and by a commitment to painting – above all to the painting of the human figure. Their art has remained largely unaffected by such successive post-war movements as Abstract Expressionism, Pop Art, Minimal Art, Conceptual Art.

They are not, of course, the only artists working during this post-war period within a figurative tradition, and their relationship to the various 'Realist' wings in British art both before and after the war demands closer investigation. Their work represents a resistance to academic naturalism and to a politically committed Realism, as well as to the accredited international avant-gardes. In certain aspects of this resistance they were by no means alone; one could instance the fact that from 1957 until 1973, that is to say during the period when the influence of North American painters such as Jackson Pollock and de Kooning was at its height, the Professor of Painting at the Royal College of Art was Carel Weight, who painted the 'forlorn gentility' of South London, its streets and parks 'sometimes haunted by the supernatural'.[1] There is, as Frances Spalding has pointed out, a kind of 'eccentric mainstream' of individuality in British Art. What can be seen as a radical opposition to fashion should not, however, be taken to imply a narrow insularity, nor an anachronistic and conservative traditionalism. There is, among the painters grouped together here, an acute awareness, an inevitable attention to the ideas and to the dominant visual practices of the time.

That some vague sense of community does exist among them is confirmed by Auerbach, although he does frame 'we' in inverted commas: 'I don't know how good "we" are, but it would obviously be better to be a minor person in 16th century Venice than a major person in 19th century Yugoslavia for the quality of one's work. There is a challenging and a vitality. I think those things do matter. And I think that one hopes to be independent and to rise away from common language and common assumptions but the better the common language and common assumptions are the further it's possible to rise. Artists usually come in gangs'[2]

In a conversation between Michael Andrews and Victor Willing, published as 'Morality and the Model', painting from life was instanced as a rare activity but one of central importance for several of these artists: 'I know it matters to you to paint from life,' Willing said to Andrews, 'to use models occasionally, but how much does it matter to the people who are teaching it, except as an academic exercise which keeps them employed – apart from those who do it with some sort of conviction. These are few – yourself, Coldstream, Uglow, Auerbach, Bacon.'[3] The distinction here, of course, is between those who taught life drawing and painting in the art schools simply because it was part of the curriculum and those who were committed to it at a more serious level. (Having been almost swept away during the Seventies, life drawing is making its way back into the schools.) The kind of painting from life Andrews and Willing had in mind was linked to Existentialism, or what was sometimes termed 'agnosticism': '"Existentialism" of one kind or another was a prevalent attitude when we were at the Slade.' Giacometti was the most influential artist in this context, and Willing describes a Slade colleague who 'talked about a kind of Giacometti art class where he considered posing the model as if she had been caught in the middle, or the corner, of the room'.

1. Frances Spalding, *British Art Since 1900*, London, 1986, p. 7.
2. From an unpublished conversation between Catherine Lampert and Frank Auerbach. I am extremely grateful to Catherine Lampert for her help.
3. Michael Andrews and Victor Willing, 'Morality and the Model', *Art and Literature*, no. 2, summer 1964, p. 52.

Giacometti was of central importance to the generation of artists starting their career in the late Forties and Fifties: his work and his ideas were brought to the fore in Britain by the critic David Sylvester. Although Giacometti was known as much for his drawings and paintings as for his sculpture, it is the latter that is relevant here (see Fig. 2). After several years of close involvement with Surrealists during the Thirties – when he had worked from imagination and dream – Giacometti returned abruptly to the model. The figure was brought into play again by an anxious scrutiny that seemed to flatten and squeeze the body and head. His thin, isolated figures were taken by many to be the epitome of 'Existentialist Man': man naked, unpropped, alone and stripped of comforting myths.[4] Given the strict relevance of Giacometti to the complex question of Realism as it concerned artists of the post-war generation, this characterization can be misleading.

Yet rather than emphasizing their powerlessness, the isolation of these figures serves to concentrate their power, or 'pent-up energy' as Giacometti described it to Sylvester: the delicate balance between despair and affirmation of life is kept in a continual state of oscillation. David Sylvester and Francis Bacon discussed Giacometti's feelings about this comparison with 'Existentialist Man':

'DS. He thought it was rather crass. He said he was only trying to copy what he saw.

FB. Exactly.

DS. On the other hand, he wasn't only copying what he saw. He was, for one thing, crystallising very complex feelings about the act of seeing, especially about gazing at someone who is gazing back at you. Perhaps you'd tell me what you feel your painting is concerned with besides appearance.

FB. It's concerned with my kind of psyche, it's concerned with my kind of – I'm putting it in a very pleasant way – exhilarated despair.'[5]

If the act of seeing is complex, there can be no simple copying of what is seen. Giacometti himself, describing seeing a model naked in his studio, said that she 'grew and simultaneously receded to a tremendous distance'.[6] Space and its relation to the figure become infinitely problematic, given that there is no longer 'a systematic idea of what painting (or sculpture . . .) was all about'.[7] And in another interview Giacometti told Sylvester that there was no such thing as an absolute value for 'life-size' in sculpture. For if, as Rodin says, the sculptor makes a head equivalent to its actual volume in space, it may be conceptually real, though not visually. We do not *see* things that size. Nor can we see the other side of a solid. 'If I didn't know that your skull had a certain depth, I couldn't guess it. Therefore, if I made a sculpture of you absolutely as I perceive you, I would make a rather flat, scarcely modulated sculpture that would be much closer to a Cycladic sculpture, which has a stylised look, than to a sculpture by Rodin or Houdon, which has a realistic look. I think we have such a received idea of what a head is in sculpture that it's become completely divorced from the real experience of seeing a head'[8] The contrast between the 'realist look' – realist because it conforms to our conventional patterns of seeing – and the 'real experience of seeing a head' – in which these conventions are 'unlearned' – is basic to the work of Bacon and Auerbach.

Giacometti was, of course, speaking of the specific condition of making sculpture, while all the artists under discussion have been committed exclusively to painting and drawing. However, Bacon has spoken of his interest at one time in making sculpture. Nothing was ever realized, and now, he says, he has 'found a way by which I could do the images I thought of more satisfactorily in paint than I could in sculpture . . . a kind of structured painting in which images would arise from a river of flesh'; they would emerge 'with their bowler hats and their umbrellas . . . as poignant as [figures from] a Crucifixion'.[9] This hardly seems ever to have been a very appropriate idea for sculpture; nevertheless, it raises the question of the figure in space, or in its own space. Bacon's paintings completely refuse their figures a site, refuse to allow them and the canvas to present a continuous illusion of space. The figure is isolated in an independent, self-sufficient space that has, as it were, its own existence. According to the number or kind of structuring lines articulating the

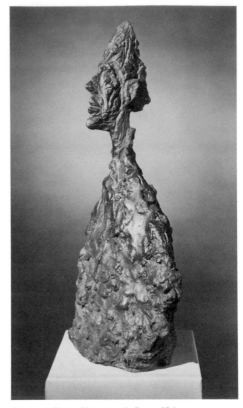

Fig. 2 Albert Giacometti, *Bust of Diego*, 1955; bronze. Tate Gallery, London

planes of colour, this space is more or less identical with the plane of the canvas itself. One result of this is that the space can seem to invade the figure, or the figure to resist it; the figure itself may be only partially realized, incomplete, with body and space placed somehow in opposition to, or dynamic contradiction with, each other. Both the splitting of the flesh and figure and the tension – contraction and expansion – between figure and space may be seen in the context of a 'dialectic of the real'.

Here, two other comments by Giacometti are relevant. Speaking of whether or not to paint a sculpture, he said that, if painted, it would probably be intolerable to look at, 'because on the one hand, it would seem too real or too great an illusion of the real, and then one would only be conscious of its immobility'.[10] Too great a realism, then, must work against the sense of life in the figure, and other ways – distortions, for want of a better term – must be found. Bacon speaks of this as a necessary injury: 'Who today has been able to record anything that comes across to us as a fact without causing deep injury to the image?'[11] The second comment by Giacometti refers to the reduction of the subject-matter: 'I shall never succeed in putting into a portrait all the power there is in a head. The sole fact of living already demands such determination and such energy.'[12]

Whether or not to work from memory or strictly from life was certainly an issue in the Forties and Fifties, but one which was crucially related to a deeper and more persistent problem, that of smashing visual cliché. The question of memory concerned different artists in different ways. For Giacometti, memory was easier to handle, it was 'just a matter of trying when I'm alone to remake things I've seen. Because in working from life, one always sees much more than one can cope with, so one gets lost in too many complications.'[13] Bacon prefers to work from memory and photographs, though the person he was painting would be much around at the time: Michel Leiris, Henrietta Moraes, George Dyer. Working from the photograph itself is also, for him, a means of avoiding visual cliché, because although it may have value as record, it is the slight 'slippage' from reality which succeeds: 'I think it's the slight remove from fact, which returns me onto the fact more violently. Through the photographic image I find myself beginning to wander into the image and unlock what I think of as its reality more than I can by looking at it.'[14] Lucian Freud, on the other hand, works from life rather than memory because in that way he can 'take liberties which the tyranny of memory would not allow'.[15] He too talks of the 'factual' rather than the 'literal', and shares Bacon's horror of the homely, the cliché and the ideal. 'My horror of the idyllic, and a growing awareness of the limited value of recording visually-observed facts, has led me to work from people I really know. Whom else can I hope to portray with any degree of profundity?'

It is clear that the avoidance of the cliché is not a matter of avoiding a certain subject-matter, as it had been for the Italian Futurists, who, at an earlier period of crisis, had placed a temporary ban on the painting of the nude. In some ways the problem is linked with the modernist 'myth of originality',[16] except that this presupposes trying to do something no one has done before. The avoidance of cliché, as it is relevant to the painters under discussion, has never been more acutely described than by D. H. Lawrence, writing of Cézanne: 'Cézanne, far too inwardly proud and haughty to accept the ready-made clichés that came from his mental consciousness, stocked with memories, and which appeared mocking at him on his canvas, spent most of his time smashing his own forms to bits Cézanne wanted something that was neither optical nor mechanical nor intellectual. And to introduce into our world of vision something which is neither optical nor mechanical nor intellectual-psychological requires a real revolution He wanted to touch the world of substance once more with the intuitive touch'[17]

The ambitions of Bacon and Auerbach to 'return sensation visually' seem also to be related to the avoidance of cliché: 'I've always hoped,' Bacon said, 'to put over things as directly and rawly as I possibly can, and perhaps, if a thing comes across directly, people feel that that is horrific'[18] For Auerbach, the aim of painting is 'TO CAPTURE A RAW EXPERIENCE FOR ART'.

4. There is a brief discussion of Bacon in relation to Existentialism in my 'Web of Images', *Francis Bacon*, Tate Gallery, London, 1985, p. 11.
5. David Sylvester, *Interviews with Francis Bacon*, London, 1980, p. 82.
6. Jean Genet, 'L'Atelier d'Alberto Giacometti', *Derrière le Miroir*, June 1957, p. 7.
7. Andrews and Willing, op. cit., p. 50.
8. 'An Interview with Giacometti by David Sylvester', autumn 1964, in *Alberto Giacometti*, Arts Council exhibition catalogue, 1981, p. 3.
9. *Interviews with Francis Bacon*, op. cit., p. 83.
10. *Alberto Giacometti*, op. cit., p. 5.
11. *Interviews with Francis Bacon*, op. cit., p. 41.
12. Jean Genet, op. cit., p. 22.
13. *Alberto Giacometti*, op. cit., p. 10.
14. *Interviews with Francis Bacon*, op. cit., p. 30.
15. *Lucian Freud*, Arts Council exhibition catalogue, 1974.
16. See Rosalind Krauss, 'The Originality of the Avant-Garde', in the collection of her essays, *The Originality of the Avant-Garde and Other Modernist Myths*, Cambridge, Mass., 1985.
17. D. H. Lawrence, 'Introduction to These Paintings', in *Selected Essays*, London, 1950, p. 338.
18. *Interviews with Francis Bacon*, op. cit., p. 48.

Two further points might be made about their work: one is the avoidance of the 'illustrational' and the other is the prevalence of metaphors drawn from theatre in many of their comments about the act of painting. These metaphors are never stressed, never elaborated, but are suggestive because they point towards a thinking about the act in terms both of complete involvement or identification with another individual and of an awareness of its necessary artificiality, or even artifice.

Naturally, the career of each of these five artists has taken its individual course. Bacon alone among them has long enjoyed a wide international reputation and sustained critical attention, though his work has usually been seen as owing almost nothing to a British context. In 1963 Andrew Forge wrote about the effect of his paintings of the late Forties and early Fifties: 'The images were impossible, and violated every taboo that existed in English painting. Not only were they figurative and illusionistic at a time when the drift was inexorably towards abstract art and even the most convinced figurative painters were obsessed with the flat surface, but they dealt with the human head in terms of its features, its grimaces and gestures. They were concrete, worldly and grand and there was no precedent for them where everything from Ben Nicholson's abstract reliefs to Graham Sutherland's landscapes was in some sense or another romantic, ideal and intimately lyrical.'[19] While comparisons with Surrealism were invited, Forge went on: '[Bacon] was involved with the issues of painting in a way that no surrealist had been.' Moreover, at the same time he challenged the 'strongest tradition in modern art . . . that . . . takes the painter out before breakfast looking for something to paint, argues that there is no hierarchy of subject matter, that any convinced study of anything can be fully revealing in a human sense and that an apple is no more and no less highly charged than a face'. Bacon once suggested that the traditional hierarchy of genres would now have to be altered, so that portraits rather than 'history painting' came first: 'Art is an obsession with life and after all, as we are human beings, our greatest obsession is with ourselves. Then possibly with animals, and then with landscapes.'[20]

Another of Bacon's early critics, Robert Melville, made a comparison with Surrealism, though not claiming him as a Surrealist painter. 'I believe that *Un Chien Andalou* has greater visual force and lucidity than anything achieved in the art of painting between the two wars, and that only the recent paintings of Francis Bacon have discovered a comparable means of disclosing the human condition, or are capable of producing . . . the same "tremendous feeling of excitement and liberation".'[21]

Bacon has been open to images from many sources, verbal as well as visual. In no sense is he a 'literary' painter; his work never illustrates a poem or play. But titles such as *Triptych inspired by the Oresteia of Aeschylus* or *Triptych inspired by T. S. Eliot's poem 'Sweeney Agonistes'* indicate that a painting can be a direct response to verbal imagery. At the same time, Bacon destroys the illustrational character of an image: he aims to make the image work upon the nervous system, 'to give the sensation without the boredom of its conveyance. And the moment the story enters, the boredom comes upon you. . . .'[22] Andrew Forge has spoken of 'the uncanny' in Bacon, in the sense in which Sigmund Freud discusses it in his 1919 essay of the same title. The extreme disquiet we experience in the face of phenomena where the distinction between animate and inanimate, or real and imaginary, is blurred, and which Freud associates with an aesthetic sensation unrelated to 'the beautiful', comes into play here.

The injury, distortion, contraction of the figure involved in the existential realism of Giacometti and Bacon is very far from Lucian Freud's treatment of his subjects. This appears at first to amount to extreme, objective realism. In his earlier paintings he seems to suppress the active subject – there is little sweeping gesture, aggressive intervention or convulsive emotion. His extraordinary talent for drawing was early recognized, and works made in his teens indicate a familiarity with the draughtsmanship, the piercing, caricatural vision of Grosz and Dix. However, although the almost naive precision in some of the early paintings, combined with what seems to be an odd, even arbitrary juxtaposition of objects, has led to a comparison with Surrealism, even in *The Painter's Room* of 1943 the huge, striped zebra's head turns

19. Andrew Forge, 'The Paint of Screams', *Art News*, October 1963, p. 38.
20. *Interviews with Francis Bacon*, op. cit., p. 63.
21. Robert Melville, 'Francis Bacon', *Horizon*, 120-121, Dec. 1949-Jan. 1950, p. 421.
22. *Interviews with Francis Bacon*, op. cit., p. 65.
23. Quoted by William Feaver, *The Proper Study: Contemporary Figurative Paintings from Britain*, London, British Council, 1984, p. 55.
24. *Interviews with Francis Bacon*, op. cit., p. 22.
25. See Norman Bryson, *Word and Image*, Cambridge, 1981, for a discussion of Watteau and his critics.

out to be a stuffed one which Freud had in his studio. Another early painting, *Girl with Roses* (Cat. 234), suggests that the *Neue Sachlichkeit* ('New Objectivity') of Dix and Grosz was indeed more important than Surrealism.

This leads to another interesting aspect of New Objectivity: the photography of the late Twenties by, for instance, Blossfeldt, whose *Urformen der Kunst* (translated as *Art Forms in Nature*, 1929) was an influential book. Concentrated close-ups and angled or unusual views stretch the camera's capacity, not just to record, but to reveal the external world, emphasizing the 'thingness' of objects. Any comparison of Freud's painting with photography obviously has to be treated with caution: the suggestion here is that his paintings have the same relationship to conventional academic naturalism as the photographs of Blossfeldt have to 'straight' photography. There is no morphological ambiguity in Freud as there is, for instance, in the Blossfeldt studies of a fern bud, which, erect and isolated, becomes a piece of exotic architecture; rather, the painter's flowers and plants possess an odd, veiled anthropomorphism. Owing to their emphatic presence for him, these are as important as a figure: his gaze does not discriminate, any more than a camera does, between plant, animal and man – there is no sentimental humanism here. Of cyclamen flowers, he said, 'they die in such a dramatic way. It's as if they fill and run over. They *crash* down; their stems turn to jelly and their veins harden.'[23] The palm in *Interior at Paddington* (Cat. 235) has equal weight with the figure. Even after adopting a looser handling of paint, freer and thicker, he still continues sometimes to choose angles of vision which suggest the photograph: he often seems to get so close to his subjects that they fill the whole canvas.

Freud makes his pictures slowly, and they are usually of people most intimate to him – his mother, daughters, lovers, friends. The *Large Interior, W. 11 (after Watteau)* (Cat. 241) took three years to paint. Each figure was painted singly, as always, from the life. They look neither at each other, nor directly at the painter, but are physically locked, crowded together. It is a bold painting, especially given the problem for the modern artist of bringing together several figures. As Bacon once put it, 'the moment there are several figures – at any rate several figures on the same canvas – the story begins to be elaborated. And the moment the story is elaborated, the boredom sets in; the story talks louder than the paint.'[24] When Freud previously brought more than one figure on to the same canvas, they were disconnected, separate, as in *Large Interior, W. 9* (Cat. 238), or the other presence was partial, sometimes reflected in a mirror. But no such device operates in the *Large Interior, W. 11 (after Watteau)*. The reference to Watteau is unusual, for unlike Bacon, Auerbach and Kossoff, all of whom have in different ways paid manifest homage to the Old Masters, Freud has generally avoided overt tributes. Here it is perhaps not as incidental as its genesis might suggest – this was the chance sighting of a poster for the Thyssen Collection, which appears in his earlier portrait of Thyssen (see Fig. 3).

Watteau was the artist who, at the beginning of the eighteenth century, closed the door on conventional history painting, the illustration of themes from mythology, history or the Bible, and presented instead paintings of his contemporaries, engaged in dancing, music making, picnics, but unconnected by a narrative.[25] Psychological relationships are hinted at but never made explicit; the figures may or may not be actors and actresses – they are somehow *déclassé*, unplaced. There is likewise a hint of dressing-up in Freud's homage. If any artist could supply a disquieting, anti-illustrational yet absorbing model for a multiple figure painting, it is Watteau, and with Freud too, the absence of any explicit historical, biographical or autobiographical information tends to lead the viewer to speculate.

In this respect alone, the approach of the two younger artists, Frank Auerbach and Leon Kossoff, has affinities with that of Freud. They were students together at the Royal College of Art, and both attended David Bomberg's evening classes at the Borough Polytechnic. From him, Auerbach felt he learned rigorous standards: 'Bomberg had, I thought, a sense of the grand standards of painting and wouldn't tolerate any fiddling around on the foothills and wouldn't tolerate decoration or some trivial success. . . .' But it was not so much the torch of tradition as the torch of

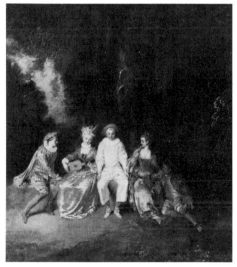

Fig. 3 Jean-Antoine Watteau, *Pierrot Content*. Thyssen-Bornemisza Collection, Lugano, Switzerland

practice that was handed down in the genealogy he traced: 'I was a pupil of Bomberg, he trained with Sickert who worked with Whistler. Whistler gleaned a lot from Degas. (Sickert too worked with Degas....) Degas learned from Ingres, who studied with David....'[26] Hundreds of artists in Britain can, as he says, claim the same genealogy: 'It is not simply technical; spirit and attitude come into it.'

With Michael Andrews, the final artist of this group, Auerbach and Kossoff had their first one-man shows at Helen Lessore's Beaux-Arts Gallery between 1956 and 1958. It was also the Beaux-Arts Gallery that had been responsible for presenting the work of, among others, Edward Middleditch, Jack Smith and John Bratby. In 1954 Bratby showed a number of kitchen still-lifes, including *Still Life with Chip Frier* (Fig. 4), which led David Sylvester to dub them 'Kitchen Sink' realists. Auerbach called these pictures of domestic trivia 'passionate illustrations', and they had their equivalents in literature – John Osborne's play *Look Back in Anger*, for instance. But the 'Kitchen Sink' artists, and the writers who may be associated with them, were involved with contemporary life in both a defensive and aggressive way. The egalitarian challenge which they put forward, with its emphasis on individual experience, was quite distinct from the Social Realism of the Thirties (see Fig. 5), but it found no response from Auerbach or Kossoff.[27] As Auerbach said, when asked about his reaction to Bratby and Smith at this time, they were young, and 'I was born old and I wanted to make a dignified perverse image, a formal image'.[28]

The critical quarterly *X*, which started publication in 1959, had a notable bias towards such young Beaux-Arts artists as Auerbach, Kossoff and Andrews, as well as Bacon and Freud. Not the organ of a specific movement, it provided an independent forum in which many of the key critical issues of the time were discussed. It was, as Cyril Connolly observed, individualist and experimental, and an important part of its policy was to present the work of young painters. At the same time it was by no means simply insular or local: both Surrealism and recent American painting were discussed, and the first issue contained a text in French by Samuel Beckett, as well as a dream story by Giacometti. This issue deserves closer attention, because it also included Auerbach's 'Fragments from a Conversation'. The context in which this was presented is revealing. An attack in verse by George Barker, parodying the Beat generation, was followed by an essay by A. J. Cronin, 'The Notion of Commitment: an Aesthetic Enquiry'. The title itself defused the social and political associations of the term 'commitment' by relating it immediately to aesthetics. The essay sums up the case for the individual human subject as opposed to social commitment, arguing that there is no such thing as a hierarchy of subjects in order of importance, and that neither theology nor the bomb 'can make a poem important if it is not so of its nature'.[29] Cronin annexes the idea of commitment by holding to the notion of a social function for poetry, while arguing that this lies more truly with the poet who 'privately probes his wound' than with the poet who turns his poetry into political rhetoric to urge people to strike, to free themselves. The social function of poetry, Cronin claims, lies in 'the impulse to self-expression, the need to express the effect the operations of external reality have had and are having on the self'.

In the same year, 1959, John Berger reaffirmed Realism, which, he had argued in the introduction to the catalogue of his 1952 exhibition 'Looking Forward', would be 'the future development of painting'. His emphasis differs from that of Cronin. In the article 'Staying Socialist' Berger wrote that, after a decade of promoting Socialist Realism, he realized it had failed; now, 'instead of worrying about the immediate political value of a work's style or subject, we must begin to understand something new and more profound: namely, that any artist who now breaks through to reality and translates it into art is bound to be in ideological opposition. The official values of our society are no longer capable of nourishing or even encouraging art. And so we who want to change the very basis of our society should realise that any artist who now succeeds in terms of his art is an ally. So complete is the inner, but not the outer collapse of our present social structure....'[30]

In the first issue of *X*, the theme of individual experience was continued by James Mahon in 'Official Art and the Modern Painter', an attack on international Modern-

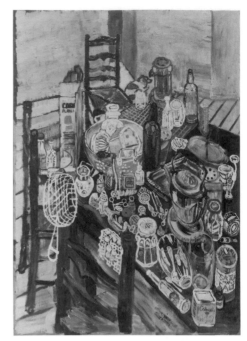

Fig. 4 John Bratby, *Still Life with Chip Frier*, 1954. Tate Gallery, London

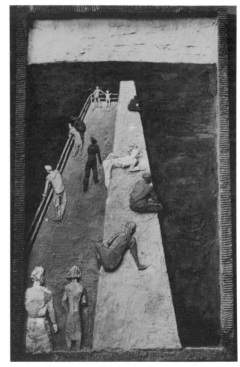

Fig. 5 Peter (Laszlo) Peri, *The Pier*, 1938. Peter Peri Estate

26. Paul Bonaventura, 'Approaching Auerbach', *Metropolis*, no. 2, 17 February 1986.
27. During the Thirties, the Artists International Association nourished strongly 'committed' painting with clear social and political content. The Euston Road Group had affiliations with the AIA, particularly through Graham Bell; William Coldstream, one of the founders of the Euston Road School in 1937, in spite of his social convictions, held to the need for a more accessible painting and to his own need for

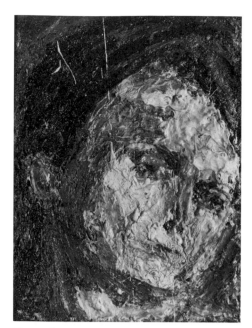

Fig. 6 Frank Auerbach, *Head of E. O. W.*, 1954.
Private collection

ism and on the commercialism involved in the proliferation of art galleries. He underlined the conformist intolerance of the 'New Art', largely non-figurative, with a quotation from the catalogue of the current Documenta exhibition at Kassel: 'There is no room for off-beat artists and for developments the significance of which is not yet apparent on an international level.' Mahon is not opposed to abstraction as such, but suggests, with some justification, that behind the claims for the New Art lurks an old bogey, the 'idea of progress in the arts' – movement in simple progression and a single direction. The 'absolutely modern', he proposes, is by contrast at that moment probably constituted by the 'odd, the personal, the curious, the simply honest'. The 'unique and heroic effort which is so much a part of the real activity of painting is more likely to be found outside the vast international movements of modern styles'.

It is immediately after this in *X* that Auerbach's 'Fragments from a Conversation' is placed, a position which is not coincidental. This is no rhetorical statement, any more than Michael Andrews's 'Notes and Preoccupations', which came one issue later. None of these artists in fact places much value on the capacity of words to convey what they do, or would willingly volunteer 'artist's statements'. Auerbach's 'Fragments' is left untidy, full of breaks and a sense of urgency. 'Painting is a practical day-to-day thing I think. One might say something clever, one might say something big, but one does something limited. It is a serious thing – like religion – like love – one does the persistent thing, and then the really remarkable happens when something's there that wasn't there before. The consciousness – the strictness – and then the image'[31]

Reproduced in this issue was a head of E. O. W. and two nude studies of 1959. All are thickly painted, but the paint in the head is shockingly thick, standing out almost in relief (although this was not the intention). Auerbach does not produce paintings fast: a canvas may take months or years before it is finished, and the question of completion is not a simple one. In fact it was knowing when the painting was finished that was part of the process of finding himself as a painter, which happened with *Summer Building, Earls Court* in 1952. The heads of E. O. W. (Fig. 6) were painted over a period of twenty years, working by electric light, in the evening, three times a week, making it 'again and again and again'.[32] He used earth colours, and the recognizable features are often as much a matter of shadow as of change in tone. The massive depth of the paint was also linked to a desire for something permanent and a revulsion against 'a sort of linear, illustrational painting' current at the time. Auerbach has said that he does not start by visualizing a picture, but with a piece of recalcitrant fact.

The same subject – head, body, landscape ('places one knows, things one loves . . .'[33]) – is endless. Over time people change, streets change; the light changes, but even a shift of a few feet alters everything: 'to move a few feet to right or left presents one with a totally different formal entity, and it's just a new problem. Even though the subject may have a similar title. Because it's the relationships within the canvas that matter to me.'[34] Cézanne spoke of much the same thing, of altering position slightly so that all the apparent points of contact between objects in the landscape motif changed. With Auerbach it is clearest in the many cityscapes and landscapes he has painted in London: the surroundings of the studio he has had for over thirty years, Mornington Crescent, Primrose Hill, Camden Theatre, building sites on, for instance, the Euston Road and Oxford Street, and, most recently, the studios themselves.

As early as 1952 Auerbach and Kossoff showed drawings together at the Beaux-Arts Gallery. Both treat drawing as a separate and serious activity – indeed, Bacon alone in this company does not draw. When he wrote a short forward to Auerbach's Hayward retrospective exhibition in 1978, Kossoff wrote, as might be written about himself, 'Whether with paint or charcoal, pencil or etching needle, it is drawing that has constantly engaged Frank Auerbach. Drawing is not a mysterious activity. Drawing is making an image which expresses commitment and involvement.'[35]

visual integrity: 'I lose interest unless I let myself be ruled by what I see.' At a debate on 'Realism and Surrealism' organized by the AIA on 16 March 1938, Bell, Coldstream and Peri argued the case for the Realists, Penrose, Trevelyan and Jennings that for the Surrealists. The Surrealists, aided by the unspeaking presence of works by Miró and Picasso, seem to have been the most persuasive; the Realists were internally divided, with Peri arguing a strong case for Socialist Realism, which was certainly distant from Coldstream. The *Left Review* praised the honesty of the Euston Road painters, but deplored their subject-matter of home and friends. See Lynda Morris and Robert Radford, *The Story of the AIA 1933-1953*, Oxford, Museum of Modern Art, 1983.

28. Catherine Lampert, 'A Conversation with Frank Auerbach', in *Frank Auerbach*, London, Arts Council exhibition catalogue, 1978, p. 21.

29. Cronin might also have had in mind Paul Hogarth's attempt to back Realism with a strong political basis in his essay, 'Humanism versus Despair in British Art Today', *Marxist Quarterly*, January 1955; quoted in *The Story of the AIA*, op. cit., p. 90.

30. John Berger, 'Staying Socialist', *New Statesman and Nation*, 31 October, 1959.

31. Frank Auerbach, 'Fragments from a Conversation', *X*, no. 1, 1959, p. 31.

32. Catherine Lampert, 'Frank Auerbach', *Frank Auerbach*, London, British Council, XLII Venice Biennale, 1986, p. 7.

33. 'Fragments . . .', op. cit., p. 31.

34. Catherine Lampert, unpublished conversation, see n. 2.

35. Leon Kossoff, 'The paintings of Frank Auerbach', *Frank Auerbach*, London, Arts Council exhibition catalogue, 1978, p. 9.

In the early Fifties, the two artists posed alternately for each other's portrait (Fig. 7 and 8), and in many ways, they are closer to one another than to anyone else in the group. Moreover, as is characteristic of them all, Kossoff paints those he knows well – his family and especially his father. His thickly painted canvases, however, have become more, rather than less easy to read: the altercation between the paint and the image is less dramatic than with Auerbach. London, that almost 'virgin territory' for artists, constantly provides subjects.

Fig. 7 Frank Auerbach, *Head of Leon Kossoff*, 1954. Collection of Mr and Mrs Michael Roemer

Once, photographs were taken of the sites he painted, and this made Kossoff apprehensive lest it were thought that he painted from photographs. 'I was born,' he wrote, 'in a now demolished building in City Road not far from St Pauls. Ever since the age of twelve I have drawn and painted London. I have worked from Bethnal Green, the City, Willesden Junction, York Way and Dalston. I have painted its bomb sites, building sites, excavations, railways and recently a children's swimming pool in Willesden.'[36] His city, unlike that of Auerbach, is often peopled – indeed, the people are locked into the whole scene and seem its true subject. The streaks of paint are bound to the matter he paints, following the plane of an arm or a head or a leg, and figures and objects are darkly outlined, although earlier he tended to dig into thick pigment to give an indented line. There is not, here, the sense of release, of 'gaiety', the word Auerbach uses, but rather of tragedy.

This was the point that John Berger made in his review of Kossoff's second one-man show at the Beaux-Arts in 1959. After saying that although Kossoff's idiom was Expressionist, he was more analytical of spatial structure than, say, Rouault or Soutine, he went on: 'Kossoff . . . paints to emphasise the primacy of matter – hence his monumentality, his emphasis of mass and his use of the medium. Yet at the same time he is overwhelmed by the powerlessness of man in the face of the material world – hence his profound pessimism. He is too honest to resort to religion, and yet can find no explanation for the crushing weight of suffering. Other critics have been made uncomfortable by his sense of tragedy. I am not. I sympathise. But to turn a sense of tragedy into a tragic work of art one must believe in the possibility of the happy alternative'[37] It does seem appropriate, for Kossoff, to couch the paradox in these terms, for whereas Bacon could talk of 'exalted despair', there cannot, it would appear, be any secular salvation for Kossoff in an acute, physical sense of life. 'Happy' implies a much more social, communal form of life. This, perhaps, is the tension that makes the swimming pool paintings so remarkable, the tension between the teeming, *noisy* life in the pool and the naked, anchorless, individual figure.

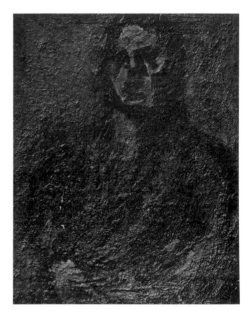

Fig. 8 Leon Kossoff, *Portrait of Frank Auerbach*, 1953. Private collection

'The idea of a first one-man show at the Beaux-Arts Gallery', David Sylvester wrote on the occasion of Michael Andrews's first exhibition there in 1958, 'calls to mind the image of walls thickly covered with paint and bursting with conviction. The latest of the series . . . bears as much resemblance to this archetype as a daisy chain to a rhododendron bush.'[38] In noting the tentative yet obsessive character of Andrews's painting, Sylvester emphasizes a characteristic that is at least partly attributable to the fact that Andrews, the only one of this group, went to the Slade School of Art while Coldstream was Professor there. Thus he too was trained in a rigorous practice, but one which laid emphasis on the visual recording of fact, the patient accruing of information laid quite tentatively on the canvas. However, Andrews very soon departed from this model, turning instead towards curious, imaginative representations of scenes which are an attempt to defy the limitations involved in this type of painting while remaining aware of the problems that were discussed above. As Sylvester wrote in the same review, 'Andrews, in his delicately bungling fashion . . . has succeeded in making every picture tell a story, as pictures used to do, without employing expressionist deformations to drive home the point and without lapsing into illustration The story is always some sort of reverie about life in our times, rather as early Bonnards are reveries about contemporary life.' Andrews himself jotted down the following remarks in 'Notes and Preoccupations': 'The painting episode is a real situation imagined. Re-enacted and rehearsed until its performance is the best possible'[39] It is interesting that he, too, uses the theatrical metaphor that was noted earlier.

36. Leon Kossoff, Statement from *Art & Artists*, 1979, reprinted in *From Object to Object*, London, Arts Council exhibition catalogue, 1980.
37. John Berger, 'The Weight', *New Statesman and Nation*, 19 September 1959, p. 352.
38. David Sylvester, 'Michael Andrews', *The Listener*, 16 January 1958.
39. Michael Andrews, 'Notes and Preoccupations', *X*, no. 2, 1959, p. 138.

The differences within this group of painters are marked. None the less the relationship of each of them to other Realist traditions in Britain provides much common ground: they share a horror of the illustrational, a fear of 'story telling', an honesty to the material of paint, a sense of the complexities and contradictions of trying to represent the 'life' and power of a figure. Each clearly cherishes his individuality and this attitude has a specific critical context in the Fifties. But the standpoint has a longer history in Britain, for Herbert Read, when trying to weld Surrealists in England into a real movement in 1936, bitterly regretted the persistent cranky individualist stance of artists in this country, who resisted all efforts to form active communities. Moreover, this was during a period when there was more 'commitment' of an active kind than at any moment in twentieth-century Britain. The other side of the argument is best put by Frank Auerbach: 'I feel there is no grander entity than the individual human being. When the word society is used, as though society had demands and rights, I am frightened. I would like my work to stand for individual experience, as that of Jacques-Louis David was, sometimes, a celebration of austere, clear and ruthless public behaviour.' This stress on the value and intensity of individual experience is, paradoxically, what both isolates these artists and binds them together.

Caroline Tisdall

Art Controversies of the Seventies

'Uncertainty in the presence of vivid hopes and fears is painful, but it must be endured if we wish to live without support of comforting fairy tales. It is not good either to forget the questions that philosophy asks or to persuade ourselves that we have found indubitable answers to them. To teach how to live without certainty and yet without being paralysed by hesitation is perhaps the chief thing that philosophy in our age can still do for those who study it.'

Bertrand Russell, Introduction, *A History of Western Philosophy*, first published 1946.

It was a sign of the times that Bertrand Russell's prophetic message from the past should have appeared in the first full-scale official show of 'The New Art' in 1972. Many younger artists no longer shared an older generation's certainty about the value of art, the exclusiveness of painting and sculpture, or the traditional role of the artist. Those concepts seemed to them to be the comforting fairy tales whose support had been withdrawn, at least for a time.

This time of uncertainty may have caused much soul searching but, far from inducing the paralysis of hesitation, it brought in its wake a tremendous wave of energy and creative thought about the whys and wherefores of art. In an increasingly specialist world there was great will to expand art beyond its known definitions, to take it into new fields informed by other disciplines as various as philosophy, linguistics, sociology, archaeology, technology, catastrophe theory and even the theatre of cruelty. 'Dedefinition', the term which has often been applied to this process, seems in retrospect too gloomy and implies some kind of disappearance. In fact art was appearing in all sorts of new guises which some were eager to dismiss as the emperor's new clothes.

By 1976 and the exhibition 'Arte Inglese Oggi' organized by the British Council in Milan, the new definitions had proliferated to include, as Richard Cork listed in that catalogue: 'Conceptual Art, Post-Minimalism, Land Art, Process Art, Theoretical Art, Arte Povera, Neo-Dada, Body Art, Post-Object Art, Impossible Art, Information Art, Art-as-Idea, Language Art and Dematerialised Art.' In addition to these critic-imposed labels there were the fields in which artists might actually recognize themselves as working: Performance Art, Film, Photography, Video, Community Art in all its nuances, Street Theatre, Art with a Social Purpose and the Art of Organizing Art.

The Seventies were in fact a decade in which personal discovery and social purpose were equally present in 'alternative' art as artists tried to put into practice some of the slogans of the Sixties in the spirit of 'the personal is political', 'small is beautiful', 'everyone is creative'. A remarkable number of artists were involved in establishing new organizations, spaces, galleries for new work and forums for discussion as various as Air and Space, Art Net, Acme Housing and Gallery, Artists for Democracy and the Artist Placement Group.

Interpretations of the role of artist became as varied as the practitioners, in startling contrast to the run-of-the-mill life of the artist up till then, though in the Eighties we have come to take this wide range for granted. The new attitudes were partly a conscious rejection of the traditional art world structure, market and public. They also reflected impatience with the American model of huge-scale art works, high prices and an ethos of self-referential art. Practically the only model of non-British art available to young artists in Britain in the early Seventies was work by Andy Warhol, Jim Dine, Claes Oldenburg, Sol LeWitt, Don Judd and Robert Morris, who all had major exhibitions in London museums.

The characteristics of the British art world itself were varied: some positive, some negative, some paradoxical. The lack of market for avant-garde art, for instance, meant that many artists did not, and still do not, set out with the ultimate aim of selling their work. While provincial museums in Germany were vying to collect the *dernier cri* because it was prestigious, Britain's own national collection of modern art, the Tate Gallery, was then very nervous of controversy, as well as having problems with conservation. It was distressing enough that a painting by Kurt Schwitters was gently crumbling, but imagine the trouble that a delicate little sand-machine by David Medalla might have caused the conservation department. Nor were there then, with the exception of E. J. Power, any private collectors looking beyond the mainstream of art who were on a scale comparable to those in Europe. There were no shampoo or coffee magnates to rival Karl Stroher in Darmstadt or Panza di Biumo in Milan as they built up their own museum-sized collections; the biggest bequest of modern art in the Seventies was the McAlpine Collection of mainstream British sculpture, given to the Tate. Moreover, Britain does not host any extravaganzas of contemporary art like the Venice Biennale, the Paris Biennale des Jeunes or the Kassel Documenta. In the Seventies this meant that much of the new work by British artists was seen and performed abroad. At home the public was shielded from exposure to the avant-garde and artists largely created their own venues.

British artists did, however, have some advantages, certainly compared to those working in experimental fields in other countries. At least at the beginning of the Seventies, many could combine their art practice with part-time teaching in art colleges. At one time or another Art & Language were teaching at Lanchester Polytechnic, Bruce McLean was setting up the Nice Style Pose Band (Fig. 1) while working at Maidstone College of Art, Paul Neagu was combining Generative Arts with teaching at Hornsey, Bill Furlong was working at Ravensbourne and publishing *Audio Arts* – the first art magazine on cassette – and Keith Arnatt was teaching photography students in Newport. It was a loss to British art and to the next generation – the students – when this possibility was whittled away first by recession and then by education cuts.

Controversy was the bugbear of public funding too. On the one hand, by its very nature experimental or alternative art in whatever medium is bound to cause a public stir; on the other hand, from many artists' point of view, funding through the Arts Council of Great Britain was constantly criticized for its conservatism. It began to seem as though the slices of subsidy-cake available were not enough to feed both the artists who defended 'art for art's sake' and those who were asking the question 'art for whom?': 'rubbish' and 'waste of public money' seemed to win the day. Art controversies through the Seventies reveal a perturbing passage from distrust and

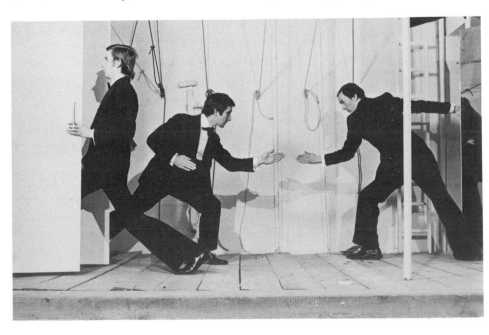

Fig. 1 Nice Style at the Garage, 1973

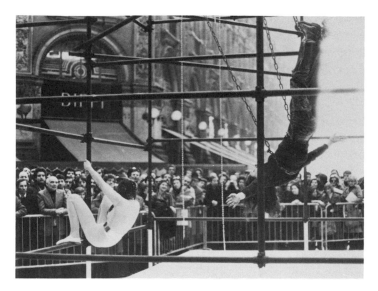

"Methinks the boy Harry doth take the mock."

Fig. 2 Genesis P-Orridge and Cosey Fanni Tutti, *Towards Thee Crystal Bowl*, 24 February 1976. Performance in Milan for 'Arte Inglese Oggi'

Fig. 3 Giles, *Three Men with a Plank*, cartoon in the *Daily Express*, 14 March 1976

mockery to something approaching full-blown hatred on the part of the media and the self-appointed spokesmen for 'decency' and 'cultural values'.

The first row – the fish tank drama – arose from an exhibition of American, not British, art organized by the Arts Council at the Hayward Gallery in October 1971. Newton Harrison, amid a bland group of artists from Los Angeles, exhibited several fish-tanks as an artwork about an alternative, more humane approach to fish-farming. As a climax two hundred catfish were to be electrocuted and eaten in the gallery at a dinner for art world worthies. The reaction was very British and indicative of the curiously woolly quality of such controversies. The attack was led by Spike Milligan campaigning against cruelty to animals. The final word from the then head of the Arts Council, Lord Goodman, was witty but hardly constituted a defence: 'It may be tasty, but is it art?'

The peak year for newspaper headlines was 1976. It was the year of 'Any child could do it' (an exhibition of cartoons at the Tate Gallery) when Carl Andre's 'bricks' were sprayed with food colouring, and the *Sun* and the *Mail* noticed for the first time that the Tate had been so bold as to purchase such work. The 'debate' was not edifying but it was nothing compared to the outcry over the 'sex show' at the ICA in October of the same year. British performers Genesis P-Orridge and Cosey Fanni Tutti were performing there with their rock band Throbbing Gristle. 'Sex show man's amazing free tour' screamed headlines in the (then) *Evening News:* 'British Council paid travel, hotels and meal bills in two-year tour.' The facts were more modest but when the *Guardian* published them it made little impression in the storm over taxpayers' money. The British Council, as is their policy, had contributed to various performance artists' costs abroad when they were invited to international venues, as happens with any sort of art. Genesis and Cosey certainly represented the ruder wing of British performance, but they were in demand in Germany in 1974 (subsidy of £52.50), at the Paris Biennale des Jeunes in 1975 (£273.58) and were included in 'Arte Inglese Oggi' in Milan in 1976 (£650.40) (Fig. 2).

The issue did not stop there. It was taken up by a lobby to 'clean up' and control art and its funding which was to become increasingly vocal over the next few years. On this occasion the spokesman was Nicholas Fairbairn, Conservative MP, whose apoplectic letter to *The Times* expressed the quite frightening loathing that the avant-garde can arouse in this country: '. . . like all modern exhibitions it was an excuse for exhibitionism by every crank, queer, squint and ass in the business.' Fairbairn went on to lead the Tory call to 'abolish the spooks with their soft-belt intellectual arrogance', the art bureaucracy 'anxious to promote every swill-bin attitude they can to denigrate language, meaning and thought'.

Needless to say, neither the Arts Council nor the British Council was abolished, but the barrage of attacks in 1976 probably marked the watershed in support for 'alternative' activities. The 'Three Men with a Plank' incident lampooned by Giles in

an *Express* cartoon (Fig. 3) demonstrated the shaky ground for public reception of some of the work funded by the committees dealing with performance and street theatre. Folksy events like this were just as likely to draw fire as 'obscene' or 'lefty' art but performance work and art with a political intent were increasingly singled out.

The exhibition 'Art for Whom?' at the Serpentine Gallery in 1978, selected by Richard Cork for the Arts Council, showed that a substantial body of work had been built up over the years by a number of artists motivated by social or political concern or by content, issues and audiences beyond those of the traditional art world. On a national and international level this was recognized as a characteristic of British art in the Seventies. Running contemporaneously was another survey, 'Art for Society', at the Whitechapel Art Gallery, selected by a committee on which – to declare an interest – I served. It was a good time to take stock of what had been happening in the twenty-six years since an exhibition on the same theme had been selected for the Whitechapel by John Berger. Then, in 1952, partly because of the selector's pre-dilection and partly because of the art available, Berger's 'Looking Forward' was restricted to Realist painting. What had changed in the years between was not simply a question of the means of art, though one of the recurrent criticisms of both 'Art for Whom?' and 'Art for Society' concerned the 'debasement' of fine art to documentation in the form of photographs, video or tracts of words. With hindsight much of the discussion about means turned out to be a red herring: in the end it is what you have to say that counts more than how it is said, a point reinforced by the number of artists who have since 'returned' to painting, from Art & Language to Bruce McLean.

The acrimony was not entirely about the content of art. There was content in the Berger selection of 1952; it was nothing new. The vacuousness of formalism and the lack of content of much of the painting and sculpture spawned by Abstract Expressionism had been attacked and lampooned from the Fifties onwards. Bruce McLean had identified the problem as a student at St Martin's in the mid-Sixties: 'I began to understand what it was all about, which was nothing. All the discussion centred on the proclamation that sculpture should be placed on the floor and not on a base. It seemed to me quite daft that adults should spend their time like that. It dawned on me that what it was really about was the making of a name for oneself.' (From an interview with the author for the *Guardian*, on the occasion of 'King for a Day', Tate Gallery, 1972; see also Fig. 29, p. 48.)

Certain subjects remain taboo in society, of course, and when introduced into art cause a stir. On a light-hearted though 'outraged' level there was the reaction to Richard Hamilton's 'Andrex' landscapes: *Soft Pink* (Fig. 4), *Soft Blue* and most particularly, *Sunsets*, veritable portraits of mammoth turds in romantic settings. Hamilton declared his 'compulsion to defile a sentimental cliché', and applied a dazzling range of artistic virtuosity to the products of a society that projects diluted experience through advertisements. 'Erotic' and 'disgraceful' were among the reactions when the series was shown at the Serpentine Gallery in September 1975.

Content of a political kind drew fire when the subject was both sensitive and presented in the art world context. While in the early Seventies Maoist-inspired events could be found regularly wherever David Medalla was appearing, they usually took place far enough away from establishment territory to elude hostile attention. The strangest venue was Gallery House, an elegant building next to the Goethe Institute in Queen's Gate, London. Here, behind the immaculate façade of a house loaned as a gallery by the West German government, scenes reminiscent of the hurried decampment of a guerrilla army marked the comings and goings of the British avant-garde under the aegis of Sigi Krauss. Medalla was a regular exhibitor with his participation art: all visitors welcome to contribute a 'Stitch in Time' to ongoing communal artworks. Nor were eyebrows raised by Medalla's later Artists for Democracy, a gallery in the tandoori belt of Whitfield Street where radical causes and minority issues were the staple content. Here could be seen work by Rasheed Araeen, editor of Britain's first and then only magazine for a struggling

Fig. 4 Richard Hamilton, *Soft Pink Landscape*, 1971-72. Ludwig Collection, on loan to Museum moderner Kunst, Vienna

body of black writers and artists, or Chilean patchworks assembled by Guy Brett, formerly art critic of *The Times*, whose contract with that paper had been terminated because his political concerns 'diverged with those of our readers'.

However, when such delicate subjects as Northern Ireland or Royalty appeared as the subject of art in publicly funded places, questions were inevitably asked and official near-panic sometimes set in. Conrad Atkinson became a veteran of such incidents, partly because he was one of the very few artists, along with the painter Rita Donagh, who was prepared consistently to tackle thorny subjects. But while Rita Donagh explored the tragedy and sorrow of Ireland, Conrad Atkinson appeared to be looking for a solution, even criticizing parties to the struggle. This, as a British ambassador made clear to the British Council, was *not* acceptable as artwork representing Britain. Neither was it acceptable that in March 1979 the Hayward Gallery's 'Lives' exhibition, selected by Derek Boshier and financed by the Arts Council, should include a work by Conrad Atkinson indirectly criticizing the Royal Family for continuing the royal warrant to the company that had failed to pay out damages to thalidomide victims. There were also objections to a series of paintings by Tony Rickaby depicting the façades of buildings belonging to the British far right. The fuss was fairly contained and the artists agreed to withdraw so that the show could go on. Thus ended the last controversy of the decade, with more of a whimper than a bang.

Yet the issue which was central to the unease of the Seventies had consistently eluded debate beyond the people and institutions it most concerned. The role of the artist in a highly compartmentalized world of specialists and specialist audiences was a serious problem for those who felt that they had more to offer than the provision of Matisse's 'arm chair'. In place of Bertrand Russell's 'comforting fairy tales', they felt the effects of a state of alienation eloquently described by R. D. Laing in *The Politics of Experience*: 'Perhaps it is partly because we have largely lost touch with our inner world in gaining control of the outer world that we have become strangers from our own experience, we are alienated from ourselves.'

Alienation was expressed in as many different ways as it was experienced, ranging from the divided self described by Laing to the prejudices women encounter in integrating their particular experience into art, and the general issue tackled by the Artist Placement Group of seeking 'a very direct method of achieving a rapprochement between the artist and the society from which he [sic] is alienated'.

In the Seventies, performance, and to a lesser extent film and video, was the most powerful means of conveying a state of alienation. For women artists working in the decade of feminist theory there were masks to be stripped away. Rose Garrard made this point at the Acme Gallery in 1977 in her performance about how history is made, based round those two well-known painters, Hitler and Winston Churchill (Fig. 5). But before she could put on the masks of these men she had first to remove the make-up with which she as a woman artist faced the world. A year earlier at the ICA Mary Kelly had courageously introduced her experience as a mother in the crucial first four years of an infant's life, not as a performance but as a *Post Partum Document*, incorporating traces of real life into a restrained and accomplished artwork which was referred to by embarrassed critics as 'the nappy show'. Although it may be objected that this was documentation rather than art, one can only hope that the world has now accepted that the role of the female artist can include and dwell on the experience of birth and motherhood.

Other artists took to the world as travellers. In their different ways they have brought back into art a sense of time and space beyond the urban studio. Richard Long on his journeys through Africa and South America, Mark Boyle and Joan Hills on their unending *Journey to the Surface of the Earth*, Richard Demarco in pursuit of the Celtic world by road and ship with Edinburgh Arts Journeys, all of these artists extended the notion of where and what the artist could be and how and when art could be found – whether it returns to the familiar space of the gallery, or remains outside.

Finally, the unsung heroes and heroines of the decade are in retrospect the artists who have continued to believe in a constructive role for the artist. Especially to be remembered in this respect are John Latham and Barbara Steveni. Since 1965 they have promoted the idea of the 'placement' of artists in industry or government departments or wherever the important decisions regulating society are taken – those areas where habit and routine frequently erase the ideas and insights that are traditionally attributed to the artist. Several major industries and government bodies from the Home Office to the Scottish Office (though not the ministry responsible for art!) have participated in the scheme. It is perhaps a sad comment on the way that art has gone, or retreated, in the Eighties, that the Artist Placement Group feels so bitterly underrated, misunderstood and underused.

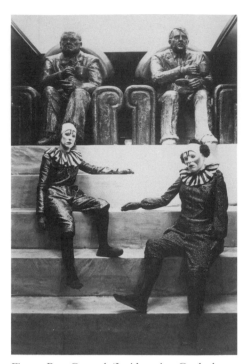

Fig. 5 Rose Garrard, 'Incidents in a Garden', *Random Dialogues*, 1977, at the Acme Gallery, London

Robert Rosenblum

British Twentieth-Century Art:
A Transatlantic View

When I was first asked to provide this catalogue with a foreigner's inevitably prejudiced view of British twentieth-century art, I recalled an indelible experience that I had had decades ago as a student crossing national borders. I had been travelling all over the Continent, crisscrossing one frontier after another, and wound up my long European trek on the other side of the Channel, where I found myself facing a British Immigration Officer. He slowly and politely asked me what seemed endless, rather impertinent questions about my past, present and future plans. At last, somewhat annoyed and impatient, I asked him why it was that I had never been so thoroughly interrogated when going in and out of any of the European countries I had just come from. 'Ah, you see,' he explained, 'now you are in a different country altogether!' The Officer's attitude is one shared by many foreigners confronting not only Britain but its art, so that even the British habit of referring to the Continent as Europe (as if Britain had discreetly abdicated from that historic family) tends to affirm an outsider's impression of an insularity that refuses to abide by international law.

Especially as viewed over the decades from my own vantage point, New York City, British twentieth-century art can seem so quirky and unpredictable that even some of its most famous imports to the United States after 1945 – Bacon, Sutherland, Hockney, Gilbert & George – seem thoroughly out of joint with mainline art history, refusing to be computed by the categories that accommodate other artists. And pre-1945 British art, at least for an American, is no less refractory. Its two most renowned masters, Ben Nicholson and Henry Moore, may impress us all by their art, but quietly refuse familiar time-slots and 'isms'. If Nicholson is seen in the role of a Cubist, he is a very belated and disloyal one indeed; and as a pioneer of geometric abstraction, he is also decades after the fact and never kept his vows in that religion of universal purity. To confuse things still more, he might often be considered in the category of British landscape artist, scrupulously recording, like a Romantic watercolourist, the stone and sea, the sky and earth, at places like Dymchurch or St Ives.

As for Moore, he is no less of a conundrum for an outsider. It is true that in the 1930s his sculpture might almost, but not quite, inhabit an international domain of Surrealism, for its muffled sexuality, its alternation of voluptuous and aggressively spiky forms mirror at a distance Picasso and Miró, Arp and Giacometti; but the same Henry Moore also emerges as an establishment figure who usually produces, at least in the States, respectful yawns in right-thinking partisans of avant-garde art. Indeed, Moore's most ambitious figure sculptures often appear to be modern, hyperborean reinterpretations of the Elgin Marbles, grandly rejuvenating the venerable British dialogue with Classical art and fulfilling the requirement of numerous public commissions to provide something at once old and new (Fig. 1).

The foreigner's impulse to seek out national traits may have something to cling to here; for the degree to which British artists have established a give-and-take relationship with Continental and, after 1945, American art movements may often seem bewildering to an outsider, who might interpret this negatively (lack of passion and conviction) or positively (commonsense flexibility and willingness to compromise). The ongoing British dialogue with the most pristine forms of abstract art is a token of this elusive position. Already, by 1915, both Vanessa Bell and Duncan Grant could produce abstract canvases (Cat. 24 and 26) which, given their precocious dates, look for startling moment like serious candidates, a step after Kupka, in an

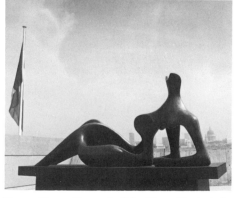

Fig. 1 Henry Moore, *Reclining Figure*, Festival of Britain, 1951

Olympics contest for the earliest manifestations of an art of pure geometry. Yet they both produced, immediately before and after these courageous if minor experiments in the giddy domain of Modernism, far more conventional, even retrograde, works which would not be out of place in the most academic art school. Similarly, both Nicholson and John Piper, when viewed from the rigorous platform of a Mondrian or a Gabo (who so dominated the British semi-conversion to abstraction in the 1930s), might be seen as heretical dissenters, reverting often from the programmatic purity of a universal language to the local dialect necessary for depicting the particular truths of a regional landscape or architectural heritage.

These seemingly abrupt fluctuations between diverse, even contradictory varieties of abstract Esperanto and a need to be empirical continue to perplex foreigners in the work of countless other British artists. Victor Pasmore, for one, dodges any consistency of chronology or identity. (Who would know whether his watercolour-like landscapes of the late 1940s pre- or post-date his severe, Biederman-inspired abstract reliefs of the 1950s, or where his Turner-inspired abstractions of spiralling forms should fit into the patterns of his development?) Or take the case of Rodrigo Moynihan, who alternated between an allegiance to quite different types of abstraction in the 1930s and 1960s and a willing response to the demands of a reality that included everything from a World War II *Medical Inspection* (Cat. 165) to, in the last decades, not only many studio still-lifes but portraits of Mrs Thatcher and the Queen. Thinking back to ancestral traditions, as one so often does in the face of modern British art, one recognizes in these constant vacillations and adjustments to the facts of both life and art the ghost of Sir Joshua Reynolds himself, who by most Continental standards was exasperatingly inconsistent, shifting without warning from high-minded history painting and the fictions of allegorical portraiture to close-up records of the plain truth about this or that sitter.

Of course, all generalizations about national traits, including this one about compromise and flexibility, are bound to be contradicted by one exception after another, but it is still the majority impression that leaves the deepest mark, especially on a foreigner. So it is that, on proceeding through British Customs and attuning one's antennae to the new inflections that attend the crossing of a national frontier, one quickly discovers that Britain is a land in which all things forceful, intense and direct are clouded by veils of restraint and fluctuation. Vanished are the hottest colours in the spectrum, the axial boulevards of Continental urban planning, the blue skies, sharp shadows and loud voices of the Mediterranean. Just as the ever-changing skies overhead keep our perceptions as fluid as the weather predictions or the landscapes of Constable and Turner, a pervasive dampness blurs our ability to make distinctions between solid and void, light and colour. Our pupils constantly dilate in response to the greyish tonality that drains every hue. And of course, for the visitor, the British social mode of reticence, understatement and gentility, internationally recognized to the point of caricature, is instantly savoured, making the outside world quite shrill and emphatic by contrast. All of this permeates much British art, which, especially for Americans used to noisier, more muscular stuff, may seem hushed, diminutive, pallid.

Ironically, it was an American, James McNeill Whistler, who was probably most responsible for laying the discreet foundations of this enduring British tradition of visual sensibility to nuance. However, despite the familiar American claim that Whistler, by birthright, is a national treasure, he was clearly as much of an expatriate in London as Henry James, and his art has only been properly understood within a British milieu, much as the art of Kitaj, who was born in Cleveland, Ohio, can be justly considered only in the context of British art. (The other side of the coin is the way that, for Americans, Malcolm Morley's art seems so thoroughly theirs that only the technicality of his British passport prevents the Whitney Museum of American Art from acquiring his work; or the way in which many Americans assume that Anthony Caro is one of them, thanks to his long sojourns in the States and his prominence in Clement Greenberg's 1960s pantheon of supreme quality, otherwise possessed presumably only by American artists of that decade.)

Whistler defined at least one of Britain's long-term aesthetic goals, an art of whispered tonalities, of the most refined adjustments of line and plane; and this frail shadow was cast well into the twentieth century. It can be perceived, for instance, in the early work of Walter Sickert, as when his bathers at Dieppe are transmuted into subtly vibrant, asymmetrical patterns against an almost Japanese sea that rises rather than recedes (Cat. 1); and it can be seen in the work of Gwen John, whose portraits look like the ghosts of Whistler's already wraith-like women and whose sensibility, akin to Virginia Woolf's, is so fragile and easily bruised that we feel the harsh light of day or the loud bustle of the street outside would make her and her art wither and vanish.

Even in the domain of abstraction, Whistler's aesthetic survived. Nicholson's geometries, for example, often look like distillations of the balanced intervals and rectangles that mark, say, the finely calibrated abstract structure of Whistler's famous pendant portraits of his mother and of Carlyle; just as Nicholson's palette, restricted to fragile modulations of the palest whites, greys, beiges, blues, conjures up Whistler's own delicacy of tone and hue. Here the missing link is probably Nicholson's own illustrious artist-father William, whose paintings belong to a belated Whistlerian Arts-and-Crafts sensibility and whose poster designs, with their subdued and elegant shuffling of word and image, made Art Nouveau advertising genteel. They may have left as much of a mark on his son's famous Cubist works (such as *Au Chat Botté*, Cat. 138) as did Parisian Cubism, their more obvious source.

To an outsider, all of this may look like a puritanical rejection of the Continental and especially French pleasures of colour and the stuff of paint. There are, of course, exceptions in the canons of British art, particularly between 1900 and 1918 when the lure of Parisian painting as represented by Gauguin and Matisse, Vuillard and Bonnard, was irresistible. Matthew Smith, for example, may still surprise us by his ability to produce, without too much of a time-lag, virtual clones of Matisse's most torrid colour and impassioned brushwork. Yet even the canvases of the earlier period that might be most easily accepted by French standards – occasional works by Spencer Gore, Charles Ginner, Malcolm Drummond – still seem to speak in a softer voice than their French counterparts and tend to employ small formats that stifle the potential of an engulfing hedonism which the British hold at bay.

It is a point that might be updated in the work of Howard Hodgkin, who is often and rightly acclaimed a brilliant colourist in the Matisse tradition, but whose more intimate scale and, recently, more atmospheric chromatic harmonies give his work a distinctly British accent. The accent is heard, too, even in the late 1950s, when British abstract art responded to the latest news from New York. Seen next to their American counterparts, the work of Roger Hilton, Peter Lanyon, Patrick Heron or William Scott (Fig. 2) seems gently muted in colour and unlikely to reach the unbalancing extremes of compositional reduction found in Rothko, Still or Gottlieb. And when, as first proclaimed by Roger Coleman in the 1960 'Situation' exhibition, British abstract painting swelled to a minimum of thirty square feet, most of the

Fig. 2 William Scott, *Ochre Painting*, 1958. Tate Gallery, London

Fig. 3 Robyn Denny, *Baby is Three*, 1960. Tate Gallery, London

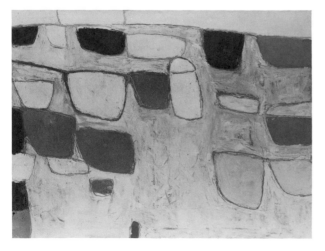

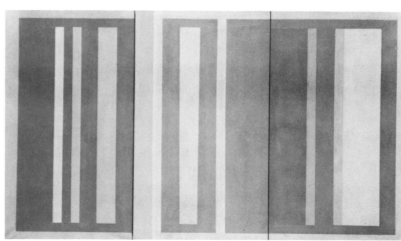

newer generation, such as Robyn Denny (Fig. 3), John Hoyland and Richard Smith, continued through the 1960s to soften the blow of first Newman and then Noland and Stella. With usual British moderation, they offered more soft-spoken and temperate variations on these clear and loud blasts from America.

Even within the more outspoken and impassioned territory of a late Expressionist style, the British tone can be heard, as in the case of Frank Auerbach, who, born in Berlin in 1931, might seem a legitimate heir to earlier German Expressionist traditions. Viewed from the Continent, his ancestors might be found in the land of Nolde and Kirchner; and viewed from the States, his ostensibly impetuous, slashing brushwork, which rips through faces and bodies, landscapes and buildings, may beg comparison with de Kooning. Yet Auerbach's domesticated scale, his frequent use of a filmy, moist tone that softens the angular jostle of lines and planes and takes the bite out of initially raw colour, fit more comfortably into a British pedigree of Expressionism. His work not only takes off from the later, turbulent landscape style of David Bomberg – again usually small in dimension – but also bears unexpected affinities with Sickert, whose later works, too, often explode quietly with a quasi-Expressionist agitation that discreetly turns his Impressionist origins inside out.

The voice of Richard Long, who like Auerbach and Hodgkin looms large on the current international scene, sounds no less British within the presumably universal territory of Earthworks. Viewed especially against the heroic, cosmic reach of his American equivalents (Smithson, de Maria, Heizer), who create a scale sublime enough for the deity himself and who bring up to date the nineteenth-century American infatuation with the vastness of the North American wilderness, Long takes on the role of an heir to Constable and Wordsworth. In fresh terms he explores a pastoral mode, ruminating upon country walks and confronting with quiet awe, as did his British Romantic ancestors, the local Druidic magic of prehistoric circles of stone and earth, attained after long and lonely journeys.

Although the internationally fabled discretion and good manners of the British (often interpreted by post-Freudian generations as the heritage of Victorian repression) easily find their visual equivalents, there are also surprising chinks in this ritual British armour which (again in post-Freudian terms) reveal the depths of the id, the volcano beneath the placid surface. It is odd to realize, for instance, that British twentieth-century art, perhaps more than that of any other nation, has dealt in countless and candid ways with the widest variety of sexual experience. The century opens with many efforts to rescue the carnal and spiritual truths of sex from their secret nineteenth-century burial grounds and to exalt this biological force through art. Appropriately, it was the artists of D. H. Lawrence's generation – especially the sculptors Eric Gill and Jacob Epstein – who first dared to tell what then seemed the urgent facts of life about man and woman as naked, sexual creatures who, like animals, propagate their species. Although Gill's style, as both sculptor and draughtsman, seems almost to revive the incorporeal chastity of John Flaxman's purest Neo-Classical outlines, this archaizing mode could be used in the cause of liberating sex from the shackles of the nineteenth century. His stone relief *Ecstasy* (Cat. 91) is an astonishingly frank fusion of the physical reality of a sexual coupling with a Doric style that conjures up ancient Greek beauty and spirituality, just as Epstein's marble doves copulate with an Arcadian innocence that rushes us back, as do the works of so many primitivizing artists, to a pagan world without sin (see Cat. 55).

More complex in its exploration of modern myths of sexuality is the New York-born Epstein's *Rock Drill* (see Cat. 57), whose shattering violence often sounds an alien chord in a British milieu. Especially in its original form, with a plaster science-fiction robot worker seated upon and attempting to control what was an actual rock drill (Fig. 5, p. 34), this icon of the Machine Age suggests a metaphor of unleashed male sexual force, a point made more explicitly phallic in some of Epstein's related drawings (Fig. 4). Like many contemporaneous works by Duchamp and Picabia, sexual and mechanical imagery are equated here, but rather than Dada wit and irony about sexual plumbing and mechanics, Epstein creates a demonic Adam for a new industrial world on the eve of war.

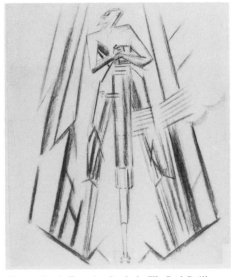

Fig. 4 Jacob Epstein, *Study for The Rock Drill,* *c.* 1913. Tate Gallery, London

Such sculptural myths of sexual energy, which might lead the human race to heaven or hell, were countered in British art by far more earthbound kinds of sexual truths which, in the case of occasional paintings of the male and female nude, told the facts of human anatomy with a relentless candour still startling today. Both Stanley Spencer and, decades later, Lucian Freud have subverted every Western tradition of the ideal nude by recording the awkward truths of undressed human beings, genitals, sagging breasts and all, in postures that suggest the kind of close-up, bedroom intimacy that few artists would consider worthy to put on canvas. Spencer, with his visionary eye always on heaven, actually intended his collected paintings of nudes to be hung in a special room in the Church House at Cookham as a kind of shrine to carnal substance that might balance the spiritual essence which he hoped to reach through the more ethereal, severely stylized figures of his narrative paintings. The effect for modern spectators, however, often remains that of an immediate confrontation with the human body as a gross, animal fact, just as Freud's nudes expose the owners of these bodies as defenceless, awkward creatures. Even the American counterpart in this harsh exploration of naked, imperfect flesh, Philip Pearlstein, seems calculated and abstract by contrast with Spencer's and Freud's raw and ungainly truths.

A more imaginative sexuality surfaced again in the work of Francis Bacon who, like Spencer and Freud, first accepted the crassness of the naked human body and then dramatized it, alone and in bizarre couplings, in theatrical spaces of lurid darkness and nightmare flashes of light. In a startling fusion of opposites, Bacon elevates the more sinister corners of sexual behaviour to the level of the venerable British ideal of the Grand Style, as if the grimiest stuff of yellow journalism had been translated into the noblest rhetoric of Western painting, fraught with allusions to Poussin, Velazquez, Van Gogh, Matisse, Picasso. In many ways, Bacon reincarnates the spirit of Henry Fuseli, the first painter in Britain, or indeed the West, to explore perverse byways of sexual behaviour and to adapt these private obsessions to the language of high art, erudite and theatrical enough to fulfil the loftiest ambitions of Reynolds's newly founded Royal Academy.

The need to assimilate the facts of sex into the fictions of art flourished in Britain from the 1960s on, responding to the revolutions of sexual frankness that changed Western culture as a whole in those decades. Allen Jones, for instance, could create from the sleaziest pop imagery of spike-heeled, leather-clad, long-limbed girlie nudes a fetishistic dominatrix who could almost make Fuseli stir in his grave and who relocated Aubrey Beardsley's privately febrile sexual fantasies of mythical *femmes fatales* squarely in the vulgar domain of mass culture. Gay liberation, too, was instantly reflected in British art, most programmatically and successfully in the work of David Hockney. Already in 1961, in *We Two Boys Together Clinging* (Cat. 260), a quote from a homoerotic poem by Walt Whitman is transformed into the emotional facts of the artist's personal life. Gradually, this kind of cryptic ideogram of gay love came to be in Hockney's work the most matter-of-fact record of ordinary domestic realities, of showering, sunbathing or just quietly relaxing together under the Californian sun.

The opposite extremes of art, locale, society, are represented by Gilbert & George who, among their multiple achievements, have chronicled in their photo-pieces the facts of their own twin lives as both observers and participants in the dense fabric of London life in general and East End life in particular. Their emblematic inventories of everything from the grit of London (pubs, toughs, derelicts, office buildings) to the chauvinistic icons of a threatened empire (bobbies, guardsmen, Big Ben, bronze war memorials) includes, with rhetorical honesty, the kind of streetside sexual graffiti that would earlier have shocked proper art audiences and apparently often still do. Dirty words and dirty pictures scribbled on city walls are singled out by Gilbert & George as integral parts of their checkerboard shrines, poignant and startling reminders of the ubiquitous presence of the coarsest sexual energies in these downtrodden urban labyrinths (Cat. 302-305). As mirrors of the seedier aspects of London life today, these photo-pieces stake a claim to journalistic modernity, but

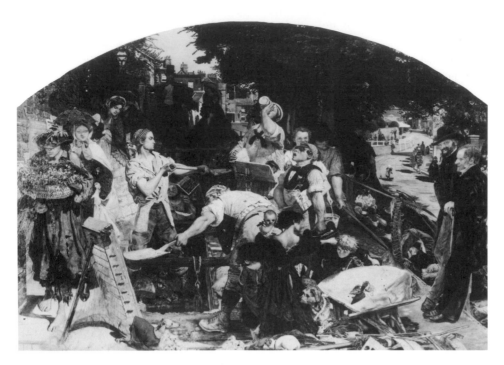

Fig. 5 Ford Madox Brown, *Work*, 1852-65. City
Art Gallery, Manchester

their spirit and their look hark back nostalgically to a Victorian world, whose visual
and cultural presence is still so conspicuous in contemporary Britain. In many ways,
then, Gilbert & George seem to perform the unlikely modern role of artist as
chronicler, as social reformer and as religious proselytizer, resurrecting with heaven-
and-hell sermonizing the kind of goals that fevered the pre-Raphaelites in the 1850s
and the creators of those ugly-beautiful Victorian churches and liturgical objects that
would bring the faithless back to the fold.

Their pedigree, in fact, goes back to the likes of Ford Madox Brown's pictorial
epic, *Work* (Fig. 5), which similarly offers to two contemporary observers of London
life, Carlyle and the Reverend Maurice, the most heartfelt documentary spectrum of
all walks of the London society of the 1850s. Moreover, the look of their art resounds
in the troubled depths of the last century, recalling Victorian stained glass not only in
the religious authority of stiffly symmetrical structures but in the shrill collision of
harshly luminous hues that proclaim the artificial colour and light of the industrial
era. Even in terms of the blatant sexual candour of these photo-pieces, one is
reminded of the Victorian precedent of Brown, Rossetti or Holman Hunt, who dealt
courageously and directly with the shocking truths of urban sexuality – prostitution,
adultery, illegitimacy – tinged nevertheless with a spirit of religious redemption.

Such echoes of nineteenth-century British art, so potent in the work of Gilbert &
George, are ubiquitous in any twentieth-century anthology. There is, for example,
the continuing vitality of a Victorian tradition of Social Realism which, subject to
countless variations of social milieu and aesthetic temperament, from Frith to Tissot,
chronicled cross-sections of British public life. These mirrors of urban reality are
found throughout this exhibition, often perpetuating the more straightforward Real-
ist styles of the nineteenth century, as when Lawrence Gowing tells us, as Atkinson
Grimshaw did before him, of the relentless, foggy gloom of a London street
(Cat. 162), or when William Coldstream updates Frith's *Paddington Station* (Fig. 6)
with an overhead view of the interior of St Pancras station that dampens our spirits
and chills our bones (Cat. 161). But this recurrent need to record the widest range of
urban experience turns up translated into an equally wide range of more overtly
twentieth-century vocabularies. Even so unlikely a subject as a public bath can be
found in the work of both David Bomberg, painting in a brashly angular Futurist
mode, and Leon Kossoff, painting as an heir to Continental Expressionism (Cat. 49
and 247). And what other country could show not one but two depictions of that
surprisingly rare subject in twentieth-century art, the interior of a cinema – one,
Malcolm Drummond's, executed in a polite Nabi style, the other, William

Roberts's, looking like a populist revolt by Léger's robots (Cat. 20 and 108)? Indeed, by choosing scenes of public life alone, one could almost write a history of avant-garde stylistic developments in Britain, from Sickert to Pop Art and Victor Burgin, so important is the sense of a shared social milieu for British artists.

It is not surprising, then, that Britain, more than any other country, reflected so explicitly in its art the inescapable public facts of the two world wars. This may be no news for foreign visitors who have troubled to go to the Imperial War Museum in Lambeth, but it is a phenomenon that counters what we usually have read in Modernist histories of twentieth-century art, in which the First World War is only the most distant rumble and the Second is adumbrated by Picasso's *Guernica* and then disappears. In Britain, there are abundant records of these periods of national and international trauma, not only in the direct response, whether documentary or metaphorical, to the facts of war, but also in the official commissions by the British government during both wars.

One renowned artist, Paul Nash, as a witness to both these catastrophes, felt compelled in 1918 and again in 1940-41 to attempt ambitious pictorial elegies on the death of nature and the machine. In the first of these war paintings, *We Are Making a New World* (Cat. 67), he creates a silent and lethal postscript to the belligerent Vorticist mood of 1914. Machines and their gleaming energies have vanished, and nature alone remains in the form of a distant sun casting its feeble rays on a blighted, uninhabited landscape which has barely survived four years of man-made destruction. And in his *Totes Meer (Dead Sea)* (Cat. 169) of 1940-41, the same post-apocalyptic mood has been invoked once more, this time before a metallic sea of battered German military fuselage at Cowley. Inspired in turn by Caspar David Friedrich's great elegy on an Arctic shipwreck, his record of the mechanical debris of war becomes a vast cemetery where human hope is forever buried.

Nash's heartfelt adaptation of Romantic landscape formulas as metaphors of wartime destruction was only one of many varied responses to the wars. It is fascinating, for instance, to see how Vorticists like Wyndham Lewis and Christopher Nevinson could temper their clanking abstractions in the direction of a more prosaic legibility capable of recording the movements of troops on war-torn landscapes (Cat. 73, 64); or how Stanley Spencer could record the eyewitness details of delivering the wounded at a dressing station in Macedonia with the pious spirit of a medieval painter narrating the life of a saint (Cat. 69). And in terms of daily London experience, there is always Hyde Park Corner, where one constantly passes the once

Fig. 6 William Powell Frith, *Paddington Station*, 1862. Royal Holloway and Bedford New College, London

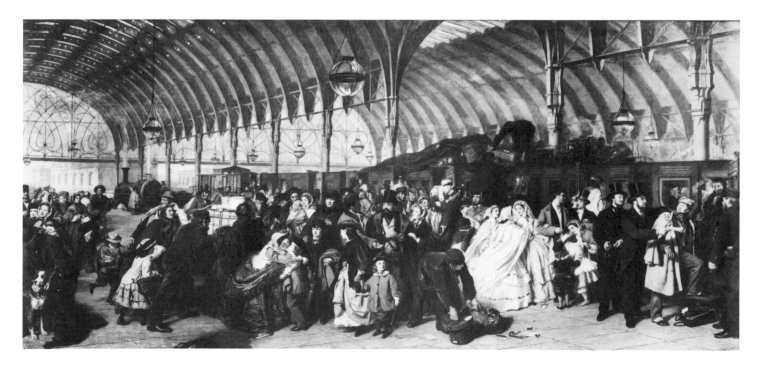

Fig. 7 Charles Sargeant Jagger, *Royal Artillery Memorial*, 1921-25. Hyde Park Corner, London

ignored but now ardently appreciated masterpiece of all public war memorials, Charles Sargeant Jagger's Royal Artillery Memorial (Fig. 7), a heroic amalgam of documentary truths about modern warfare with the symbolic enthronement of a huge howitzer and reliefs in an audacious archaizing style that looks backwards to Assyrian battle sculpture and forwards to the zigzagging geometries of Art Deco. Particularly surprising in this copious British anthology of war images is the most metaphorical of them all, Mark Gertler's *The Merry-Go-Round* (Cat. 74) of 1916 (acquired as recently as 1984 by the Tate Gallery), which is potent enough to be absorbed into any international history of twentieth-century art. Not only does its lockstep delirium of robot fun-makers create, like Ravel's *La Valse*, a relentless crescendo that will end in a death-leap, but its date, 1916, makes it a precocious innovator in a post-1918 international style of machine-tooled humanoids who, like those of Léger and Schlemmer, govern many pictorial worlds after the Treaty of Versailles.

If it was difficult to turn the realities of the First World War into painting and sculpture, it was even harder to assimilate the experience of the Second World War into art, which during the blackest years must have seemed totally helpless and irrelevant. The agonies, often explicitly or implicitly Christian, found in Bacon's and Sutherland's work of the 1940s clearly reflect the anguished temper of the time; but it was perhaps only Henry Moore who, supported by the War Artists' Advisory Committee under Kenneth Clark's direction, was able to probe the more immediate visual and emotional truths of those years. His drawings of Londoners during the Blitz finding shelter in the tubular bowels of the underground stations maintain, even generations later, their gloomy power (Cat. 191, 202, 203). Not only do they document the grotesque reality of modern human beings burrowing in the ground like animals for protection from the death above, but they conjure up archetypal images of shrouded resignation, of womb and tomb, of the earth as death and as life, associations which give noble resonance to the murderous facts of air-raids and their huddled, terrorized victims who must flee the domain of sky and sun.

The very fact that Moore's drawings of bomb shelters, or Sickert's and Roberts's vignettes of low-down dance halls, or Gilbert & George's sacred altars to secular London street life, are so arresting as records of a specifically British experience may indicate that for a foreigner, at least, the story of British twentieth-century art must be looked at from both inside and outside national boundaries. As for international relations, Britain's role in the evolution of early Modernism still needs to be dis-

Fig. 8 Anonymous, Sketch of the Cave of the Golden Calf, reproduced in the *Daily Mirror*, 4 July 1912

Fig. 9 Meredith Frampton, *Portrait of a Young Woman*, 1935. Tate Gallery, London

closed, especially across the Channel and across the Atlantic, where so little has been seen. Although New York's Museum of Modern Art owns two small paintings by Sickert, neither his early nor his later work is familiar to Americans. Given a chance, they might wish to add him to a turn-of-the-century international pantheon of Vuillard-like refinement, and might well be startled by his later works inspired by candid news photographs, ghostly prefigurations of Warhol's own mix of journalistic imagery and smudged veils of paint. For foreigners, a more strident entry in the international Modernist league is the once underground, and now at last overground, story of the aggressive facets of British art on the threshold of World War I. Thanks to the full and overwhelmingly energetic display of Vorticism at the 1986 Futurist show in Venice, the churning, engine-room imagery of the likes of Bomberg and Lewis may at last transcend their local British reputations and be integrated into the international account of those 'isms' that exploded before 1914.

Similarly, the totally and ferociously Modernist art environment found in London's notorious and short-lived (1912-14) cabaret, the Cave of the Golden Calf, should soon earn an important place in the story of Bohemian extremities of life and art silenced by the war, even though it is preserved only through the memory of old documents (Fig. 8) and preparatory studies (Cat. 30-36). And so too should Roger Fry's cult of a more sensitive variant of abstract beauty, propagated likewise by a community of artists and realized in the total environments of the Omega Workshop interiors. This development provides an important link between the communal reform efforts of the late nineteenth-century Arts and Crafts Movement and the ambition of so many younger artists of the 1970s and 1980s to embrace in their concept of art not only painting and sculpture, but furniture, wallpaper, ceramics and clothing.

For remotely Olympian observers of the succession of international 'isms', such early British contributions may be fairly recent news. However, it has long been known that after the inter-war period, with the more global achievements of Nicholson and Moore, Britain deserved many places in a world pantheon of artists and art history. Anthony Caro, for one, has always commanded a full treatment in any history of American, British or just plain Western sculpture. Moreover, no one could deal with the international phenomenon of Op Art without giving Bridget Riley pride of place; for her immaculate, finely honed visual achievement far transcends the now nostalgic period look of most 1960s optical vibrations. Nor could the international story of Pop Art be told without its British foundations, whether the post-war incunabula of the movement (Paolozzi's collages of 1947 onwards) or Richard Hamilton's virtual launching of this low-art battleship in 1956 in the 'This is Tomorrow' exhibition. It is only the chauvinism of American Pop Art enthusiasts that keeps artists like Allen Jones or Patrick Caulfield from getting a fuller exposure in the States. Similarly, the story of Conceptual Art could not be told without the major role of Art & Language, which, through the editorial role of Joseph Kosuth in New York, was happy to establish an Anglo-American alliance.

Retrospectively, too, in these years of widening toleration towards Realist modes of painting (once censored out of the history of twentieth-century art and now back in fashion), many British artists insufficiently known abroad are beginning to fit more comfortably into the international context. The recently resurrected official portraitist of the inter-war years, Meredith Frampton, can hold his own, in terms of glacial temperatures, dustless atmosphere and uncanny marmoreal calm, in any company of German or Italian hyper-Realists of the post-1918 period (Fig. 9). And Lucian Freud and Michael Andrews may finally be welcomed by American eyes that have lately accepted in their range of vision the possibilities of Realist portraiture like Alice Neel's and Philip Pearlstein's or Realist narrative like Eric Fischl's. It is a point that suggests, too, that the time may well be ripe, at least in the States, for another look at the 'Kitchen Sink' realists, who were welcomed across the Atlantic in the 1950s but then strangely disappeared from sight.

Yet the view of British art in the twentieth century that would impose the evolutionary sequence of international Modernism or the standards of other coun-

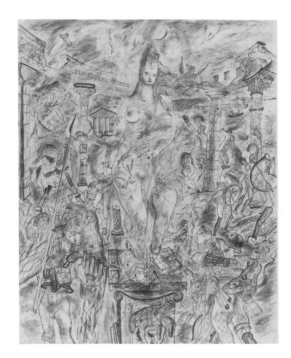

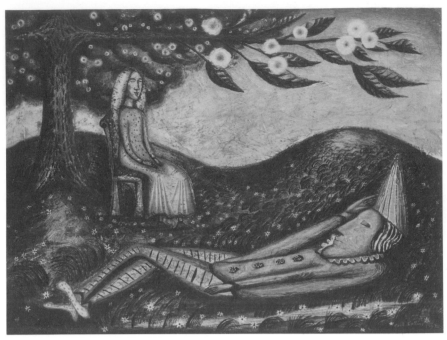

Fig. 10 David Jones, *Aphrodite in Aulis*, 1941.
Tate Gallery, London

Fig. 11 Cecil Collins, *The Sleeping Fool*, 1943.
Tate Gallery, London

tries needs constantly to be adjusted to take into account the more stubborn facts of local experience and traditions. If a history of British nineteenth-century art were written from the standpoint of avant-garde Parisian developments, masters like Turner and Constable would have to be seen mainly as prophets of Impressionism, and many unforgettable artists – religious visionaries like Blake and Palmer, fanatical realists and reformers like the Pre-Raphaelites, lunatic illustrators like Richard Dadd – would have to be given short shrift. In the present century, too, many of the most potent and startling British artists ignore or work against the international grain, often conjuring up the ghosts of the last century's most passionate and eccentric masters. What is one to make, for instance, of one of this exhibition's highest moments, Stanley Spencer's *The Centurion's Servant* (Cat. 102) of 1914? It seems to have nothing at all to do with that year as either history or art history, but it is nevertheless indelible as a hallucinatory masterpiece of localized death, fear and suffering. Perhaps it is best understood in terms of specifically British traditions, looking backwards to the Pre-Raphaelites in its intensity of emotion and obsessive observation of homely detail, or forwards to Bacon in its near-hysterical ambiance of a grim drama enacted in the starkest domestic interior.

Often, too, the visionary calling of British Romantic masters is heard across the century. There are masters like Spencer himself, who, seeking Christian truths in the most humble, daily experience of Cookham, might be seen as reincarnating Palmer in his Shoreham years. Or David Jones (Fig. 10) and Cecil Collins (Fig. 11), whose symbolic, ethereal art, refusing to obey the laws of gravity or the dictates of a reality outside the studio door, might well, we feel, have been nurtured by the aged Blake when he gathered disciples in his last years. Even in the work of the far less hermetic Sutherland, such as his landscapes of the late 1930s (Cat. 173, 174, 176), everything swells and burgeons with a force closer to spirit than to matter. As Sutherland himself wished, the magic of those early Palmer landscapes which extract a supernatural mystery from the natural truths of one small corner of British earth and sky, sun and moon, was to be revived.

But Sutherland also referred to Palmer as 'a kind of English Van Gogh', revealing his own dual allegiance to both sides of the Channel. This see-sawing balance may be difficult to maintain, but Sutherland was right. British twentieth-century art is best looked at through bifocal lenses, with one view aimed towards the Continent and the United States, and the other kept within those insular boundaries where foreigners often feel like visitors to a small, but infinitely fascinating planet.

Artists in the Exhibition

Michael Andrews
Kenneth Armitage
Art & Language
Frank Auerbach
Gillian Ayres
Francis Bacon
Graham Bell
Vanessa Bell
Peter Blake
David Bomberg
Mark Boyle and Joan Hills
Stuart Brisley
Victor Burgin
Edward Burra
Anthony Caro
Patrick Caulfield
William Coldstream
Alan Davie
Frank Dobson
Malcolm Drummond
Jacob Epstein
Barry Flanagan
Lucian Freud
Henri Gaudier-Brzeska

Mark Gertler
Gilbert & George
Eric Gill
Harold Gilman
Charles Ginner
Spencer Gore
Lawrence Gowing
Duncan Grant
Richard Hamilton
Barbara Hepworth
Patrick Heron
Roger Hilton
Ivon Hitchens
David Hockney
Howard Hodgkin
John Hoyland
Gwen John
Allen Jones
Phillip King
R. B. Kitaj
Leon Kossoff
Peter Lanyon
John Latham
Bob Law

Percy Wyndham Lewis
Richard Long
Bruce McLean
Henry Moore
Malcolm Morley
Rodrigo Moynihan
Paul Nash
Christopher Nevinson
Ben Nicholson
Eduardo Paolozzi
Victor Pasmore
John Piper
Bridget Riley
William Roberts
Walter Richard Sickert
Matthew Smith
Richard Smith
Stanley Spencer
Graham Sutherland
William Turnbull
Edward Wadsworth
John Walker

Captions give only the name of the artist, the title and date of each work;
full details are given in the List of Works in the Exhibition (pp. 409-17).

Frederick Gore

Camden Town

The artists most active in the formation of the Modern Movement in Britain were the members of the Camden Town Group – Sickert, Spencer Gore, Harold Gilman, Charles Ginner and Malcolm Drummond, together with Vanessa Bell and Duncan Grant, the associates of Roger Fry in the Bloomsbury Group. It was Sickert who paved the way. His vigorous advocacy of the direct and honest perceptual study of everyday life has remained a recurring influence on British art.

After Gore had been brought to see him in Dieppe, Sickert was persuaded that the time had come to end his self-appointed exile and return to London. There he found himself in the not unhappy position of didactic leadership to a younger generation of artists, but also able himself to profit, reforming his own practice in pursuing new interests with them. From Gore he was curious to learn about paintings built up in touches of pure colour, for Gore had earlier made friends with Lucien Pissarro and by 1907 had committed himself to a form of Neo-Impressionism.

From 1907 the group which formed round them in Fitzroy Street began showing their work at No. 19 on Saturday afternoons. This led first to the formation of the Camden Town Group (1911) and was finally enlarged two years later into the London Group, the exhibiting society to which, until recently, modern thinking artists have at one time or another belonged.

Sickert's painting *The Bathers, Dieppe* (Cat. 1) belongs to a group painted for a café proprietor. Probably based on a snapshot, it illustrates Sickert's lifelong fascination with Dieppe and all aspects of popular life. It also makes a link with his late work when he emulated the qualities of newspaper photographs in ironic sympathy with popular sentiment.

He had made his debut at the New English Art Club in 1888 with a painting of a music hall and, on finally settling again in London in 1906, he painted a series of this subject which shows his sympathy for the people and affection for the places. With *Noctes Ambrosianae* (Cat. 4) he made his return to the New English: concentrating on the pale, rapt faces of the audience at the Middlesex Music Hall, otherwise known as the Mogul Tavern.

Mornington Crescent Nude (Cat. 2) dates from the early days of Sickert's collaboration with the much younger Gore. In London Sickert enriched the dark tones of the intimate nudes he had started to paint in Dieppe

with thicker paint and the cool glitter of *contre-jour* light. The Dieppe nudes had been painted direct from the model, but in this painting the critical cut-off to include so little of the mirror, window and bedhead suggests that it was worked from a very precise drawing.

Without altogether forsaking his subdued tonal colour, by 1911 Sickert was working in a lighter key and using touches of brighter colour. *The Mantelpiece* (Cat. 6) and *The Studio. The Painting of a Nude* (Cat. 3) appear to have been painted in the same room. Both make play with mirrors, each recounting a little human drama, each exquisitely and abstractly designed. In the first the large area of fireplace suggests domesticity and Sickert emphasizes the woman reflected in the mirror behind the clutter of ornaments, regarding her hair and face with anxiety.

In contrast *The Studio* is more complicated, since we are in the position of the artist who sees his own arm in the mirror, resting, brush in hand, before attacking the canvas again; through his eyes we see the model and her back reflected in the tall-boy mirror. The handling suggests that the model is directly painted but, once more, critical relationships in the composition lead to the conclusion that Sickert was true to his recommended recipe of working from a squared-up drawing.

'The clean and solid mosaic of thick paint in a light key' cited by Sickert as the contemporary style and his wish 'to recast my painting entirely and observe colour in the shadows' were what in a sense he had come back to London to learn in association with Gore. This influence becomes much more obvious after Gore's death, in 1914. In *The Brighton Pierrots* (Cat. 5), painted the year afterwards, Sickert has taken out into the Brighton night that feeling for the half-lit space between the audience and the glowing stage so characteristic of Gore's theatre paintings such as *The Alhambra* (Cat. 8) of 1908.

While Sickert dominated the Camden Town Group, Gore held them together by gentle persuasion, tact and the affection which his personality generated. But he also led them in a modern direction through the development of his own work. For he was the first to fuse elements from Sickert and the Neo-Impressionists into one single and rational method and later to add elements from Fauvism without hesitation or losing his way. His intention in drawing and colour was always easily read.

What Gore discovered, Gilman and Drummond with the latecomer Ginner and

even Sickert himself were able to pursue further in their own ways. In the same way that much earlier Sickert had found new subjects in the music hall and discovered the iron bedstead in which three-quarters of the population were born, slept, loved and died, Gore found his own modern subjects in such things as the suburban railway station and the iron footbridge, flying at Hendon (Fig. 6, p. 65), the garden city, even a stage set of New York or a friend in bed with influenza. He was the first to paint subjects which rapidly entered the vernacular and became commonplace: the unprepossessing backs and back gardens of London houses, and shabby but still beautiful squares. He had what Sickert called 'the digestion of an ostrich'.

The Alhambra of 1908 is one of a series which Gore completed between 1906 and 1912. It shows the corps de ballet in a scene from *Paquita*, revived early in 1908. He used small touches of pure colour and undiluted pigment. The other four canvases by Gore come from a series painted at Letchworth in 1912 just after he had completed decorations for the Cave of the Golden Calf (see Cat. 31, 32) and before Roger Fry's Second Post-Impressionist Exhibition. Gore spent the late summer and autumn at Gilman's unused house at Letchworth (Cat. 12) where his daughter was born. The foreground is a tangle of flowers grown from a few packets of seeds thrown into the garden; boldly organized in Fauve colour, it was probably painted directly from the subject. *Letchworth Station* (Cat. 11) was shown at the Second Post-Impressionist Exhibition. Together with *Crofts Lane* and *Sunset, Letchworth* (Cat. 9, 10), it is among the paintings which suggested a similar synthesis of Post-Impressionist and Modernist tendencies not only to his Camden Town colleagues Gilman and Drummond but also to other London Group artists such as Paul Nash. They have been recognized as the first solid achievement in the development of a Modern Movement in Britain.

Frank Rutter wrote of Gilman and Gore rather as if they were twins – with some justification, since in work and in the politics of art they were so closely allied. It is their work and influence rather than Sickert's which gave to Camden Town painting its special flavour. Gilman did not move into Impressionism until 1910 and his approach to it was mediated by Sickert (in drawing) and Gore's (in colour). But *The Model, Reclining Nude* (Cat. 14), 1911-12, has a freedom of

attack and an intensity of concentration on the sensual reality of a woman lying very naturally on the bed which makes it a landmark in the history of nude painting. A Rembrandtesque seriousness envelops the head.

Gilman examined the possibility of each advance towards a more contemporary stance with resistance; at each stage he had to suffer the throes of sudden conversion followed by boundless enthusiasm. In common with Gore his first favourite among the Post-Impressionists was Gauguin. At one moment he sent to the Allied Artists' exhibition of 1912 a portrait entitled 'Thou shalt not put a blue line round thy mother' and a few months later was maddening his colleagues by his insistence that they should all move off to the South Seas. There must be some truth in Ginner's claim that it was with difficulty that he persuaded Gilman to give his mind to Van Gogh. But when he did he gave his whole heart too.

An Eating House (Cat. 16) continues his new appetite for paint and splendid colour with all the integrity of Camden Town drawing – Sickert's legacy. During his visits to Sweden and Norway he painted remarkable cavases including *Norwegian Street Scene (Kirkegatan Flekkefjord)* (Cat. 13), very close

in subject to Van Gogh and a moving evocation of Northern sunlight. The interior known as *Tea in the Bedsitter* (Cat. 17) is set in 47 Maple Street where Gilman lived in proximity to the battered and formidable landlady Mrs Mounter; the sitter on the right is the painter Sylvia Hardy whom Gilman married the following year.

According to Walter Bayes it was on the proposal of Gore (who had done a good deal of the spade work) that Gilman was elected president of the London Group. Because of his obsessive and sometimes misplaced enthusiasms it had not previously occurred to anyone that he would make a good leader. But he proved a great success, which was fortunate because Sickert's influence had waned and Gore died in 1914. Gilman filled the gap left by both of them and steered the London Group towards a stable future.

Ginner joined the group in 1910. Brought up in France, he passed his life in a modest and reasonable French bourgeois tradition and was the survivor of the group. He found Gilman at much the same stage of development as himself but less well informed on current developments. Gore roped Ginner in to help with the decorations of the Cave of the Golden Calf (see Cat. 33) and during that

and the next year he painted a few radical paintings, dark but *cloisonné* in Somerset, brilliant and writhing in the London Embankment Gardens. *Piccadilly Circus* (Cat. 18) belongs to this moment, sharing with Futurism a flurry of movement and the machine in modern life but painted in a very unfuturistic style belonging to the *Punch* woodblock tradition beloved of Van Gogh. Note the men on the Clapham Omnibus and the poster for the Alhambra, loved by fellow artists. By 1913 Ginner had adopted the Sickertian method of a precise preliminary drawing duly squared. Ginner's positive but even line gave rise to a certain appropriate rigidity, apparent here in his view of a sunlit Victoria Station (Cat. 19).

The youngest member of the Camden Town Group was Malcolm Drummond, a pupil of Sickert who followed Gore's tendency to pick on a variety of new subject-matter. He painted unusual pictures of bewigged barristers, the Brompton Oratory or a dance hall with a cool, rather flat observation. *In the Park* (Cat. 21) is a familiar view of St James's Park made notable by the way it is seen. *Interior of a Cinema* (Cat. 20) links interestingly with *The Cinema* of William Roberts (Cat. 108), from whom Sickert once declared that he would like to take finishing lessons.

Judith Collins

Bloomsbury

The term 'Bloomsbury' came to denote a group of people both hated and revered in British art circles for a period of about thirty years, from 1910 to circa 1940. Bloomsbury is an area of London, near the British Museum, which was the chosen residence for many influential figures in the arts, including Virginia Woolf, Lytton Strachey, Clive and Vanessa Bell, Duncan Grant and Roger Fry. The first book to announce the Bloomsbury aesthetic was Clive Bell's *Art*, published in the spring of 1914 by Chatto and Windus. Fry had been asked in 1913 by these publishers to write a book on Post-Impressionism, an interesting request since he had invented the word in 1910 to define the major styles in painting that came after Impressionism. He was too busy himself and passed the commission on to Bell, whose main thesis was that the way to discern the essential qualities in a work of art was by responding to its 'Significant Form'. This term then became the catchword by which Bloomsbury operated; either Roger Fry and Clive Bell promoted it in the printed and spoken word, or Vanessa Bell and Duncan Grant evoked it with paint and canvas.

The essence of Bell's aesthetic theory is probably best expressed in his own words: '. . . lines and colours combined in a particular way, certain forms and relations of forms, stir our aesthetic emotions. These relations and combinations of lines and colours, these aesthetically moving forms, I call "Significant Form".' The effect of this theory (although not an intentional one) was to dispose

the painters in the group towards more experimentation, leading ultimately to abstract art. Neither Clive Bell nor Fry advocated abstract art; Fry wanted Vanessa Bell and Grant to continue to copy the natural appearance of objects, but with a 'disinterested vision'.

A greater opportunity for practical experimentation with the raw elements of picture-making – lines, colours, forms and the relations of forms – was offered to Vanessa Bell and Grant in the summer of 1913 when they became co-directors with Fry of his Omega Workshops. This was a venture initiated by Fry and it offered moral and financial patronage to his painter friends by employing them part-time as decorators of domestic objects – tables, chairs, curtains. His other aim for the Omega Workshops was to use these painters' ideas and skill to improve the standard of the applied arts in Britain, which he considered abysmal. Artists were only employed part-time so that practice of applied arts did not overwhelm their primary role as serious painters. As such, Vanessa Bell chose her subject-matter directly from people and places personal to her life, as in *Portrait of Iris Tree* (Cat. 22) and *A Conversation* (Cat. 23); Grant did the same, but also had a vivid imagination, and often chose mythological subjects like *Venus and Adonis* (Cat. 29) which frequently included animals. This aptitude was used to advantage in the practical world of the Omega, for example in his painted screen (Cat. 27). When this screen was first exhibited in March 1913, a critic remarked: 'One

could imagine living in a room with this remarkable screen and being totally oblivious to the English climate outside.'

Duncan Grant and Vanessa Bell found that the silvery grey light of the English climate had a dampening effect on their palettes, and they regularly sought the brighter light of southern France. Fry thought that the best contemporary painting came from France; for him Cézanne and Matisse were supreme, the former for his sense of form, the latter for his sense of colour. The four works by Vanessa Bell in this exhibition indicate how enriched she was by her first-hand experience of the work of these two French painters, using their heightened forms of expression to create something uniquely her own. Her *Abstract Painting*, *c*. 1914 (Cat. 24) was the most starkly geometric picture that she ever produced, paring forms and colour relations to their essentials. Grant's *The White Jug* (Cat. 28) was an equally geometric abstract picture when first painted in 1914, but by 1919, when he reworked it to include the still-life elements in the foreground, the Omega Workshops experiment was over and the adventurous exploration of Significant Form was losing its impetus. Fry believed that communal art, as for example in medieval workshops, was the greatest and most progressive form of art, and during the years that he was able to sustain the shared working relationship between himself (he too was a practising painter), Grant and Vanessa Bell, his theories bore spectacular fruit.

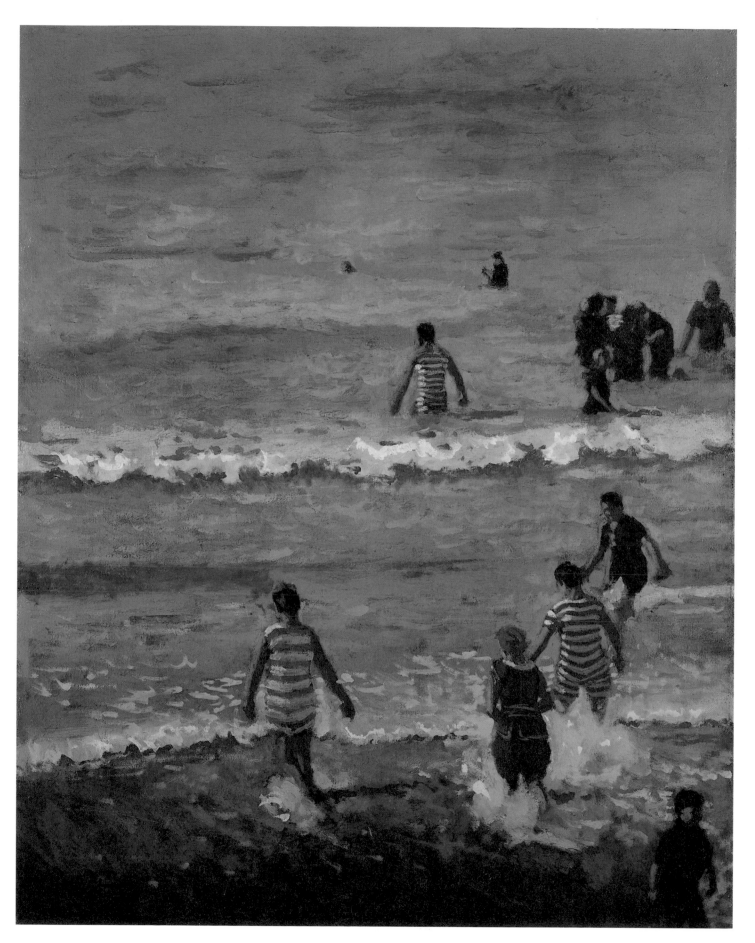

1 Walter Richard Sickert, *The Bathers, Dieppe* 1902

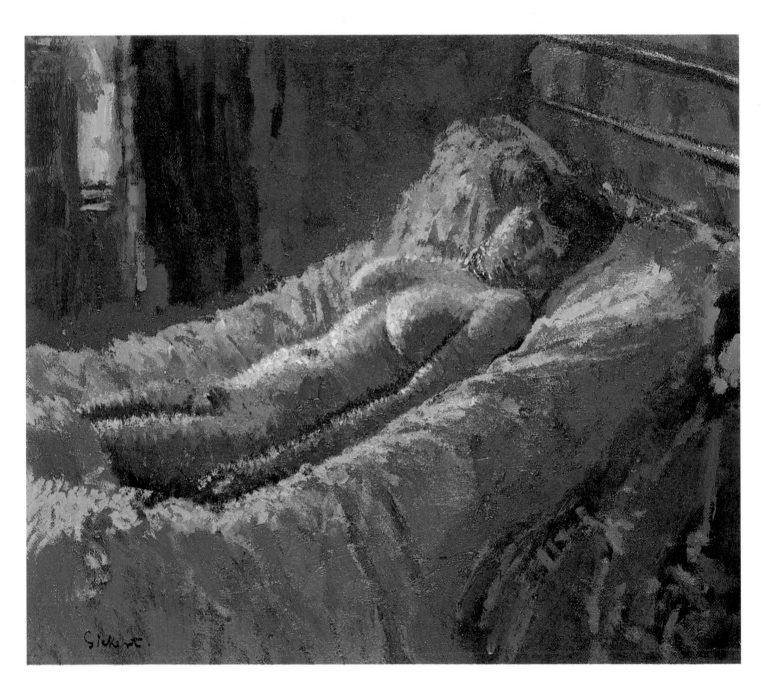

2 Walter Richard Sickert, *Mornington Crescent Nude* *c.* 1907

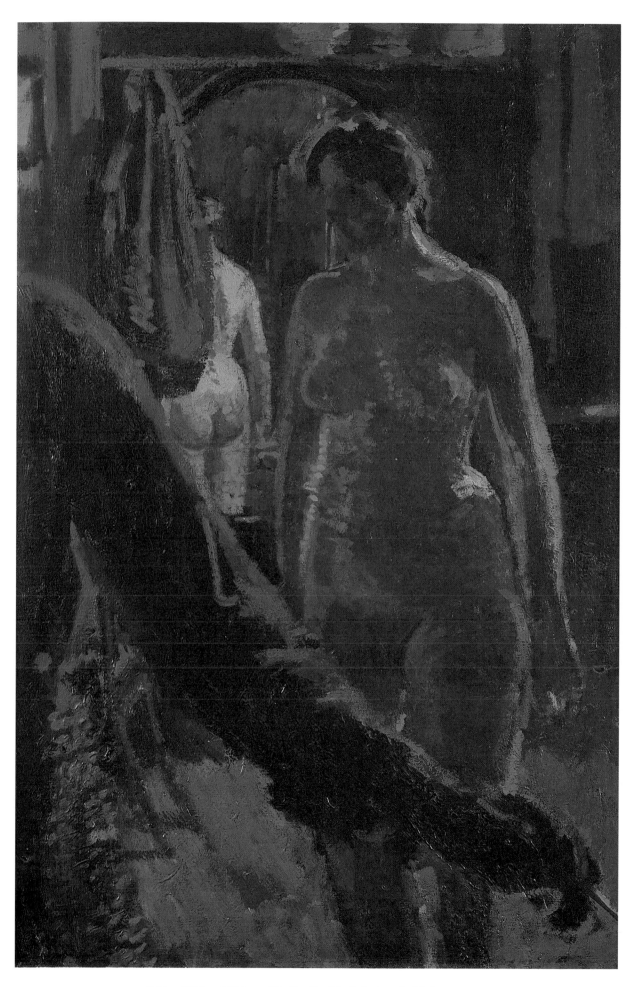

3 Walter Richard Sickert, *The Studio. The Painting of a Nude* *c.* 1911-12

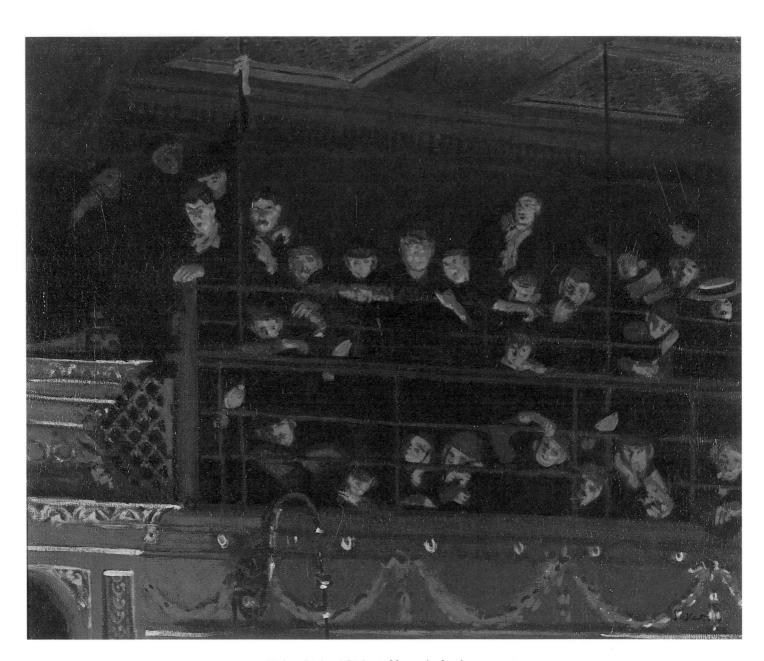

4 Walter Richard Sickert, *Noctes Ambrosianae* 1906

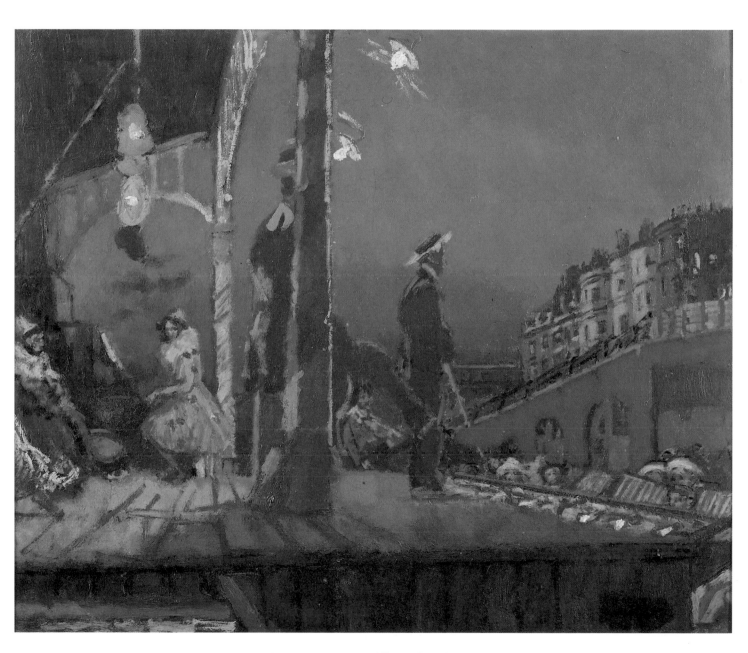

5 Walter Richard Sickert, *The Brighton Pierrots* 1915

6 Walter Richard Sickert, *The Mantelpiece* c. 1911-12

7 Walter Richard Sickert, *The New Bedford* *c.* 1915-16

8 Spencer Gore, *The Alhambra* 1908

9 Spencer Gore, *Crofts Lane, Letchworth* 1912

10 Spencer Gore, *Sunset, Letchworth, with Man and a Dog* 1912

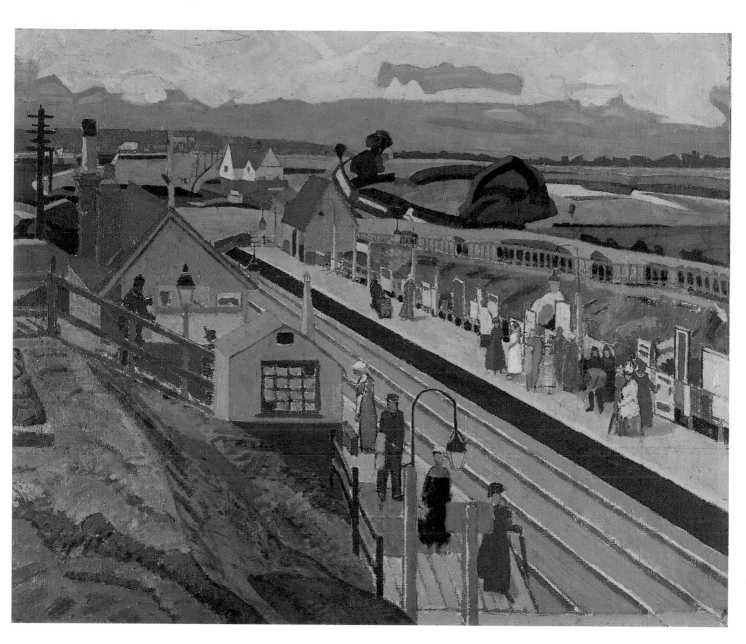

11 Spencer Gore, *Letchworth Station* 1912

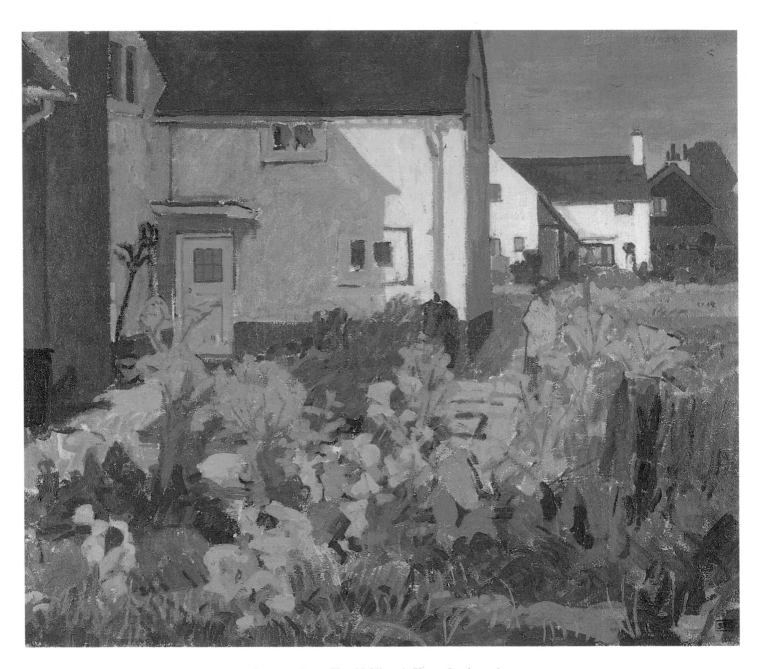

12 Spencer Gore, *Harold Gilman's House, Letchworth* 1912

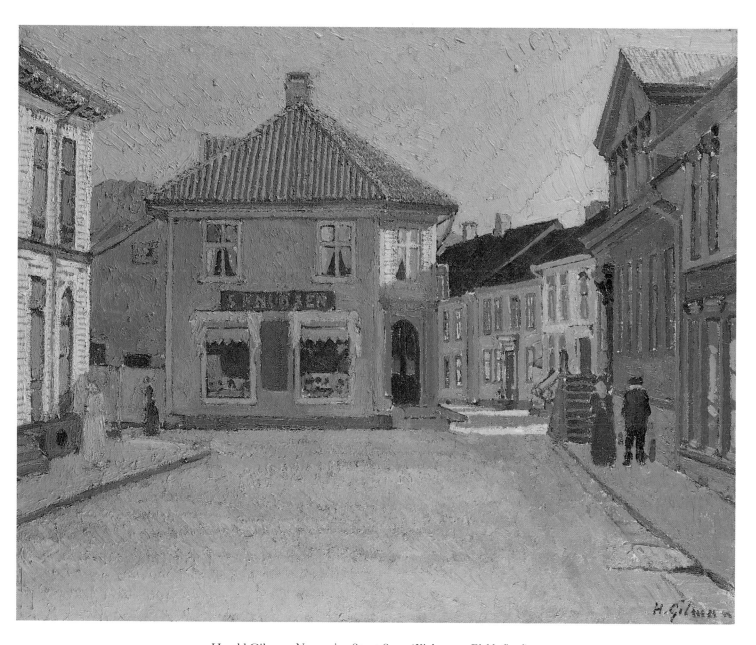

13 Harold Gilman, *Norwegian Street Scene (Kirkegatan Flekkefjord)* 1913

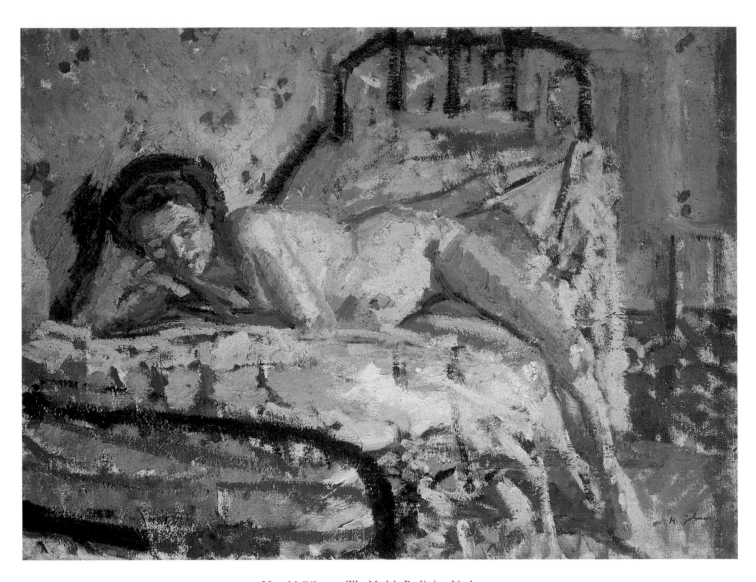

14 Harold Gilman, *The Model, Reclining Nude* 1911-12

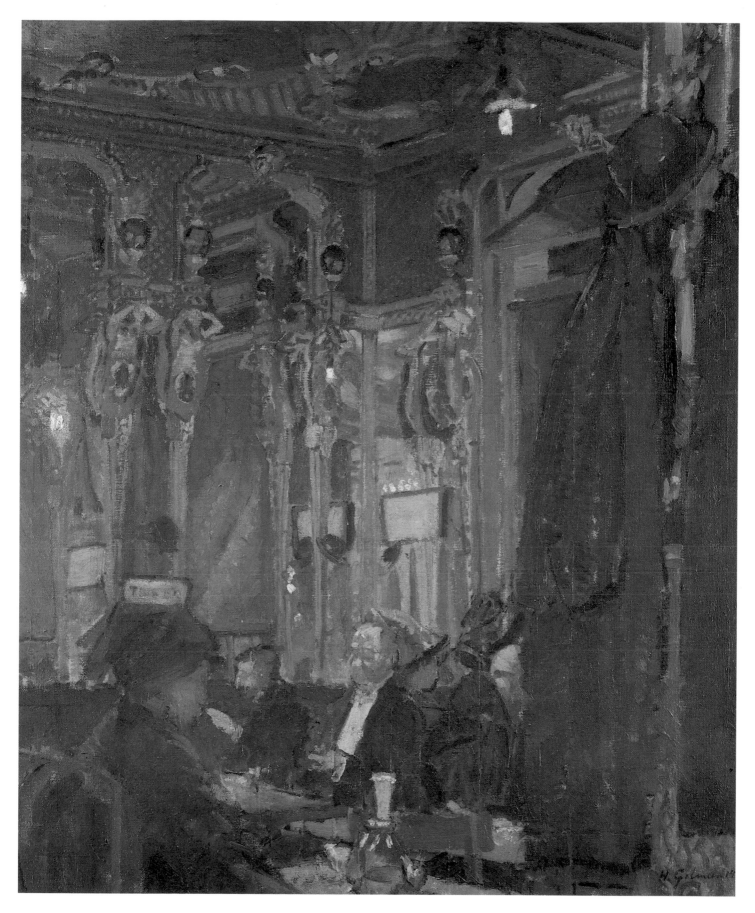

15 Harold Gilman, *The Café Royal* 1912

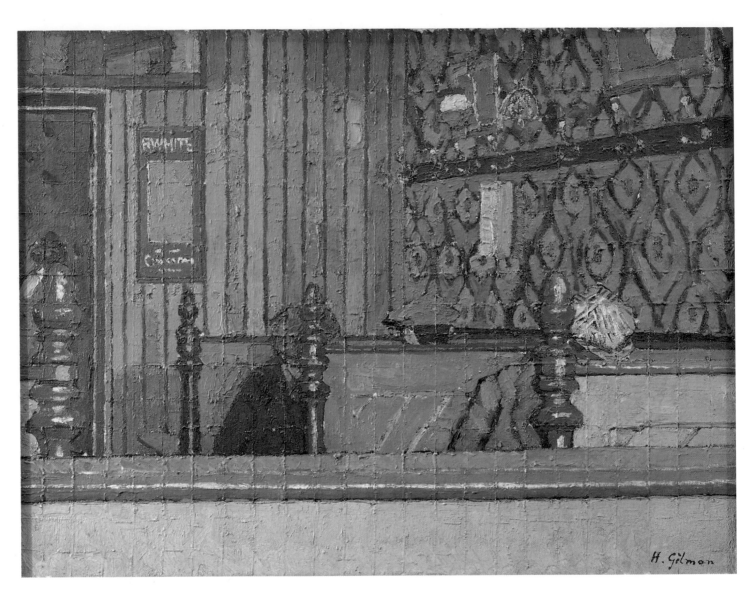

16 Harold Gilman, *An Eating House* c. 1914

17　Harold Gilman, *Tea in the Bedsitter*　1916

18 Charles Ginner, *Piccadilly Circus* 1912

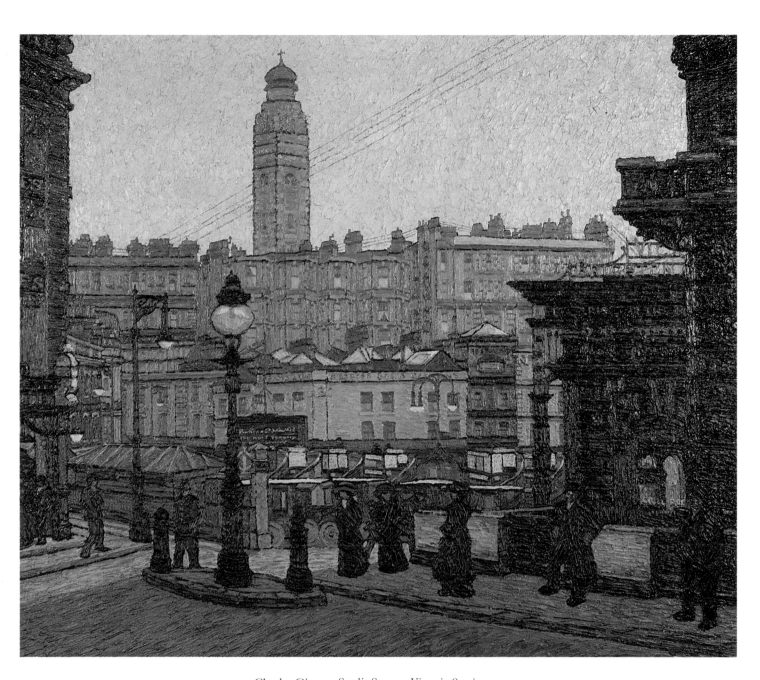

19 Charles Ginner, *Sunlit Square, Victoria Station* 1913

20 Malcolm Drummond, *Interior of a Cinema* *c.* 1913-14

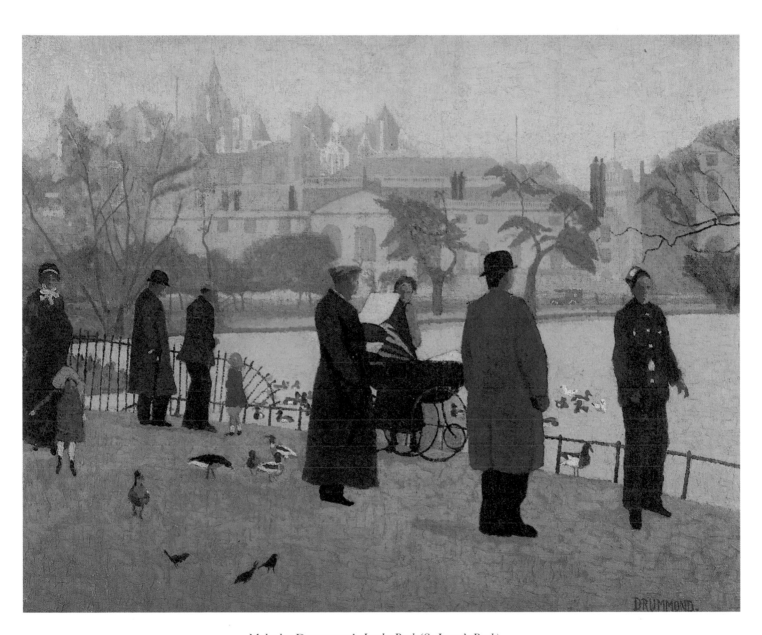

21　Malcolm Drummond, *In the Park (St James's Park)*　1912

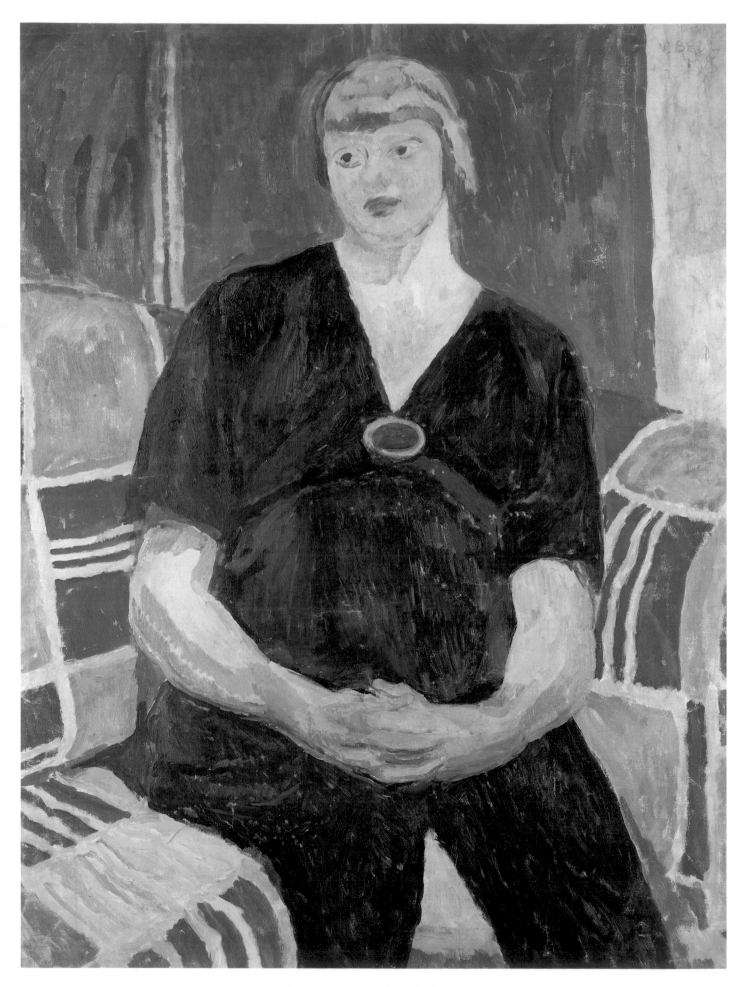

22 Vanessa Bell, *Portrait of Iris Tree* 1915

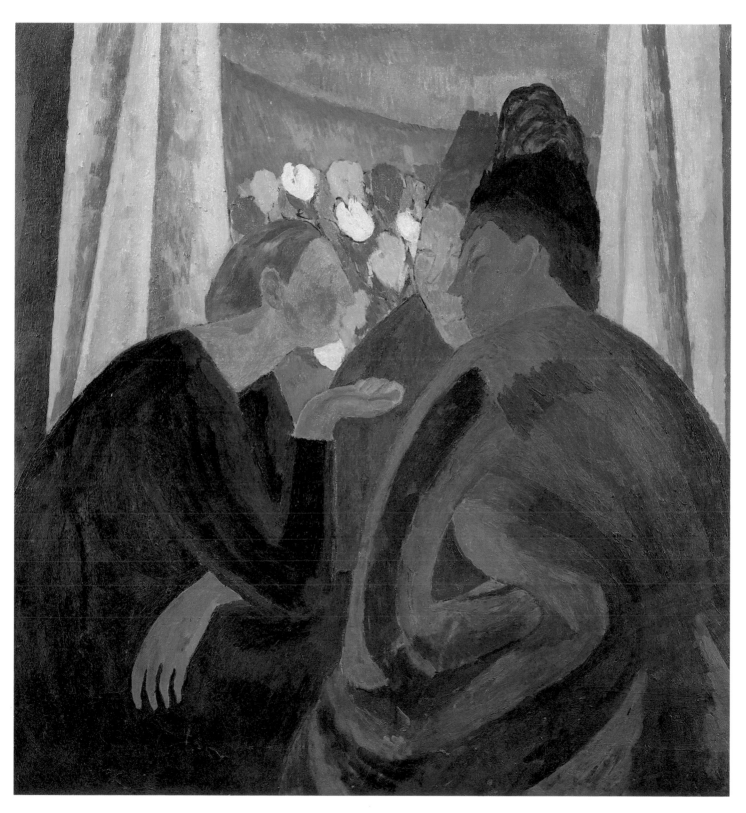

23 Vanessa Bell, *A Conversation* 1913-16

24 Vanessa Bell, *Abstract Painting* c. 1914

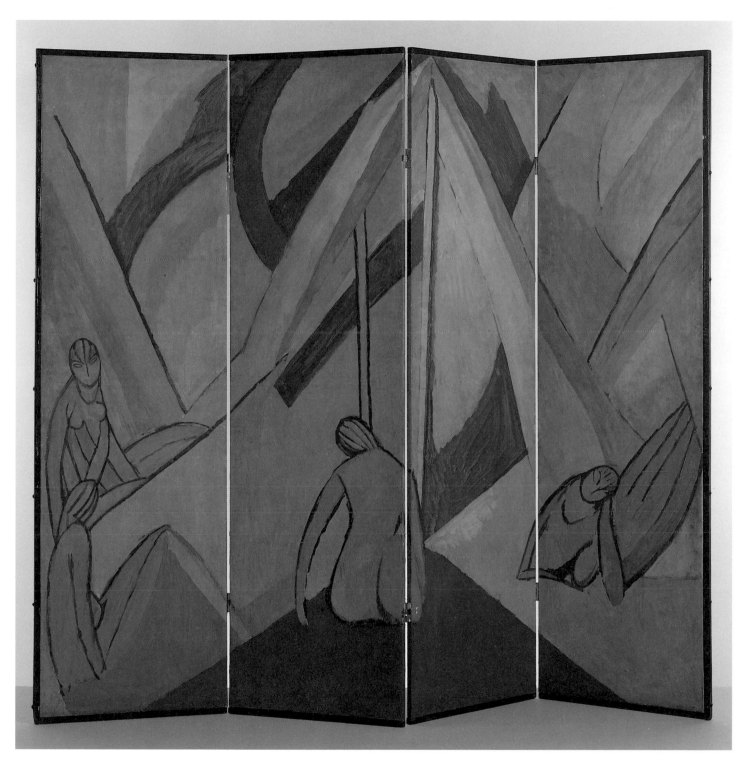

25 Vanessa Bell, *Bathers in a Landscape* 1913-14

26 Duncan Grant, *Abstract* 1915

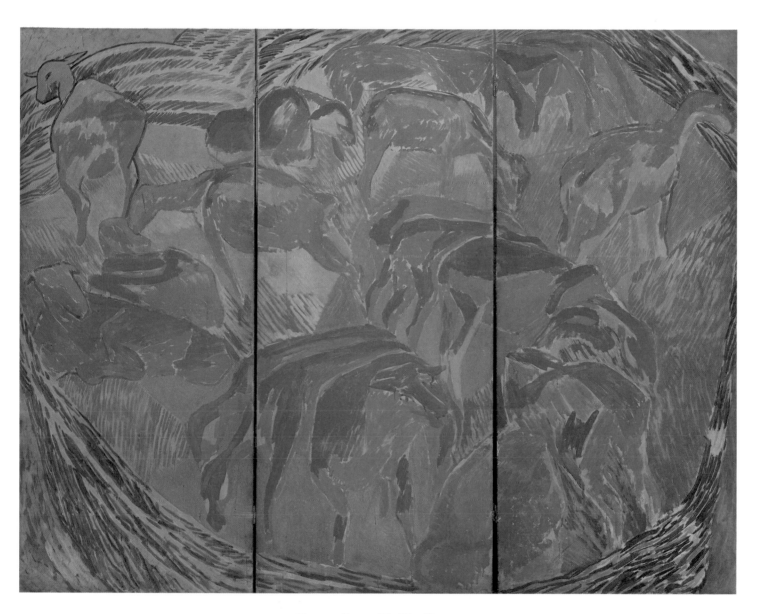

27 Duncan Grant, *The Blue Sheep* 1913

28 Duncan Grant, *The White Jug* 1914-19

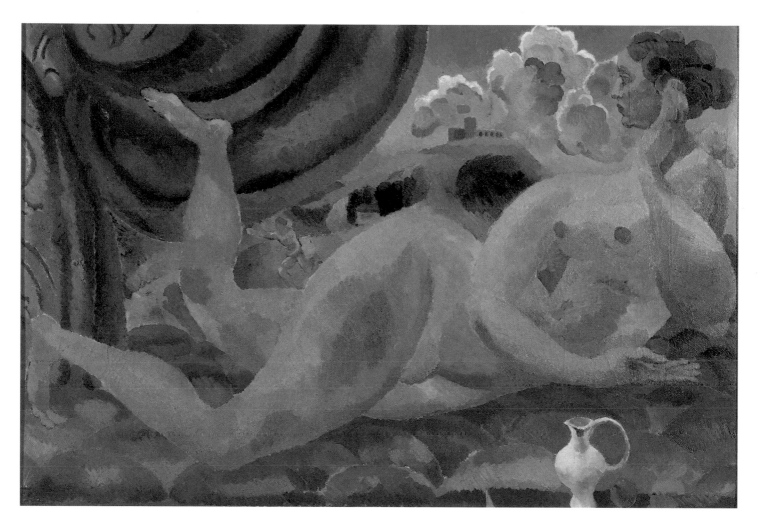

29 Duncan Grant, *Venus and Adonis* 1919

Richard Cork

The Cave of the Golden Calf

A remarkable cross-section of Britain's most adventurous young artists were commissioned to decorate the Cabaret Theatre Club. When it opened in June 1912, London's first 'artists' cabaret' immediately became notorious for the paintings and sculpture enlivening its main arena – the Cave of the Golden Calf. Astonished visitors discovered that the inflammatory new art, which had previously been confined to gallery exhibitions like Roger Fry's first Post-Impressionist Exhibition, now assailed their eyes from the walls, pillars and stage of a subterranean cavern unashamedly dedicated to the pleasure principle. The biblical story of the golden calf was employed as the unifying symbol of a cabaret given over to hedonism of the most defiant kind, in art, music, drama and dance. It was 'barbarous' in colour and imagery alike, prompting one critic to comment that the blazing decorations evoked 'the primitive simplicity of the days when art was in its infancy. It was, after all, on bones and on the walls of caves that the artistic instinct found its first expression.'

The woman who founded the Cave and commissioned its artists was a formidable individual in her own right. Madame Strindberg, who had long since terminated her marriage to the playwright August Strindberg, was a wealthy Austrian journalist, translator and author. Her sexually permissive inclinations drew her to the story of the revelling Israelites and their gilded idol, but she also knew exactly how to choose the young painters and sculptors who would do her theme full justice. With great daring, she invited five of them to devise the spectacular scheme of murals, carvings, painted plaster reliefs and other decorations which made the Cave a showpiece for London's most advanced art.

Her cosmopolitan career must have made Madame Strindberg aware of European precedents for her venture, most notably the Kabarett Fledermaus in Vienna designed by Josef Hoffmann and the Wiener Werkstätte. But no cabaret had ever been animated by images as elaborate and extensive as the Cave of the Golden Calf. Situated in an appropriately underground setting, the basement of a cloth merchant's warehouse in Heddon Street, it was only a short walk from the still-fashionable Café Royal. Madame Strindberg ensured, however, that her audacious Cabaret offered a range of bizarre and arresting delights far removed from any rendezvous London had ever possessed.

The sequence of decorations was supervised by Spencer Gore, who also became responsible for the overall colour scheme employed in the Cave. Both he and his fellow Camden Town painter, Charles Ginner, carried out several enormous wall-paintings with exotic jungle locations. The challenge stimulated them into achieving a simplification and rasping attack they had never attempted before (Cat. 32, 33). Fusing the influence of artists as disparate as Gauguin, the Douanier Rousseau and Kandinsky, they transformed the Cave into a South Seas paradise where monkeys gazed wide-eyed at a tiger hunt and horsemen galloped over 'primitive' terrain in pursuit of their prey.

Wyndham Lewis, the other painter employed on the project, was also liberated by the exhilarating opportunity to work on a large scale in a context which appealed to his most rebellious instincts. Arriving at his own fierce alternative to Cubism, Futurism and Expressionism, he executed a huge canvas called *Kermesse* (see Cat. 36) for the Cabaret's staircase. Probably the first painting visitors encountered as they descended from pavement level, it rapidly came to be regarded as a landmark in British avant-garde painting of the time. Taking his cue from the festivals celebrated in the Low Countries, Lewis transformed his three dancing figures into a characteristically combative embodiment of lunging energy. He also painted a drop-curtain of a 'primitive' scene which was still wet on the opening night, and stuck fast when hung over the stage. With another mural of militant dancers elsewhere in the Cave, and prime responsibility for the design of brochures, programmes and posters, Lewis was able to stamp his provocative identity on the entire venture and emerge as an artist admired by Sickert on the one hand and Fry on the other.

The sculpture was equally compelling. Jacob Epstein covered the two large iron pillars supporting the ceiling with plaster images, half human and half animal, which he painted in clamorous colours (see Cat. 34). His close friend Eric Gill carved a relief image of the calf itself near the Cabaret's entrance (Cat. 30), and he gilded a larger sculpture of the same idol for the Cave's interior. Here it would have served as the focal point for wild dancing which went on until the small hours, fulfilling the promise made by the Cave's manifesto: 'We want a place given up to gaiety, to a gaiety stimulating thought, rather than crushing it. We want a gaiety that does not have to count with midnight. We want surroundings, which after the reality of daily life, reveal the reality of the unreal.'

It must all have amounted to an exuberant demonstration of the new art's ability to transform an entire architectural setting. The Cave quickly became accepted by many people who disapproved of the same artists' work in galleries, and Madame Strindberg encouraged experimental activities in all the arts: Margaret Morris and her band of children doing 'Greek dancing', rumbustious performances by Marinetti and a macabre shadow-play by Ford Madox Ford. Her extravagance brought about the Cave's downfall in 1914, but by then it had played a vital part in the prodigious spirit of artistic renewal which galvanized British art in the years leading up to the First World War.

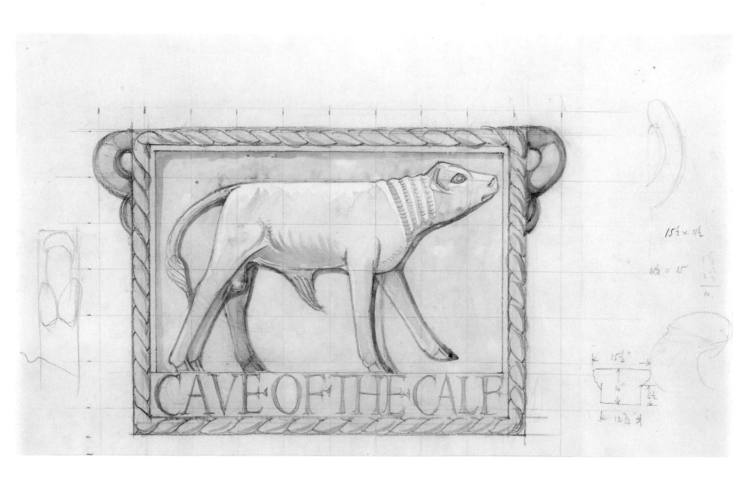

30 Eric Gill, *Study for Bas-relief in the Cave of the Golden Calf* 1912

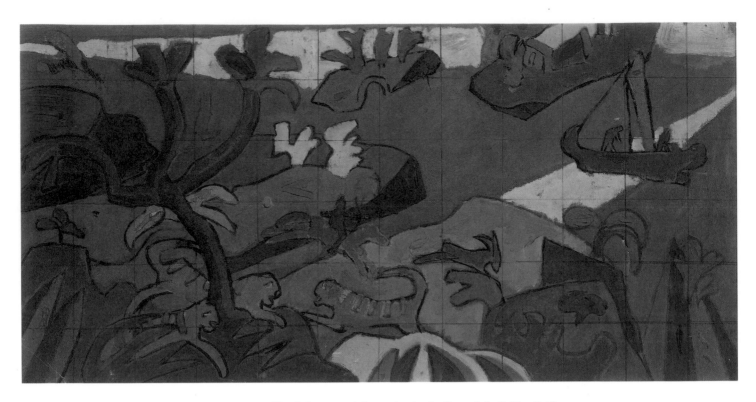

31 Spencer Gore, *Sketch for a mural decoration in the Cave of the Golden Calf* 1912

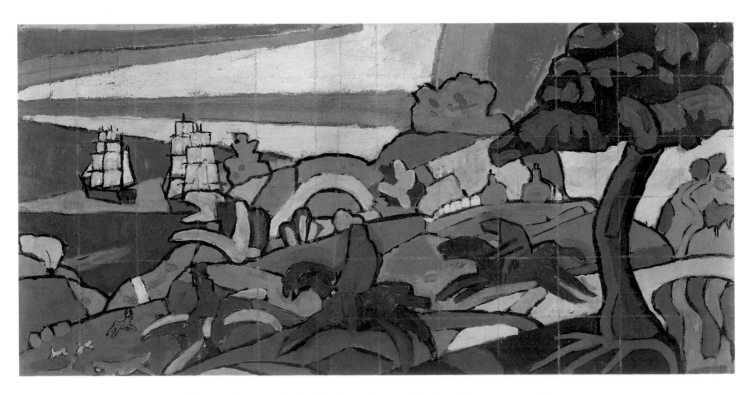

32 Spencer Gore, *Design for Deer Hunting mural in the Cabaret Theatre Club* 1912

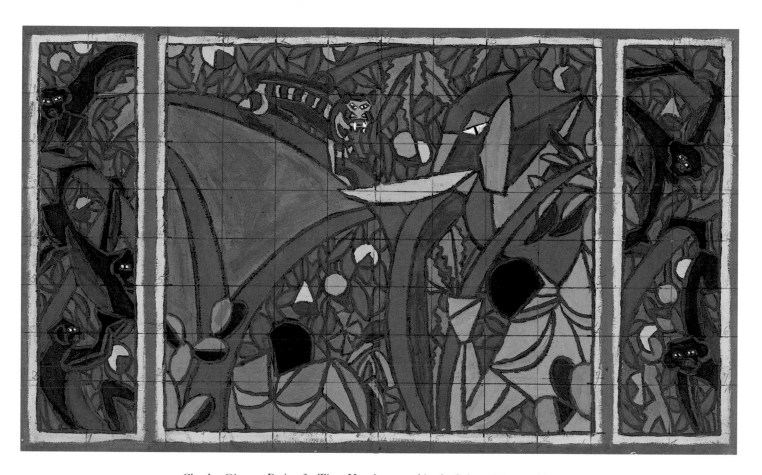

33 Charles Ginner, *Design for Tiger Hunting mural in the Cabaret Theatre Club* 1912

34
Jacob Epstein
Totem
c. 1913

35
Percy Wyndham Lewis
Abstract Design
1912

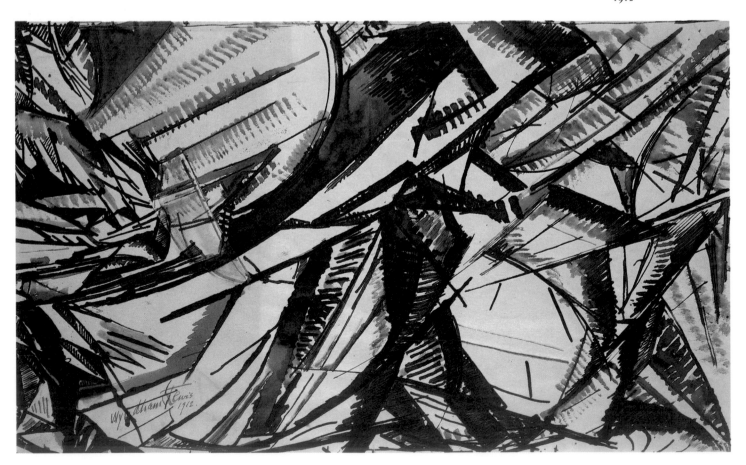

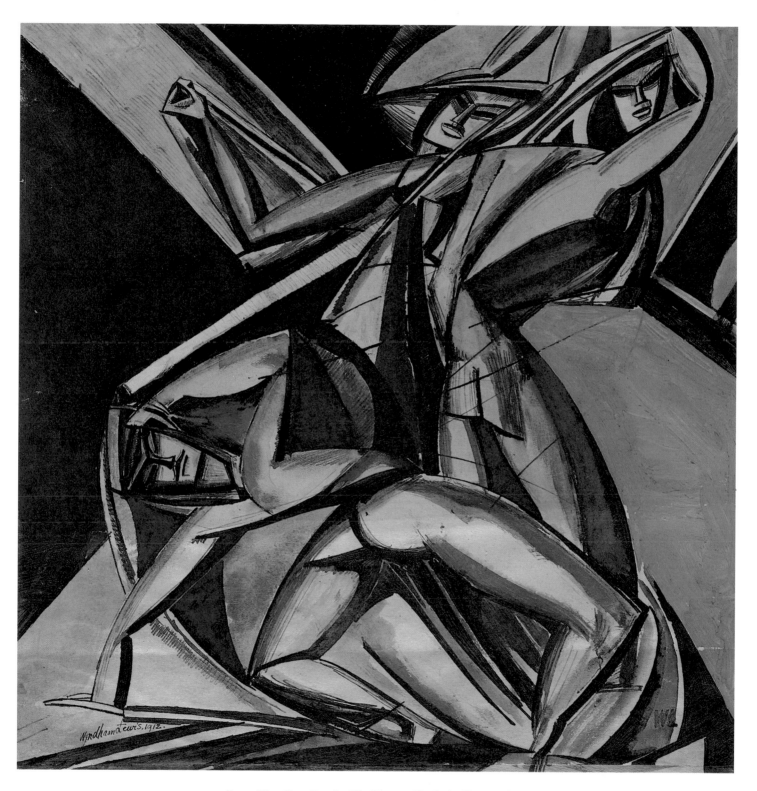

36 Percy Wyndham Lewis, *The Dancers (Study for Kermesse?)* 1912

Richard Cork

The Vorticist Circle, Bomberg and the First World War

In July 1914 Vorticism launched itself with irresistible gusto and rumbustious humour through the pages of the aptly entitled journal, *Blast*. With a typography as brash and noisy as a loud-hailer, it set out to demolish the legacy of the Victorian era once and for all. Wyndham Lewis, the many-talented editor of *Blast*, who was a formidable critic and fiction writer as well as a painter, wanted British artists to realize that the spirit of a new century should be fully embodied in the art they produced. 'Blast years 1837 to 1900,' roared the witty and belligerent opening manifestos, before going on to insist that the Vorticists were 'Primitive Mercenaries in the Modern World'.

The harshness and dynamism of that world demanded of its painters and sculptors a similarly single-minded energy. They used laughter 'like a bomb', bursting the cultural establishment into satirical fragments so that British art could liberate itself 'from politeness', laziness and a cosy complacency fostered by a climate notorious for its 'sins and infections, dismal symbol, set round our bodies, of effeminate lout within'. Now, declared the Vorticists, the time had come to assert a vital new order directly inspired by the dramatic transformation of modern society. They wanted to arouse the dormant potential of the nation so roundly cursed by *Blast*, for 'a movement towards art and imagination could burst up here, from this lump of compressed life, with more force than anywhere else'.

The illustrations reproduced in this exuberant first issue, with its clamorous puce cover and title page dated 20 June 1914, proved that a group of artists was already producing work which backed up the theoretical thrust of the manifestos. But the term 'Vorticism' had also been in existence for some months. Ezra Pound coined it in the hope of nurturing a movement which would compensate for his disappointment over the progress of Imagism, a venture which had previously set out to revolutionize British poetry. Disillusioned with Imagism, and increasingly excited by the work of the young artists he now befriended, Pound became a tireless propagandist and critical supporter of the 'Great English Vortex'. He defined it as 'a radiant node or cluster . . . from which, and through which, and into which, ideas are constantly rushing'. But the essence of Vorticism lay in the concept of a still centre. Lewis, who shared Pound's enthusiasm for the new movement and saw himself as its natural leader, described the vortex by telling a friend to think 'at once of a whirlpool At the heart of the whirlpool is a great silent place where all the energy is concentrated. And there, at the point of concentration, is the Vorticist.'

The importance of this 'great silent place' lay in its ability to generate clarity, hardness and strength of definition. Italian Futurism had initially helped the Vorticists to realize the importance of interpreting the machine age in their art, but Lewis and his group abhorred the blurred multiplicity and flux admired by Marinetti. The incessant motion celebrated in so many Futurist images was anathema to Vorticist artists, who preferred to enclose single forms in steely contours which took on the thrusting, clean-cut efficiency of the modern machine. The industrial world fed their imaginations as powerfully as it fascinated the Futurists, but the British artists did not view it with unqualified Marinettian ecstasy. Lewis in particular understood its darker side, its capacity for dehumanization, and both his surviving Vorticist canvases convey a disquieting harshness far removed from Futurist romanticism (Cat. 39, 40).

Industrialization had come to Italy long after Britain, and Lewis believed that Vorticism should view the mechanized age with a greater understanding of its complexity. Hence the distinctive tension in a Vorticist picture between the explosive force of twentieth-century dynamism, with its rasping colours and aggressive diagonal thrust threatening to burst the borders of the composition, and an altogether cooler emphasis on order and control. 'Once this consciousness towards the new possibilities of expression in present life has come,' Lewis wrote, 'it will be more the legitimate property of Englishmen than of any other people in Europe They are the inventors of this bareness and hardness, and should be the great enemies of Romance.'

Of all the Vorticists, Lewis was the most preoccupied with the theme of the modern metropolis. Although he had not visited New York himself at that time, Alvin Langdon Coburn's photographs of the city were displayed at a London exhibition in the autumn of 1913. Lewis may well have used them as a springboard for pictures like *New York* (Cat. 41), where urban structures lean at a vertiginous diagonal and are shot through with strident shafts of scarlet lightning. This resolutely 'modern' image contrasts with *Sunset among Michelangelos* (Cat. 37), a satirical farewell to the heroic Renaissance tradition which had dominated Lewis's training in his days at the Slade School of Art.

The other painters most closely associated with Vorticism also studied at the Slade, albeit a few years later than Lewis. Perhaps his closest ally was Edward Wadsworth, who drew on personal knowledge of the great industrial cities of the North when he developed his vision of Britain. The title of his

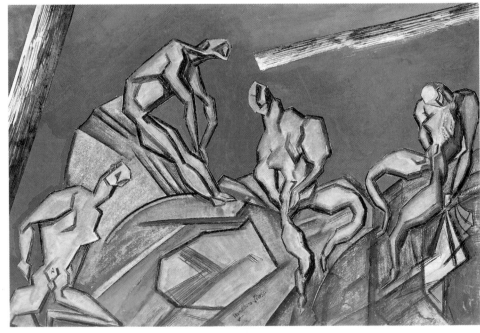

Cat. 37 Percy Wyndham Lewis, *Sunset among Michelangelos*, 1912

dissonant gouache *Enclosure* (Cat. 46) echoes the fragment 'ENCLO' visible in Lewis's canvas *The Crowd* (Cat. 40), and both men were concerned with the stern, containing structures of urban centres. But for all the points of similarity between the two artists, their differences were just as striking. Wadsworth rarely admitted the human figure to his images of ports, ships and conurbations seen from above. He was far less restless and explosive in temperament than Lewis, and Pound contrasted the two artists with each other: 'turbulent energy: repose. Anger: placidity, and so on.'

Although Wadsworth executed several enormous paintings at the height of the Vorticist period (1914-15), none has survived. Indeed, the history of Vorticism is plagued by the loss of many major works. Only a dozen of the forty-nine pictures displayed by members of the movement at the Vorticist Exhibition have so far been traced, and most of the others were probably destroyed during the First World War. If monumental canvases like Lewis's *Plan of War* and *Christopher Columbus* or Wadsworth's mighty *Combat* had survived, the Vorticist achievement could be more accurately assessed. Without them, we are obliged to rely on photographs and contemporary descriptions of the lost work. Fortunately, Lewis wrote a great deal about his friends' paintings, and in an analysis of Wadsworth's *Blackpool* he made clear that the Vorticists employed near-abstraction in order to return the onlooker to a more complete awareness of modern life. *Blackpool*'s 'striped ascending blocks' were, according to Lewis, 'the elements of a seaside scene, condensed into the simplest form possible for the retaining of its vivacity'. He explained that 'its theme is that of five variegated cliffs', and described how 'the striped awnings of cafés and shops, the stripes of bathing tents, the stripes of bathing machines, of toy trumpets, of dresses, are marshalled into a dense essence of the scene'. In other words, the Vorticists used an advanced degree of abstraction to encourage a wide range of interpretative responses in the viewer. Rather than excluding visible reality from their work, they wanted to convey what Lewis termed 'the quality of LIFE'. Indeed, he went on to maintain that a compressed sense of vitality lay at the very centre of their art: 'To synthesize this quality of LIFE with the significance or spiritual weight that is the mark of all the greatest art, should be, from one angle, the work of the Vorticists.'

William Roberts's contemporaneous work suffered equally grievous losses, and his only extant oil from these years is a small-scale composition which tackles the frankly un-Vorticist theme of *The Return of Ulysses* (Cat. 43). But a vibrant *Study for Two Step* (Cat. 44) gives a very dramatic idea of what his large *Two Step* canvas must have looked like. The dancers it contains were a popular subject among the Vorticists: Lewis focused

on them in his *Kermesse* (see Cat. 36) and Gaudier's *Red Stone Dancer* (Fig. 4, p. 34) is one of his masterpieces. But in Roberts's watercolour the figures have almost become merged with the fabric of the modern city. Forms redolent of pistons, girders and skyscrapers threaten to overwhelm the dancers, and Roberts's extraordinarily high-keyed colours add to the deliberate discordance.

David Bomberg, a contemporary of Roberts's at the Slade School of Art and his close friend at the time, shared this fascination with the dance. In his case, the enthusiasm stemmed from the hugely successful London seasons of Diaghilev's *Les ballets russes* and from Margaret Morris's experimental activities. They inspired a whole sequence of brilliant watercolours (Cat. 47, 48), which suggest the influence of Picabia's *Star Dancer* series but at the same time constitute a sturdily individual achievement. Although Bomberg was close to many of the Vorticists, and owed a similar debt to both Cubism and Futurism, he always resisted Lewis's invitations to join the movement. Refusing to allow his work in *Blast*, he retained an independence which is reflected in his precocious paintings of the time.

In the Hold (Cat. 50) takes as its starting point a scene Bomberg would have witnessed in the docks near his Whitechapel home. The men working there, moving passengers from one part of the ship to another, are heroic figures whose awesome stature is surely affected by Bomberg's awareness of the dockworkers' much-publicized militancy during that period. But even as the painting pays tribute to their strength and resolution, it imposes a sixty-four-square grid which fragments their forms to the point of near-abstraction. The splintered rhythms created by the grid accentuate the dynamism of the subject and give the entire painting a disquieting sense of explosive unease as well.

Mechanization was already overtaking the manual worker, and when the twenty-three-year-old Bomberg held his first one-man show at the Chenil Gallery in July 1914 he stressed that 'I look upon *Nature*, while I live in a *steel city*'. His awareness of this fast-changing environment led him to pursue a radically simplified language which culminated in his early masterpiece *The Mud Bath* (Cat. 49). 'My object is the *construction of Pure Form*,' he declared in the Chenil catalogue, adding, 'I reject everything in painting that is not Pure Form.' His defiant words clearly apply to the tense, stripped-down language of *The Mud Bath*, but the composition still depends to a fundamental extent on Bomberg's involvement with the muscular agility of the human figure. It also employs the red, white and blue of Britain's national flag, and Bomberg emphasized this reference by hanging *The Mud Bath* outside the gallery and festooning its frame with Union Jacks.

Some of the angular and machine-like forms in this tersely organized painting recall

Epstein's original conception of the monumental *Rock Drill* (Fig. 5, p. 34). Bomberg remembered visiting the sculpture before its completion and he described how the 'tense figure' was 'perched near the top of the tripod . . . operating the Drill as if it were a Machine Gun, a Prophetic Symbol, I thought later of the impending war'. The original version of *Rock Drill*, which combined a man-made plaster figure with a ready-made machine Epstein purchased for the purpose, had much in common with Vorticist theories. It was also indebted to the support of T. E. Hulme, a wholehearted critical champion of Epstein's pre-war work who believed that the new art would make extensive use of machine forms. Although Epstein did not sign the manifesto in *Blast*, he allowed two drawings to be reproduced in its pages. He also told Pound that Lewis's drawings had 'the qualities of sculpture', and gave his driller an automaton-like character closely related to Lewis's figure drawings of the period.

In other respects, though, Epstein was as fiercely independent of Vorticism as Bomberg. The phallic symbolism of the drill parallels the exploration of sexuality in a smaller work like the third marble *Doves* (Cat. 55), where the act of copulation is openly represented. The refinement of form in this carving suggests a debt to Brancusi, whom Epstein had befriended in 1912 when he travelled to Paris for the unveiling of his scandalous *Tomb of Oscar Wilde* in Père Lachaise cemetery. Epstein was ready to pursue a radical paring down of form soon after he met Brancusi.

The mesmerizing *Sunflower* (Cat. 53), carved around then, is a remarkably extreme image which heralds a bold departure from the Hellenic and Renaissance tradition espoused by previous British sculptors. Its sawtooth 'halo' of sun-rays is brazen in impact, evoking a 'primitive' world where his *Figure in Flenite* (Cat. 56) would also be at home. Bending over her pregnant stomach with a watchfulness at once tender and defensive, the mother's body terminates in legs which emphasize the solidity of the material Epstein carved. In opposition to all those sculptors who had forsaken any direct manual contact with stone or marble, Epstein asserted the prime importance of 'carving direct' and respecting the identity of the block itself.

His younger friend Gaudier-Brzeska followed the same precepts in his *Hieratic Head of Ezra Pound* (Cat. 58). While carving this monumental marble image, he constantly warned his admiring sitter not to expect a likeness. Rather did Gaudier aim at a totemic presence, as phallic as anything which Epstein attempted and frankly indebted to the 'primitive' sculpture they both respected. Gaudier signed the Vorticist manifesto and he also contributed a provocative 'Vortex' article to *Blast*, where he aligned himself not

only with Epstein but Brancusi, Archipenko and Modigliani as well, who 'through the incessant struggle in the complex city, have likewise to spend much energy'.

Gaudier did not spare his own formidable physical and imaginative resources. As if aware that he did not have long to live, the young Frenchman was a tireless experimenter during his London years. Rather than conveying his interest in machine forms as directly as Epstein's *Rock Drill*, he preferred to invest animals and birds with mechanistic properties. *Bird Swallowing Fish* (Cat. 61) transforms a predatory incident from nature into a sinister Vorticist ritual, where the fish's tail sticks up like the butt of a weapon from the bird's armoured head. But Gaudier could be a marvellously gentle artist, too: *Birds Erect* (Cat. 60), inspired by a cactus he kept in his studio, is a tender image despite the austerity of its formal structure. It eschews the technical virtuosity so evident in the small *Crouching Figure* (Cat. 62), a *tour de force* of direct carving which revels in the freedom to distort limbs with irresistible vivacity. It also serves as a reminder that Gaudier was too various in his experiments to be regarded solely as a Vorticist sculptor. He could not resist exploring an abundance of stylistic directions, and one of his last carvings, *Seated Woman* (Cat. 59), moves away from Vorticism to affirm a distilled serenity of its own.

Soon after completing this remarkable sculpture, Gaudier enlisted in the French army and met his death in the trenches. The war also helped to persuade Epstein that the machine should be taken away from *Rock Drill*, thereby giving the remaining bronze *Torso* (Cat. 57) a tragic helplessness it had not possessed before. The continuing hostilities eventually obliged many of the Vorticists to serve at the Front, and the movement died once they departed. But before he went, Lewis managed to publish a second issue of *Blast* and to organize a Vorticist Exhibition at the Doré Galleries in London (June 1915), while Pound subsequently persuaded the great American collector John Quinn to stage an 'Exhibition of the Vorticists' at the Penguin Club in New York (January 1917).

Pound also christened the 'Vortographs' which were taken by Alvin Langdon Coburn in 1917 using a 'Vortoscope' made from broken fragments of the poet's shaving-mirror. These prismatic images, an inventive form of Vorticist photography, were exhibited at a one-man show in the Camera Club, London, in February 1917. He used three pieces of mirror fastened together like the prism in a kaleidoscope to 'split' for instance the head of Pound. The resulting near-abstract designs bore out Coburn's claim that 'I do not think we have even begun to realise the possibilities of the camera . . . if it is not possible to be "modern" with the newest of all the arts, we had better bury our black boxes'. Pound agreed, announcing in bold capitals

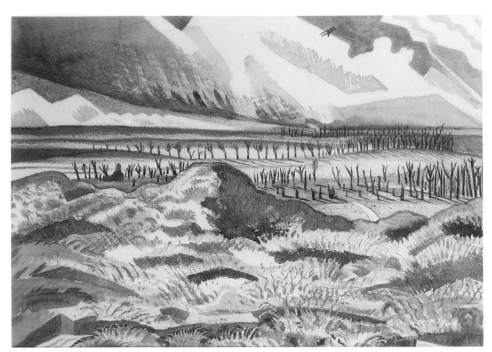

Cat. 38 Paul Nash, *Ruined Country, Old Battlefield, Vimy*, 1917-18

that Vortography meant 'THE CAMERA IS FREED FROM REALITY'. He also told John Quinn that Coburn's invention 'will serve to upset the muckers who are already crowing about the death of Vorticism'.

But the movement was virtually at an end, and for a while only Nevinson benefited from first-hand experience of war. Having earlier been a disciple of Marinetti, most successfully in a painting called *The Arrival* (Cat. 63) which applied Futurist ideas about simultaneity to the theme of a Channel crossing, he found a more personal voice in 1915. *Flooded Trench on the Yser* (Cat. 65) is an uncompromisingly bleak image, devoid of the heroic propaganda which marked the British government's attempts to sustain patriotic support for the conflict. Deploying an almost Japanese economy of style, Nevinson presents the Front as a submerged wilderness where human life seems impossible to sustain. No victories are feasible in such a desolate place, and his *Troops Resting* (Cat. 64) are resigned to the inevitability of a long, futile struggle. The war pitched Nevinson into sudden maturity as an artist, forcing him to abandon the callow excitement of his Futurist period and develop an independent stance. The paintings he produced during this, the finest phase of his career, sometimes fell foul of official censorship, but Nevinson was determined to tell the truth about the conflict, and for a few years he succeeded in doing so.

Paul Nash shared this admirable aim. His first visit to the Front in 1917 transformed him from a visionary landscapist, in the tradition of Blake and Palmer, to an altogether fiercer artist. He could still describe the experience in lyrical terms, writing about 'those wonderful trenches at night, at dawn, at sundown', and his initial drawings and watercolours lack the anger that his second

visit engendered (Cat. 38). 'It is unspeakable, godless, hopeless,' he now wrote with furious eloquence from the trenches. 'I am no longer an artist interested and curious. I am a messenger who will bring back word from the men who are fighting to those who want the war to go on for ever. Feeble, inarticulate, will be my message, but it will have a bitter truth, and may it burn their lousy souls.' This crusading resolve to make his work sear the nation's conscience turned Nash into a formidable artist almost overnight. Employing oils for the very first time, he managed in *The Mule Track* (Cat. 66) and *We Are Making a New World* (Cat. 67) to convey something of the war's cataclysmic horror. The terrain of battle, with its blasted trees and gouged mud, is seen as nothing more than a forlorn wasteland. It has been given over to the process of dying, and Nash refuses to offer any reassurance in his vision of total annihilation.

The war had a profound effect even on artists who, like Wyndham Lewis, attempted to remain as detached from the experience as possible. Working as an Official War Artist after serving as a gunner, he executed a panoramic canvas of *A Battery Shelled* (Cat. 70) for the proposed Hall of Remembrance. The Committee that commissioned the work expected him to adopt a more representational style than the language he had employed as a Vorticist, and Lewis felt constricted by the demands of the brief. But he also knew that the war had been 'a sleep, deep and animal, in which I was visited by images of an order very new to me. Upon waking I found an altered world: and I had changed, too, very much. The geometrics which had interested me so exclusively before, I now felt were bleak and empty. They wanted filling.' The change in outlook is

openly dramatized in *A Battery Shelled,* where the three figures on the left seem to stand outside the rest of the scene, both physically and in stylistic terms. It is almost as if they signify the mood experienced by Lewis himself, awakened from his 'sleep' and pondering on the more 'geometrical' idiom employed in the muddy, devastated landscape peopled by robot-like soldiers who recall his earlier work.

No such outright clash of styles was experienced by Stanley Spencer, who also received a commission from the British government. Although he later claimed that 'my ideas were beginning to unfold in fine order when along comes the war and smashes everything', he harnessed his pre-war language to the task of war painting with conspicuous success. *Travoys Arriving with Wounded at a Dressing Station* (Cat. 69) commemorates an incident which he witnessed during the Macedonian campaign. Huddled on stretchers and swathed in strangely billowing blankets, the injured soldiers await treatment. The outstretched arms of the medical orderlies protect them from harm, and inside the warmly lit room beyond, a surgeon attempts to bring comfort and relief. The operating

theatre, a small Greek church converted for the purpose, is given a sacred significance. Always ready to discover the religious in the everyday, Spencer shows a characteristic desire to redeem the suffering of war through his sturdily compassionate art.

When the former Vorticists returned from active service, they found that everything had altered. With Gaudier and Hulme dead at the Front, and Pound restlessly considering a move to Paris, the whole context which once fostered *Blast* and the widespread desire for radical renewal had disappeared. Lewis attempted for a while to plan a third issue of the magazine, but it was never published. All the artists felt, in their different ways, an urge to return to more representational modes of working. Roberts's *The Dancers* (Cat. 45), their grotesque distortions surely signifying a bitter disillusion engendered by his horrific experiences during the war, reveal a new determination to forge a figurative art of disturbing power. *The Dancers* was painted for a room in the Restaurant de la Tour Eiffel, Percy Street, where Lewis had created an entire Vorticist Room with painted walls, lampshades and decorated tablecloths in 1915. Its proprietor, Rudolph

Stulik, had allowed the Vorticists to dine there as often as they wished, and many uninhibited group evenings were held in this rasping environment before the rebel artists went away to war. Now, however, the former allies felt no desire to reassemble at Stulik's restaurant and recapture the solidarity of that intoxicating period.

Lewis attempted to bring them together once again in March 1920, when a mixed exhibition was held at the Mansard Gallery. But it was given the cautiously non-committal title 'Group X', and even Lewis was obliged to admit in the catalogue introduction that the exhibition put forward 'no theory or dogma that would be liable to limit the development of any member'. Bomberg summed up the prevailing mood in 1920, when he painted *Ghetto Theatre* (Cat. 51). The subject was drawn from the same East End locality which once inspired *The Mud Bath,* but now the earlier exuberance has gone. The audience in this picture looks hunched and defensive, eerily constrained behind a railing with the restrictive force of bars in a prison cell. The old world was perceived as a place of wearisome constraints, and the time had come to move on.

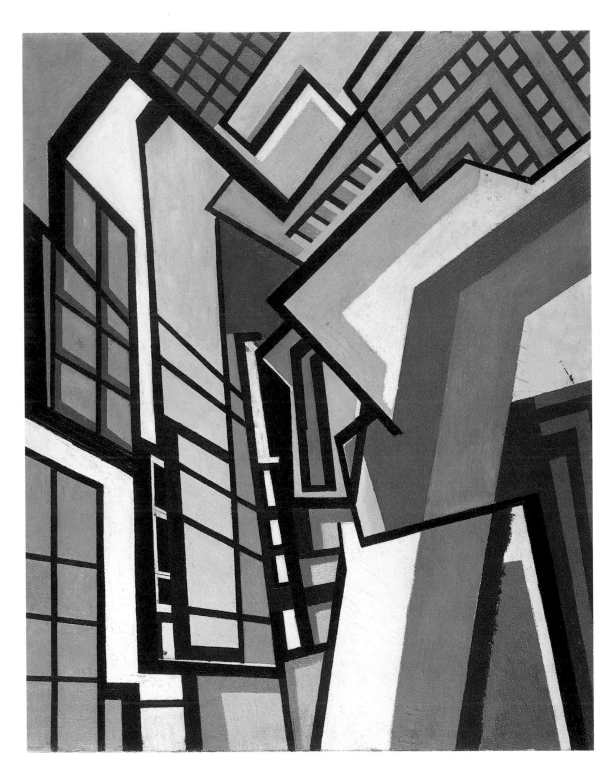

39 Percy Wyndham Lewis, *Workshop* 1914-15

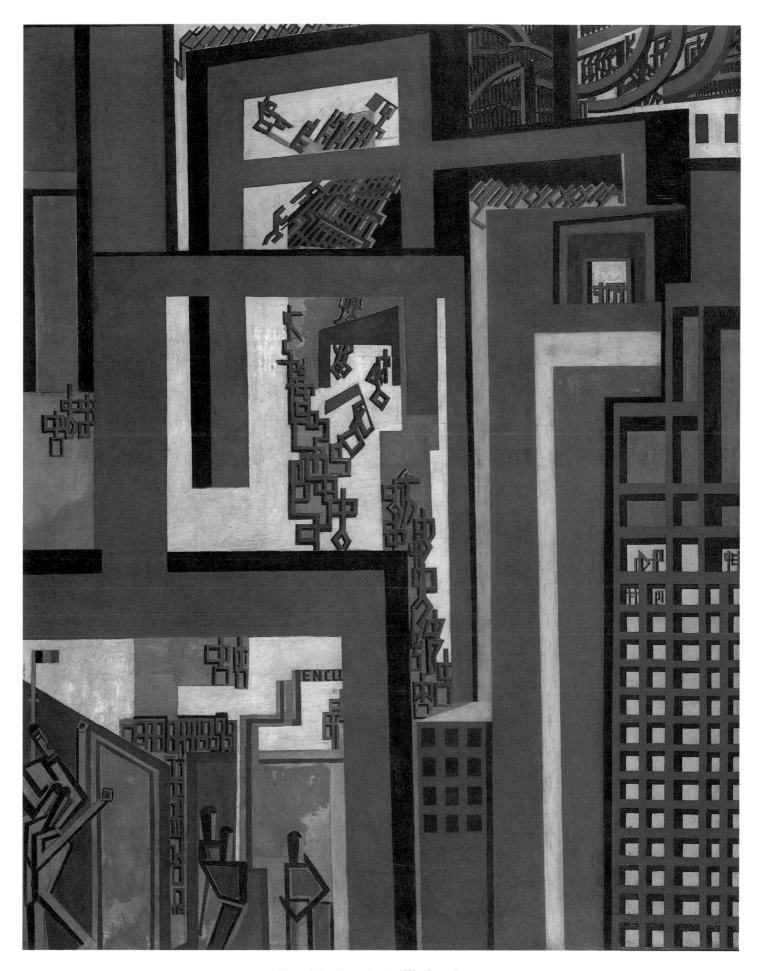

40 Percy Wyndham Lewis, *The Crowd* 1914-15

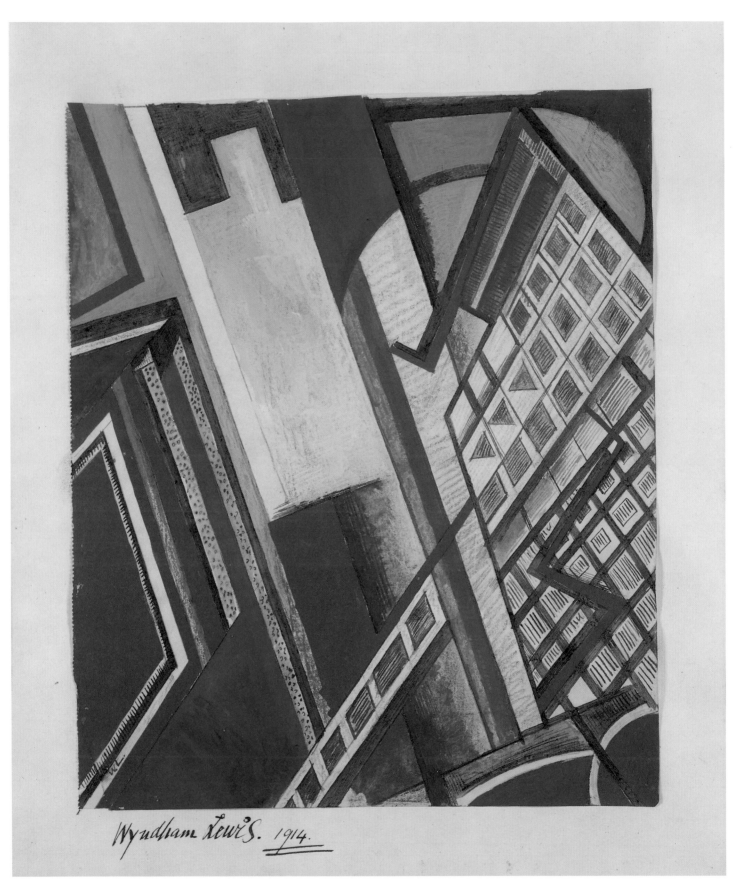

Wyndham Lewis. 1914.

41 Percy Wyndham Lewis, *New York* 1914-15

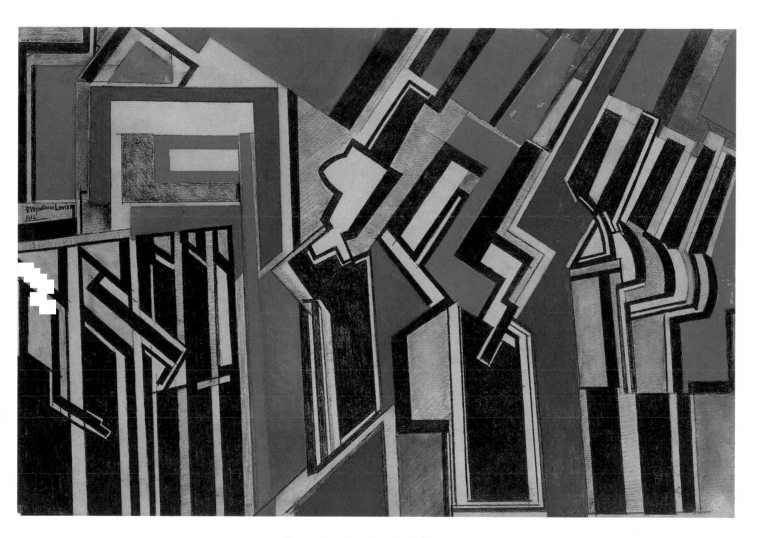

42 Percy Wyndham Lewis, *Red Duet* 1914

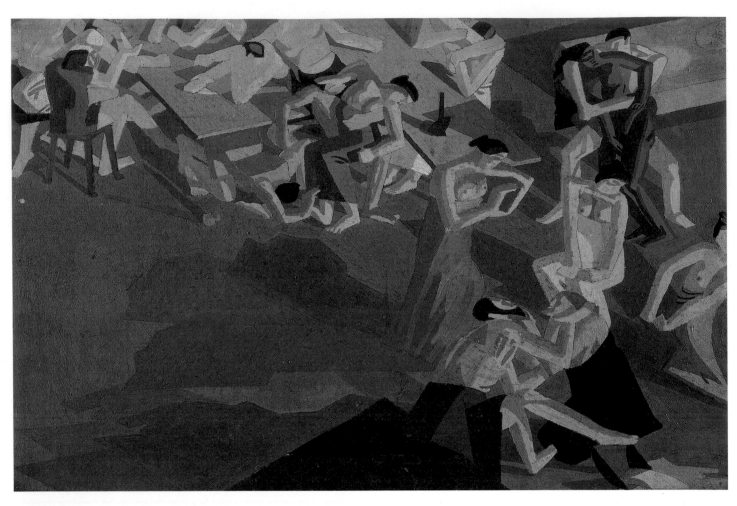

43
William Roberts
The Return of Ulysses
1913-14

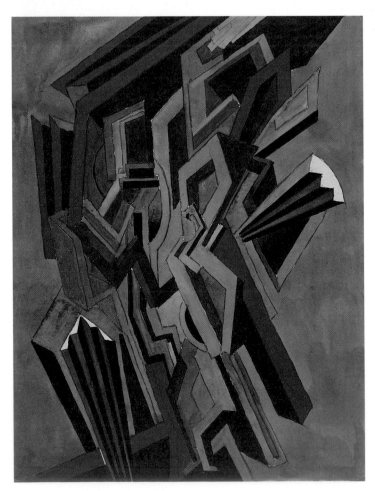

44
William Roberts
Study for Two Step
c. 1915

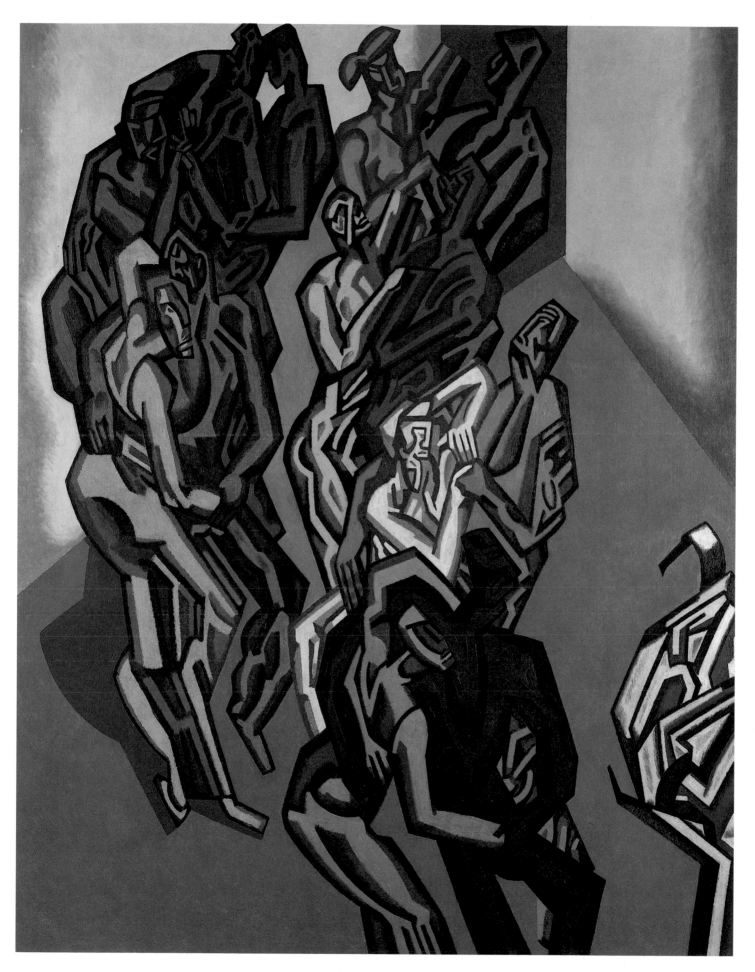

45 William Roberts, *The Dancers* 1919

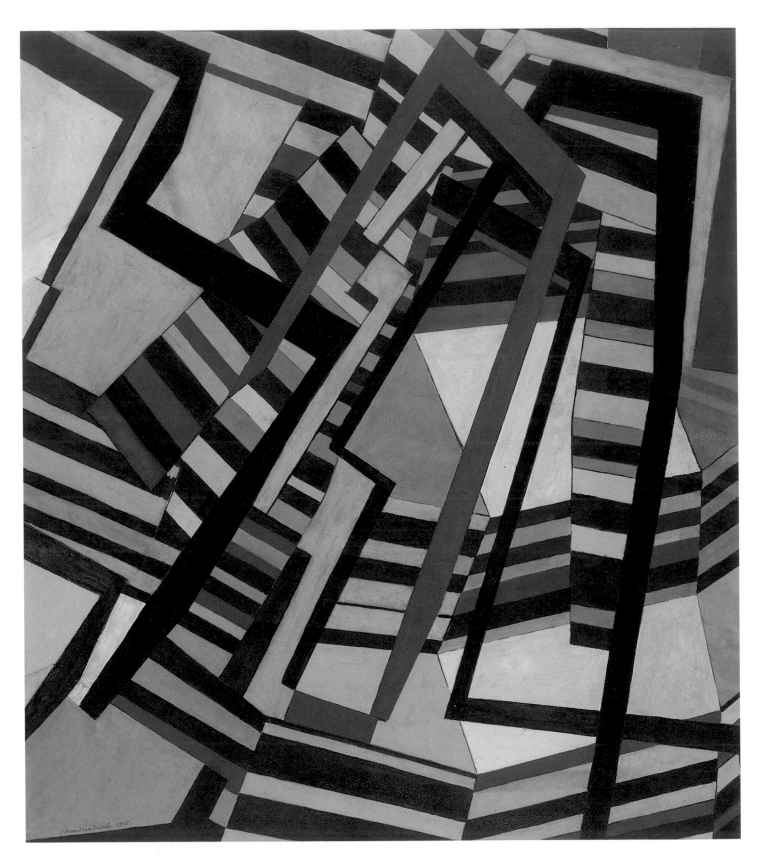

46 Edward Wadsworth, *Enclosure* 1915

47
David Bomberg
The Dancer
1913-14

48
David Bomberg
The Dancer
1913-14

49 David Bomberg, *The Mud Bath* 1912-13

50 David Bomberg, *In the Hold* c. 1913-14

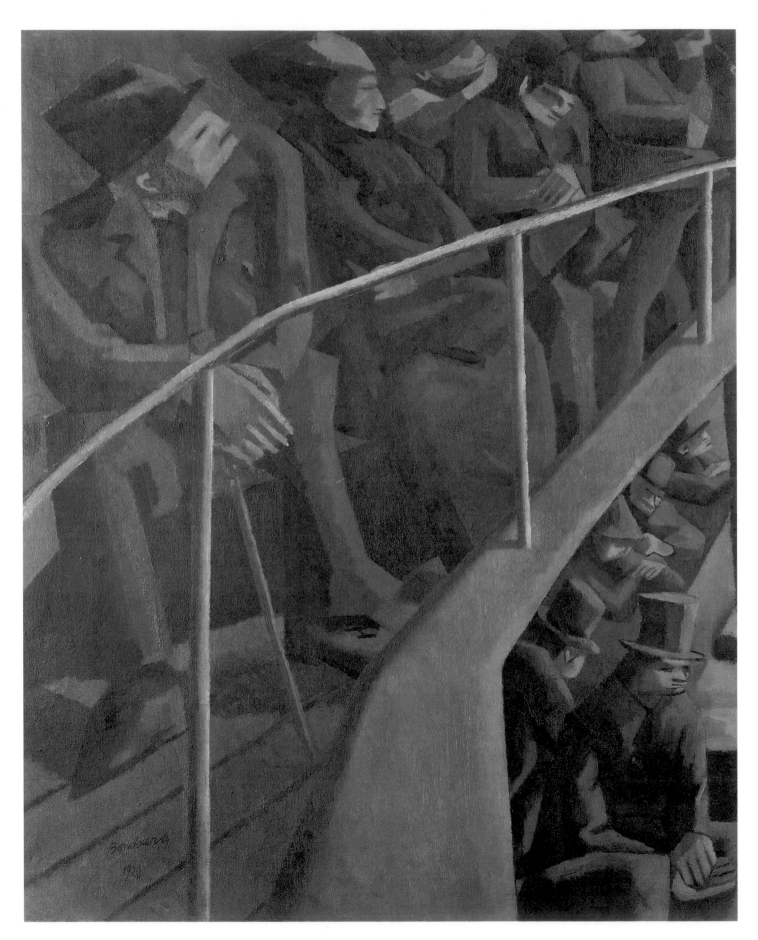

51 David Bomberg, *Ghetto Theatre* 1920

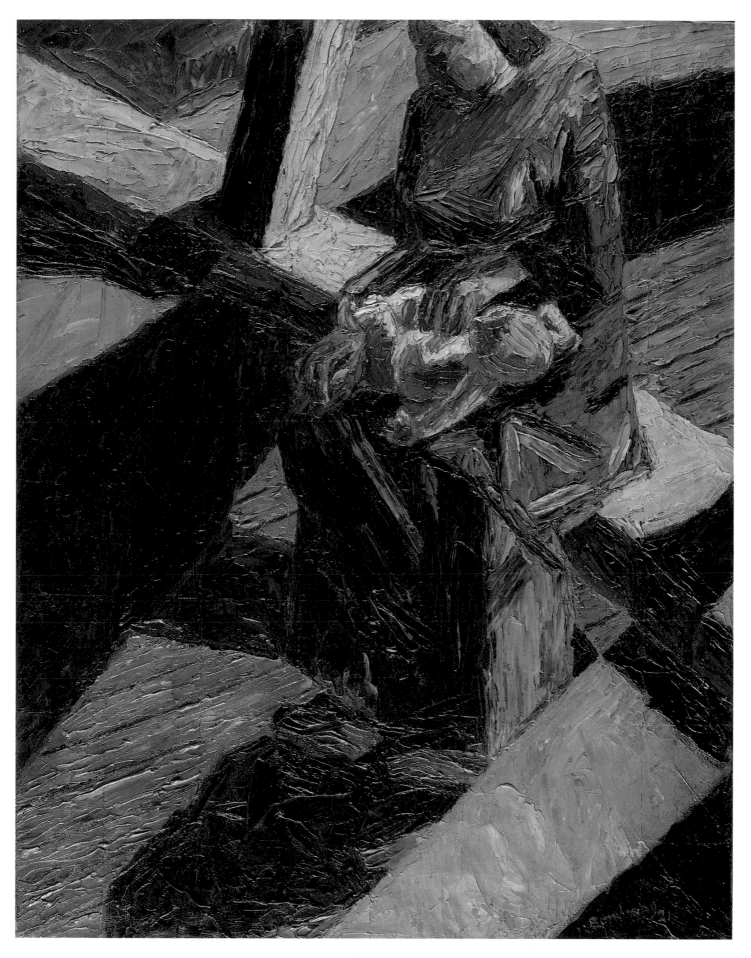

52 David Bomberg, *Bargee, Mother and Child* 1921

53　Jacob Epstein, *Sunflower*　1912-13

54
Jacob Epstein
Sun Goddess, Crouching
c. 1910

55
Jacob Epstein
Doves
1914-15

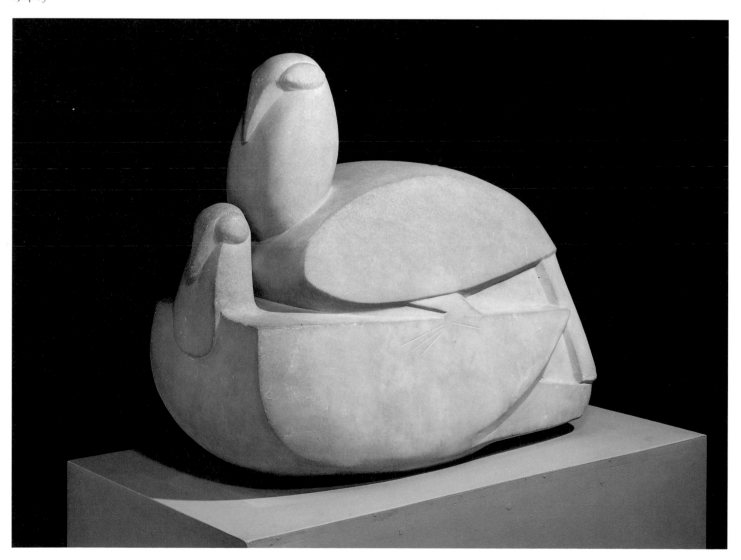

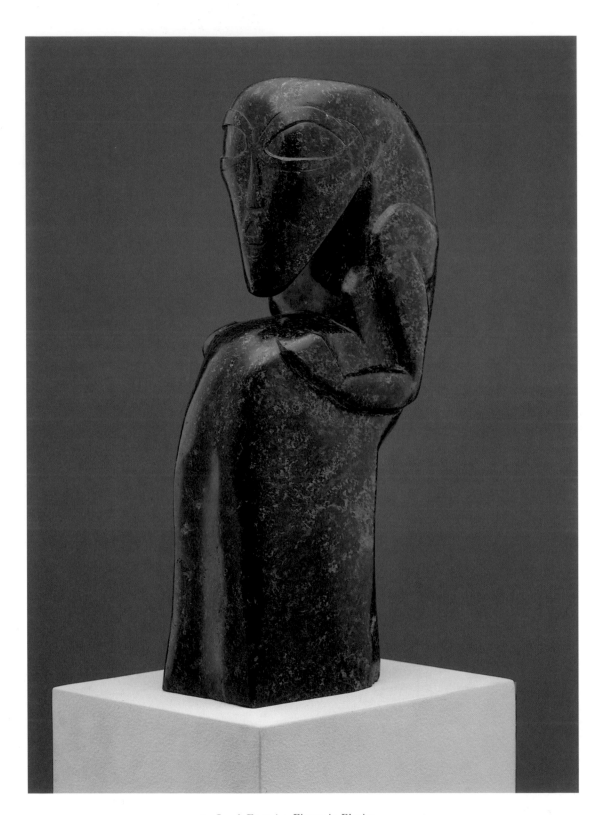

56 Jacob Epstein, *Figure in Flenite* c. 1913

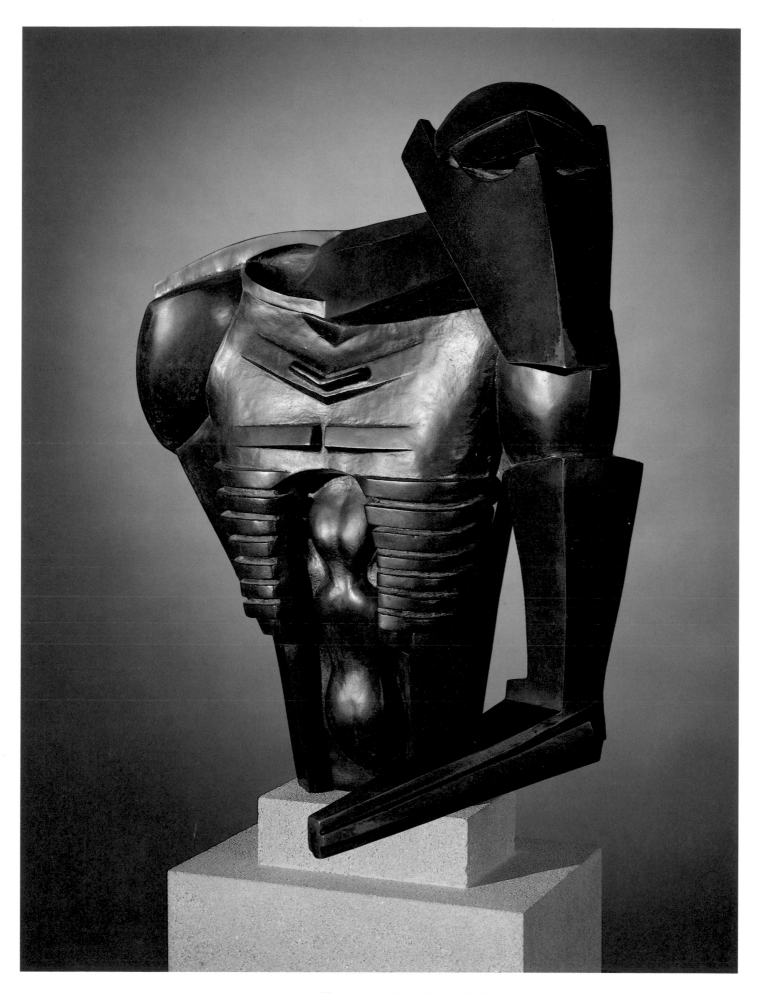

57 Jacob Epstein, *Torso in metal from The Rock Drill* 1913-14

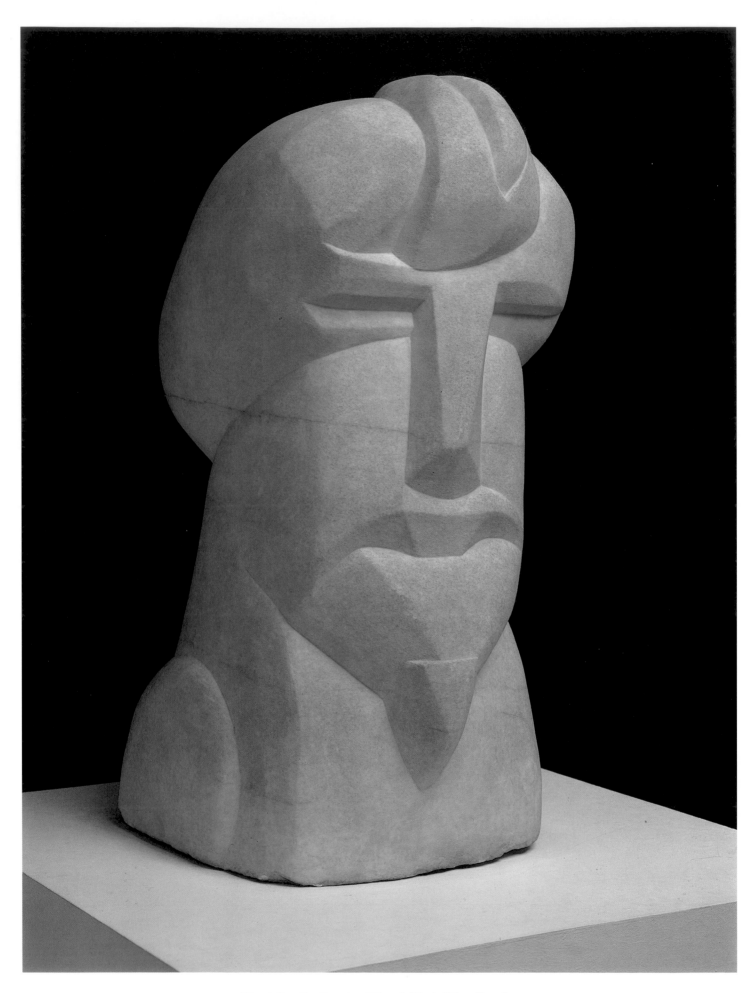

58 Henri Gaudier-Brzeska, *Hieratic Head of Ezra Pound* 1914

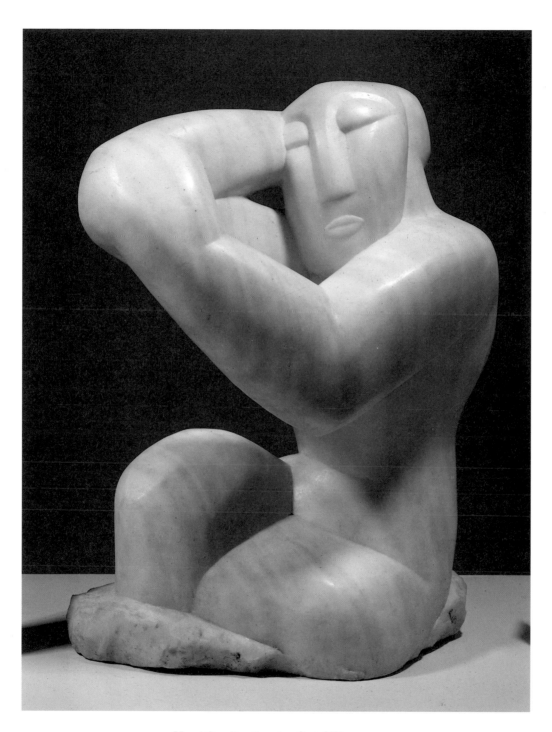

59 Henri Gaudier-Brzeska, *Seated Woman* 1914

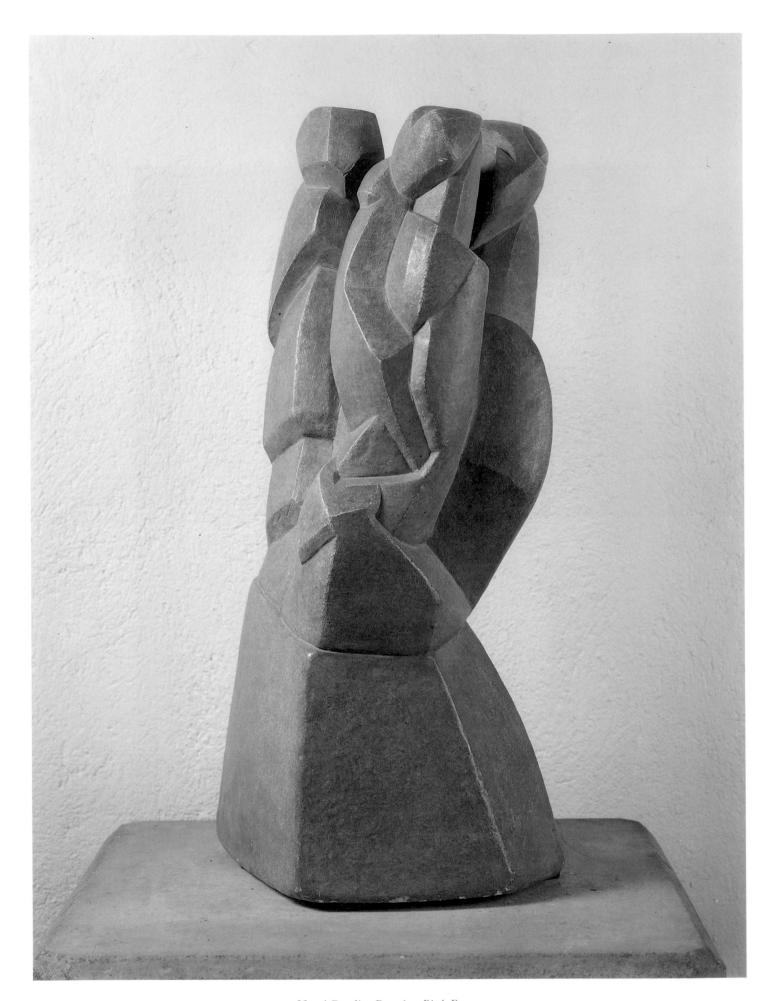

60　Henri Gaudier-Brzeska, *Birds Erect* 1914

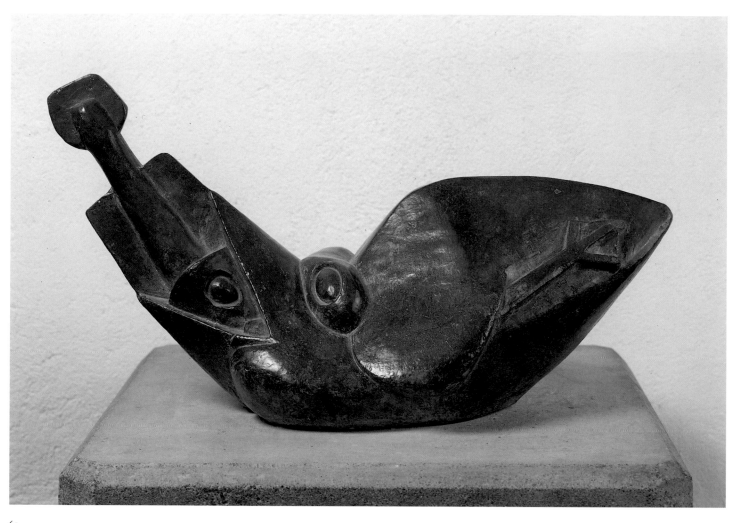

61
Henri Gaudier-Brzeska
Bird Swallowing Fish
1914

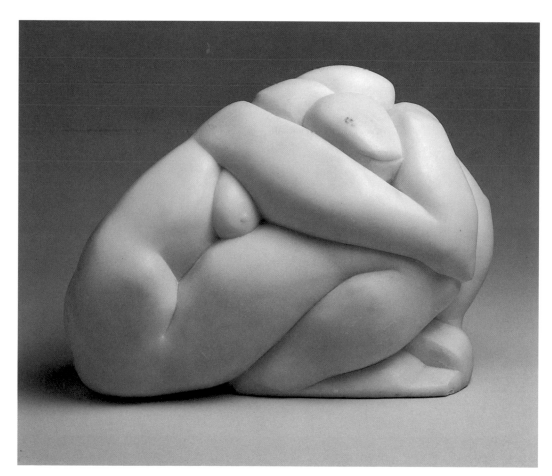

62
Henri Gaudier-Brzeska
Crouching Figure
1913-14

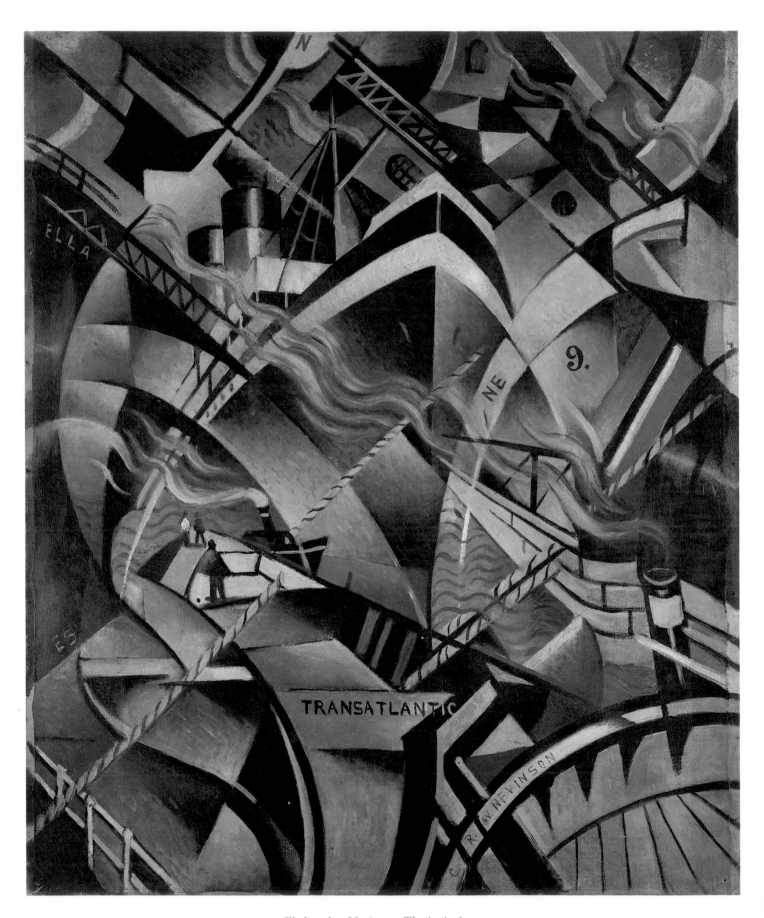

63 Christopher Nevinson, *The Arrival* 1913-14

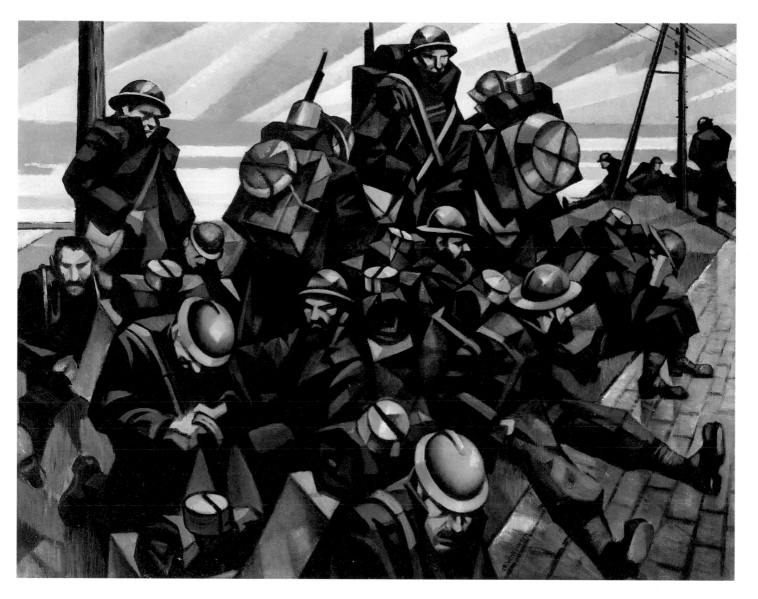

64 Christopher Nevinson, *Troops Resting* 1916

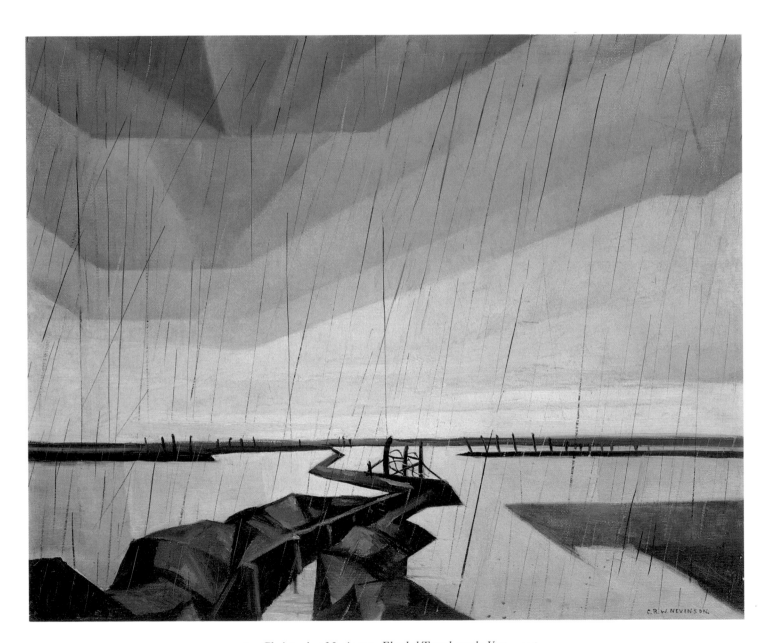

65 Christopher Nevinson, *Flooded Trench on the Yser* 1916

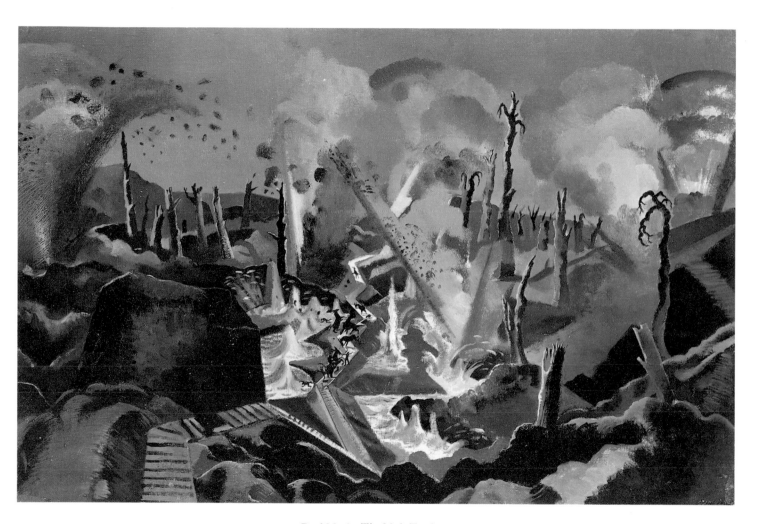

66 Paul Nash, *The Mule Track* 1918

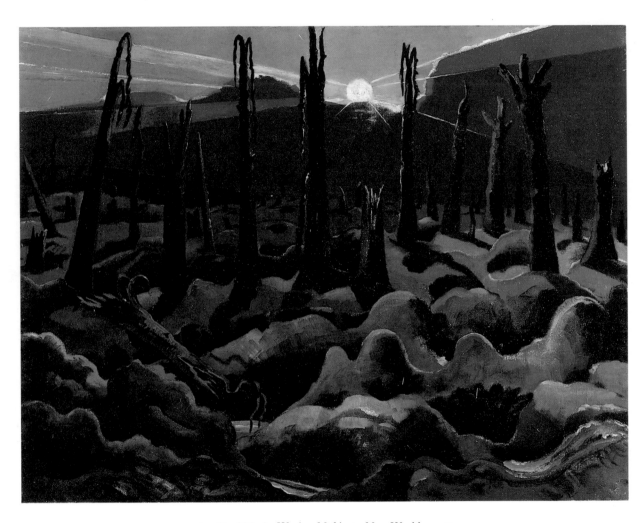

67　Paul Nash, *We Are Making a New World*　1918

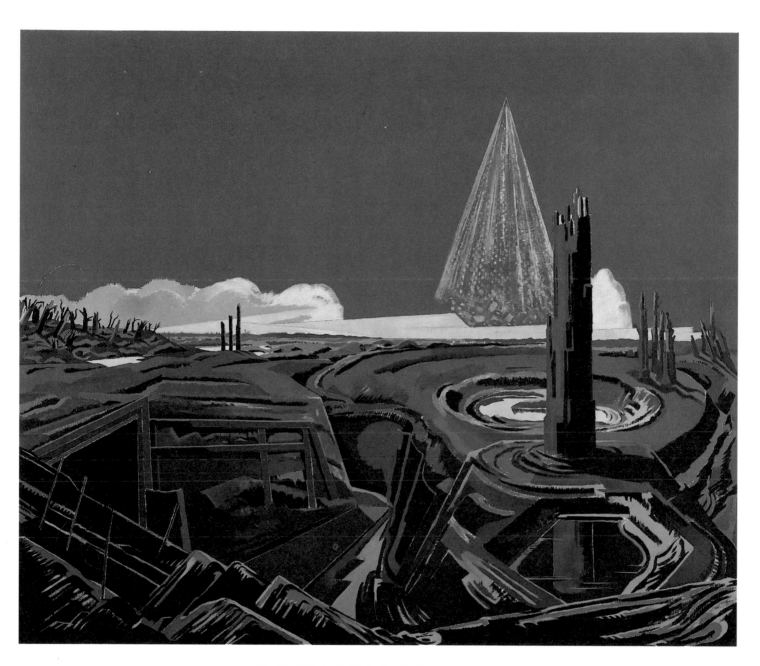

68 Paul Nash, *A Night Bombardment* 1919-20

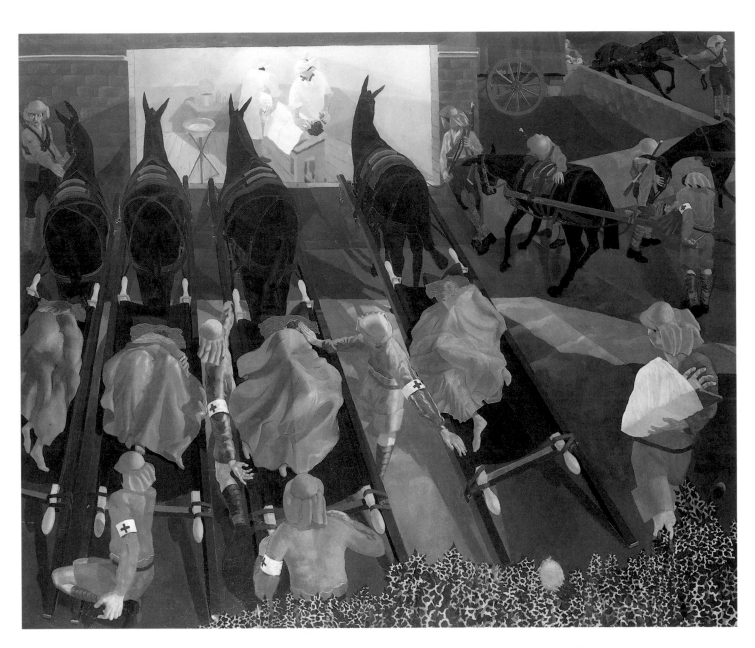

69 Stanley Spencer, *Travoys Arriving with Wounded at a Dressing Station at Smol, Macedonia* 1919

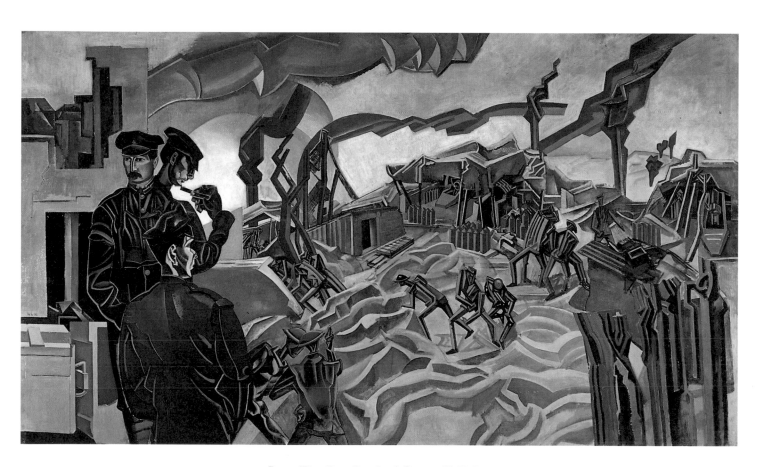

70 Percy Wyndham Lewis, *A Battery Shelled* 1919

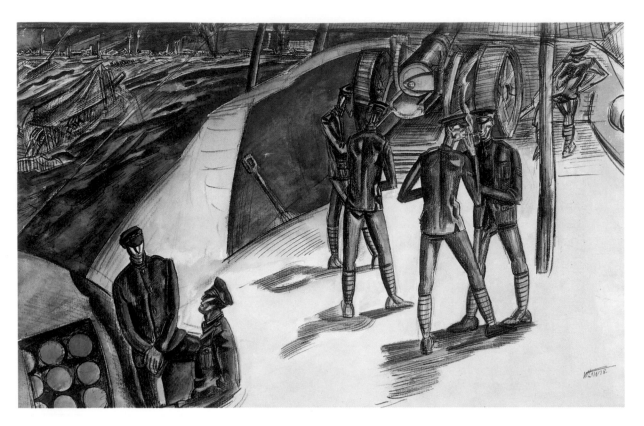

71 Percy Wyndham Lewis, *The Menin Road (Drawing of Great War No. 1)* *c.* 1918

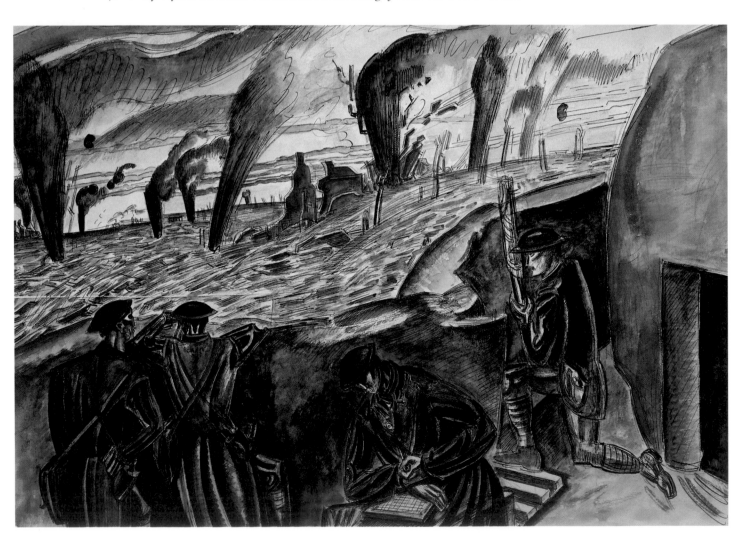

72 Percy Wyndham Lewis, *Drawing of Great War No. 2* *c.* 1918

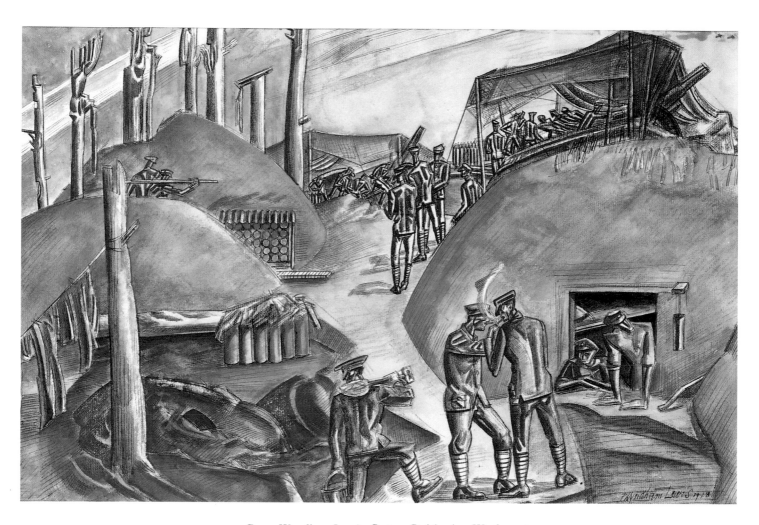

73 Percy Wyndham Lewis, *Battery Position in a Wood* 1918

Frederick Gore

The Resilient Figure: Mark Gertler and Matthew Smith

Mark Gertler's early work is closely related to his family and has an emotional power associated with the striving of a Jewish émigré community to achieve modest prosperity. At the same time the early recognition of his talent brought quite dazzling opportunity for social, intellectual and artistic enlargement. *The Rabbi and his Grandchild* (Cat. 75) belongs to this period. Painted with slow precision over months, it has some of that barbaric flavour which in some of Gertler's work both disquieted and delighted his admirers. He started it as a painting of an old Jew, and added the child, thus converting it to the theme of age and youth. The child who sat was astonished later to find that she appeared sitting on the knee of a rabbi whom she had never met.

The Merry-Go-Round (Cat. 74) is a post-Vorticist painting and Gertler's first really large canvas parallel to the ambitious work of Lewis and Bomberg. Two paintings exhibited at the London Group in 1915 had caused a storm, and when he devoted all his efforts through 1916 to this painting of soldiers and sailors like mechanical toys on a Hampstead merry-go-round, his friends were concerned that it would be treated as a satire on the war effort and get him into trouble with the authorities. In the event, at the 1917 London Group it had some success, though Lytton Strachey commented: 'I felt if I were to look at it for any time I would be carried away with shell shock. I admired it of course, but for liking it, one might as well think of liking a machine gun.'

Gertler continued all his life to search a route which combined the vitality of Modernist method and images of modern life with the capability of the Old Masters to make of each painting a separate enduring masterpiece. His *Bathers* (Cat. 76) of 1917-18 dates from a period of intensive research into Cézanne. Fry had invited him to exhibit with Vlaminck, Friesz and Derain – followers of Cézanne – and put him in the way of examining Cézannes belonging to private collectors. Gertler enjoyed long conversations on the subject with Fry. *Bathers* combines this research into Cézanne's processes with ideas for a new development, which he shared with Bomberg, whom he often visited.

Basket of Fruit (Cat. 79) with *Reclining Nude* (Cat. 77) and *Supper* (Cat. 78) all belong to the high plateau which Gertler reached in the Twenties when he resolved the conflict between belief in the practices of the Old Masters and admiration for Renoir and Cézanne, and equally between those post-Impression-ists and the challenge of French Modernism. The Modernist challenge was relieved by the direction towards Classicism taken by Picasso, Derain and Braque in the Twenties. Against the organization of their Cubist still-life compositions, Gertler could set up realistic still-life as elaborately realized as the Dutch or Spanish Masters, but with spatial and compositional devices taken from Post-Impressionism. In *Supper*, Cubism and the sensuality of Renoir are resolved in a return to painting from nature. *Reclining Nude* is the most beautiful of the many nudes that Gertler painted in this period, wholly successful in the resolution of changing colours and in subtlety of form.

As times changed in the Thirties and British art entered into the European stream with a tendency to simplification and abstraction through the work of Paul Nash, Henry Moore and Ben Nicholson, Gertler felt compelled to change. He had never painted pictures which could be repeated. He found a new inspiration in the French school which he revered, drawing on earlier work by Picasso, Gris and Derain. *The Spanish Fan* (Cat. 80) is the grandest of Gertler's still-life compositions. It is sad that his life ended at a moment of despair, for he was recognized by a younger generation as the finest painter among the experimental artists of his generation and the one most likely to give a future lead.

Although Matthew Smith and Mark Gertler share in the sensual enjoyment of colour and pigment, Matthew Smith's method is almost the reverse of Gertler's. Gertler worked everything out on the canvas and painted every part of every picture three times, whereas Matthew Smith turned to the transparent brilliance of paint liberally loosened by linseed oil applied spontaneously once. His early work, *Dulcie* (Cat. 82) or *The Little Seamstress* (Cat. 83), is closest to French Fauve painting. The stonger control of structure in *Fitzroy Street Nude No. 2* (Cat. 84) is related to Gilman's solidly coordinated planes of colour.

Matthew Smith's early painting both here and in the Cornish landscapes is not very far distant from Camden Town and Blooms-bury, for he belongs to the London Post-Impressionist development rather than to France. His radical attack on colour, which had been reinforced by friendship with the erratic Roderic O'Conor, singled him out as a positive and extraordinary artistic personality. He became for almost a decade the most admired painter in London and legend sug-gested that he had started rather late and un-taught, having found his way round Pont Aven and the free studios of Paris. In fact he had had a thorough training in Manchester, at the Slade and informally in France; the full enjoyment of his career was delayed by active service and war injury.

The Cornish landscapes (Cat. 85, 86), painted in 1920 with very low tone and brilliant in dark red and purple colours, re-main among his most surprising work. He is said to have attributed them quite simply to the observation of a very wet summer. His broadcast in 1950 indicated briefly his thoughts on nature as the source of art, a nature which is 'overhidden' and cannot alone give vision; he quoted Leonardo: 'Art struggles with and attempts to rival nature.'

In common with other British painters of the day, the full maturity of his work came as he related his experiments in art and the emotions derived from life to the record of similar experiences left in the work of Old Masters, in particular Rubens. From the winter of 1923-4 he began the noble series of paintings of Vera Cuningham at the Villa Brune, which are surely love poems as fine as any in the English language. The opulence of the work which stems from that moment was bound up with the generosity of her spirit and her physical presence. The elation with which he approached his canvas and the speed necessary to capture the moment produced a simplification (at first almost naive) of colour and form with complete unity of both: form is seen as colour. Pure ultra-marine, crimson lake and viridian (the natur-ally transparent colours) dominated his palet-te; the figure is picked out in a slightly de-based orange; there is a simple expressive black line and minimal modelling. *The Falling Model* (Cat. 87) is among the more sophisti-cated but equally spontaneous compositions coming at the end of this Villa Brune period.

Girl Holding a Rose (Cat. 88) is one of many enchanting nudes, some lighter, some darker, which at the end of the decade brought him closer to an older tradition. A strong chiaroscuro elaborates the composi-tion with a pattern of light and dark, to de-fine a flexible space and the movement of solid and sensual forms within it. The character of the model is always acutely per-ceived and economically realized. The por-trait of *Augustus John* (Cat. 89) demonstrates Matthew Smith's ability to capture personal-ity and make a true pictorial statement in a short burst of intense and creative observa-tion.

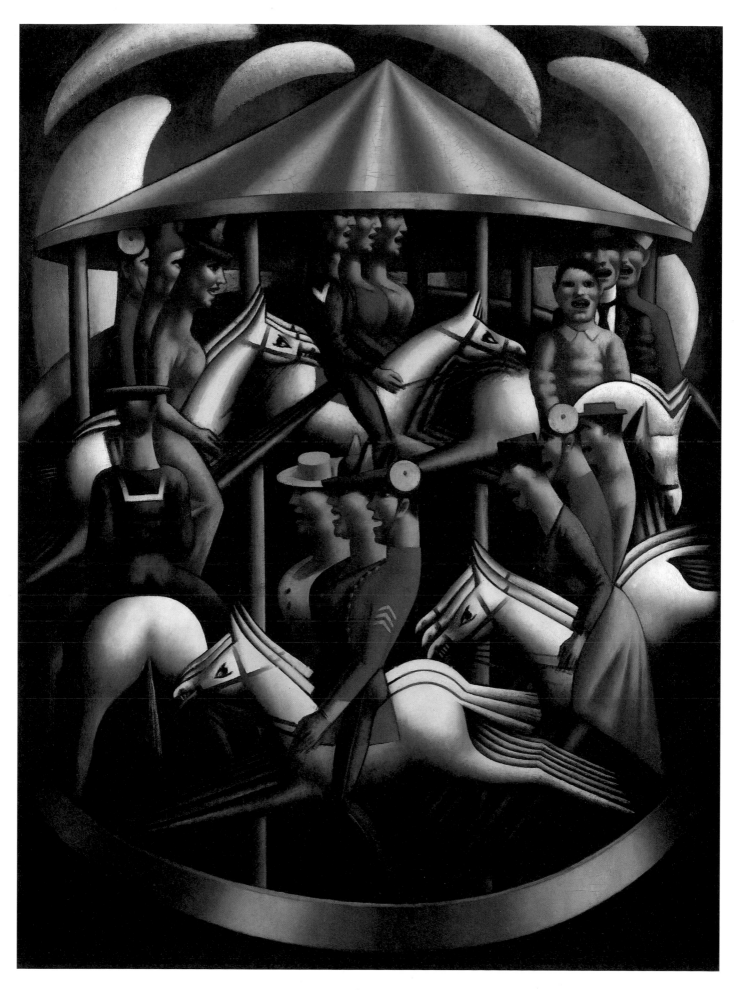

74 Mark Gertler, *The Merry-Go-Round* 1916

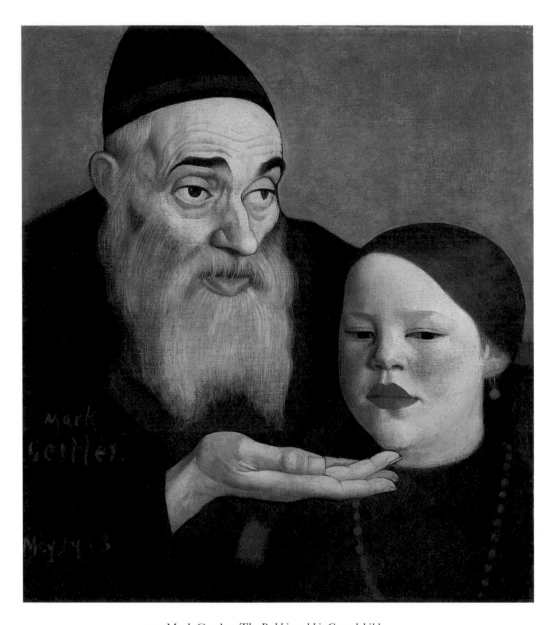

75 Mark Gertler, *The Rabbi and his Grandchild* 1913

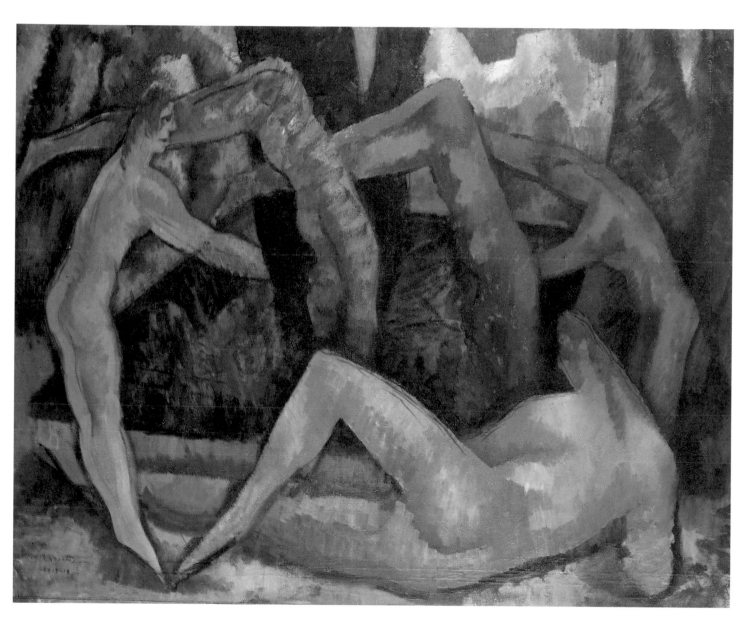

76 Mark Gertler, *Bathers* 1917-18

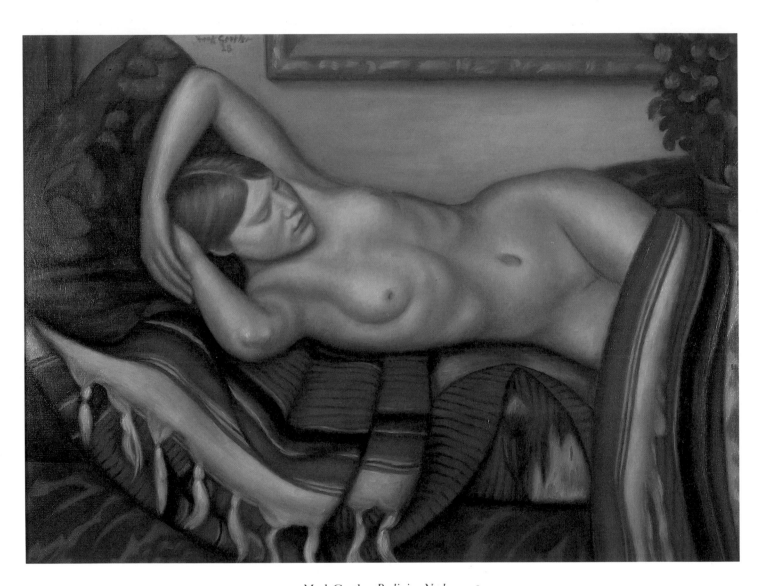

77 Mark Gertler, *Reclining Nude* 1928

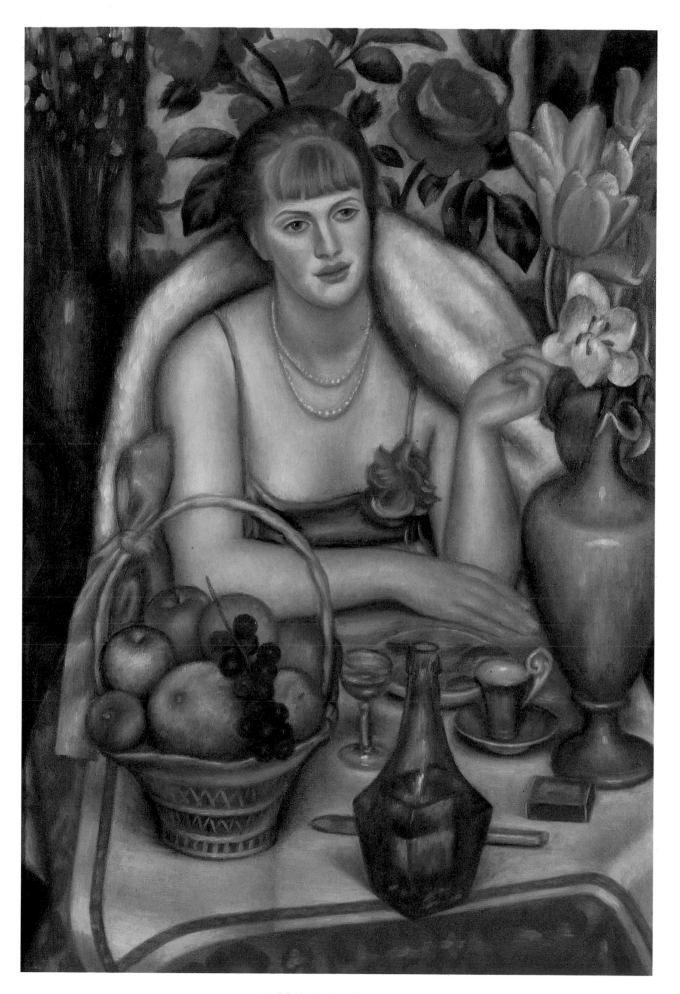

78 Mark Gertler, *Supper* 1928

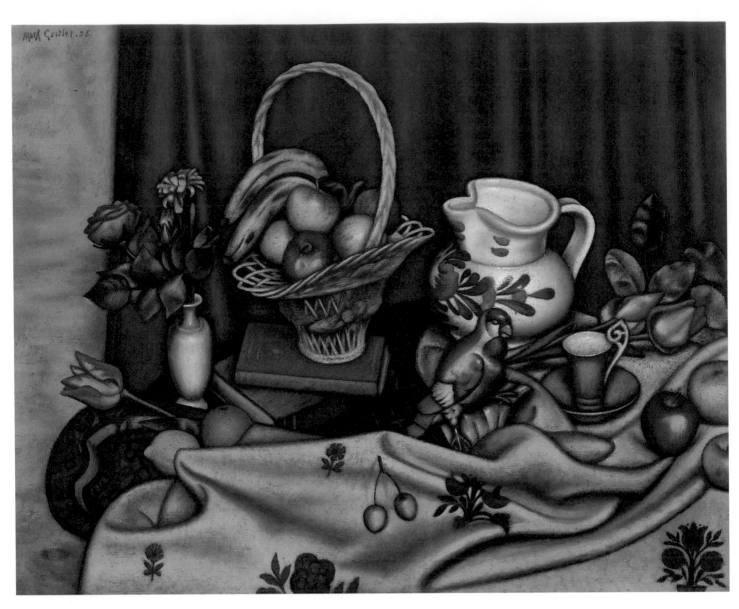

79
Mark Gertler
Basket of Fruit
1925

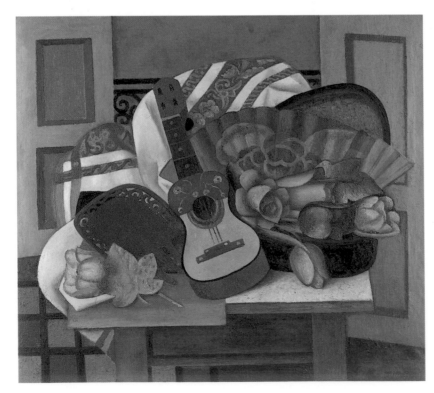

80
Mark Gertler
The Spanish Fan
1938

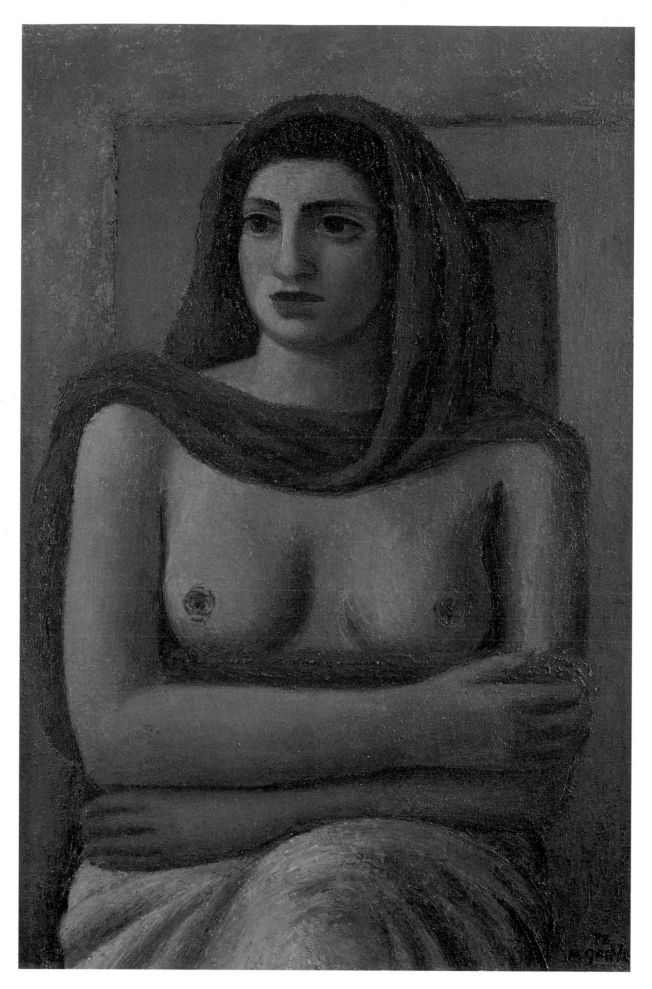

81 Mark Gertler, *The Red Shawl* 1938

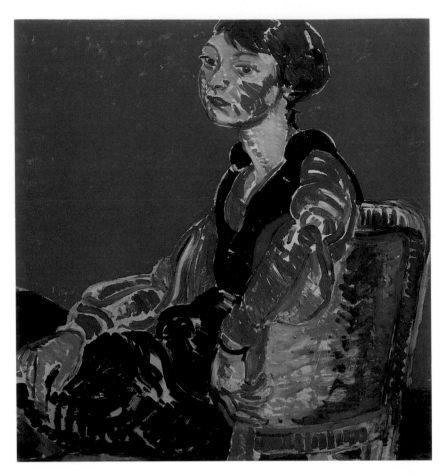

82
Matthew Smith
Dulcie
c. 1913-15

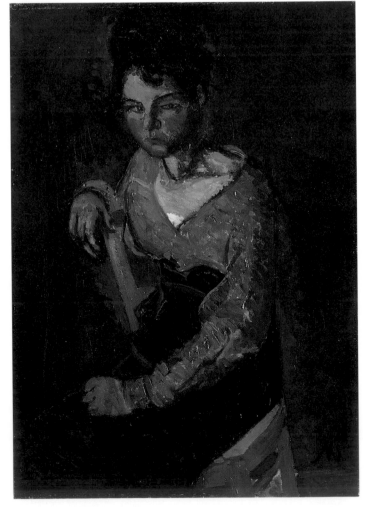

83
Matthew Smith
The Little Seamstress
c. 1917

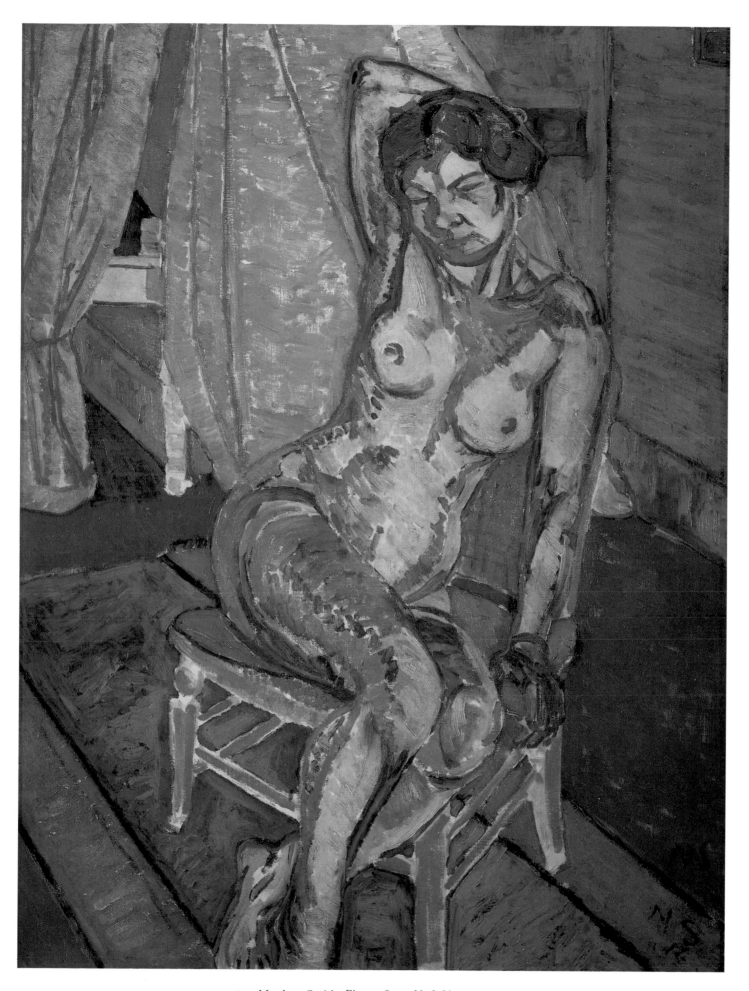

84　Matthew Smith, *Fitzroy Street Nude No. 2*　1916

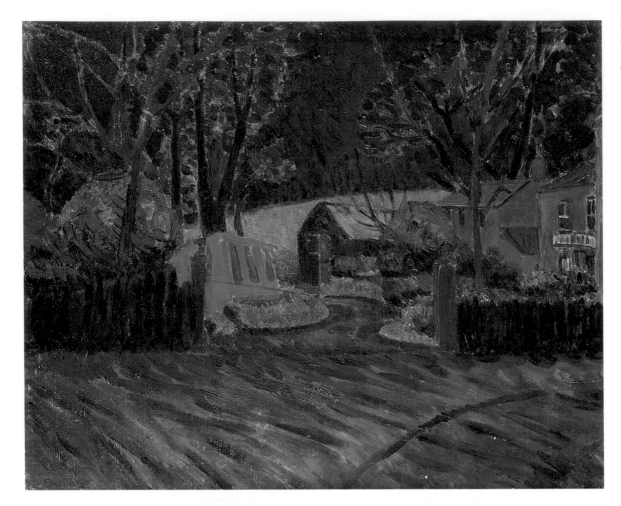

85
Matthew Smith
*Winter Landscape,
Cornwall*
1920

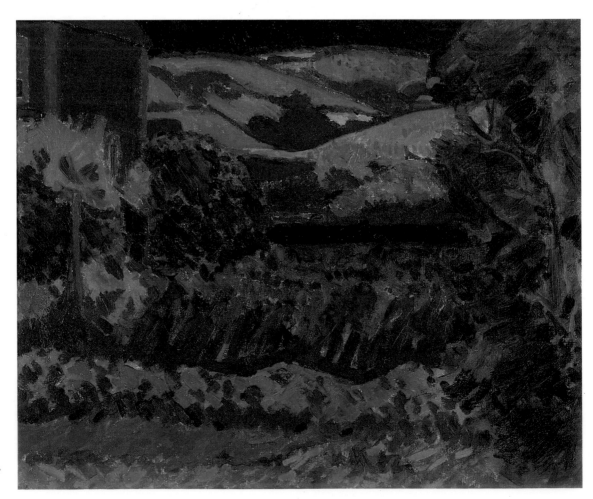

86
Matthew Smith
Cornish Landscape
1920

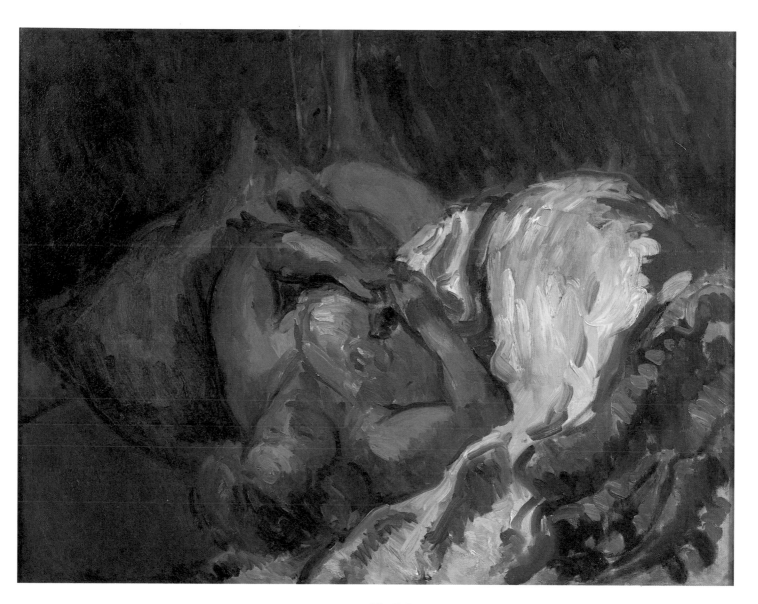

87 Matthew Smith, *The Falling Model* 1926

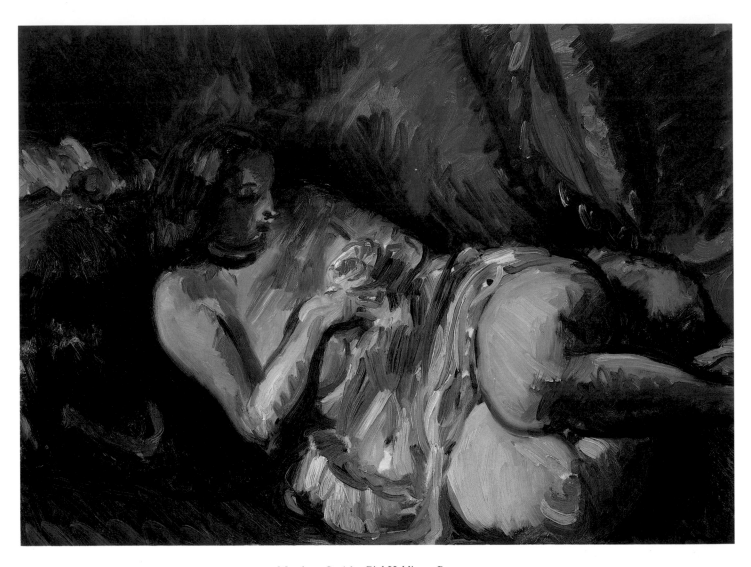

88 Matthew Smith, *Girl Holding a Rose* *c.* 1930

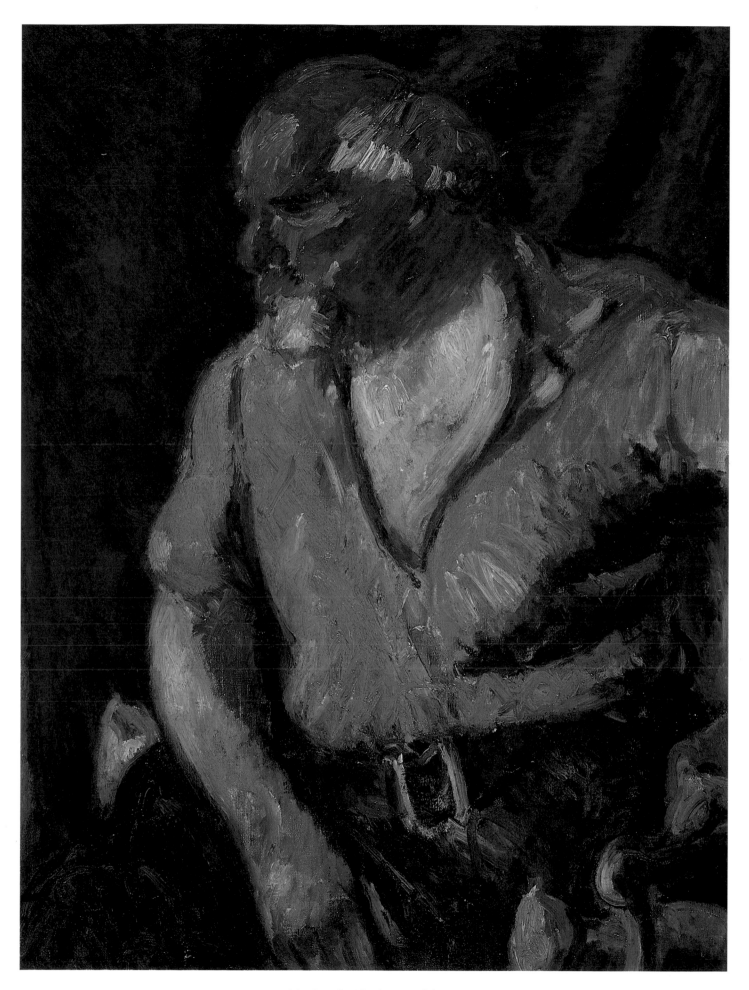

89 Matthew Smith, *Augustus John* 1944

Richard Cork

The Resilient Figure: Dobson, Epstein and Gill

When Eric Gill held his first one-man show at the Chenil Gallery in January 1911, Wyndham Lewis was sufficiently impressed to declare that 'his works are small, excellent and ribald. He has done a Christ immolating himself on the Cross: next door to it, a saucy female figure, with gilded brush, typifying Lechery.' Soon Gill's reputation as a leading young exponent of 'carving direct', employing techniques and stylistic sources dramatically at variance with the older generation of British sculptors, was confirmed when Roger Fry included his work in the Second Post-Impressionist Exhibition of 1912.

Mother and Child (Cat. 92), which was probably inspired by the birth of Gill's third daughter Joanna in 1910, possesses an almost religious solemnity. Fry admired it enough to ask Clive Bell: 'has anyone ever looked more directly at the real thing and seen its pathetic animalism as Gill has? Merely to have seen what the gesture of pressing the breast with the left hand means, as he has, seems to me a piece of deep imagination.' The critic was impressed by a sculptor whose range encompassed the erotic delight of *Ecstasy* (Cat. 91) and the belligerence of *Boys Boxing* (Cat. 90), although Gill's conversion to Roman Catholicism then led him to the austere and stoical medievalism of the *Stations of the Cross* in Westminster Cathedral.

The principle of 'carving direct' and respecting the identity of his materials continues in *Deposition* (Cat. 93). It exemplifies the intensity of Gill's religious feeling, although he reserved his greatest scorn for priests who advised him to 'remember that life here below is like being in the W. C. (quite pleasant, not necessarily sinful, but only a dirty function)'. He was convinced

that a full comprehension of religious truth could only be attained by savouring sensual pleasures without any puritanical guilt.

Gill had never pursued machine-age abstraction, so his work presents a more unified approach than that of his old friend Jacob Epstein, whose sculpture underwent a fundamental change after the First World War. In 1917 he was already dissatisfied enough with extreme innovation to tell the American collector John Quinn: 'I think you are inclined to overrate what you call advanced work; not all advanced work is good, some of it is damn damn bad.' Soon afterwards Epstein began a successful career as a modeller of vigorously expressive portrait busts. The concerns of his pre-1914 career survive more or less intact only in carvings which continued to attract vilification. *Genesis* (Cat. 99) was one of the most roundly abused, prompting the *Daily Express* to call it a 'Mongolian Moron That Is Obscene' and to declare that 'artistically the thing is absurd. Anatomically, it is purely comic. It is a bad joke on expectant motherhood.'

Genesis is, in fact, a sincere and long-meditated work which develops the preoccupations already evident in his *Figure in Flenite* (Cat. 56) nearly twenty years before. Although the 'primitive' influence dominating the earlier work is still pronounced here, particularly in the woman's head, the rest of her body is more naturalistic. But *Elemental* (Cat. 100) proves that Epstein never wanted his carvings to become excessively involved in anatomical detail. This crouching figure is rough-hewn and brusquely simplified – like a human body not yet fully emerged from evolutionary development. The same primal quality animates *Jacob and the Angel* (Cat. 101),

even if the forms are now more fully defined than in *Elemental*. It is an impassioned and highly personal work, fusing intense physicality with an equally ardent desire to become absorbed in religious beneficence. 'The deeply intimate and the human were always sought by me,' Epstein explained in his autobiography, 'and so wrought, that they became classic and enduring.'

During the 1920s Epstein's position as the leading Modernist sculptor in Britain was threatened by the emergence of Frank Dobson. The only sculptor to be included in the 'Group X' exhibition of 1920, where Lewis brought together many of the former Vorticists for the last time, he showed early carvings that were clearly indebted to pre-war experimentation. *Pigeon Boy* (Cat. 98) and *Two Heads* (Cat. 95) reveal an early interest in Chinese and Indian art, fused with Dobson's admiration for contemporary sculptors such as Gaudier and Modigliani.

As the decade proceeded, Dobson moved away from the Vorticist orbit. In 1922 his gleaming brass head, *Sir Osbert Sitwell Bt* (Cat. 97), still possessed a Lewis-like rigidity and detachment, but by 1927 the newly completed *Cornucopia* (Cat. 96) announced a very different emphasis on rounded Mediterranean fulfilment. Gill admired the carving enormously and its classical amplitude won extravagant approval from Clive Bell, who called it 'the finest piece of sculpture by an Englishman since – since I don't know when. Here is pure sculpture.' The spirit of serene, Maillolesque classicism persisted in Dobson's work during the 1930s, though by then Hepworth and Moore had supplanted his short-lived pre-eminence among the exponents of innovative British sculpture.

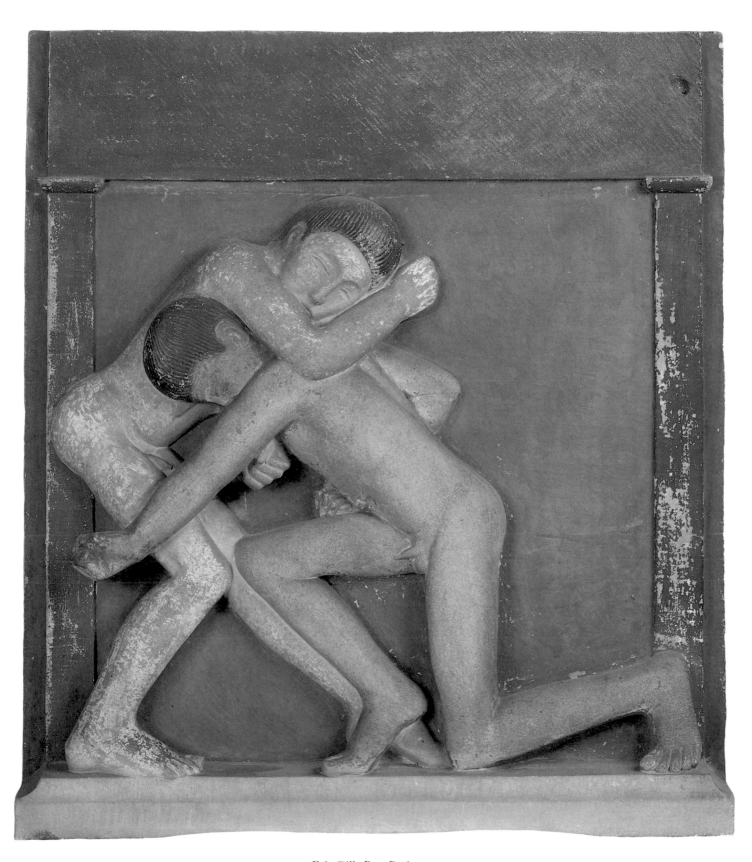

90 Eric Gill, *Boys Boxing* 1913

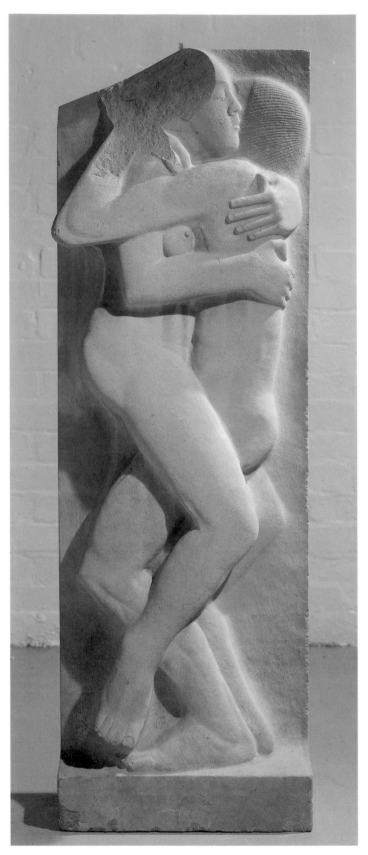

91 Eric Gill, *Ecstasy* 1911

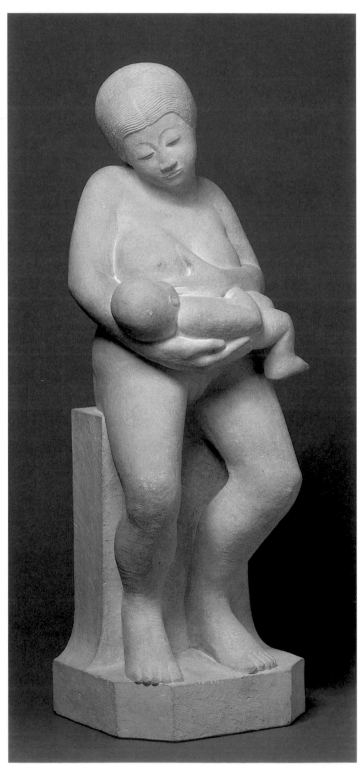

92 Eric Gill, *Mother and Child* 1910

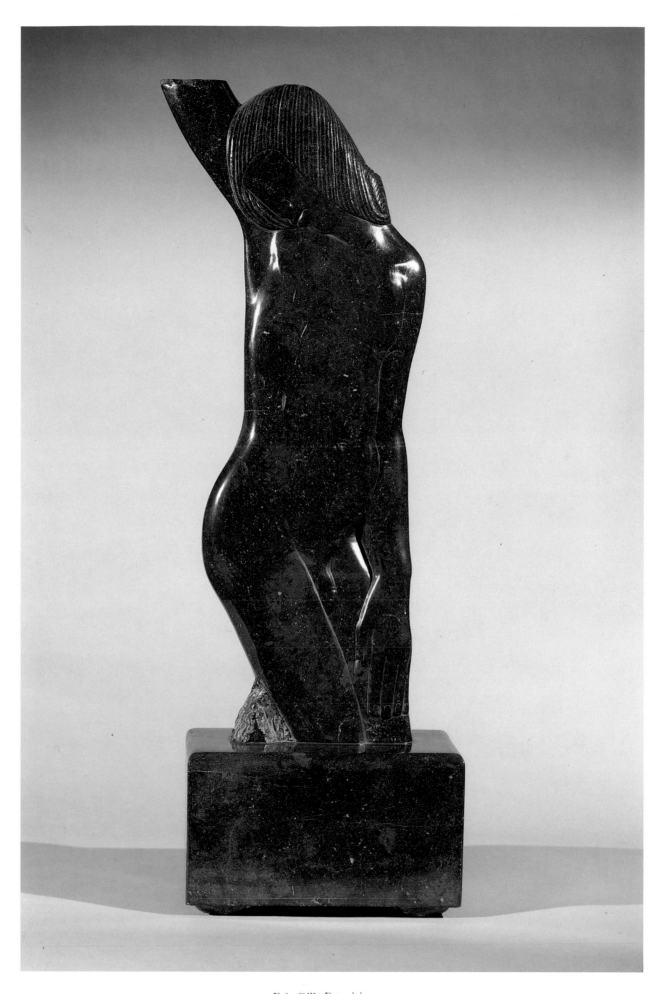

93　Eric Gill, *Deposition*　1924

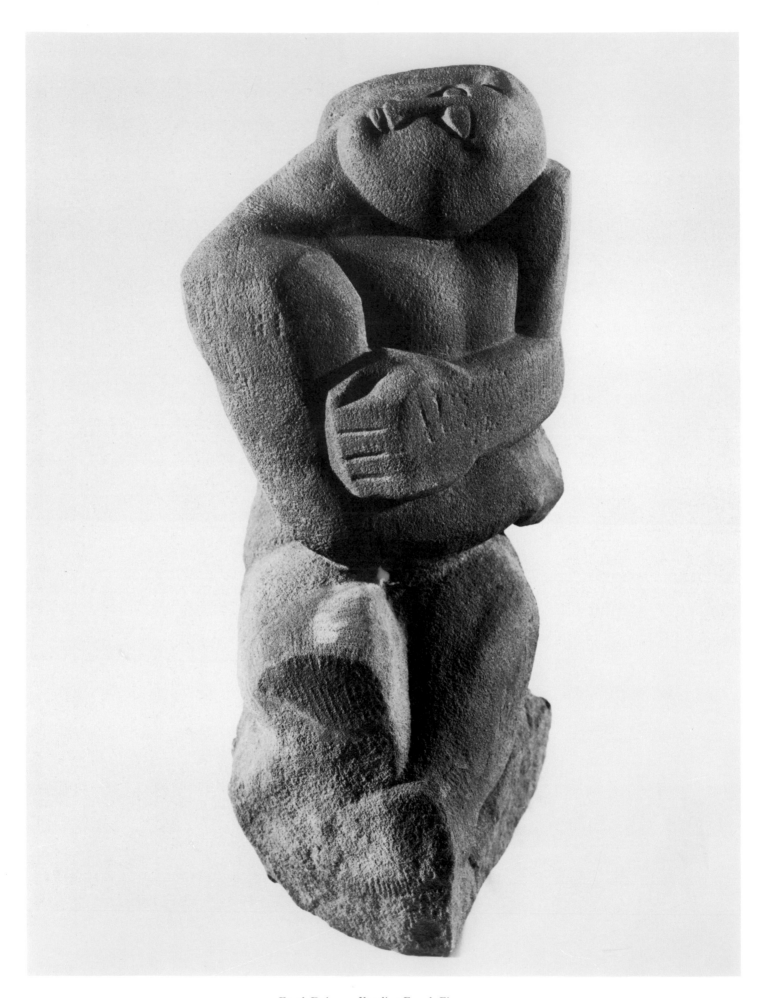

94 Frank Dobson, *Kneeling Female Figure* c. 1915

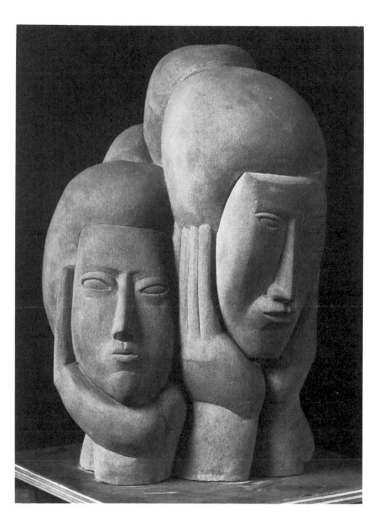

95 Frank Dobson, *Two Heads* 1921

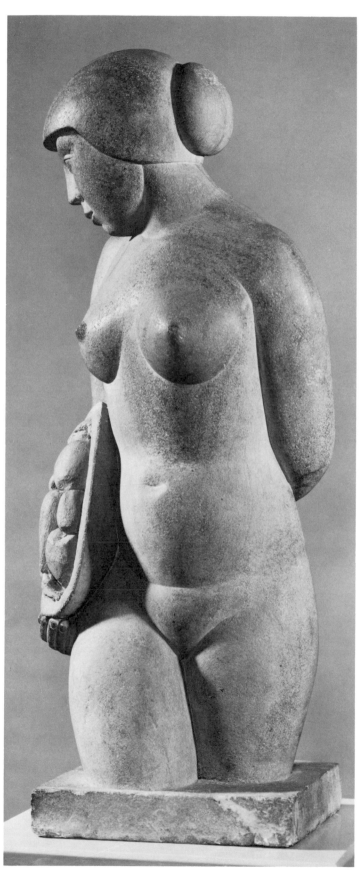

96 Frank Dobson, *Cornucopia* 1925-27

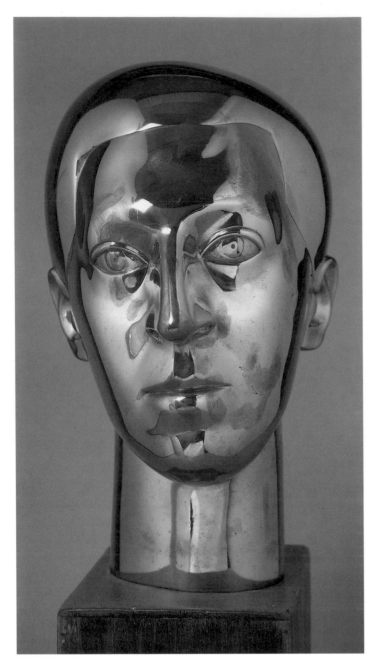

97 Frank Dobson, *Sir Osbert Sitwell Bt* 1923

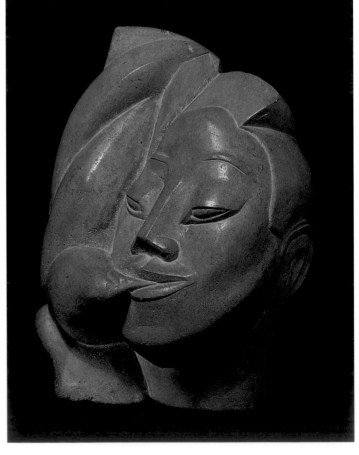

98 Frank Dobson, *Pigeon Boy* 1920

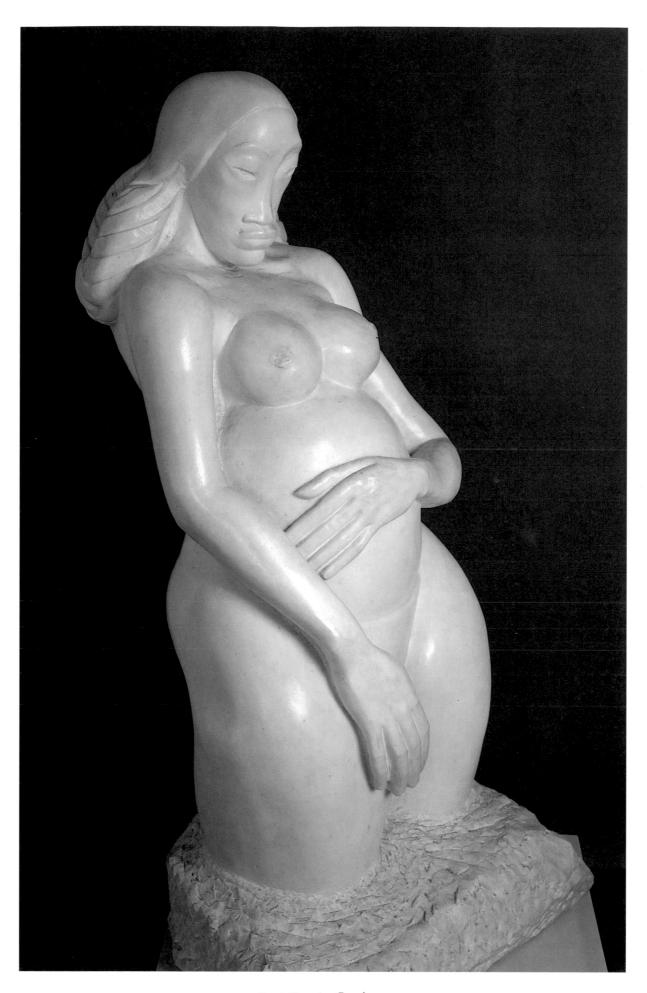

99 Jacob Epstein, *Genesis* 1931

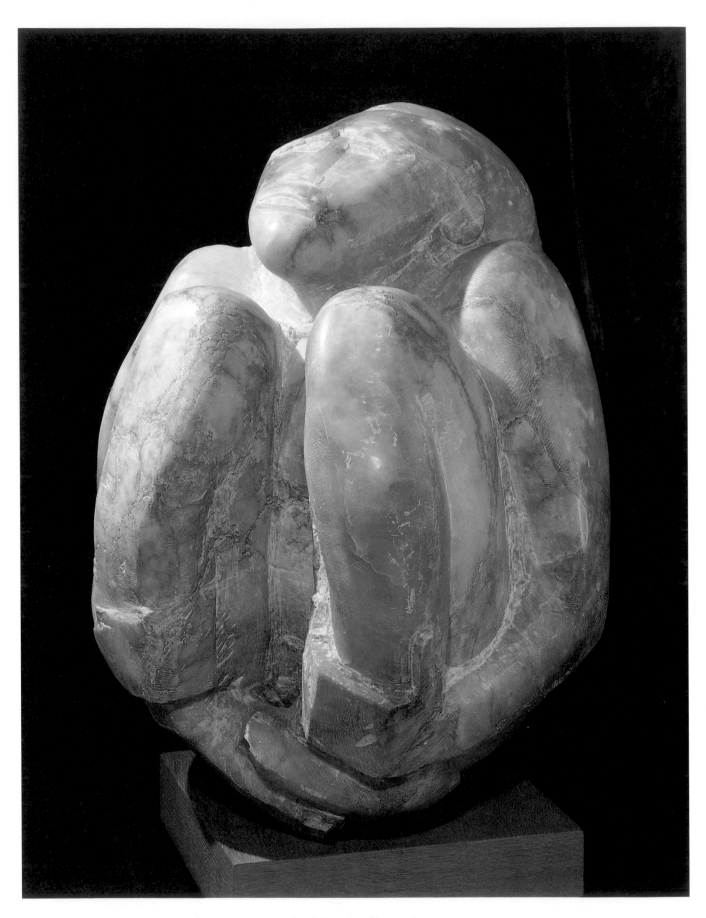

100 Jacob Epstein, *Elemental* 1932

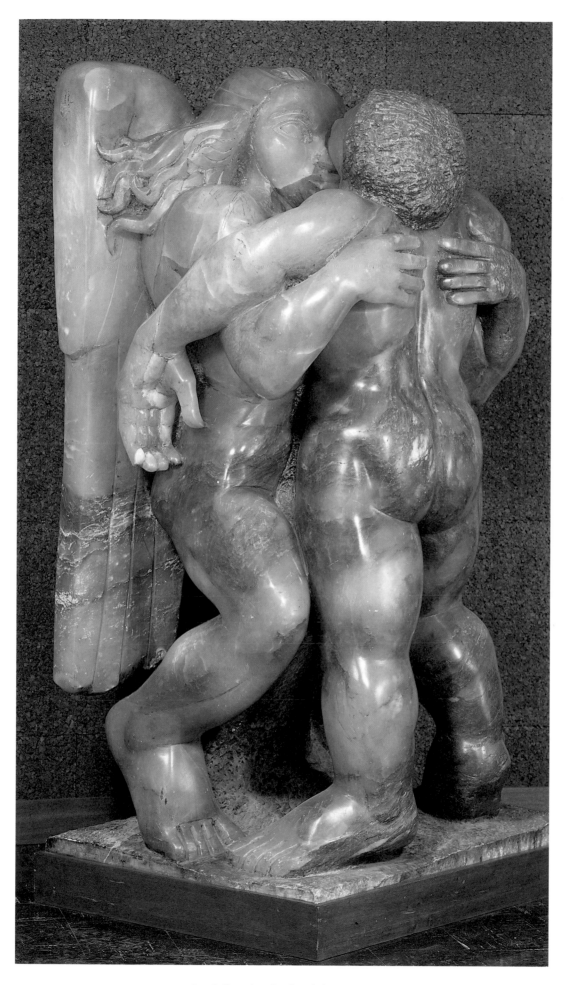

101 Jacob Epstein, *Jacob and the Angel* 1940

Andrew Causey

The Everyday and the Visionary

The post-war years saw the radical innovations of 1914 checked and a universal return to figurative imagery. This was in keeping with developments in Paris, where Picasso's Neo-Classicism was a reaction against his more revolutionary pre-war styles. Wyndham Lewis made a single attempt to revive Vorticism by organizing the 'Group X' exhibition in 1920, but the movement had in effect already dissolved, and Lewis himself in *A Battery Shelled* (Cat. 70) and the war pictures in his 1919 exhibition 'Guns', had already demonstrated that his concern was with the re-evaluation of the human figure.

Praxitella (Cat. 117) is a portrait of Lewis's friend Iris Barry, who was later to be founder and first curator of the film department at the Museum of Modern Art in New York. It is Byzantine in its grandeur and absence of subjective involvement on the part of the artist; it still shows traces of Lewis's characteristic hard angular style of the pre-war period, now adapted to a post-Vorticist idiom. At the same time Lewis was working on a series of grotesques which he christened Tyros. They were shown at his 1921 exhibition 'Tyros and Portraits' and feature in *The Tyro*, the second in the series of occasional periodicals Lewis published that had begun with *Blast*. 'These immense novices', he wrote, 'brandish their appetites in their faces, lay bare their teeth in a valedictory, inviting, or merely substantial laugh.' The Tyros represented the elemental, bodily side of man in the division, which Lewis regarded as absolute, between body and intellect.

Self-Portrait as a Tyro (Cat. 115), with its glowing yellow background, is reminiscent of certain of the paintings of peasants at Arles by Van Gogh, an artist who interested Lewis on account of the sultry, brooding character – as he saw it – of these portraits. *A Reading of Ovid (Tyros)* (Cat. 116) seems to be a satire on the idea of elemental physical man engaging in study of Classical poetry (it was a time when Classical values were central to art critical discussions). Though they relate to Hawaian war gods with red feathered faces and sharks' teeth that Lewis would have seen in the British Museum, and themselves instil a degree of terror, Lewis typically introduces also an element of burlesque, making the Tyros slightly ridiculous by giving them an air of innocence.

The counterpart of these types in Lewis's work was his *Portrait of the Artist as the Painter Raphael* (1921, Manchester City Art Gallery), a sober and composed self-portrait which is near to being a paradigm of the meaning of

Classicism at the time. Regrettably, Lewis, whose initiatives after the war showed him still to be as much the potential leader of British painting as he had been in the Vorticist years, temporarily abandoned painting in 1923 in favour of writing fiction and philosophy. The lack of his powerful intellect behind British art in the Twenties is evident, though some of his ideas for figure painting were taken up by William Roberts.

Roberts had been the youngest painter in the Vorticist group and was still only twenty-three when the war ended. The Twenties were to be a particularly strong decade for Roberts, who responded positively to the pressures for a return to figuration with scenes of urban life which, at least until about 1927, retained links with Cubism and his earlier Vorticism. Roberts showed with Group X, then separated from Lewis, and by the time of his first one-man exhibition in 1923 had evolved what was to remain his characteristic subject-matter: he painted largely leisure themes, sports, including boxing and cycling, and popular entertainments, such as cinema, music hall and dancing, but also scenes of work. Roberts was very skilled at adapting Cubism to urban genre subjects. He had a strong sense of form which enabled him, despite the variety of narrative detail in his paintings, to create powerful and lucid designs; he was never just an illustrator on a large scale. Though Roberts was a subject painter, it is not altogether surprising to find him gaining support from the Bloomsbury Group, which advocated design and structure as against subject, and becoming in 1927 an early member of the London Artists' Association in which one leading Bloomsbury figure, Maynard Keynes, was financially involved.

Critics between the wars, led by *The Times* reviewer of his 1923 exhibition, felt that Roberts had the making of a mural-scale painter. '*Dock Gates*, to name only one example, shows that Mr Roberts would be the ideal decorator of a municipal or commercial building,' the reviewer said, 'and it is indeed remarkable that the picture has not been secured by one of our shipping companies.' Writing about later exhibitions in 1929 and 1931, the same writer felt that Roberts was the nearest England had to a truly popular artist because he felt for the richness of life in the London streets and 'one feels that the man in the street would understand his pictures'. It is a tragedy that Roberts did not have the opportunity as a mature artist that was given to Stanley Spencer at Burghclere

to design a set of complex figure compositions on a grand scale (Fig. 6, p. 21): he and Spencer were the two artists of the inter-war years best fitted to such a task.

Like Roberts, Spencer painted everyday people, who were often the inhabitants of his native village of Cookham in Berkshire, as Roberts's characters belong to central London where he lived. While Roberts gave a new poignancy to paintings of daily life by looking at ordinary people with a fresh eye, Spencer went beyond this and fused a vision of Christian love and brotherhood, which drew on stories from the New Testament, with events in Cookham. *The Centurion's Servant* (Cat. 102), for example, refers to the miracle by which Jesus healed a sick man who was far away. Spencer recalled that the bedroom in the painting was suggested to him by the servants' bedroom at 'Fernlea', the Spencers' home in Cookham High Street; he was not normally allowed in but occasionally heard mysterious voices coming from it (which turned out to be the maid conversing with neighbours through the party wall). This connected in his mind with his mother's telling him how Cookham people gathered to pray round the beds of the sick. There are several ideas fusing here, connected with servants, sickness and healing, words heard from afar, and rooms unknown except in the imagination. But, strangely, no explanation accounts for the child on the bed whose terror is the real subject of the picture. When the art critic Frank Rutter later assumed it to be connected with the war, Spencer was dismissive and, even without the clues Spencer did give to its inspiration, the picture seems too complex and personal for Rutter's explanation that it was the reaction of children to an air raid. It has a strong autobiographical element and stands on the borders of innocence and experience. It is the point in Spencer's art at which sexuality, so central later (see Cat. 104), seems to play a significant part for the first time, as a force that is felt but only slightly understood.

In *Christ's Entry into Jerusalem* (Cat. 103) the events of Palm Sunday are represented in Cookham High Street near the house where Spencer had lived as a child. In *The Dustman or The Lovers* (Cat. 106) Spencer reflected on the religious subject that occupied his attention more than any other – the Resurrection of the Body at the Last Judgment.

Spencer had devoted much of his energy in the Twenties to the mural paintings in the Sandham Memorial Chapel at Burghclere, which represented memories of his war ser-

vice in Salonika and focused not on violence or suffering but on war as service, fraternity and collaboration. He came to think of himself as a mural painter and in the Thirties nurtured a second scheme on to which to concentrate his energy and ideas, the Church House. This project, of which *The Dustman or The Lovers* was one element, failed because no patron emerged. For the rest of Spencer's life the Church House remained a kind of pipe dream; the fact that the project never quite stabilized is typical of the perpetually disorganized state of Spencer's mind resulting from the constant crowding of fresh ideas. The basic idea of the Church House, for which he made a number of designs, was for a church-shaped building, based on a Gothic plan with a nave and two aisles, which was to be filled with paintings on the theme of God in the world and the propagation of his message of love. The focus of the Church House was to have been a canvas of the Pentecost over the chancel arch, painted in such a way that the steps the apostles would take down from the Upper Room to spread the word of God through the world would lead them into Cookham High Street – the spaces above the arches on either side of the nave being the two sides of the street. It was a brilliant concept, and if Spencer had been fortunate enough to find a patron to pay for the building, as at Burghclere, he might have seen the project through. In the event what we are left with is a collection of individual pictures, like *The Dustman*, which show how exciting the finished project could have been.

On one level *The Dustman or The Lovers* simply shows a dustman and other labourers reunited with their wives amid the topiary and picket fencing of a Cookham garden, but Spencer also intended it as a Resurrection, part of a projected Last Judgment series for the Church House. The dustman of the title is held high in the centre of the picture by his wife. Spencer wrote that 'the joy of his bliss is spiritual in his union with his wife who carries him in her arms and experiences the bliss of union with his corduroy trousers. . . . They are gazed at by other reuniting wives of old labourers . . . in ecstasy at the contemplation that they are reuniting and are about to enter their homes.' It is a religious picture: the meeting of the saved at the Last Judgment, the apotheosis of the working man, and a celebration of a new life in which even the refuse – an old teapot, an empty tin and some discarded cabbage leaves – are valued and special.

Spencer continued to see his paintings as belonging together in sets, and the Clydeside shipbuilding series in the Second World War provided him with an opportunity of the Church House type but on a slightly more modest scale. In 1940 Spencer was sent by the War Artists' Advisory Committee to Lithgow's Yard at Port Glasgow on an official commission to record the building of warships. He loved the shipyards because he found camaraderie and concentration on work there, and the pictures that emerged from the commission (see Cat. 107) tell as much about the dedication and concentration of the shipyard workers as about the building processes themselves.

Though Spencer, unlike Roberts, had scarcely been affected by the modern movements before the war, neither this nor his individual and innocent approach to life compromised his skills as a designer of complex figure compositions, in which he was Roberts's equal. While Roberts, in pictures like *The Dance Club* (Cat. 109) and *Les Routiers* (Cat. 114), liked spare designs in which plain, abstract shapes surround the figures and concentrate attention on the rhythm and energy of the groups, Spencer liked to pack narrative detail into all parts of the compositions; it is a tribute to his capability as a designer that pictures like *The Dustman* remain, for all their elaboration, extremely lucid.

All three painters were impressive portraitists. Lewis's portraits are the most severe and reserved, the most iconic and the least concerned with expression of emotion or communication between subject and viewer. Roberts preferred broad planes of paint to the detail and finish of Edwardian portraiture which he was escaping from, and the rich, creamy paint surface of *A Woman (Sarah)* (Cat. 113) shows him at his most sensual. Even his portraits have that sardonic humour which marks Roberts's painting in general. In contrast to Lewis's need for distance between himself and his sitter, Spencer is involved in an intense emotional exchange as he searches out each vibration of energy in face and hand. In the *Self-Portrait with Patricia Preece*, (Cat. 104) the saturating light that floods over the bodies and leaves no shadow marks a desire for total revelation which, in this double portrait, leaves Spencer looking quizzical and apprehensive. The absence of any hint of idealization in the nude is bold, if rather alarming, and shows Spencer taking nude portraiture in a direction hitherto unexplored in British art.

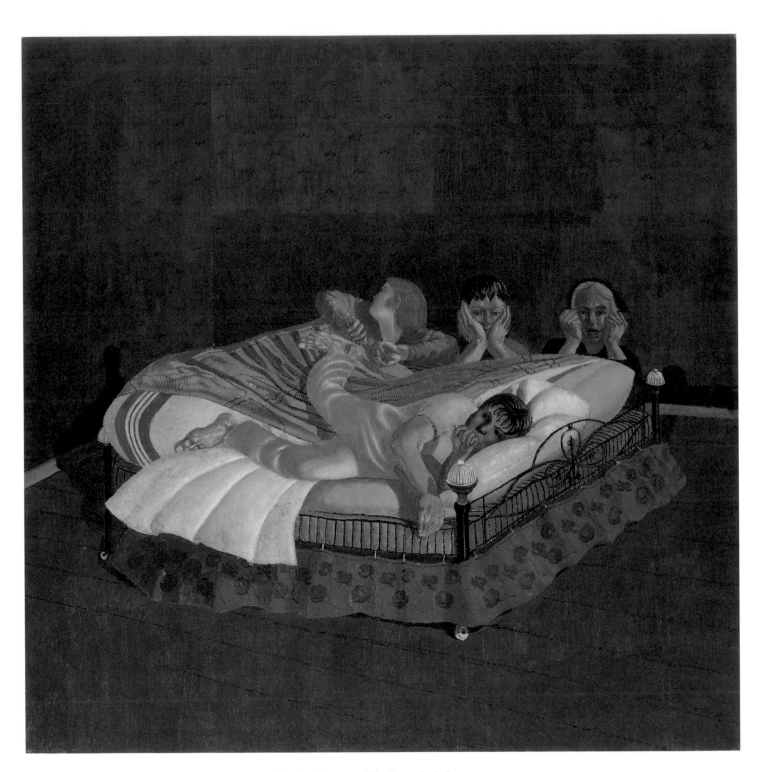

102 Stanley Spencer, *The Centurion's Servant* 1914

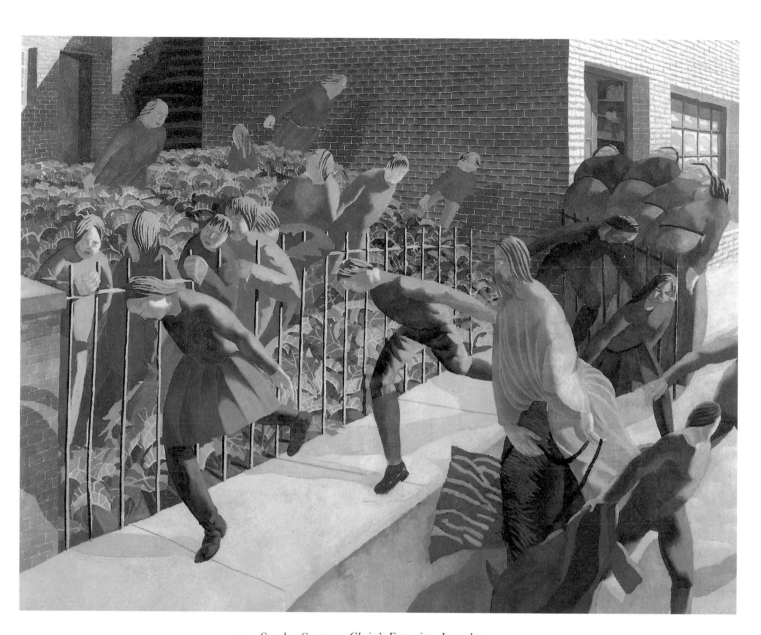

103 Stanley Spencer, *Christ's Entry into Jerusalem* 1921

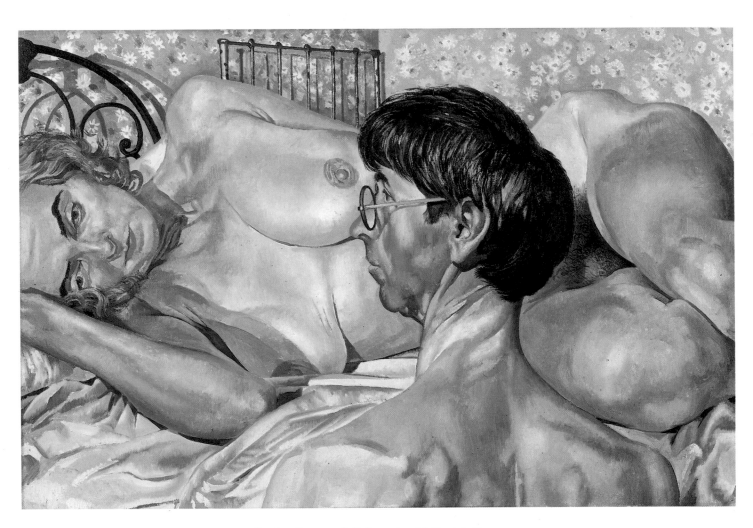

104 Stanley Spencer, *Self-Portrait with Patricia Preece* 1936

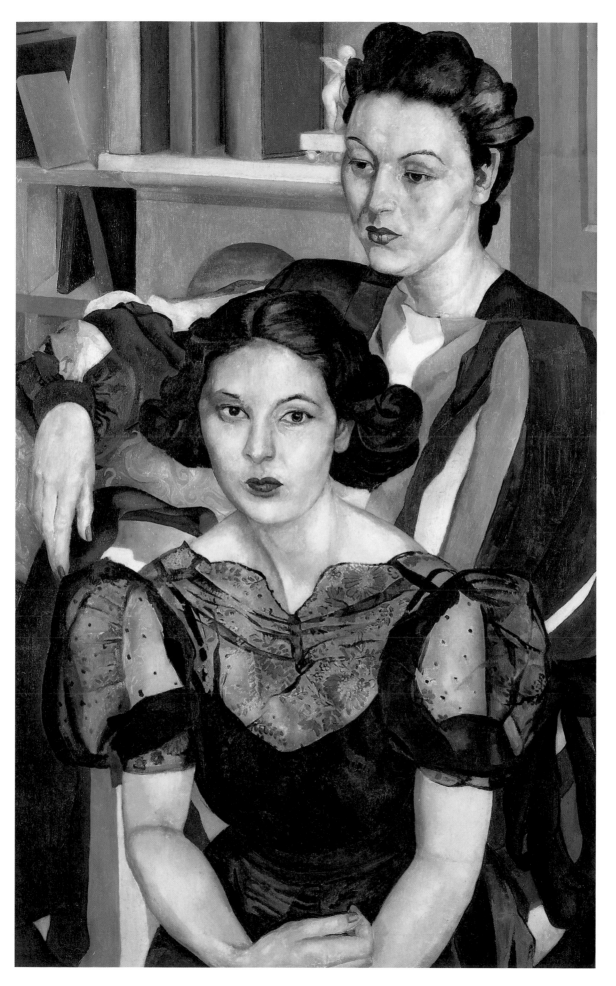

105　Stanley Spencer, *The Sisters*　c. 1940

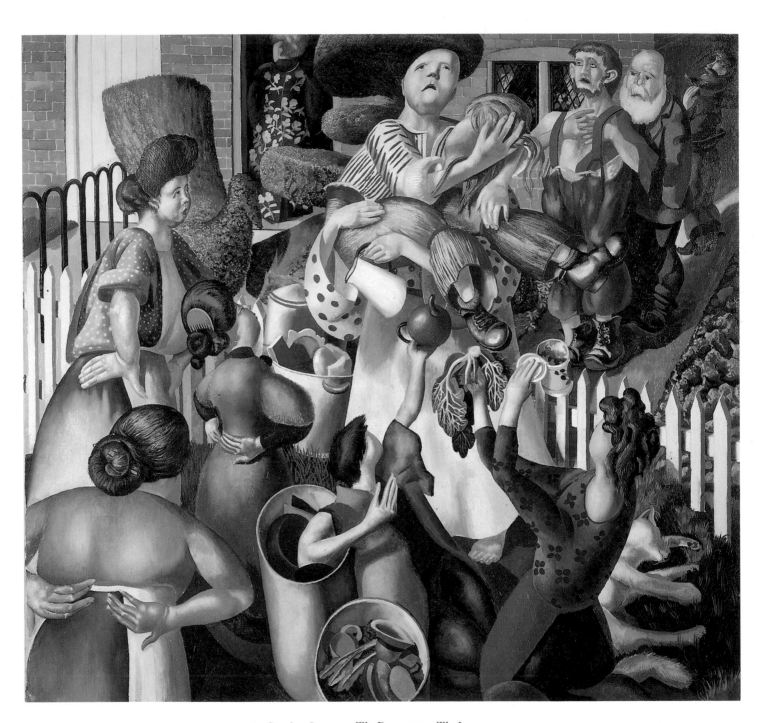

106 Stanley Spencer, *The Dustman or The Lovers* 1934

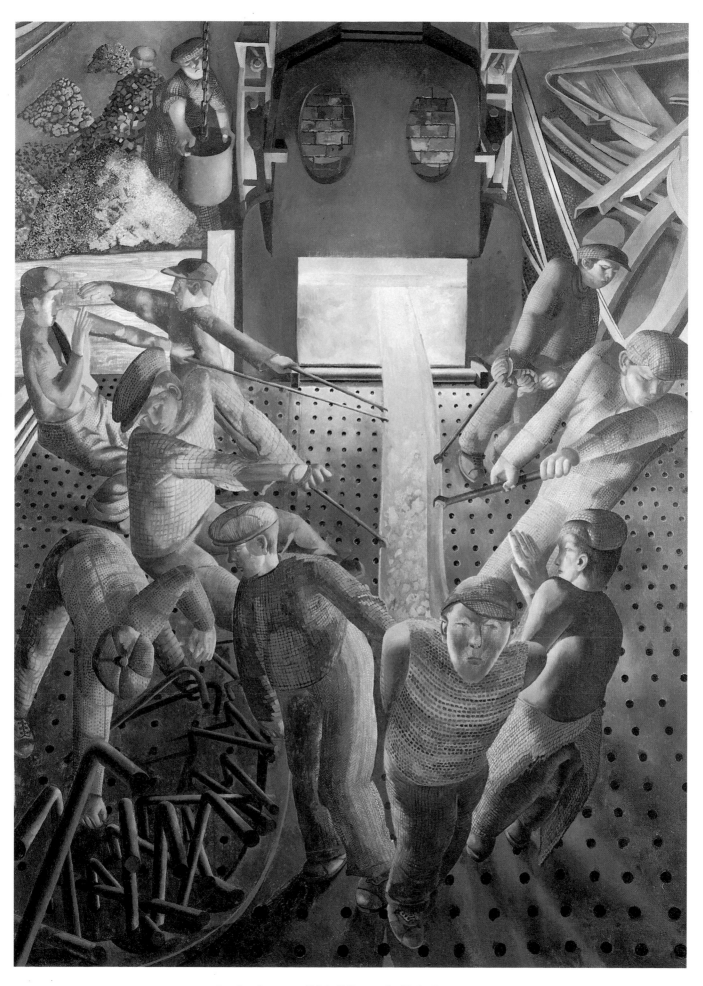

107 Stanley Spencer, *Shipbuilding on the Clyde: Furnaces* 1946

108 William Roberts, *The Cinema* 1920

109 William Roberts, *The Dance Club* 1923

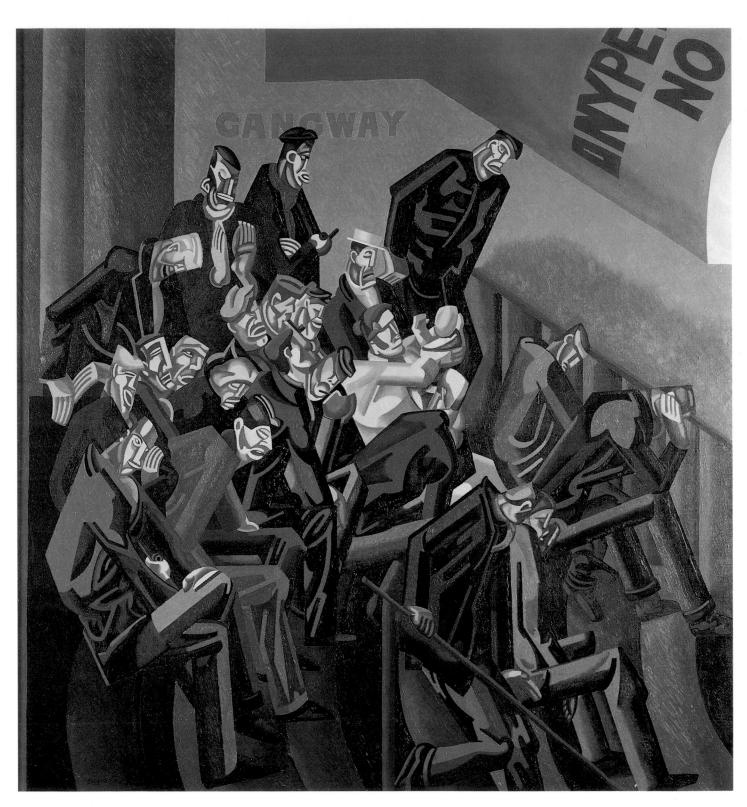

110 William Roberts, *At the Hippodrome* *c.* 1921

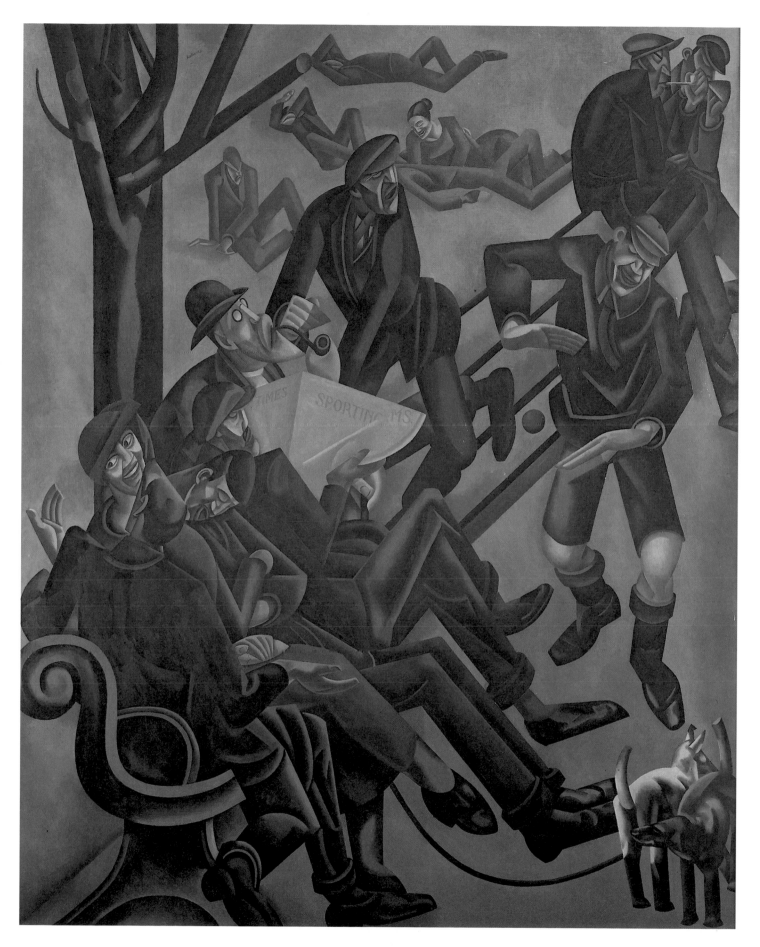

111 William Roberts, *Bank Holiday in the Park* 1923

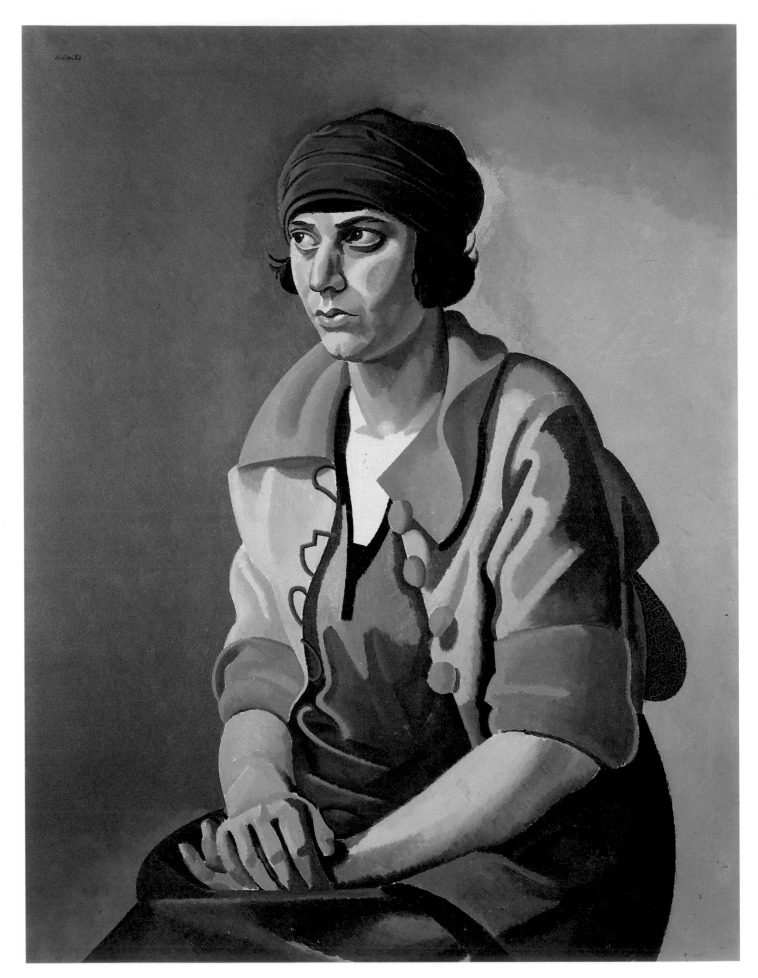

112 William Roberts, *The Red Turban* 1921

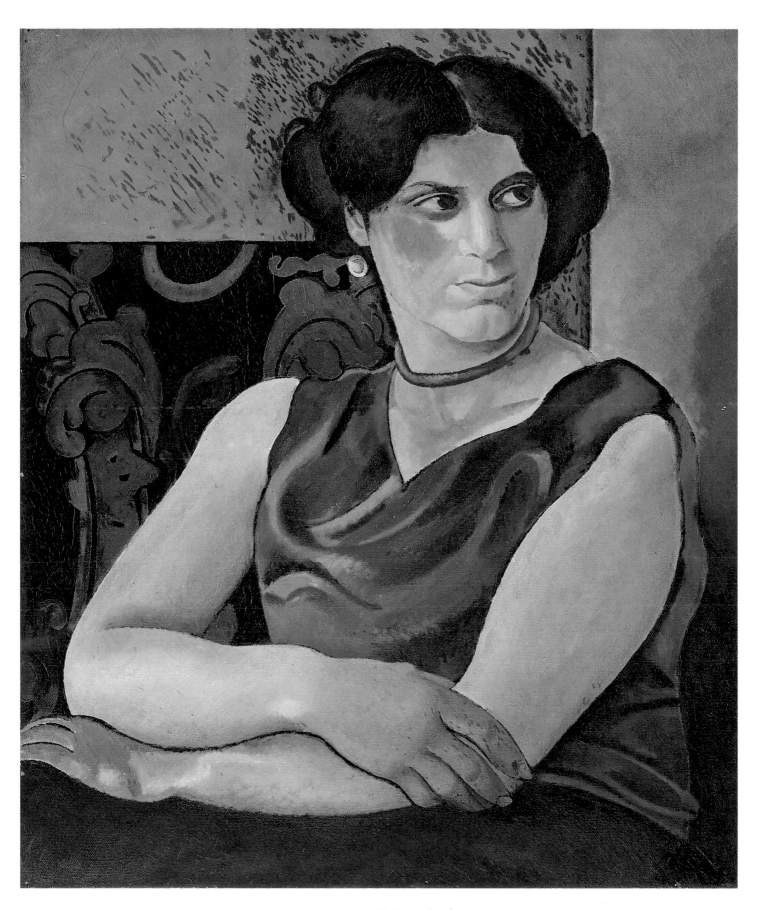

113 William Roberts, *A Woman (Sarah)* c. 1927

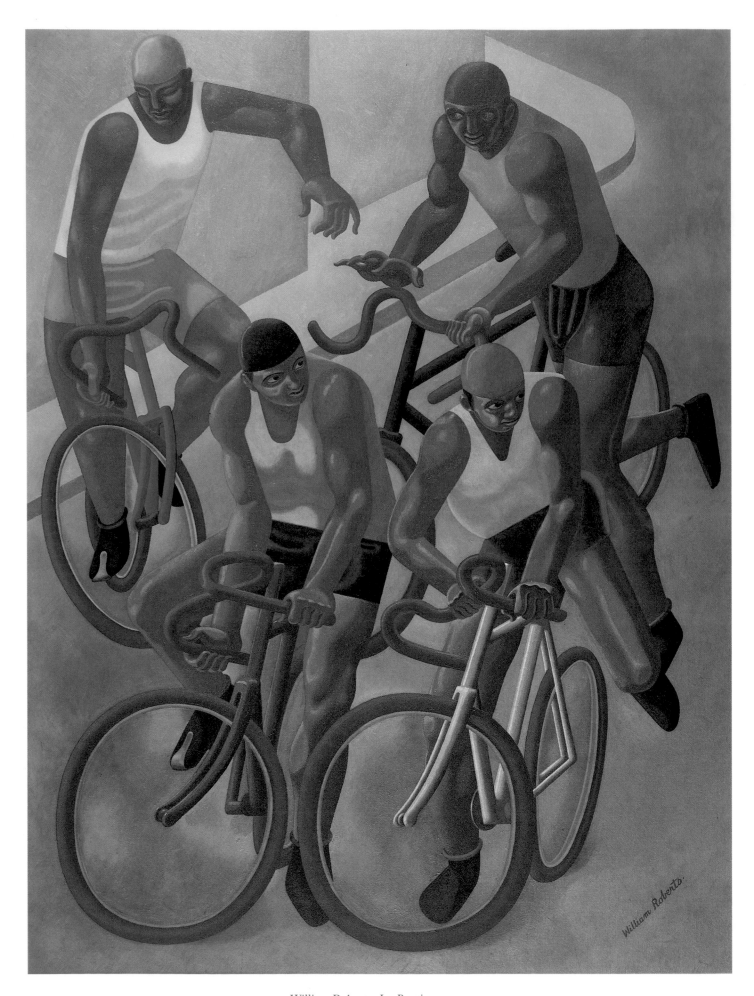

114 William Roberts, *Les Routiers* c. 1930-32

115 Percy Wyndham Lewis
Self-Portrait as a Tyro 1920-21

116 Percy Wyndham Lewis, *A Reading of Ovid (Tyros)* *c.* 1920

117 Percy Wyndham Lewis, *Praxitella* 1920-21

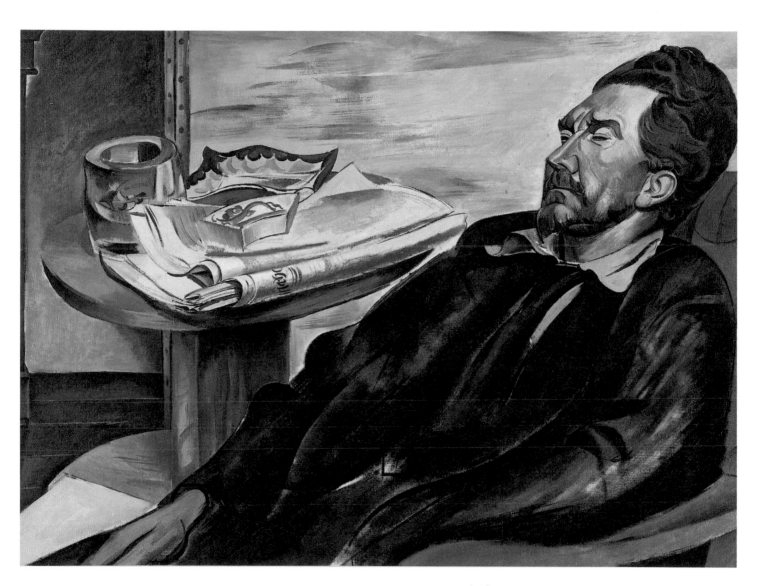

118 Percy Wyndham Lewis, *Ezra Pound* 1939

Susan Compton

Unit One – Towards Constructivism

In the decade leading to the declaration of war in 1939, some British artists were acutely aware of a small but intense international avant-garde. This was made more immediate in the late Thirties by the exodus to London of leading European artists escaping from the repressive regime of Nazi Germany. With a prevailing mood of idealism, in strong contrast to the bleak realities of the depressed economic situation, they shared a hope that art might be able to bring a radical change for the better in society. Thus the paintings and sculpture in this section demonstrate British Modernism with an international flavour, on the one hand leaning towards Surrealism and on the other towards Constructivism. In the work of Paul Nash, Edward Burra and Edward Wadsworth, imagination and the unconscious impinge on everyday life; in that of Ben Nicholson and Barbara Hepworth, more abstract forms seem to echo the creative processes of nature herself. Strong, entirely abstract paintings by John Piper, such as *Forms on Dark Blue* (Cat. 135), represent the short-lived commitment of this younger artist to a radical standpoint: in 1936 he hoped that abstract painting would become 'lucid and popular, not in the least "highbrow"'.

The group Unit One, which with the exception of Piper included these artists, was formed at the instigation of Nash, who in 1930-1 felt the lack of a cohesive group and set about gathering together artists who he hoped would form a unit. His work as an exhibition reviewer enabled him to pick out artists who might join his group, and during 1932 he discussed his aims with Henry Moore, Edward Wadsworth and the architect Wells Coates. Nash wanted to include architects in this group as well as painters, sculptors and decorators, for he thought that together they might form an important movement. By 1933 he had also invited Nicholson and Hepworth, amongst others, and had enlisted the support of Herbert Read. Read encouraged the group and suggested they produce a book of statements and photographs; he edited the resulting *Unit 1: the Modern Movement in English Architecture, Painting and Sculpture*, which was published to coincide with the first and only Unit One exhibition held at the Mayor Galleries in April 1934.

This exhibition attracted more public attention than any art event since Fry's Second Post-Impressionist Exhibition of 1912, and for the next year some of the works went to Merseyside, the Midlands and Wales. The inclusion of Belfast in the tour provided Northern Ireland with the first ever exhibition of modern art. A reviewer in the *Scotsman* detected a 'Soviet-like flavour, savouring of mass production, the collective man and the like'. Ironically, the work of Nicholson was singled out as the most extreme 'Left' by a public and its critics ignorant of the fate of pioneering abstractionists in the Soviet Union, whose work was by then denigrated in favour of Socialist Realism.

Nicholson and Hepworth came to identify their position with Constructivism, even including reproductions of work by the Russian pioneers Tatlin and Malevich in the book *Circle* published in 1937. But instead of an urban art form suitable for an emerging technological society, which Russian Constructivism had purported to be, the Western European version of the Thirties is shown in the pages of *Circle* as well as of *Abstraction-Création* to be an idealist attempt for abstract art to rival the structures of natural forms. Both Nicholson and Hepworth contributed to this Parisian international journal which brought together the ideas and reproductions of work by leading Constructivists. They visited studios in France, and their work increasingly developed in response to the deceptively simple forms used by Arp, Brancusi, Hélion and Giacometti. However, a very British concern with the effect of light is apparent in their reliefs and sculptures, extreme examples of their fully abstract style being Nicholson's *Painted White Relief* (Cat. 143) and Hepworth's *Conicoid, Sphere and Hollow II* (Cat. 148).

Neither artist had reached such a degree of abstraction when Nash originally invited them to join Unit One. Nicholson's paintings of 1932-3 reveal his surprisingly late absorption of Cubist principles. However, instead of the convoluted geometry of still-lifes by Braque from the 1920s, Nicholson evolved a way of retaining the integrity of the underlying picture surface by means of colour modulation. On this he deployed his still-life forms or, in the case of *St Rémy, Provence* (Cat. 139), his profile heads; the resulting subtle spatial shifts are atmospheric and were often achieved by scraping the underlying paint surface. In *Milk and Plain Chocolate* (Cat. 140) he deliberately incises some of the lines as though intent on carving a painting. The picture represents a most sophisticated response to Modernist art: there are echoes of advanced Cubism in the method of assembling the parts, and suggestions of the influence of Calder whom Nicholson and Hepworth knew at this time.

Nicholson speaks of his admiration for the work of Miró and there is a new freedom of form in *Composition in Black and White* (Cat. 141) which belongs also to 1933, the year of his most fertile inventions. The freely scratched, curving lines are still related to the profiles and jugs that had been the staple of his earlier pictures such as *Au Chat Botté* (Cat. 138), but there is an amorphous ambiguity in this *Composition* which allows one to decipher the body of a woman or even a large musical instrument from the tangled lines. It is perhaps not surprising that he went on to make actual shallow reliefs by altering the real levels of the traditional picture support. *Six Circles* (Cat. 142) is the second relief that he made: the circles are cut into the board and the lines gouged out so that Nicholson achieves a totally new sense of texture; light causes real shadows to increase the complexity of the picture surface – for, in spite of being carved, the work seems to remain in the domain of painting.

Other reliefs painted white – such as Cat. 144, which used to belong to Herbert Read – reveal the deliberate unevenness of the carving, which is not systematically restricted to geometric forms. The edges are not invariably straight and the variations create a sense of surprise in these otherwise austere creations, dating from the years when Constructivism became almost a creed for Nicholson and Hepworth.

The self-avowed turning point for Barbara Hepworth was the visit she paid to Meudon (with Nicholson) to the studio of Jean Arp in 1932. She was inspired by the way Arp had 'fused landscape with the human form' and from then onwards, naturalistic rendering of a carving like *Head* of 1930 (Cat. 146) gave way to the idea of 'the earth rising and becoming human' (as she herself expressed it in *A Pictorial Autobiography*, published in 1970). It is possible to recognize antecedents for her *Torso* (Cat. 147) carved in African black wood in 1932 – in the simplified forms of Epstein's *Figure in Flenite* (Cat. 56) and even of Gill's *Deposition* (Cat. 93) – although, like these sculptors, Hepworth enjoyed the resistance of carving a hard substance, she seems already to have embarked on a quest which led away from the primitive imagery of earlier cultures which had so influenced them. Her own *Torso* anticipates the paring down of sculptural form which was both the consequence of her visit to Meudon and of a pause in her working life caused by the birth of triplets to herself and Nicholson in 1934.

After this break, she turned to a far more radical abstraction. *Form* (Cat. 149) and *Conicoid, Sphere and Hollow II* (Cat. 148) break new territory for sculpture. In them there remains no hint of naturalism. By her own account, she was 'absorbed in the relationship in space, in size and texture and weight, as well as in the tension between forms'. Nevertheless, the scientist J. D. Bernal, writing in the catalogue for an exhibition of Hepworth's work at the Alex. Reid & Lefevre Gallery in 1937, found a similarity between her forms, such as *Conicoid, Sphere and Hollow II*, and the Menhirs and Dolmens of neolithic carvers. He saw her work as reflecting on a small scale the 'alignments and rings of stones which mark the central shrines in the Megalithic world'. Although one might at first be wary of such an analogy, it must be remembered that Paul Nash came under the spell of the standing stones at Avebury in the mid-Thirties and the mystery of the ancient places was then much discussed.

Today it may seem surprising to find Bernal stating that the five single forms by Hepworth on view at that exhibition 'may indeed be considered to introduce a fourth dimension into sculpture, representing by a surface the movement of a closed curve in time', for a fourth dimension had been much talked about in the early years of the century (as in the nineteenth) but has now generally disappeared from discussion. Bernal saw Hepworth's sculptures as vaguely spiritual forms – making a connection with 'those of a religious significance' like the Menhirs – and he also wished that her art might have some relationship to everyday life (perhaps with modern architecture, he suggested). Present-day interpretations of Constructivism do not often place the work in such a wide context.

It is in the final group of works, made during her first years in Cornwall, that Hepworth's full maturity as an artist is to be seen. In them she developed a way of using strings in conjunction with wood, so as to add a plane which is neither opaque nor transparent. Thus she conveys a new type of surface which defines a penetrable space that is neither fully closed nor open and therefore has a peculiar mystery. This device was originally invented by mathematicians who made models for students (there are some in the Science Museum in London); it was well-known to Naum Gabo, the Russian Constructivist who settled in England in 1936, and to Henry Moore. Both were close friends of Hepworth, and each of them explored the use of strings of differing materials to convey 'transparent' planes in their sculptures. Hepworth exploited natural and organic shapes found in nature's own constructions – the shell, the womb or the weathered stone.

In addition, many of her Cornish sculptures include recognizable allusions to the natural world, such as the weathering caused by water and wind. The wind seems to linger round *Wood and Strings* (Cat. 150) of 1944 and, of course, the sea echoes in the shell-like *Sea Form (Porthmeor)* (Cat. 152). By the time she made it – in 1958 – she was permanently settled in St Ives, Cornwall, yet she still felt part of an international movement in art. She wrote: 'Looking out from our studios on the Atlantic beach we became more deeply rooted in Europe; but straining at the same time to fly like a bird over 3,000 miles of water towards America and the East to unite our philosophy, religion and aesthetic language.' Thus she described *Sea Form* as 'the ebb and flow of the Atlantic'.

Although Hepworth's work continued to encompass the ideas of natural forms in essence if not appearance, she had returned briefly to a more representational mode after the war: *The Cosdon Head* (Cat. 145) looks back to the *Head* (Cat. 146) of 1930, but its simplified form with features merely interrupting the smooth flow of the blue marble serves more to remind of a head than portray one. It is as though the human head itself had emerged from the battering of war, as though the violence had weathered the human form so that its inherent humanity could only just survive.

In Ben Nicholson's work there was also a partial return to figuration at this time (though his marriage to Hepworth had ended). In *Contrapuntal, Feb. 25-'53* (Cat. 119) there are residual lines of a head with still-life elements which convey the essence of everyday shapes. The method of assembling these traces on the canvas is derived from his renewed exploration of Cubist methods, but the experience of the reliefs he had made allowed Nicholson a new freedom to use line in an expressive and decisive way to convey depth, even though the individual lines remain almost on the surface of the picture. The associations with the human form and with objects allowed him to use a wider range of colours, again hinting at the everyday world.

There is no doubt that paintings like this one by Nicholson, and the presence of Barbara Hepworth, inspired the post-war generation, who found in St Ives a congenial work-

Cat. 119 Ben Nicholson, *Contrapuntal, Feb 25 - '53*, 1953

ing environment. However, the torch of a harder line Constructivism which Nicholson and Hepworth had carried in the Thirties, and found its purest expression in *Circle*, now passed to Victor Pasmore, who in those years had belonged to the Euston Road School. When he chose abstraction in the late Forties, he was greatly encouraged by Hepworth and Nicholson – indeed he visited St Ives and joined the Penwith Society there. The mural that he painted in 1950 for the bus depot at Kingston in Surrey shows his affinity with Nicholson.

However, Pasmore moved on to a far more radical Constructivist position, inspired by his study of Charles Biederman's book, *Art as the Evolution of Visual Knowledge*. His works like the relief *Abstract in White, Black and Maroon* (Cat. 136) of 1956-7 mark the flowering of a true Constructivist movement in Britain, embraced by a group of artists who can properly be called British Constructivists. The adherents of this 'pure' art, for the most part based on mathematics, have remained faithful to the 'Realistic Manifesto' propounded by Gabo and his brother Pevsner in Moscow in 1920. It represents a rather different foundation from the organic basis of the art of Hepworth and Nicholson, and even of the more recent work of Pasmore himself. None the less by their attitudes these artists have all kept Britain in the mainstream of a European movement, a position which many other artists have not felt the need to adopt.

Andrew Causey

Unit One – Towards Surrealism

The initiative of Paul Nash in forming Unit One, described in 'Unit One – Towards Constructivism' (p. 214), was the outcome of a new understanding of Continental modern movements and coincided with a period of unprecedented experiment in his painting. Following a well-received exhibition at the Leicester Galleries in 1928, made up mainly of Post-Impressionist landscapes of the kind he had been doing all through the decade, Nash made the conscious decision to confront Modernism directly. He was by then one of the most respected artists in what was by European standards a relatively conservative avant-garde, and he began to study foreign art periodicals attentively. In 1930 he explored the Paris galleries concerned with contemporary art in the company of the younger Edward Burra, who had been watching new developments on the Continent for some years.

Writing art criticism for the *Listener* and the *Weekend Review* between 1930 and 1933, Nash followed the London contemporary art scene in detail. Though he was later to align himself with the Surrealist movement, in the period leading up to Unit One (1928-33) his work shows interest in Cubism and even non-figuration as well as Surrealism. Unit One was intended as a mirror of Modernism in its widest ramifications and it was not only Nash who was feeling his way at the time between the demands of abstraction and the Surreal. Edward Wadsworth, who was perhaps the first English painter to show an interest in Surrealism, was passing through a non-figurative phase between 1930 and 1933, and even Ben Nicholson, though by 1933 gaining confidence in abstraction, had the previous year passed through a phase of brilliant semi-abstract still-life painting (Cat. 138) which one critic, R. H. Wilenski, had termed – admittedly, somewhat stretching the meaning of the word – Surrealist. The period was one of great ferment in British art, with more new lines of enquiry being opened up and developed than at any moment since 1914. The reproductions of Nash's work in *Unit 1* mirror this ferment in the sense that they include one of his most abstract works, *Kinetic Feature*, 1931 (Tate Gallery), and one of his first efforts in a Surrealist direction, *Northern Adventure* (Cat. 129).

Nash's first reaction to Surrealism was to value the way that it broke down the traditional art categories, such as landscape, still-life and portraiture. While Nash had been mainly a landscape painter till 1928, new pictures such as *Northern Adventure* and *Harbour and Room* (Cat. 130) are harder to categorize; they are urban scenes, founded like all Nash's art in visual reality, but are imaginative reinventions that show him taking liberties with his subjects in a way that he had not done before. *Northern Adventure* is based on the view from Nash's London *pied-à-terre* in Queen Alexandra Mansions, Judd Street, which then had a clear view of the Neo-Gothic edifice of St Pancras Station across a vacant lot on which the present Camden Town Hall was built a few years later. The site was then occupied by the advertisement hoardings seen in the painting. *Northern Adventure* is a strange painting: abstracted, decorative and concerned with pattern, on the one hand, it is at the same time a subject painting with narrative overtones. Though empty of people, it is full of implications, of possible human presence, from the ladders propped against the hoardings to the roads in the station entrance which one would expect to be crowded with travellers. The picture's penumbral colouring may have been suggested originally by the dark colour of the brick of the station building, but it has come to dominate most of the design and form the core of the painting's mystery.

Though Nash took his subjects from the real world, his treatment of them is dream-like and, as in dream, the scenes have sharpness and clarity while confounding logic. The paintings are often highly theatrical, with each object posed in such a way as to give it presence, to make it like an actor in a drama, albeit a drama whose exact nature is unexplained.

Harbour and Room was also based on an actual scene, experienced on a visit the Nashes made with Burra to Toulon in 1930; the Nashes' hotel bedroom faced the harbour and the reflection of two boats could be seen in the huge gilt mirror over the mantelpiece opposite the window. Like *Northern Adventure*, it is a dark nocturnal painting, its origins in private experience and its meaning elusive. In many respects Nash was influenced by the art of de Chirico; he had shared de Chirico's tendency to isolate objects in a dramatic way, to surprise the viewer with strange distorted perspectives, and to conjure up an uneasy sense of premonition. De Chirico's term 'Metaphysical' describes these pictures by Nash at least as well as does Surrealist.

After the rapid break-up of Unit One Nash moved in the direction of Surrealism, becoming a member of the committee of the International Surrealist Exhibition in London in 1936, where *Harbour and Room* was first exhibited. But by then his interest had largely reverted to landscape: not landscapes treated simply as scenes, as they had been in his Twenties' painting, but as locations for imaginary happenings. As he became increasingly interested in Surrealism, Nash explored the realm of sleep, dream and the unconscious, and in *Landscape from a Dream* (Cat. 131) he expanded in a new context this interest by employing mirrors, reflections and the world of dreams.

Wadsworth was Nash's exact contemporary – both were born in 1889. Like Nash, he had built up a solid audience for his painting as a result of several exhibitions in the Twenties. But unlike Nash, whose art had then been loose and painterly, Wadsworth had developed the sharp line and clearly defined forms of the Vorticist movement in which he had participated (see Cat. 46) into a most impressive art where clear, austere harmonies were more important than expressive verve. The accent in his work was on control and deliberation, and in his port scenes (such as *The Cattewater, Plymouth Sound*, Fig. 16, p. 71) the Impressionist evocation of a particular place and moment, which is present in Nash's painting, is exchanged for objectivity and absence of atmosphere. In conformity with the predominantly Classical values of the decade Wadsworth emphasized design values rather than personal emotions, yet, in a seeming paradox, no other work by a British artist in the period shows a greater individuality.

Wadsworth was always interested in boats and ports, and from 1928 evolved a new kind of still-life made up of objects with marine associations in mysterious juxtaposition, often arranged against a background of sea. There is an extraordinary stillness and precision in these paintings, created partly by Wadsworth's use of tempera, a water-based paint which can be applied in clear luminous patches with minimal effect of brushmark. The word Surrealism was applied to Wadsworth's painting as early as 1927 by the critic of the Amsterdam newspaper *De Telegraaf* on the occasion of the purchase of one of his paintings by the Stedelijk Museum. This is probably the first use of the term with reference to a British painter. As with Nash, however, Wadsworth's painting is perhaps better described as Metaphysical than Surrealist. The way he singles out individual objects in clearly measured space recalls de Chirico, who had a remarkable appeal to

English artists at this period, partly perhaps because this Italian painter's interest in space and perspective had particular meaning in this country with its traditional love of Italian art, especially of the Quattrocento.

Between 1930 and 1933 Wadsworth's painting was much more abstract and shows his leadership here as well as in Surrealism. But again, as with Nash, there is often a sense that the paintings are abstractions derived from objects in life rather than designs conceived abstractly, as Nicholson's paintings and reliefs were a year or two later. Though Wadsworth never lost interest in abstraction – as the much later *Triangles* (Cat. 134) shows – he found, as did Nash, that abstraction by itself was unsatisfying.

Edward Burra was a much younger painter whose contribution to the Unit One exhibition was a kind of fantastic Surrealism, representing one extreme in the avant-garde of the period. Unashamedly illustrative by temperament, Burra – who was only twenty-nine at the time of the exhibition – felt no responsibility towards 'significant form', as the older artists brought up in the shadow of Bloomsbury did. He had spent much of his time in 1929 in Paris and the Mediterranean ports of Toulon and Marseilles. A sardonic observer of the seamier sides of life, he frequented music and dance halls, bars and cafés, where his sharp eye and a peculiar appetite for all kinds of eccentricity from the pretentious to the grotesque focused on the antics of the *demi-monde*, petty criminal riff-raff, dancers, performers of all kinds, prostitutes. As was seen in his first one-man exhibition at the Leicester Galleries in 1929, Burra's art represented a sceptical view of the frenetic fun-making of the dying years of the roaring Twenties.

By the time of the Unit One show his art had become more mysterious and obscure. *Wheels* (Cat. 125) and *Still Life with Figures in a Glass* (Cat. 124) were both shown in that exhibition; they involved dreams and fantasies which run parallel with Nash's work of the same time, all strange, sometimes threatening, but private to the extent that the viewer cannot expect a full explanation or understanding of them. Though Burra, like Nash, exhibited both at Unit One and at the International Surrealist Exhibition in 1936 (*Wheels* was shown at both), he was by no means an orthodox Surrealist. In the Thirties his interest focused increasingly on Spain and he personally experienced the violence that preceded the Civil War. His art was too personal ever to be purely documentary and Burra was neither politically motivated nor a polemical artist, but he was absorbed by all aspects of human behaviour, not least cruelty. A picture such *The Three Fates* (Cat. 126) is reminiscent of a Goya etching worked on a much larger scale, and obviously refers to events in Spain.

The opening of the Surrealist exhibition in London in June 1936 marked both the demise and fulfilment of Paul Nash's attempt to push forward a united Modern Movement in Britain. The artists whom he had invited to join Unit One had by then moved apart into two camps. Nicholson and Hepworth participated in a large international exhibition 'Abstract and Concrete' organized by Nicolete Gray and they were already working towards the publication of a Constructivist periodical. In the meantime Nash and Burra were exhibitors in the Surrealist exhibition. An artist who kept a foot in both camps was Henry Moore, whose sculpture and drawings are discussed on pp. 276-7.

Unlike in Paris, where a manifesto of Surrealism had been issued in mid-1924, the nearest that the English artists came to formally signing a manifesto was approving the contents of the *International Surrealist Bulletin* for September 1936. However, just as Surrealism as a movement was propagated in France by the periodical *La Révolution Surréaliste*, with twelve issues from December 1924 to December 1929, so the *London Bulletin* supported Surrealism in Britain, with fifteen issues from April 1938 to June 1940 (exceptionally, the first issue was entitled *Bulletin of the London Gallery*). The *London Bulletin* has a distinctly English flavour, and a page from the last issue in 1940 is not unlike a page from Wyndham Lewis's *Blast No. 1* of 1914, though with a curiously muted flavour: 'the enemies of desire and hope have risen in violence. They have grown among us, murdering, oppressing and destroying. Now sick with their poison we are threatened with extinction. FIGHT HITLER AND HIS IDEOLOGY WHEREVER IT APPEARS WE MUST.' Through the *London Bulletin*, international connections were pushed forward: under the title of the sixth issue are the names 'Paris – Brussels – Amsterdam – New York', and ties with Belgium were strengthened by the role of E.L.T. Mesens, who is named as editor from the third issue onwards. The pages of the *London Bulletin*, as equally of the single issue of the publication *Circle* (1937), show a rich representation of contemporary international art.

Together and separately Surrealists and Constructivists forged links between Britain and the Continent which proved invaluable for a new generation of artists after the enforced isolation of the years of the Second World War.

120 Edward Burra, *Opium Den* 1933

121 Edward Burra, *The Terrace* 1929

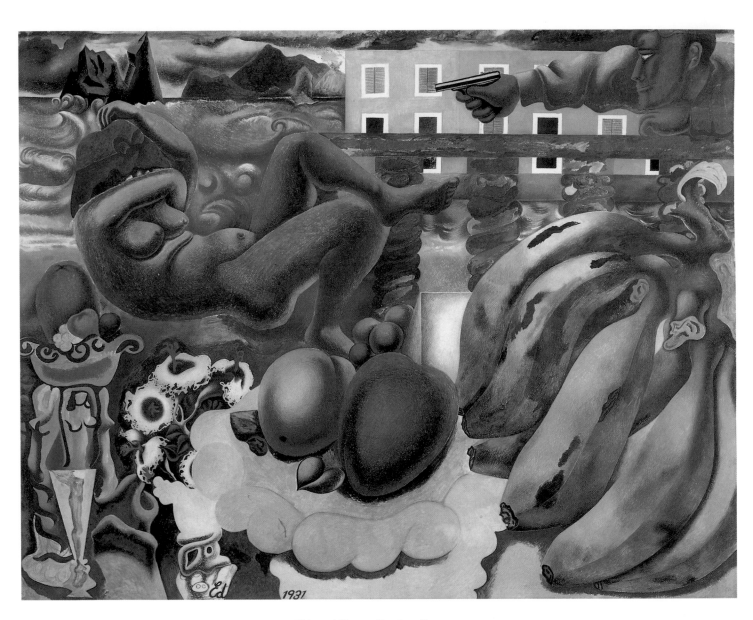

122 Edward Burra, *Revolver Dream* 1931

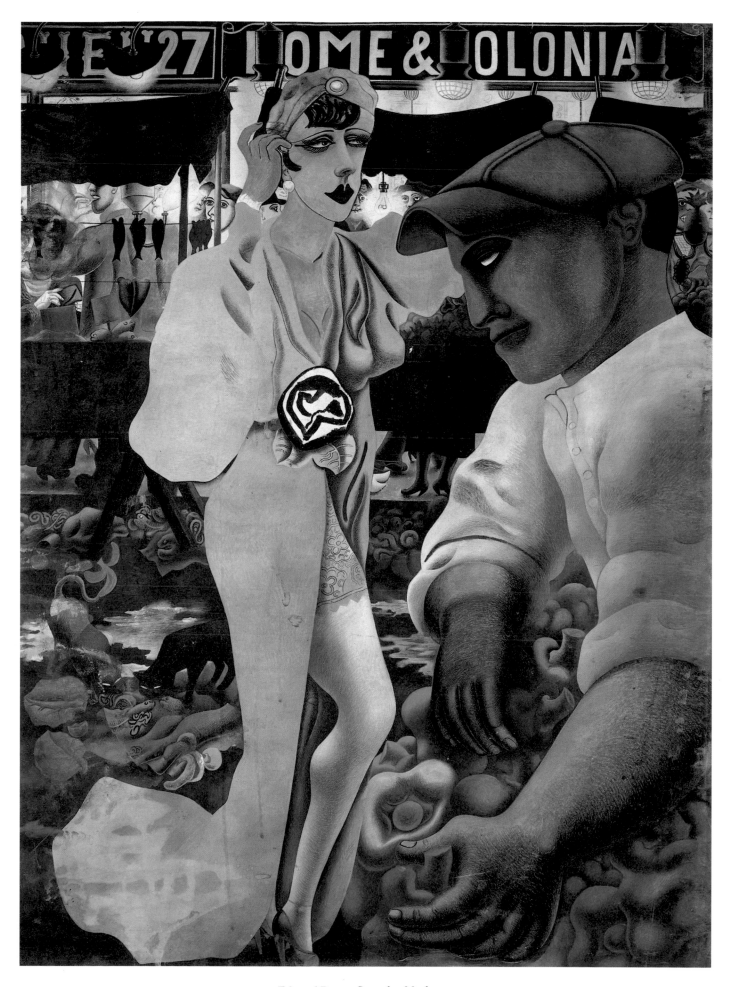

123 Edward Burra, *Saturday Market* 1932

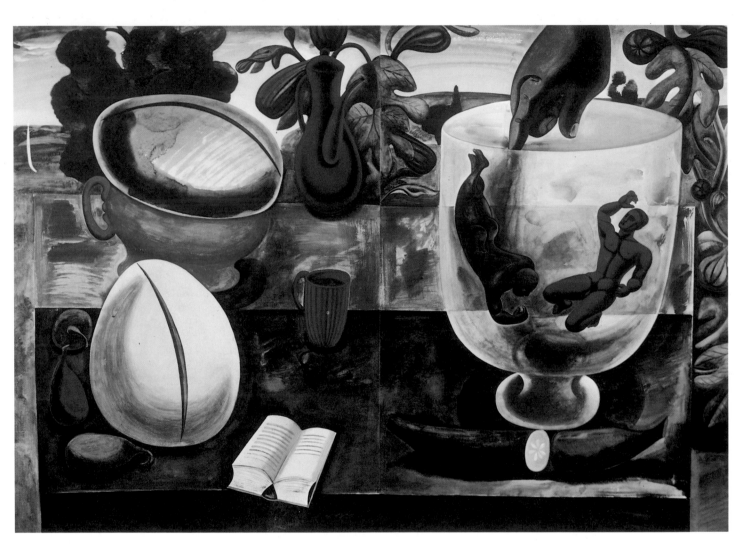

124　Edward Burra, *Still Life with Figures in a Glass*　1933

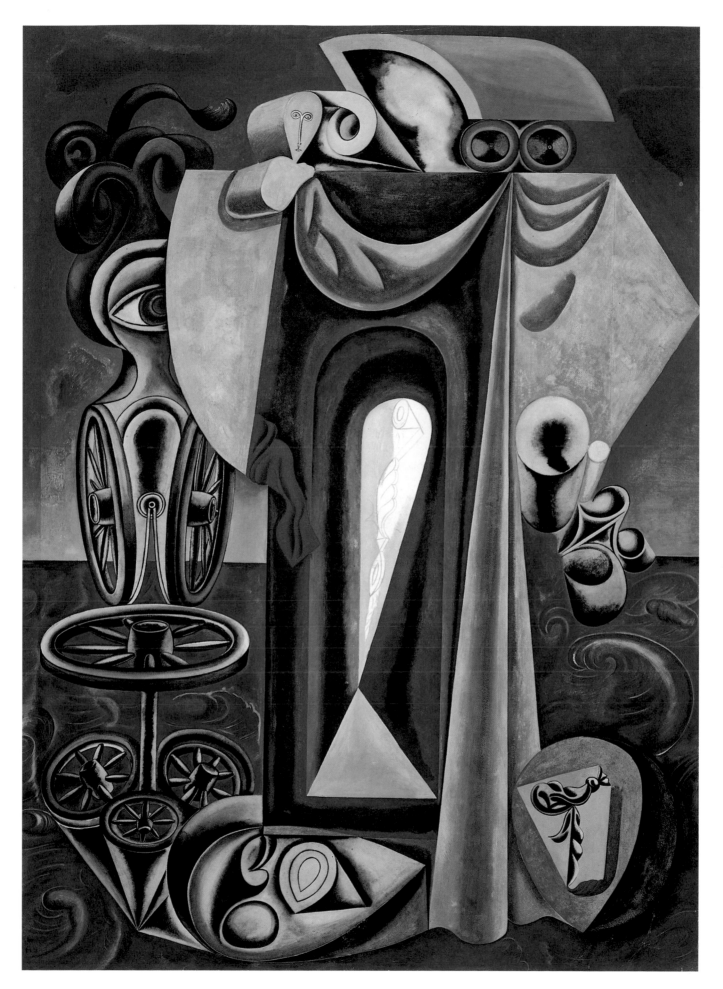

125 Edward Burra, *Wheels* 1933

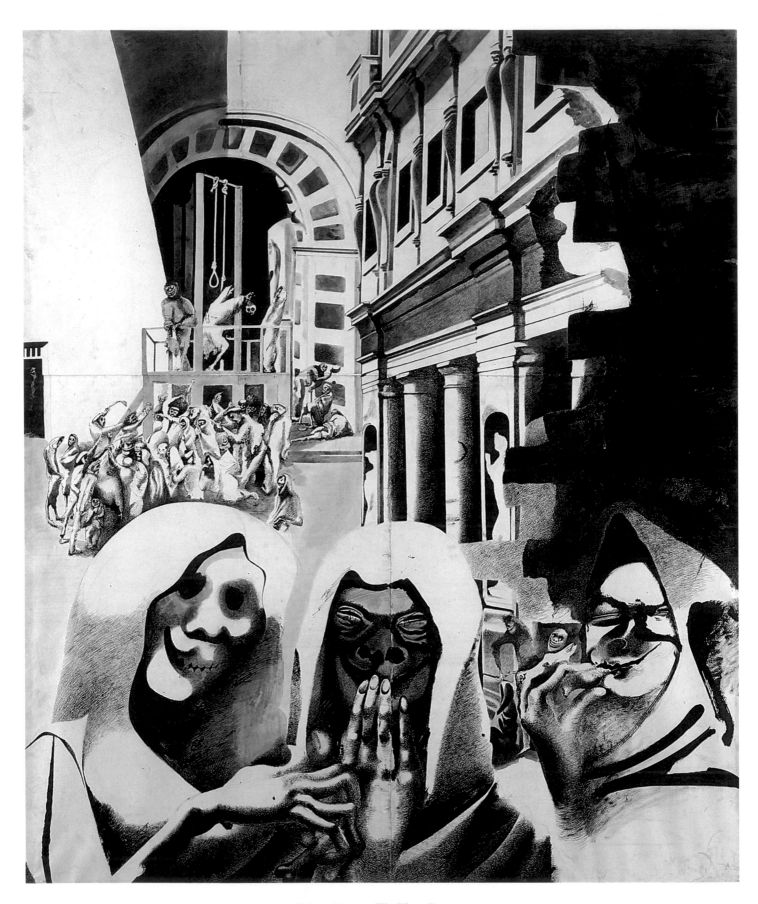

126 Edward Burra, *The Three Fates* c. 1937

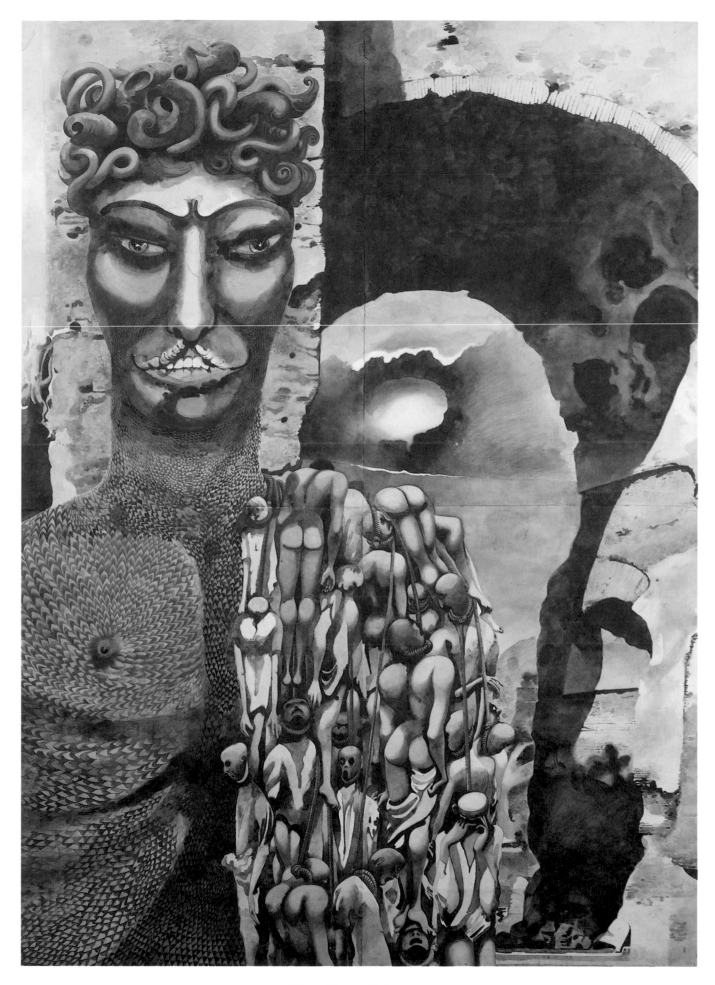

127 Edward Burra, *Medusa* *c.* 1938

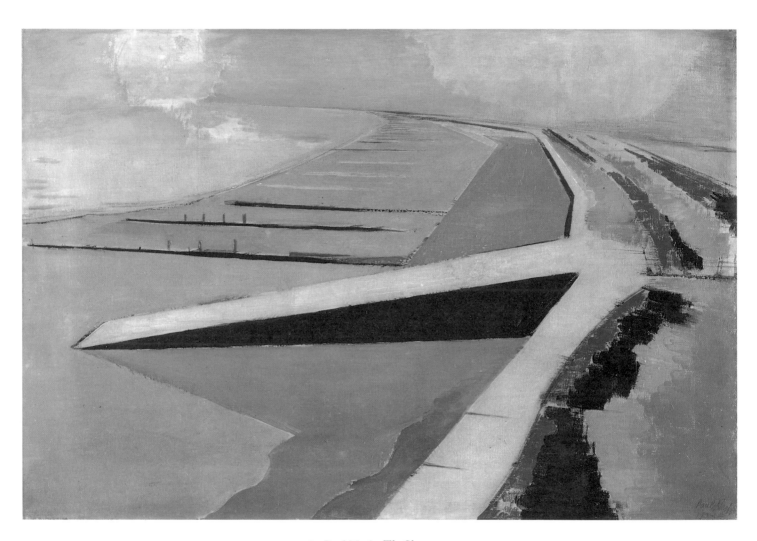

128 Paul Nash, *The Shore* 1923

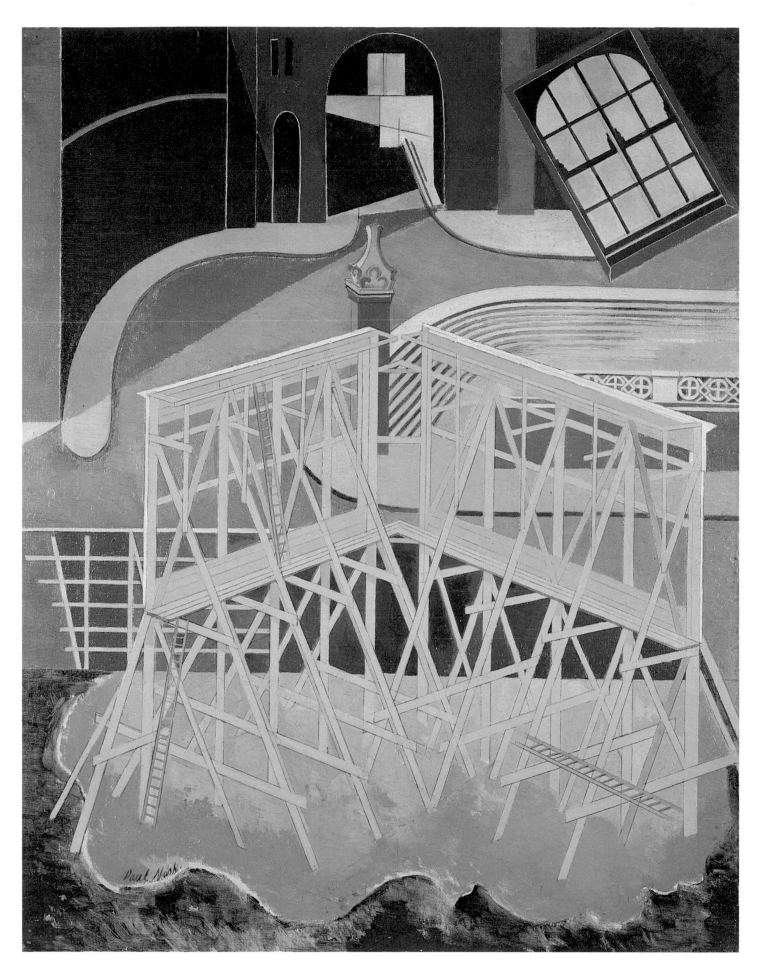

129 Paul Nash, *Northern Adventure* 1929

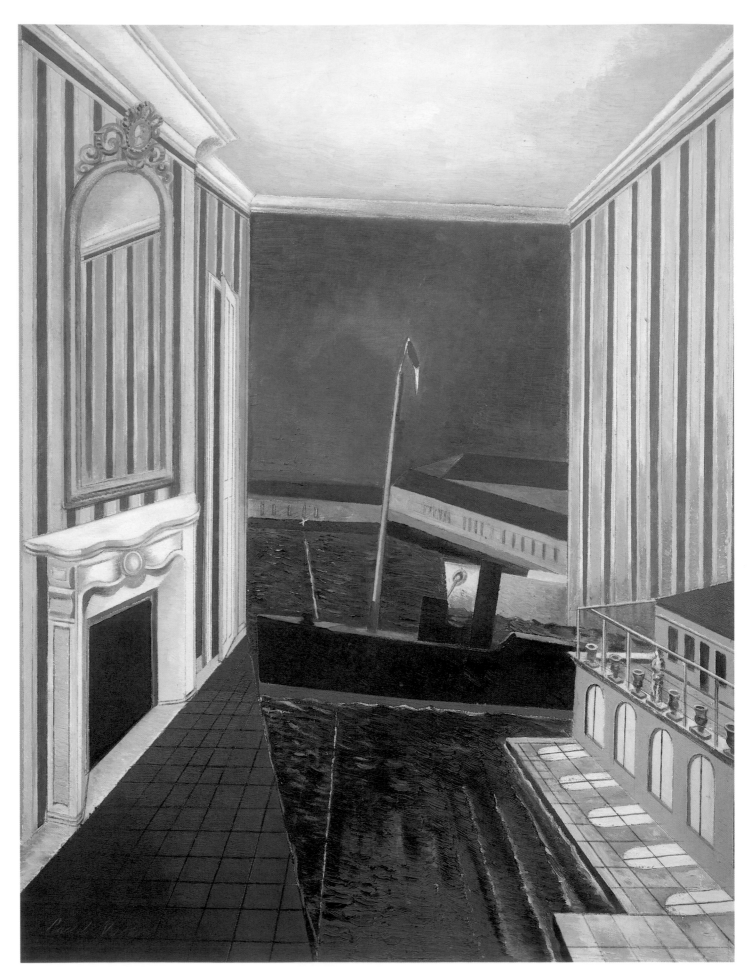

130 Paul Nash, *Harbour and Room* 1932-36

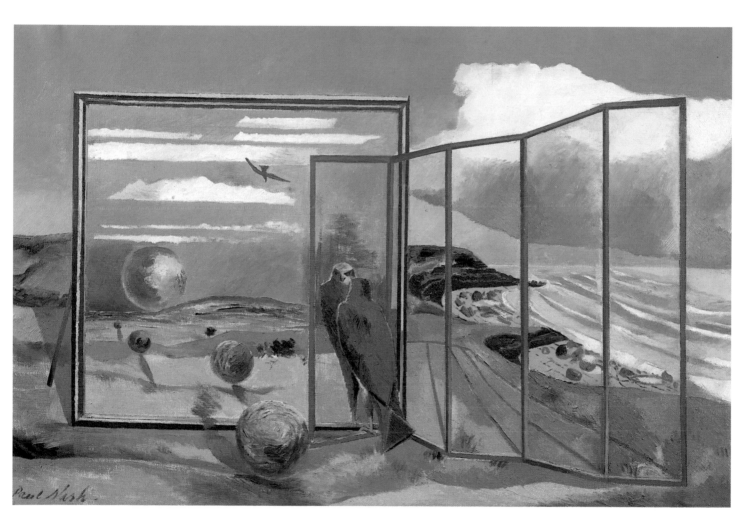

131 Paul Nash, *Landscape from a Dream* 1936-38

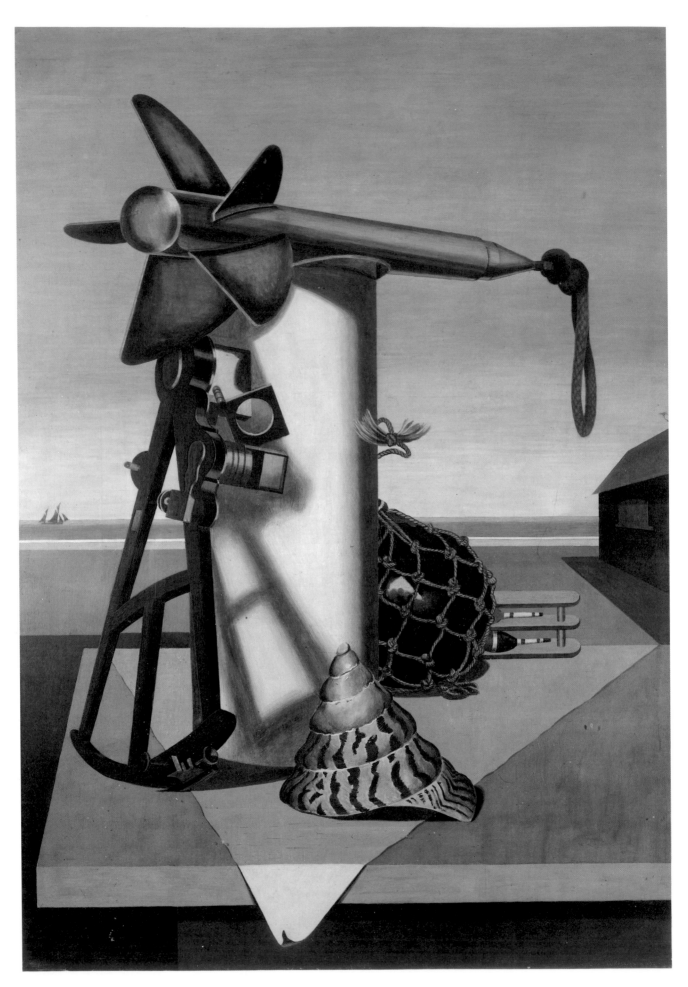

132 Edward Wadsworth, *North Sea* 1928

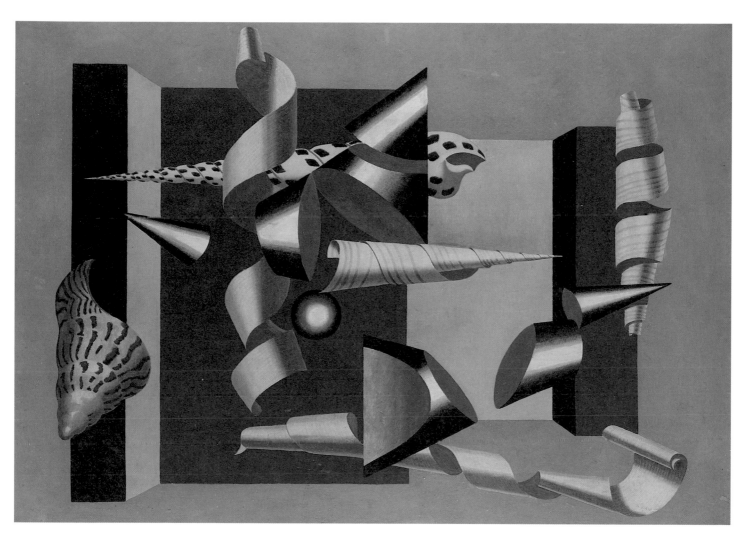

133 Edward Wadsworth, *Composition* 1930

134 Edward Wadsworth, *Triangles* 1948

135
John Piper
Forms on Dark Blue
1936

136
Victor Pasmore
*Abstract in White,
Black and Maroon*
1956-57

137 Ben Nicholson, *Musical Instruments* 1932-33

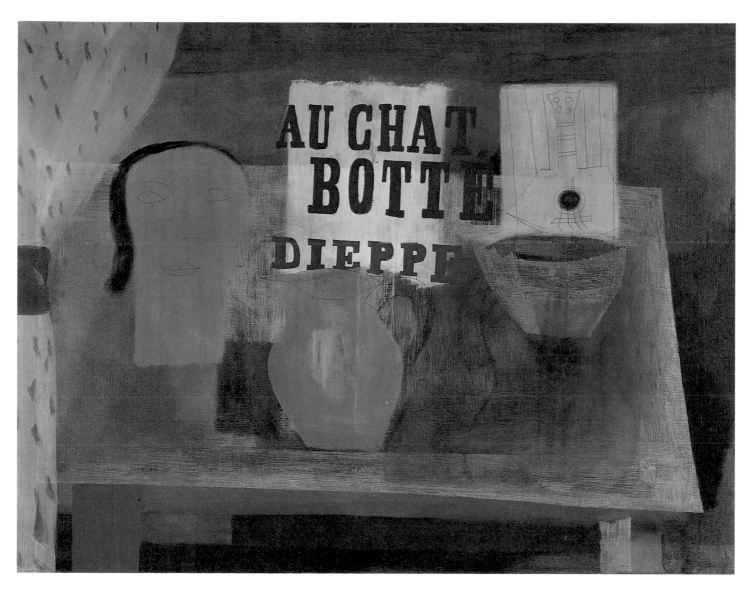

138 Ben Nicholson, *Au Chat Botté* 1932

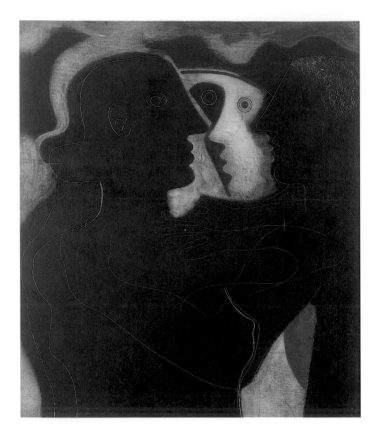

139
Ben Nicholson
St Rémy, Provence
1933

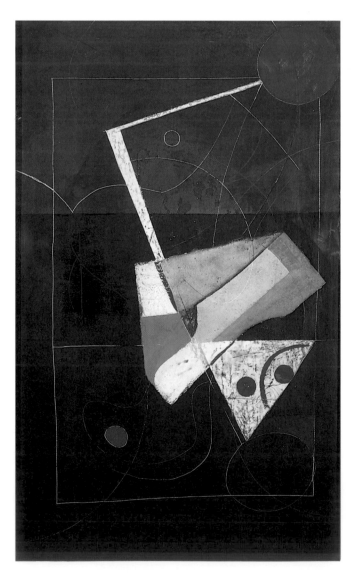

140
Ben Nicholson
Milk and Plain Chocolate
1933

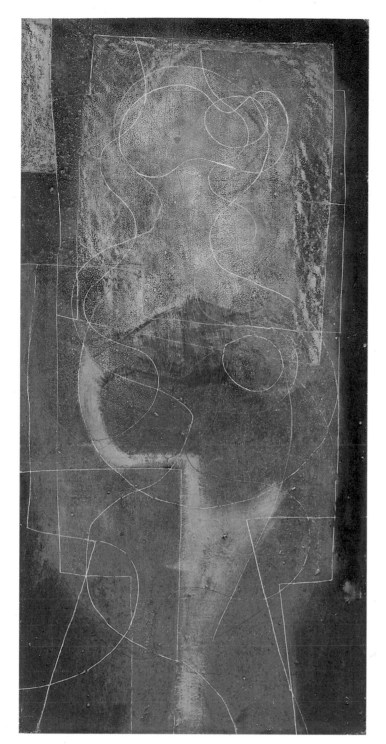

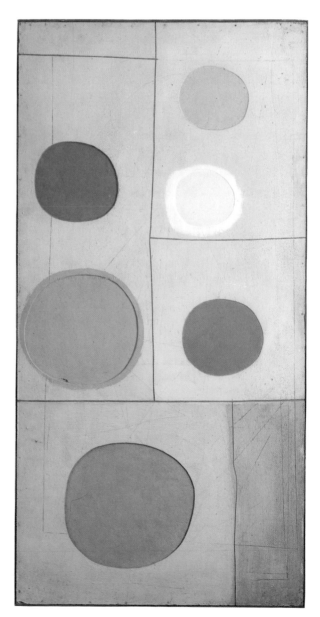

141
Ben Nicholson
*Composition in Black
and White*
1933

142
Ben Nicholson
Six Circles
1933

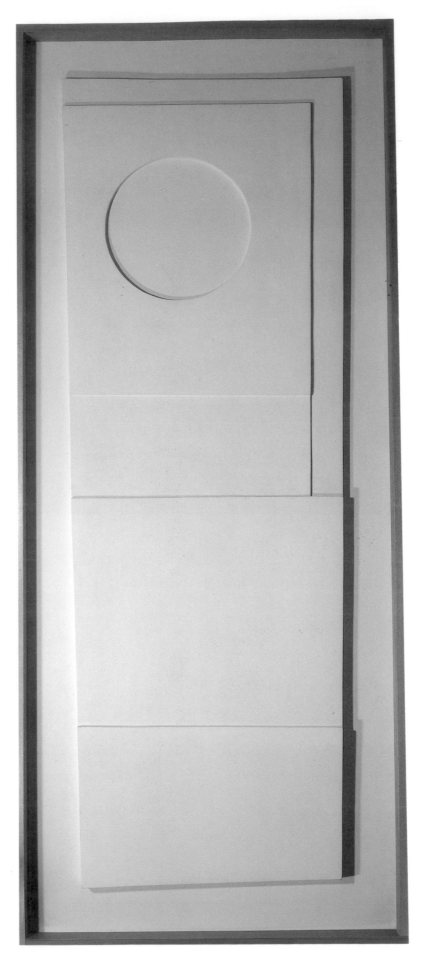

143 Ben Nicholson, *Painted White Relief* 1936

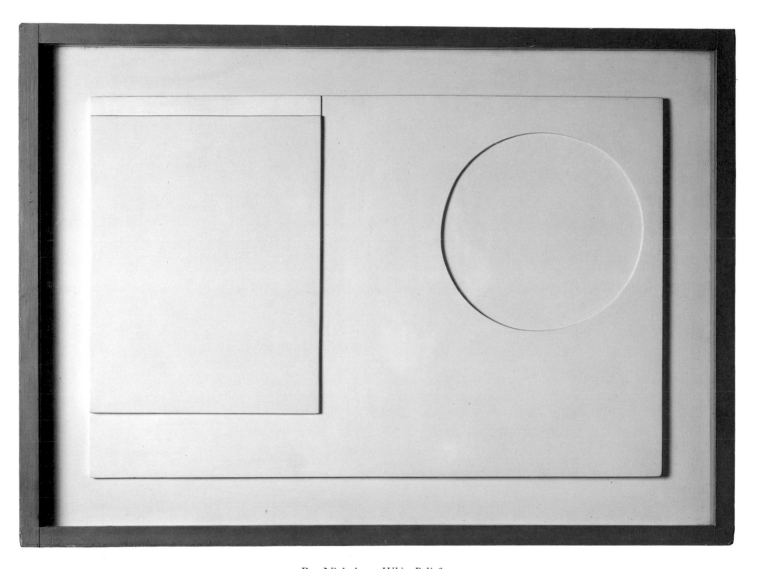

144 Ben Nicholson, *White Relief* 1935

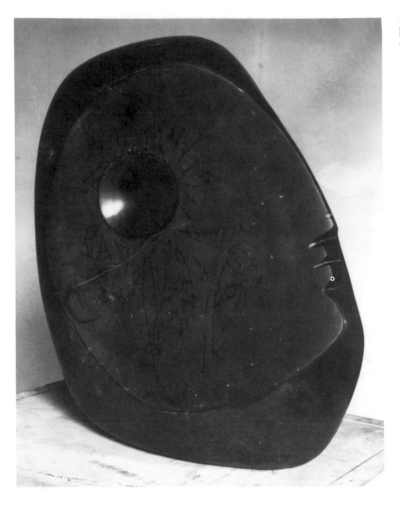

145
Barbara Hepworth
The Cosdon Head
1949

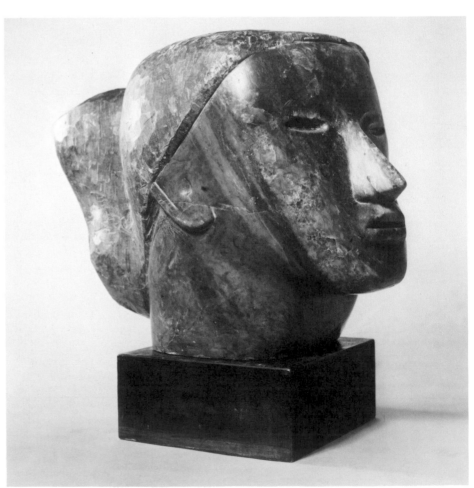

146
Barbara Hepworth
Head
1930

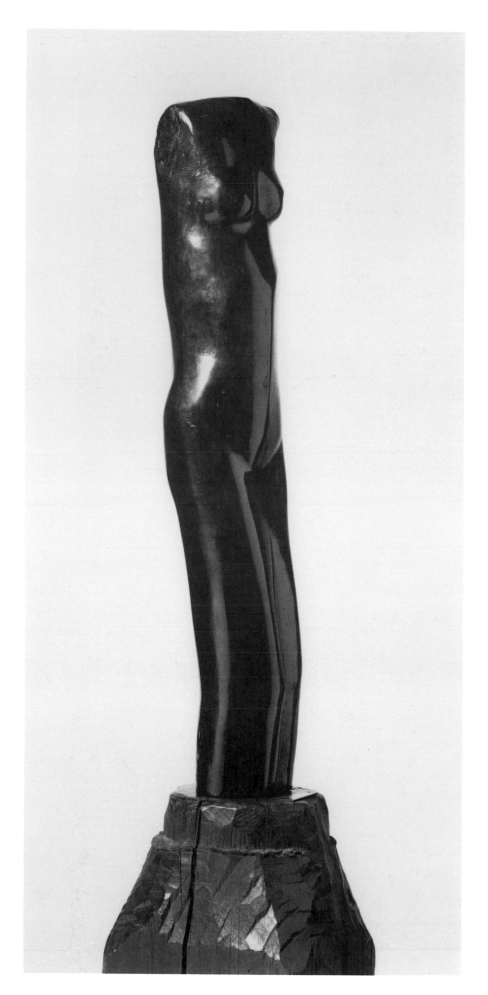

147 Barbara Hepworth, *Torso* 1932

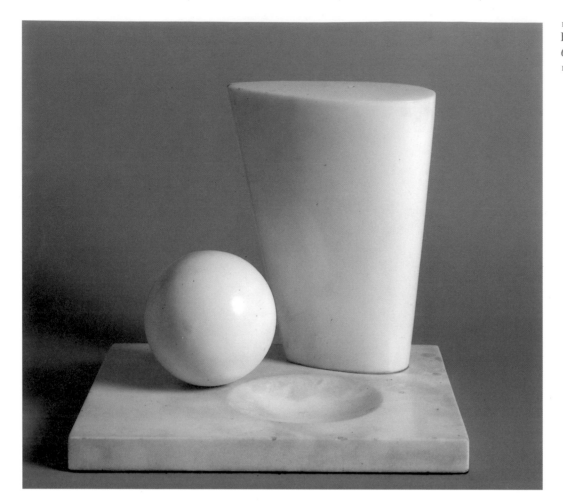

148
Barbara Hepworth
Conicoid, Sphere and Hollow II
1937

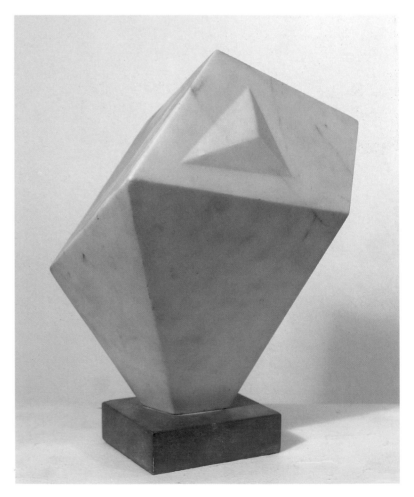

149
Barbara Hepworth
Form
1936

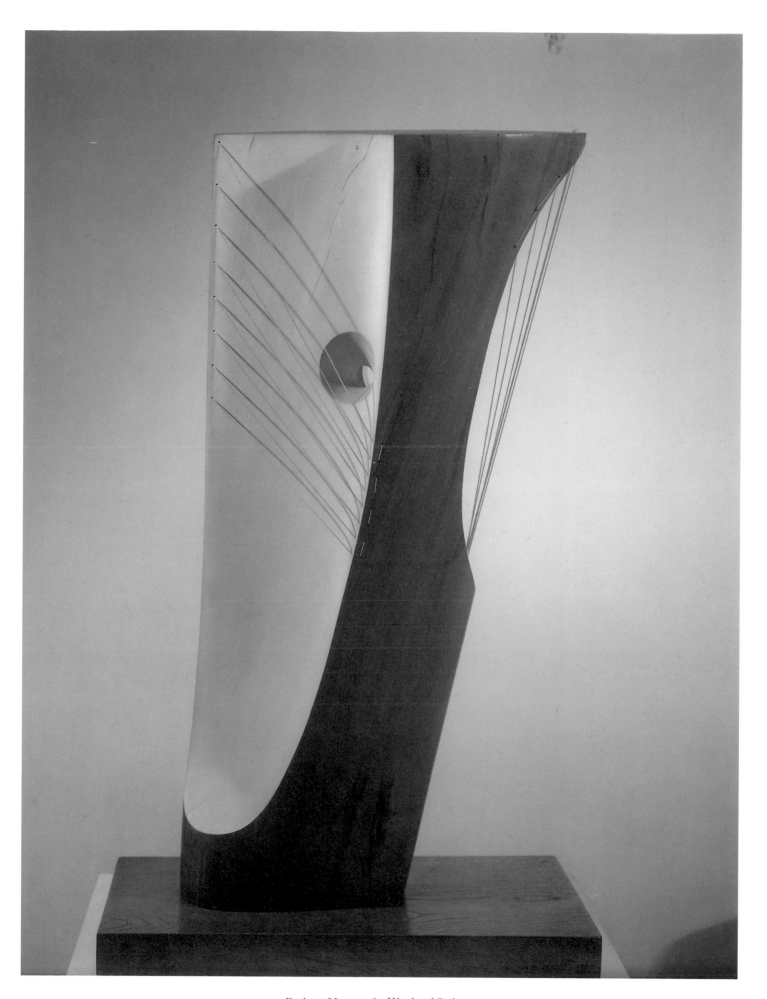

150 Barbara Hepworth, *Wood and Strings* 1944

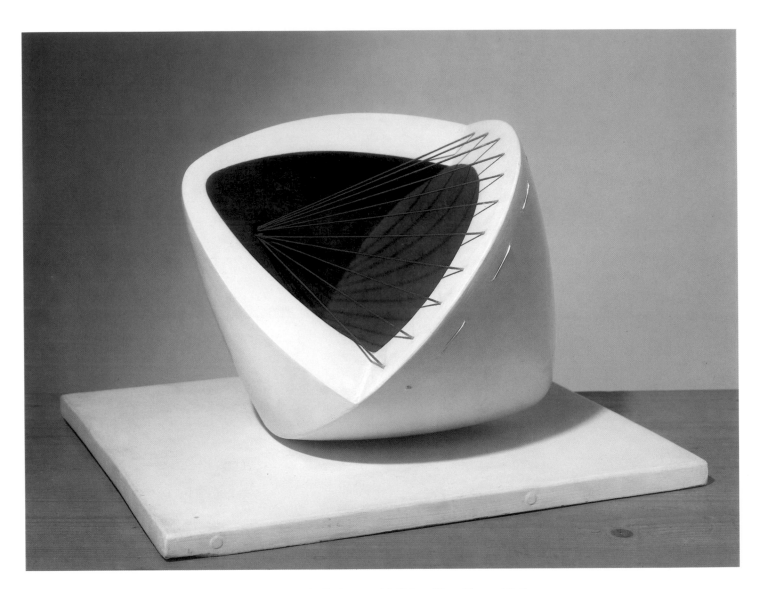

151 Barbara Hepworth, *Sculpture with Colour (Deep Blue and Red)* 1940-43

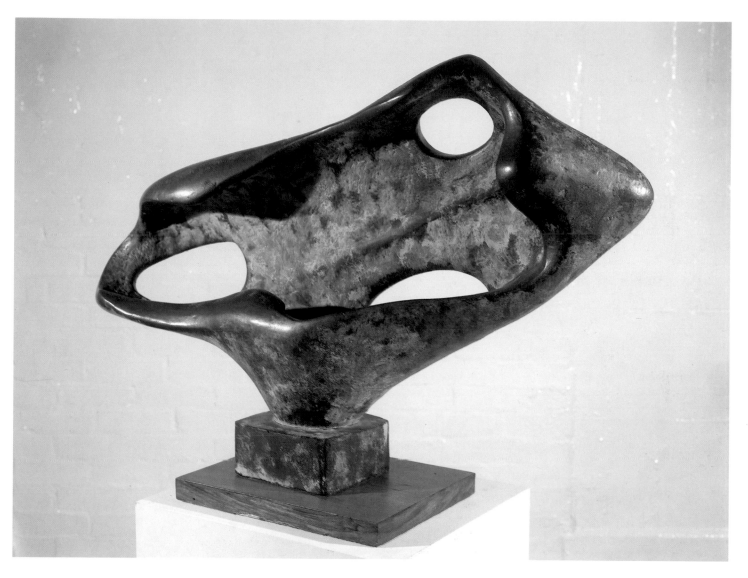

152 Barbara Hepworth, *Sea Form (Porthmeor)* 1958

Richard Cork

Gwen John, Late Sickert and the Euston Road

Although Gwen John belongs to the remarkable generation of women artists who established themselves in the early years of the twentieth century, her sole exhibition was held in London as late as 1926. Only then did an audience wider than her own family, friends and patrons begin to realize her true stature. The extreme privacy of Gwen John's life, and the reticence of her art, contrast absolutely with her brother Augustus's career. He revelled in personal notoriety, technical bravado and a prolific output. She preferred a reclusive existence, mainly in Paris, and avoided virtuoso display in favour of quiet, single-minded refinement. Her output was small and her influence slight beyond the circle of the admiring New York collector John Quinn, who became her principal patron. But Gwen's achievement now seems far more impressive and coherent than Augustus's, and her reputation continues to grow apace.

Throughout a working career which came to an end soon after her 1926 exhibition, she always stayed close to her immediate surroundings. As if reluctant to move beyond the confines of a studio where she felt relatively secure, Gwen John painted her cats, her furniture and above all the solitary women who posed for the purpose (Cat. 154, 155). The influence of Whistler, Cézanne, the Camden Town Group and Vuillard can be discerned in her work, but Gwen John's vision is ultimately an independent achievement. The women she paints all seem becalmed by their isolation. Even though some may be accompanied by a cat or a book, nothing is allowed to alleviate their essential loneliness. Nor do they protest against this condition. With arms hanging at their sides or crossed on their laps, these grave and dignified sitters seem stoically reconciled to their fate.

The muted range of colours employed by Gwen John serves to confirm this air of sobriety, and yet within these self-imposed constraints she displays a deceptively unassuming subtlety. The dating of her work is often uncertain, and her fondness for returning to the same obsessive themes might suggest that significant change never disrupted the continuity of her work. But there is, in fact, a definable move away from the relative tightness and exactitude of her earlier paintings towards a greater freedom and breadth of handling in the 1920s. Her touch, always searching and never ready to arrive at a facile or hasty resolution, became more broken and 'unfinished' as she grew older. The women's bodies sometimes seem on the verge of dissolution in these later canvases, where the light invades them and they begin to merge with their austere backgrounds.

The result is an access of spirituality, doubtless reflecting Gwen John's religious concerns after her conversion to Roman Catholicism in 1913. Prayer became of enormous importance to her, and the new emphasis on devotion received its most overt expression in the portraits of nuns at the Meudon Convent where Mère Poussepin had been Abbess in the seventeenth century. The paintings of the Abbess herself (Cat. 153), based in part on an engraved portrait, led her to develop the three-quarter-length pose she favoured in her later work. In *Mère Poussepin* the body is flattened and achieves a curiously weightless quality, so that the flared white sleeves and the wings of the nun's headdress seem to hover in space. Augustus John considered that his sister was 'the greatest woman artist of her age or, as I think, of any other', and she occupies a position in the history of modern British painting much cherished by men and women alike.

Sickert's later work was equally distinctive, but he drew his inspiration from very different sources. Casting aside the interiors of his Camden Town period, he explored in his old age an astonishingly inventive and unpredictable range of subjects which demonstrated his lively interest in every aspect of British society. For many years this final extraordinary decade of painting activity was widely regarded as an unfortunate period of Sickert's decline. But his late work ought to be regarded instead as the magnificent climax of his career, and Frank Auerbach recently declared that 'Sickert showed himself, most clearly, in the last years of his life to be a great artist'.

Basing his images very largely on photographs culled from newspapers, magazines and even film stills, he displayed an omnivorous appetite for depicting the life of the nation. The camera enabled him to catch everything on the wing, in Cat. 159 providing a candid and unconventional glimpse of the young King Edward arriving at a Welsh Guards service in a uniform which emphasizes his vulnerability as well as his boyish charm. The hint of satire in Sickert's portrayal of Royalty becomes even more open in his full-length portrait of Lord Faringdon (Cat. 160), a tanned and dapper figure in a self-conscious double-breasted suit who grins with a suavity worthy of Noël Coward. The elegant aristocrat tripping down the steps of his ancestral home could hardly be more divorced from the roughness and ardour of *The Miner* (Cat. 157), embracing his wife with so much robust relish that he does not appear to care about smearing her apron with coal dust. Sickert was sufficiently pleased with this vigorous canvas to ask Denton Welch: 'That picture gives you the right feeling, doesn't it? You'd kiss your wife like that if you'd just come up from the pit, wouldn't you?' The embarrassed Welch found himself 'appalled by the dreadful heartiness of the question'.

Sickert, however, was unrepentant. His work grew increasingly outspoken and broadly expressive with his advancing years, and he favoured a bold handling of pigment which flouted all accepted canons of taste. Always on the look-out for new ways of escaping from neatness, facility and beguiling 'finish', he told Helen Lessore that he 'sometimes left a partly painted canvas on a balcony, sloped to catch the rain, for several days, because this roughened and pitted the surface, giving it a granular look and increasing the effect of breadth he wanted'. Hence the marvellous spirit of uninhibited delight animating many of his final works, most spectacularly evident in *High Steppers* (Cat. 156). Using a large canvas which matched the expansiveness of his mood, he transformed the chorus line of Plaza Tiller Girls performing 'Up with the Lark' into an explosion of kicking limbs and foaming costumes. The *joie de vivre* of this effervescent painting testifies to the prodigious energy of an artist approaching his eightieth year with unflagging audacity and zest.

Sickert's infectious enthusiasm for even the most seemingly 'vulgar' and 'banal' aspects of contemporary life, as well as his appetite for visual fact and veneration of Degas, earned him the particular respect of the Euston Road School. It was founded in 1937 by Victor Pasmore and Claude Rogers – soon joined by William Coldstream. They were determined to return modern art to an engagement with recognizable aspects of the social world. Some members were more committed to this aim than others. 'The slump had made me aware of social problems,' recalled Coldstream, a powerful influence within the School, 'and I became convinced that art ought to be directed towards a wider public. Whereas all ideas I had learned to be artistically revolutionary ran in the opposite direction.'

In a brave attempt to reconcile these two interests, Coldstream developed an art based

on tenacious observation of everyday scenes like *St Pancras Station* (Cat. 161). His realist ambitions made him predisposed towards writers like W. H. Auden, whose determined bulk looms large in one of Coldstream's most successful early portraits. Both men had been involved in documentary film-making under John Grierson at the GPO Film Unit, and in 1938 Coldstream visited Bolton with another Euston Road member, Graham Bell, at the suggestion of Tom Harrisson. Mass Observation, an ambitious venture dedicated to studying working-class life in Britain with the help of painters, photographers, film-makers and writers, led Coldstream to paint a smoke-shrouded view of Bolton from the roof of the Art Gallery. Like Graham Bell's *The Café* (Cat. 164), it exemplifies the Euston Road desire to depict ordinary life with quiet sincerity and an austere attention to the fundamentals of pictorial structure.

Lawrence Gowing, who attended the School of Drawing and Painting in Euston Road, afterwards maintained that its adherents 'opposed to the aesthetics of discrimination an aesthetic of verification', and his own painting of *Mare Street, Hackney* (Cat. 162) implements such an approach. 'I privately thought of the subdued but respectful manner in which I painted as in some way identifying with people deprived of the fruits of their labour, among whom I should have numbered the entire population of Hackney,' Gowing wrote later. He went on to become a distinguished writer on art as well as a memorable portrait painter (Cat. 163).

A fellow Euston Road associate, Rodrigo Moynihan, was appointed an Official War Artist in 1943. Having started his career a decade before with some pioneering *Objective Abstractions*, Moynihan became a sober and compassionate recorder of the nation at war. His *Medical Inspection* (Cat. 165) is an especially perceptive image, revealing the vulnerability of the semi-naked men as they present themselves for examination by an army doctor. Moynihan's vision of war is entirely without bogus heroism and on the side of the ordinary soldier's apprehensive attitude to the conflict.

During the same period Victor Pasmore, who had been a founder of the Euston Road School, executed some of his most lyrical and heartfelt landscapes (Cat. 166, 167). Working in a tradition which extends back at least as far as Whistler's nocturnes of the Thames, Pasmore painted Hammersmith and a municipal park with a rare sensitivity. It was as if he wanted to savour the survival of places which had so recently been under the threat of appropriation by Fascist invaders. These landscapes were received with critical acclaim in 1947, but Pasmore went on to forgo representational art and establish himself as the leading Constructivist in post-war Britain.

Though his aims became increasingly removed from those of other members of the Euston Road School, there is a consistent development in his work, from the abbreviated yet meticulous observation of a landscape in *The Hanging Gardens of Hammersmith, No. 1* (Cat. 166) to his exploration of underlying structure in the fully Constructivist *Abstract in White, Black and Maroon* (Cat. 136).

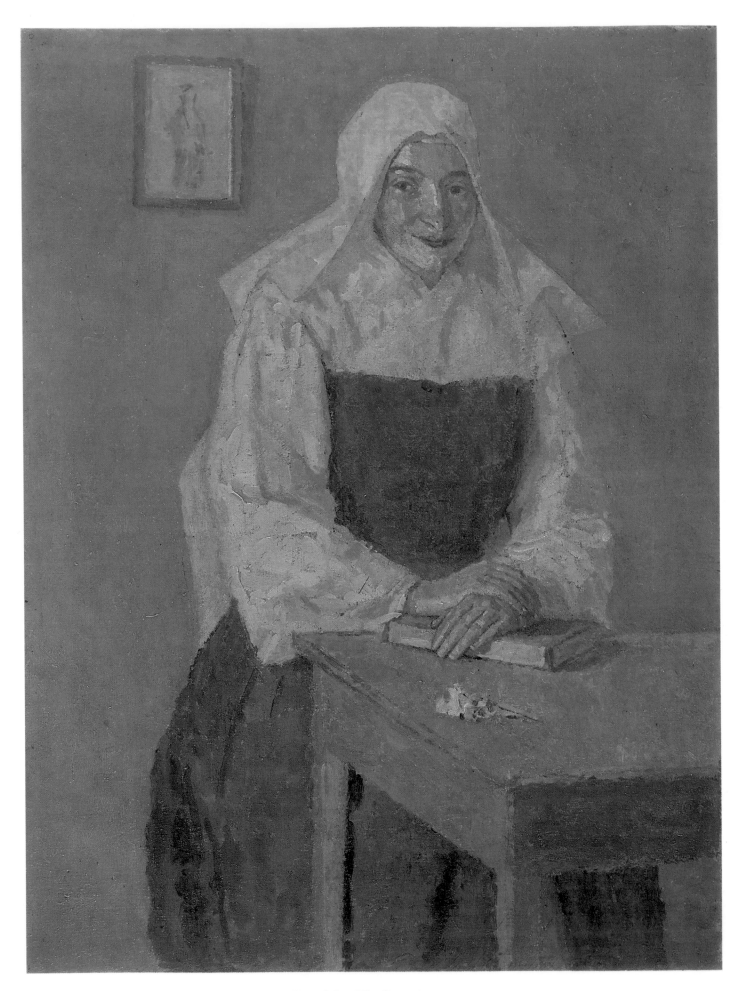

153 Gwen John, *Mère Poussepin* c. 1913-21

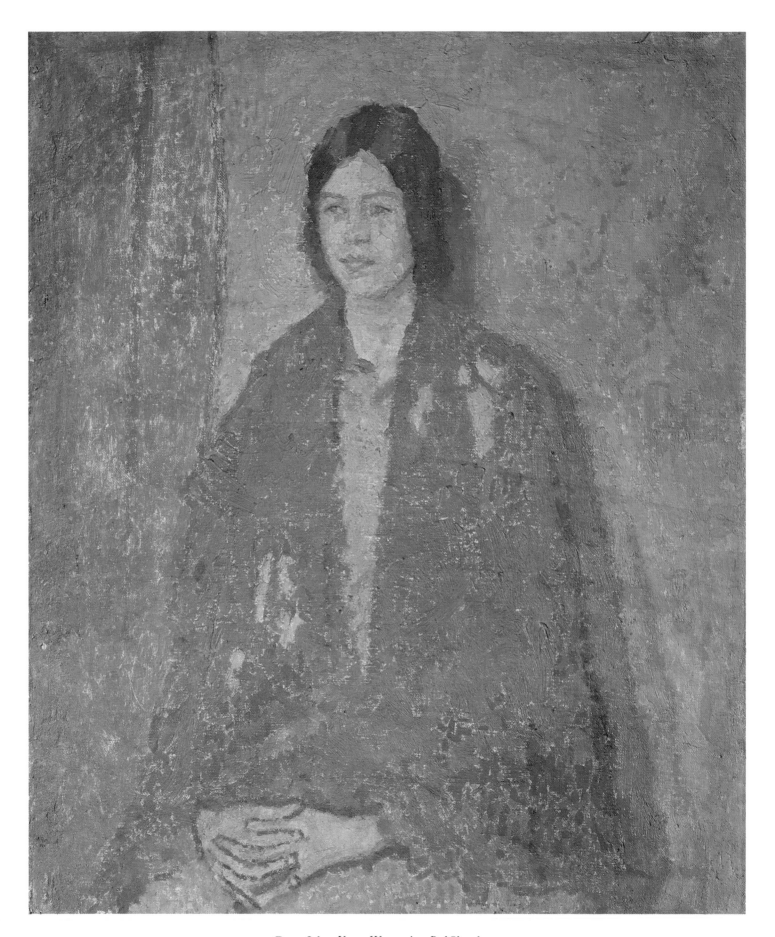

154 Gwen John, *Young Woman in a Red Shawl* 1922-25

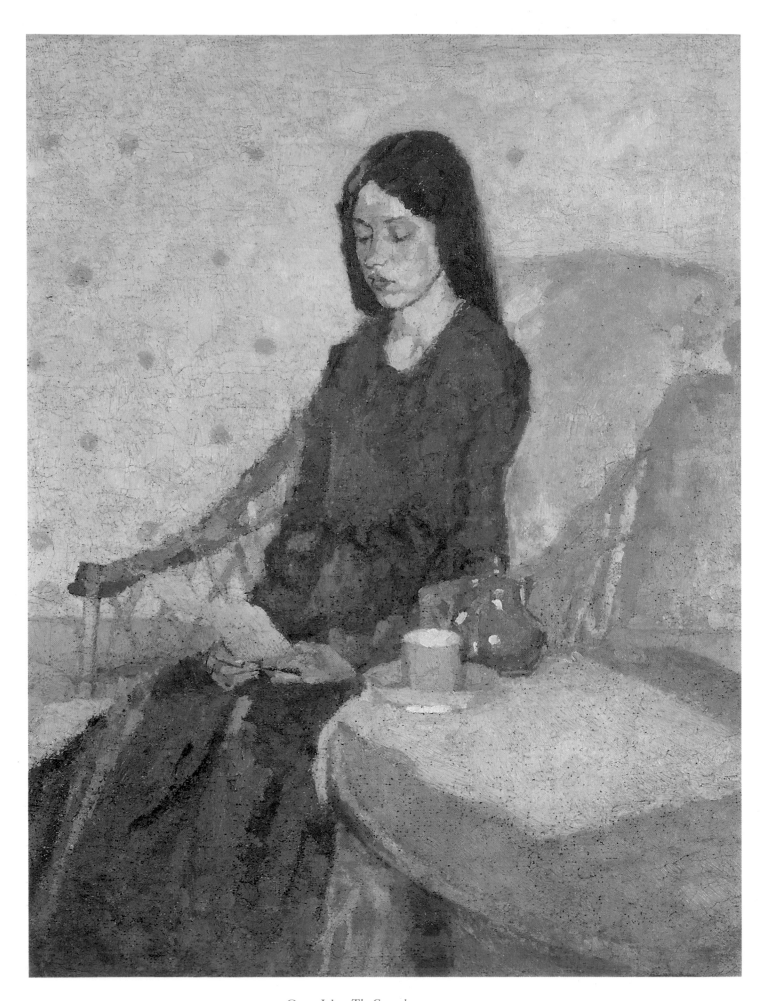

155　Gwen John, *The Convalescent*　*c. 1915–c. 1925*

156 Walter Richard Sickert, *High Steppers* *c.* 1938-39

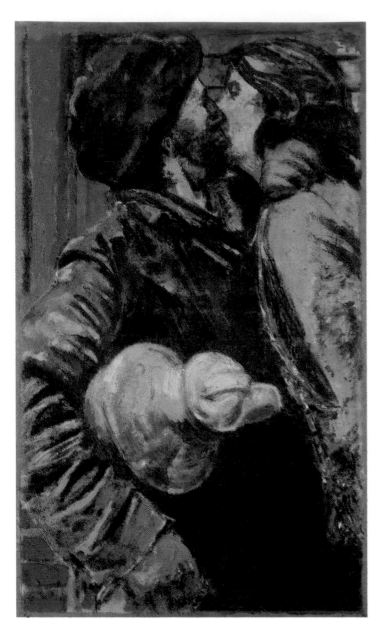

157
Walter Richard Sickert
The Miner
c. 1935-36

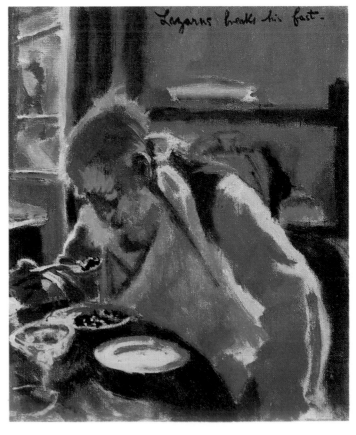

158 Walter Richard Sickert, *Lazarus Breaks his Fast*
(*Self Portrait*) c. 1927

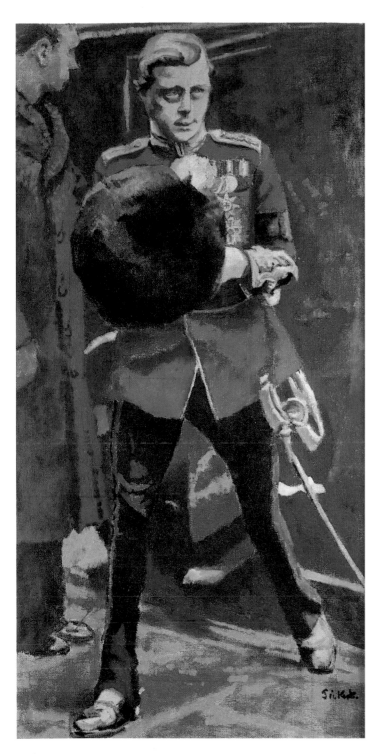

159 Walter Richard Sickert, *H.M. King Edward VIII* 1936

160
Walter Richard Sickert
Alexander Gavin Henderson,
2nd Lord Faringdon

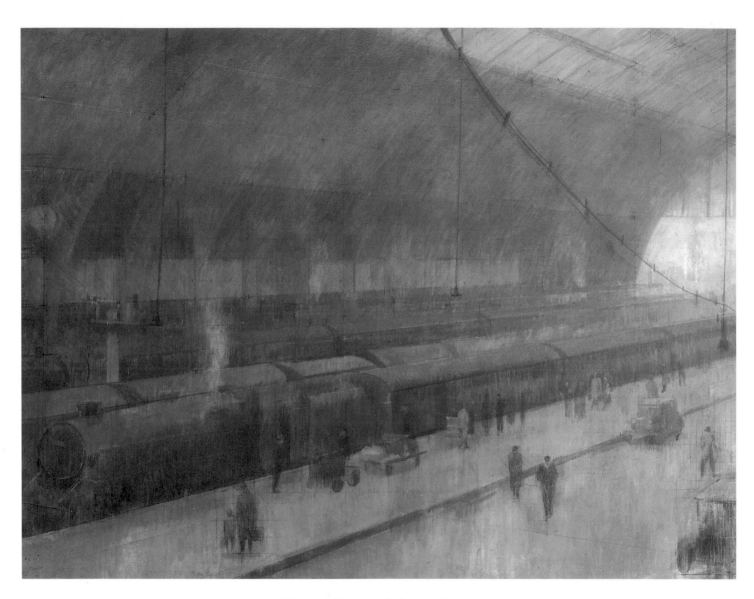

161 William Coldstream, *St Pancras Station* 1938

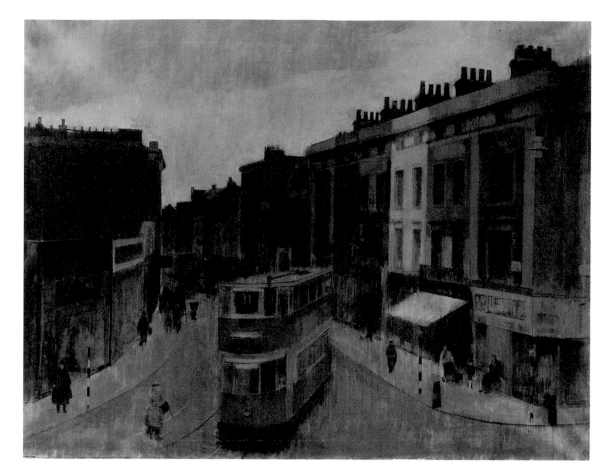

162
Lawrence Gowing
Mare Street, Hackney
1937

163
Lawrence Gowing
Girl in Blue
1946

164 Graham Bell, *The Café* 1937-38

165 Rodrigo Moynihan, *Medical Inspection* 1943

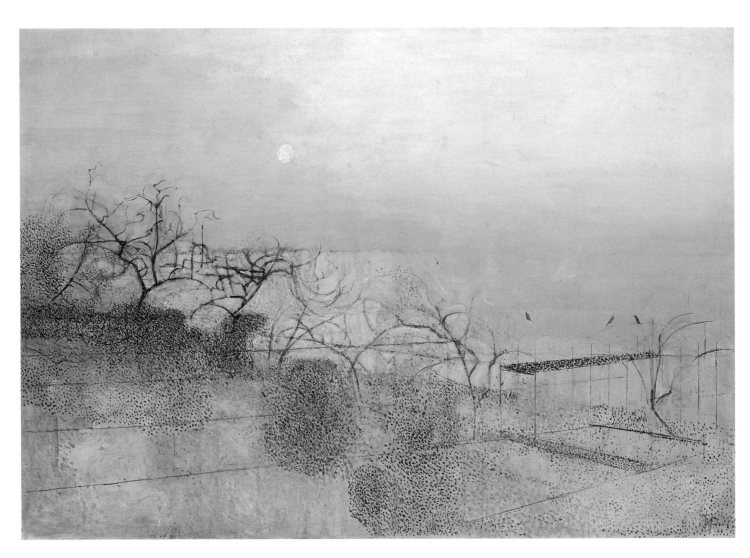

166 Victor Pasmore, *The Hanging Gardens of Hammersmith, No. 1* 1944-47

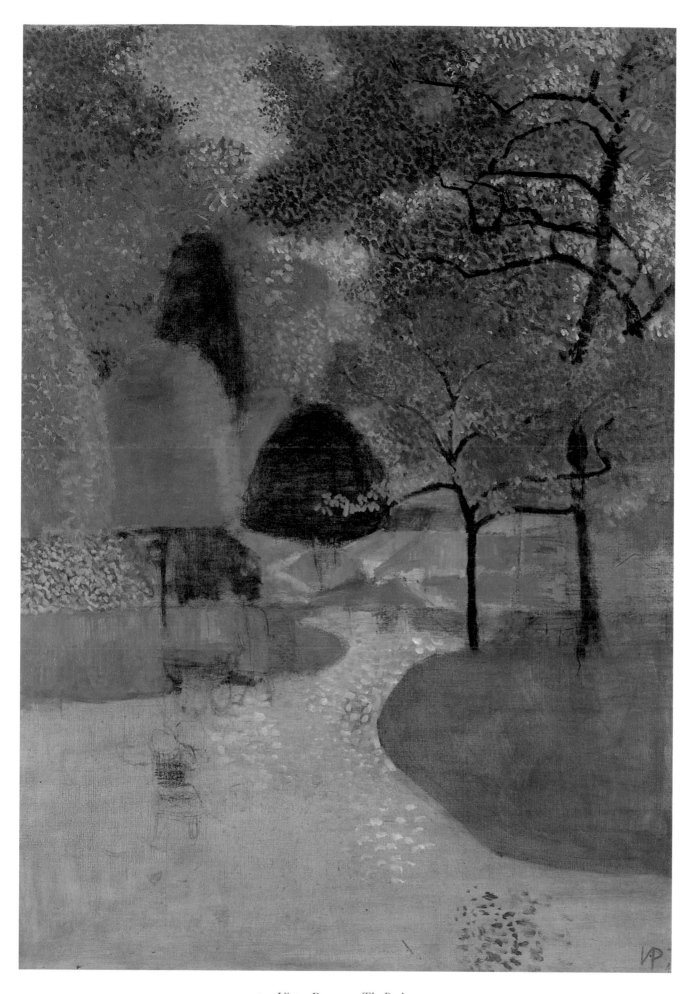

167 Victor Pasmore, *The Park* 1947

Andrew Causey

The Spirit of the Landscape

The mid-1930s saw a new imaginative power brought to landscape painting in the Surrealist work of Paul Nash and Graham Sutherland. This was followed in the 1940s by the discoveries of Ivon Hitchens whose landscapes have a strength and authority equal to that of the Surrealists but expressed without recourse to symbol or metaphor. Nash was the key figure in the mid-Thirties, and his work forms a link with the earlier post-war revival of landscape painting. Whereas that had been concerned with design and structure and the formal lessons of Post-Impressionism, the Surrealists explored the inner animation of landscape; nature was seen as a source of ideas about birth and growth, decay and death. Clear-cut distinctions are difficult to make: Nash's earlier paintings, *The Shore* (Cat. 128) and *Winter Sea* (Cat. 168), are simplified in form – the product of Nash's individual way of looking at Cézanne and Cubism – but are also expressive of mood; the warm atmosphere of *The Shore* contrasts with the cold-steeliness of *Winter Sea*. Nash worked on *Winter Sea* in both periods – it is dated 1925/37 – and it is therefore the key linking work.

'Gradually, however, the landscape as a scene ceased to be absorbing,' Nash wrote in 1937, 'some drama of beings, after all, seemed to be necessary.' With *Landscape from a Dream* (Cat. 131) Nash entered a new, more dramatic and richly coloured phase of landscape painting with works that are fusions of familiar locations with dramas generated in his imagination. Nash was an Official War Artist in the Second World War and, as in his earlier pictures of the Western Front,

there is a sense that in his war records he is always reaching beyond simple documentation. *Totes Meer (Dead Sea)* (Cat. 169) was based on photographs that Nash took of wrecked German aircraft collected in a field at Cowley near Oxford. Looking beyond immediate appearances, Nash reanimated the wrecks in the form of a threatening moonlit sea – not unlike that in the earlier *Winter Sea* – a danger to the land in the same way that the aircraft had once been.

In late works, like *Eclipse of the Sunflower* (Cat. 170), Nash reached out with the help of popular myth to penetrate the hidden sources of nature's power, making many of his finest paintings on the themes of the rise and fall of tides, the courses of the sun and moon, as well as the mythical sunwheel and symbolic sunflower. It is a Romantic art which, not surprisingly, was more detached from European Modernism than his painting of the Unit One period, since it was made under the siege conditions of war.

Sutherland had been an etcher in the printmaking revival of the 1920s, and his painting is marked by the same devotion to the intricacies of nature rather than to broad panoramas that his etchings had shown. In 1936 he showed, like Nash, in the International Surrealist Exhibition in London, and the two became leaders of English landscape Surrealism. Like Nash, Sutherland drew inspiration from particular places; with Nash it had been the Chilterns, Dymchurch and the Dorset coast; for Sutherland it was the wooded inlets and estuaries and the bare moorland roads of Pembrokeshire in western Wales. His pictures, mainly small, and glow-

ing and intense in colour, focus on individual objects – boulders, pieces of driftwood, the branches of an overhanging tree – or a road snaking across the landscape (Cat. 173-176). They evoke mystery through the suggestion of animate presence and of the power concealed behind ordinary forms. Sutherland's places are dreamlands, often nightmarish ones, where man is a tiny figure (as in *Welsh Landscape with Roads*, Cat. 174) fleeing from consuming forces that can be felt but not easily described.

A Londoner until the Second World War, Hitchens moved in 1940 to a piece of scrubby woodland (which he owned) below the South Downs near Petworth in Sussex, and this became his 'place' as much as western Wales was Sutherland's. Hitchens had not been a contributor to the International Surrealist Exhibition; his allegiance in the Thirties was to the abstract side of British art. He was an admirer of Roger Fry and, like him, saw in the clear spatial construction used by a Renaissance painter such as Piero della Francesca an example for modern art. Hitchens wanted to reveal by means of colour the basic structure of landscape. Though he did not set out, like Nash, Sutherland and their Neo-Romantic followers, to draw out the secret life of nature through use of metaphor or symbol, his paintings of tangled woodlands and dark pools (Cat. 178) are mysterious and evocative, and his intense and expressive colours have much in common with Sutherland's. There was scarcely a painter in England in the 1940s who was not subject to the Romantic impulse in some degree.

Richard Cork

Late Bomberg

The gathering civil unrest in Spain forced David Bomberg to leave the country in 1935 just as his painting reached a peak of impassioned eloquence. *Valley of La Hermida: Picos de Europa, Asturias* (Cat. 180), with its broadly expressive brushwork allied very closely to his observation of the mountainous terrain, conveys Bomberg's ardent response to a valley alive with the turbulent action of light.

His sudden return to England, where he suffered from increasing neglect by critics, curators, dealers and collectors alike, interrupted the momentum he had established in Spain. His mood darkened, but the advent of a world war revived his hopes of securing the patronage he so desperately needed. In 1942 the War Artists' Advisory Committee reluctantly invited him to paint one picture of an underground bomb store for a fee of twenty-five guineas. Bomberg was elated, and produced during his fortnight at the store an abundance of exceptional drawings and oil studies (Cat. 181).

The scenes he studied in the disused mine, stacked with bombs waiting to be used in raids against Germany and elsewhere, awakened his memories of the Sappers he had painted during the First World War. Rather than depicting the store as a secure and mighty arsenal, Bomberg charged his paintings with intimations of the destruction that modern armaments could unleash. His loosely gestured and yet fiery brushmarks animate the bombs with a troubled awareness of the devastation to come, when Ger-

man cities were finally laid waste by air attacks. The Committee could not stomach such forebodings, and it terminated Bomberg's contract after accepting three drawings instead of the commissioned painting. But Bomberg's interpretation of the bomb store, which refused to rest content with a cosmetic vision of war, turned out to be uncannily prescient. In November 1944 the Burton-on-Trent store was itself ripped apart by the biggest explosion ever recorded in Britain. The accidental detonation of one bomb led to the the blasting of 3,500 tons of high explosives, and the conflagration annihilated people, cattle and buildings over a wide area.

The bomb store paintings are among the most impressive of Bomberg's later works, but his reputation was now at such a low ebb that he was rejected for hundreds of teaching posts during this period. In 1945, however, he eventually found a part-time job at the Borough Polytechnic in London, where his legendary classes continued for several years. Frank Auerbach and Leon Kossoff were among the young artists who studied there, and the stimulus Bomberg found in teaching coincided with the flowering of his landscape painting. An expedition to Devon in 1946 yielded results as memorable as *North Devon, Sunset – Bideford Bay* (Cat. 182), in which land, water and sky are alive with the agitated rhythm of his passionate involvement with the natural world. This intensity quickened the following year at Trendrine in Cornwall, which inspired Bomberg to transmit his heightened apprehension of the land-

scape in great swooping brushstrokes with a life of their own (Cat. 183).

The spectacular climax of this development came in Cyprus a year later, when he attained such a complete fusion of the observed landscape and his own subjective reaction that it is impossible to tell where one ends and the other begins. *Castle Ruins at St Hilarion* (Cat. 185) is the masterpiece of the canvases Bomberg painted there, and its abundant vitality proved that he had succeeded in defining what he described as 'the spirit in the mass'. He attached enormous importance to the fulfilment of this aim in his painting and teaching. Disillusioned by the dehumanization of the machine age, he believed that artists could redeem the world by re-establishing a relationship with nature. 'With the approach of the scientific mechanisation and the submerging of individuals,' he wrote in 1953, 'we have urgent need of the affirmation of man's spiritual significance and his individuality.'

The figure paintings of his last years show how tormented Bomberg had become by the indifference and scorn of the British art establishment. The neglect was unforgivable, and in *'Hear O Israel'* (Cat. 184) and the *Last Self-Portrait* (Cat. 186) he gave vent to his wounded emotions. They bear tragic witness to the plight of an artist without honour in his own country, and yet behind the mortification lies a defiant resilience as well. Even as they reveal the despair of a lonely and ailing man, these final testaments offer affirmative proof of his formidable expressive power.

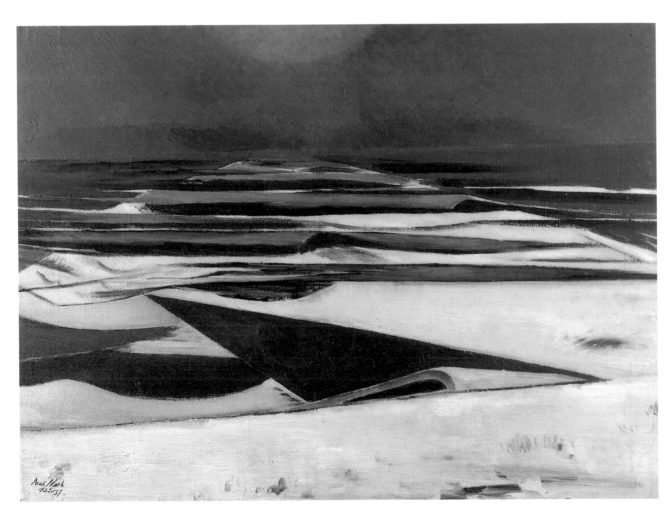

168 Paul Nash, *Winter Sea* 1925-37

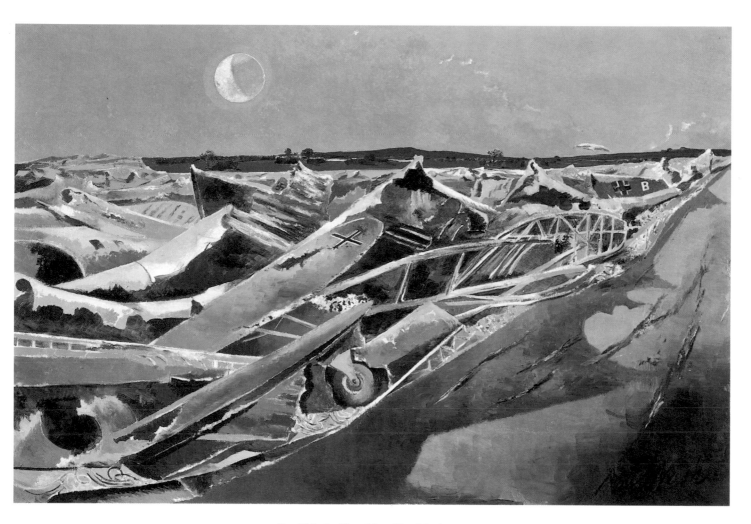

169 Paul Nash, *Totes Meer (Dead Sea)* 1940-41

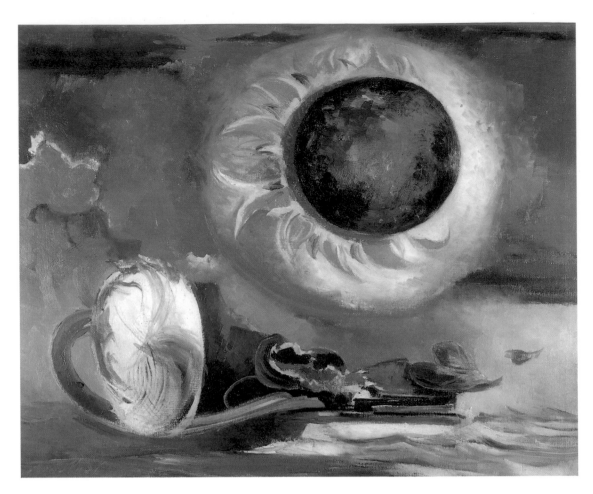

170
Paul Nash
Eclipse of the Sunflower
1945

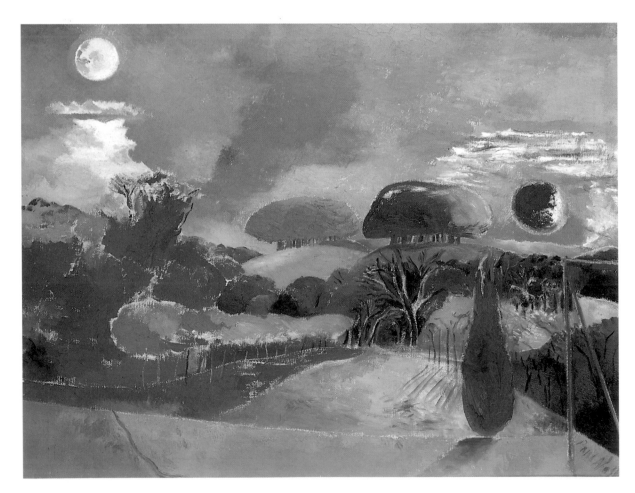

171
Paul Nash
*Landscape of the
Vernal Equinox*
1944

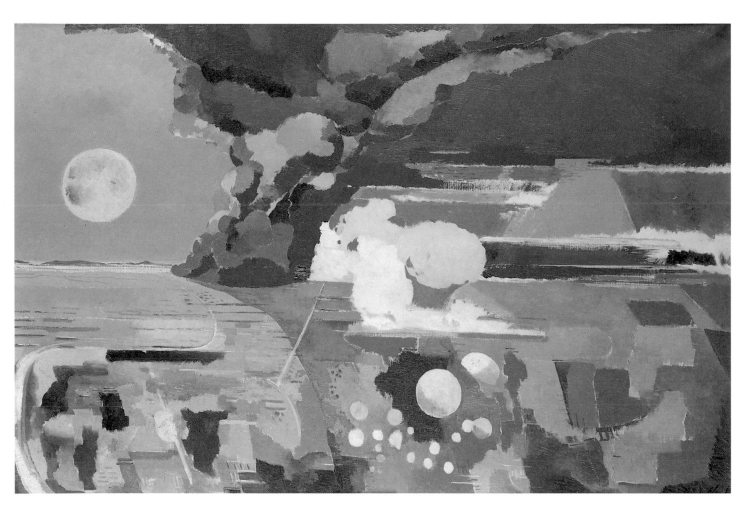

172 Paul Nash, *Battle of Germany* 1944

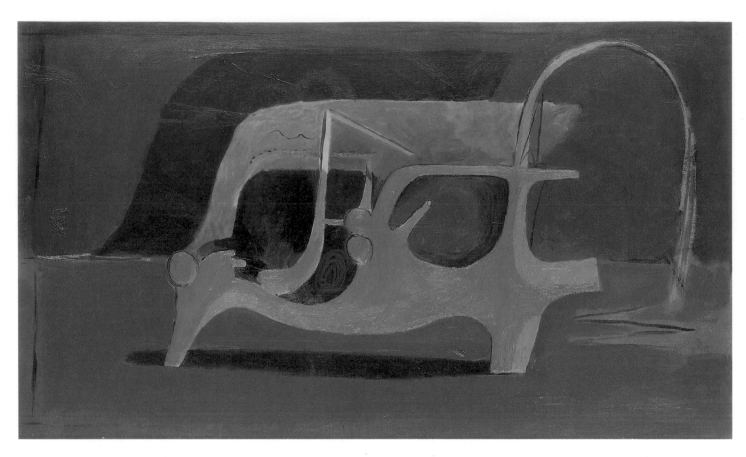

173 Graham Sutherland, *Red Tree* 1936

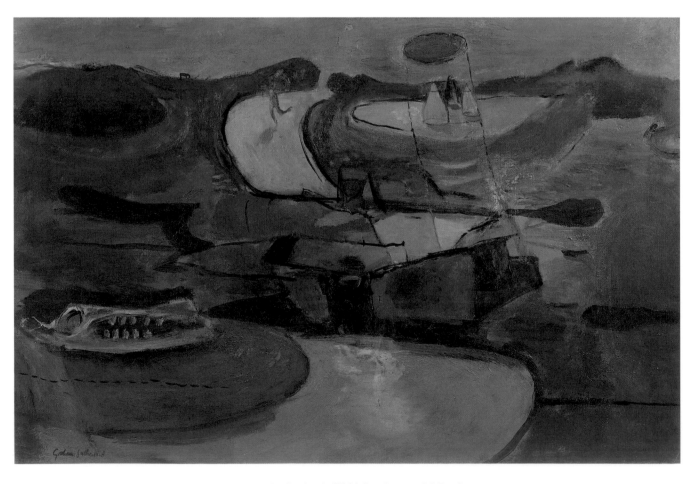

174 Graham Sutherland, *Welsh Landscape with Roads* 1936

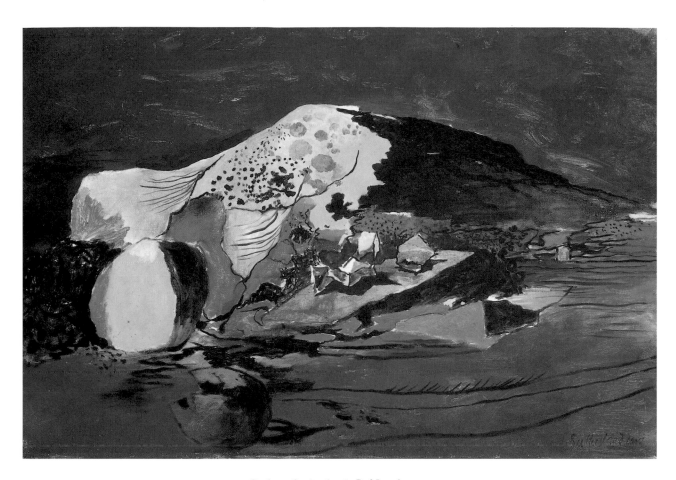

175 Graham Sutherland, *Red Landscape* 1942

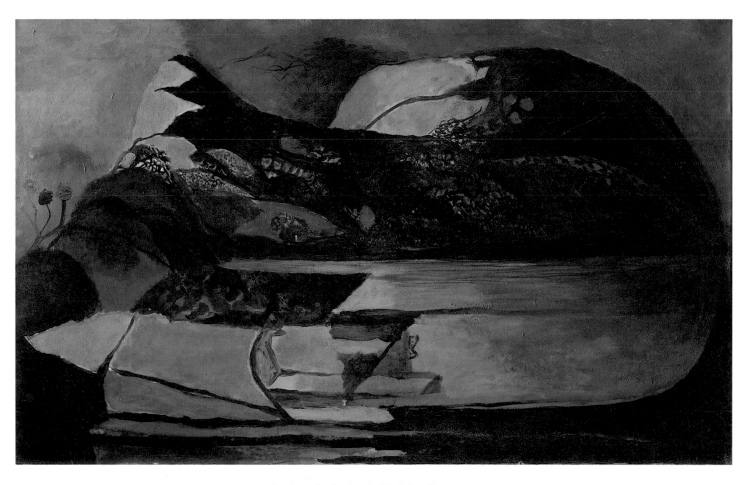

176 Graham Sutherland, *Black Landscape* 1939-40

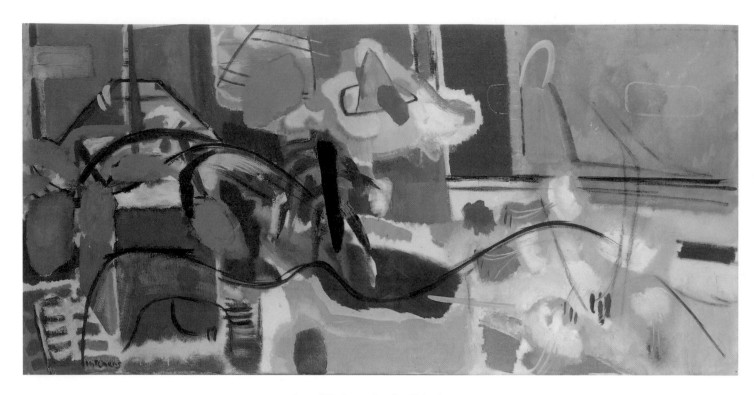

177 Ivon Hitchens, *London Painting* *c.* 1932

178 Ivon Hitchens, *Hazel Wood* 1944

179 Ivon Hitchens, *Flower Piece* 1943

180 David Bomberg, *Valley of la Hermida: Picos de Europa, Asturias* 1935

181 David Bomberg, *Underground Bomb Store* 1942

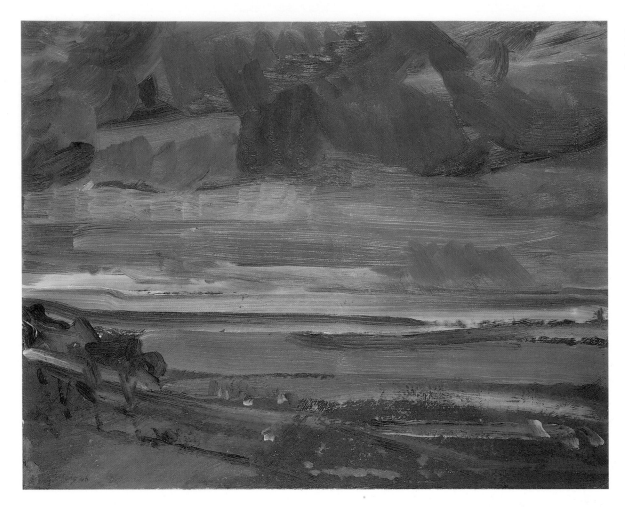

182
David Bomberg
*North Devon,
Sunset – Bideford Bay*
1946

183
David Bomberg
*Trendrine in Sun,
Cornwall*
1947

184 David Bomberg, *'Hear O Israel'* 1955

185 David Bomberg, *Castle Ruins at St Hilarion* 1948

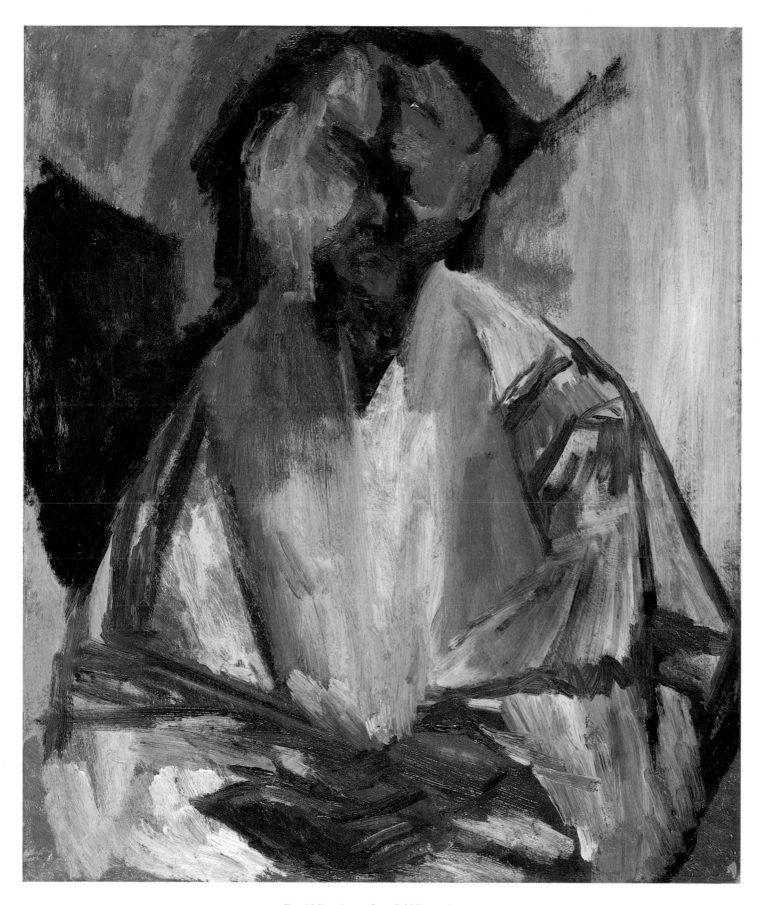

186 David Bomberg, *Last Self-Portrait* 1956-57

Dawn Ades

Henry Moore, Sculpture and Drawings

Henry Moore's sculpture and drawing are here presented together even though, far from being isolated from his contemporaries, Moore was closely associated in the early Thirties with Paul Nash, Ben Nicholson and Barbara Hepworth. A little later, like Nash and Herbert Read, he was a founder member of the Surrealist group in England. Also he knew and responded to the work of sculptors abroad, mainly in Paris, although from the very start his assimilation of the work of Brancusi and Modigliani was so complete that there is never any sense of his work being derivative. In Britain, Epstein and Gaudier-Brzeska were important to him, but above all, for Moore, as for many of his contemporaries in France, non-Western art provided a major source of inspiration.

Roger Fry's *Vision and Design* (1920), which Moore read in Leeds before moving to the Royal College in London in 1921, contained two key essays, 'Negro Sculpture' and 'Ancient American Art' in which the formal, plastic power of objects hitherto regarded in Britain at least as chiefly of archaeological or ethnographic interest was discussed. 'Some of these things', Fry wrote of African art, 'are great sculpture – greater, I think, than anything we produced even in the Middle Ages.'

Moore defined 'truth to material' as the first of his aims and found in non-Western art a key to its realization; in addition, non-Western art opened up for him a new world of constructive forms. He disliked the term 'primitive' because of its misleading connotations of crude and simplistic forms and, rather than seeing the art of other cultures as an alien if invigorating tradition, he per-

Cat. 188 Henry Moore, *Mask*, 1929

ceived African and Pre-Columbian art as belonging to 'the main world tradition of sculpture'. For him European Romanesque and early Gothic belonged equally to this tradition, whereas the 'realistic ideal of physical beauty in art which sprang from fifth-century Greece was only a digression'.

Both of the earliest works included here, made just after Moore left the Royal College, are in stone. *Mother and Child* (Cat. 192) and *Woman with Upraised Arms* (Cat. 193) are monumental in effect in spite of their relatively small size. *Mother and Child* in particular has a concentrated power summed up in the child's expression, while the ingenious position of the child perched on the mother's head emphasizes the vertical unity of the piece. *Woman with Upraised Arms*, with its simplified mask-like face, more explicitly if still in a generalized way reveals its 'primitive' inspiration.

Moore first saw Pre-Columbian Mexican and African art in the British Museum in the days when the ethnographic collections were ranged together in a glorious crowded jumble, and every visit revealed something new. For Moore there was a direct link between the eleventh-century stone carvings he had loved as a boy and Mexican art, which influenced the tiny but impressive *Mask* (Cat. 188) of 1929, with its hollow circular eyes. The quality he had felt in Mexican sculpture was vitality, a quality that he understood as being opposed to beauty. Vitality was power that did not necessarily please the senses: it did not lie in physical beauty and was not to do with implied movement nor with harmony and decoration, but with a kind of 'pent-up energy'. It should be, he felt, an 'expression of the significance of life'.

Another form of primitive art inspired *Composition* (Cat. 195) of 1931, which marked

a radical development simultaneously towards abstraction and Surrealism. This source was Cycladic sculpture of *c*. 2000 BC, examples of which were reproduced in the Parisian journal *Cahiers d'Art* in 1929. The Cycladic *Lyre-playing Idol* lies behind Picasso's *Project for a Monument* of that year, which was reproduced in the review *Documents* of which Moore owned a copy. Picasso's sculpture incorporates the open musical instrument into the figure itself, a move that Moore was to develop further. As he wrote, 'The first hole made through a piece of stone is a revelation A hole can itself have as much shape-meaning as a solid mass'

The new morphological freedom of this *Composition* in green Hornton stone and of another one in alabaster of the same year (Cat. 194) recalls as well the paintings of Miró and Tanguy and anticipates Arp's *Concretions*. With these sculptures Moore was developing a new Surrealist language of bolder analogies and juxtapositions, with pierced and dismembered forms, which plays with the fact that in sculpture there are 'no two points of view alike'. The forms, however, remain firmly rooted in the organic world.

Moore not only participated in the International Surrealist Exhibition in London in 1936 but was on the organizing committee. But despite the fact that he described himself

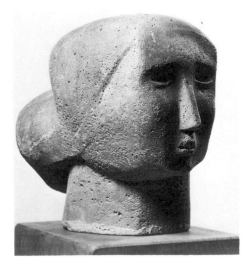

Cat. 187 Henry Moore, *Head of a Woman*, 1926

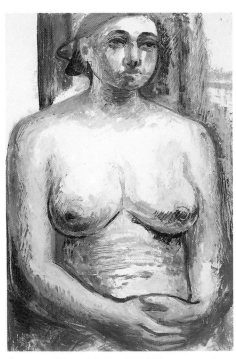

Cat. 189 Henry Moore, *Seated Woman*, 1929

as a Surrealist and was in sympathy broadly with the aims of the movement, he avoided any specific theoretical commitment to it or any programmatic adoption of the principles of automatism. Yet a certain Surrealist element remained a natural part of Moore's sculptural thought and even transformations that seem to result in abstraction – such as those operative in *Three Points* (Cat. 205) – reveal an imagination compatible with Surrealism. The form of this sculpture evolved, as can be seen from a sheet of drawings, from the breasts of the female torso, which Moore defined in these drawings as spaces enclosed by pointed forms. In the sculpture the points themselves become the subjects, concentrating all the charge and tension in themselves, threatening and violent, almost the direct opposite of the original source.

It is difficult to realize today that Moore was for much of his life the most controversial artist in Britain. Like Epstein he aroused critical and public anger in the Thirties, as he had with exhibitions in the late Twenties, and he continued to do so after the war. His work was seen as an attack on the sanctity of the human form and as either too abstract or too distorted.

The human figure was the natural centre of Moore's work and the subjects of 'Mother and Child' and the 'Reclining Figure' remained two of his major preoccupations. While the former tended to extend into social and cultural dimensions, the latter opened on to a whole range of organic forms. The *Reclining Figure* of 1929 (Fig. 9, p. 37) was inspired by a cast that he saw in Paris in 1925 of a Chacmool, a Toltec male warrior priest from which he conjured a female whose body already begins to invite analogy with the mountains, hills and valleys of the natural landscape. As Moore himself said, 'The human figure is what interests me most deeply, but I have found principles of form and rhythm from the study of natural objects such as pebbles, rocks, bones, trees, plants etc.'

The *Draped Reclining Figure* (Cat. 207) is rather an exception. Made in 1952-3, soon enough after the war to recall 'Shelter' drawings (such as Cat. 191) in which the massed human forms are swathed in clothes that both define and swell with their shape, it also refers to the drapery of Classical Greek carving which Moore knew from his long acquaintance with the Elgin Marbles and also from a recent visit to Greece.

The great *Internal and External Forms* (Cat. 206) of the following year traces back to

another image of the early war years, *The Helmet* of 1939-40. But whereas the hollow helmet enclosing the tiny figure both protects and threatens, in *Internal and External Forms* there is not so much an oscillation between protection and threat as a sculptural meditation on the resolution of opposites. The 'mother and child' becomes the child in the womb and the figure in a tomb, an Egyptian sarcophagus holding the dead.

The latest sculpture included here is *Standing Figure: Knife Edge* (Cat. 208), where Moore explores on a monumental scale a new source of vitality, of plastic energy, the sculptural implications of bone edges, sharp as a knife. They flatten out into planes which swell and fall and are capable of representing volume.

Moore's drawings, rather than deriving their importance from their relationship with a particular sculpture, are often works in their own right. Sheets of drawings may teem with sculptural ideas – as in *Ideas for Sculpture* (Cat. 199) – and there are single figures drawn from life (Cat. 189), but not since the early years of his career were they precise drawings exactly equivalent to a sculpture. Two drawings of 1936 do relate to the direction that his sculpture was then taking: the geometricized *Square Forms* (Cat. 196) compares with the sculpture of the same title (now in the Sainsbury Centre) with block-like shapes still ultimately referring to the human figure. In *Stones in a Landscape* (Cat. 197) the Greek temple façades emphasize the architectural extensions of the body/stone, while a carefully worked drawing of 1942, *Reclining Figure and Red Rocks* (Cat. 198), even recasts the rocky landscape itself into a sculpture.

Moore's 'Shelter' drawings were commissioned by the War Artists' Advisory Committee and, as Herbert Read said, 'had a precise intention – to depict the reactions of the people of London to the nightly bombardment inflicted on them' In Cat. 191 and 202 Moore observes the positions of individuals and of bodies massed together, relaxed or exhausted in sleep, seen against the deep shadow of the tube. In 1942 Read suggested that Moore should study miners at work on the coalface. Since they were engaged in war work this would still fall within the terms of his commission. Many of the resulting drawings such as *At the Coalface* (Cat. 201) draw their force from a tension between the idea of the dignity of labour and the grim claustrophobic cage-like darkness in which the men work. In contrast, *Coalminer Carrying a Lamp* (Cat. 200) is a rare instance – perhaps provoked by the grimness of 1942 – of Moore making a close reference to a well-known image from British art, *The Light of the World* by Holman Hunt, of which a print hung in his parents' home. The 'Shelter' drawings perhaps have the greater impact because the subject was both unique and innately Surrealist and the artist correspondingly developed a unique manner for dealing with it.

Moore is one of the rare artists, like Picasso, who, while being undeniably part of a Modernist tradition, responds directly in his art to the immediate conditions of human life. This is not only true of the war drawings but also of the *Spanish Prisoner* (Cat. 190). Out of the contradictions between often threatening or deadly conditions and Moore's irrepressible belief in the significance of life in its human and organic aspects, there comes a tension which contributes to the vitality of all his work.

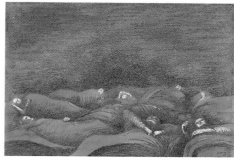

Cat. 191 Henry Moore, *Sleeping Shelterers*, 1941

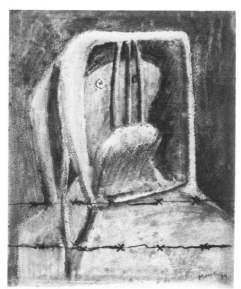

Cat. 190 Henry Moore, *Spanish Prisoner*, 1939

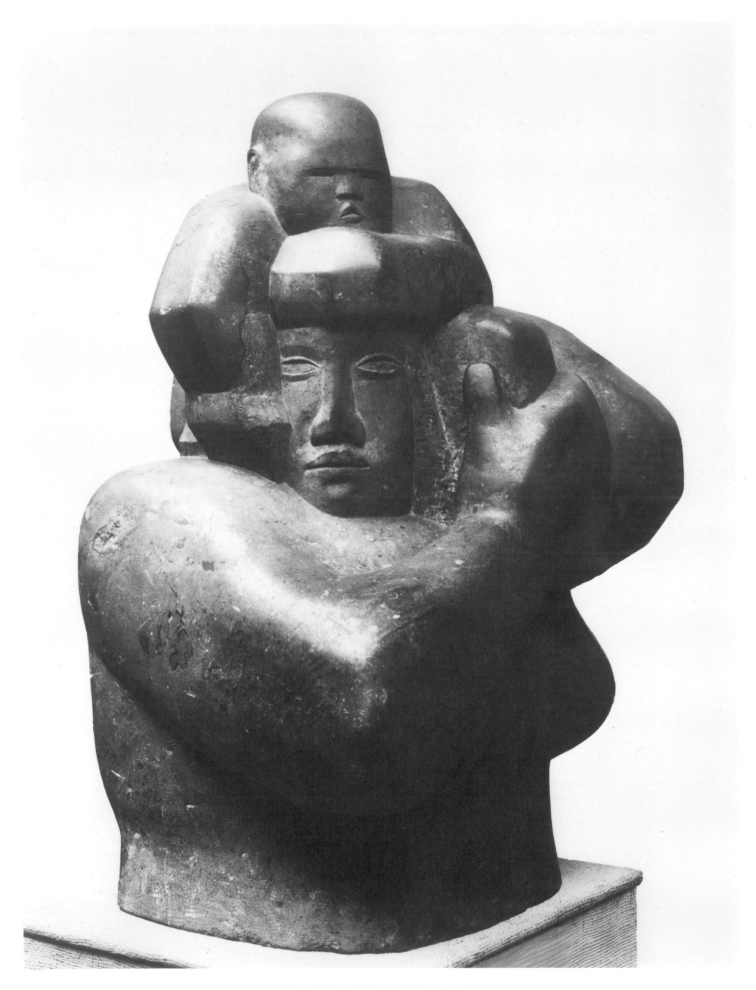

192 Henry Moore, *Mother and Child* 1925

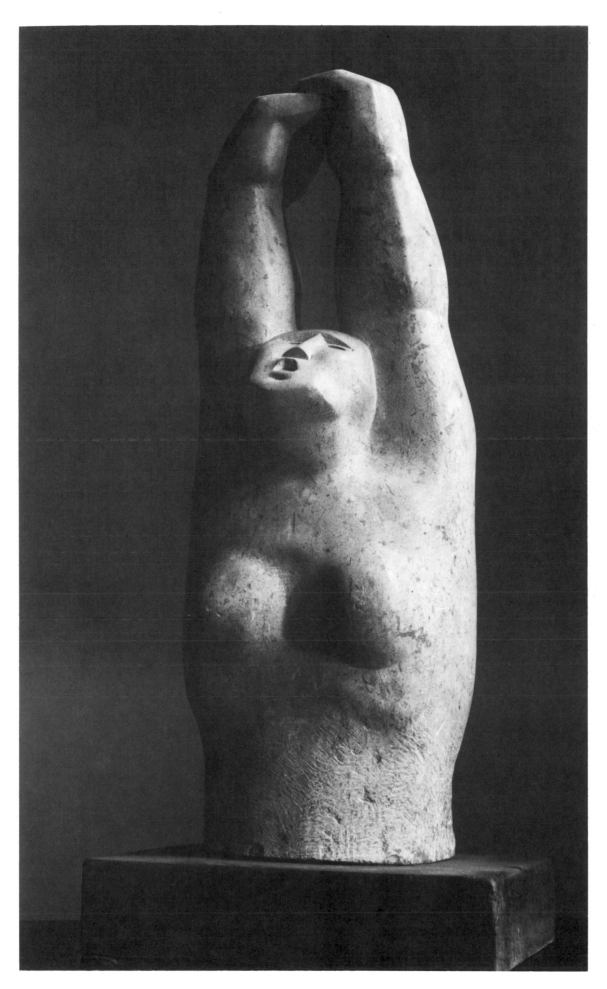

193 Henry Moore, *Woman with Upraised Arms* 1924-25

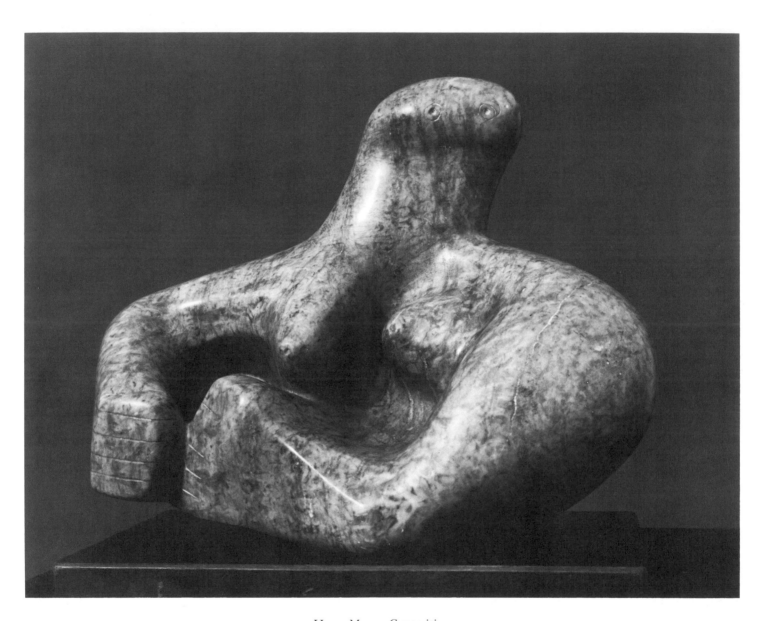

194 Henry Moore, *Composition* 1931

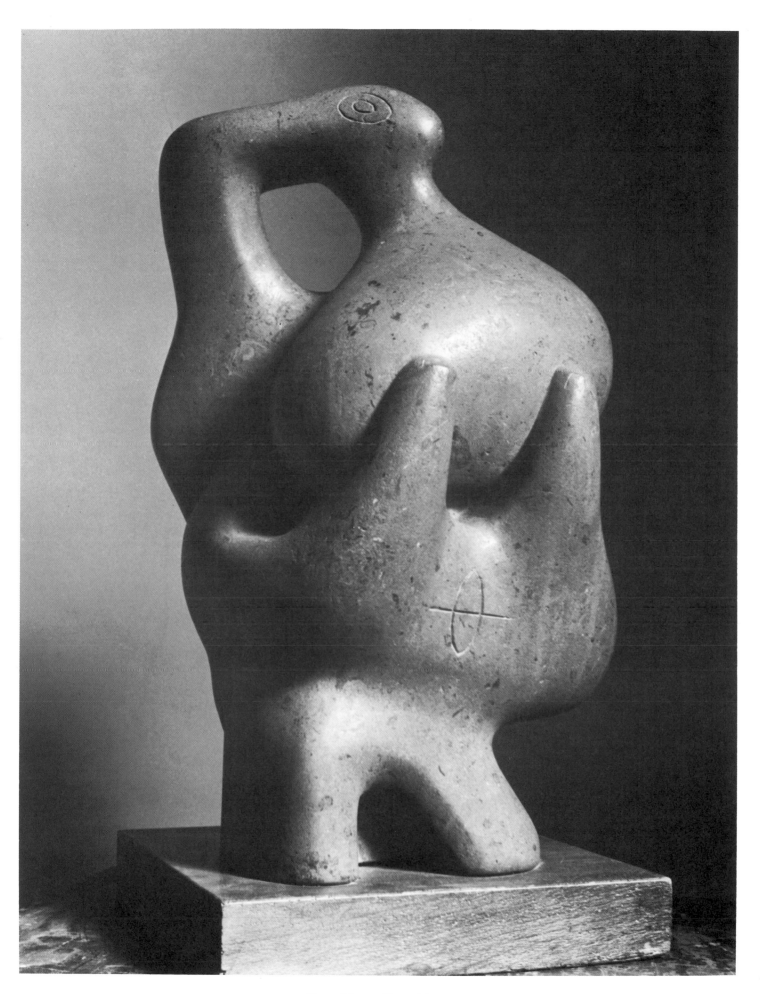

195 Henry Moore, *Composition* 1931

196
Henry Moore
Square Forms
1936

197 Henry Moore, *Stones in a Landscape* 1936

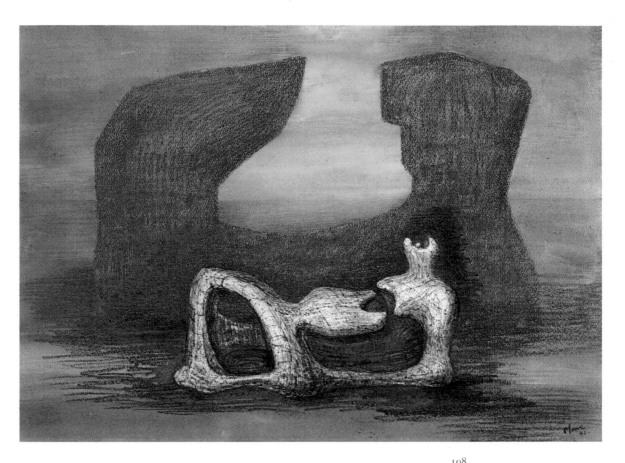

198
Henry Moore
Reclining Figure and Red Rocks
1942

199
Henry Moore
Ideas for Sculpture
1942

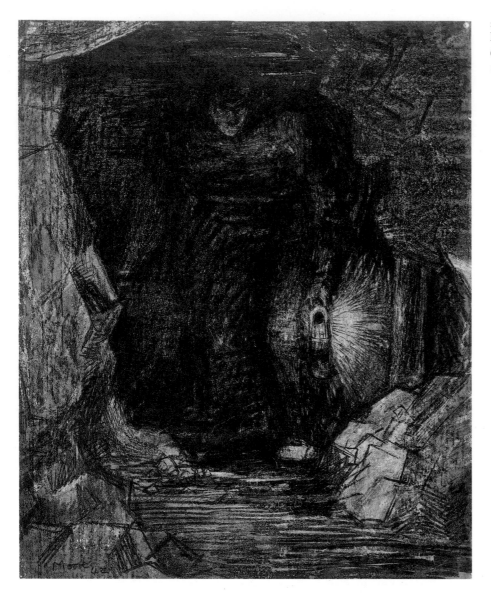

200
Henry Moore
Coalminer Carrying a Lamp
1942

201
Henry Moore
At the Coalface
1942

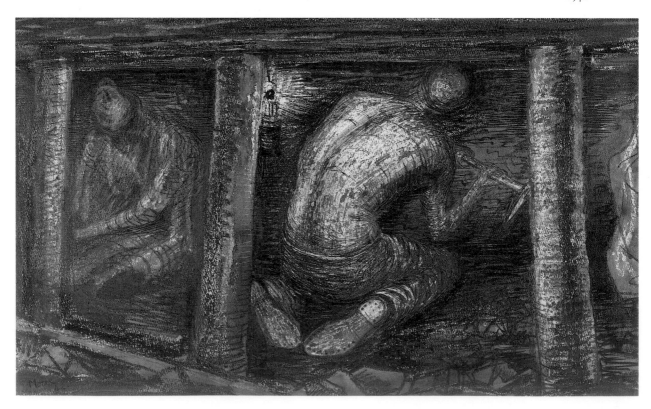

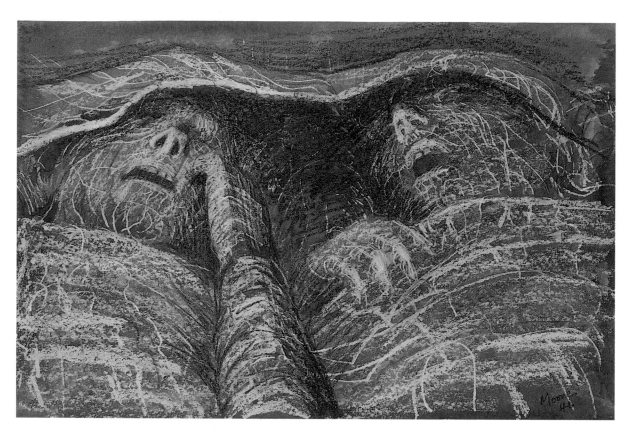

202 Henry Moore, *Two Sleepers* 1941

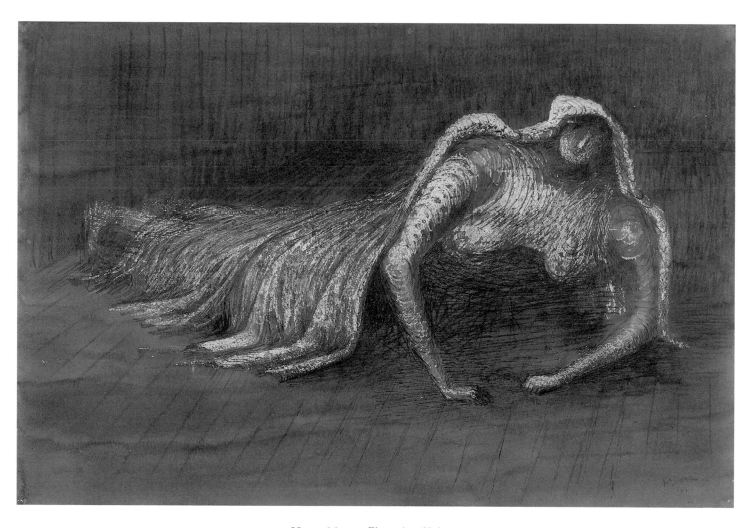

203 Henry Moore, *Figure in a Shelter* 1941

204
Henry Moore
Family
1935

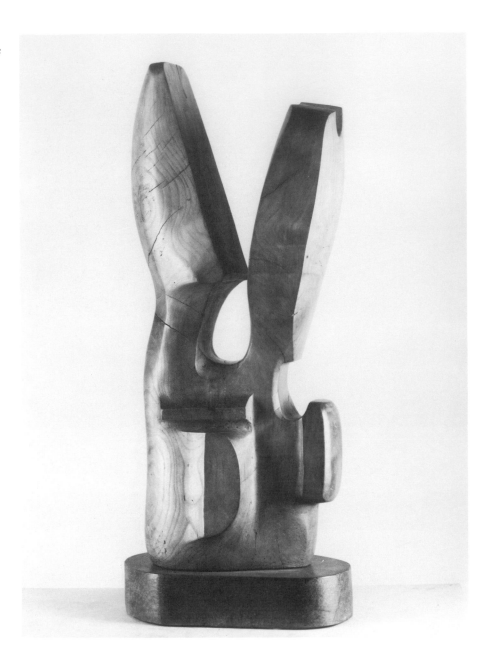

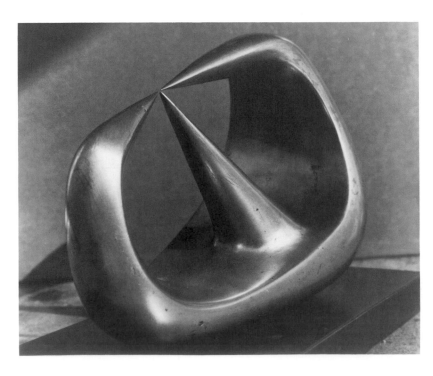

205
Henry Moore
Three Points
1939-40

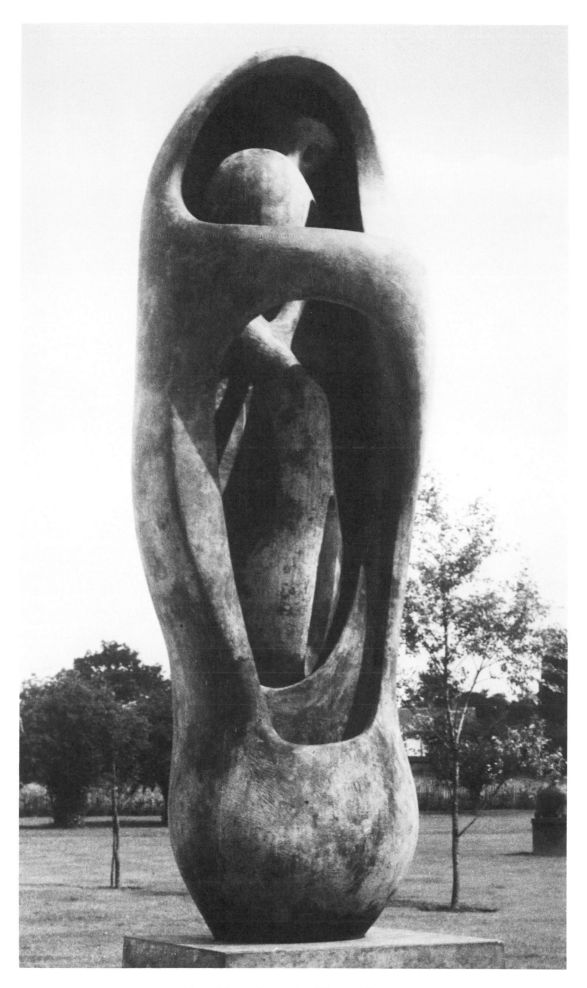

206 Henry Moore, *Internal and External Forms* 1953

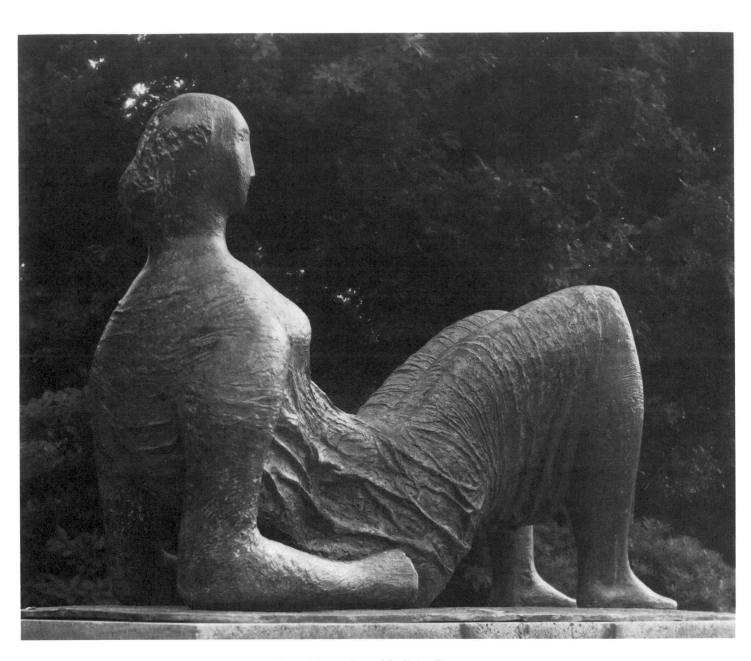

207 Henry Moore, *Draped Reclining Figure* 1952-53

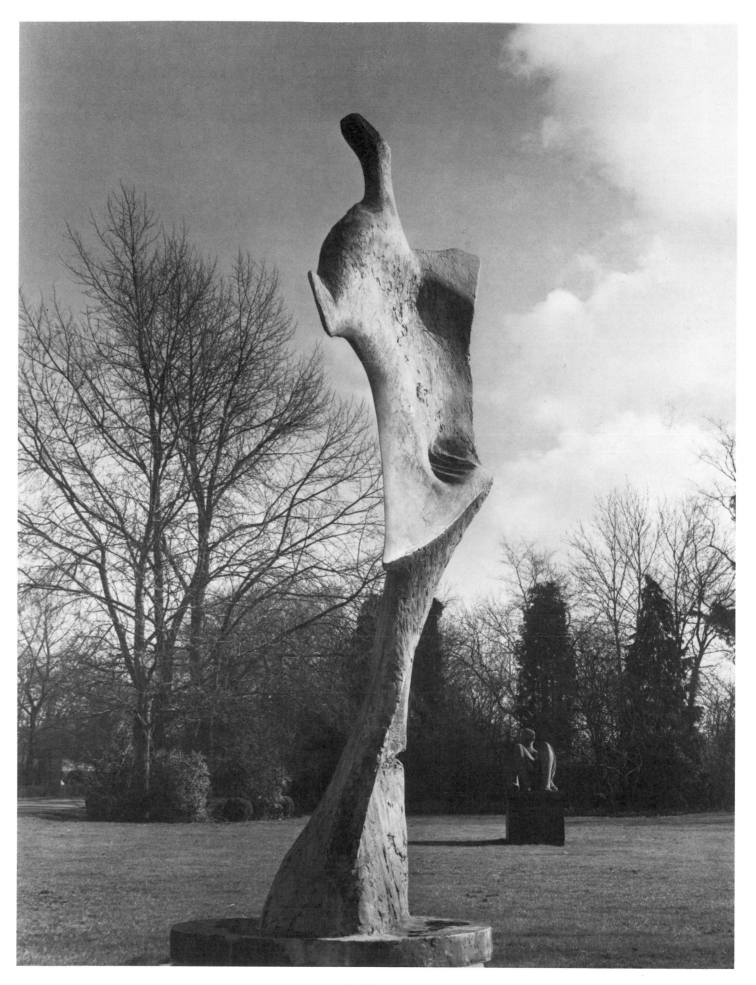

208 Henry Moore, *Standing Figure: Knife Edge* 1961

Andrew Causey

Fifties Abstraction

The paintings in this room reflect the ambitiousness and confidence of abstract painting in the Fifties. Often large in size, and loose and gestural in handling, the paintings of Peter Lanyon, Patrick Heron, Roger Hilton and Alan Davie opened up new possibilities for abstract art in Britain. Inspired in Davie's case by themes of myth, magic and religion, and in the others' by nature and the human body, these paintings, though pushed to the borders of abstraction, generally retain allusions of some kind to natural forms.

Just as the creation of non-figurative painting in the Thirties had been mainly Ben Nicholson's initiative, so it was he who again took the lead in drawing younger artists like Lanyon away from the Romanticism of the war years. Nicholson had been living at St Ives in Cornwall since 1939, and the painters in this room have all been associated with the town. Lanyon was born and always lived there, Heron was a regular visitor before settling there in 1955, Hilton frequently stayed in St Ives before going to live a few miles away near St Just in 1965. Davie's connections were slighter, and though the sea has been an occasional theme in his painting, the surroundings of St Ives – the sea, cliffs and boulder-strewn moorland – did not inspire his painting to the degree it did the others'.

Lanyon, the only native of St Ives in the group, was also the most attached to landscape. Like Paul Nash and Graham Sutherland in the previous generation, Lanyon felt that his painting was the outcome of an intimate knowledge of particular places. And as with Constable in Suffolk a hundred and fifty years before, Lanyon took as his subject the life and industry of his native region – the fishing, farming and mining of western Cornwall. He was reluctant to have *St Just* (Cat. 214) – or indeed any of his paintings – described as abstract, as the design included specific references to the mining town of St Just; the grey granite buildings and green cliff-top grass are alluded to, and the tall black form running down the centre of the picture suggests a mine-shaft and he saw *St Just* as also a Crucifixion. Paradoxical though it may seem, he was a subject painter as well as an abstract one. He respected the earlier Cornish painters of Newlyn and St Ives, going back to Stanhope Forbes at the end of the nineteenth century. He saw a continuity between their painting and his, Lanyon's task being to make a new Cornish art on similar themes that would be as modern in its time as theirs had been.

Lanyon's later paintings, like *Wheal Owles* (Cat. 213), which followed his first visit to the United States in 1957 and a new interest in the Abstract Expressionism of Pollock, de Kooning and others, remain subject pictures. His painting became bolder and more gestural, but allusions to mines with their black shafts, the sea, and orange patches of iron ore are specific. 'Wheal Owles' is the Cornish for 'mine on the cliff' and refers both to a mine on the site of his own home which was called Little Park Owles and also to nearby Levant Mine; the red, Lanyon said, was the colour of iron oxide, and the cliff at Levant is indeed covered with a reddish-brown sludge. The painting appears to show a black mineshaft with a forked top (which looks like a throwback to the parallel image in *St Just*, Cat. 214) and the sea rushing across it. This is an angry picture and may be in part a reference to the flooding of Levant Mine by the sea in 1893 with the loss of twenty lives. Lanyon was by instinct a Cornish nationalist, who felt that both the people and the mineral wealth of the county had been exploited ruthlessly and carelessly by outsiders who had been quick to abandon the mines when they became uneconomical.

Lanyon welcomed the new American painting – he met his generation of American painters on visits to New York where he (and other St Ives artists) had successful exhibitions. But Lanyon was never a true Abstract Expressionist because his painting was less impulsive and, however Expressionist it appeared, it was always the outcome of ideas gathered and deliberated upon over a period of time. In the late Fifties Lanyon took up gliding to give himself a wider range of sensations and a new perspective on the landscape. This pursuit led to his tragic early death, for he died as the result of a gliding accident.

Heron was a critic as well as a painter until the late Fifties; he was a close observer of post-war French art and, by the mid-1950s, of the new American painting. In his own work he was drawn to French colourists such as Matisse and Bonnard, and to Braque, and the still-lifes and interiors that he painted up to the mid-Fifties, concentrating on problems of colour and form, are very different from the more openly emotional and Romantic early paintings of Lanyon.

In 1962, three years after he made *Yellow Painting, October 1958-June 1959* (Cat. 212), Heron wrote that 'for a very long time now, I have realized that my overriding interest is *colour*. Colour is both the subject and the means; the form and the content; the image

and the meaning in my painting today....' The conviction that colour was the primary way forward for painting was already in Heron's mind when he organized the exhibition 'Space in Colour' in 1953 (where Lanyon's *St Just* was first exhibited). He wrote in the catalogue introduction about the functions of colour in the interplay between spatial illusion and picture surface in non-figurative painting, and this central interest has remained unchanged.

As a critic Heron's constant plea was for the importance of form rather than for descriptive drawing or subject interest, and in this he was the true successor of Nicholson whose studio he took over after Nicholson left St Ives in 1957. But Heron's passionate interest in colour has taken him beyond Nicholson, and the St Ives abstracts, particularly the earlier ones like *Yellow Painting*, incorporate the light and colour of the local landscapes in an allusive not an imitative way. Among the landscape painters of the older generation it was Ivon Hitchens, on whom Heron published a short book in 1955, who appealed to him, because he saw Hitchens's broadly brushed designs as painterly and modern rather than draughtsmanly and descriptive as, for example, Sutherland's pictures were.

Like Lanyon, Heron started to look seriously at American painting in the mid-Fifties; but for Heron it was the colour field painting of Rothko and others that mattered, rather than the Abstract Expressionists to whom Lanyon looked. Heron and Lanyon both painted larger canvases from the middle of the decade. Though this, too, was partly due to the impact of the Americans, both artists had already been led to experiment with large canvases by the imaginative requirement of the Arts Council that pictures in their 1951 Festival of Britain exhibition 'Sixty Paintings for '51' – to which both Heron and Lanyon were asked to submit – should have a minimum canvas size of 45 by 60 inches.

Hilton spent most of the Thirties in Paris and after the war turned to abstraction, becoming friendly with the Dutch painter Constant through whom he came to know the work of Mondrian. Though Hilton's work was only for a short time as geometrical as Mondrian's, it always retained a directness, even severity. He was included by Lawrence Alloway with Pasmore and others in his anthology *Nine Abstract Artists* (Tiranti, 1954). These artists were searching for a more geometric and constructive art than anything

that was happening at St Ives, and Hilton's statement in Alloway's book represents a radical claim for the work of art not as a representation of space but as a space-creating object, and as such looks forward to ideas associated with hard-edged abstraction in the Sixties more than to St Ives art with its allusions to nature: 'I have moved away from the sort of so-called non-figurative painting where lines and colours are flying about in an illusory space; from pictures which still had depth or from pictures which had space *in* them; from spatial pictures in short to space-creating pictures. The effect is to be felt outside rather than inside the picture: the picture is not primarily an image, but a space-creating mechanism.'

After Hilton started regular visits to St Ives in 1956, references to sea, sky and landscape become apparent. The human figure meant more to him than to any other leading St Ives artist; sometimes a few sensual curves refer to a breast or buttock, at other times, as in *Figure and Bird, September 1963* (Cat. 217), Hilton would describe the figure more fully.

'Painting', Hilton said in 1951, 'is feeling. There are situations, states of mind, moods etc., which call for some artistic expression; because one knows that only some form of art is capable of going beyond them to give an intuitive contact with a superior set of truths.' His purpose in the pictures of his St Ives period is not to describe, but to evoke feeling through allusion to the visual world,

and it is this allusiveness in painting within formats that are otherwise often abstract that is the common interest of the St Ives artists. Hilton's painting can be rich in texture and vibrant in colour – as *Large Orange, Newlyn, June 1959* (Cat. 215) shows – but there is an equal strain of spareness and austerity. Nicholson's firm drawing was an influence, as were the sharp edges of Matisse's paper cut-outs. Restrained and never rhetorical, Hilton, of the major St Ives artists, was least affected by paintings from the United States.

Davie was born and trained in Scotland, and though he left there permanently in 1948, he has carried with him a feeling for richness of colour – the reds and black in his early work, especially – that link him back to the traditions of Scottish colour painting at the beginning of the century. Davie was affected by the vein of Expressionism that has recurred in Scottish painting during this century. This, together with an open-mindedness and lack of prior commitment to Paris that a London-based painter might have had, enabled Davie to become the first European artist to recognize the importance of Jackson Pollock when he saw Pollock's paintings in Peggy Guggenheim's collection in Venice in 1948. Encouraged by Peggy Guggenheim, who bought one of his own paintings that year, Davie began to see, as Pollock had done a few years before, ways in which the Surrealists' preoccupation with myth could be developed. In the paintings of

the next ten years, three of which are exhibited here (Cat. 209-211), he evolved the complex images that occupy his mature painting: birth, the erotic, sea, moon, serpent, night, the witches' sabbath, sacrifice and martyrdom. They are suggestive rather than specific in meaning, conjuring up ideas and stimulating emotion, intuitive rather than schematic.

Davie has used a range of sources, such as church façades, stained glass windows, jewellery, mosaics and the rhythms of jazz, that are different from those of other artists in this room. His technical resource has been as varied as have the origins of his ideas. To escape from conventional ways of composing, Davie has worked rapidly on the floor, he has let the paint splash, incorporated bits of rubbish, made use of accident, and turned pictures round when wet so that they drip and run. As an improviser ready to take advantage of chance he has something in common with Lanyon.

The painters in this room do not form a tightly knit group, but their paths all crossed in the course of the Fifties and they share loosely similar interests. Historically, their achievement was to take abstract painting at the point to which Nicholson and one or two others had brought it by the early Fifties, enlarge its base and ambitions by bringing in ideas from America as well as Europe, and give it a far more secure future than it had enjoyed in Britain before.

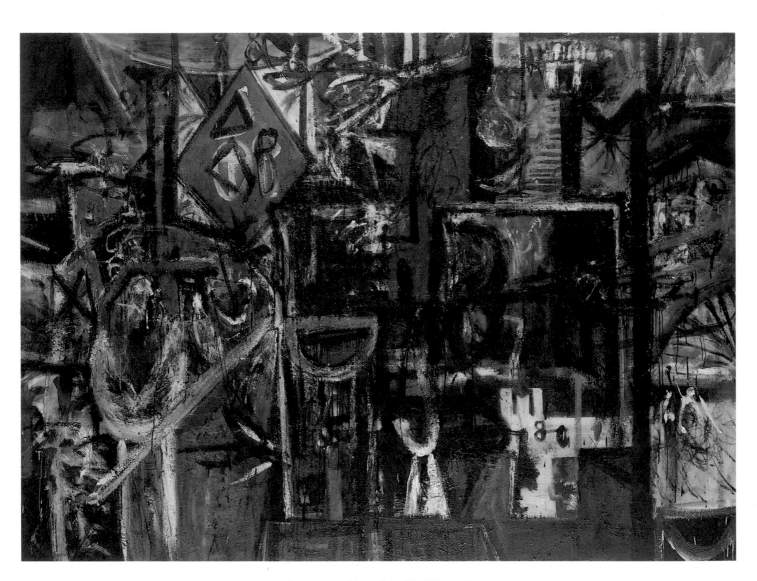

209 Alan Davie, *Altar of the Blue Diamond* 1950

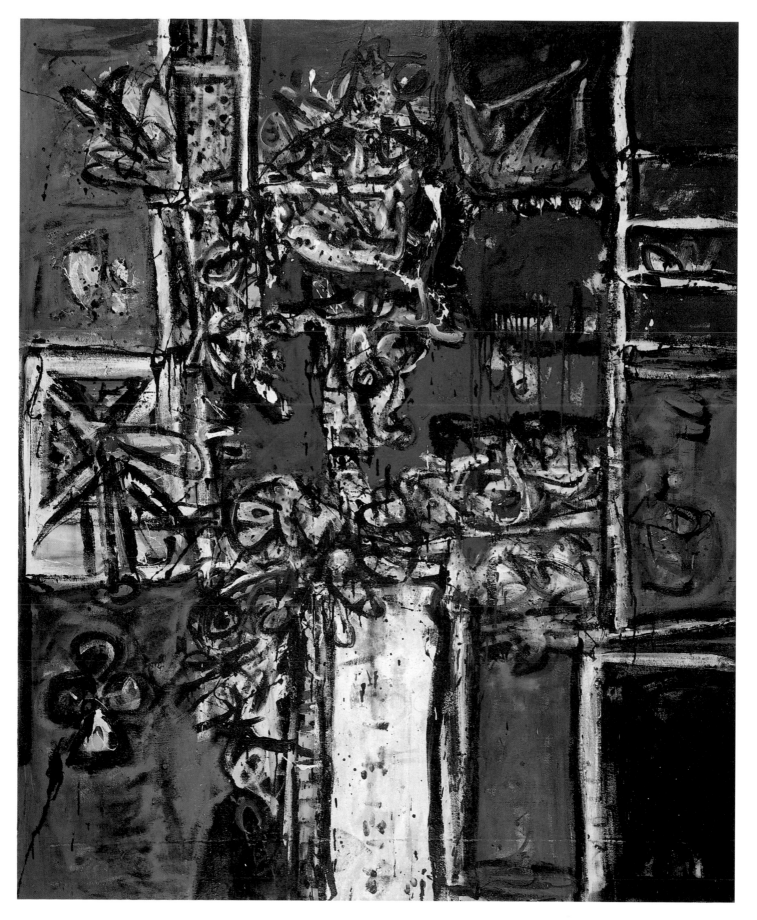

210 Alan Davie, *Imp of Clubs* 1957

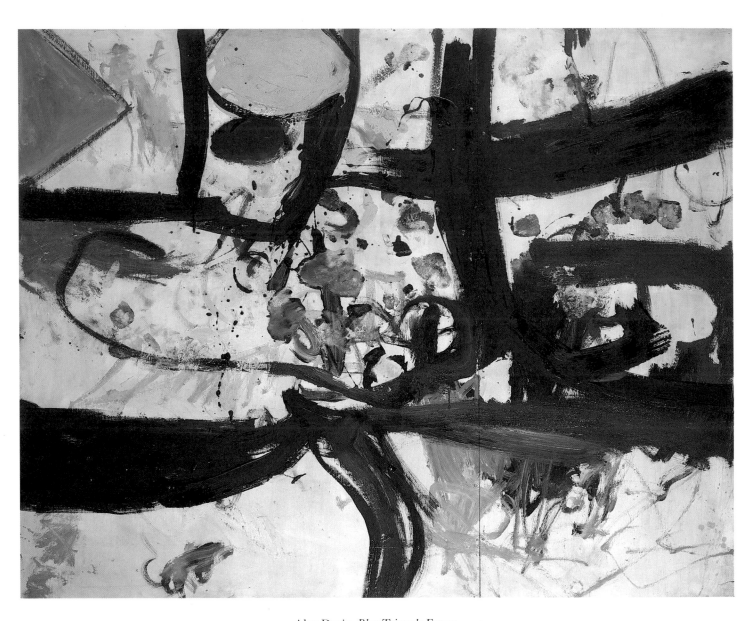

211 Alan Davie, *Blue Triangle Enters* 1953

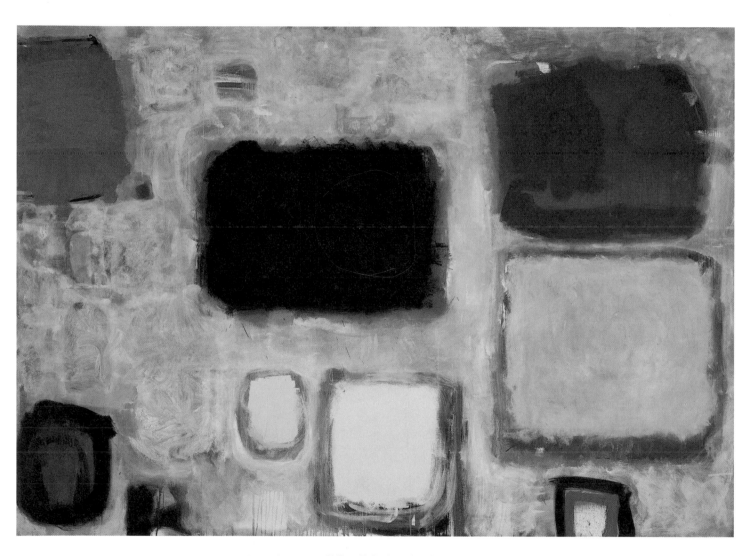

212 Patrick Heron, *Yellow Painting, October 1958-June 1959*

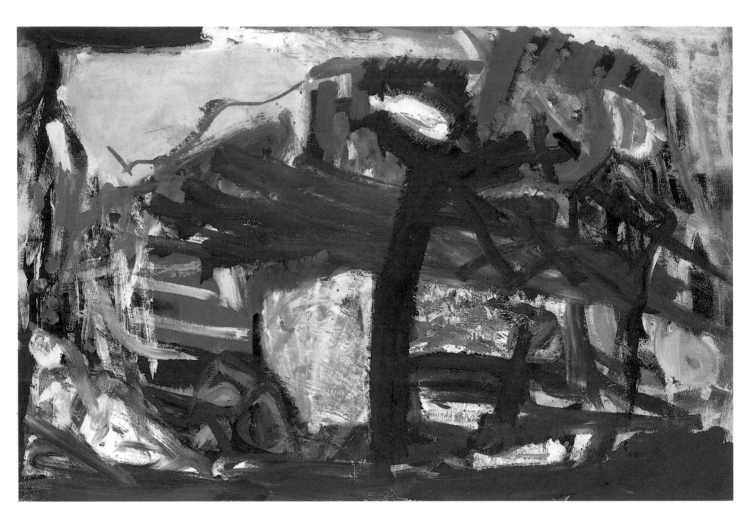

213 Peter Lanyon, *Wheal Owles* 1958

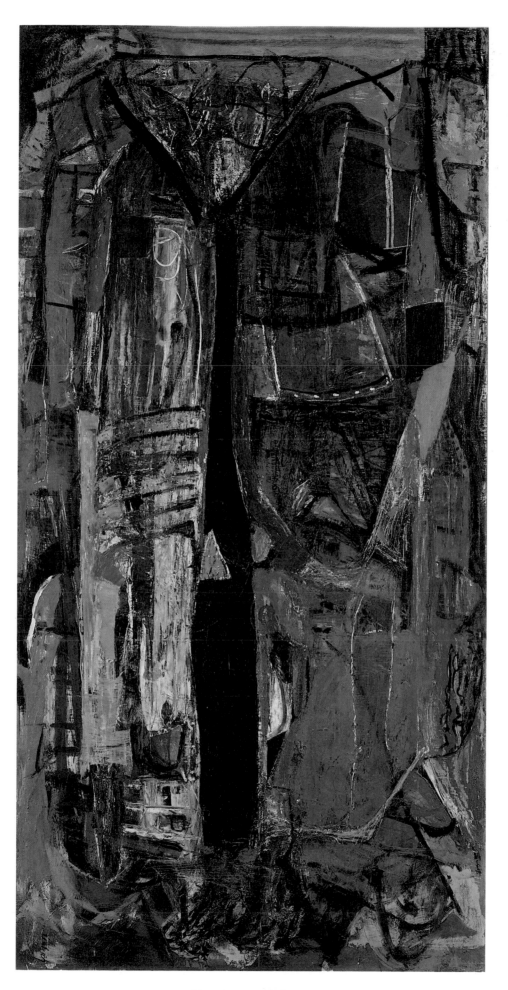

214 Peter Lanyon, *St Just* 1953

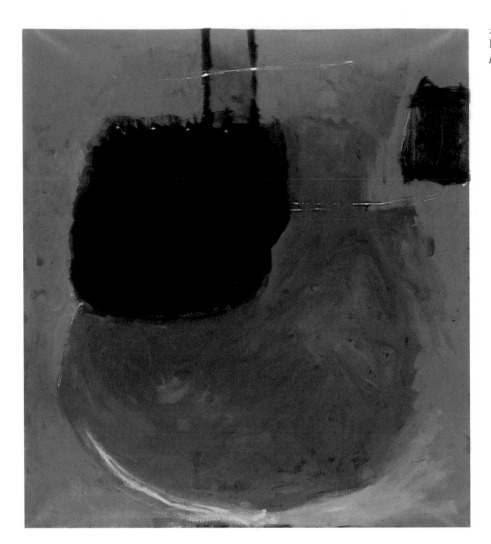

215
Roger Hilton
Large Orange, Newlyn, June 1959

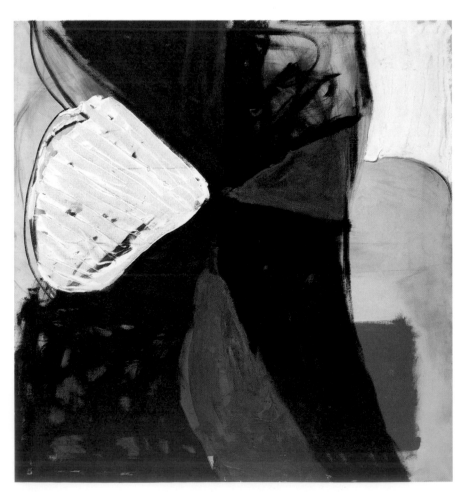

216
Roger Hilton
March, 1961

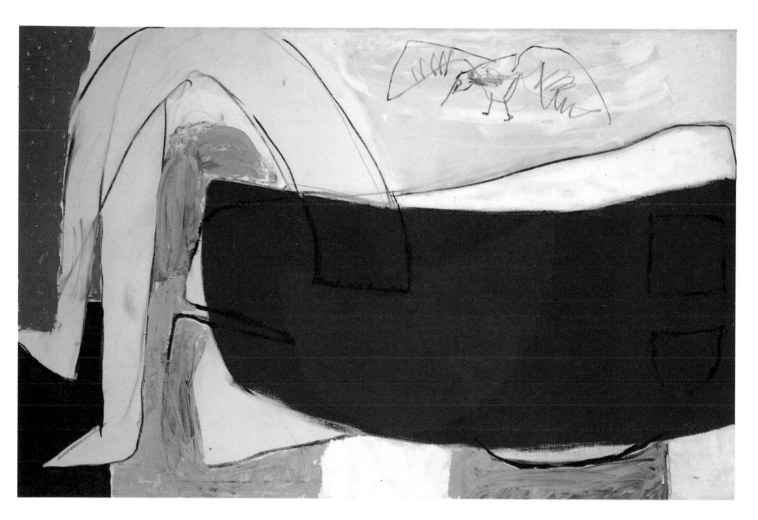

217 Roger Hilton, *Figure and Bird, September 1963*

Richard Cork

Aspects of Sculpture in the Fifties

The most familiar view of new British sculpture after the Second World War takes its cue from Herbert Read, who wrote in 1952 of 'images of flight, of ragged claws "scuttling across the floors of silent seas", of excoriated flesh, frustrated sex, the geometry of fear'. Those emotive words appeared in the catalogue of the widely praised British pavilion at the Venice Biennale, an exhibition selected by Read, Philip Hendy and John Rothenstein. The generation of young sculptors who had emerged in the aftermath of war was represented there by Robert Adams, Kenneth Armitage, Reg Butler, Lynn Chadwick, Geoffrey Clarke, Bernard Meadows, Eduardo Paolozzi and William Turnbull. But their work can hardly be encompassed by the much-quoted phrase which has come to stand for the new mood supposedly pervading British sculpture at the time: 'the geometry of fear'.

Anxiety was only one of the emotions evident at the Biennale, and it was certainly too strong a word to apply to Armitage's *People in a Wind* (Cat. 218). Although the figures in this small bronze are combating the rigours of the British climate at its most blustery, they give no overt sign of the apprehensiveness Read wanted to detect. Nor is their 'geometry' particularly apparent. Armitage is essentially a warm and modest sculptor, not given to dramatic gestures or the brandishing of open neurosis. Even his *Figure Lying on its Side (No. 5)* (Cat. 219) is tender rather than tragic, and Armitage's technique is closer to Henry Moore's bronzes than to the strategies pioneered by Butler or Chadwick. They introduced cut and forged metal to sculpture, replacing Moore's emphasis on monumental bulk with a lighter and more wiry alternative. Butler's essentially linear figures may bear a superficial resemblance to anorexic victims, but their etiolation arises more from his technical procedures than from a fearful vision of the world.

William Turnbull's sculpture does not seem unduly impelled by anxiety, either.

Horse (Cat. 221), one of his most memorable works from the 1950s, looks somewhat precarious at first sight. Even so, the bronze 'arch' balanced so surprisingly on a block of rosewood is stable enough, and its willingness radically to depart from any 'likeness' of a horse carries no desire to arrive at an agonized distortion of the animal. Rather does it stress Turnbull's interest in producing an image through a specific working process, not by imposing a preconceived idea on whatever materials happen to be at hand. Inspired by some of Picasso's 1940s sculpture, the marks scored into the surface of the bronze are the result of 'pressing corrugated paper direct into soft plaster', as Richard Morphet has explained. Turnbull set great store by the action of chance while he was implementing this procedure, and the outcome does not proclaim the intimate manual shaping of its maker. It offers instead a more Classical presence, reminiscent of the fragments from the Parthenon frieze preserved in the British Museum. Far less exclamatory than *Pegasus* (in the Tate Gallery), which Turnbull also made in 1954, this commanding form rises up from its stone base with imperturbable poise.

Its fragmentary appearance testifies to Turnbull's keen interest in prehistoric sculpture. The Hellenic strain in *Horse* is untypical of his 1950s work, which preferred to find its inspiration in Cycladic, Egyptian and other early civilizations. The series of 'Idol' figures – pacific, fertile and beneficent – culminates in the more disconcerting *War Goddess* (Cat. 222) of 1956. Here the plant-like and fruitful 'Idols' have given way to an armoured woman equipped with defensive components which turn even her breasts into forms menacingly close to cannonballs.

Paolozzi, a fellow Scot and friend of Turnbull's since their student days at the Slade, shared this preoccupation with war. Although his gaunt standing figure of 1957 is called *The Philosopher* (Cat. 224), he resembles

an automaton whose machinery has been burnt out by some terrible encounter with a ruthless aggressor. Paolozzi was fascinated by the dehumanization which David Bomberg found so distressing in the second half of the twentieth century (see 'Late Bomberg', p. 261). Figures like *The Philosopher* show how the image of man was in danger of being overwhelmed by the mechanized products of modern existence. Far from being enhanced by his non-organic attributes, he appears helpless and – paradoxically – obsolescent.

The strength of Paolozzi's work at this period lies in its ambivalence. Haunted by the modern world's unprecedented capacity for destruction, he also retained a childhood obsession with the mass-produced ephemera of Western urban society. His appetite for such material, channelled into scrapbook collages which anticipate the iconography of Pop Art with astonishing prescience, ensured that even a frog (Cat. 223) was not immune to the detritus of throw-away consumerism. This creature might appear sturdy enough, standing on eerily elongated legs, but its body has been disrupted – or even, perhaps, polluted – by a disfiguring mass of machine parts, toys and other 'junk' components scavenged from the waste-lots of the modern metropolis.

Compared with Paolozzi's apocalyptic vision of a society despoiled by its own technological prowess, Anthony Caro's *Woman Waking Up* (Cat. 220) appears to affirm a more straightforwardly sensual response to the female nude. But even Caro's figure has been subjected to disturbing distortions, so that it ends up looking like a woman in distress rather than a blissful awakening. Within a few years of completing this straining bronze, Caro decided to opt for an unashamed emphasis on the steel and aluminium of the machine world. These new materials enabled him to escape from the ungainliness of *Woman Waking Up* and explore a far more joyful realm of zestful, acrobatic experience.

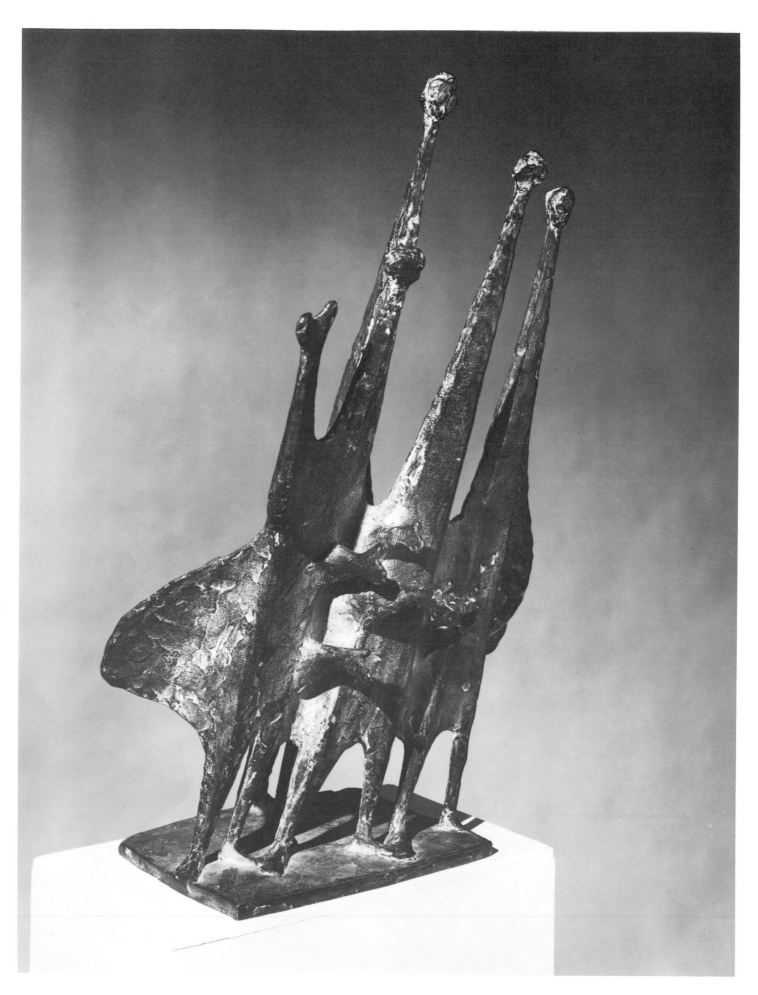

218 Kenneth Armitage, *People in a Wind* 1950

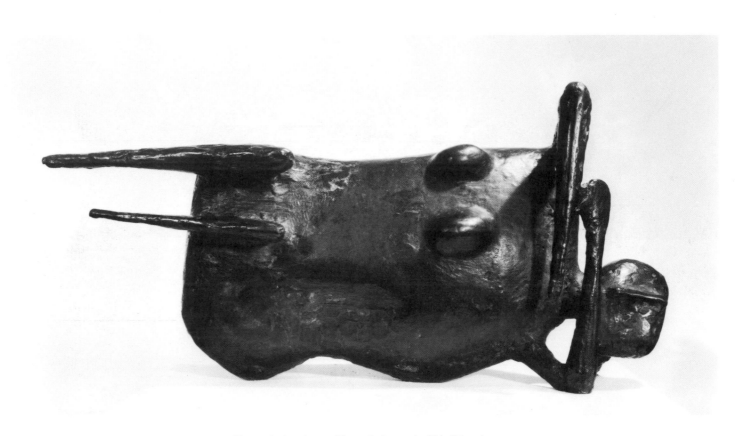

219 Kenneth Armitage, *Figure Lying on its Side (No. 5)* 1957

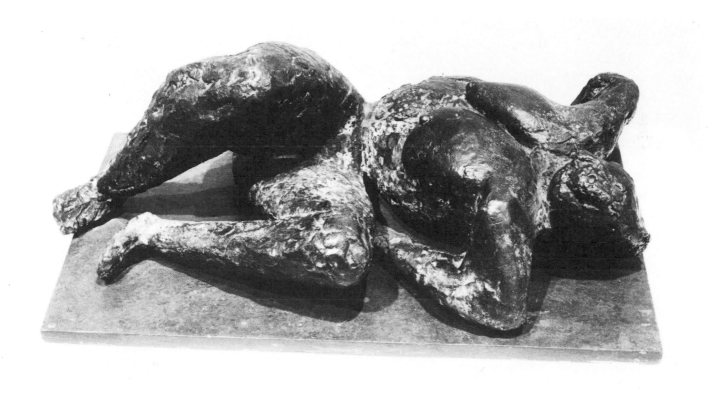

220 Anthony Caro, *Woman Waking Up* 1956

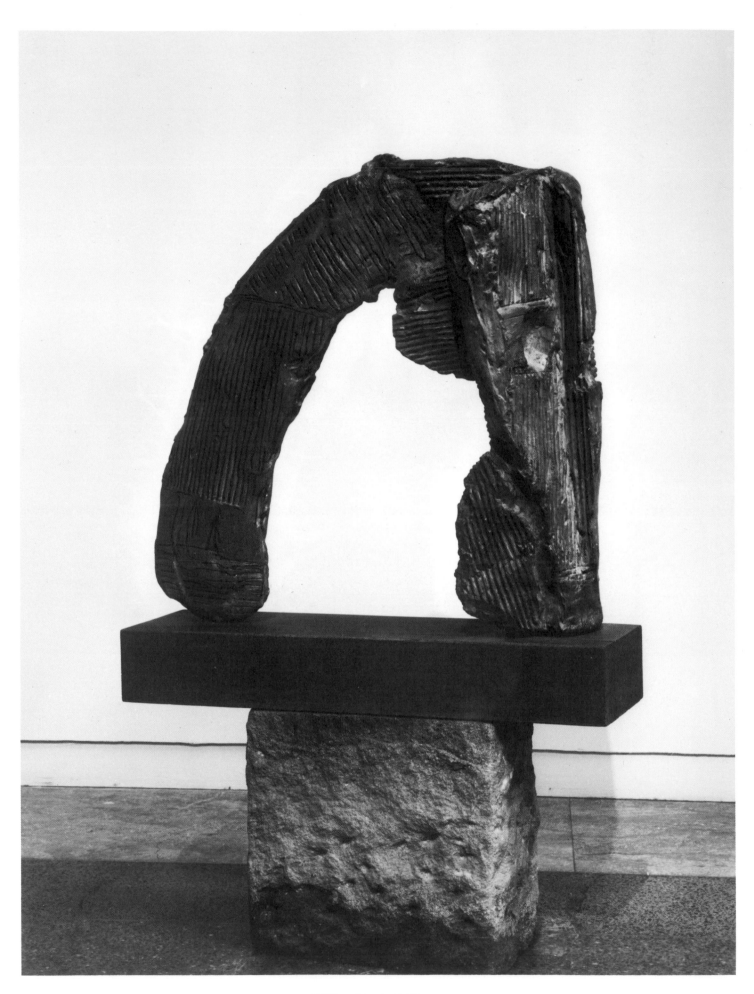

221 William Turnbull, *Horse* 1954

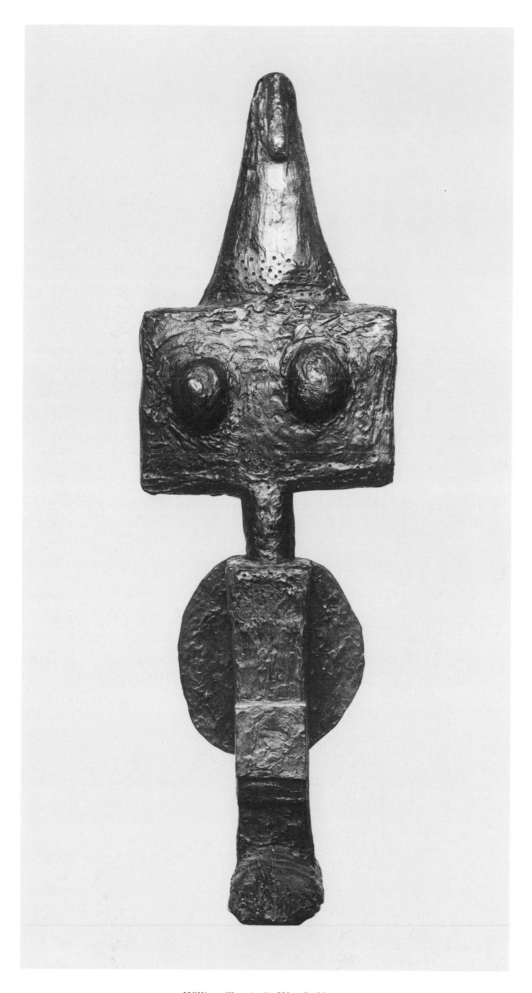

222 William Turnbull, *War Goddess* 1956

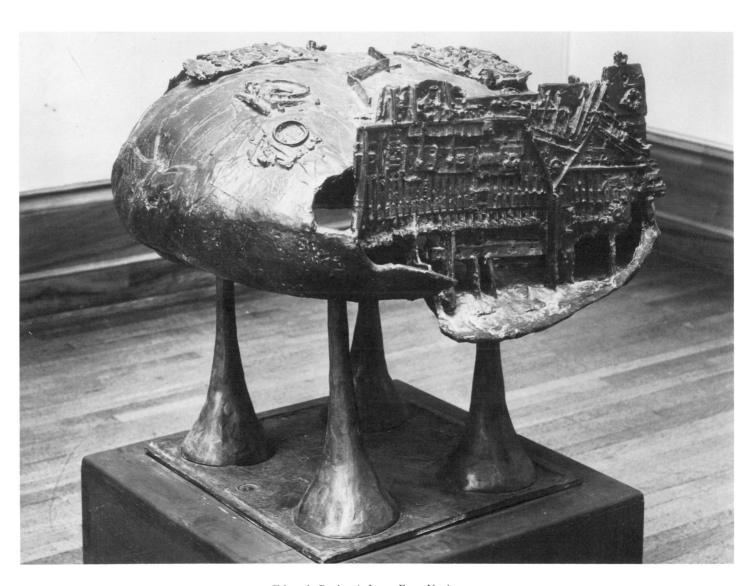

223 Eduardo Paolozzi, *Large Frog, Version II* 1958

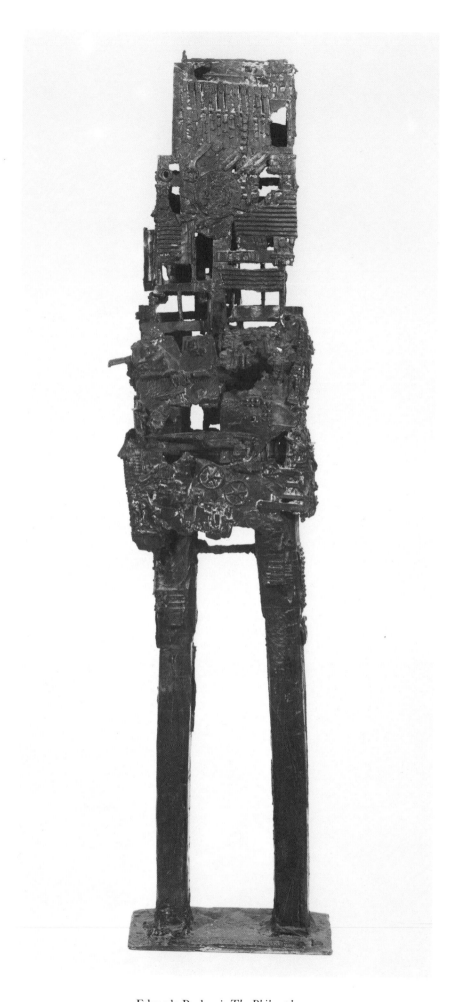

224 Eduardo Paolozzi, *The Philosopher* 1957

Dawn Ades

The School of London

The work of the five painters in this section, Francis Bacon, Lucian Freud, Frank Auerbach, Leon Kossoff and Michael Andrews, can be seen to belong to a broad post-war figurative tradition; the term 'School of London' has been put forward in an attempt to give them a name, but it often has a broader application than to the work of these five artists alone. It is possible, however, to distinguish their work from other approaches to figuration in Britain in the pre- and post-war period. For instance, it differs from the politically committed realism of artists who supported the Artists International Association; from the Euston Road School and the academic naturalism of William Coldstream; and from the depiction of domestic trivia of the so-called 'Kitchen Sink' realists like John Bratby, who first came to public attention, as did Auerbach, Kossoff and Andrews, through exhibitions at Helen Lessore's Beaux-Arts Gallery in the Fifties.

The ideas and practice of these five artists were also connected to a moral and aesthetic reaction against a committed didactic art in favour of individual expression – what might almost be called a myth of individuality (which is discussed further in 'Figure and Place: A Context for Five Post-War Artists', pp. 73-81).

In spite of the stylistic diversity of their work, these artists share certain attitudes to the painting of the human figure and its surroundings. They have preserved a belief in the particular importance of painting itself when the move among the avant-gardes was 'beyond painting' in the direction of constructions, of Minimal Art, of Conceptual and Land Art. At the same time they shun the illustrational or narrative, that kind of painting in which the 'story' might speak, as Bacon put it, louder than the paint. This should alert us to the danger of stressing too much the element of reaction, of resistance to Modernism, in their work. The gestural marks of Auerbach's canvases link him undeniably to an Expressionist tradition, but at the same time the unblended, raw surfaces relate his practice to that central concern of Modernism, the material means of the medium itself. Bacon walks a kind of tightrope between figure and abstraction, and as early as the Sixties was welcomed in France as a precursor of 'the new figuration'. It is not a matter, in other words, of a blinkered unresponsiveness to Modernist art.

Their attitudes towards the question of abstraction tend to differ. Francis Bacon, the oldest, is also the most dismissive; he stated bluntly (in an interview with David Sylvester) that abstract painting is virtually meaningless pattern-making, and that any claim to experience a real, 'visceral' response to it was simply the result of the conditioning of fashion. Auerbach, however, does not see the question in terms of a simple opposition between abstraction and figuration. In a radio interview with Richard Cork in 1985 he said, 'I don't disapprove of abstraction. . . . All painting is abstraction in the sense that one abstracts form for one's sensations from the object which has given rise to these sensations. An unfigurative art is a subject. It's a subject in the sense that other generalised mystical philosophies have tried to find an underlying rhythm or current or secret structure to the whole of the world. And . . . unless it's purely decorative this is what all abstract art – whether gestural or geometrical – represents as the secret mathematics of the universe. Well, this is a subject as landscape is a subject, as portraiture is a subject and it would simply be ludicrous for me to . . . disapprove of a subject. On the other hand, I must say I prefer Shakespeare to Khalil Gibran – I mean I prefer an art that deals with the concrete to one that juggles generalised concepts.' For Auerbach, as for the others in the group, the concrete is both the physical fact of the real word and the physical fact of paint.

Bacon is the only artist among them to have a long-established international reputation, although critical opinion about his work is divided. He has passionate supporters, but others find his view of man disturbing. He began painting in the late Twenties, but in the early years of the war destroyed most of his work, and has seen the 1944 triptych, *Three Studies for Figures at the Base of a Crucifixion* (Fig. 8, p. 24), as his real starting point, though it still has connections with his Picasso-influenced pictures of the Thirties. There have been many retrospectives of his work in Europe, the United States and in Britain, where in 1985 the Tate Gallery held its second major retrospective.

By contrast, it is only comparatively recently that the reputations of the other four artists have begun to spread outside this country. Freud, Auerbach and Andrews have had retrospective exhibitions in London at the Hayward Gallery (in 1974, 1978 and 1980-1 respectively) – each of which was greeted as a revelation; Auerbach was chosen to represent Britain at the Venice Biennale of 1986, yet it was only, for example, in 1983 that Kossoff had his first one-man exhibition in New York. For years, it seems, a relatively narrow circle of friends, fellow artists, dealers and collectors has, with its serious support, cushioned them against a largely unresponsive public.

In the main, these artists have not avoided the art of the past. The element of tradition is deliberately and often provocatively used. They have not simply renovated the practice of life-drawing but have often gone so far as to rework Old Masters. Best known is Bacon's use of a *Portrait of Pope Innocent X* by Velazquez and a self-portrait by Van Gogh, *The Painter on the Road to Tarascon*. Auerbach, who regularly draws in the National Gallery, has made a series of drawings and paintings based on Titian's *Bacchus and Ariadne* and *Tarquin and Lucrece*, and also studies after a Deposition by Rembrandt (see Cat. 243). Kossoff has painted studies from *Cephalus and Aurora* by Poussin (1981) and, earlier, made drawings from Grünewald. Freud has less explicitly engaged with other paintings, but recently entitled a large picture *Large Interior, W. 11 (after Watteau)*, 1981-3 (Cat. 241).

In this company, Bacon makes not necessarily the freest, but the most transgressive use of his model. He has, perhaps, the most ambivalent attitude to tradition: he was, for instance, the only one of this group not, as Helen Lessore put it, to have 'gone through the schools'. He makes an unusually explicit use of poetry and drama in his paintings, with references, for example, in titles to the *Oresteia* of Aeschylus and to T. S. Eliot, while at the same time being more engaged in the problem of combating the 'illustrational'.

In Bacon's paintings there is no continuously realized setting, and the figural elements are isolated, sometimes placed within a localized space indicated by a cage or frame of lines on the often monochrome canvas surface. *Figure Study II* (Cat. 226) has an orange ground similar to that in the triptych *Three Studies* but with a slightly more emphatic indication of an interior. Hints of a 'Grand Hotel' together with the figure's overcoat and umbrella, provide a characteristic clash between a modern world and the Classical reference of the figure itself. This is related to the figures in *Three Studies*, identified by Bacon as the Eumenides, or Greek Fates, who pursued the matricide Orestes. The impossible distance between the grandeur of the ancient myths and a modern consciousness is as sharply indicated here as it is in, for example, T. S. Eliot's 'Sweeney among the Nightingales'. The part-human, part-animal figures of *Three Studies*, pagans on Golgotha,

are in the throes of intense physical spasm, both mourning/howling at the foot of the Cross and, as Furies, engaged in vengeful pursuit.

In *Figure Study II*, the figure, its eyes hidden as in so many of Bacon's early heads and figures, its neck unnaturally extended, still hints at the animal. The human-ness is ambiguous, and can be related to the writings of Georges Bataille, in which conventional orders of value such as man/animal, noble/base, high/low are disrupted. As in many of the studies from Velazquez's *Portrait of Pope Innocent X*, the mouth is open wide, screaming. This motif has been linked to, among other things , Poussin's *Massacre of the Innocents* and the image of the screaming nursemaid from Eisenstein's film *Battleship Potemkin*, and can also be understood in the light of Bataille's text 'La Bouche', which suggested that man at his most intense moments of sensation – at, in other words, his most human – becomes, physiognomically, nearest to an animal. It is not a matter of simple debasement, though, but rather of a refusal to accept a simple opposition between man and animal, ideal and base. There are multiple echoes of Bataille's ideas in Bacon's constant equivocation between the grand and the commonplace.

In the 1965 *Study from Portrait of Pope Innocent X* (Cat. 231) the Velazquez portrait is less visibly injured than in some of the earlier studies; there is less obvious clash between the dignity of the 'Papa' and the erasures or effacements imposed upon it. However, compared with earlier versions, the marks that make up the face are in a sense more irrational; they are almost unrelated, individually, to the features of a face; the paint is swept on to or pressed into the canvas, as it is in *Three Studies of Isabel Rawsthorne* (Cat. 232). These marks, destructive of conventional likeness, almost deliberately chaotic, are a kind of imposed chance; they are worked until they come back, still raw, to a sense of physical presence.

In *Three Studies of Isabel Rawsthorne*, who was one of Bacon's closest friends, three portrayals of the same woman are separated in an out-of-scale interior. On the left, the head is a painted portrait, nailed to but not quite separate from the wall. On the right, a casually dressed Isabel Rawsthorne turns, Alice-like, a key in a giant door, revealing or shutting out another self, dressed in black to merge with the void behind. This was painted in the same year as the *Triptych inspired by T. S. Eliot's poem 'Sweeney Agonistes'* and it is difficult not to recall the end of that poem:

And you wait for a knock and the
turning of a lock
for you know the hangman's waiting for
you . . .
And perhaps you're alive
And perhaps you're dead. . . .

The painting is unusual in placing three figures on one canvas in spite of the fact that the connections between them cannot be rationalized. By choosing triptychs Bacon found a method of relating more than one figure to another without setting up the story-telling that he detests. In the *Three Studies of a Male Back* (Cat. 233) identity is disquietingly revealed only through the mirror before which the casual, naked, yet socialized figure (shaving, reading a newspaper) is placed. In the central panel the mirror is blank but the shadow leaks like another presence down the pedestal of the chair. The uncanny double is even more obvious in the earlier *Painting* of 1950 (Cat. 227). Here, the figure and its setting are dislocated in a different way: the unusually emphatic, geometric ground balances the fleshly presence of the figure, but the figure's identifying features are hidden and presented through its shadowy double.

Bacon rarely paints directly from life but by preference from memory and from photographs – which inhibit him less, he said in conversation with David Sylvester, than an actual presence would. Freud, by contrast, paints only in the presence of the model, who is known well to him. Freud's move away, towards the end of the Fifties, from the precise clarity of pictures like *Girl with Roses* (Cat. 234) to a thicker, looser manner was not accompanied by any relaxation in the direction of a softer gaze. Neither his sitters – mother, lovers, friends, children – nor his studio, nor the cityscapes, ever fall into any ideal or picturesque view. His *Large Interior, W. 11 (after Watteau)* (Cat. 241) has been discussed on p. 77. The great size of this painting is as startling as the small size of some of the early single heads, like *A Writer* (Cat. 225), when seen for the first time. The jewel-like precision of touch in *A Writer*, reminiscent of the painting of a miniaturist, works on the smallest scale; but when Freud moved to larger canvases and especially when he included so many figures as in his *Large Interior*, he adopted a much more painterly technique.

In his monograph on Freud Lawrence Gowing has discussed the loaded, granular paint of more recent works and the effect, as Freud described it to him, of using Kremnitz White, a pigment with twice as much lead as Flake White. Freud sometimes scrapes down the lumps of paint, sometimes leaves them. Gowing expressed concern to him about a threat posed by the lumps and spots of paint to 'the equation of flesh with paint that I enjoy'. Freud replied: 'When you talk about the equation, it makes me uneasy. I want paint to *work as flesh*, which is something different. I have always had a scorn for " la belle peinture" and "la delicatesse des touches". I know my idea of portraiture came from dissatisfaction with portraits that resembled people. I would wish my portraits to be *of* the people, not *like* them. Not having a look of

the sitter, *being* them. I didn't want to get just a likeness like a mimic, but to *portray* them, like an actor. . . . As far as I am concerned the paint *is* the person. I want it to work for me just as flesh does.'

There has probably been no stronger recent formulation of the belief in the capacity of oil paint to constitute flesh. It is also interesting that Freud uses, as does Auerbach, metaphors drawn from the theatre, which imply both empathy and identification with the subject and also the necessity for some artifice. Perhaps, too, the theatrical metaphor masks another, sexual one, and it is difficult not to see in these – all male – painters' work a sense of the active possession of the flesh through paint.

Both Freud and Auerbach speak of the visualizing of the factual, as a starting point, rather than the visualizing of a *picture*. Auerbach's paintings, however, unlike Freud's, can be initially difficult to 'read'. Recognition of the subject may be momentarily delayed but subsequently this has the effect of locking the subject inescapably into the material of the paint. His early paintings, whose surfaces were thickly encrusted with paint, seemed at the time, he said, the 'natural result of the way I worked which was to go on a very long time indeed on a painting and not scrape it down . . . when I did them they looked banally true to me'. In the work that has succeeded them, the much greater appearance of immediacy, of violence, chance and the fact captured raw, bears a complex relation to the picture's production. Each canvas is still worked for a long time, and no mark is made without the presence of the model – almost always someone he knows well; it is scraped down or, if a drawing, erased before each sitting. But there is no obvious deliberation in the act of painting: the paint 'is launched onto the canvas with velocity and risk and ends up as paint threads, tracks, waves and impacted surfaces'.

Auerbach's city- and landscapes are not painted from nature: to paint *Primrose Hill* (Cat. 244), for instance, he could not very easily 'go up to Primrose Hill with eight huge kegs of paint and a large canvas and avoid all the dogs and joggers and paint a picture'. So he makes many drawings in front of the landscape which then in the studio call up what it was like to draw from the landscape that morning. In looking at the drawings in the studio later, Auerbach says, 'the sunlight and trees and hill' become visible again, and he finds that the drawings even signal colours. The colours may in the end turn out to be more vehement than in life – this is especially true of more recent paintings – they may even be quite arbitrary. None the less, the colour of the weather in some sense always gets in, and this – the blue or the grey of the sky – determines all the relationships, and these are in the end what matters, rather than any strict fidelity to specific local colours.

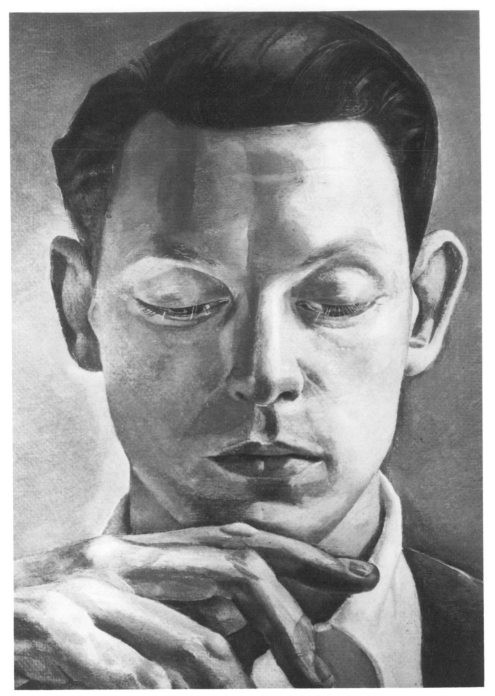

Cat. 225　Lucian Freud, *A Writer*, 1955

burn Underground station or the Willesden swimming pool, which naturally imply bustling human activity. At the same time there is often a sense of suffering rather than of joy in Kossoff's human figures, which are heavily outlined and massive in scale in comparison with the buildings. His outlines contain his figures, almost weighing them down; in contrast Auerbach's gestured lines seem to give a sense of release. In Kossoff's series of canvases painted at the swimming pool, such as Cat. 247, however, there is perhaps a lightening of mood, for in them he creates a balance between play and suffering. He once wrote, referring to his London subjects: 'The strange ever changing light, the endless streets and the shuddering feet of the sprawling city linger in my mind like a faintly glimmering memory of a long forgotten, perhaps never experienced, childhood which, if rediscovered and illuminated, would ameliorate the pain of the present.' A particular season or sometimes even time is frequently so important to Kossoff that he includes it in many of his titles. The paintings are often made in series, their different character emphasized by differing times or seasons. It is as though, perhaps, he were paying tribute to Monet's series of 'Haystacks' and 'Cathedrals', in which the variations of sunlight and shadow at evening or morning which were experienced by the artist at different times of the year played such an important role.

As well as places, Kossoff enjoys painting figures, for example *Portrait of George Thompson* (Cat. 249). In *Nude on a Red Bed* (Cat. 248) the sadness of the childlike figure with its wide eyes, and limbs suggested rather than recorded, makes a dramatic contrast with Freud's *Naked Portrait with Reflection* (Cat. 239), where the heavy body is explored with an unflinching regard for detail. Among people, however, above all Kossoff enjoys portraying his parents, whose faces and forms seem almost to act as invitations to meditate on the nature of old age. Like Auerbach, he puts stress on the activity of drawing and has said: 'Drawing is making an image which expresses commitment and involvement. This only comes about after seemingly endless activity before the model or subject, rejecting time and again ideas which are possible to preconceive. And, whether by scraping off or rubbing down, it is always beginning again, making new images, destroying images that lie, discarding images that are dead. The only true guide in this search is the special relationship the artist has with the person or landscape from which he is working. Finally, in spite of all this activity of absorption and internalisation the images emerge in an atmosphere of freedom.'

Kossoff is concerned with individual experience and beyond that with the condition of mankind. He moves, in a sense, between the biblical and the everyday. At his first

The colours may be 'transposed into a different key', as Auerbach described it, using a musical analogy, but the relationships remain the same.

Auerbach draws emphatic lines of paint which mark the edge of building, tree or hill. Casual as these may appear, they structure the spatial relationships within the painting, defining the points where the tree, path and hill touch, overlap, rise against each other. A shift of only a few feet changes all these closely observed relationships. At the same time, in spite of the fact that he is so closely locked with the physical fact of what he paints, Auerbach thinks of himself as a dreamer, and has said 'I think it is all imagination'. He finds in painting city- and

landscapes 'the freedom to make crazy inventions'.

London has provided an endless subject for Auerbach, and for Kossoff, though they do not choose its more obviously picturesque aspects. Building and demolition sites, waste land, streets and back lots are their preferred motifs (as they are also for Lucian Freud). There is something epic and grand in their treatment of them, as for instance in Auerbach's *Maples Demolition, Euston Road* (Cat. 242) or Kossoff's *Outside Kilburn Underground Station, Summer 1976* (Cat. 246). However, while there is almost never any human presence in Auerbach's cityscapes, Kossoff frequently peoples his scenes and indeed often deliberately chooses sites, such as Kil-

one man exhibition in 1957 he showed not only portraits of Auerbach, pictures of building sites and drawings of nudes, but also etchings with the titles *Joseph Telling his Dreams* and *Bringing home the Coat of Many Colours*. His imagination is nourished by the Bible, by myth and history, and at the same time it is rooted in his immediate experience, his family and surroundings.

Michael Andrews records a different, social London. His 'preoccupation with human behaviour, with social similarities and difference' was already visible in his Slade Diploma paintings, *A Man Who Suddenly Fell Over* (1952) and *August for the People*. In 1963 he exhibited *The Colony Room 1* (Cat. 250) at the Beaux-Arts Gallery, a work which approaches the tradition of the 'conversation piece'. It depicts Andrews's friends and acquaintances at Muriel Belcher's Soho drinking club, with the mural Andrews had painted there in 1959, a copy of a Bonnard, on the wall behind. Francis Bacon is seated, turned away from us on the right, while from left to right are Jeffrey Bernard, the photographer John Deakin, Henrietta Moraes, Bruce Bernard and Carmel. Freud alone, placed furthest back of those whose faces are visible, engages the painter's eye. This painting was succeeded by several other large canvases on the theme of parties and pure pleasure, like the *Deer Park* of 1962 (its title from Norman Mailer's novel), which call to mind such films as Antonioni's *La Notte*, where there is a similarly disengaged spectator, fascinated by human behaviour in such situations.

Just as, unusually in this group, he was unafraid of story-telling, so Andrews has gone on to use a series of motifs which operate as unforced metaphors for his own experience and the nature of painting: the balloon, shoals of fish, stalking. *Melanie and Me Swimming* (Cat. 251) followed the group of pictures that examined the behaviour of shoals of fish, which Andrews studied in a large aquarium at his house. In the same period, Andrews's daughter was preparing to enter school. 'These two preoccupations', as Catherine Lampert wrote in her introduction to the catalogue of the Andrews retrospective of 1980, 'coincided with his earlier sense of the similarity in people's behaviour. He now thought being of different species was not an unsurmountable block to similarity.' *Melanie and Me Swimming* is based, as are the stalking pictures, on a photograph taken by his friend Jean-Loup Cornet. The practice of using photography, and indeed his unique employment of templates to determine certain shapes in his paintings, is unusual in this group of artists. Otherwise, only Bacon makes direct use of photography, and for him it is less a matter of making it serve to fix scale and distance than to offer a different purchase on 'fact'.

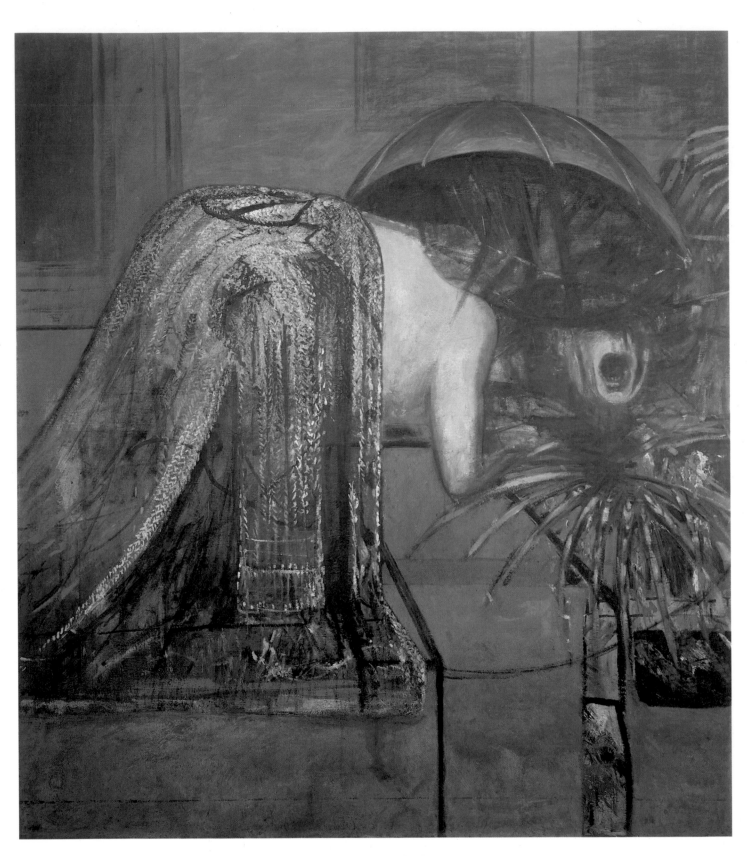

226 Francis Bacon, *Figure Study II* 1945-46

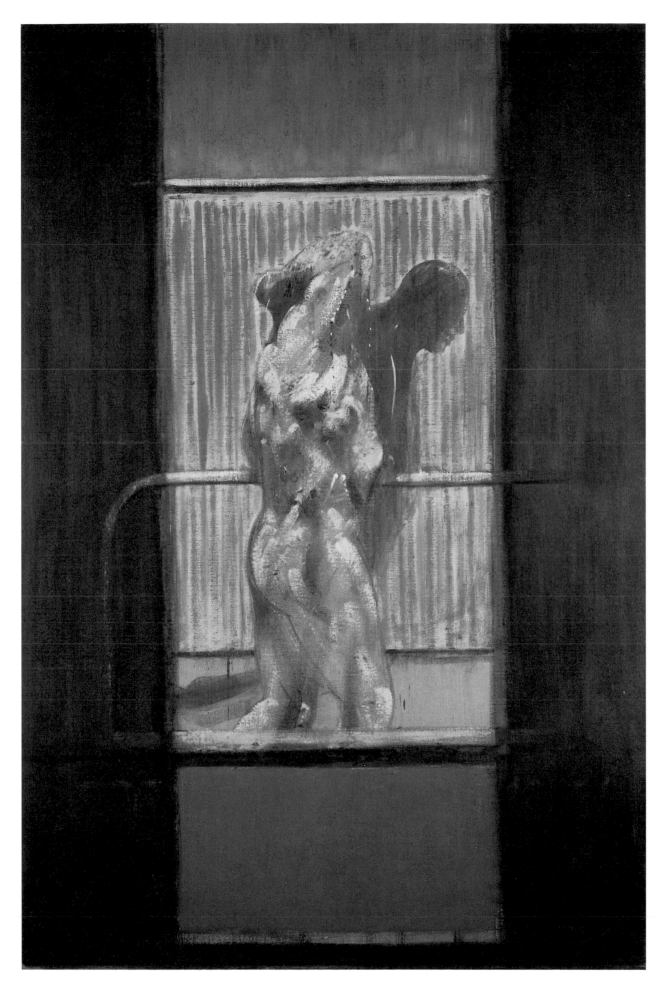

227 Francis Bacon, *Painting* 1950

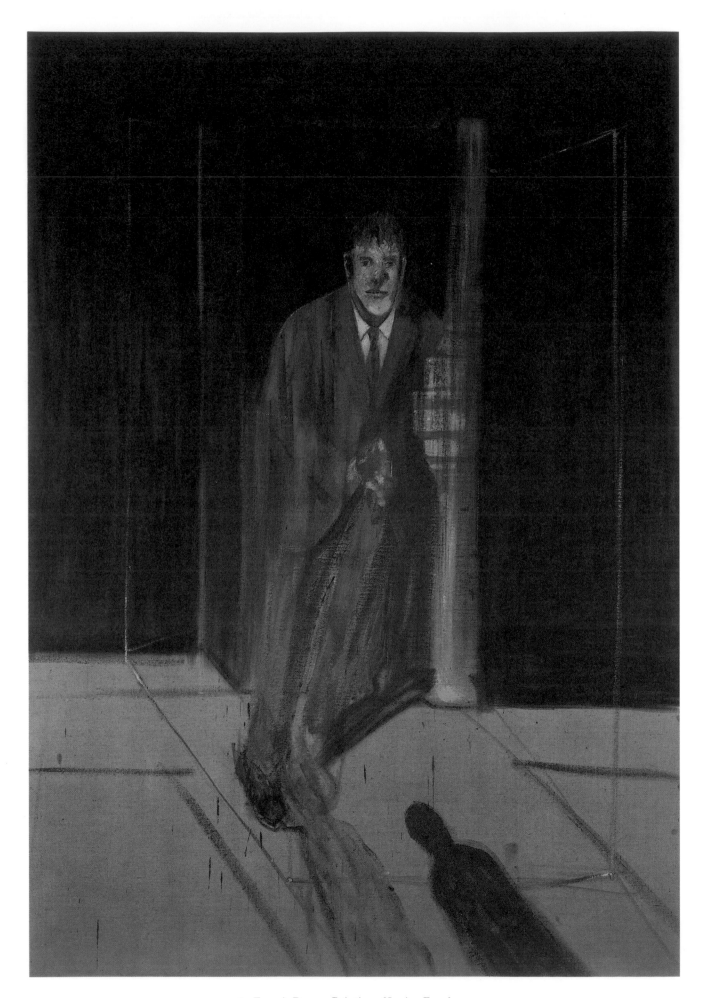

228 Francis Bacon, *Painting of Lucian Freud* 1951

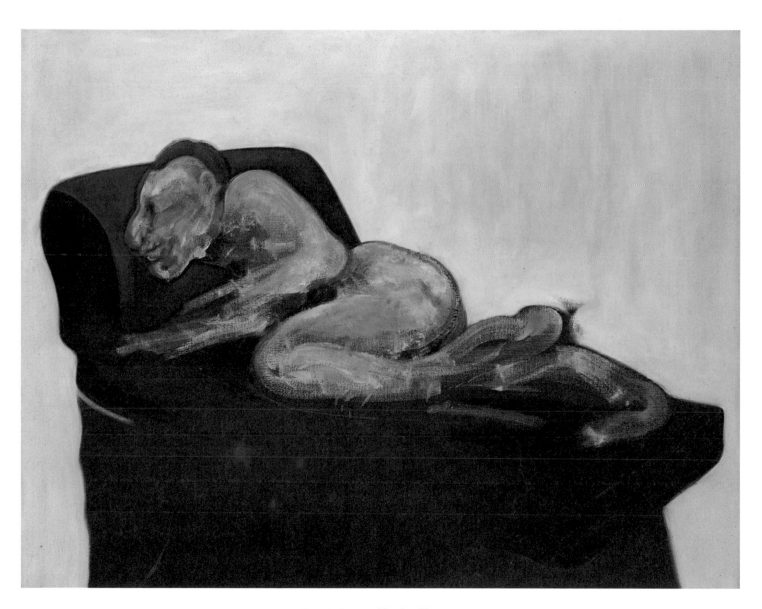

229 Francis Bacon, *Sleeping Figure* 1959

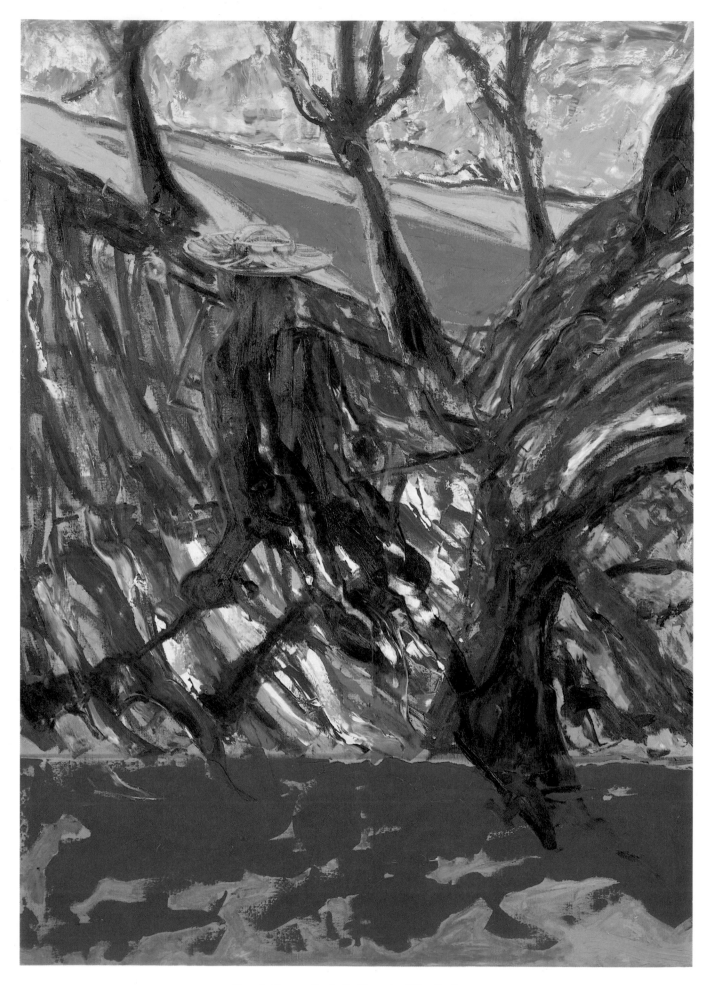

230 Francis Bacon, *Study for Portrait of Van Gogh VI* 1957

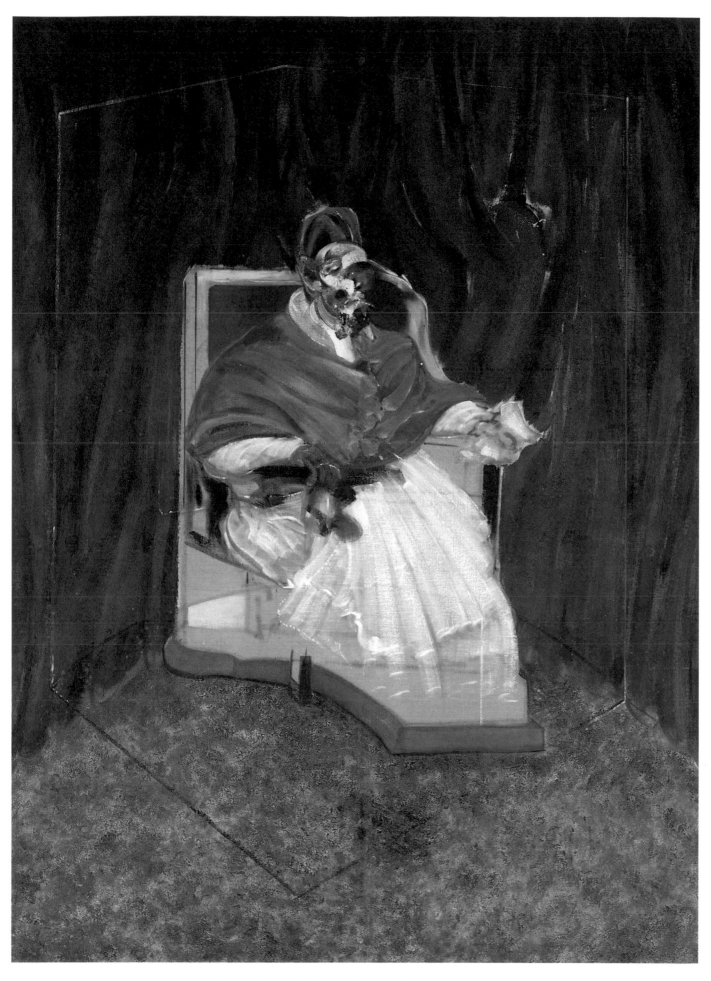

231 Francis Bacon, *Study from Portrait of Pope Innocent X* 1965

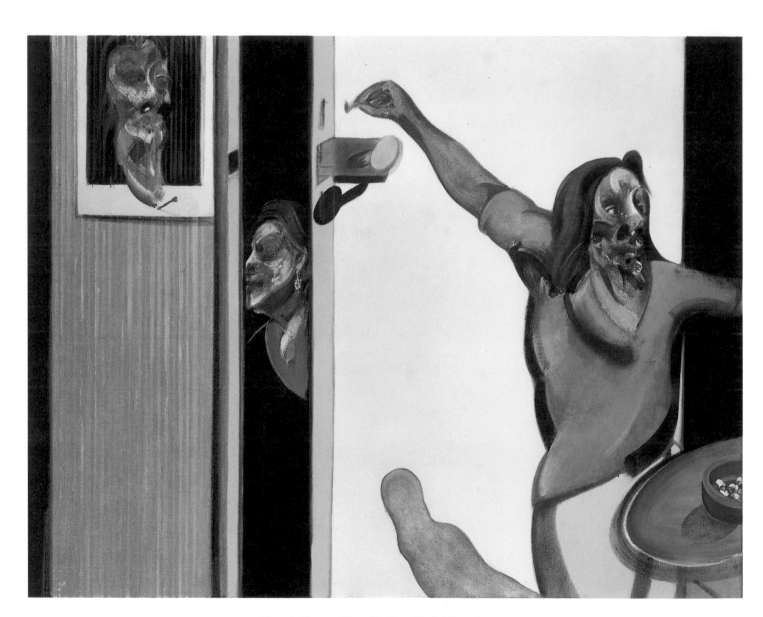

232 Francis Bacon, *Three Studies of Isabel Rawsthorne* 1967

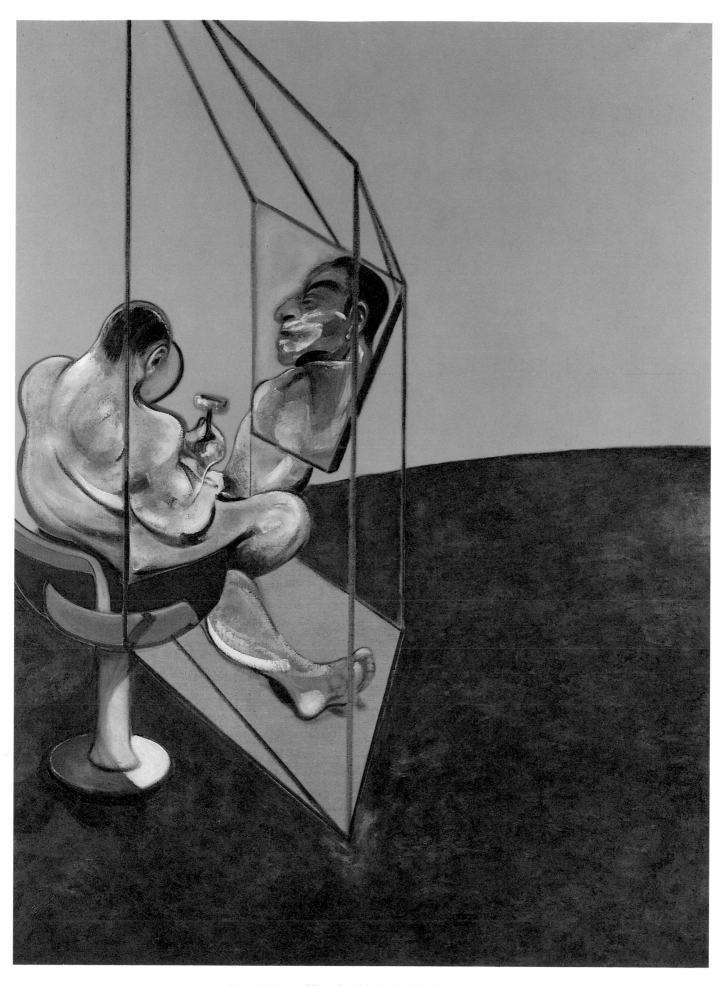

233 Francis Bacon, *Three Studies of a Male Back* 1970 (left)

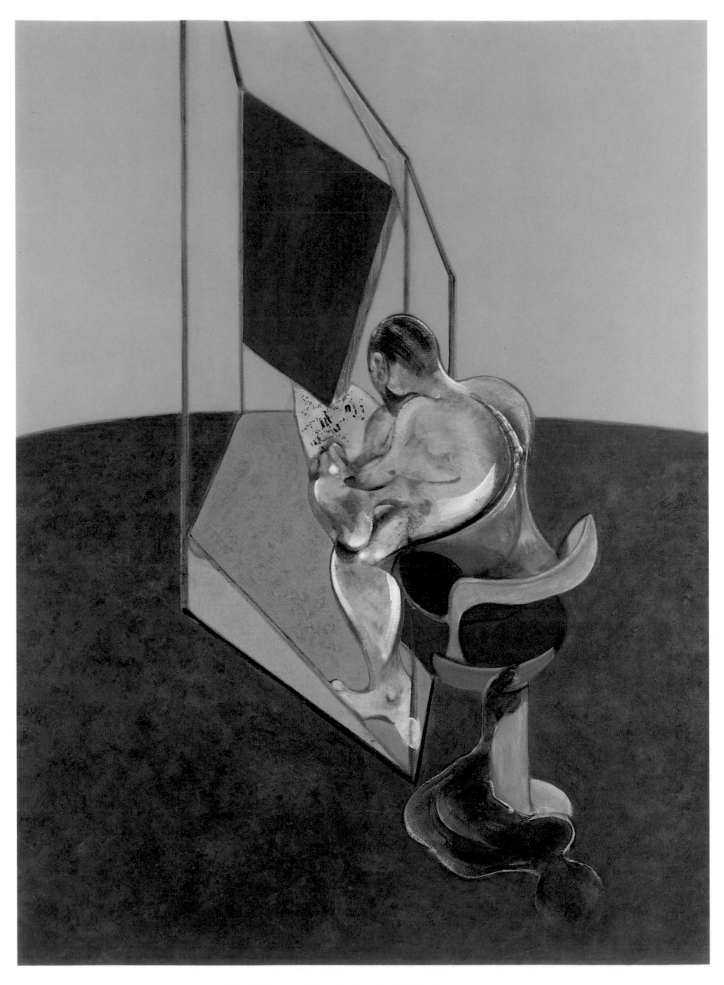

233 Francis Bacon, *Three Studies of a Male Back* 1970 (centre)

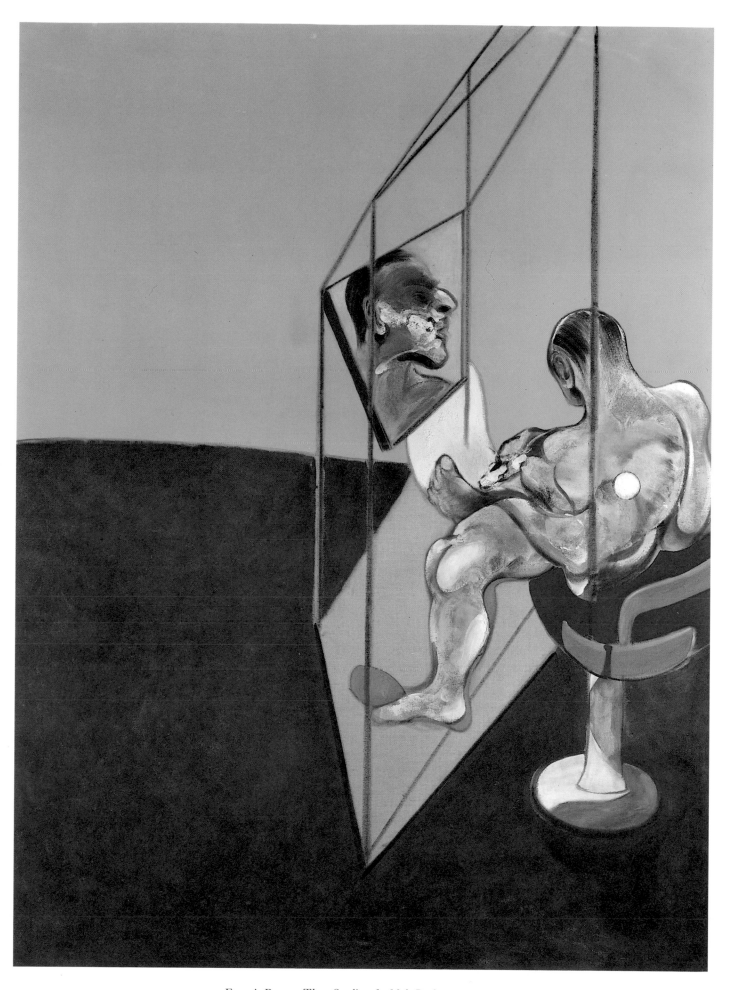

233 Francis Bacon, *Three Studies of a Male Back* 1970 (right)

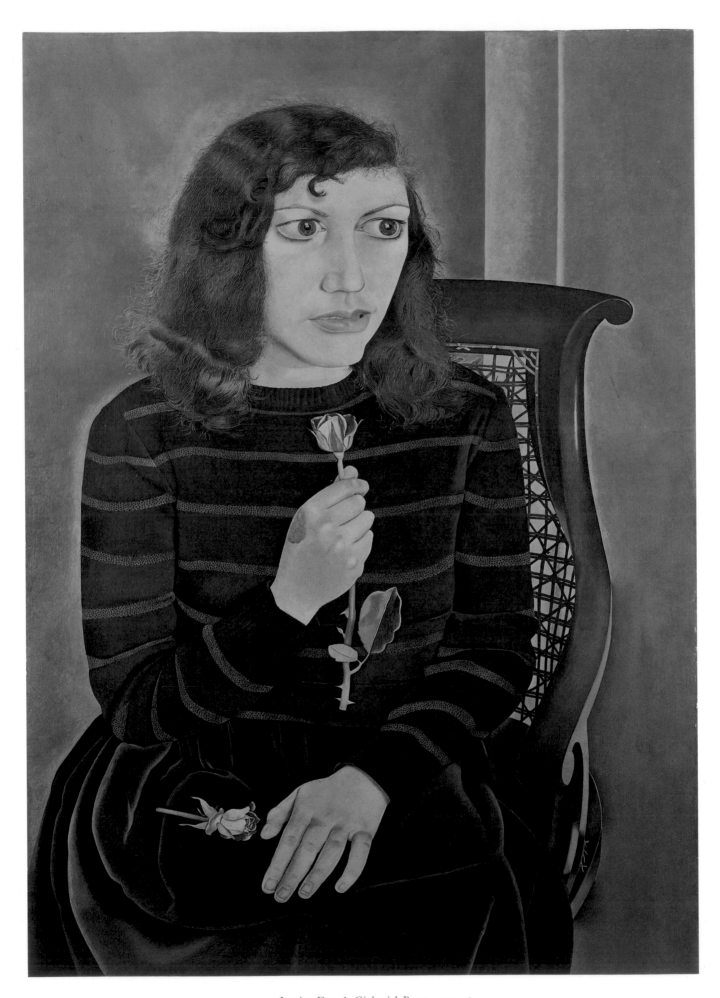

234 Lucian Freud, *Girl with Roses* 1947-48

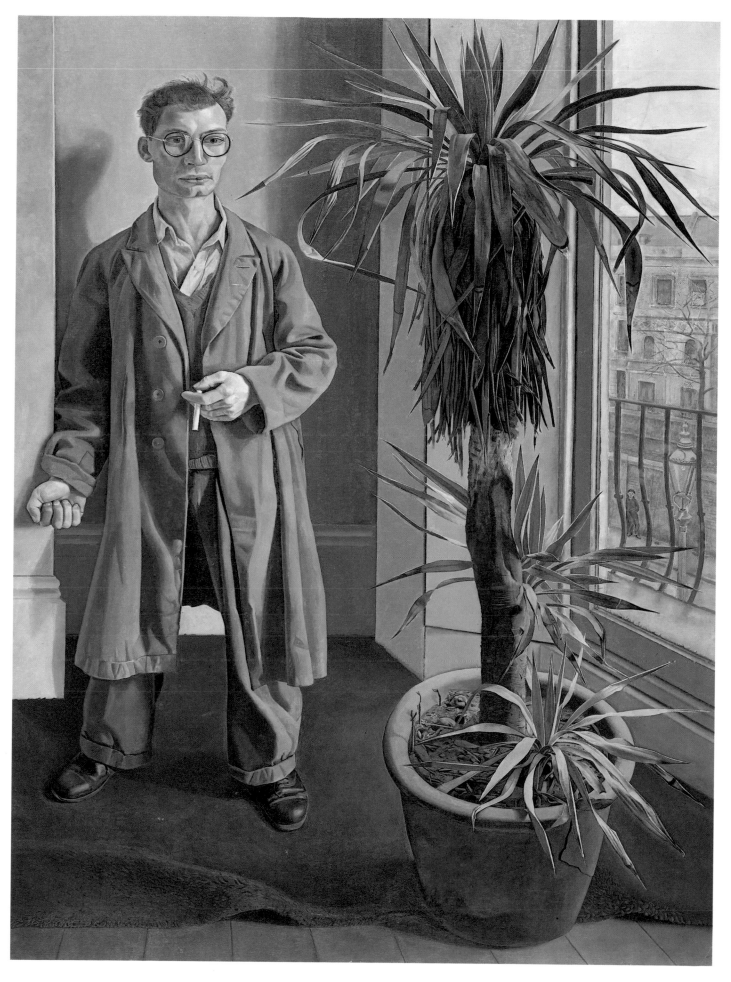

235 Lucian Freud, *Interior at Paddington* 1951

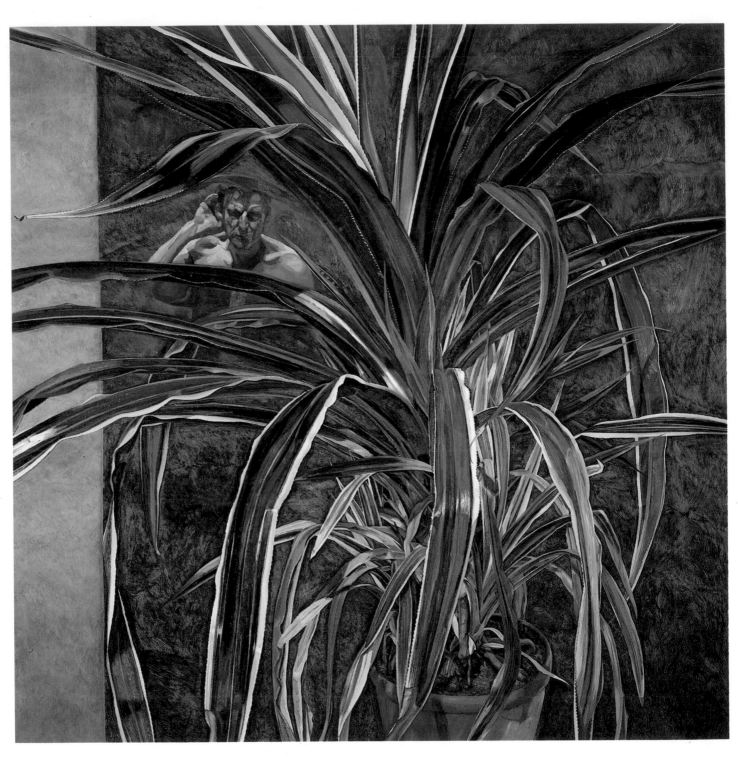

236 Lucian Freud, *Interior with Plant, Reflection Listening* 1967-68

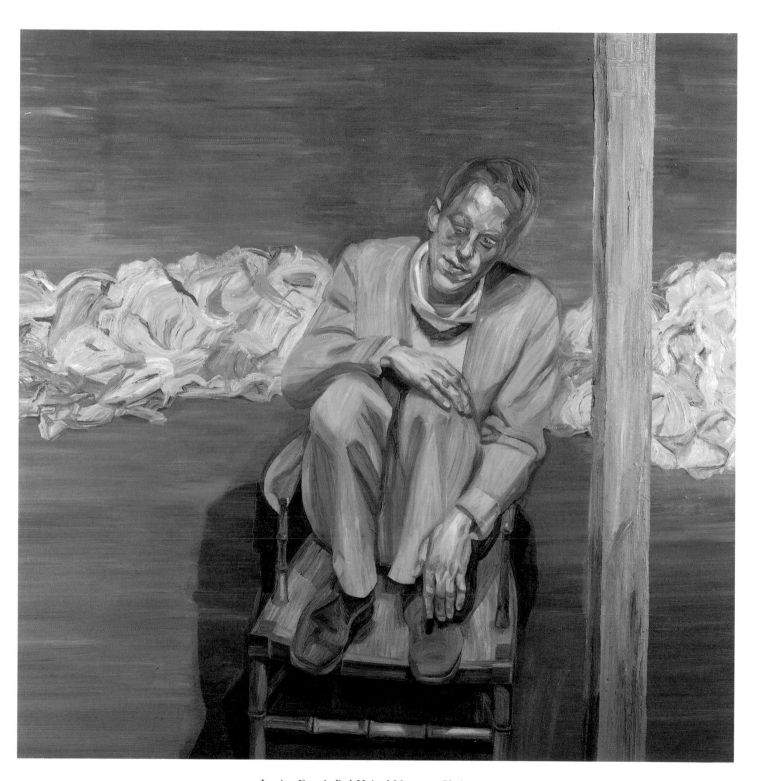

237 Lucian Freud, *Red-Haired Man on a Chair* 1962-63

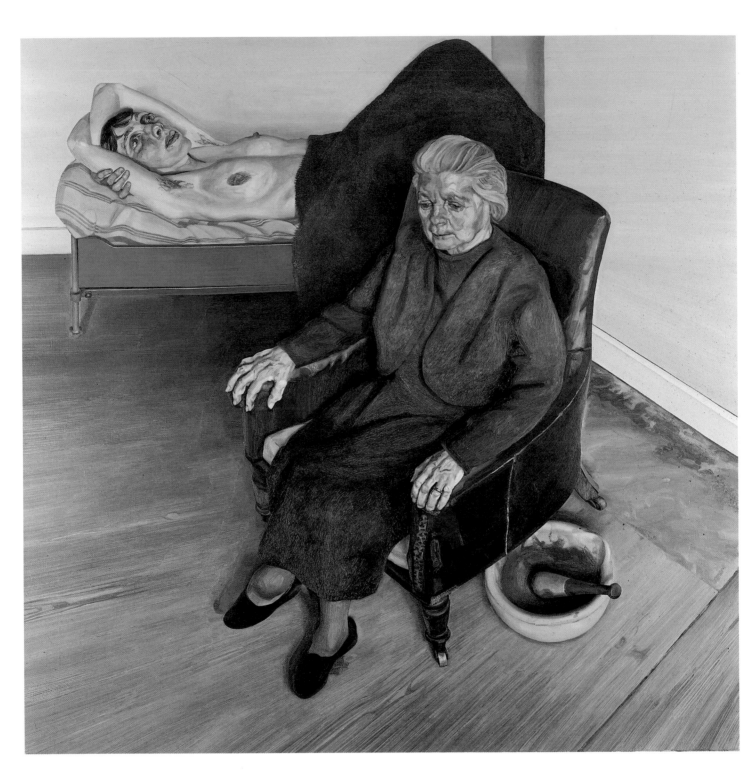

238 Lucian Freud, *Large Interior, W. 9* 1973

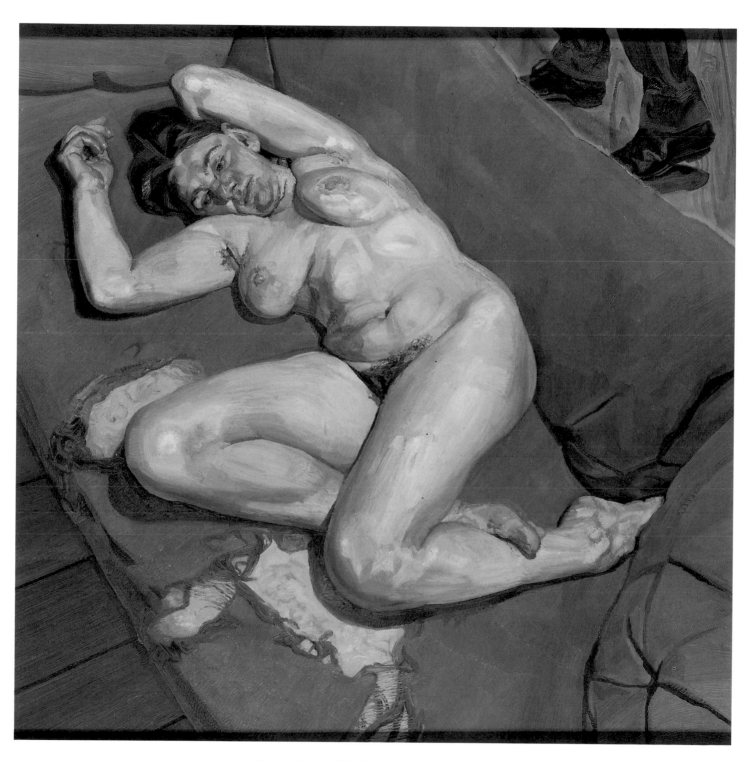

239 Lucian Freud, *Naked Portrait with Reflection* 1980

240 Lucian Freud, *A Factory, North London* 1972

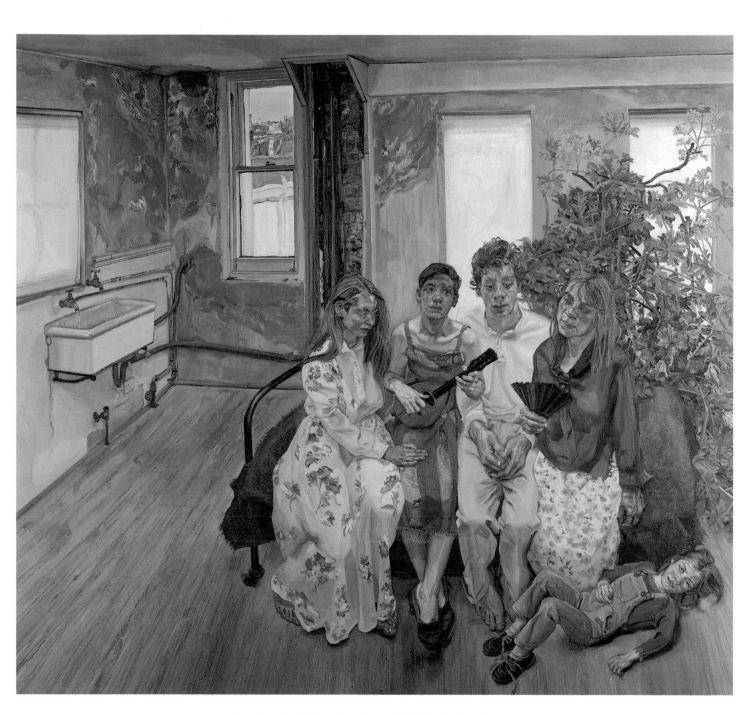

241 Lucian Freud, *Large Interior, W. 11 (after Watteau)* 1981-83

242 Frank Auerbach, *Maples Demolition, Euston Road* 1960

243 Frank Auerbach, *Study after Deposition by Rembrandt II* 1961

244 Frank Auerbach, *Primrose Hill* 1985

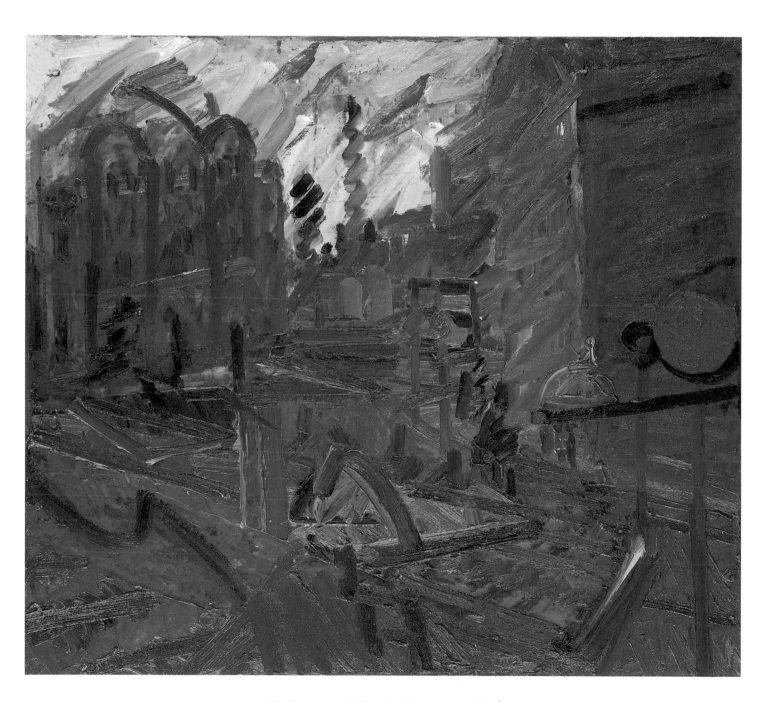

245 Frank Auerbach, *Camden Theatre in the Rain* 1977

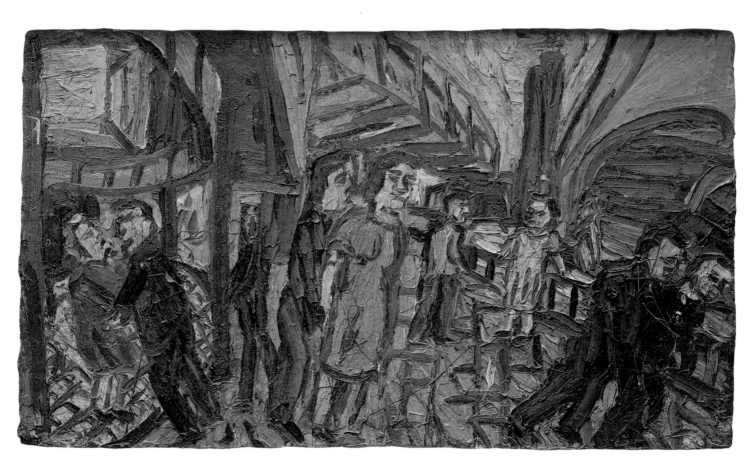

246 Leon Kossoff, *Outside Kilburn Underground Station, Summer 1976*

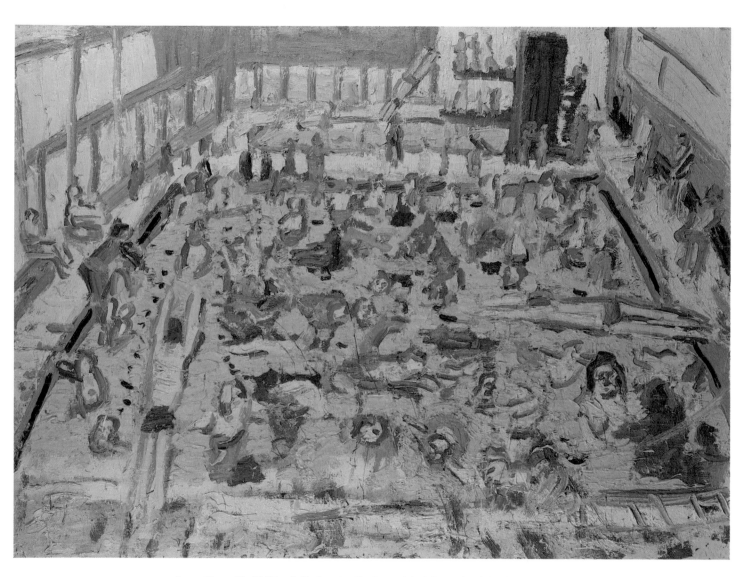

247 Leon Kossoff, *Children's Swimming Pool, 11 o'clock Saturday Morning, August 1969*

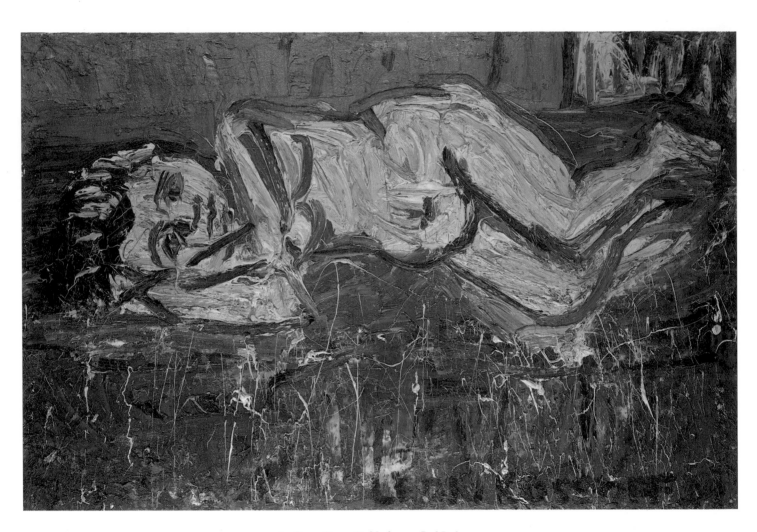

248 Leon Kossoff, *Nude on a Red Bed* 1972

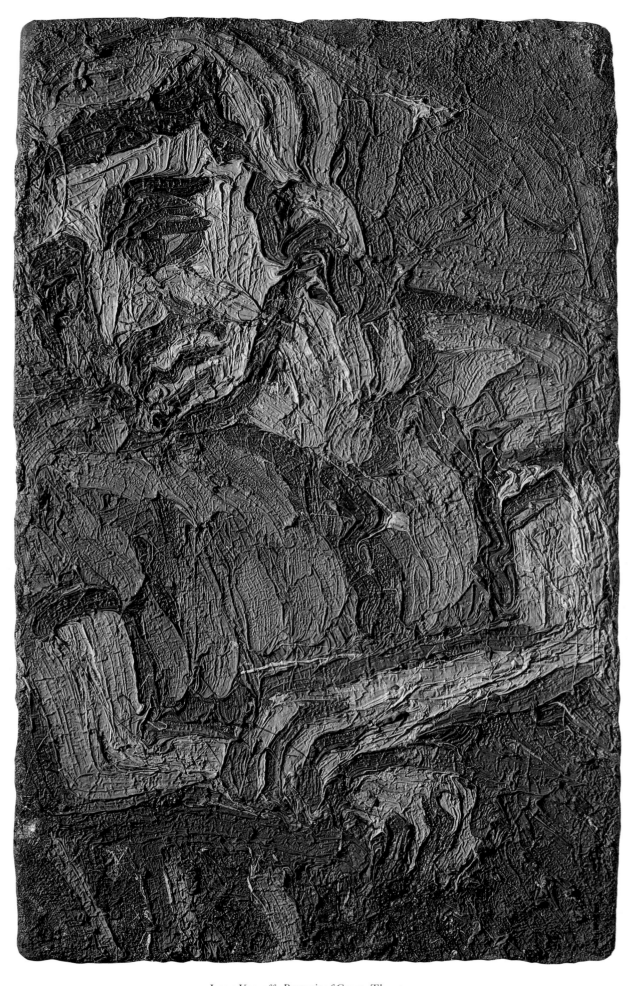

249 Leon Kossoff, *Portrait of George Thompson* 1975

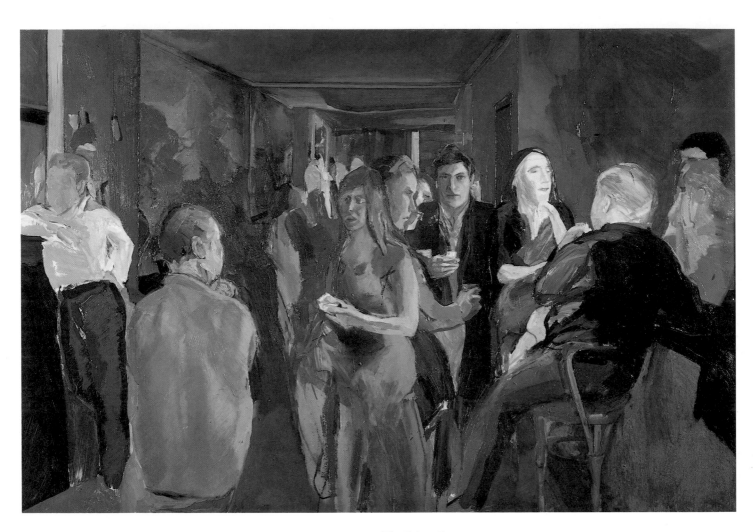

250 Michael Andrews, *The Colony Room I* 1962

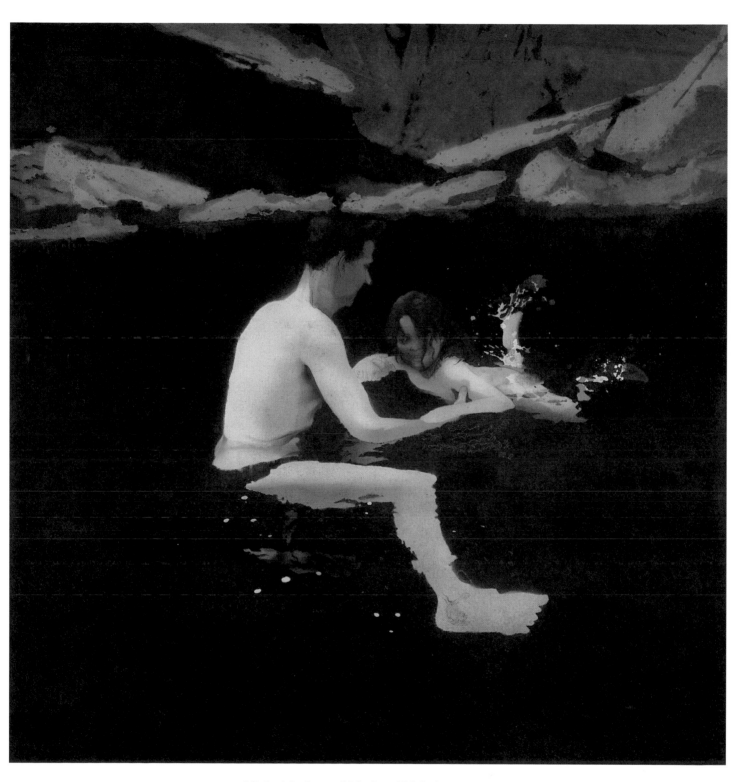

251 Michael Andrews, *Melanie and Me Swimming* 1978-79

Susan Compton

Pop Art – New Figuration

Works of art in this section reflect a vitality and exuberance unparalleled in British twentieth-century art. The subjects may be exotic, erotic or even quixotic, but generally they are readily accessible and often refer to films and film stars, records and pop stars of the day. The pictures seem easy to look at because most of the artists closed the gap between popular culture and 'fine' art, giving rise to the tag 'Pop Art' which has subsequently defined their new figuration.

The first public manifestations of a new approach were to be seen in the Whitechapel Art Gallery in 1956 at the exhibition 'This is Tomorrow' which included a photo-mural made from a collage by Richard Hamilton with the title: *Just what is it that makes today's homes so different, so appealing?* (Fig. 13, p. 27). This shows a 'modern' interior, complete with punning references: the word 'Pop' is sported by a muscle-man, closer to the world of comic books than to the museum gallery of Classical nudes. The phrase 'Pop Art' was not used until two years later when the critic Lawrence Alloway coined it to praise the graphics of advertising, packaging, etc. – products of the mass media – rather than the works of art that drew upon them, in an article entitled 'The Arts and the Mass Media'. The term was not used to label the work of artists until the early 1960s.

Hamilton has written of the desire of painters in the Fifties, both in London and New York, to search for the unique attributes of the epoch. As early as 1950, regular informal gatherings had taken place at the home of Reyner Banham, the art historian and critic, and included architects and writers as well as artists. They formed the nucleus of the Independent Group which met on a more formal basis at the Institute of Contemporary Arts in Dover Street from 1952; among the artists were, besides Richard Hamilton, William Turnbull and Eduardo Paolozzi. From the first their wide-ranging interests included jazz, car styling, car racing, all forms of locomotion, science fiction, films and comic books from the USA. These were not regarded as 'kitsch' for, as Alloway has recorded, they saw all types of human activity as worthy of aesthetic judgment and attention. Of this first generation only Hamilton was wholly involved with figurative art and, in retrospect, he can be seen as the 'father' of the movement.

Hommage à Chrysler Corp (Cat. 252), which he made in 1957, may look very like abstract art at first sight, but Hamilton describes it as his coming to terms with an engagement with life at a banal level (by borrowing from advertisements) without relinquishing his commitment to fine art (by using a title which looks back to French art). It includes quotations from Chrysler's advertisements for Plymouth and Imperial automobiles, as well as material from General Motors and Pontiac, the American car manufacturers which then had the edge on car styling. Sex was already in use as a gimmick for selling cars and Hamilton incorporated a diagram for the very latest 'Exquisite Form' bras in conjunction with Voluptua's lips. While working on the picture he remembers thinking about Marinetti's aphorism, 'A racing car . . . is more beautiful than the *Winged Victory of Samothrace*', which he admits he found 'corny'. He began a systematic exploration of the possible languages of art, triggered by an almost obsessive interest in the works of Marcel Duchamp. This gives to all his work a particular ingredient of irony, and distinguishes him from the younger Pop artists, though he shares with them the use of subject-matter taken from popular media.

Hamilton used a still from the first film to be shot in Panavision, *White Christmas*, for *I'm Dreaming of a White Christmas* (Cat. 255). Although this was painted in 1967-8, he had had the photograph since 1959 and used it because it allowed him to explore negative colour reversal. This fitted in with Duchamp's idea that everything has its opposite, but the sophisticated reasoning underlying the work is largely concealed by the accessible subject-matter. By using Bing Crosby as the subject he has identified and immortalized a hero of our time, rather as Sickert had chosen *King Edward VIII* (Cat. 159) some thirty years previously. While Sickert had often painted from photographs, he did not go so far as to use a photographic negative instead of an underpainting; indeed, it would not have been technically feasible for him to have done so in his lifetime.

A comparison between the earliest painting in the exhibition, Sickert's *The Bathers, Dieppe* (Cat. 1) of 1902 and Hamilton's version of a similar scene, *Whitley Bay* (Cat. 253) of 1965, shows how in the space of some sixty years an artist's view of this archetypically British subject changed. Hamilton is not trying to reproduce the uniqueness of figures; instead, he is fascinated by the faculty of observation by which a collection of marks on a two-dimensional surface is perceived as people. He began with a 'true likeness', a picture postcard view of the beach at Whitley Bay, Northumberland. 'The camera cannot lie', but after the artist has enlarged part of the image and reproduced it on the canvas, the resulting screen of half-tone dots simultaneously serves as a distraction and confuses the viewer. Sickert's brushmarks create an equivalent for the viewer of what the artist sees, Hamilton has used the mechanical marks to make a visual pun on conventional brushstrokes. In a series of works made at the time, Hamilton was trying to find out how much distortion the brain could accept, how much he could enlarge a photographic image and retain marks which would still be recognized by the viewer as a representation of figures.

In 1961 Peter Blake had included a 45 rpm Pop record, *Got a Girl*, in his work of the same title (Cat. 256). Born ten years after Hamilton, Blake had grown up through the war years and had embraced the influx of Americana as a simple fact of post-war life in Britain. He arranged six photographs of Pop stars (Fabian, Frankie Avalon, Ricky Nelson, Bobby Rydell and two of Elvis Presley) next to the recording by the Four Preps of a song expressing the frustration of a boy whose girl can only think of those Pop stars whenever he wants to kiss her. Whereas in Hamilton's work the references to fine art are married to collage elements (for instance, the 'headlamp' in *Hommage à Chrysler Corp*), Blake separates this work into distinct sections, the 'real' – as it were – occupying its own space above a triptych which might at first be taken for an abstract painting. A closer look shows the red, white and blue chevrons to be more like a battered hoarding than the smooth surfaces of Sixties abstraction. Blake was very conscious of 'style' at this time: he had trained as a graphic artist before going on to the Royal College of Art, where both Paolozzi and Hamilton had short-term teaching posts. His development as an artist is coloured by the year he spent studying popular arts in Europe, from 1956 to 1957, and his work is generally much less America-orientated than this example might suggest.

Richard Smith also left the College in 1956 and his connections with the United States became very direct, since in 1959 he won an award to study there for two years. *Product* (Cat. 257) was painted in 1962 when he was teaching at St Martin's School of Art: he deliberately uses imagery derived from fine art (targets or discs) and – as indicated by the title – from packaging. Smith knew Blake and Hamilton, and Alloway, who in a catalogue introduction described Smith's translation of the glamorous soft and blurred colour

of high fashion photographs into abstract art. Smith was anxious to annexe into his work stylistic devices available to the spectator in the consumer world, thus creating a shared world of references between 'high' art and everyday illustrative material. He was concerned to find the level of legibility at which associations between these two apparently opposite poles could take place.

While Hamilton's art represents the first phase of Pop Art and, in this exhibition, that of Blake and Smith represents the second, a third was apparent at the Young Contemporaries exhibition of 1961. This included work by Patrick Caulfield, David Hockney, R.B. Kitaj and Allen Jones, who were all students at the Royal College together. Alloway, who wrote the catalogue for that exhibition, avoided using the term 'Pop Art' when discussing their work. In retrospect he believes that the influence of Blake, whom they all knew, pushed these younger artists decisively in the direction of figuration (rather than of contemporary Sixties abstraction). He describes the other crucial influence as R.B. Kitaj, who was considerably older than the others and who had already been studying since 1950 in New York, Vienna and at the Ruskin School of Art in Oxford. Jones has paid him the tribute of providing an influence of 'dedicated professionalism and real toughness about painting'.

Kitaj also forms a link back to the progenitors of new figuration in Britain through his association with Paolozzi, with whom he collaborated on two works between 1960 and 1962. The extensive use of a wide variety of found materials (from all sorts of magazines) which Paolozzi had collaged together in the scrapbooks which served him as sketchbooks (Fig. 10, p. 26) probably influenced the way that Kitaj drew liberally from all kinds of source material in his compositions. However, Kitaj used references culled not just from the world of science fiction, comic books and space flight but from the whole history of the twentieth century. His admixture of drawing as well as painting and of deliberately abstract passages embedded in such compositions as *An Early Europe* (Cat. 258) served to his peers as a paramount example of a new form of picture-making.

Hockney has credited Kitaj with releasing him from a battle between abstraction and figuration, and he been able to go on, he says, to 'paint what I like, when I like and where I like with occasional nostalgic journeys. . . . I am sure my sources are classic or even epic themes.' These are made very clear in his early canvases on which he often in-

cluded words; for example, *We Two Boys Together Clinging* (Cat. 260) is a line from a poem by Walt Whitman. The lines of poetry are all the more poignant because Hockney's original inspiration came from a newspaper headline, 'Two boys cling to cliff all night', which actually referred to a mountaineering accident but suggested to the artist that the boys were fans of the singer Cliff Richard. Such multiple references may seem surprising in a work which in some ways resembles graffiti. But *Berlin: A Souvenir* (Cat. 261) was painted on Hockney's return from a visit to that city and also suggests many interpretations. Here the freely marked, graffiti-like surface of the previous work has given way to a more formal style apparently related to American Abstract Expressionism: there seems to be a veiled reference to Rauschenberg in the imprinting by transfer of the white paint with newsprint. This style in turn gave place almost immediately to a more obviously narrative approach in *Great Pyramid at Giza with Broken Head from Thebes* (Cat. 262), which followed a visit to Egypt. The triangular form of the pyramid creates a monumental compositional device: the broken head is almost Surrealistic in its implications (even anticipating a 'Monty Python' cartoon), though it is based on a photograph of an ancient Egyptian head. Photography was increasingly important to Hockney, who became a keen and brilliant photographer himself, and he made use of his own photographs in such paintings as *Sunbather* (Cat. 263). Below the figure, lovingly recreated from a photograph, is an area of canvas with a stylized and abstracted vision of the water of a swimming pool. Hockney has always denied that he is a Pop Artist but his pictures, with their strong suggestion of story-telling and brilliant use of colour, have a wide appeal which has made his art extremely popular.

Caulfield likewise insists that he is not a Pop Artist: next to his disarmingly direct figure entitled *Portrait of Juan Gris* (Cat. 264), he has deployed some groups of black tram-lines which refer to the fully abstract painting styles explored both in the early twentieth century and in recent years by British Constructivists such as Victor Pasmore (see Cat. 136). By naming his figure after one of the inventors of Cubism, Caulfield has drawn attention to the history of art, though he has cleary subverted it for his own ends, even choosing enamel house paint for his rich yellow background. The viewer looks at an apparently simple figure painting, but then begins to wonder how the artist has pro-

duced such a convincing statement with such economy of means.

Jones, undeniably a Pop Artist, nevertheless seems to use the excuse of a bus (in *Bus II*, Cat. 259) to explore movement (by staggering the sides of his canvas) as well as to identify an object with the shape of the canvas (by adding extra pieces to suggest wheels). His wheels double as the targets which were a favourite device of artists at the time (when the 'target' paintings of Jasper Johns were much admired). As in Blake's *Got a Girl*, figures occupy the top third of the main canvas but they are formed only of clothes, painted schematically to double as abstract pattern and to imply movement.

The final work in this section is a large sculpture, *Wittgenstein at Casino* (Cat. 265) by Paolozzi, whose early work (Cat. 223, 224) is discussed on page 300. It is fitting to place *Wittgenstein at Casino* in the centre of the gallery devoted to Pop Art since, with Hamilton, Paolozzi can be regarded as a founder of the new figuration of the Sixties. It is apparent that a radical change took place between the earlier work and this sculpture. It was due to his stay in Germany, in particular in Hamburg, where Paolozzi was appointed Visiting Professor at the Hochschule für bildende Künste in 1960. Hamburg provided him with first-hand experience of a great tradition of heavy engineering which he had first admired in Fritz Lang's film *Metropolis*. From about 1962 most of his sculptures were made from factory-made machine parts.

The subject of *Wittgenstein at Casino* is related to a set of twelve screen prints entitled *As is When* which Paolozzi planned in Hamburg (though they were not printed until 1964-5). The theme was the life and writing of the philosopher Wittgenstein, in part mediated by the tribute *Ludwig Wittgenstein, A Memoir* written by Norman Malcolm and published in London in 1958.

Wittgenstein's *Tractatus-Logico-Philosophicus* – first published in German in 1922 – offers a basis for art, being a theory of Symbolism, expressed in what Wittgenstein termed 'molecular propositions'. No doubt it provided inspiration for the titles of some of Paolozzi's other sculptures in the series, especially *The Word Divides into Facts*. Yet, in view of the discussion of work by Anthony Caro in the next section, it is necessary to add that Paolozzi coloured these sculptures at a slightly later date. He evidently thought of them at first as agglomerations of metal parts rather than as coloured assemblages. Now that colour has become such a central ingredient of them, it is hard to imagine them without it.

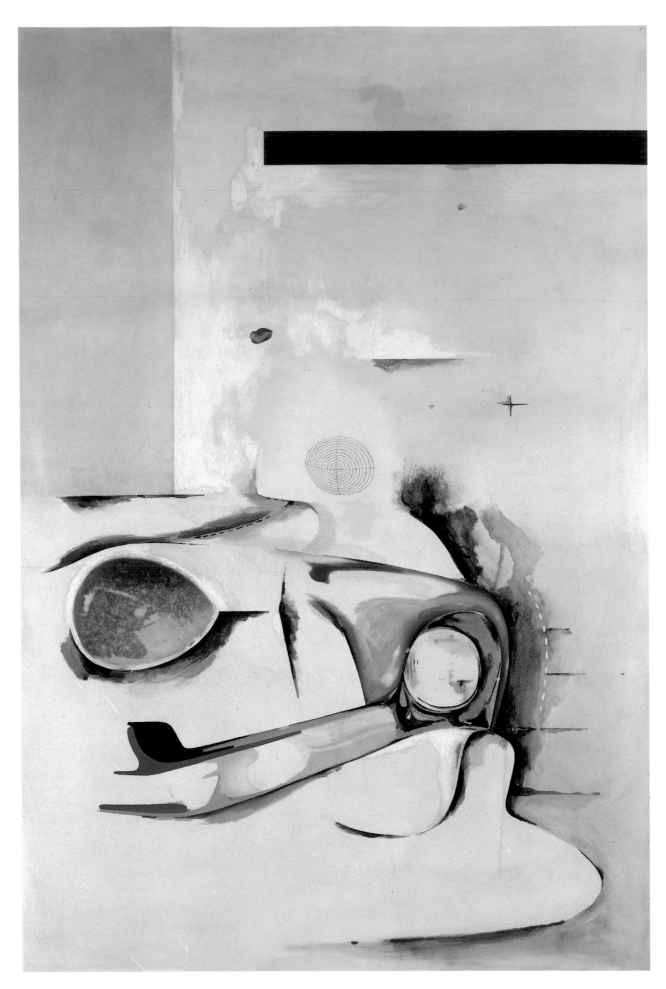

252 Richard Hamilton, *Hommage à Chrysler Corp* 1957

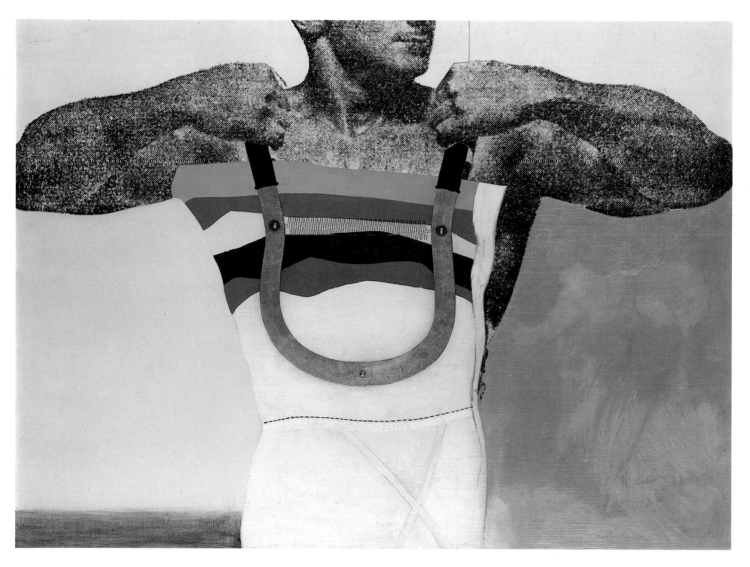

253 Richard Hamilton, *Towards a definitive statement on the coming trends in men's wear and accessories (c) Adonis in Y-fronts* 1962

254 Richard Hamilton, *Whitley Bay* 1965

255 Richard Hamilton, *I'm Dreaming of a White Christmas* 1967-68

256 Peter Blake, *Got a Girl* 1960-61

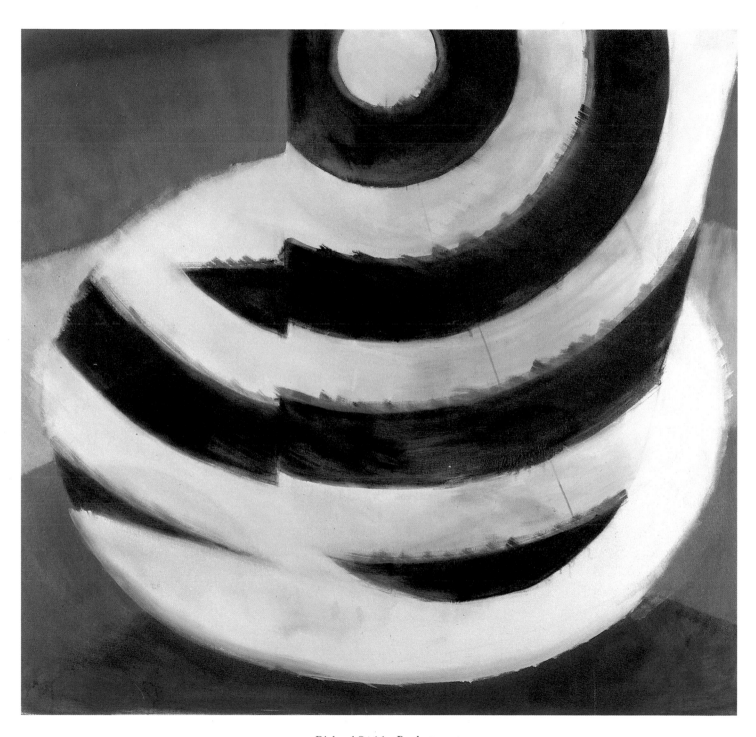

257 Richard Smith, *Product* 1962

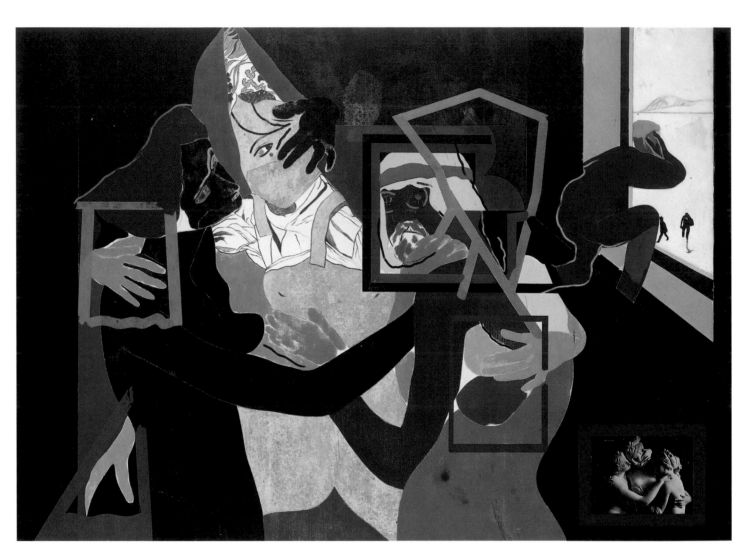

258 R.B. Kitaj, *An Early Europe* 1964

259 Allen Jones, *Bus II* 1962

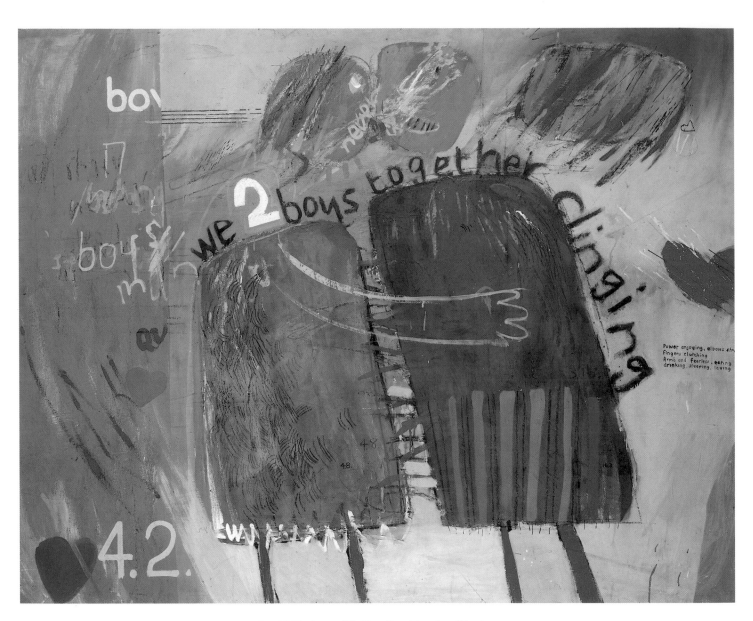

260 David Hockney, *We Two Boys Together Clinging* 1961

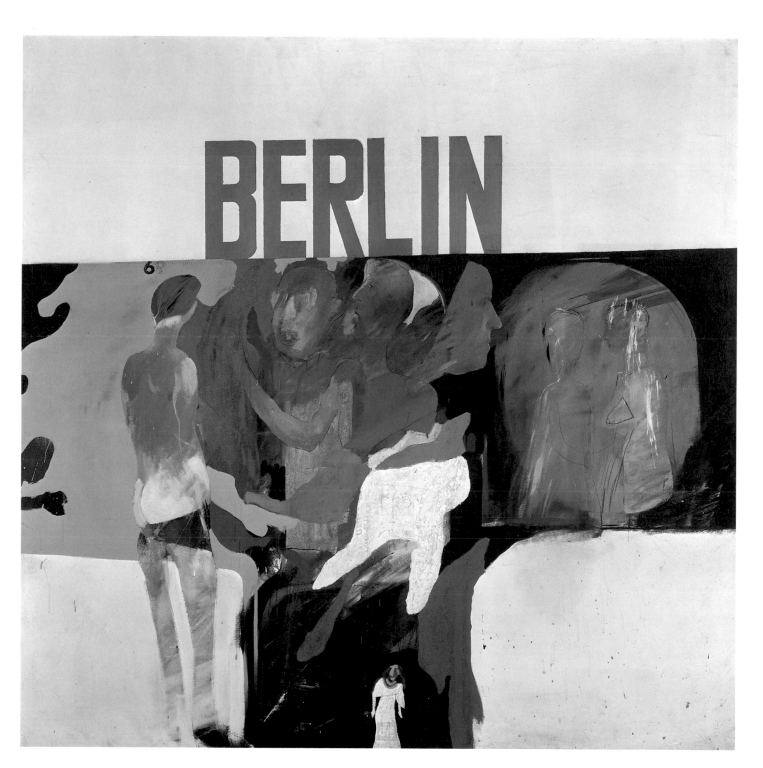

261　David Hockney, *Berlin: A Souvenir*　1963

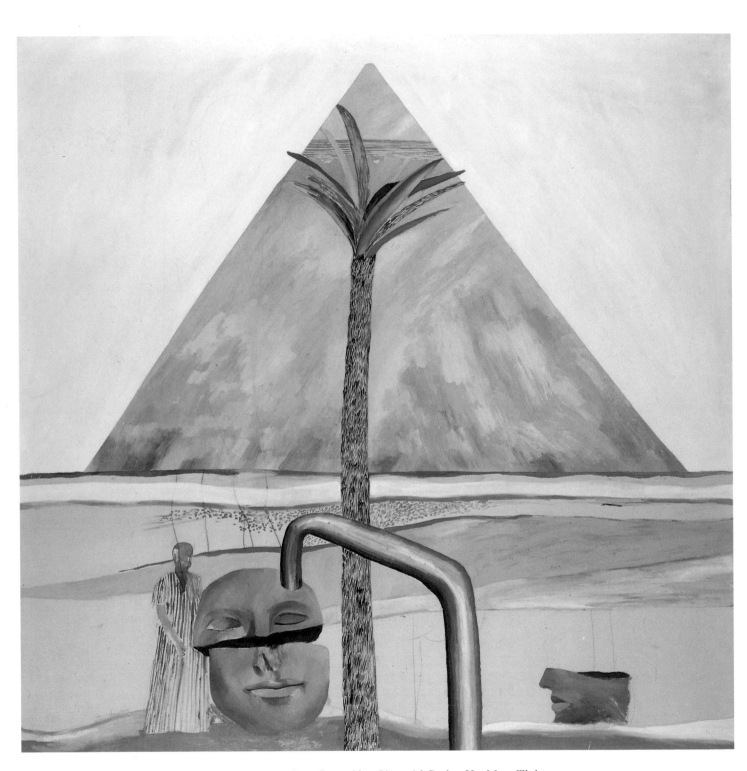

262 David Hockney, *Great Pyramid at Giza with Broken Head from Thebes* 1963

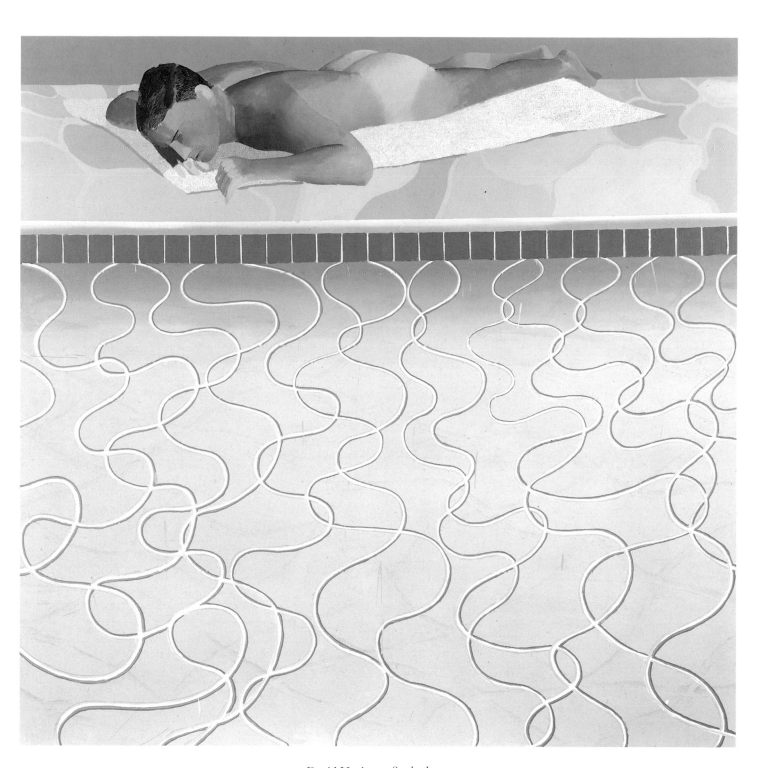

263 David Hockney, *Sunbather* 1966

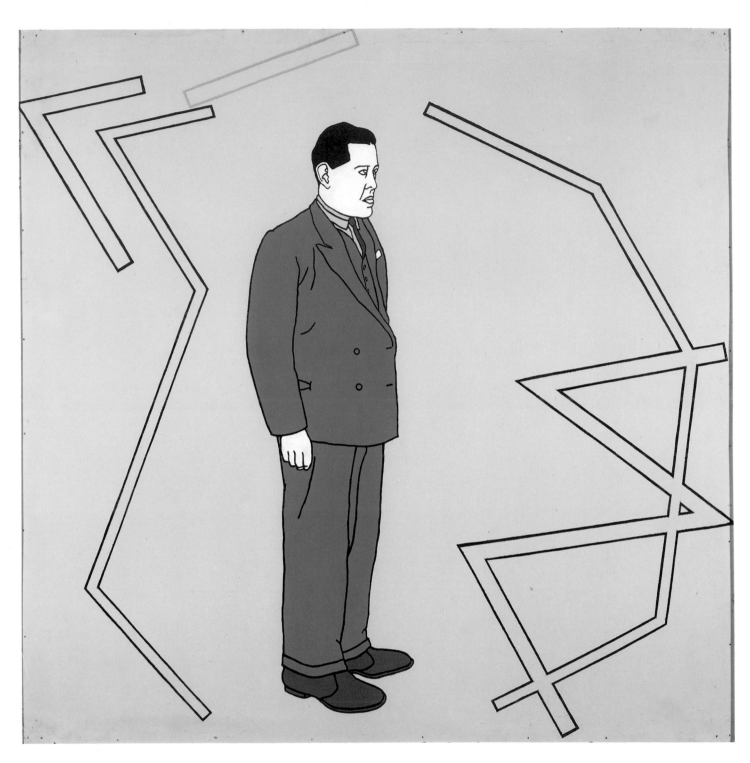

264 Patrick Caulfield, *Portrait of Juan Gris* 1963

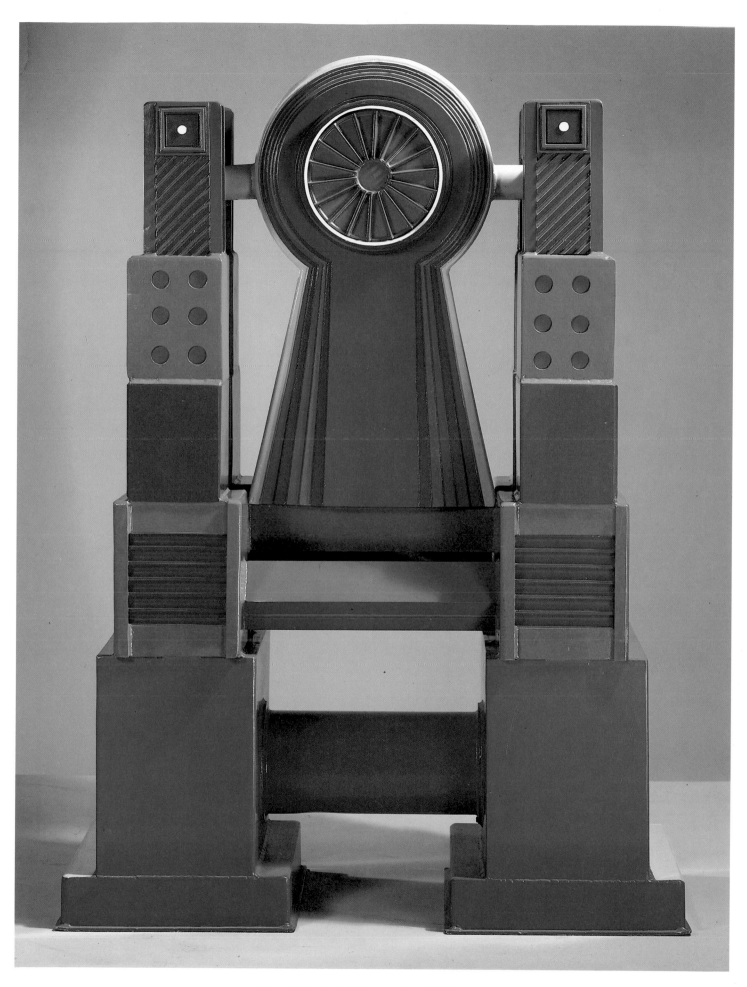

265 Eduardo Paolozzi, *Wittgenstein at Casino* 1963-64

Susan Compton

Anthony Caro and Sixties Abstraction

1960 was a decisive year for abstract art in Britain. It was the year of the 'Situation' exhibition in London where work by John Hoyland, Gillian Ayres and Bob Law, amongst others, was shown. It was also the year when Anthony Caro virtually single-handed changed the shape of British sculpture. His achievement is shown here by *Sculpture Three* (Cat. 266), dating from the next year (1961) but representative of his radical new approach. This work is complemented by *Prairie* (Cat. 267), made six years later and a culmination of his invention in the Sixties.

Each of these sculptures consists of individual elements of basic shape added to each other to create a three-dimensional entity which is strengthened by the application of colour. This original way of making sculpture is most easily described in terms usually applied to abstract painting, for Caro creates a fluid arrangement of horizontals, verticals and diagonals, of flat planes and more solid shapes which are held together in an almost magical manner by the physical joins of the welder. At a stroke he transferred from the quarry to the foundry that concern for truth to materials which had been so potent for sculptors in Britain earlier in the century.

Unlike Henry Moore, for whom he had worked as an assistant in the early Fifties, Caro had not adopted the chisel as a tool, but had preferred the additive process of building up his early figures (of which few survive). This method of working, by pressing raw material on to an underlying armature and then leaving the trace of his working method on the surprisingly rough surface of the figure, can be seen in *Woman Waking Up* (Cat. 220). Early photographs of this sculpture in the making record it not raised up but lying on the ground. The relationship of a sculpture to the world about it was evidently already a matter of critical concern to Caro.

As Moore's assistant, he must have been aware of the stipulations that Moore always made about the size, proportion and even the colour of bases for his sculpture. The function of a base has traditionally been to separate the space occupied by the sculpture from that of the viewer, rather as a frame separates a canvas from the wall behind it. In 1960 Caro effectively destroyed the sculptural base by removing it. After this, his work has always been shown without a base – indeed, characteristically his sculptures 'hug' the ground: he has forced the viewer to consider the horizontal dimension of sculpture in a new light.

By painting the sculptures, Caro transformed the raw steel. In *Sculpture Three* the colour – a rich green – makes a single entity of the separate units and emphasizes the pictorial quality. The horizontal rods of *Prairie* are anchored to their supports at one end only and the sculpture almost appears to hover above the ground. The rods are so long that they often move gently in space, suggesting the wind which blows across a corn-laden prairie. No doubt Caro intended some such visual pun, for otherwise he would hardly have chosen the title and selected the colour to reinforce the analogy.

The substitution of colour by varnish together with the prosaic title of the place of manufacture distinguishes the third sculpture *Veduggio Sound* (Cat. 268) from the work of the Sixties. In 1972-3 Caro made a series of 'Veduggio' sculptures on two short visits to a particular steel mill in this small town in Italy. He wanted to explore the possibilities of working with malleable raw steel straight from the rolling mills and he was especially keen to use the off-cuts that fell aside from the rollers. At the mill he was able to use an electric hoist which facilitated his work; the resulting sculptures have a particularly 'unworked' quality, partly because the Italians knew no English nor he Italian. The Veduggio sculptures may also have been influenced by the American artist Helen Frankenthaler, who had worked with Caro in his London studio in 1972. However, it is hard to identify a North American influence in these works, unless it be that the new sense of freedom resulted from Frankenthaler having been a pioneer Abstract Expressionist.

Ten years before, for Caro as for the 'Situation' painters, the influence from the United States had been very powerful. In 1959 the exhibition 'New American Painting' at the Tate Gallery had greatly impressed a majority of the artists included in this section. They were surprised by the size of the paintings by Rothko, Still, Newman and Ellsworth Kelly, which had not been conveyed by the photographs which they had previously seen.

It was in the following year that the 'Situation' exhibition was organized and an individual British response to the new scale and radical abstraction of American painting became apparent. No canvas less than thirty feet square (2.79 square metres) was included, nor were 'references to landscape, boats or figures' allowable. These criteria excluded work by the Fifties abstractionists, Alan Davie, Patrick Heron, Roger Hilton or Peter Lanyon (discussed in an earlier section), both on the grounds of size and because the colours and forms which they were using retained connections with the natural world.

The title was an abbreviation of 'the situation in London now', so in spite of the temptation to refer with hindsight to a 'Situation Group', this would be a false interpretation of the exhibition, which had no programme and no manifesto and was a temporary alliance for professional purposes only. Yet although poorly attended, the show was significant enough for the Marlborough New London Gallery to host a sequel 'New London Situation' in 1961.

In his introduction to the catalogue of 'Situation', Roger Coleman identified 'values implicit in the large painting'. He expressed the view that when artists relinquish pictorial depth, a logical expansion occurs both horizontally and vertically, to the extent that a painting acquires environmental definition, without becoming a mural. He went on to describe the large painting as the recording of a sequence of actions, with the result that it becomes a 'real object'. He singled out the work of Gillian Ayres for her use of paint as 'a physical substance' and this has remained a characteristic, which has found fulfilment in her recent works, such as *Scilla* (Cat. 275).

Around 1960 new words were coined to describe the new approach to abstraction, such as 'field painting'. A British 'studio term' was a 'blimp' to describe the 'freely placed ovals in a field painting'. These can be seen in *Lure* (Cat. 274), which Gillian Ayres painted in 1963, though here they are not the discrete 'blimps' she had used in her painting of that title. By the time she painted *Lure* her love of colour and expansive methods of working had spilled out on the canvas: the juxtapositions of colours – which never become muddy – anticipate the freedom with which she has developed the use of brilliant pigments in the thickly painted canvases of her maturity (Cat. 275).

Ayres had early appreciated the way that Jackson Pollock had dribbled paint on to a canvas spread out on the floor without marking the surface with conventional brushes. In contrast, John Hoyland was more impressed by the way Rothko applied paint. He found 'process' (that is, the way paint is put on) important, though he said that it should be natural, like the way water flows. Accidents should be controlled, though they clearly play a creative part in *17.7.69* (Cat. 273) which takes its title from the date of painting. Even

though this large canvas represents Hoyland's mature style and is unlike the pictures he showed at 'Situation', some words from Coleman's catalogue introduction seem particularly appropriate to it: 'The organisation of the canvas . . . expresses itself through an image; not an image in a directly figurative sense, but an image in the sense that the marks on the canvas cohere to communicate a specific, deeply felt experience, even if the spectator is not aware of what the experience is.'

When he visited Documenta II held in Kassel in June 1959, the sculptor Phillip King found American painting far more interesting than other sculpture. It is too simplistic to 'read' the verticals of *Call* (Cat. 269) as the stripes of some grand three-dimensional painting, although King himself described it as 'about' colour and space acting together. He made it in fibreglass, a material that he was one of the first to exploit, painting it afterwards so that he could adjust the colours to achieve exactly the balance between them that he required. The distances between the elements create an interval that is neither too small nor too great for the eye to be 'called' from one to the other, now following one of the verticals right up into the air, now returning to one of the more cubic forms, which are carefully balanced to contribute to the experience of colour, weight and form. Unlike Caro, whose steel sculptures are welded so that the separate elements are joined together, King forces the viewer himself to make the connections between the individually spaced parts. Yet the interactions are so strong that they set up tensions, as do the colours in Bridget Riley's paintings.

Riley did not develop her own more precise colour notation from the stimulus of North American art: her roots are in Europe, especially in the work of the Post-Impressionist Seurat, whom she greatly admired. However, through meeting John Hoyland she became close to 'Situation', which she regarded as the most relevant new development of its time. When she began to invent pictures like *Arrest IV* (Cat. 270) it was not with the intention simply of creating a physiological disturbance in the brain. She wanted the viewer to savour the perceptions which she sets in motion by the precisely formulated notations on the canvas. The term 'Op Art' was invented to describe the paintings and Riley's work stimulated an extraordinary acclaim in the 1960s. Indeed, commercial imitations carried out on fabric flooded the clothes market for a short time. On one level this can be seen as an unusual conjunction of the tempo of art and life. On another, it was the ultimate misunderstanding of her art form, which in its fullest implications is intended to be metaphysical.

The same is true of the work of Bob Law, who has entitled most of his canvases 'metaphysical field paintings'. By this he loosely means his surfaces to be taken as 'a kind of environmental chart, a thesis of ideas, energies, transmutations'. Although his *Bordeaux Black Blue Black* (Cat. 272) was made more than a decade after he had taken part in 'Situation', his preoccupations with black and white remained constant, though his method of working changed from drawing to painting. This picture will be seen as black, but Law achieved his almost living surface by superimposing one colour on another, usually in a single session in the studio, so that there are no variations in the resulting painting. He did this to avoid any graduations which might give spatial connotations to the canvas. He feels that pictures can change people in an almost mystical way and he once called part of his series of black paintings 'Twentieth Century Icons', describing them as 'involving the new proposition of western Mandalas through the pure aesthetic dictums of form and colour'.

Bordeaux Black Blue Black is coincidentally a black square, though unlike the 'icon' of that title created in 1915 by the Russian painter Malevich, it has no surrounding white border. The black square that hovers in an almost menacing way in John Walker's *Tense II* (Cat. 276) serves more as a reminder of these preoccupations of earlier artists in the century than as an icon in itself. Walker uses painting as a vehicle for his personal concerns: when he approaches the canvas he tries to paint a very honest painting 'that's a piece of me, whatever I'm into at that time'. His is another approach to abstraction, one that is almost Expressionist in outlook, though this particular work is not executed with the painterly bravura usually associated with that standpoint. In this case, what Walker was 'into at that time' was a thorough investigation of the roots of twentieth-century abstraction. He showed *Tense II* in the Young Contemporaries exhibition that Hoyland contributed to in 1960, but he spent the year studying in Paris so he did not exhibit at 'Situation' or its sequel. He belongs to a generation younger than Hoyland and Ayres which enabled him to bypass some of the uncertainties about abstraction as a means of working which had haunted his seniors.

Furthermore, Walker's approach has allowed him recently to reintroduce an element of figuration into works such as *Conversation* (Cat. 277). Like Law he paints his pictures preferably without interruption, but this is not because of wanting to keep a surface unity as Law does, but because he wants to work without conscious thought. Thus he has returned to the goal of the early Abstract Expressionists, or perhaps to a reconsideration of the attitude of the Surrealists before them. The head-form which haunts *Conversation* (one of a series) was originally inspired by the impact on him of Australia – with its surviving primitive art carried out by the Aborigines. In contrast, the persistent central block-like form, also apparent in paintings in this series, refers to Goya's *Duchess of Alba*. The allusion is indicated by the titles of some of the works, so the viewer is given a stronger awareness of 'content' than is usual in the work of abstract painters. Recent work by Ayres hints likewise at 'content'. The title *Scilla* refers to the flower of that name, but in addition it reveals her enjoyment of the act of painting, of loading the canvas with a rainbow of colours. In her work she has remained loyal to the activity pioneered by Abstract Expressionists, but her individuality arises from the relief-like web of brushstrokes combined with the celebration of the joy of colour.

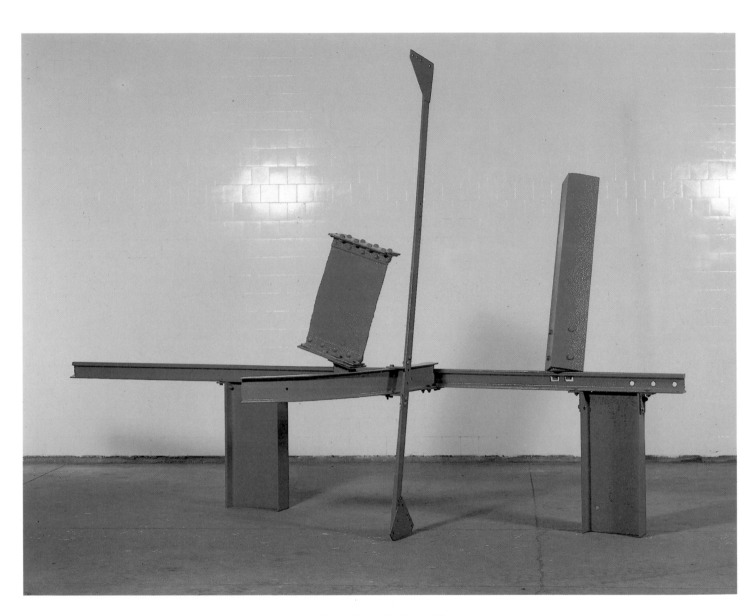

266 Anthony Caro, *Sculpture Three* 1961

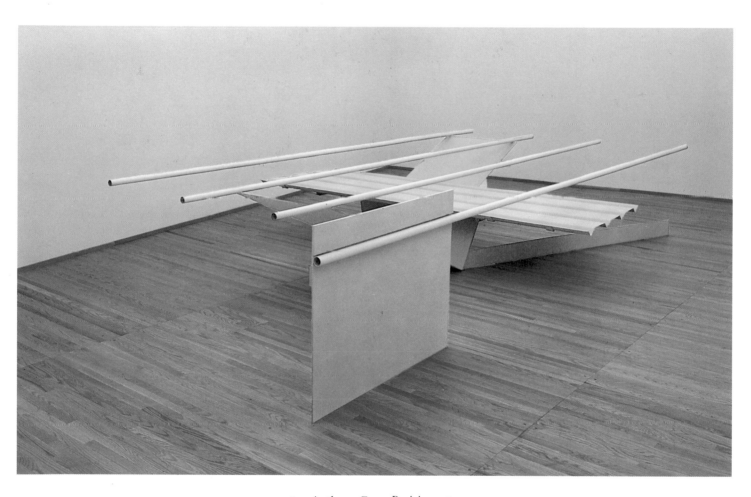

267 Anthony Caro, *Prairie* 1967

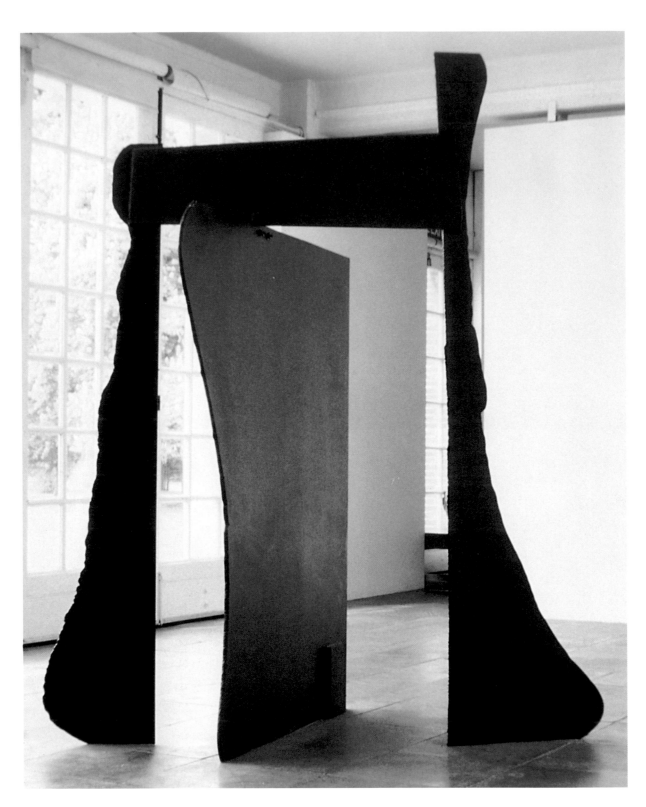

268 Anthony Caro, *Veduggio Sound* 1972-73

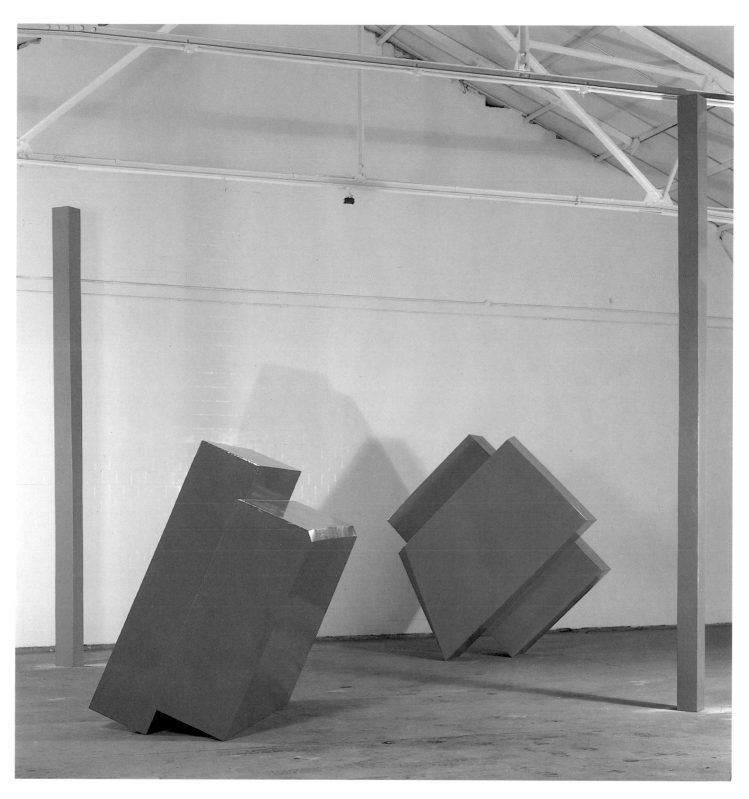

269 Phillip King, *Call* 1967

270 Bridget Riley, *Arrest IV* 1965

271 Bridget Riley, *Vapour* 1970

272 Bob Law, *Bordeaux Black Blue Black* 1977

273 John Hoyland, *17.7.69*

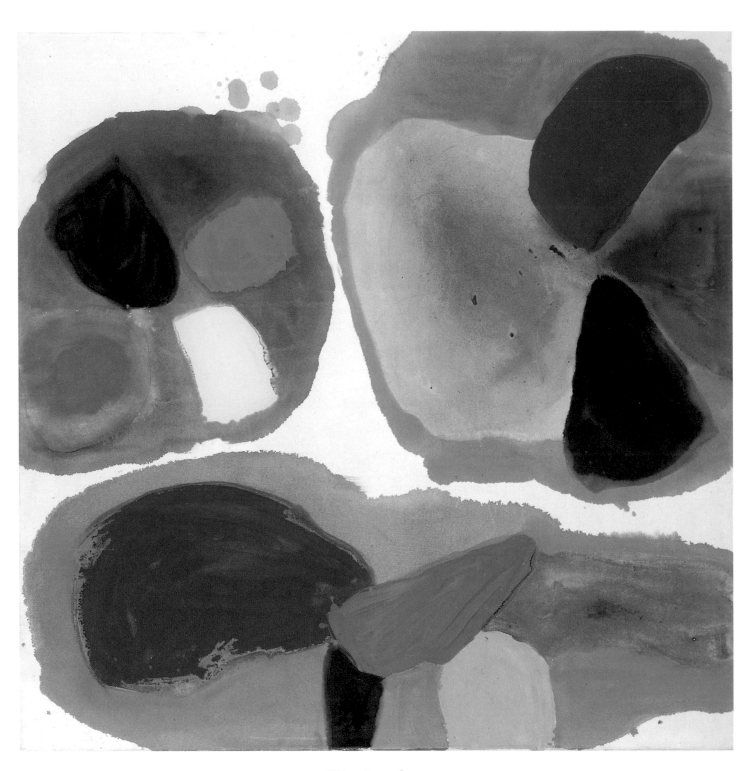

274 Gillian Ayres, *Lure* 1963

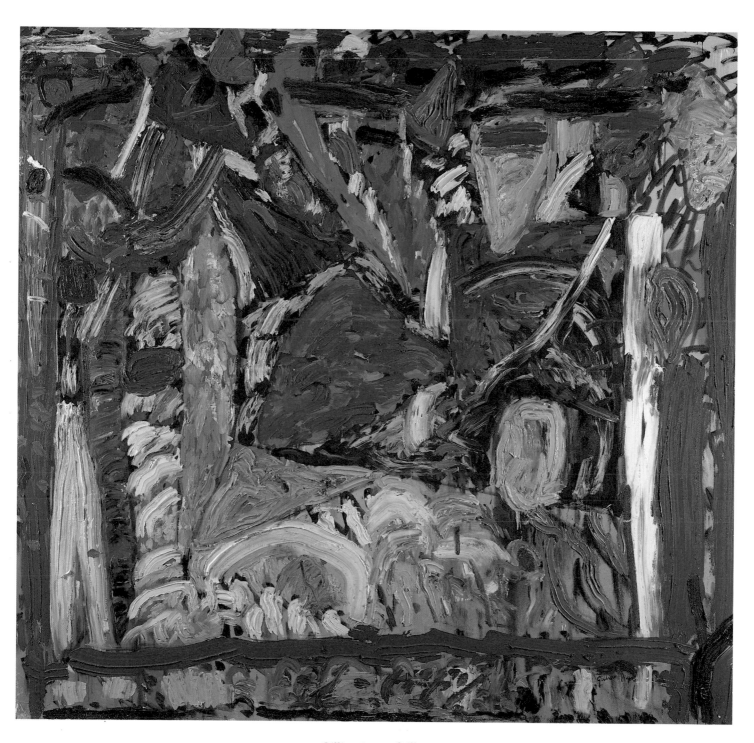

275 Gillian Ayres, *Scilla* 1984

276 John Walker, *Tense II* 1967

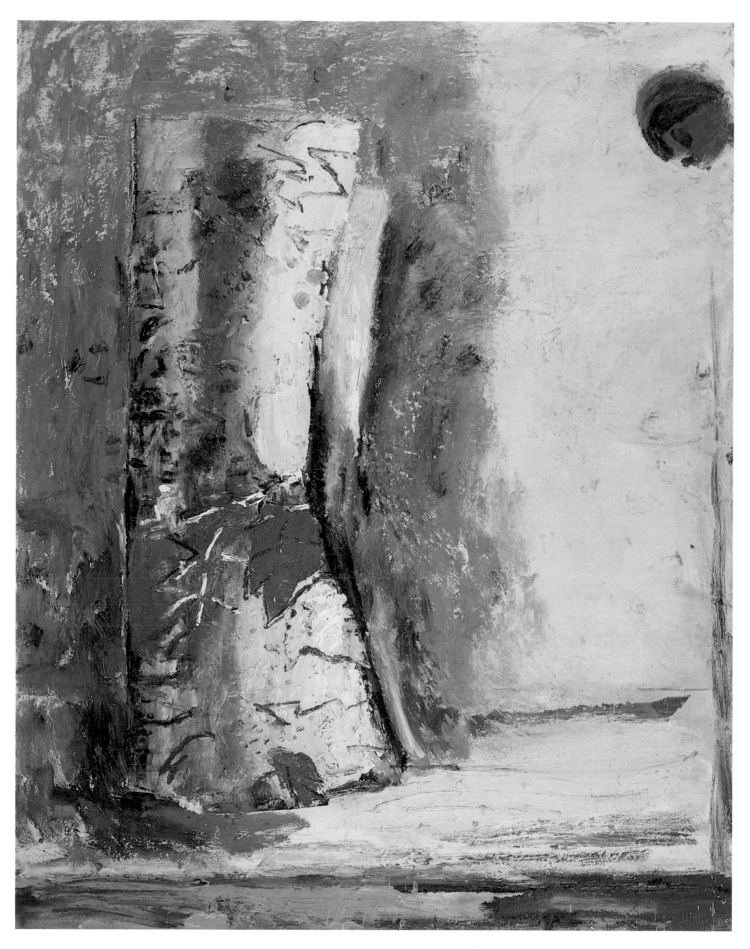

277 John Walker, *Conversation* 1985

Richard Cork

Breaking the Boundaries

As the 1960s gathered pace, a growing number of artists became dissatisfied with the traditional boundaries within which their work was supposed to be confined. The convention that 'art' automatically takes the form of an 'object' was replaced by a more questioning attitude. They maintained that artists had the right to pursue a range of alternatives which did not necessarily culminate in a solid, permanent artefact for sale. They wanted the freedom to experiment with possibilities less bound by mercantile priorities, to stage events and make art that thwarted any attempt to treat it as investment fodder. Rather than see their work disappear into museum storerooms, or even bank vaults, they preferred to stay outside the dealer system and contact an audience beyond the restricted territorial limits of the 'art world'.

There is no doubt about the artist who, more than anyone, deserves to be seen as their forerunner. During the 1950s John Latham came into contact with Gregory and Kohsen's proposal that, in order to overcome the barriers preventing one branch of science from communicating with another, the fundamental unit of the universe should be seen as an event, not an atom. The advantage of establishing such an event-structure was that it set up a system of comparison which cuts across disciplinary boundaries altogether. Everything can be gauged according to the length of its time-base, thereby facilitating a unified view which fights against our tendency to deal with the world in isolated, disconnected fragments. The growing awareness of ecology's importance has shown us all the dangers of pursuing short-term profiteering at the expense of long-term natural resources. Myopic habits of thought, or what Latham more vividly calls our 'Mental Furniture Industry', are to blame for failing to take account of the entirety of events which make up the universe. And books, so often the guardians of that Industry, became a particular focus of attack in his work (Cat. 279, 281). Charred, battered, torn, painted and otherwise defaced, their pages hang down from the surfaces of sizeable wall-reliefs like the remnants of some global conflagration. Latham uses the conventions of painting, sculpture and drawing in order to affirm the importance of cosmological priorities which lie beyond space-based objects. He sees the artist as an Incidental Person capable of standing outside the categories of 'painter' or 'sculptor' and affirming, on behalf of all those people who are confined to fragmented job-roles, a time-based totality.

Elsewhere in this book, I have discussed the work Latham initiated during the 1960s beyond the limits of the gallery, most notably through the Artist Placement Group (see 'The Emancipation of Modern British Sculpture', pp. 31-52). But he was by no means alone in experimenting with new ways of presenting his art to the public. One Sunday afternoon in 1964 Mark Boyle and Joan Hills conducted a group of people down Pottery Lane, London, and ushered them in through a dilapidated back entrance marked 'Theatre'. After walking along a dark corridor, they were invited to sit down on kitchen chairs in front of some blue plush curtains. Instead of unveiling a performance, however, the curtains parted to reveal a shop window, through which the audience found themselves staring into the street beyond. It was a succinct demonstration of Boyle and Hills's determination to examine even the most seemingly mundane aspects of reality with unprejudiced eyes. They soon began work on a project which still absorbs their energies today, an ambitious and extended 'Journey to the Surface of the Earth'. As its title implies, this enterprise is of Jules Verne-like dimensions and aims to make 'multi-sensual presentations of 1,000 sites selected at random from the surface of the earth'. In their eagerness to be as objective as possible, Boyle and Hills cull their source-material from locations chosen for them by blindfolded friends and acquaintances throwing darts at a map of the world. The chance selection process was carried out between August 1968 and July 1969, although the first pieces in the series had been made at Shepherds Bush and Camber Beach in 1966 (Cat. 282).

Boyle and Hills's first loyalty lies with the dignity of the found object, and they have a profound belief in the importance of not tampering with its natural state. They accept and respect what they find, whether it is a patch of snow or a cobbled street, with an equal amount of self-effacing good grace. The organic outcrops of moss sprouting through the cracks in a wall are recorded as faithfully as the mechanical spare parts lodged in the otherwise haphazard tangle of earth and weeds on a stretch of waste ground – the kind of detritus which would be used, for very different purposes, by young sculptors like Tony Cragg in the 1980s.

The exact details of their casting process are kept a secret, for fear of destroying the mystique and encouraging others to imitate their uncanny ability to simulate slices of reality. But at a time when we have become increasingly conscious of the need to regain contact with the natural order, their solid, matter-of-fact commemoration of random phenomena carries with it a sustained demand to look at our surroundings in a more respectful and understanding way.

The human body has not been excluded from their investigations, though they have never regarded it as a central expressive vehicle in their art. Stuart Brisley, by contrast, focused for many years on his own body alone. Dissatisfied with more conventional aspects of the sculptural tradition, he wrote in 1969 that 'in environmental work the public . . . may be exposed to totally unexpected and uncatered-for responses'.

This element of surprise, often developing into dramatic and even shocking confrontation, became a vital element in Brisley's subsequent work. Strongly influenced by the optimistic libertarian politics of the period, he decided to use his own bodily resources as a means of attacking the degradation of the individual by unseen mechanisms of power in society. Rituals were devised, often of extended duration, within which Brisley would subject himself to gruelling tests of endurance. We would prefer to avoid contemplating the privation which the victims in our society are forced to undergo, and the cruel forces that allow such injustices to exist. But Brisley insists on exposing us to the full force of their obscenity, often timing his rituals to coincide with periods of the year or other events which sharpen his meaning.

Throughout the Christmas period in 1978, he inhabited the Acme Gallery and refused to eat. Food, cooked by a professional chef and served with due solemnity, was abandoned on the table untouched. Then, at the end of the tenth day, Brisley crawled through all the mouldering meals before terminating the performance with an evening banquet for himself and his friends. The sense of generating a new attitude from the remains of over-indulgence became, in the end, affirmative. *Survival in Alien Circumstances* (Cat. 283) was equally positive in outcome. Brisley carried it out at the 1977 Kassel Documenta where the American artist Walter de Maria had spent around a quarter of a million pounds of a Texas oil company's money drilling a hole in the ground to a depth of a kilometre. Since both the hole and the 5-centimetre brass rod inserted in it were invisible, the whole project appeared to be nothing more than a disgracefully extravagant whim. I remember understanding

at once why Brisley had decided to dig his own hole nearby as a reaction to this absurd wastefulness. The sobering spectacle of one artist shovelling earth near the Orangerie, and occasionally coming across remains of the devastation caused by wartime bombing, was a corrective to the flagrant profligacy evident elsewhere in the exhibition. After building a wooden structure at the bottom of the hole, Brisley inhabited it over a two-week period, living off his own resources and thereby implying that the excesses of Western society may one day terminate in a calamity which reduces everyone to a rudimentary existence once again.

While Brisley used silence as one of his most potent weapons, speaking only rarely to viewers who otherwise found themselves staring at his bodily exertions, Art & Language addressed themselves to a primarily verbal assessment of 'those fraudulent conceptualisations by means of which normal art was supported and entrenched'. Caustic, garrulous, irreverent and determined to ask each other 'what sort of concept is art?', the members of Art & Language used analytical philosophy to help them examine the discourse underlying cultural production. During the first few years of the group's existence, after it was formed in 1968, Terry Atkinson, David Bainbridge, Michael Baldwin, Charles Harrison, Harold Hurrell and Mel Ramsden played a leading role in its activities. They decided early on that 'conversation, discussion and conceptualism' should become 'their primary practice as art', and they published the outcome of this intense debate in their journal *Art-Language*, the first volume of which appeared in May 1969.

But words were not the only weapons they employed in their critique of 'first-order art'. Filing cabinets were exhibited in galleries, containing indexes filled with the outcome of Art & Language's incessant attempts to talk to each other and learn from their consistent refusal to censor any topic which might come up for discussion. The whole notion of mapping and territorial boundaries was important to them in these first years, and as early as 1967 Atkinson and Baldwin made a monochrome print called *Map to not indicate . . .* (Cat. 287), part of a series which found a visual form for one aspect of their debates. As its title suggests, the map itself only contains two American states, floating in a void where their neighbours should have been. But other areas are listed in a dense block of text beneath, which makes their exclusion from the map all the more provocative. A second in this series of 'bookprints' maps an area of the Pacific Ocean simply by outlining a border within a blank sheet (Cat. 278), which might in another context look like a work by the most extreme of Minimal artists. The work as a whole raises questions about the difference between image and concept, reflecting Art & Language's belief that contemporary art objects – especially of the non-representa-

Cat. 278 Art & Language (Atkinson/Baldwin), *Map of a thirty-six square mile surface area of the Pacific Ocean west of Oahu*, 1967

tional kind – function according to their designation.

Victor Burgin prefers to avoid employing the resources of drawing and painting. Photography is now his principal medium, usually in alliance with texts. But in the late 1960s he concentrated for a while on words alone. While studying at Yale between 1965 and 1967, he encountered American Minimalist sculptors like Robert Morris and Donald Judd. Intrigued by the idea that a sculpture could be simply 'one of the terms in a room, no more important than any of the other terms', he began to question the desirability of making unwieldy objects at all. 'It seemed the only solution to this one was to take it out of the physical court entirely,' he explained in 1972, 'so that you could talk, analogically, about psychological forms, and from there about temporal rather than spatial extension – but of course not positing time as something which exists independently of events.'

Burgin's involvement with the whole process of thinking about seeing led, logically enough, to a series of works that took the form of numbered statements alone. They proposed ways in which readers could construct their own experiences, and the rigorously organized sentences added up to a demanding and complex whole. But Burgin's increasing desire to consider art's purpose within society at large soon led him to combine photographic and written elements in a single work (Cat. 284). Drawing on a framework of semiology, he set about dismantling 'existing communication codes' and recombining them in order to deal with 'the social mediation of the physical world through the agency of signs'. The rhetoric of advertising has provided Burgin with some, but by no means all, of his most potent images, and in 1976 he exhibited 500 copies of a poster-work called *What does possession mean to you?* on street sites in the centre of Newcastle-upon-Tyne. The photo-text works he has produced since then remain an influential force among artists similarly devoted to the dismantling and restructuring of social codes.

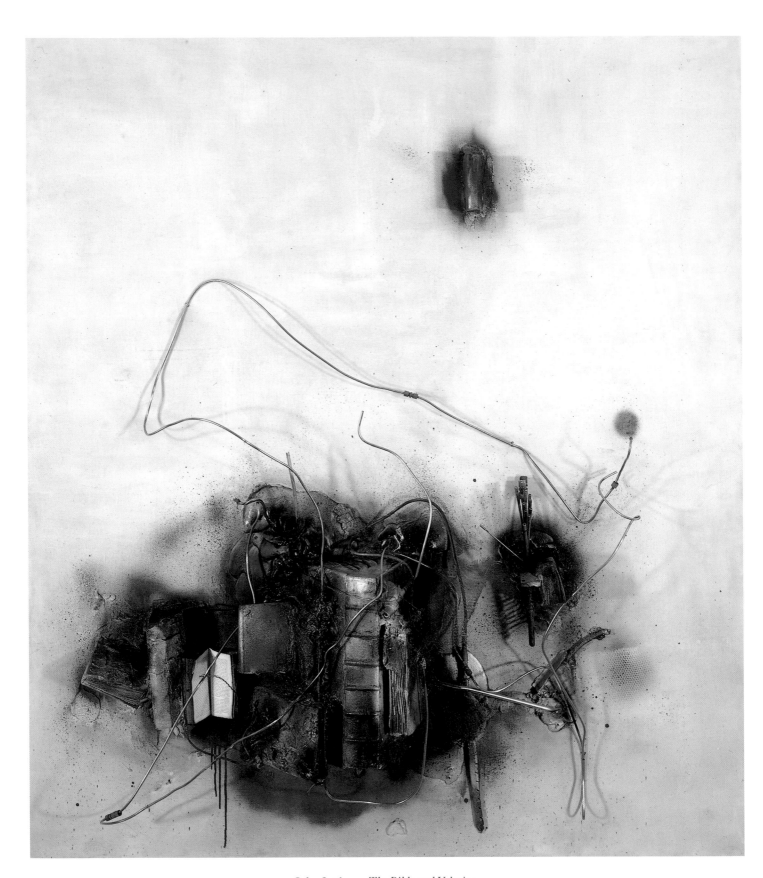

279 John Latham, *The Bible and Voltaire* 1959

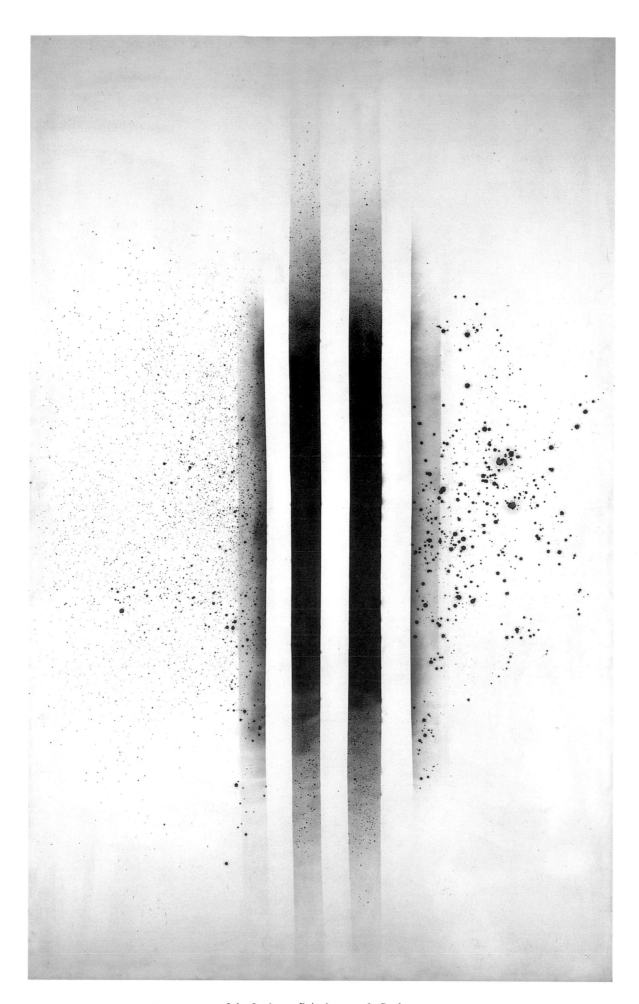

280 John Latham, *Painting out of a Book* 1963

281 John Latham, *Untitled Relief Painting* 1963

282 Mark Boyle and Joan Hills, *Shepherds Bush, London* 1966

283 Stuart Brisley, *Survival in Alien Circumstances, Kassel/London* 1977/81

Sensation

Create a little sensation
Feel the difference that everyone can see
Something you can touch
Property
There's nothing to touch it

ContraDiction

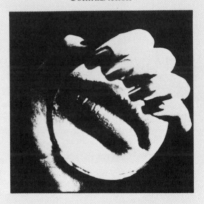

You've got it
You want to keep it
Naturally. That's conservation
It conserves those who can't have it
They don't want to be conserved
Logically, that's contradiction

Logic

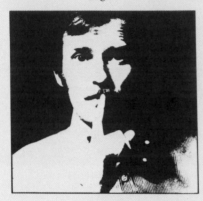

Everything you buy says something about you
Some things you buy say more than you realise
One thing you buy says everything
Property
Either you have it or you don't

284　Victor Burgin, *Sensation*　1975

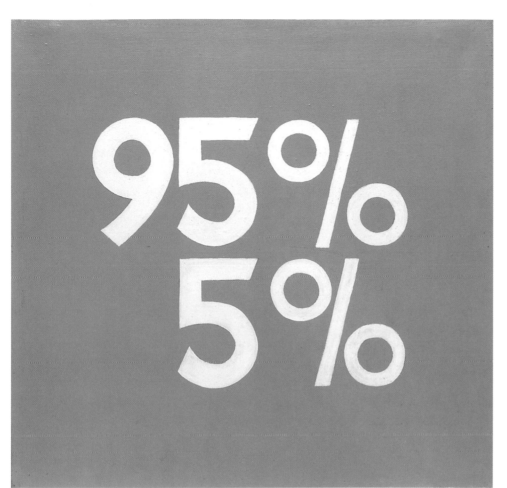

Art & Language (Ramsden)
100% Abstract (95% + 5%)
1968

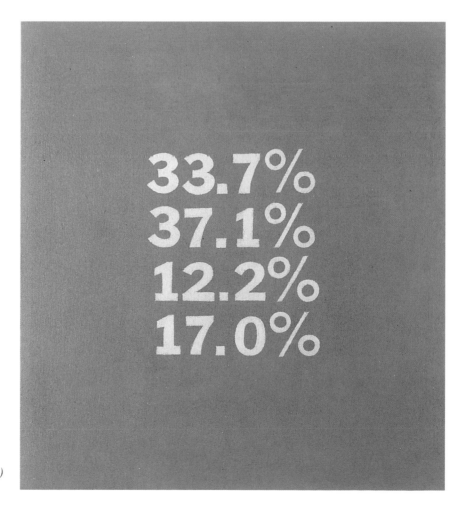

286
Art & Language (Ramsden)
100% Abstract (33.7% + 37.1% + 12.2% + 17%)
1968

Map to not indicate: CANADA, JAMES BAY, ONTARIO, QUEBEC, ST. LAWRENCE RIVER, NEW BRUNSWICK, MANITOBA, AKIMISKI ISLAND, LAKE WINNIPEG, LAKE OF THE WOODS, LAKE NIPIGON, LAKE SUPERIOR, LAKE HURON, LAKE MICHIGAN, LAKE ONTARIO, LAKE ERIE, MAINE, NEW HAMPSHIRE, MASSACHUSETTS, VERMONT, CONNECTICUT, RHODE ISLAND, NEW YORK, NEW JERSEY, PENNSYLVANIA, DELAWARE, MARYLAND, WEST VIRGINIA, VIRGINIA, OHIO, MICHIGAN, WISCONSIN, MINNESOTA, EASTERN BORDERS OF NORTH DAKOTA, SOUTH DAKOTA, NEBRASKA, KANSAS, OKLAHOMA, TEXAS, MISSOURI, ILLINOIS, INDIANA, TENNESSEE, ARKANSAS, LOUISIANA, MISSISSIPPI, ALABAMA, GEORGIA, NORTH CAROLINA, SOUTH CAROLINA, FLORIDA, CUBA, BAHAMAS, ATLANTIC OCEAN, ANDROS ISLANDS, GULF OF MEXICO, STRAITS OF FLORIDA.

287 Art & Language (Atkinson/Baldwin), *Map to not indicate: Canada, James Bay . . . Straits of Florida* 1967

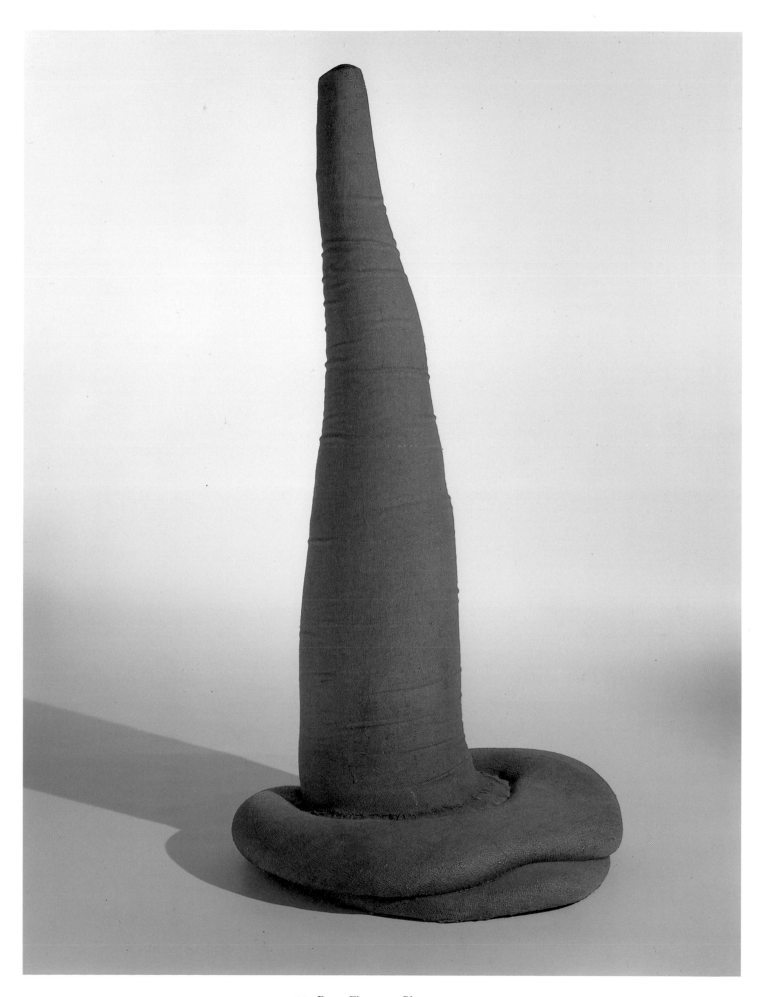

288 Barry Flanagan, *Plant I* 1971

Norman Rosenthal

Three Painters of this Time: Hodgkin, Kitaj and Morley

Howard Hodgkin, R. B. Kitaj and Malcolm Morley were all born within a year of each other, though very little else can be said to link them. They do not form a group and each has a very different slant on both art and life. Each has come through the art of the Sixties with a tangential relationship to Pop Art and Abstract Expressionism to develop an individual and painterly mode of expression: all are now at the height of their powers as artists. They remain individualists, each in his own way making a distinct and powerful contribution to contemporary art, within the tradition of figurative painting. It is their respective early backgrounds which are the determining factors accounting for the different paths their art has taken.

Hodgkin was born in 1932 into a conventional but intellectual English family; the obsessions of his art reflect to a considerable degree an emphasis – epitomized by the Bloomsbury circle – on personal relationships as the central issue of meaning in art and life. Hodgkin's paintings concern themselves precisely with this. Kitaj, born in 1931 in Cleveland, Ohio, has, like any number of American artists and writers – one need only think of Henry James, T. S. Eliot or John Singer Sargent – come to Europe and more specifically to Britain, where they have consciously set out to engage themselves with a European cultural problem. Kitaj's art reflects this. Morley has done just the opposite. Born in 1931 in London in unsettled circumstances, he emigrated to the United States in 1958 and has lived and worked in New York ever since. His is not a tasteful art, nor culturally reflected, but rather direct and violent in its approach to subject-matter in a way that British art (if one may call it that) has not often been since Turner.

The renewed dominance of expressive figurative painting is something that has strongly re-emerged in the 1980s, though Kitaj first postulated the existence of a 'School of London' as early as 1976. As his point of departure, he took that group of painters centred on the outstanding figure of Francis Bacon and including Lucian Freud, Frank Auerbach and Leon Kossoff. All were painters who, against the apparent trends of post-1945 art, persisted in the expressive figurative tradition that appeared to some to be exhausted but which can ever more clearly be seen as the central achievement of post-war British art. That is what this exhibition argues for. But theirs is a painterly and textural achievement not grounded in a sense of brilliant colour. The colours used by Auerbach, Kossoff and Freud are for the most part deliberately restricted in their range. In contrast, the three artists grouped together in this section have each, again in his own way, arrived at a point where it is intensity of colour as much as carefully contrived compositions that conveys the force of their works of art to the spectator.

Hodgkin relies primarily on colour to convey feeling. Sitting uncomfortably between abstraction and precise figurative content, his work is generally small in its dimensions, a smallness and an intimacy which is emphasized by the painted frame. For in a period when painters have very often dispensed with the picture frame – which has traditionally sealed off the pictorial space of the canvas from the wall on which it is hung – Hodgkin has found a new use for the device. He has not been satisfied by the simple border with which many artists have framed their pictures, but has returned to an earlier convention and used an often very wide frame. Since he always paints on wood, he treats his wooden frame as an extension of the picture surface, and in many cases this articulated border gives a natural third dimension to the painting, which becomes a shallow relief. Thus he extends an idea pioneered by the Neo-Impressionists, Seurat and Signac, who were themselves intent on gaining the maximum intensity of colour in their pictures. However, Hodgkin incorporates what even they thought of as a boundary into the picture itself, so easing the transition between the central image and the outside world. Even in relatively large works like *Menswear* (Cat. 291) the frames draw the spectator into an intimate dialogue with the pictures, suggesting a personal encounter.

None of Hodgkin's paintings is easy to read at first glance, though their titles, such as *Interior at Oakwood Court* (Cat. 290), give clues to the moment or place or encounter that the artist is trying to evoke. Apparently spontaneous in their effect, they are none the less in the first place redolent of Kandinsky's *Improvisations* though avoiding any suggestion of cosmic meaning. In addition, they seem to owe much to the world of French painting, to the *Intimisme* of Bonnard and Vuillard, and also to Matisse, with whom Hodgkin has a very strong affinity in both style and subject-matter, confining himself as he does to domestic observation. This observation is of course elusively conveyed, implicitly rather than explicitly. Each painting has a private meaning for the artist, being the encapsulation and reconstruction, often over

a long period, of the transient moment which we, the viewers, cannot share but with which we can only try to achieve empathy. In this way the paintings resemble an exercise in self-analysis; as Hodgkin himself has stated, 'My pictures are finished when the subject comes back and the painting actually becomes a "physical object" that stands for feeling.'

Hodgkin is only satisfied with the work when he feels that his 'subject' has remained intact, in spite of the agitation of the coloured marks with which he obscures the underlying, more open conception. Apparently contradicting his aim to preserve the 'subject', these marks contribute the aura of the particular moment or encounter. Thus the surface of *In the Green Room* (Cat. 289) seems to break out in large, freely applied brushmarks of scintillating orange paint and due to their joyful intensity, the resulting surface gives an impression of freedom. Yet Hodgkin has worked on the picture for at least three years, adjusting the relationship of one section to another. The effect of spontaneity is achieved by controlled and painstaking effort which finally results in a composition which combines logic and sensuality in a unique way.

The emotional charge that Hodgkin's finest paintings have is their strength. They are realizations of a position which the painters of Bloomsbury momentarily aspired towards but did not reach, taking refuge for the most part in a style that avoided engaging with true emotion. Where they failed, Hodgkin succeeds in the careful reconstruction of feeling, through the individual brushstroke, often applied with the concentration of the calligrapher in order to delineate mood, and through the expressive force of colour, often very bright. This represents Hodgkin's significant contribution to the debate on the nature of Expressionism in the Eighties which has in part been so central to recent discussions on art and its possibilities.

To that debate and the power of the painterly surface to convey meaning, Kitaj's work at first seems to be irrelevant. His paintings with their esoteric reference to the large stage of history, literature and art seem designed to be read as intellectual puzzles, the recognition of the cultural milieu being essential to the aesthetic appreciation of the painting. Certainly, early in his career Kitaj was very much part of and contributed to Pop Art, using imagery drawn mainly from high culture in a unique way that alienated many critics and observers to whom *I'm Dreaming of*

a White Christmas (see Cat. 255) seemed more suitable for art at that time. His collage-based early style is represented in this exhibition by An Early Europe (Cat. 258). There he did not reject the discoveries of the Cubists and other early Modern Masters but took what he would from the panorama of fine art and popular art to create his large-scale canvas. Already in An Early Europe he used multiple references, alluding to traditional European art and to recent history, juxtaposed in a composition which shows his mastery of twentieth-century techniques of assemblage. But in the mid-1970s Kitaj consciously rejected this mode in favour of drawing and, ultimately, of creating a new type of composition. This strategy was possibly derived from reflection on the history of art and its greatest European exponents over four centuries to which in his writings and statements he attaches much significance. It was not for nothing that he led the revival of life drawing as a means towards, in his case, an entirely new kind of painterly surface. This is dry but increasingly free, at once Italian – almost recalling the art of the fresco – and at the same time somewhat equivalent to the technique of Balthus.

Early paintings of street scenes by Balthus also seem to be the model for one of Kitaj's most remarkable paintings of recent years, Cecil Court, London W.C.2 (The Refugees) (Cat. 293). Here, collage remains, but as an intellectual rather than practical means of composition. As in much of his early work, there is the evocation of a cultural landscape with a highly charged ambiance. Like his painting The Jewish School of 1980, Cecil Court is an emblem of what, to Kitaj, is of increasing importance, namely his position as a wandering alienated Jew, existing, thinking and working within a spiritually hostile culture. The picture is a representation of the famous alley between Charing Cross Road and St Martin's Lane in London, a bibliophile's paradise, the haunt of refugee book dealers like the legendary Mr Seligman, but also the haunt of the pornographer, who thus finds himself incongruously intertwined with the European intellectual. Both are represented, and in the foreground lies recumbent on a Corbusier reclining couch a self-portrait of the artist. Although he is ostensibly holding up a book, in reality he is meditating on the almost surreal scene that he conjures up in his mind's eye with a sense of near-hysterical madness, as though the street were a kind of theatre. Indeed, Kitaj has referred to the Yiddish theatre described by Kafka as a source for this painting. Almost like a writer, Kitaj has presented a cast of characters – the prostitute stretched across the middle ground of the painting, the book dealer Mr Seligman carrying white flowers and looking like a character by George Grosz, the street sweeper in the background with other strange younger men stretched across the street, looking out of the painting even while retaining some kind of relationship with the girl. Kitaj describes the painting as a shopsign, and indeed, in its subject-matter and even in its technique, it does seem to evoke the great Gersain's Shopsign by Watteau, itself an extraordinary emblem of human activity and social tension.

Amerika (Baseball) (Cat. 294) is also an evocation of an Old Master painting, this time The Boar Hunt by Velazquez in the National Gallery, London. Here Kitaj's obsession with his own Americanness is evident. The baseball players do not apparently connect with each other, being observed again by the artist, who occupies the foreground and is unable – like the wanderer that he is – to join the strange and alienating game that is being played. The dreamlike quality of the scene is emphasized by its brushed painterliness, which paradoxically brings the baseball players back to the surface of the canvas, reducing the effect of distance which is none the less conveyed by the extremely small scale of the figures. This handling also gives an even greater sense of unreality to a scene which, on close inspection, seems to have more to do with the vigour of the chase (suggested by the subject-matter of Velazquez's original) than with sportsmen practising baseball. As if in bewilderment at this America, the artist has placed himself like a donor in a Renaissance altarpiece, in a space half way to that of the spectator, as though unsure of which world he is a part.

The most recent painting shown here is The Jewish Rider (Cat. 292), a monumental portrait of the art historian Michael Podro, seated in a railway carriage astride an imaginary horse. Along the corridor the guard comes threateningly, perhaps to look at the passport of this refugee passenger; outside the window we can see a cross on the mountain (Golgotha) and the chimney often present in Kitaj's recent paintings as the symbol of the Holocaust. All of his recent paintings are imbued with a profound melancholy in spite of their inherent painterliness and rich colour. They are in strong contrast to the artist's earlier collage technique, which had ultimately led him to the avoidance of feeling.

Morley is a very different case, though he does share with Kitaj the distinction of having in his youth run away to sea. Like Kitaj, Morley worked through a hard, in his case, realistic style, analogous to Super Realism – a term that he invented – but gradually, from the early Seventies onwards, he began breaking up his hard-won 'realistic' surface. In so doing he profoundly disturbed the equilibrium of his subject-matter, creating expressive, not to say, often disjointed and deliberately awkward compositions that do nothing if not evoke the constant possibility of mass destruction. This process was again analogous to Kitaj.

It goes, however, without saying that Kitaj and Morley approach the cataclysm from totally opposite directions. The paintings of Morley seem imbued with strong historical qualities that imply the fragmentation of history and nature within the often cataclysmic vision of the artist. It is perhaps not a coincidence that his figures are often drawn from toys, such as the Mexican dolls that threateningly inhabit the desert of Arizonac (Cat. 296). This is a hot wild landscape in which the miniature cowboy at the bottom left of the canvas is helpless before the Indian gods, who like giants bestride the scene. There is an apparent contradiction between the free handling of the landscape, rendered in a myriad of colours applied with freely placed, highly charged brushstrokes, and the realistic depiction of the gods. The 'real' human being (the Indian on his horse) is treated both in scale and rendering as a part of the 'real' landscape, in an expressive manner; in contrast Morley gives the mythical figures the most life-like treatment reminiscent of his own earlier style. Over the years he has begun to tap a richer vein of subject-matter and methods of presentation. In his recent work he has rejected the truth to appearances which had fascinated him in the Sixties and he has allowed the manner of execution to reflect the great variety of levels of meaning – which in turn have partially dictated an appropriate style.

In Macaws, Bengals, with Mullet (Cat. 295) we are presented with an atheistic vision of the universe, devoid of human beings, an earth assembled in three layers and inhabited by fowl, fish and, lying between them, Bengal tigers. The scene is, as it were, below, on and above the earth, which is now ruled by an animal kingdom, as it may have been before (or indeed after) the existence of humankind. Macaws, Bengals, with Mullet is based on a watercolour, a difficult medium of which Morley is an outstanding exponent: one is reminded of studies of fish by Turner, an artist whom Morley reveres and tries to emulate. In this painting he achieves an intensity of expression and imagination that rivals his hero of the last century. The dribbles and spatters of paint are echoed by a variety of coloured trails and marks which enhance the primordial subject with their own vitality.

This freedom of handling finds its fulfilment in the most recent work included here, Seastroke (Cat. 297). This painting marks the most extreme point that Morley has achieved in his work: he acknowledges a debt to Jackson Pollock, both in the unorthodox methods with which that artist handled paint and the new spatial unity that he invented by building up paint layers so that the discrete surfaces of Cubist painting were replaced by integrated skeins of colour. In Pollock's work these methods of execution resulted in canvases with a high degree of pictorial sophistication. The same is true of Morley's Seastroke, which lies on the optical border between abstraction and figurative Expressionism.

The concept of British art in our own century must perforce be a complex one that allows for many contradictions. The twentieth century does not allow, as did the nineteenth, an easy concept of nationality, least of all applied to art. Any story of art must be viewed in some degree as arbitrary, basically allowing a dominant voice to a sense of priority and order. Is, for instance, the School of Paris the real story of French art in our century, given all the outsiders – starting for one with Picasso the émigré? The truth is, of course, that Picasso 'belongs' to French art as much as to the Spanish tradition of which he is undoubtedly a part. It is in this sense that one must argue for the inherent British-

ness – each in his own way – of Kitaj and Morley.

Morley took a risk and removed himself to the centre of creative activity, New York, the Paris of the post-war art world. Although other British artists have been to New York and have worked there for considerable periods, none has perhaps done so as consequentially as Morley. Yet his work, for all its individuality, can also be seen to belong to the history of British art. His vision of horror finds its precedent in the work of Bacon, a vision which – like Morley's – is translated into the language of paint. This makes the art of both men equally disturbing, and argues greatly against those who find British art too

polite by half. The dreams of Kitaj are also profoundly disturbing for those who care to look inside them, threatening as they do the return of a new holocaust.

In spite of the fact that the work of Hodgkin presents a very different set of priorities from that of Kitaj and Morley, for it is more personal, more private, it is equally passionate and has its own sense of transience and mutability. Each of these three artists has an innate colour sense; each has invented a private iconography that must be recognized before their paintings will reveal more than a surface meaning. Their work is fully possessed of that fearful quality which is the mark of the finest Expressionist art.

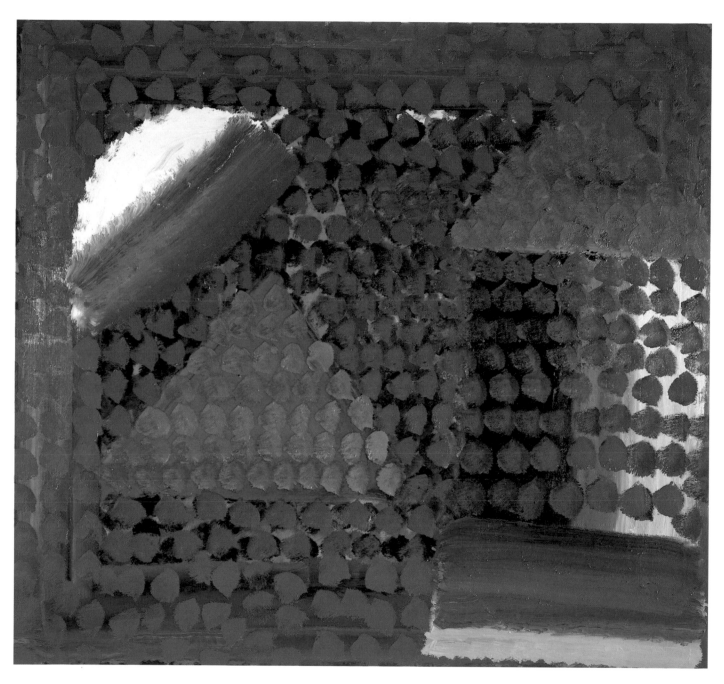

289 Howard Hodgkin, *In the Green Room* 1984-86

290 Howard Hodgkin, *Interior at Oakwood Court* 1978

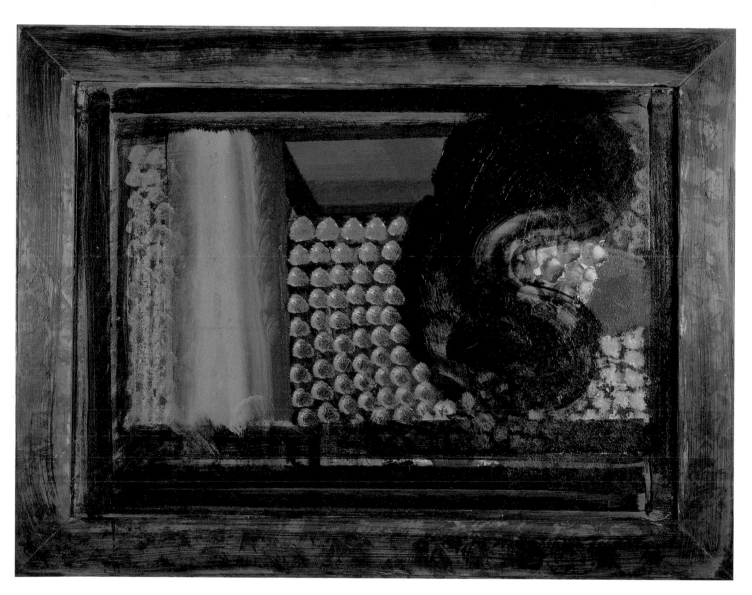

291 Howard Hodgkin, *Menswear* 1980-85

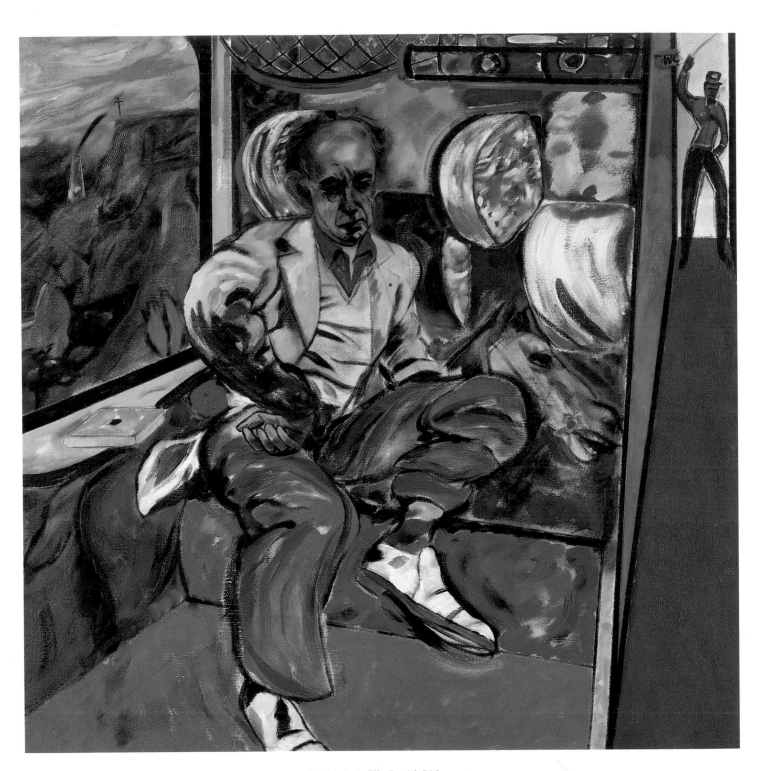

292 R.B. Kitaj, *The Jewish Rider* 1984

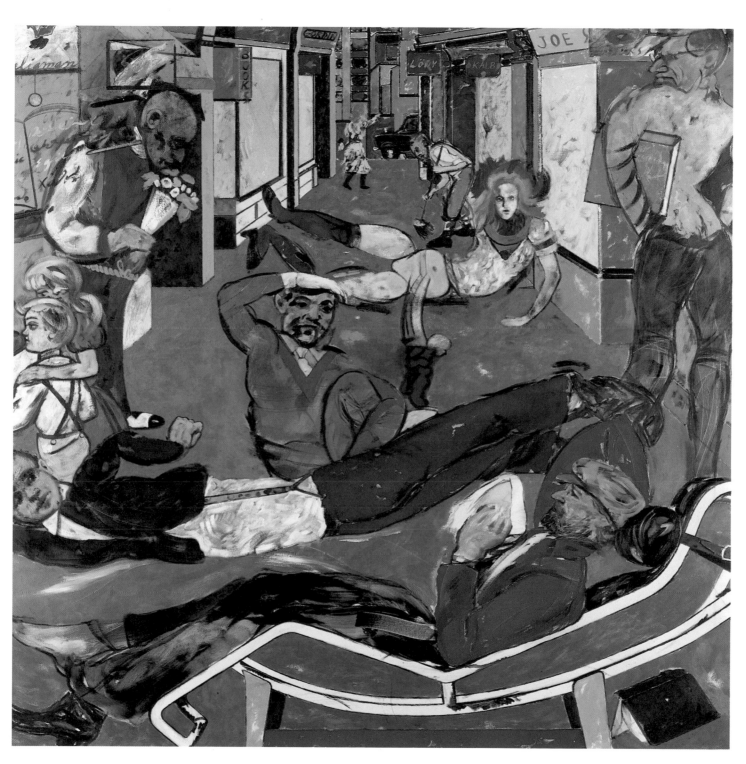

293 R.B. Kitaj, *Cecil Court W.C. 2 (The Refugees)* 1983-84

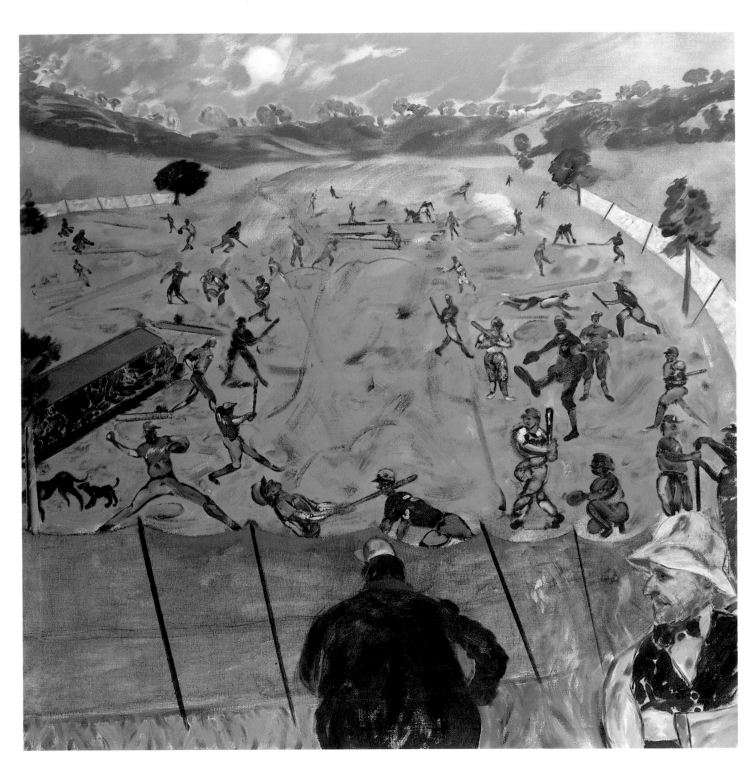

294 R.B. Kitaj, *Amerika (Baseball)* 1983-84

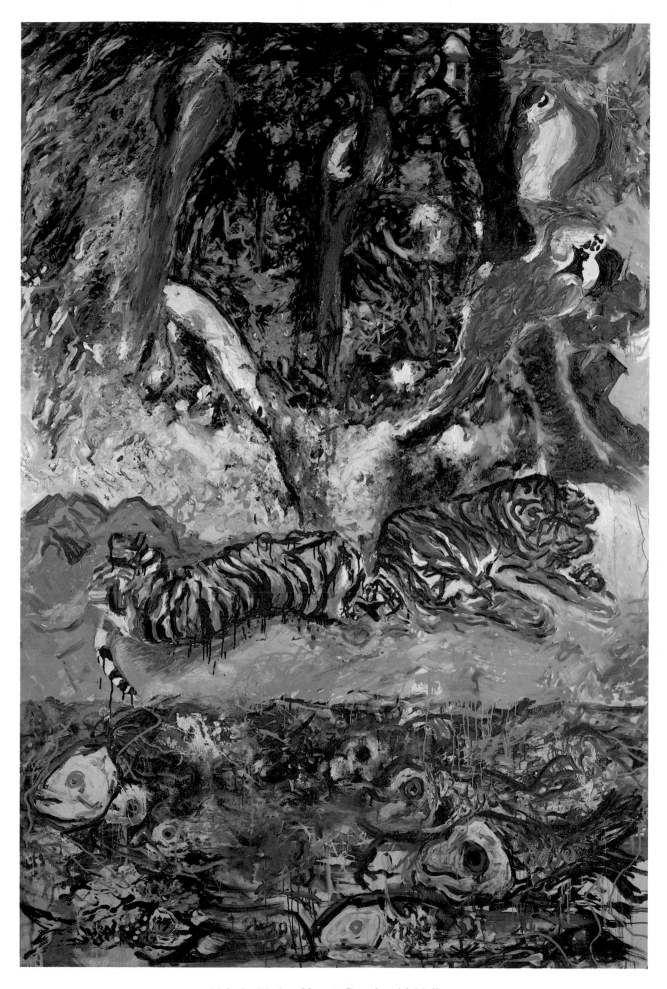

295 Malcolm Morley, *Macaws, Bengals, with Mullet* 1982

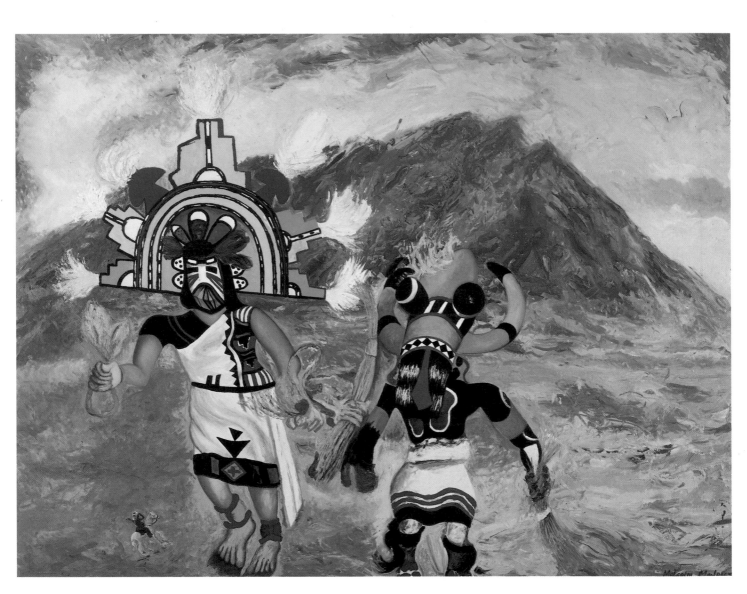

296 Malcolm Morley, *Arizonac* 1981

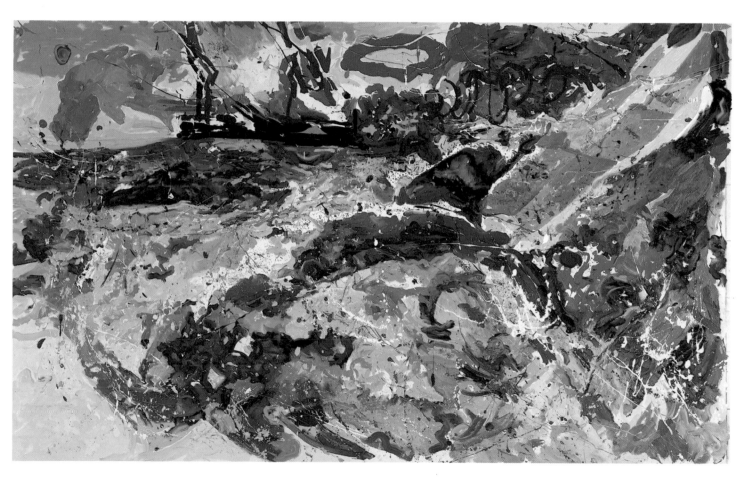

297　Malcolm Morley, *Seastroke*　1986

Richard Cork

The Seventies and After

All the artists discussed here in this final section had established their identities by the early 1970s. They began working, a few years before, by questioning and even subverting the most powerful Modernist orthodoxy of the time. At St Martin's School of Art, where they studied, sculpture was a particular focus for debate, and in their very individual ways Barry Flanagan, Gilbert & George, Richard Long and Bruce McLean reacted against the so-called 'New Generation' work of their seniors. In 'The Emancipation of Modern British Sculpture' (see pp. 46-52), I have discussed the various forms taken by their fruitful dissent, but in subsequent years all these artists have moved far beyond a desire to challenge the precepts upheld by their teachers. Some of them, while retaining an involvement with the sculptural tradition, have gone on to employ materials and strategies which can no longer be encompassed by the term 'sculpture' at all. Others have returned to the oldest forms of sculptural expression, and discover their continuing viability in a present-day context which welcomes the re-examination of traditional sources of inspiration.

Gilbert & George, after leaving behind their versatile early experiments with sculptural propositions of the most audacious kind (see Fig. 30, p. 50), decided to concentrate on photo-pieces in subsequent work. Continuing to use images of themselves as indispensable elements, they have developed an increasingly elaborate, ambitious and outspoken art. Relying on their own photographs rather than ready-made material culled from magazines or newspapers, Gilbert & George moved from relatively straightforward black-and-white work in the early 1970s towards sumptuous, multicoloured images of often colossal dimensions. Alongside this dramatic expansion in scale and palette, they have managed to enlarge the scope of their vision as well. In the first half of the 1970s Gilbert & George were almost wholly absorbed with their own interior world: the two familiar figures were seen in the context of the East London house they inhabit, enclosed by its panelled walls and often oppressed by 'bad thoughts' and 'dead boards'. During the latter half of the decade, though, they began to direct their attention beyond these claustrophobic limits. The street life in their neighbourhood penetrated the work, filling it with faces, buildings, crowds and – most provocatively of all – the graffiti they found scrawled on walls or windows (Cat. 302-305).

Gilbert & George retained their presence in these powerful, multi-part images, but by now their interrelationship with the people, statuary and architecture of London by day and night was stressed. It is, for the most part, a clangorous and jarring spectacle. Gilbert & George focus on images of anger, destruction and acute loneliness. Using a combination of dramatically lit monochrome and fiery red dye, they contemplate the alienation of a world where alcoholics sprawl by the roadside while the impersonal façades of gleaming office-blocks loom over the city's inhabitants. At once detached from the life they survey and engrossed by its teeming diversity, the observant pair create altarpieces emblazoned with the frieze-like objects of their ardent scrutiny.

Surrounded by images drawn in particular from the poor, multi-racial East End area, Gilbert & George manage to confront some of the mounting tension, prejudice and aggression in British society which finally erupted in the street violence of 1981. Their thoughtful, resigned faces preside over these huge composites of modern urban life. Gradually, as policemen appear, insults are exchanged, and teenagers looking for trouble at a time of high unemployment line up to stare brazenly out at the viewer. It is possible to sense the fear and frustration of deprived inner-city life. Gilbert & George meditate on these troubled scenes, sometimes identifying with the outcasts and delinquents they study, and sometimes stressing their aloof detachment. The separate elements of the photo-pieces are bunched together in vast, compact blocks, so that the thin black frames around each image assume the structure of a severe grid stamped over the seething unrest the artists survey. Having started their career as artists with nothing but themselves in their work, they have now discovered that dreams underneath the arches can grow into nightmares which involve not just Gilbert & George but the rest of humanity as well.

Although Gilbert & George have elsewhere employed images from the natural world, they view these outsize flowers and trees from the vantage point of confirmed city-dwellers. Richard Long, on the other hand, is thoroughly at home in the countryside and regards it as the only territory worth exploring. References to urban life cannot be found in his work, apart from the names of towns and cities glimpsed occasionally on his map pieces. But he is aware that rural areas should not be considered in isolation from the places where most of us live, and once

emphasized that 'the natural world sustains the industrial world'.

It certainly sustains Long, who has always taken his fundamental inspiration from the earth's surface. An ecological conscience underpins his consistent determination to 'use the world as I find it', and he remains content to take his cue from the existing character of the land rather than arrogantly transforming it in accordance with his own presumptuous designs. So although Long's art remains highly personal, stemming above all from the exercise of 'my senses, my instinct, my own scale and my own physical commitment', it is subtly understated. His desire to arrive at a harmonious fusion of the earth and his discreet yet decisive mark-making mean that he is even prepared to accept the inevitable transience of his outdoor sculptures.

The photographs taken by Long justify their role as intermediaries between the work and its audience by recording the appearance of pieces that are bound to change with the passing of time (see Fig. 27, p. 47). They preserve the identity of a beach sculpture, as subject as flotsam from the sea around it to destruction by the incoming tide; the lines formed by cutting paths through a field of daisies, doomed to disappear as soon as the daisies themselves die; and the patterns created by Long's feet walking among cattle-tracks, all of which will be erased either by succeeding herds or by the action of wind and rain. He is equally content to expend a great deal of thought and energy making ephemeral installations for galleries, like the hand-executed mud work carried out on the wall especially for the Royal Academy show. As monumental in dimensions as some of his outdoor sculptures (Cat. 301), and made with the same directness and economy of touch, it will last only as long as the duration of the exhibition.

But Long's contribution to British art is substantial and enduring. He uses maps, words, photographs and stones with the utmost limpidity, knowing as well as the writer of a Japanese *haiku* that the most sparing elements can often convey the most powerful emotions. The lines which trace the course of his walks on ordnance survey sheets, or the primal forms assumed by his sculpture in gallery and countryside alike, make no inordinate demands on the spectator's intelligence and do not require any specialized knowledge. The work that he makes, however, ends up by radically extending the tradition of landscape art. For

Long views the countryside as an inexhaustible source of wonder which can only be fully savoured by the committed traveller.

Most artists who concentrate on landscapes subscribe to the notion that their subjects should be viewed from a single, fixed position. Although they may have wandered miles in order to reach their chosen site, no hint of journeying can be found in the images they finally produce. Behaving more like spectators than explorers, they admire the prospect from a suitable distance and would not dream of regarding it as a terrain to be traversed. But Long has never been content with such a static role. To him, a landscape is above all something worth walking across. Only thus can he make the discoveries which fire him, and so the act of travelling is placed at the very centre of his work. On his trips Long cuts himself off from all avoidable contact with other people, so that he can regain at least a semblance of the relationship humanity used to have with the earth. Undistracted by anything except the fundamental elements of the land itself, he becomes alert to the possibilities inherent in the simplest materials that he encounters. The value of such an attitude, especially at a time when the abuse of our natural resources still continues apace, hardly needs to be stressed. Now that Western societies have become so divorced from the natural world, we need his restorative art more urgently than ever.

Bruce McLean is likewise at home on an epic scale. Ever since he began performing with Nice Style (see Fig. 1, p. 84, and 'The Emancipation of Modern British Sculpture', pp. 48-49), he has felt at home in an arena as ample as a stage. For all his willingness to cock a snook at art-world fashions and deflate pretentiousness, McLean harbours serious ambitions which lead him towards the demanding goal of the *Gesamtkunstwerk*. His performances may have become less frequent in recent years, but they are usually conceived as colossal spectacles involving collaboration with other artists, performers, composers and musicians. In September 1986, for example, he worked with David Ward and Gavin Bryars on an arresting performance called *A Song for the North*, staged in Albert Dock at Liverpool with the help of local musicians and technicians.

When McLean committed himself to painting in the latter half of the 1970s, the imagery he explored was intimately related to the concerns evident in his performance work. He began working with deceptive ease on enormous sheets of paper. Huge mask-like faces are often juxtaposed with diminutive figures, as McLean jumps with dizzying rapidity from gigantism to a vision of humans at their most vulnerable. Outrageous humour is never very far away, and he clearly relishes the absurdity of the figures who struggle, often unsuccessfully, to retain their balance in a world filled with obstacles, pitfalls and menacing structures. But McLean's work also conveys an apprehension of the essential fragility of these figures, who gesticulate and contort their limbs in order to assert themselves against forces that might otherwise overwhelm them altogether (Cat. 308, 309).

McLean has been energetic and resourceful enough to turn his attention to stone sculpture on a monumental scale in recent years. At first glance these rough-hewn works might seem as imposing as the sculpture that he used to satirize in his muscle-flexing, convoluted pose-on-plinth pieces (see Fig. 29, p. 48). But the more we examine these carvings, the less agonized and ponderous they become. One battered lump of Derby stone, with apparently explosive gestures, is entitled *Reclining Figure with Cheese*. Another, showing three heads labouring under the weight of a vast slab, punctures any tragic meaning it might have conveyed: one of the heads has fallen over sideways, as if bored and fatigued by the task of carrying such a burden. McLean's sly, anti-heroic attitude is still there in the sculpture, and his debunking sense of humour is never very far away.

Barry Flanagan's humour is more gentle, in some respects akin to the impishness of Henri Gaudier-Brzeska whose sculpture he admired in an exhibition held at Bristol City Art Gallery in 1959. Like Gaudier, he feels an instinctive affinity with animals as well as humans, and Flanagan also shares Gaudier's delight in moving from one set of concerns to another with athletic rapidity. After exploring the possibilities of unconventional materials like sand, polystyrene, rope and light in his early work (see 'The Emancipation of Modern British Sculpture' and Cat. 288), he began to look at traditional modes of sculptural production. Working with marble, stone and subsequently bronze, in attentive collaboration with the expertise on offer at quarries and foundries, Flanagan deliberately returned to the origins of sculptural expression. Many of his carvings from the mid-1970s resemble prehistoric sculpture, and his readiness to honour the identity and texture of the stone meant that his own manipulation of the material was kept at a minimum. Marble assumed the form of fossils, while a lump of Hornton stone contained references to the archetypal *Venus of Willendorf*.

Flanagan avoided the dangers of pastiche by reserving the right to combine these materials in aggregates as surprising, in their way, as his earlier sculpture. In *Ubu of Arabia* he employed stone, acrylic and canvas in a quirky homage to the continuing inspiration of Alfred Jarry. Moreover, the bases of his sculpture often took a more ordered and geometric form than the organic and relatively rough-hewn images they support. At the same time as he pursued these investigations into sculptural tradition, Flanagan also made large-scale semi-abstract works in more contemporary materials like mild and sheet steel. But his involvement with figurative sculpture remained strong enough for him to model a bronze head of Paul Potts and exhibit it at the 1981 Royal Academy Summer Exhibition.

Tradition and innovation run hand in hand throughout Flanagan's current work, giving it enormous freshness and supple complexity of meaning. Sometimes he explores a moment of sudden violence, as in the bronze *Soprano* (Cat. 307) pierced by a gilded arrow. The title of the work implies, however, that even in painful death a note of paradoxical beauty can be sounded, and his most impressive sculptures of the past decade manage to embrace destruction and celebration in equal measure. In his *Elephant* (Cat. 306) he catches the mighty beast at an inopportune moment, perhaps tamed by the ringmaster of some circus and forced to balance on a man-made ball. The traditional role of the elephant as a 'king of the jungle', who trumpets his defiance of his animal foes, is emasculated by man, who subjugates and reduces him to an object for his own amusement. Flanagan can be seen here as making a comment on the relationship of humans and animals, with the fullest implications of irony. He chooses animals with the greatest regard for the multiplicity of nuances which the image can convey.

This is nowhere more felicitous than in his choice of the hare. His extended sequence of 'hare' sculptures exemplifies this infectious optimism, rising phoenix-like from a bell or leaping effortlessly across any barriers placed in their path (Cat. 310). The hares embody an exhilarating sense of hope, and at the same time celebrate the spirit of renewal which has flowed back from 'alternative developments' to charge work by the younger British sculptors of the 1980s with so much inventiveness and vitality.

WIND STONES

LONG POINTED STONES

SCATTERED ALONG A 15 DAY WALK IN LAPPLAND
207 STONES TURNED TO POINT INTO THE WIND

1985

MISSISSIPPI RIVER DRIFTWOOD

A THOUSAND PIECES OF DRIFTWOOD
PLACED FOLLOWING THE WATERLINE
AND ALONG THE WALKING LINE

MYRTLE GROVE WEST POINTE-A-LA-HACHE DIAMOND
PORT SULPHUR NAIRN TROPICAL BEND
EMPIRE BURAS TRIUMPH BOOTHVILLE
VENICE THE JUMP TIDEWATER CAMP

THE MISSISSIPPI DELTA LOUISIANA 1981

FROM TREE TO TREE

PALM
CRAB APPLE 3 MILES
OAK 9 MILES
SCOTS PINE 15 MILES
HAWTHORN 22 MILES
WILLOW 29 MILES
HORSE CHESTNUT 33 MILES
LAUREL 45 MILES
HOLLY 53 MILES
ASH 58 MILES
YEW 60 MILES
COPPER BEECH 62 MILES
CEDAR OF LEBANON 70 MILES
SYCAMORE 71 MILES
REDWOOD 80 MILES

A WALK IN AVON
ENGLAND 1986

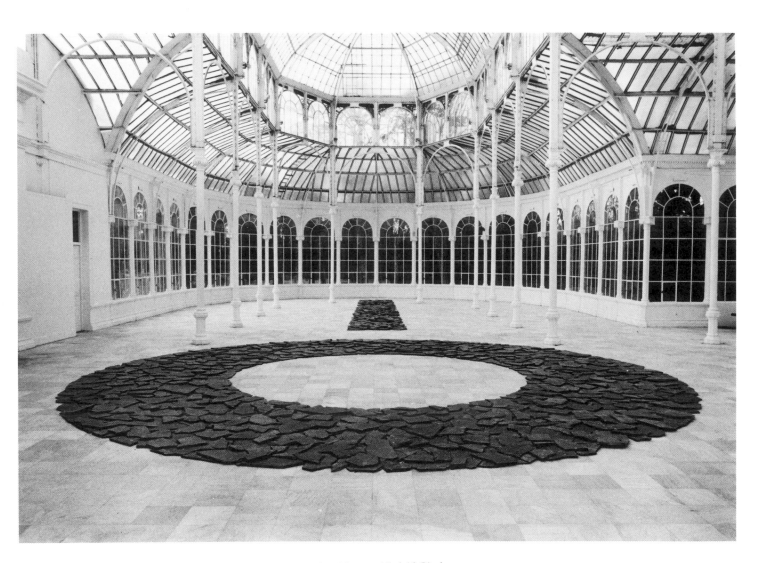

300 Richard Long, *Madrid Circle* 1986

301 Richard Long, *A Line in Ireland* 1974

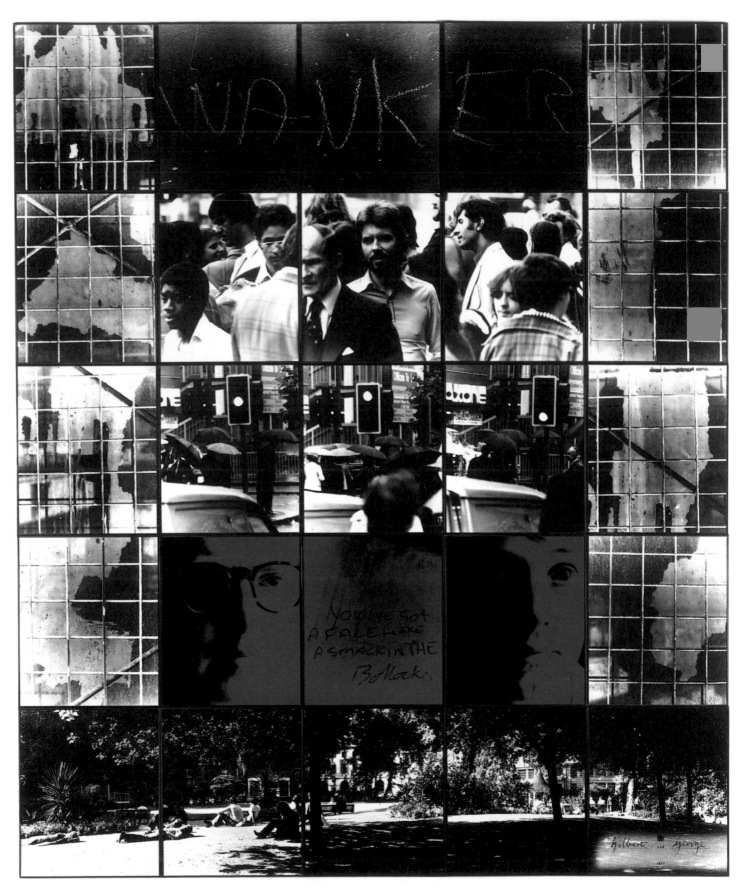

302 Gilbert & George, *Wanker* 1977

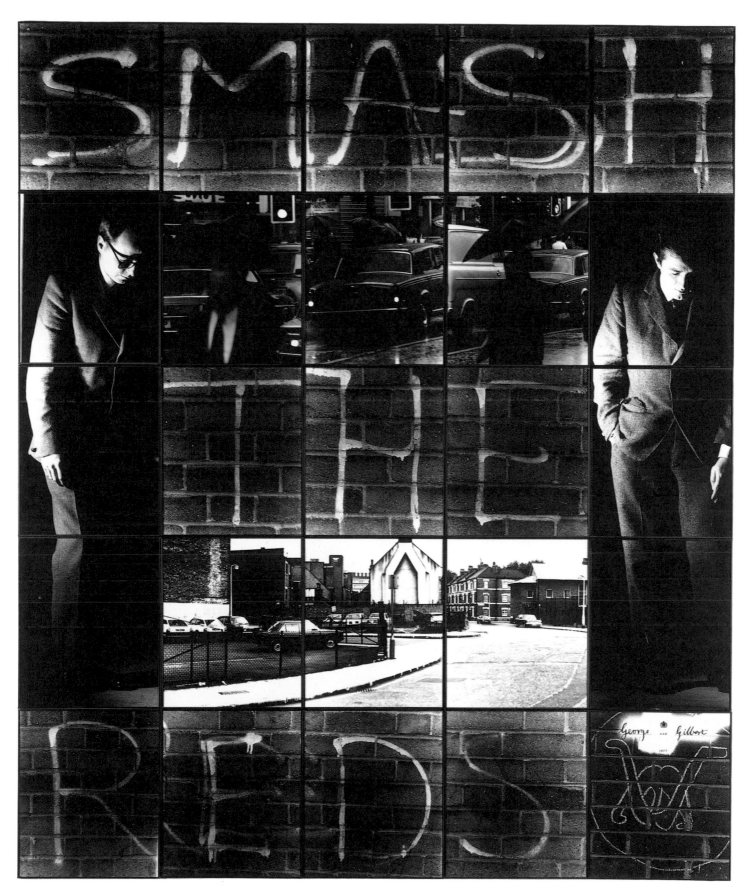

303 Gilbert & George, *Smash the Reds* 1977

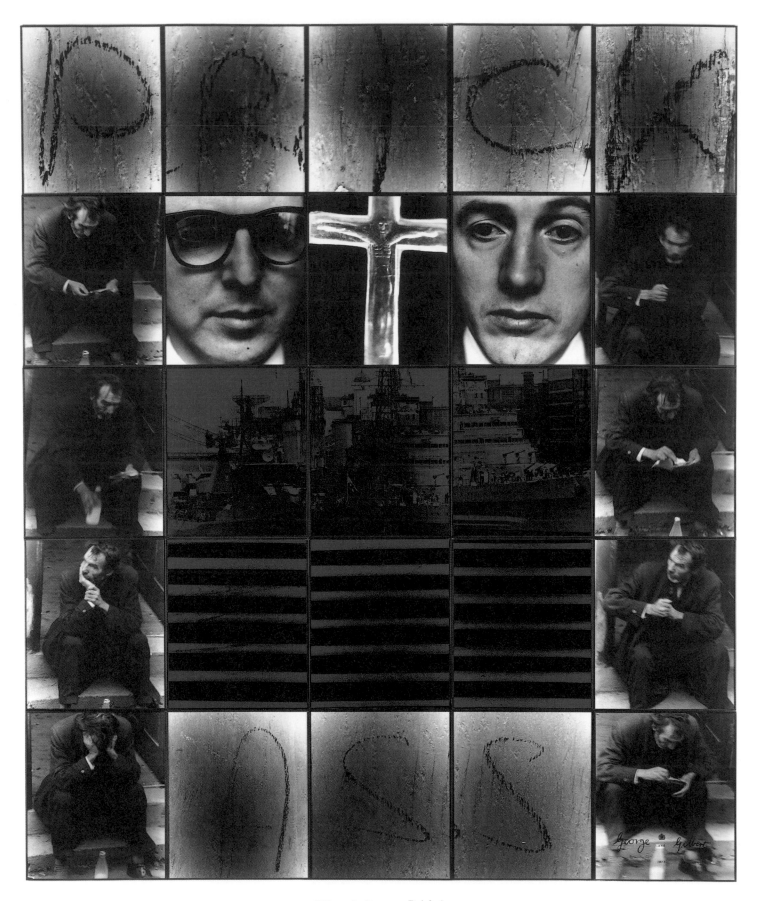

304 Gilbert & George, *Prick Ass* 1977

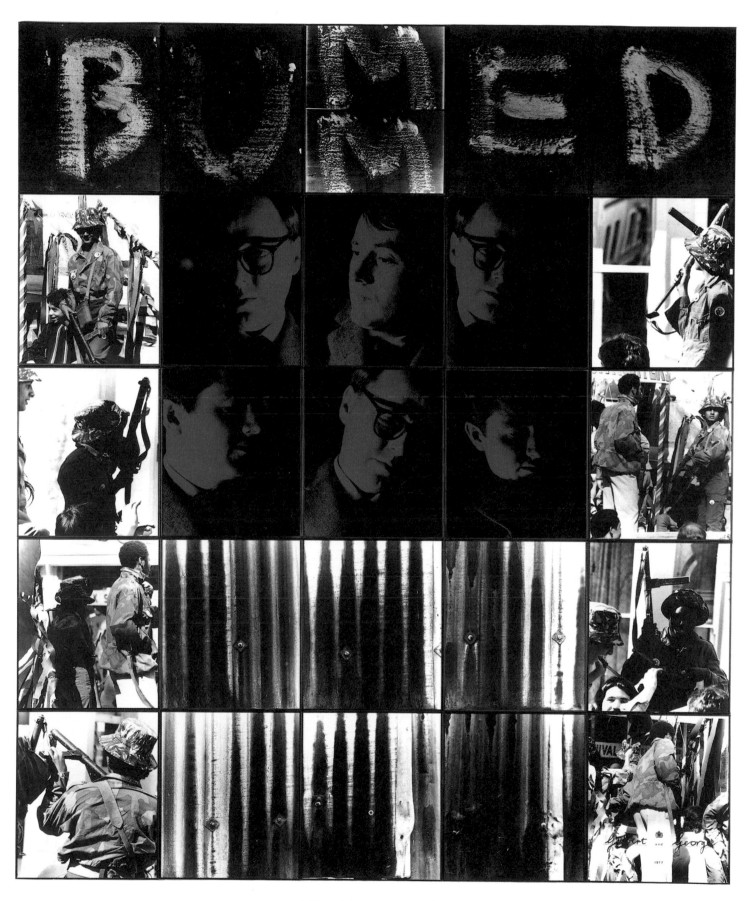

305 Gilbert & George, *Bummed* 1977

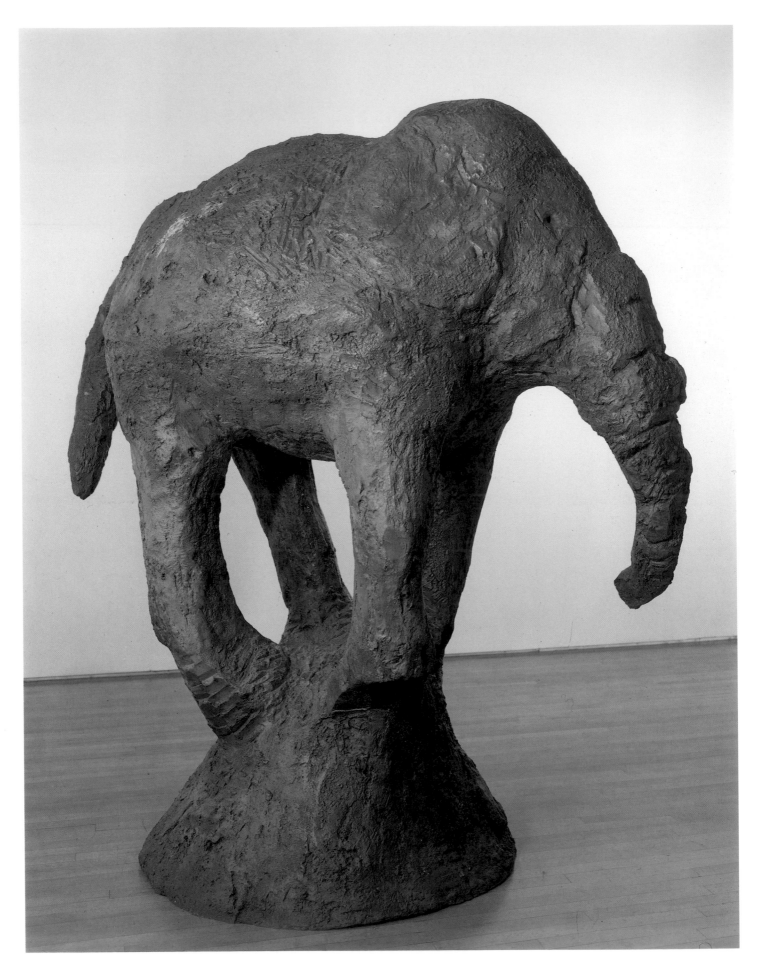

306 Barry Flanagan, *Elephant* 1986

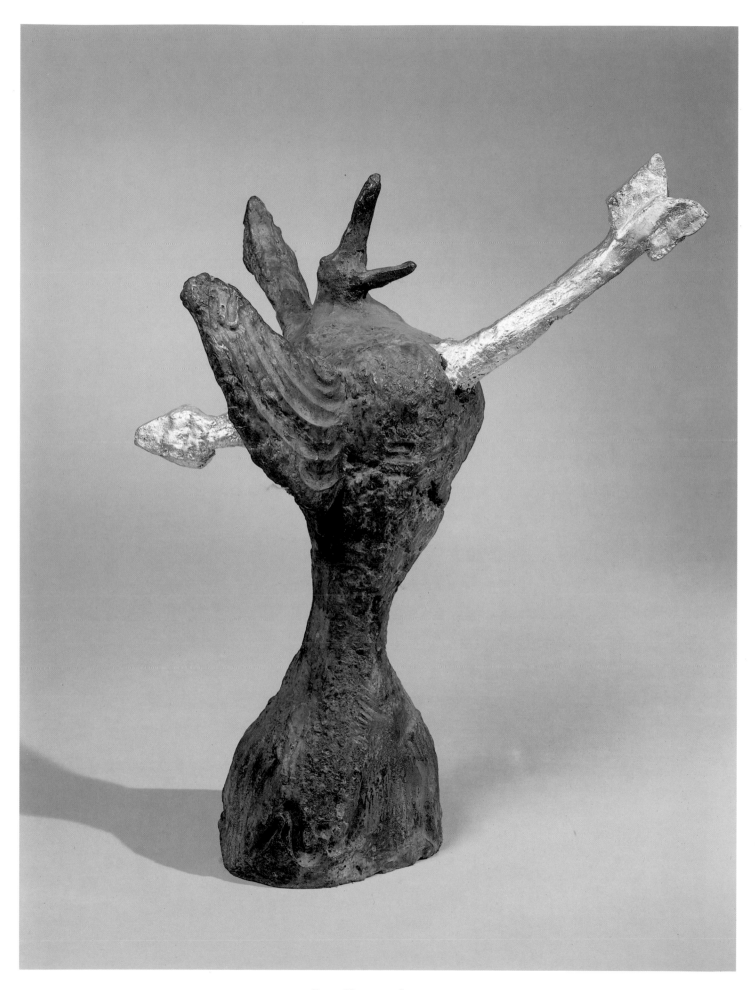

307 Barry Flanagan, *Soprano* 1981

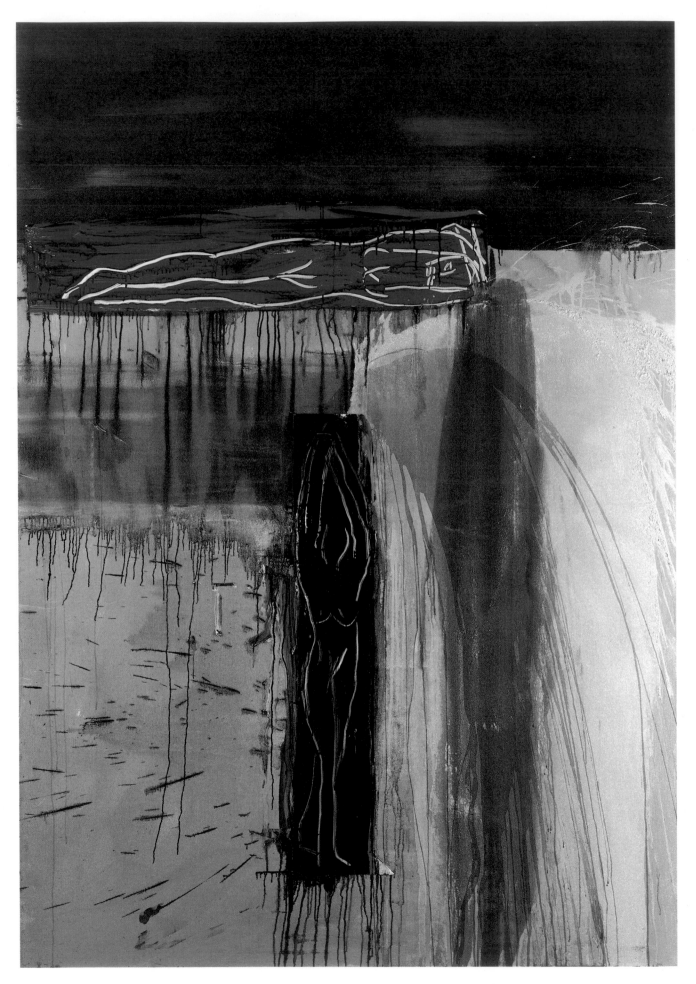

308 Bruce McLean, *Untitled* 1986

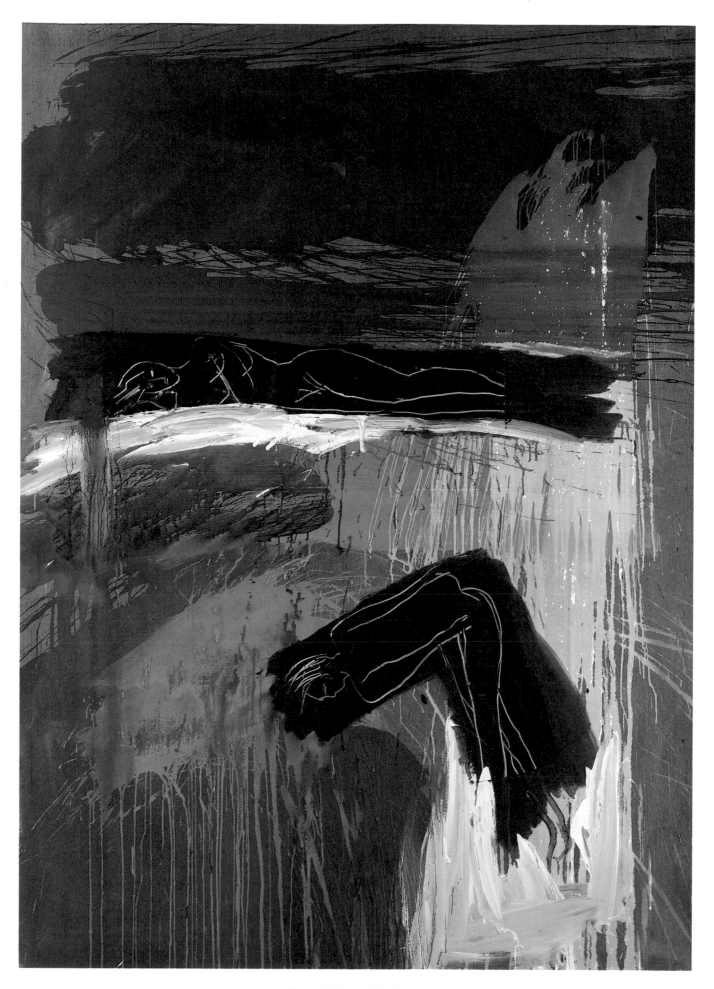

309 Bruce McLean, *Untitled* 1986

310 Barry Flanagan, *Leaping Hare* 1980

List of Works in the Exhibition

Walter Richard Sickert
1 *The Bathers, Dieppe* 1902
Oil on canvas, 131.5 x 104.4 cm
National Museums and Art Galleries on
Merseyside, Walker Art Gallery

Walter Richard Sickert
2 *Mornington Crescent Nude* c. 1907
Oil on canvas, 45.7 x 50.8 cm
Mrs Philippa Hill

Walter Richard Sickert
3 *The Studio. The Painting of a Nude*
c. 1911-12
Oil on canvas, 75 x 49.5 cm
Collection of the late Morton H. Sands

Walter Richard Sickert
4 *Noctes Ambrosianae* 1906
Oil on canvas, 63.5 x 76.2 cm
Nottingham Castle Museum

Walter Richard Sickert
5 *The Brighton Pierrots* 1915
Oil on canvas, 62.2 x 75 cm
Collection of the late Morton H. Sands

Walter Richard Sickert
6 *The Mantelpiece* c. 1911-12
Oil on canvas, 76.2 x 50.8 cm
Southampton Art Gallery

Walter Richard Sickert
7 *The New Bedford* c. 1915-16
Tempera and oil on canvas,
185.5 x 72.4 cm
Leeds City Art Galleries

Spencer Gore
8 *The Alhambra* 1908
Oil on canvas, 51 x 61 cm
Private Collection

Spencer Gore
9 *Crofts Lane, Letchworth* 1912
Oil on canvas, 61 x 66 cm
Private Collection

Spencer Gore
10 *Sunset, Letchworth, with Man and a
Dog* 1912
Oil on canvas, 50 x 60 cm
Private Collection

Spencer Gore
11 *Letchworth Station* 1912
Oil on canvas, 63.2 x 76.2 cm
National Railway Museum, York

Spencer Gore
12 *Harold Gilman's House, Letchworth* 1912
Oil on canvas, 63.5 x 76 cm
Leicestershire Museums and Art
Galleries, Leicester

Harold Gilman
13 *Norwegian Street Scene (Kirkegatan
Flekkefjord)* 1913
Oil on canvas, 50 x 61 cm
Private Collection

Harold Gilman
14 *The Model, Reclining Nude* 1911-12
Oil on canvas, 45.7 x 61 cm
The Arts Council of Great Britain

Harold Gilman
15 *The Café Royal* 1912
Oil on canvas, 76.2 x 63 cm
Private Collection

Harold Gilman
16 *An Eating House* c. 1914
Oil on canvas, 56.2 x 73.7 cm
Sheffield City Art Galleries

Harold Gilman
17 *Tea in the Bedsitter* 1916
Oil on canvas, 71 x 92 cm
Kirklees Metropolitan Council,
Huddersfield Art Gallery

Charles Ginner
18 *Piccadilly Circus* 1912
Oil on canvas, 81.3 x 66.3 cm
The Trustees of the Tate Gallery,
London

Charles Ginner
19 *Sunlit Square, Victoria Station* 1913
Oil on canvas, 76 x 88 cm
Bootle Collection of Paintings, Atkinson
Art Gallery, Southport

Malcolm Drummond
20 *Interior of a Cinema* c. 1913-14
Oil on canvas, 69.5 x 69.5 cm
Ferens Art Gallery: Hull City Museums
and Art Galleries

Malcolm Drummond
21 *In the Park (St James's Park)* 1912
Oil on canvas, 72.5 x 90 cm
Southampton Art Gallery

Vanessa Bell
22 *Portrait of Iris Tree* 1915
Oil on canvas, 121.9 x 91.4 cm
Private Collection

Vanessa Bell
23 *A Conversation* 1913-16
Oil on canvas, 86.3 x 81.3 cm
Courtauld Institute Galleries, London
(The Fry Collection)

Vanessa Bell
24 *Abstract Painting* c. 1914
Oil on canvas, 44 x 38.5 cm
The Trustees of the Tate Gallery,
London

Vanessa Bell
25 *Bathers in a Landscape* 1913-14
Four-fold screen, gouache and pencil on
paper laid on canvas; 175.6 x 205 cm
overall
The Board of Trustees of the Victoria
and Albert Museum, London

Duncan Grant
26 *Abstract* 1915
Oil and collage on panel, 62.9 x 45.1 cm
Courtesy Anthony d'Offay Gallery,
London

Duncan Grant
27 *The Blue Sheep* 1913
Three-fold screen, gouache on paper laid
on canvas; 106.2 x 205 cm overall
The Board of Trustees of the Victoria
and Albert Museum, London

Duncan Grant
28 *The White Jug* 1914-19
Oil on panel, 106.6 x 44.5 cm
Private Collection

Duncan Grant
29 *Venus and Adonis* 1919
Oil on canvas, 63.5 x 94 cm
The Trustees of the Tate Gallery,
London

Eric Gill
30 *Study for Bas-relief in the Cave of the Golden
Calf* 1912
Pencil and watercolour on paper,
24 x 40 cm
Yale Center for British Art, Paul Mellon
Fund

Spencer Gore
31 *Sketch for a mural decoration in the Cave of
the Golden Calf* 1912
Oil on paper mounted on card,
30 x 60 cm
The Trustees of the Tate Gallery,
London

Spencer Gore

32 *Design for Deer Hunting mural in the
 Cabaret Theatre Club* 1912
 Oil and chalk on paper, 28 x 61 cm
 Yale Center for British Art, Paul Mellon
 Fund

Charles Ginner

33 *Design for Tiger Hunting mural in the
 Cabaret Theatre Club* 1912
 Oil and pencil on card, 34.3 x 57.5 cm
 Yale Center for British Art, Paul Mellon
 Fund

Jacob Epstein

34 *Totem* c. 1913
 Pencil and watercolour on paper,
 58.1 x 41.6 cm
 The Trustees of the Tate Gallery,
 London

Percy Wyndham Lewis

35 *Abstract Design* 1912
 Ink, watercolour and collage on paper,
 24 x 39 cm
 The British Council

Percy Wyndham Lewis

36 *The Dancers (Study for Kermesse?)* 1912
 Pencil, pen and black ink, body colour
 and watercolour on buff paper,
 30.1 x 29.2 cm
 Manchester City Art Galleries

Percy Wyndham Lewis

37 *Sunset among Michelangelos* 1912
 Pen and ink with gouache on paper,
 32.5 x 48 cm
 The Board of Trustees of the Victoria
 and Albert Museum, London

Paul Nash

38 *Ruined Country, Old Battlefield,
 Vimy* 1917-18
 Watercolour and chalk on paper,
 28 x 39 cm
 The Trustees of the Imperial War
 Museum, London

Percy Wyndham Lewis

39 *Workshop* 1914-15
 Oil on canvas, 76.5 x 61 cm
 The Trustees of the Tate Gallery,
 London

Percy Wyndham Lewis

40 *The Crowd* 1914-15
 Oil on canvas, 200.7 x 153.7 cm
 The Trustees of the Tate Gallery,
 London

Percy Wyndham Lewis

41 *New York* 1914-15
 Pen and ink, crayon, watercolour and
 gouache on paper, 31 x 26 cm
 Courtesy Anthony d'Offay Gallery,
 London

Percy Wyndham Lewis

42 *Red Duet* 1914
 Chalk and gouache on paper,
 37.5 x 55 cm
 Ivor Braka Ltd, London

William Roberts

43 *The Return of Ulysses* 1913-14
 Oil on canvas, 30 x 45 cm
 Nottingham Castle Museum

William Roberts

44 *Study for Two Step* c. 1915
 Pencil, watercolour and gouache on
 paper, 29.7 x 22.8 cm
 The Trustees of the British Museum,
 London

William Roberts

45 *The Dancers* 1919
 Oil on canvas, 152 x 116.5 cm
 Glasgow Art Gallery and Museum

Edward Wadsworth

46 *Enclosure* 1915
 Gouache, ink, pencil and painted paper
 on paper, 71 x 54.7 cm
 The Museum of Fine Arts, Houston
 (museum purchase with funds provided
 by The Brown Foundation)

David Bomberg

47 *The Dancer* 1913-14
 Crayon and watercolour on paper,
 67.5 x 55 cm
 The Board of Trustees of the Victoria
 and Albert Museum, London

David Bomberg

48 *The Dancer* 1913-14
 Crayon, watercolour and gouache on
 paper, 67.5 x 55.5 cm
 Courtesy Anthony d'Offay Gallery,
 London

David Bomberg

49 *The Mud Bath* 1912-13
 Oil on canvas, 152.4 x 224.2 cm
 The Trustees of the Tate Gallery,
 London

David Bomberg

50 *In the Hold* c. 1913-14
 Oil on canvas, 196.2 x 231.1 cm
 The Trustees of the Tate Gallery,
 London

David Bomberg

51 *Ghetto Theatre* 1920
 Oil on canvas, 75 x 62.5 cm
 Ben Uri Art Society, London

David Bomberg

52 *Bargee, Mother and Child* 1921
 Oil on canvas, 91.5 x 71 cm
 Thyssen-Bornemisza Collection,
 Lugano, Switzerland

Jacob Epstein

53 *Sunflower* 1912-13
 San Stefano stone, 58.5 x 26 x 24 cm
 National Gallery of Victoria, Melbourne
 Felton Bequest 1983

Jacob Epstein

54 *Sun Goddess, Crouching* c. 1910
 Limestone, 36 x 11 x 13 cm
 Castle Museum, Nottingham

Jacob Epstein

55 *Doves* 1914-15
 Marble, 65 x 79 x 34 cm
 The Trustees of the Tate Gallery,
 London

Jacob Epstein

56 *Figure in Flenite* c. 1913
 60.9 x 15.3 x 20.3 cm
 The Minneapolis Institute of Arts, Gift
 of Samuel H. Maston, Charles H. Bell,
 Francis D. Butler, John Cowles, Bruce
 B. Dayton and anonymous donor.

Jacob Epstein

57 *Torso in metal from The Rock Drill*
 1913-14
 Bronze, 70.5 x 58.4 x 44.5 cm
 The Trustees of the Tate Gallery,
 London

Henri Gaudier-Brzeska

58 *Hieratic Head of Ezra Pound* 1914
 Marble, 91.5 x 48.3 x 42 cm
 Private Collection

Henri Gaudier-Brzeska

59 *Seated Woman* 1914
 Marble, 65 x 70 x 20 cm
 Musée National d'Art Moderne, Centre
 Georges Pompidou, Paris

Henri Gaudier-Brzeska

60 *Birds Erect* 1914
 Composite plaster cast of original lime-
 stone, 66.7 x 26 x 31.4 cm
 Kettle's Yard, University of Cambridge

Henri Gaudier-Brzeska

61 *Bird Swallowing Fish* 1914
 Bronze, 31.5 x 59.5 x 31 cm
 Kettle's Yard, University of Cambridge

Henri Gaudier-Brzeska

62 *Crouching Figure* 1913-14
 Marble, 21.8 x 30 x 10 cm
 Collection Walker Art Center,
 Minneapolis

Christopher Nevinson

63 *The Arrival* 1913-14
 Oil on canvas, 76.2 x 63.5 cm
 The Trustees of the Tate Gallery,
 London

Christopher Nevinson
64 *Troops Resting* 1916
Oil on canvas, 71 x 91.5 cm
The Trustees of the Imperial War
Museum, London

Christopher Nevinson
65 *Flooded Trench on the Yser* 1916
Oil on canvas, 50 x 61 cm
Private Collection

Paul Nash
66 *The Mule Track* 1918
Oil on canvas, 60 x 90 cm
The Trustees of the Imperial War
Museum, London

Paul Nash
67 *We Are Making a New World* 1918
Oil on canvas, 71 x 91.5 cm
The Trustees of the Imperial War
Museum, London

Paul Nash
68 *A Night Bombardment* 1919-20
Oil on canvas, 182.9 x 213.4 cm
National Gallery of Canada, Ottawa

Stanley Spencer
69 *Travoys Arriving with Wounded at a Dress-
ing Station at Smol, Macedonia* 1919
Oil on canvas, 183 x 218.5 cm
The Trustees of the Imperial War
Museum, London

Percy Wyndham Lewis
70 *A Battery Shelled* 1919
Oil on canvas, 182.8 x 317.8 cm
The Trustees of the Imperial War
Museum, London

Percy Wyndham Lewis
71 *The Menin Road (Drawing of Great War
No. 1)* c. 1918
Watercolour on paper, 29.8 x 46.6 cm
Southampton Art Gallery

Percy Wyndham Lewis
72 *Drawing of Great War No. 2* c. 1918
Pen and ink, watercolour on paper,
38.1 x 54.2 cm
Southampton Art Gallery

Percy Wyndham Lewis
73 *Battery Position in a Wood* 1918
Pen and ink, chalk, watercolour on
paper, 32 x 47 cm
The Trustees of the Imperial War
Museum, London

Mark Gertler
74 *The Merry-Go-Round* 1916
Oil on canvas, 189.2 x 142.2 cm
The Trustees of the Tate Gallery,
London

Mark Gertler
75 *The Rabbi and his Grandchild* 1913
Oil on canvas, 50.8 x 45.9 cm
Southampton Art Gallery

Mark Gertler
76 *Bathers* 1917-18
Oil on canvas, 113.5 x 137.5 cm
Ivor Braka Ltd, London

Mark Gertler
77 *Reclining Nude* 1928
Oil on canvas, 75.5 x 101 cm
Collection Ulster Museum, Belfast

Mark Gertler
78 *Supper* 1928
Oil on canvas, 105 x 70 cm
Private Collection

Mark Gertler
79 *Basket of Fruit* 1925
Oil on canvas, 78.7 x 100.3 cm
The Trustees of the Tate Gallery,
London

Mark Gertler
80 *The Spanish Fan* 1938
Oil on canvas, 106.6 x 121.9 cm
Private Collection

Mark Gertler
81 *The Red Shawl* 1938
Oil on canvas, 90 x 60 cm
Private Collection

Matthew Smith
82 *Dulcie* c. 1913-15
Oil on canvas, 82.5 x 77 cm
Southampton Art Gallery

Matthew Smith
83 *The Little Seamstress* c. 1917
Oil on canvas, 91.4 x 66 cm
Leeds City Art Galleries

Matthew Smith
84 *Fitzroy Street Nude No. 2* 1916
Oil on canvas, 101.5 x 76 cm
The British Council

Matthew Smith
85 *Winter Landscape, Cornwall* 1920
Oil on canvas, 54.2 x 64.6 cm
The Glynn Vivian Art Gallery,
Swansea Museum Services

Matthew Smith
86 *Cornish Landscape* 1920
Oil on canvas, 52.5 x 63.7 cm
Private Collection

Matthew Smith
87 *The Falling Model* 1926
Oil on canvas, 90 x 116.8 cm
Private Collection

Matthew Smith
88 *Girl Holding a Rose* c. 1930
Oil on canvas, 55.8 x 76.2 cm
Paul J. Cortese

Matthew Smith
89 *Augustus John* 1944
Oil on canvas, 102.3 x 77 cm
Scottish National Gallery of Modern
Art, Edinburgh

Eric Gill
90 *Boys Boxing* 1913
Portland stone, 55.8 x 49.5 x 19.7 cm
Stephen Keynes

Eric Gill
91 *Ecstasy* 1911
Portland stone, 137.2 x 45.7 x 22.8 cm
The Trustees of the Tate Gallery,
London

Eric Gill
92 *Mother and Child* 1910
Portland stone, 62.3 x 20.3 x 17.5 cm
National Museum of Wales, Cardiff

Eric Gill
93 *Deposition* 1924
Black Hopton-wood stone, 75 x
25 x 15 cm
The King's School, Canterbury

Frank Dobson
94 *Kneeling Female Figure* c. 1915
Sandstone, 50 x 21 x 21 cm
Bradford Art Galleries and Museums

Frank Dobson
95 *Two Heads* 1921
Mansfield sandstone, 48.3 x
27.9 x 30.5 cm
Courtauld Institute Galleries, London
(Courtauld Collection)

Frank Dobson
96 *Cornucopia* 1925-27
Ham Hill stone, 107.5 x 35 x 35 cm
The University of Hull Art Collection

Frank Dobson
97 *Sir Osbert Sitwell Bt* 1923
Polished brass, 31.8 x 17.8 x 22.9 cm
The Trustees of the Tate Gallery,
London

Frank Dobson
98 *Pigeon Boy* 1920
Portland stone, 30.5 x 17.9 x 17.9 cm
Private Collection

Jacob Epstein
99 *Genesis* 1931
Seravezza marble,
162.5 x 83.8 x 78.7 cm
Granada Television

Jacob Epstein
100 *Elemental* 1932
Alabaster, 86.3 x 63.5 x 63.5 cm
Private Collection

Jacob Epstein
101 *Jacob and the Angel* 1940
Alabaster, 218 x 108 x 110.5 cm
Granada Television

Stanley Spencer
102 *The Centurion's Servant* 1914
Oil on canvas, 114.5 x 114.5 cm
The Trustees of the Tate Gallery,
London

Stanley Spencer
103 *Christ's Entry into Jerusalem* 1921
Oil on canvas, 114.2 x 144.8 cm
Leeds City Art Galleries

Stanley Spencer
104 *Self-Portrait with Patricia Preece* 1936
Oil on canvas, 61 x 91.2 cm
The Syndics of the Fitzwilliam
Museum, Cambridge

Stanley Spencer
105 *The Sisters* c. 1940
Oil on canvas, 121.9 x 76.2 cm
Leeds City Art Galleries

Stanley Spencer
106 *The Dustman or The Lovers* 1934
Oil on canvas, 115 x 123.5 cm
Laing Art Gallery, Tyne and Wear
Museums Service, Newcastle-upon-
Tyne

Stanley Spencer
107 *Shipbuilding on the Clyde: Furnaces* 1946
Oil on canvas, 154 x 113 cm
The Trustees of the Imperial War
Museum, London

William Roberts
108 *The Cinema* 1920
Oil on canvas, 91.4 x 76.2 cm
The Trustees of the Tate Gallery,
London

William Roberts
109 *The Dance Club* 1923
Oil on canvas, 76.2 x 106.6 cm
Leeds City Art Galleries

William Roberts
110 *At the Hippodrome* c. 1921
Oil on canvas, 97.8 x 92.6 cm
Leicestershire Museums and Art
Galleries, Leicester

William Roberts
111 *Bank Holiday in the Park* 1923
Oil on canvas, 152.5 x 120 cm
Private Collection

William Roberts
112 *The Red Turban* 1921
Oil on canvas, 90 x 70 cm
Sheffield City Art Galleries

William Roberts
113 *A Woman (Sarah)* c. 1927
Oil on canvas, 61 x 50.8 cm
Manchester City Art Galleries

William Roberts
114 *Les Routiers* c. 1930-32
Oil on canvas, 101.7 x 76.3 cm
Collection Ulster Museum, Belfast

Percy Wyndham Lewis
115 *Self Portrait as a Tyro* 1920-21
Oil on canvas, 74.4 x 44.4 cm
Ferens Art Gallery: Hull City
Museums and Art Galleries

Percy Wyndham Lewis
116 *A Reading of Ovid (Tyros)* c. 1920
Oil on canvas, 165.1 x 88.9 cm
Scottish National Gallery of Modern
Art, Edinburgh

Percy Wyndham Lewis
117 *Praxitella* 1920-21
Oil on canvas, 142.2 x 101.6 cm
Leeds City Art Galleries

Percy Wyndham Lewis
118 *Ezra Pound* 1939
Oil on canvas, 76 x 102 cm
The Trustees of the Tate Gallery,
London

Ben Nicholson
119 *Contrapuntal, Feb 25 -'53* 1953
Oil on board, 167.6 x 121.9 cm
Arts Council of Great Britain

Edward Burra
120 *Opium Den* 1933
Watercolour on paper, 57 x 77.5 cm
Lord Montagu of Beaulieu

Edward Burra
121 *The Terrace* 1929
Watercolour on paper, 60.3 x 47.6 cm
The Lefevre Gallery, London

Edward Burra
122 *Revolver Dream* 1931
Watercolour and gouache on paper,
45 x 57 cm
Antonia Gibbs

Edward Burra
123 *Saturday Market* 1932
Watercolour on paper, 73 x 53.7 cm
The Lefevre Gallery, London

Edward Burra
124 *Still Life with Figures in a Glass* 1933
Watercolour and gouache on paper,
77.5 x 110.5 cm
Private Collection

Edward Burra
125 *Wheels* 1933
Watercolour on paper, 75 x 55 cm
Sunderland Museum and Art Gallery

Edward Burra
126 *The Three Fates* c. 1937
Watercolour on paper, 130 x 110 cm
Ivor Braka Ltd, London

Edward Burra
127 *Medusa* c. 1938
Watercolour on paper, 154.9 x 111.7 cm
Manchester City Art Galleries

Paul Nash
128 *The Shore* 1923
Oil on canvas, 62.2 x 94 cm
Leeds City Art Galleries

Paul Nash
129 *Northern Adventure* 1929
Oil on canvas, 92.7 x 71.6 cm
Aberdeen Art Galleries and Museums

Paul Nash
130 *Harbour and Room* 1932-36
Oil on canvas, 91.4 x 71.1 cm
The Trustees of the Tate Gallery,
London

Paul Nash
131 *Landscape from a Dream* 1936-38
Oil on canvas, 67.9 x 101.6 cm
The Trustees of the Tate Gallery,
London

Edward Wadsworth
132 *North Sea* 1928
Tempera on panel, 86.4 x 60.9 cm
Private Collection

Edward Wadsworth
133 *Composition* 1930
Oil on canvas, 87.5 x 62.5 cm
The Board of Trustees of the Victoria
and Albert Museum, London

Edward Wadsworth
134 *Triangles* 1948
Tempera on panel, 75 x 62.5 cm
Private Collection

John Piper
135 *Forms on Dark Blue* 1936
Oil on canvas, 91.4 x 121.9 cm
Private Collection

Victor Pasmore
136 *Abstract in White, Black and
Maroon* 1956-57
Relief, painted wood; 108 x 101.5 cm
Private Collection

Ben Nicholson
137 *Musical Instruments* 1932-33
Oil on board, 104.1 x 90.2 cm
Kettle's Yard, University of Cambridge

Ben Nicholson
138 *Au Chat Botté* 1932
Oil and pencil on canvas, 92.3 x 122 cm
Manchester City Art Galleries

Ben Nicholson
139 *St Rémy, Provence* 1933
Oil and pencil on board, 105.5 x 93 cm
Helen Sutherland Collection

Ben Nicholson
140 *Milk and Plain Chocolate* 1933
Oil on board, 135 x 82 cm
Private Collection

Ben Nicholson
141 *Composition in Black and White* 1933
Oil on board, 114.3 x 55.9 cm
Borough of Thamesdown, Swindon
Art Collection

Ben Nicholson
142 *Six Circles* 1933
Oil on carved board, 115 x 56 cm
Private Collection

Ben Nicholson
143 *Painted White Relief* 1936
Oil on carved walnut, 178 x 73.5 x 7 cm
Gimpel Fils

Ben Nicholson
144 *White Relief* 1935
Oil on carved board, 51.2 x 72.5 cm
Ivor Braka Ltd, London

Barbara Hepworth
145 *The Cosdon Head* 1949
Blue marble, 63 x 33 x 51 cm
Birmingham Museums and Art Gallery

Barbara Hepworth
146 *Head* 1930
Cumberland stone, 28 x 17 x 40 cm
Leicestershire Museums and Art
Galleries, Leicester

Barbara Hepworth
147 *Torso* 1932
African black wood, 108 x 23 x 17 cm
Aberdeen Art Gallery and Museums

Barbara Hepworth
148 *Conicoid, Sphere and Hollow II* 1937
Marble, 30.5 x 35.5 x 30.5 cm
Government Art Collection

Barbara Hepworth
149 *Form* 1936
White marble, 29 x 21.5 x 19 cm
Gimpel Fils

Barbara Hepworth
150 *Wood and Strings* 1944
Plane wood, part painted pale blue and
grey, with strings; 86.4 x 38.1 x 22.9 cm
Private Collection

Barbara Hepworth
151 *Sculpture with Colour (Deep Blue and
Red)* 1940-43
Wood, painted white and deep blue,
with red strings; 25.4 x 27.9 x 30.5 cm
Private Collection

Barbara Hepworth
152 *Sea Form (Porthmeor)* 1958
Bronze, 76.8 x 113.7 x 25.4 cm
The British Council

Gwen John
153 *Mère Poussepin* c. 1913-21
Oil on canvas, 88.9 x 66 cm
National Museum of Wales, Cardiff

Gwen John
154 *Young Woman in a Red Shawl* 1922-25
Oil on canvas, 45 x 35 cm
York City Art Gallery

Gwen John
155 *The Convalescent* c. 1915-c. 1925
Oil on canvas, 40 x 32.4 cm
Private Collection

Walter Richard Sickert
156 *High Steppers* c. 1938-9
Oil on canvas, 132 x 122.5 cm
Scottish National Gallery of Modern
Art, Edinburgh

Walter Richard Sickert
157 *The Miner* c. 1935-36
Oil on canvas, 127.6 x 76.7 cm
Birmingham Museums and Art Gallery

Walter Richard Sickert
158 *Lazarus Breaks his Fast (Self Portrait)*
c. 1927
Oil on canvas, 64 x 76 cm
Salome and Eric Estorick

Walter Richard Sickert
159 *H.M. King Edward VIII* 1936
Oil on canvas, 183 x 91.5 cm
Neil L.D. McLean

Walter Richard Sickert
160 *Alexander Gavin Henderson, 2nd Lord
Faringdon*
Oil on canvas, 227.5 x 83.7 cm
Lord Faringdon

William Coldstream
161 *St Pancras Station* 1938
Oil on canvas, 71 x 91.4 cm
Private Collection

Lawrence Gowing
162 *Mare Street, Hackney* 1937
Oil on canvas, 71.1 x 91.4 cm
Shrewsbury College of Arts and
Technology

Lawrence Gowing
163 *Girl in Blue* 1946
Oil on canvas, 40.6 x 50.8 cm
Private Collection

Graham Bell
164 *The Café* 1937-38
Oil on canvas, 121.9 x 91.7 cm
Manchester City Art Galleries

Rodrigo Moynihan
165 *Medical Inspection* 1943
Oil on canvas, 90.5 x 121.5 cm
The Trustees of the Imperial War
Museum, London

Victor Pasmore
166 *The Hanging Gardens of Hammersmith,
No. 1* 1944-47
Oil on canvas, 78.7 x 109.2 cm
Private Collection

Victor Pasmore
167 *The Park* 1947
Oil on canvas, 110 x 78.5 cm
Adrian Heath

Paul Nash
168 *Winter Sea* 1925-37
Oil on canvas, 74 x 99.5 cm
York City Art Gallery

Paul Nash
169 *Totes Meer (Dead Sea)* 1940-41
Oil on canvas, 101.2 x 152.4 cm
The Trustees of the Tate Gallery,
London

Paul Nash
170 *Eclipse of the Sunflower* 1945
Oil on canvas, 71.2 x 91.4 cm
The British Council

Paul Nash
171 *Landscape of the Vernal Equinox* 1944
Oil on panel, 70 x 90 cm
Her Majesty Queen Elizabeth, The
Queen Mother

Paul Nash
172 *Battle of Germany* 1944
Oil on canvas, 121 x 181.5 cm
The Trustees of the Imperial War
Museum, London

Graham Sutherland
173 *Red Tree* 1936
Oil on canvas, 56.4 x 92.1 cm
B.P. International PLC

Graham Sutherland
174 *Welsh Landscape with Roads* 1936
Oil on canvas, 61 x 91.4 cm
The Trustees of the Tate Gallery,
London

Graham Sutherland
175 *Red Landscape* 1942
Oil on canvas, 68 x 99.8 cm
Southampton Art Gallery

Graham Sutherland
176 *Black Landscape* 1939-40
Oil and sand on canvas, 82 x 132 cm
The Trustees of the Tate Gallery,
London

Ivon Hitchens
177 *London Painting* c. 1932
Oil on canvas, 76.2 x 152.4 cm
Private Collection

Ivon Hitchens
178 *Hazel Wood* 1944
Oil on canvas, 55.8 x 149.8 cm
Leeds City Art Galleries

Ivon Hitchens
179 *Flower Piece* 1943
Oil on canvas, 103 x 68.5 cm
Sheffield City Art Galleries

David Bomberg
180 *Valley of la Hermida: Picos de Europa,
Asturias* 1935
Oil on canvas, 91.5 x 109 cm
Sheffield City Art Galleries

David Bomberg
181 *Underground Bomb Store* 1942
Oil on panel, 76 x 91.5 cm
Private Collection

David Bomberg
182 *North Devon, Sunset – Bideford Bay*
1946
Oil on canvas pasted on panel,
61.2 x 76.3 cm
Laing Art Gallery, Tyne and Wear
Museums Service, Newcastle-upon-
Tyne

David Bomberg
183 *Trendrine in Sun, Cornwall* 1947
Oil on canvas, 58.9 x 76.8 cm
Manchester City Art Galleries

David Bomberg
184 *'Hear O Israel'* 1955
Oil on panel, 90 x 70 cm
Miss Cecily Deirdre Bomberg

David Bomberg
185 *Castle Ruins at St Hilarion* 1948
Oil on canvas, 93.5 x 127.5 cm
National Museums and Art Galleries
on Merseyside, Walker Art Gallery

David Bomberg
186 *Last Self-Portrait* 1956-57
Oil on canvas, 76 x 68.5 cm
Colin St. John Wilson

Henry Moore
187 *Head of a Woman* 1926
Cast concrete, 22.1 x 16 x 27.5 cm
Wakefield Art Galleries and Museums

Henry Moore
188 *Mask* 1929
Stone, 12.7 cm
Private Collection

Henry Moore
189 *Seated Woman* 1929
Oil on paper, 55.6 x 37.5 cm
Whitworth Art Gallery, University of
Manchester

Henry Moore
190 *Spanish Prisoner* 1939
Charcoal, white wax crayon, coloured
chalks and watercolour wash on paper,
37.6 x 30.7 cm
Private Collection

Henry Moore
191 *Sleeping Shelterers* 1941
Chalk and watercolour on paper,
37.8 x 52.7 cm
The Syndics of the Fitzwilliam
Museum, Cambridge

Henry Moore
192 *Mother and Child* 1925
Hornton stone, 56 x 42 x 32 cm
Manchester City Art Galleries

Henry Moore
193 *Woman with Upraised Arms* 1924-25
Hopton-wood stone, 48 x 21 x 15.3 cm
The Henry Moore Foundation

Henry Moore
194 *Composition* 1931
Cumberland alabaster, 54 x 27 x 27 cm
Private Collection

Henry Moore
195 *Composition* 1931
Green Hornton stone, 38 x 41.9 x 25 cm
Private Collection

Henry Moore
196 *Square Forms* 1936
Charcoal and red chalk, wax crayon
and watercolour wash on paper,
44.5 x 27.9 cm
Private Collection

Henry Moore
197 *Stones in a Landscape* 1936
Charcoal with wash, crayon, pen and
Indian ink on paper, 55.9 x 38.1 cm
Private Collection

Henry Moore
198 *Reclining Figure and Red Rocks* 1942
Ink and chalk on paper, 43 x 56 cm
The Trustees of the British Museum,
London

Henry Moore
199 *Ideas for Sculpture* 1942
Initial pencil, white wax crayon,
yellow crayon, black crayon, water-
colour, pen and black ink on paper,
50.7 x 40.5 cm
Thomas Gibson Fine Art, London

Henry Moore
200 *Coalminer Carrying a Lamp* 1942
Pencil, white wax crayon, watercolour
wash, under black wax crayon, yellow
and brown crayon on paper,
48.1 x 39 cm
Private Collection

Henry Moore
201 *At the Coalface* 1942
Chalk, pen and ink on paper,
32.5 x 54.4 cm
Whitworth Art Gallery, University of
Manchester

Henry Moore
202 *Two Sleepers* 1941
Chalk, wax crayon and watercolour
on paper, 31 x 46.5 cm
Pallant House Gallery, Chichester
(Hussey Bequest)

Henry Moore
203 *Figure in a Shelter* 1941
Ink and watercolour pastel on paper,
37.9 x 56.1 cm
Wakefield Art Galleries and Museums

Henry Moore
204 *Family* 1935
Elm wood, 90.2 x 38 x 20.3 cm
The Henry Moore Foundation

Henry Moore
205 *Three Points* 1939-40
Bronze, 15.2 x 10.2 x 20.3 cm
The Henry Moore Foundation

Henry Moore
206 *Internal and External Forms* 1953
Bronze, 203.2 x 59 x 59 cm
Kunsthalle, Hamburg

Henry Moore
207 *Draped Reclining Figure* 1952-53
Bronze, 109 x 164 x 74 cm
The Henry Moore Foundation

Henry Moore
208 *Standing Figure: Knife Edge* 1961
Bronze, 358 x 124.5 cm
The Henry Moore Foundation

Alan Davie
209 *Altar of the Blue Diamond* 1950
Oil on board, 181 x 242 cm
Private Collection

Alan Davie
210 *Imp of Clubs* 1957
Oil on canvas, 213 x 172.7 cm
Collection Ulster Museum, Belfast

Alan Davie
211 *Blue Triangle Enters* 1953
Oil on masonite, 152.4 x 190.5 cm
Gimpel Fils

Patrick Heron
212 *Yellow Painting October 1958 - June 1959*
Oil on canvas, 152.4 x 213 cm
Private Collection, London

Peter Lanyon
213 *Wheal Owles* 1958
Oil on board, 120.5 x 181.5 cm
Private Collection

Peter Lanyon
214 *St Just* 1953
Oil on canvas, 244 x 122 cm
Private Collection

Roger Hilton
215 *Large Orange, Newlyn, June 1959*
Oil on canvas, 152.5 x 137 cm
The Syndics of the Fitzwilliam
Museum, Cambridge

Roger Hilton
216 *March, 1961*
Oil on canvas, 132 x 139.7 cm
Whitworth Art Gallery, University of
Manchester

Roger Hilton
217 *Figure and Bird, September 1963*
Oil and charcoal on canvas,
117 x 178 cm
Private Collection

Kenneth Armitage
218 *People in a Wind* 1950
Bronze, 65 x 40 x 34 cm
The Trustees of the Tate Gallery,
London

Kenneth Armitage
219 *Figure Lying on its Side (No. 5)* 1957
Bronze, 38.1 x 82.9 x 22.3 cm
Arts Council of Great Britain

Anthony Caro
220 *Woman Waking Up* 1956
Bronze, 30.5 x 66 x 38 cm
Arts Council of Great Britain

William Turnbull
221 *Horse* 1954
Bronze, rosewood and stone,
113 x 71.8 x 27 cm
The Trustees of the Tate Gallery,
London

William Turnbull
222 *War Goddess* 1956
Bronze, 161.3 x 48.3 x 40.6 cm
Mr Alex Turnbull

Eduardo Paolozzi
223 *Large Frog, Version II* 1958
Bronze, 67.9 x 81.3 x 86.2 cm
Ferens Art Gallery: Hull City
Museums and Art Galleries

Eduardo Paolozzi
224 *The Philosopher* 1957
Unique bronze, 183 x 42 x 18 cm
The British Council

Lucian Freud
225 *A Writer* 1955
Oil on canvas, 23 x 16 cm
Private Collection

Francis Bacon
226 *Figure Study II* 1945-46
Oil on canvas, 145 x 128.5 cm
Kirklees Metropolitan Council,
Huddersfield Art Gallery

Francis Bacon
227 *Painting* 1950
Oil on canvas, 198 x 132 cm
Leeds City Art Galleries

Francis Bacon
228 *Painting of Lucian Freud* 1951
Oil on canvas, 198.1 x 137.1 cm
Whitworth Art Gallery, University of
Manchester

Francis Bacon
229 *Sleeping Figure* 1959
Oil on canvas, 119.5 x 152.5 cm
Private Collection

Francis Bacon
230 *Study for Portrait of Van Gogh VI* 1957
Oil on canvas, 198.1 x 142.2 cm
Arts Council of Great Britain

Francis Bacon
231 *Study from Portrait of Pope Innocent X*
1965
Oil on canvas, 198 x 147.5 cm
Private Collection

Francis Bacon
232 *Three Studies of Isabel Rawsthorne* 1967
Oil on canvas, 119 x 152.5 cm
Staatliche Museen Preussischer Kultur-
besitz, Nationalgalerie, Berlin

Francis Bacon
233 *Three Studies of a Male Back* 1970
Oil on canvas, each 198 x 147.5 cm
Kunsthaus, Zurich, Vereinigung
Zürcher Kunstfreunde

Lucian Freud
234 *Girl with Roses* 1947-48
Oil on canvas, 106 x 75 cm
The British Council

Lucian Freud
235 *Interior at Paddington* 1951
Oil on canvas, 152.4 x 114.3 cm
National Museums and Art Galleries
on Merseyside, Walker Art Gallery

Lucian Freud
236 *Interior with Plant, Reflection Listening*
1967-68
Oil on canvas, 121.8 x 121.8 cm
Private Collection

Lucian Freud
237 *Red-Haired Man on a Chair* 1962-63
Oil on canvas, 91.5 x 91.5 cm
Erich Sommer

Lucian Freud
238 *Large Interior, W.9* 1973
Oil on canvas, 91.4 x 91.4 cm
Private Collection

Lucian Freud
239 *Naked Portrait with Reflection* 1980
Oil on canvas, 90.3 x 90.3 cm
Odette Gilbert Gallery, London

Lucian Freud
240 *A Factory, North London* 1972
Oil on canvas, 71.1 x 71.1 cm
Private Collection

Lucian Freud
241 *Large Interior, W. 11 (after
Watteau)* 1981-83
Oil on canvas, 185.5 x 198.2 cm
Private Collection, Courtesy James
Kirkman Ltd, London

Frank Auerbach
242 *Maples Demolition, Euston Road* 1960
Oil on board, 148.6 x 153.7 cm
Leeds City Art Galleries

Frank Auerbach
243 *Study after Deposition by Rembrandt II*
1961
Oil on board, 183.5 x 123 cm
Private Collection

Frank Auerbach
244 *Primrose Hill* 1985
Oil on canvas, 101.9 x 127.3 cm
Private Collection

Frank Auerbach
245 *Camden Theatre in the Rain* 1977
Oil on board, 121.9 x 137.1 cm
Private Collection

Leon Kossoff
246 *Outside Kilburn Underground Station,*
Summer 1976
Oil on board, 107 x 184 cm
Leicestershire Museums and Art
Gallery, Leicester

Leon Kossoff
247 *Children's Swimming Pool, 11 o'clock*
Saturday Morning, August, 1969
Oil on board, 152.4 x 205.7 cm
Saatchi Collection, London

Leon Kossoff
248 *Nude on a Red Bed* 1972
Oil on board, 121.9 x 182.8 cm
Saatchi Collection, London

Leon Kossoff
249 *Portrait of George Thompson* 1975
Oil on board, 123 x 78 cm
Arts Council of Great Britain

Michael Andrews
250 *The Colony Room I* 1962
Oil on hardboard, 121.9 x 182.8 cm
Colin St. John Wilson

Michael Andrews
251 *Melanie and Me Swimming* 1978-79
Acrylic on canvas, 182.9 x 182.9 cm
The Trustees of the Tate Gallery,
London

Richard Hamilton
252 *Hommage à Chrysler Corp* 1957
Oil, metal foil and collage on panel,
122 x 81 cm
Private Collection

Richard Hamilton
253 *Towards a definitive statement on the com-*
ing trends in men's wear and accessories (c)
Adonis in Y-fronts 1962
Oil and collage on panel, 61 x 81 cm
Private Collection

Richard Hamilton
254 *Whitley Bay* 1965
Oil and photo on panel, 81 x 122 cm
Private Collection

Richard Hamilton
255 *I'm Dreaming of a White*
Christmas 1967-68
Oil on canvas, 106.5 x 160 cm
Kunstmuseum Basel (Leihgabe
Ludwig)

Peter Blake
256 *Got a Girl* 1960-61
Oil on hardboard, with wood, photo-
collage and gramophone record,
68.5 x 154.9 cm
Whitworth Art Gallery, University of
Manchester

Richard Smith
257 *Product* 1962
Oil on canvas, 123 x 132 cm
Private Collection

R. B. Kitaj
258 *An Early Europe* 1964
Oil on canvas, 152.4 x 213.4 cm
Private Collection

Allen Jones
259 *Bus II* 1962
Oil on canvas, 122 x 155 cm; plus two
canvases, each 31 x 31 cm
Private Collection

David Hockney
260 *We Two Boys Together Clinging* 1961
Oil on board, 122 x 153 cm
Arts Council of Great Britain

David Hockney
261 *Berlin: A Souvenir* 1963
Oil on canvas, 213 x 213 cm
Knoedler Kasmin Ltd, London

David Hockney
262 *Great Pyramid at Giza with Broken Head*
from Thebes 1963
Oil on canvas, 183 x 183 cm
Trustees of the Earl of Pembroke

David Hockney
263 *Sunbather* 1966
Acrylic on canvas, 183 x 183 cm
Museum Ludwig, Cologne

Patrick Caulfield
264 *Portrait of Juan Gris* 1963
Gloss paint on hardboard,
122 x 122 cm
Colin St. John Wilson

Eduardo Paolozzi
265 *Wittgenstein at Casino* 1963-64
Painted aluminium,
183 x 138.8 x 49.5 cm
Leeds City Art Galleries

Anthony Caro
266 *Sculpture Three* 1961
Steel painted green,
297 x 439 x 139.7 cm
Kasmin Ltd, London

Anthony Caro
267 *Prairie* 1967
Steel painted matt yellow,
96.5 x 582 x 320 cm
Collection Lois and Georges de Menil,
Paris

Anthony Caro
268 *Veduggio Sound* 1972-73
Steel, rusted and lacquered,
231 x 203.5 x 132 cm
Kunsthaus, Zurich, Gift presented by
Dr. W. A. and Mr H. C. Bechtler

Phillip King
269 *Call* 1967
Fibreglass and steel, painted; two pieces
each 442 x 15 x 15 cm, two pieces
each 152.5 x 183 x 91 cm
Juda Rowan Gallery, London

Bridget Riley
270 *Arrest IV* 1965
Emulsion on canvas, 179.1 x 179.1 cm
Luciana Moores

Bridget Riley
271 *Vapour* 1970
Acrylic on canvas, 96 x 90 cm
Private Collection

Bob Law
272 *Bordeaux Black Blue Black* 1977
Acrylic on cotton duck, 152.5 x 160 cm
Arts Council of Great Britain

John Hoyland
273 *17.7.69*
Acrylic on canvas, 198.2 x 365.8 cm
Waddington Galleries, London

Gillian Ayres
274 *Lure* 1963
Oil on canvas, 152.4 x 152.4 cm
Arts Council of Great Britain

Gillian Ayres
275 *Scilla* 1984
Oil on canvas, 274.3 x 274.3 cm
Private Collection

John Walker
276 *Tense II* 1967
Acrylic on cotton duck,
213.3 x 213.3 cm
Collection John Golding

John Walker
277 *Conversation* 1985
Oil on canvas, 214 x 169.4 cm
Arts Council of Great Britain

Art & Language (Atkinson/Baldwin)
278 *Map of a thirty-six square mile surface area*
of the Pacific Ocean west of Oahu 1967
Bookprint, 60 x 50 cm
Lisson Gallery, London

John Latham
279 *The Bible and Voltaire* 1959
Books, metal fittings, brushes, plaster
and cellulose spray paint on canvas on
board, 198 x 160 cm
Lisson Gallery, London

John Latham
280 *Painting out of a Book* 1963
Acrylic on duck, 243.8 x 121.9 cm
Lisson Gallery, London

John Latham
281 *Untitled Relief Painting* 1963
Books, metal, plaster and emulsion
paint on canvas on board,
91 x 121.9 cm
Lisson Gallery, London

Mark Boyle and Joan Hills
282 *Shepherds Bush, London* 1966
Earth, wood, stones, etc. on fibreglass,
on board; 153 x 153 cm
Hansjorg Mayer

Stuart Brisley
283 *Survival in Alien Circumstances,
Kassel / London* 1977/81
Eleven framed photographs by Janet
Anderson, mounted on board,
228.6 x 274.3 cm
Paul Johnstone, London

Victor Burgin
284 *Sensation* 1975
Photographic prints; three panels, each
119.4 x 83.8 cm
Arts Council of Great Britain

Art & Language (Ramsden)
285 *100% Abstract (95% + 5%)* 1968
Oil on canvas, 41 x 42.5 cm
Lisson Gallery, London

Art & Language (Ramsden)
286 *100% Abstract (33.7% + 37.1%
+ 12.2% + 17%)* 1968
Oil on canvas, 45 x 40.5 cm
Lisson Gallery, London

Art & Language (Atkinson/Baldwin)
287 *Map to not indicate: Canada, James
Bay... Straits of Florida* 1967
Bookprint, 50 x 60 cm
Lisson Gallery, London

Barry Flanagan
288 *Plant I* 1971
Hessian, mutton cloth, residual sand
and resin, 130.8 x 25.4 cm
Waddington Galleries, London

Howard Hodgkin
289 *In the Green Room* 1984-86
Oil on wood, 175.3 x 190.5 cm
Courtesy of M. Knoedler & Co. Inc.,
New York

Howard Hodgkin
290 *Interior at Oakwood Court* 1978
Oil on panel, 81.3 x 137.6 cm
Whitworth Art Gallery, University of
Manchester

Howard Hodgkin
291 *Menswear* 1980-85
Oil on wood, 83.1 x 108.5 cm
Saatchi Collection, London

R. B. Kitaj
292 *The Jewish Rider* 1984
Oil on canvas, 152.4 x 152.4 cm
Private Collection

R. B. Kitaj
293 *Cecil Court W.C. 2 (The Refugees)*
1983-84
Oil on canvas, 183 x 183 cm
The Trustees of the Tate Gallery,
London

R. B. Kitaj
294 *Amerika (Baseball)* 1983-84
Oil on canvas, 152.4 x 152.4 cm
Private Collection

Malcolm Morley
295 *Macaws, Bengals, with Mullet* 1982
Oil on canvas, 304.8 x 203.2 cm
Saatchi Collection, London

Malcolm Morley
296 *Arizonac* 1981
Oil on canvas, 203.2 x 266.7 cm
Saatchi Collection, London

Malcolm Morley
297 *Seastroke* 1986
Oil on canvas, 152.4 x 248.9 cm
Xavier Fourcade Inc., New York

Richard Long
298 *Wind Stones* 1985
Mississippi River Driftwood 1981

Richard Long
299 *From Tree to Tree* 1986

Richard Long
300 *Madrid Circle* 1986

Richard Long
301 *A Line in Ireland* 1974

Gilbert & George
302 *Wanker* 1977
Photo-piece, 300 x 250 cm
Courtesy Anthony d'Offay Gallery,
London

Gilbert & George
303 *Smash the Reds* 1977
Photo-piece, 300 x 250 cm
Collection of Judy and Harvey
Gushner, Brynmawr, Pennsylvania,
Courtesy Anthony d'Offay Gallery,
London

Gilbert & George
304 *Prick Ass* 1977
Photo-piece, 300 x 250 cm
Courtesy Anthony d'Offay Gallery,
London

Gilbert & George
305 *Bummed* 1977
Photo-piece, 300 x 250 cm
Courtesy Anthony d'Offay Gallery,
London

Barry Flanagan
306 *Elephant* 1986
Bronze, 196.2 x 188 x 105.4 cm
Waddington Galleries, London

Barry Flanagan
307 *Soprano* 1981
Bronze with gilded arrow,
87 x 48.2 x 71.7 cm
Jean Pigozzi, Lausanne

Bruce McLean
308 *Untitled* 1986
Acrylic and enamel and collage on
canvas, 284 x 198 cm
Courtesy Anthony d'Offay Gallery,
London

Bruce McLean
309 *Untitled* 1986
Acrylic and enamel and collage on
canvas, 281 x 200.5 cm
Courtesy Anthony d'Offay Gallery,
London

Barry Flanagan
310 *Leaping Hare* 1980
Gilded bronze, 68 x 69.5 x 17 cm
Southampton Art Gallery

Biographies of the Artists

Biographies of the artists have been compiled by Mary Rose Beaumont (M. R. B.), Susan Compton (S. C.), Monica Bohm-Duchen (M. B.-D.) and Gray Watson (G. W.). Each entry is followed by a list of up to three major catalogues or in rare instances where they do not exist by books. Full bibliographies will be found in the recent Arts Council and Tate Gallery catalogues cited. Photographs of the artists have been found and selected by Joanna Skipwith.

Michael Andrews

was born in Norwich on 30 October 1928 into a devout Methodist family. He was educated at the City of Norwich School from 1940 to 1947 and attended classes at Norwich School of Art in his last year, having determined very early on to be an artist. He served in the Royal Army Ordnance Corps between 1947 and 1949 (in England and Egypt); and from 1949 to 1953 studied at the Slade School. In 1952 and 1954 he participated in two films made by fellow Slade student Lorenza Mazzetti. In 1953 he was awarded a two-year Rome scholarship but stayed in Italy for only five months. Early influences on his work include Coldstream and the Euston Road School, and Francis Bacon. The two paintings *August for the People* and *A Man Who Suddenly Fell Over*, which Andrews submitted in the final examination for the Slade Diploma, attracted considerable interest and the latter was bought for the Tate Gallery when it featured in his first one-man show at the Beaux-Arts Gallery in 1958. He taught at Norwich Art School in 1959, at Chelsea School of Art in 1960 and at the Slade between 1963 and 1966. In 1963 he met June Keeley, later to become his wife; his daughter Melanie, who also features in his paintings, was born in 1970. He lived in London until 1977, when he moved back to Norfolk.

Andrews's reputation rests on a comparatively small number of paintings, for he works slowly, exhibits relatively rarely and shuns publicity. He is unusual among contemporary artists in his staunch adherence to figuration and his choice of ambitious group compositions, particularly in his works of the Sixties, as his primary subject-matter. People, usually friends or relatives of the artist, are depicted in everyday situations and often in deceptively informal postures, since formal relationships are in fact of major concern to Andrews. Although all his images are based on observable reality – photographs are sometimes used as a substitute for preliminary sketches or are transferred directly on to the canvas – what Lawrence Gowing calls a strong 'sense of the numinous quality of the real' pervades his work. Andrews himself has spoken of his desire to achieve a 'mysterious conventionality'. His most recent exhibited works were inspired by a visit made in 1983 to Australia's Ayers Rock.

M. B.-D.

Michael Andrews. Paintings 1977-78, London, Anthony d'Offay Gallery, 1978
Michael Andrews, London, Arts Council, 1980
Rock of Ages Cleft for Me. Recent Paintings by Michael Andrews, London, Anthony d'Offay Gallery, 1986

Kenneth Armitage

was born in Leeds on 18 July 1916. After attending Leeds College of Art from 1934 to 1937, he studied for two years at the Slade School; the main artistic influences on his student days were Egyptian and Cycladic sculptures which he saw at the British Museum. During the war he served in the Army and afterwards became head of the Sculpture Department at the Bath Academy of Art, Corsham, where he remained from 1946 until 1956. He destroyed nearly all his pre-war carvings and, using plaster (later cast into bronze), began creating groups of figures involved in casual everyday activities such as going for a walk or listening to music, in which limbs emerge out of textured membrane-like torsos.

His first one-man show took place at Gimpel Fils, London, in 1952. In the same year his work featured in the exhibition 'New Aspects of British Sculpture', Britain's contribution to the Venice Biennale, where it won him an international reputation. Although Armitage's work of the early 1950s is often described as part of what Herbert Read designated the 'geometry of fear', it stands apart from that of contemporaries such as Chadwick, Butler and Paolozzi in its general lack of *angst*. Between 1953 and 1955 he was Gregory Fellow in Sculpture at the University of Leeds. His first one-man exhibition in New York took place at the Bertha Schaefer Gallery in 1954 and two years later he won first prize in an international competition for a war memorial for the town of Krefeld in Germany. In the late 1950s he changed over from plaster to clay as a modelling material, and his works tended to become larger and more public, more hieratic and monumental; the torsos of his figures are flattened into plaques or tablets from which protrude architectonic limbs. He was one of the three British representatives at the Venice Biennale of 1958, when he won the David E. Bright Foundation award for the best sculptor under forty-five.

In the 1960s Armitage experimented with new materials such as wax, resins and aluminium, and with the application of paint to surfaces. The works of the early part of the decade are unusually abstract, if still figurative in implication, and often menacingly so. In the later Sixties the sculptures become increasingly playful, witty and allusive. More recently, he has returned to bronze, always his favourite medium, and in the late Seventies for the first time he turned, in his *Richmond Oaks* series, to non-human subject-matter. He visited Caracas in 1964 to work with local sculptors; between 1967 and 1969 he was Guest Artist of the City of Berlin, in 1970 Visiting Professor at Boston University, and from 1974 Visiting Tutor at the Royal College of Art in London. He was made a CBE in 1969.

M. B.-D.

Kenneth Armitage, London, Whitechapel Art Gallery, 1959
Kenneth Armitage, London, Marlborough New London Gallery/Marlborough Fine Art, 1965
Kenneth Armitage, London, Arts Council, 1972-3

Art & Language

came into being with the founding of the Art & Language Press in 1968 and the publication of the first issue of its journal *Art-Language* in 1969, although some of its members were in active dialogue as early as 1966. The original group consisted of the following: Terry Atkinson (born in 1939, studied at Barnsley School of Art 1959-60 and the Slade 1960-4, taught at Birmingham College of Art 1964-6 and Lanchester Polytechnic, Coventry 1966-73); Michael Baldwin (born in 1945, studied at Coventry School of Art 1964-7, taught at Lanchester Polytechnic 1969-71 and Leamington School of Art 1969-71); David Bainbridge (born in 1941, studied at St Martin's School of Art, London, 1963-6, taught at Birmingham College of Art 1966-9, Lanchester Polytechnic 1969-71, Hull College of Art 1971-4 and Stour-

bridge College of Art from 1971); and Harold Hurrell (born in 1940, studied at Sheffield College of Art 1961-4 and the Institute of Education, London, 1964-5, taught at Hull College of Art 1967-76).

Joseph Kosuth (born in the USA in 1945) became the editor of *Art-Language* in 1969, and in 1971 Ian Burn (born in Australia in 1939) and Mel Ramsden (born in 1944, studied at Nottingham College of Art 1961-3 and National Gallery School, Victoria, Australia 1963-4) joined the group. Also in 1971 Charles Harrison (born in 1942, studied Cambridge University and the Courtauld Institute of Art, London 1961-7, assistant editor of *Studio International* 1966-71, taught at St Martin's School of Art, Maidstone College of Art and the University of East Anglia 1967-72 and currently teaching for the Open University) became the Press's general editor. In the Seventies membership increased to thirty, but in 1975 Atkinson left the group to become an independent, highly politicized artist (in 1977 he became a Lecturer at Leeds University) and by 1977, Baldwin, Ramsden and Harrison were its only remaining members.

Art & Language arose out of a Marxist conviction that 'a claim as to what a given painting expresses is . . . a claim about its history, its cause and genetic character', which has little or nothing to do with 'the autobiographical and psychological pronouncements of cultural mandarins'. Setting out to question and subvert the avant-garde tradition, particularly the notion of 'art for art's sake' and the related concepts of individualism (since 1973 all work produced by its members has been subsumed under the Art & Language name), novelty, historicism and 'art-historical Darwinism', it is equally committed to the idea that all 'visual art is conceptually dependent on language'.

Thus, the group's activities have taken the form of printed texts, based on conversations between its members, relying heavily on analytical philosophy and the ideas of Wittgenstein in particular, which in turn 'generate inquiry into themselves'. Since *c.* 1979 Art & Language has reverted to picture-making in the studio, but largely with ironic intent, producing, for example, a (literally) *Painted by Mouth* series and a number of works painted in the 'style of Jackson Pollock'.

M. B.-D.

Art & Language 1966-1975, selected essays, Oxford, Museum of Modern Art, 1975
C. Harrison and F. Orton, *A Provisional History of Art & Language*, Paris, Editions Eric Fabre, 1982
Art & Language, Confessions: Incidents in a Museum, London, Lisson Gallery, 1986

Frank Auerbach

was born in Berlin on 29 April 1931, the son of a patent lawyer and an ex-art student mother. He was sent to England in 1939 just before his eighth birthday and spent the war years at a Quaker school in Kent; he was never to see his family again. In 1947, the year he acquired British nationality, he came to London with ambitions of becoming an actor. He attended art classes at the Hampstead Garden Suburb Institute and then at the Borough Polytechnic, where his teachers included David Bomberg, in whose classes, Auerbach recalls, 'there was an atmosphere of research and of radicalism that was extremely stimulating'. He studied at St Martin's School of Art between 1948 and 1952, and at the Royal College of Art from 1952 to 1955. Immediately after this he went to work at a frame moulders, and then took a job teaching in a secondary modern school. Between 1956 and 1968 he taught part-time at the Sidcup, Ealing, Bromley, Camberwell and Slade Schools of Art. His first one-man show took place at the Beaux-Arts Gallery in 1956; and in 1978 he was accorded a major retrospective exhibition by the Arts Council. In 1986 he represented Britain at the Venice Biennale.

Auerbach has worked in the same studio in Primrose Hill, London, ever since 1954, treating a deliberately narrow range of motifs (essentially the buildings and parks of his immediate environment and portraits of people close to him). From the start his work was characterized by a heavily impastoed surface, the paint being applied with brushes, knives and his own hands. In his works of the Fifties his palette tended to be limited to earth colours and black and white (the only colours he could then afford to buy in quantity), and through constant superimposition of paint layers, the paintings became almost three-dimensional. More recently his colours have extended in range, and he now tends to scrape down and repaint his surfaces over and over again.

He works slowly and is profoundly aware of painting as 'a cultured activity': his favourite artists from the past appear to be Dürer, Titian, Hals and Rembrandt, all artists with a strong sense of the dignity but also the pathos of mankind. Stephen Spender has characterized Auerbach's human subjects as 'people who themselves seem burdened with perhaps terrible experience . . . like refugees conscious of concentration camps', and he has suggested that even Auerbach's preoccupation with construction sites relates back to the destruction of the world of his childhood. While what Auerbach

calls the 'recalcitrant, inescapable thereness of . . . everyday objects' is undoubtedly central to his art, his paintings are also very much about the process of painting. The paintings' own 'inescapable thereness' thus exists in fruitful tension with the world of facts to which they refer.

M. B.-D.

Frank Auerbach, London, Arts Council, 1978
Frank Auerbach, London, Marlborough Fine Art, 1982
Frank Auerbach. Paintings and Drawings 1977-1985, British Pavilion, XLII Venice Biennale, London, British Council, 1986

Gillian Ayres

was born in London on 3 February 1930. She was educated at St Paul's School and during the war attended concerts at the National Gallery. She decided to become a painter at the age of fourteen and studied from 1946 to 1950 at Camberwell School of Art, where she rejected Euston Road teaching. On leaving Camberwell she spent a year working as a chambermaid in Cornwall and in a bookshop in London, but in 1951 – when her work was included in the first Young Contemporaries exhibition – she found a job at the AIA Gallery. She worked there for three days a week until 1959, sharing the post with Henry Mundy, whom she married and who was also a teacher at the Bath Academy of Art, Corsham, where she taught from 1959 to 1966. Their two sons were born in 1958 and 1966. She has had a distinguished career as a teacher: at St Martin's School of Art, 1966-78 (as Senior Lecturer for the last two of those years), and as head of painting at Winchester School of Art from 1978 to 1981, when she moved to Wales and devoted herself full-time to painting.

During the entire period of her maturity as an artist she has produced abstract paintings of strong individual flavour owing both to European post-war abstraction and to American Abstract Expressionism. The former influence came indirectly through her meeting, while working at the AIA Gallery, with Roger Hilton when he was experimenting with free abstraction. He was, she recalls, the first person 'really' to talk to her about painting. Of equal importance were the photographs that she saw of Jackson Pollock working on his paintings on the floor, which encouraged her to work without brushes and with physical movements unlike those of conventional easel painters. In 1957 she received a commission to paint massive panels for the dining hall at South Hampstead School (since destroyed).

She soon began exhibiting in London and abroad. In 1960 she took part in the 'Situation' exhibition at the RBA Galleries with, among others, Hoyland, Law, Richard Smith and Turnbull. 'Situation' enabled these artists to show their large-scale abstract works; the following year a sequel, 'New London Situation', also included Caro. Her contributions were freely painted and informal: *Break-off*, 1961 (Tate Gallery), with its freely placed shapes on a neutral ground, reveals that abandon with which she approached the surface in contrast to the 'over all' painting of Situation abstractionists such as Hoyland and Law. In the succeeding years she continued to develop her almost instinctive approach to colour, especially after 1978 when she turned from using acrylic paint to oil. In her recent work, on both large and small scale, she has sometimes continued to apply the paint until the surface gives way under the strain. Notwithstanding the density of the surface she achieves, the colours miraculously retain their brilliance and individual quality.

The diligence with which Ayres has demonstrated her persistent belief in painting as a creative act has recently served as a strong incentive to much younger artists; she was chosen for the Hayward Annual in 1980, and had one-woman shows at the Museum of Modern Art in Oxford in 1981 and the Serpentine Gallery in 1983. She was elected an ARA in 1982.

S. C.

Gillian Ayres, Bristol, Arnolfini Gallery, 1964
Gillian Ayres: paintings, Oxford, Museum of Modern Art, 1981
Gillian Ayres, London, Arts Council, 1983

Francis Bacon

was born on 28 October 1909 in Dublin of English parents; his father was a racehorse trainer. On account of childhood asthma, he had little conventional schooling but worked on his father's farm. In 1925 he came to London and set up as a furniture designer and interior decorator, spending some time in Berlin and Paris in 1927-8, when he began to make drawings and watercolours. In 1929 he started painting in oils; he never attended art school but benefited from the advice of his friend Roy de Maistre. He gradually gave up work as a decorator in favour of painting in 1931 and one of three 1933 Crucifixions was reproduced by Herbert Read in *Art Now* (1934), though his work remained commercially unsuccessful. Disappointed,

he virtually ceased painting but resumed in 1944 after full-time work in Civil Defence in London during the war years. The triptych *Three Studies for Figures at the Base of a Crucifixion* (Tate Gallery), based, he wrote in 1959, 'on figures for the Eumenides', was shown at the Lefevre Gallery in 1945. The effect was electrifying. John Russell wrote: 'Visitors … were brought up short by images so unrelievedly awful that the mind shut with a snap at the sight of them….' In 1948 the Museum of Modern Art, New York, bought *Painting 1946*. In 1949 he made the first of a series of paintings based on reproductions of Velazquez's *Pope Innocent X* (Palazzo Doria, Rome) and in 1954, together with Nicholson and Freud, he represented Britain at the Venice Biennale.

Since the mid-1950s Bacon's work has been shown internationally and he has come to be accepted by many critics and fellow artists as the greatest living British painter. His subject is the human condition, man as essentially vulnerable and alone. The violence of his imagery is reflected in the handling of the paint, which is sweepingly applied, scrubbed around and often thrown at the canvas. Bacon is a gambler and he enjoys the element of chance involved in such risk-taking. He has said: 'There is an area of the nervous system to which the texture of paint communicates more violently than anything else.'

He is widely read, and his sources of inspiration include Aeschylus's *Oresteia*, the poetry of T. S. Eliot, especially 'Sweeney Agonistes', and the letters of Van Gogh. His artistic forbears include Rembrandt, Grünewald and Picasso. Many of his paintings take the form of triptychs, resembling secular altarpieces. The Crucifixion is a recurring subject, not because of its religious significance but because it is an example of man's innate cruelty. His screaming heads are inspired by a still of the nurse in Eisenstein's film *Battleship Potemkin* as well as by the coloured illustrations in a book on diseases of the mouth.

In 1957 Bacon painted a series of six *Studies for a Portrait of Van Gogh*, based on Van Gogh's self-portrait *The Painter on the Road to Tarascon*, 1888 (now destroyed), a supreme example of one artist's homage to another. In painting this image Bacon transformed it entirely into his own idiom. He is opposed to discursive or narrative painting and the image stands on its own, with no relationships and therefore no story.

He has painted many portraits of himself and of people he knows well, generally from photographs or from memory: 'If they were not my friends I could not do such violence to them.' He does not aim for a likeness but for an equivalent, although sometimes the likeness which emerges from the plethora of brushstrokes is startling. He does not draw but paints directly on to the canvas, improvising and distorting during the process. 'Painting is pure intuition,' he says. Newspapers and photographs often provide his source material, and Muybridge's book of photographs of humans and animals in motion (published in 1887) has been a rich mine of images. He is utterly opposed to the notion of abstract or non-representational art, which some artists have adopted in reaction to the 'realism' of photography.

Bacon has had many retrospective and selected exhibitions, the first at the Richard Feigen Gallery, Chicago, in 1959, and subsequently, amongst others, at the Solomon R. Guggenheim Museum, New York, in 1963-4; a retrospective at the Hamburg Kunstverein and Moderna Museet, Stockholm, in 1965; at the Grand Palais, Paris, in 1983; and two at the Tate Gallery in 1962 and

1985. He has shown with the Marlborough Gallery in London and New York for twenty-five years.

Since 1970 Bacon's paintings have become spatially freer, although he still often encloses his figures in a metal armature, as though to draw attention to the limitations of the human condition. The colours have become more brilliant – vivid oranges and pinks – and the images have a new clarity while still communicating an inherent violence and feeling of desperation as strongly as ever.

M. R. B.

Francis Bacon, London, Tate Gallery, 1962
Francis Bacon, Paris, Grand Palais/Düsseldorf, Städtische Kunsthalle, 1972
Francis Bacon, London, Tate Gallery/Thames and Hudson, 1985

Graham Bell

was born in the Transvaal, South Africa, on 21 November 1910, and after working on a farm and in a bank, studied at the Durban School of Art. His first one-man show took place in 1930; he himself said later that 'it included imitations of John and Paul Nash, Duncan Grant, Cézanne, Matisse, Bonnard, Teddy Wolfe and many other artists with even less well known names whose works had been reproduced in magazines like *Colour*…. In Durban I had been slapdash and sanguine ….' In 1931 he made his way to England, where years of poverty and disillusionment followed. A passion for the work of Duncan Grant sustained him: not only his 'blobby still-lifes and landscapes but also … his lyrical decorative pictures'. Seeking in turn those artists who might have inspired Grant, Bell made some free adaptations of paintings by Rubens, Tiepolo, Chardin and Constable in the National Gallery.

Contact with William Coldstream gave Bell what Kenneth Clark described as 'a purposeful severity, a certain bleakness, even', which, 'after the aimless euphoria of the Duncan Grant period … was a necessary corrective'. Bell soon became part of a small group of painters, which included Coldstream, Geoffrey Tibble, Pasmore and Moynihan, who experimented with abstraction as a means of expressing the feelings aroused in them by the natural world. The group held an exhibition of its work at the Zwemmer Gallery, London, in 1934, under the title 'Objective Abstractions'. Shortly after this Bell gave up painting altogether

and turned to journalism, but he returned to painting and in 1937 became a founder member of the Euston Road School. Inspired by extreme left-wing political sympathies, he denounced painting that was merely decorative and instead advocated an unemphatic but poetic naturalism mediated by the example of Cézanne. Portraits and – most successfully – landscapes occupied most of Bell's attention at this time. In 1939 he announced in *The Artist and His Public*: 'This, then, is my general contention. That the decadence of modern painting is due to the failure of artists to search deeply into their natures, a feat which can only be accomplished if they are serious to a degree which I call religious. And that this is due to the general decadence of capitalist society which detests and fears art at its serious levels, which seeks only to escape from itself in its horrible diversions. That in general great painters have risen when the craft of painting was respected; they have disappeared when patronage got into the hands of connoisseurs of art, or a class that wanted to bolster its self-respect with bogus elegance.' Bell volunteered for the RAF in 1939, training as a navigator. He was killed in England on a training flight on 9 August 1943.

M. B.-D.

Graham Bell, *The Artist and His Public*, Hogarth Sixpenny Pamphlets, No. 5, London, Hogarth Press, 1939
Kenneth Clark, *Paintings of Graham Bell*, London, Lund Humphries, 1947

Vanessa Bell

was born in London on 30 May 1879; her father was the critic and biographer Sir Leslie Stephen, her maternal great aunt the Victorian photographer Julia Margaret Cameron. After private schooling she studied at the Royal Academy Schools from 1901 to 1904, where one of her teachers was the fashionable portrait painter John Singer Sargent. Of more lasting relevance, however, were her brother Thoby's literary gatherings, for their home became the meeting place for writers and artists who became known as the Bloomsbury Group. The circle included Clive Bell, whom Vanessa married in 1907, and Leonard Woolf, who married her sister Virginia; Vanessa subsequently designed the covers for Virginia's novels, which were published by the Woolfs' Hogarth Press. In the autumn of 1905 Vanessa organized the Friday Club, an informal art society for lectures and discussions which from 1911 was based on the Alpine Club, where exhibitions were

continued until 1922. Members included Duncan Grant, Nevinson, Gertler, Bomberg, Dobson, Roberts and Eric Gill.

Although on visits to Florence, Greece and Turkey she had passed through Paris, she was profoundly influenced by the two Post-Impressionist exhibitions organized in London in 1910 and 1912 by Roger Fry and her husband. The work of Matisse affected her strongly and in response she turned from rather quiet portraits and still-lifes to compositions characterized by their simplified and striking shapes outlined against areas of high-keyed colour. Whilst Clive Bell was writing *Art* (published in 1914) in which he set out a doctrine of 'significant form', she produced pioneering abstract paintings alongside her figurative ones. At the same time she was working on decorative commissions, at first for Omega Workshops, formed by Roger Fry in 1913. She was a co-director with Duncan Grant and even after the closure of the Workshops in 1919 she continued to execute designs. With Duncan Grant she decorated Charleston, the house near Lewes in Sussex which the Bells shared with Grant from 1916. Charleston has now been restored as a memorial to Bloomsbury and it celebrates the close association of Grant and Vanessa Bell, who worked together for more than fifty years.

She joined the London Group in 1919, exhibiting with them for the remainder of her life; in 1920 and 1922 she visited Picasso in Paris and during the Twenties she frequently travelled in France, staying regularly at Cassis from 1928 to 1939. In 1938 she taught at the Euston Road School, so she is linked with the generation of Pasmore, Coldstream and Graham Bell (who was no relation). Her death on 7 April 1961 at Charleston was followed three years later by an Arts Council memorial exhibition. It was another ten years before her early work as a painter and designer was reappraised and its particular originality rediscovered.

S. C.

Vanessa Bell. A Memorial Exhibition of Paintings, London, Arts Council, 1961
Vanessa Bell. A Memorial Exhibition of Paintings, London, Arts Council, 1964
Vanessa Bell. Paintings and Drawings, London, Anthony d'Offay Gallery, 1973

Peter Blake

was born on 25 June 1932 in Dartford, Kent. He was a student from 1946 to 1951 at Gravesend Technical College and School of Art, where he executed many graphic works already showing a high degree of accomplishment. He was accepted by the Royal College of Art, London, in 1950 but his studies were interrupted by a period of National Service with the RAF from 1951 to 1953. He then resumed his studies at the Royal College, leading to a first class diploma in 1956. Two main categories of work from this period can be distinguished: essentially naturalistic paintings with a strongly autobiographical element, typically featuring boys and girls wearing badges or reading comics; and paintings of a more fantastical nature, based on the theme of the circus. Although both of these categories were helping to pave the way to Pop Art, neither could be called Pop as such, and Blake's properly Pop work did not begin until towards the end of the decade. In 1956-7 he travelled in Holland, Belgium, France, Italy and Spain on a Leverhulme research award to study popular art.

In 1959 he made collage works such as *Kim Novak Wall*, beginning a formally most inventive series: a typical, if particularly successful, example is *Got a Girl* (1960-1), in which pin-up pictures of the pop singers Fabian, Frankie Avalon, Ricky Nelson, Bobby Rydell and Elvis Presley were collaged, together with a record, above a large painted area with a chevron design, all reminiscent of a pin-board. Even in such indisputably Pop works, however, the emphasis was not on a sophisticated analysis of mass communications – as with, say, Hamilton – but on the experience of the average consumer of popular culture. As often as not, furthermore, this was not of the moment but noticeably out of date.

From 1960 to 1962 he taught at St Martin's School of Art, London; from 1960 to 1964 at Harrow School of Art; and from 1961 to 1964 at Walthamstow School of Art. In 1963 he married Jann Haworth and visited Los Angeles to execute a portfolio of drawings for the *Sunday Times*. He was given a retrospective exhibition at the City Art Gallery, Bristol, in 1969; in the same year he moved to Wellow, Avon, where he stayed until 1979. In 1974 he became an Associate of the Royal Academy. Together with Jann Haworth, Ann and Graham Arnold, David Inshaw, and Annie and Graham Ovenden, he was a founder member of the Brotherhood of Ruralists in 1975: they first exhibited as a group at the Royal Academy Summer Exhibition in 1976; in 1981 there was a major group exhibition at the Arnolfini Gallery, Bristol, which subsequently travelled to Birmingham, Glasgow and the Camden Arts Centre, London; in the same year he was elected an RA. He separated from Haworth and they divorced two years later; he has lived with Chrissy Wilson since 1980. In 1983 there was a major retrospective exhibition at the Tate Gallery, London, and at the Kestner-Gesellschaft, Hanover.

G. W.

Peter Blake, Bristol, City Art Gallery, 1969
Peter Blake, Amsterdam, Stedelijk Museum, 1973
Peter Blake, London, Tate Gallery, 1983

David Bomberg

was born in Birmingham on 5 December 1890, the fifth child of Polish-Jewish immigrants; his father was a leather-worker. In 1895 the family moved to London's East End and from *c.* 1905 Bomberg was apprenticed to lithographer Paul Fischer; he simultaneously studied with Walter Bayes at the City and Guilds Institute. In 1908 he broke his inden-

tures in order to become an artist, and between 1908 and 1910 attended evening classes in book production and lithography at the Central School of Arts and Crafts and Sickert's evening classes at the Westminster School. In 1907 he had met J. S. Sargent and, through him, Solomon J. Solomon; on the latter's recommendation the Jewish Educational Aid Society enabled Bomberg to study at the Slade between 1911 and 1913. In the latter year he began exhibiting, to considerable acclaim, and in May-June he paid a short visit to Paris in the company of Jacob Epstein, where he met Picasso, Derain, Max Jacob, Kisling and Modigliani. On his return he continued to exhibit successfully in several important group shows and in July 1914 had his first one-man exhibition at the Chenil Gallery. Although the radical geometricized elements of his figure compositions of this period have affinities with the work of the Vorticists and he exhibited on their invitation in their 1915 exhibition, he avoided any formal connection with them. The London Group was in fact the only organization he was prepared to join – in 1914, and he continued to show at its exhibitions intermittently throughout his life.

In 1915 Bomberg enlisted in the Royal Engineers, later transferring to the Eighteenth King's Royal Rifles. In 1916 he married Alice Mayes. He was commissioned in late 1917 to paint a picture for a Canadian war memorial but his first version was rejected as too 'radical' and he was forced to compromise. Disillusioned by this and the failure of a one-man show in 1919, he retired from active participation in British artistic life, living in Hampshire 1920-2 and in Palestine 1923-7, when he made two expeditions to Petra. His work of this period can be divided into minutely detailed topographical compositions and more freely handled oil sketches which anticipate the expressionistic, thickly painted landscapes, flower pieces and figure compositions of the Thirties, Forties and Fifties.

From the late 1920s onwards, Bomberg travelled extensively, above all in Spain where he was to live between 1934 and 1935 but also in Morocco, the Greek islands, the USSR, Cyprus and the wilder parts of Britain, usually accompanied by fellow painter Lilian Holt, whom he later married. During the Second World War he worked briefly as an Official War Artist (1942) and began a part-time teaching career that lasted until his death. From 1945 to 1953 he taught at the Borough Polytechnic, numbering Auerbach and Kossoff among his students and gathering around him a significant following in the form of the Borough Group (1947-9) and the Borough Bottega (1953). In 1954

he moved to Spain, increasingly embittered by the lack of recognition accorded his later works and misrepresentation of his earlier ones as Vorticist. In 1957 he became seriously ill and was moved to Gibraltar, then to London, where he died on 19 August.

M. B.-D.

David Bomberg 1890-1957, London, Arts Council, 1967
Bomberg. Paintings, Drawings, Watercolours, Lithographs, London, Fischer Fine Art, 1973
David Bomberg. The Later Years, London, Whitechapel Art Gallery, 1979

Mark Boyle and Joan Hills

Mark Boyle was born in Glasgow on 11 May 1934. He studied law at Glasgow University from 1955 to 1956, having previously served in the British Army (1950-3) and worked as a steelyard labourer (1953-4). Between 1955 and 1958 he was a poet, working in London and supporting himself by taking jobs as a park keeper, office clerk, barman and head waiter, while Joan Hills, who had studied architecture for a year at Edinburgh, was a painter, often also working in casual jobs, sometimes with Boyle. During this time they visited an Arts Council northern touring exhibition at which Boyle was inspired by Bacon's *Figure Study II* (Cat. 226) to become a painter; as an artist he was virtually self-taught.

Since 1958 Boyle and Hills have worked in London as independent artists. His first one-man show took place at the Woodstock Gallery, London, in 1963 and in 1966 their first joint exhibition was held at the Indica Gallery. From 1960 to 1965 they collaborated on light-environments for theatrical events and since 1966 they have been co-directors of the Sensual Laboratory; they produced light-shows for the UFO Club in London (1967) and light-environments for the Soft Machine and Jimi Hendrix Experience tour in the USA (1967-8). In 1966-7 Boyle taught for six months at the Watford School of Art and he also received a prize for painting at the Biennale des Jeunes in Paris; at the same time he was directing and providing the light-environment for *Lullaby for Catatonics*, with Soft Machine and dancers (also part of this Biennale). In 1978 he represented Britain at the Venice Biennale.

Almost from the start, Boyle and Hills have been preoccupied with the natural world and with ecological issues, attempting to replicate reality as

closely as possible so as to intensify the viewer's perception of nature, even in its most conventionally unpromising aspects and in all its specificity. Their major project to date, *Journey to the Surface of the Earth* (started in 1968), and related projects such as the *Shepherds Bush, London, Tidal* and *Skin* series, grew out of their earlier 'happenings' and a constant preoccupation with using random techniques to confront reality. Essentially, what all these projects involve is the choice of certain geographical sites, often made by friends and acquaintances of the artists, at parties held especially for that purpose. In *Journey to the Surface of the Earth*, for example, friends were blindfolded and asked to throw darts at a map of the world: Boyle and Hills then visit these sites, aiming at the creation of what they call a 'multi-sensual presentation' of an area usually about two metres square from each geographical location; there are some works which are larger, however, and also smaller studies and technical sketches. In addition, sections in depth are taken; tape-recorders and cameras are used to record the climatic conditions and the plant, animal and human life associated with a given spot, as well as the physical reactions of the artists to that environment. Throughout, an attempt is made to keep the recording techniques as unobtrusive and meticulous as possible. In all this their techniques rely on the notion of random sample as used by biologists and botanists, though they admit the artistic influence of, amongst others, Kurt Schwitters.

M. B.-D.

Mark Boyle, *Journey to the Surface of the Earth, Mark Boyle's Atlas and Manual*, Cologne, London and Reykjavik, Editions Hansjörg Mayer, 1970
J. L. Locher, *Mark Boyle's Journey to the Surface of the Earth*, Stuttgart and London, Editions Hansjörg Mayer, 1978
Mark Boyle, British Pavilion, XXXVII Venice Biennale, London, British Council, 1978

Stuart Brisley

was born at Grayswood, near Haslemere, Surrey, in 1933. He studied at Guildford School of Art (1949-54), the Royal College of Art, London (1956-9), the Akademie der Bildenden Künste, Munich (1959-60) and Florida State University, Tallahassee (1960-2). Having settled in London in 1963, he constructed during the mid-1960s a number of structures in perspex and similar materials. Kinetic works led in the late 1960s to works, often in collaboration with Bill Culbert, utilizing

light. Increasingly, however, Brisley felt that he wanted to enter the works himself and in 1968 he began doing performances. His most famous early performance was *And for today ... nothing*, part of a mixed exhibition in 1972 at Gallery House, London, where he lay in a bath with only his nose and mouth above water, while raw meat lay rotting on the floor – until, after ten days, the other participating artists asked him to stop. Also in 1972 he made *Arbeit Macht Frei*, the first of many films in collaboration with Ken McMullen.

In 1973, when in West Berlin on a DAAD scholarship, he performed *Ten Days*, over the Christmas period: every day at mealtimes he would be served with *haute-cuisine* food which he consistently refused, leaving it to rot, primarily as a comment on Western society's over-consumption. Several works performed over the next few years with Leslie Haslam included the six-day *Moments of Decision/Indecision* in Warsaw in 1975 and *Homage to the Commune* at the 'Arte Inglese Oggi' exhibition in Milan in 1976. He was artist in residence in 1976 at Peterlee New Town, Co. Durham; his work with the community in this mining area probably influenced the nature of his protest against the waste of resources that he witnessed at the Kassel Documenta 6 show the following year – notably the burial of a brass rod by de Maria at a cost of £ 250,000; his response, entitled *Survival in Alien Circumstances*, was to live for two weeks at the bottom of a hole which he had bare-handedly dug with the help of Christoph Gericke. Gericke was his collaborator again in *Measurement and Division* at the 1977 Hayward Annual, London.

Brisley's use of ritual has been divided into two main types: the purification ritual, in which endurance is a major element; and, more recently, the contest ritual, two examples of the latter, both created in collaboration with Iain Robertson, being *Between* (1979), performed on a steep, slippery slope, and *Approaches to Learning* (1980), where the two men subjected each other to violent blows. All his work is political: consumption, power and authority – and how these relate to the human body – being amongst his principal themes. *Leaching out at and from the Intersection* (1981) was the first work of his *Georgiana Collection*, which he described as 'a developing institution' centred on animate and inanimate life on a piece of wasteland in Georgiana Street where he lived in north-west London. The resulting collection of works, which included sculpture, was exhibited in 1986-7 in Glasgow, Derry, Belfast and the Serpentine Gallery in London. His *Normal activities may be resumed: an obstruction/instruction Guide* – a sound installation on the subject of nuclear attack – was mounted in 1985 at the ICA, where a retrospective had been held in 1981.

G. W.

Stuart Brisley, London, Institute of Contemporary Arts, 1981
Stuart Brisley: Georgiana Collection, Glasgow, Third Eye Centre/Derry, Orchard Gallery, 1986

Victor Burgin

was born in Sheffield on 24 July 1941. He studied painting at the Royal College of Art, London, between 1962 and 1965 and at Yale University from 1965 to 1967. Since then he has been based in London, and has taught at Trent Polytechnic (1967-73) and the Polytechnic of Central London (since 1973). In 1976 he was the recipient of a

US/UK Bicentennial Arts Exchange Fellowship, and in 1978-9 of a DAAD Fellowship, giving him a year's residence in West Berlin. In 1980 he was Visiting Professor at Colgate University, Hamilton, New York. He lectures widely and, as well as producing his own books, has published theoretical articles in journals such as *Artforum, Studio International, 20th Century Studies* and *Screen*.

As a student in the early to mid-Sixties, Burgin shared with other contemporaries a dissatisfaction with, in his own words, 'the sorts of formal stylistic games that were prevalent then'. Ever since his first work comprising nothing but writing (1969) Burgin's basic concern has been 'to underline the contingency of the physical object and the primacy of the observer's *act* of observation'. Since the early Seventies, relying heavily on semiotic theory, he has been involved with photography as a signifying practice inseparable from language; he has sought to subvert modernist notions of the pre-eminence and 'purity' of the art object, above all, painting, and has been concerned instead 'with looking into art's *instrumentality* within the wider social context'.

Burgin's earliest photo-essays were presented in the form of a series of photographs accompanied by cryptic, instruction-like sentences, each modifying or adding to the previous one. Since the late Seventies he has abandoned this open-ended structure in order to mount a more direct attack on social relationships in contemporary society, with particular emphasis on issues of power and sexuality. Images culled from advertising photography are juxtaposed with written quotations obviously at variance with them, creating a thought-provoking multiplicity of texts.

Burgin makes no hierarchical distinction between his activities as writer, photographer and manipulator of verbal and visual texts, and teacher: all are part of an essentially pedagogic approach to art as a form of political education.

M. B.-D.

Victor Burgin, Oxford, Museum of Modern Art, 1978
Victor Burgin, Eindhoven, Van Abbemuseum, 1977
Between, Oxford, Basil Blackwell/London, Institute of Contemporary Arts, 1986

Edward Burra

was born on 29 March 1905; his father was a barrister. Due to chronic arthritis and anaemia he was withdrawn from preparatory school and privately educated at home; his parents encouraged his early talent for drawing. From 1921 to 1923 he studied at the Chelsea Polytechnic, where he learned life drawing and illustration, quickly becoming an accomplished draughtsman; he then spent two years at the Royal College of Art. Thereafter he lived the greater part of his life at his parents' home near Rye in Sussex. He was an avid cinema-goer and particularly enjoyed films that were meretricious and absurd, just as in his work he preferred to depict the cheap and squalid side of life. In the late 1920s and early 1930s he made drawings and collages which are indebted to Dada, particularly to George Grosz, whom he admired, but whereas Grosz's collages and paintings have a political content, Burra's are satirical without being political.

In 1927 he met Paul Nash with whom he studied avant-garde periodicals, especially German ones. Burra loved to travel, when his health permitted, and was often in Paris and Toulon. He and his friends spent many evenings at the cinema, dance halls and music halls, which were constant sources of inspiration to him. In 1933 he went to America, first to New York where he discovered the night-spots of Harlem, and then to Boston to stay with his lifelong friend, the poet Conrad Aiken. Also in 1933 he was included in the exhibition 'Art Now' at the Mayor Gallery, and in 1934 in the 'Unit One' exhibition at the same gallery, both accompanied by publications by Herbert Read. In 1936 he showed in the International Surrealist Exhibition in London and in 'Fantastic Art, Dada and Surrealism' at MOMA, New York.

He was deeply distressed by the Spanish Civil War, which broke out in 1936. Many of his paintings of this period have an atmosphere of violence, almost of sadism, such as *Destiny*, 1937. At the same time he began to paint religious pictures, the first, *Mexican Church*, 1938, being derived from postcards that he had acquired whilst in Mexico City. These paintings serve as an antidote to his more frivolous output, such as his portrayals of Mae West, whom he admired above all film stars.

During the Second World War he was unable to travel except for occasional visits to London. He

did, however, record the presence of soldiers in Rye, whom he portrayed as sinister, bird-headed creatures. After the war he designed costumes and décor for several ballets and made book illustrations. In 1955 he went to New York and Boston where he painted the *Silver Dollar Bar*, perhaps the finest of his nightclub scenes. From the late 1950s onwards he showed an increasing interest in still-lifes and landscapes, and these sparely composed landscapes are at once beautiful yet slightly menacing. Burra almost always used watercolour, since he was not strong enough to paint in oils. He exhibited frequently, at the Lefevre Gallery since 1952. He had a retrospective exhibition at the Tate Gallery in 1973 and another at the Hayward Gallery in 1985. He died on 22 October 1976.

M. R. B.

Edward Burra (partial retrospective), London, Redfern Gallery, 1942
Edward Burra, London, Tate Gallery, 1973
Edward Burra, London, Arts Council, 1985

Anthony Caro

was born on 8 March 1924 in New Malden, Surrey. He was educated at Charterhouse (1937-42) and Christ's College, Cambridge (1942-4), where he read engineering; during the vacations he attended Farnham School of Art. Having served with the Navy from 1944 to 1946, he studied sculpture at the Regent Street Polytechnic in 1946-7. From 1947 to 1952 he studied at the Royal Academy Schools, then almost wholly unaffected by the existence of modern art, during which time he received various awards. He married Sheila Girling, a fellow student, in 1949. In 1951, before he had finished his studies, he went to work at Much Hadham, Hertfordshire, as a part-time assistant to Henry Moore. Although Moore vastly broadened his horizons, Caro avoided being influenced in too specific a sense. He looked, rather, in his work of the mid-1950s, towards Picasso's Expressionist sculpture and to Bacon, de Kooning and Dubuffet; he was modelling in clay, experimenting from 1955 with incorporating other materials such as pebbles before casting into bronze.

He began teaching at St Martin's School of Art, London, with Frank Martin the Head of Sculpture, in 1953. There he devised studio projects which were in advance even of his own practice; the shortcomings in that practice were clarified for him by Clement Greenberg, who visited his London studio in 1958, and who also pointed to exciting new possibilities. He was therefore well prepared for the dramatic conversion, following his visit in 1959-60 to New York on a Ford Foundation travel scholarship, from figurative modelled sculpture to abstract constructed steel sculpture; the latter not only did away with the base, being placed directly on the ground, but also was soon to be brightly coloured. In New York he had met several leading artists, including Kenneth Noland and David Smith. On his return to London he bought oxyacetylene welding equipment and a supply of scrap metal, and also set up a welding studio at St Martin's. In addition he re-thought his teaching methods, becoming a catalyst of the first importance for the next generation of sculptors: Flanagan, Long and Gilbert & George were among his many celebrated students.

If the first abstract sculptures were characterized by a certain roughness, a lyrical quality pervades his work from about 1962; after the high-

ly economical sculptures of 1965, those of the late 1960s were marked by extraordinary variety and inventiveness, many having associations with landscape. In 1967 he bought a stock of materials which had been owned by David Smith, who had recently died. His first major retrospective exhibition was at the Hayward Gallery, London, in 1969; the next took place at the Museum of Modern Art, New York, in 1975, followed by a US tour. In 1978 he carried out a commission for the East Wing of the National Gallery, Washington DC. A British Council exhibition of the *Table Sculptures 1966-1977* toured the world between 1977 and 1979. Working at the Triangle Workshop, New York State, in 1983, he drew regularly from a model, which has resulted in some figurative bronzes since 1984 that look back to his pieces of the 1950s, a line of work, however, which until now has remained subordinate to his main, abstract production.

G. W.

Anthony Caro, London, Arts Council, 1969
Anthony Caro, New York, Museum of Modern Art, 1975
Anthony Caro. Sculpture 1969-84, London, Arts Council, 1984

Patrick Caulfield

was born in London on 29 January 1936. He studied at the Chelsea School of Art from 1956 to 1960 and returned to teach there from 1963 to 1971. However, the three intervening years marked a watershed in his career: he spent them at the Royal College of Art, where students one year

his senior included Hockney, Kitaj and Jones. At Chelsea he had explored an approach to painting based partly on the work of Douanier Rousseau before coming into direct contact with American painting at 'The New American Painting' shown at the Tate Gallery in 1959. Although this exhibition included work by Pollock and de Kooning, he was more attracted by the work of Philip Guston and made some nearly abstract pictures. He next came under the influence of Jack Smith who taught at Chelsea from 1959 and, by Caulfield's own account, he took some time to find his own style when he arrived at the Royal College. None the less his work was chosen by Lawrence Alloway and his fellow jurors for inclusion in the Young Contemporaries exhibition of 1961. At that time Caulfield was seen as one of the third generation of Pop painters, though his work has little in common with that of his contemporaries except a concern with style.

For a short time he applied wooden grids to his canvases which he subsequently destroyed but they resulted in his first mature works, black-and-white paintings dating from his last year at the College. He was quite open in his admiration for the work of earlier artists, especially that of Léger and Gris, so he distanced himself deliberately from subject-matter drawn from popular imagery which attracted many of his contemporaries. He seemed to be intent on exploring the possibilities of maintaining strong links with a European tradition though 'modernizing' the subjects such as views and still-lifes which are the hallmarks of Western art. By using house paint on hardboard he reduced the conventional importance of brushmarks on canvas and by creating a banal surface for his cliché-subjects, the irony of his presentation was increased. He developed a strongly recognizable personal style using non-modelled deep tones outlined in a contrasting colour. His personal stamp has earned him recognition in exhibitions in Britain and abroad where he has shown not only easel paintings but also prints (he won the *Prix des Jeunes Artistes* for graphics at the 4th Biennale des Jeunes in Paris in 1965).

Unlike many of his artist friends he has remained in London, resisting the lure of the countryside which attracted his friends Richard Smith, Hodgkin and others to leave London for the West Country in the 1970s. For the first eight years after leaving the Royal College he taught at the Chelsea School of Art, and subsequently he has devoted himself to painting and printmaking. He was the subject of a monograph published by Penguin Books in 1971 in a series on New Art and a retrospective exhibition was held at the Tate Gallery and the Walker Art Gallery in Liverpool in 1981.

S. C.

Patrick Caulfield: Paintings and Prints, Edinburgh, Scottish Arts Council, 1975
Patrick Caulfield Print Retrospective: Complete Works 1964-1976, Santa Monica, California, Tortue Gallery, 1977
Patrick Caulfield. Paintings 1963-81, London, Tate Gallery/Liverpool, Walker Art Gallery, 1981

William Coldstream

was born on 28 February 1908 in Belford, Northumberland; his father was a doctor who moved with his family to London in 1910. Owing to illness he was educated privately from the age of twelve; his principal interest was natural science and he planned to study medicine. From 1925 he

took up drawing and painting seriously and attended the Slade School for the following three years. In 1934 after election to the London Group, he became uncertain about his own painting and, in order to work in a medium more accessible to the public, he joined the GPO Film Unit under John Grierson. Coldstream directed *The King's Stamp* (1935) and worked with W. H. Auden on *Coal Face*. In 1937 Kenneth Clark gave him financial support so that he could resume full-time painting; he visited Bolton with Graham Bell at the suggestion of Tom Harrisson, who was conducting his 'Mass Observation' project there. The style of Coldstream's resulting *Bolton* (National Gallery of Canada), with its view of roofs and chimney stacks, was described by the artist: 'The slump had made me aware of social problems, and I became convinced that art ought to be directed towards a wider public. Whereas all ideas I had learned to be artistically revolutionary ran in the opposite direction. Public art must mean realism.'

In the same year, with Claude Rogers and Pasmore, he recognized a need for a school of art which would specialize in drawing and painting rather than applied arts and design. When Rogers rented a studio at 12 Fitzroy Street and with Pasmore opened a School of Drawing and Painting, Coldstream soon joined them and signed the prospectus. This included: 'In teaching, particular emphasis will be laid on training the observation, since this is the faculty most open to training.' The phrase sums up Coldstream's subsequent practice, both in his own paintings and in his influential career as a teacher. The independent school soon moved to Euston Road and gave the title 'Euston Road School' to the work of its teachers and pupils. It closed soon after the outbreak of war and Coldstream's career was interrupted by service in the Royal Artillery until 1943, when he was appointed an Official War Artist, working in Cairo and then Italy.

On his demobilization he began teaching at Camberwell School, before being appointed Slade Professor at University College, London, in 1949. Ten years later he became Chairman of the National Advisory Council on Art Education; through the 'Coldstream Report', the Diploma in Art and Design replaced the National Diploma in Design in 1963. Effectively this changed the structure of art school teaching in Britain, introducing compulsory study of art history for art students and, eventually, the award of degree status to recognized art school courses. Coldstream's exceedingly painstaking method of arriving at a faithful likeness in portraiture, nudes and landscape has

resulted in a form of realism that has remained a measure for his students, even when they have moved away from his own particularity.

S. C.

William Coldstream, London, Arts Council, 1962
William Coldstream, London, Anthony d'Offay Gallery/ Edinburgh, Fine Art Society Ltd, 1976
William Coldstream, New Paintings, London, Anthony d'Offay Gallery, 1984

Alan Davie

was born in Grangemouth, Scotland, on 28 September 1920, the son of artistically and musically gifted parents; his father was a painter and etcher. From 1937 to 1941 he attended Edinburgh College of Art; as well as painting, he made silver jewellery and read many books on exotic art; he also played several musical instruments and began his lifelong interest in jazz. While in service with the Royal Artillery during the Second World War, he discovered under a barrack room bed Whitman's *Leaves of Grass*, which led to wide reading in modern literature and to writing his own poetry, influenced by translations from the Chinese and by Joyce's *Finnegans Wake*. On leave in London in 1945, he was impressed by exhibitions of Klee and Picasso and made his first contact with modern English painting. His interest in primitive art was stimulated by African sculpture seen at the Berkeley Galleries, London, in 1946; that year also saw his first solo exhibition at an Edinburgh bookshop.

In 1947 he briefly became a full-time jazz musician, and in October married the artist-potter Janet Gaul. During his extensive travels through Europe in 1948 he met Peggy Guggenheim, who bought his *Music of the Autumn Landscape* and in whose collection he saw early paintings by Rothko, Motherwell and Pollock, with which his own work shows deep affinity. Returning to London in 1948, he made his living by making gold and silver jewellery; the first of many solo shows at Gimpel Fils took place in 1950. In 1955 he became interested in Zen Buddhism and oriental mysticism, and began recording a personal philosophy of creativity. On a visit to New York in 1956, he met the leading Abstract Expressionists but was as excited by the primitive art in the American Natural History Museum as by theirs. From 1956 to 1959

he held the Gregory Fellowship in Painting at the University of Leeds; he also gave a series of public lectures and broadcasts on his own work and on the creative act.

In 1960 he took up gliding, which exercised a considerable influence on his art. Many of his paintings of the 1950s had been concerned with eroticism, magic, primitive religion and sacrifice; in the 1960s this continued but in, for example, *Joy Stick*, 1962, a more light-hearted spirit becomes detectable. He was awarded the prize for the best foreign painter at the VII Bienal at São Paulo, Brazil, in 1963, and the first prize at the International Print Exhibition at Cracow in 1966. In 1971 his first record was produced; and from 1973 to 1975 he gave concerts and broadcasts with the Tony Oxley Group. The titles of recent exhibitions at Gimpel Fils, 'Homage to the Earth Spirits' (1981), 'Village Myths...' (1983) and 'Meditations and Hallucinations' (1985), testify to his continuing interest in the primitive and magical. He lives in Hertfordshire, Cornwall and St Lucia in the Caribbean.

G. W.

Alan Davie: Retrospective, London, Whitechapel Art Gallery, 1958
Alan Davie, Amsterdam, Stedelijk Museum, 1962
Alan Davie, Aberdeen, City of Aberdeen Art Gallery and Museum, 1977

Frank Dobson

was born in London on 18 November 1886; his father was a commercial artist specializing in flowers and birds. He was a scholarship student at Leyton Technical School and briefly attended the Hastings School of Art before working as a studio apprentice to the decorative sculptor Sir William Reynolds-Stephens from 1902 to 1904. For the next two years he lived in Cornwall and then in 1906 went as a scholarship student to Hospitalfield Art Institute in Arbroath, Scotland, where, beginning to draw from life and to paint in oils, he encountered French Impressionism for the first time. In London between 1910 and 1912 he attended classes at the City and Guilds School of Art in Kennington; the two Post-Impressionist exhibitions of 1910 and 1912 hit Dobson like an 'explosion'. Particularly impressed by the work of Gauguin, he began to frequent the British Museum to study primitive art. In 1913-14 he was in Cornwall, where he first tried his hand at sculpture in wood, from the start establishing himself as a pioneer of direct carving. A meeting with Augustus John led to Dobson's first one-man show – of paintings and drawings only – at the Chenil Gallery in 1914. In the same year he enlisted in the Artists' Rifles but his war service was curtailed by a stomach ulcer. Although he had little contact with other artists during the war, he did produce a number of portraits and war-incident scenes.

In 1919, after returning to Cornwall to get married (this marriage was to break up and Dobson remarried in 1926), he settled in Chelsea, London, intent on concentrating on sculpture. He was the only sculptor to feature in the 'Group X' show organized by Wyndham Lewis at Heal's Mansard Gallery in 1920 and in November of the following year he held his first one-man exhibition as a sculptor, at the Leicester Galleries. His early sculptures reveal an awareness of primitive carving as well as of Cubism and the work of Brancusi. In 1922 he joined the London Group and was soon to become its president (1924-8).

Dobson's reputation reached its zenith in the 1920s, partly due to the enthusiastic support of Roger Fry and other members of the Bloomsbury set. His sculptures of this period, praised for their 'purity', became increasingly Neo-Classical. By the early Thirties, however, his reputation was beginning to suffer an eclipse, from which it has never fully recovered. Although he received many public honours in the 1940s and was Professor of Sculpture at the Royal College of Art between 1946 and 1953, his work, with its almost exclusive concern with the female nude (although there are also a number of portrait busts), was increasingly dismissed as following the obsolete Classical tradition of Maillol and Despiau. None the less he was elected an ARA in 1942 and an RA in 1953. Dobson died in London on 22 July 1963.

M. B.-D.

Frank Dobson, CBE, RA, 1886-1963. Memorial Exhibition, London, Arts Council, 1966
Frank Dobson 1886-1963. True and Pure Sculpture, Cambridge, Kettle's Yard Gallery, 1981

Malcolm Drummond

was born at Boyne Hill, near Maidenhead in Berkshire, on 24 May 1880; his father, a canon, was of Scottish origin. After schooling in Henley and Birmingham, he read history at Christ Church, Ox-

ford, from 1898 to 1902, during which time he spent several months in Munich. On his graduation he followed his parents' advice to train as an estate agent but in 1903 he resolved to become a painter and entered the Slade School, which he attended until 1907. In 1906 he married Scottish-born Zina Lilias Ogilvie, who was also an artist, specializing in woodcuts, book illustration and, later, portraiture; they had one son and two daughters. From 1908 to 1910 Drummond studied at the Westminster School of Art under Walter Sickert, whose loyal disciple he soon became: he began frequenting the Saturday afternoon tea parties at 19 Fitzroy Street and in 1910 became a founder member of Sickert's etching class at Rowlandson House. It was in this year that he first exhibited with the Allied Artists' Association. A founder member of the Camden Town Group, although he lived in Chelsea, he exhibited at all three of its exhibitions at the Carfax Gallery, where his quiet, undemonstrative talent tended to be overshadowed by that of his more forceful colleagues; special friends within the Group were Gore and Ginner.

In 1914 Drummond became a founder member of the London Group, remaining a member until 1932 (in 1921 he acted as the Group's treasurer). While he stayed loyal to Sickert both personally and artistically, his work after c. 1910 shows signs of his admiration for the Post-Impressionists, notably Cézanne. In 1913 he sent three of his works to the Paris Salon des Indépendants, where they were well received. The outbreak of the First World War, however, forced Drummond to give up painting almost completely, and between 1915 and 1919 he worked first on munitions and then at the War Office. 1919 saw the beginning of a period of renewed artistic activity: the paintings that he produced in the 1920s of Chelsea Public Library, the Hammersmith Palais de Danse and the Law Courts are notable for their passages of pure colour and their tendency to simplification of form. A schoolboy convert to Catholicism, in 1922 he received the first of many commissions from the Church, for the *Sacred Heart* altarpiece for St Peter's Church in Edinburgh. In the late Twenties he taught at the Westminister School of Art but in 1931, the year of his wife's death, he left London for Moulsford in Berkshire, where he lived the rest of his life; in 1934 he married Margaret Trignet Browning. In 1937 Drummond lost the sight of one eye and six years later he became totally blind. He died in Moulsford on 10 April 1945 and his first one-man show was held posthumously that year, a small memorial exhibition included in the London Group show.

M. B.-D.

Malcolm Drummond 1880-1945, London, Arts Council, 1963
Malcolm Drummond 1880-1945, London, Maltzahn Gallery, 1974

Jacob Epstein

was born on 10 November 1880 in New York of Russian-Polish Jewish parents. In 1902 he went to Paris where he studied at the Ecole des Beaux Arts and later at the Académie Julian. During this time visits to the Louvre aroused his interest in ancient and primitive sculpture, an interest which was to last all his life and influenced much of his carved work. In 1905 he moved to London and in 1907 became a British citizen. In that same year he received his first commission, to carve eighteen

figures for the British Medical Association's headquarters in the Strand. The emphatic nudity of the figures and the theme of procreation offended public taste and a furore of abuse arose. The figures were mutilated in 1935 when the building was acquired by the Rhodesian government.

From 1911 he worked on his monumental *Tomb of Oscar Wilde*, which was installed in the Père Lachaise cemetery in Paris. Epstein showed the poet as 'a winged demon angel', but the authorities were outraged, again because of the nudity of the figure. While in France Epstein met Brancusi whose work had a profound effect upon his own during the next five years. On his return to England in 1913 he rented a bungalow near Hastings in Sussex for three years, during which time he produced a group of carvings which constitute his greatest contribution to the history of modern sculpture. They include carvings in flenite and three pairs of mating doves.

Although not a member of the Rebel Art Centre, Epstein was briefly associated with the Vorticists and Wyndham Lewis; he exhibited the original version of *The Rock Drill*, a mechanistic plaster figure of a man mounted on a real mining drill, with the London Group in 1915, and contributed two drawings to the first number of the Vorticist magazine *Blast* (June 1914).

Epstein's large carved sculptures aroused controversy and public antagonism throughout his life, mainly because of their primitivism and expressive distortion. His principal commissions were *Rima*, 1925, for the W. H. Hudson memorial in Hyde Park, and the figures *Night* and *Day*, 1929, for St James's Park Underground headquarters, after which he received no public commissions for twenty-two years. Among his other important carved sculptures are *Genesis*, 1930, *Ecce Homo*, 1934, and *Consummatum Est*, 1937.

From the 1920s he devoted himself more and more to modelling portrait busts for casting in bronze, the best known of which is probably his portrait of *Albert Einstein*, 1933. They are regarded by many as his most successful accomplishments; in them he achieved exceptional sensitivity and psychological insight, continuing the Romantic tradition of expressive naturalism stemming from Rodin. Among his large bronze groups are *Madonna and Child* for the Convent of the Holy Child of Jesus in Cavendish Square, London, 1951, *Christ in Majesty* for Llandaff Cathedral, 1954, and *St Michael and the Devil* for Coventry Cathedral, 1957.

Throughout his life Epstein drew continuously from the figure and painted watercolours of landscapes and still-lifes. He died on 19 August 1959, a man of wide culture, fond of poetry and music, and an exceptional collector of primitive art, especially African.

M. R. B.

Jacob Epstein. Memorial Exhibition, London, Tate Gallery, 1961
Jacob Epstein. The Rock Drill Period, London, Anthony d'Offay Gallery, 1973
Epstein Centenary, 1980, London, Ben Uri Art Gallery, 1980

Barry Flanagan

was born on 11 January 1941 in Prestatyn, Flintshire, North Wales; his father was an employee of Warner Brothers. He was educated at Foxhunt Manor Preparatory School and Mayfield College, Sussex. He enrolled at Birmingham College of Arts and Crafts as an architecture student in 1957, transferring the following year to the Fine Art Department. 1960 saw him in London working on sets for *Cleopatra* and gilding for the frame-maker Robert Savage, amongst other jobs. He also spent some time at various art schools, including St Martin's, where he attended Caro's Friday evening classes. He did not, however, become a full-time student there until 1964; in the meantime, having spent three weeks at Flintshire Technical College, he went in 1961 to Montreal, where he met a number of poets; in 1963 he married Sue Lewis, a student at the Old Vic Theatre School; and early in 1964 he discovered and became a fan of Alfred Jarry. In addition to his sculptural studies at St Martin's, where his personal tutor was Phillip King, he co-edited the periodical *Silâns*, in which he published some of his own poems; and in 1965 he took part in the 2nd International Exhibition of Experimental Poetry at St Catherine's College, Oxford.

His first solo exhibition was at the Rowan Gallery, London, in 1966. Exhibitions in Italy and Germany followed, and he made his first visit to New York for his exhibition there, at the Fischbach Gallery, in 1969. It was in that year too that the Tate Gallery purchased his *aaing j gni aa*. He made his first etching in 1970. In 1972 he received a Gulbenkian Foundation grant to work with the London dance group Strider and in the autumn attended dance classes given by Carolyn Carlson at The Place, London.

Around 1973 a shift occurred in his work towards more conventional materials. He re-took up carving in stone and visited the atelier of Balderi at Pietrasanta, Italy: amongst the works which followed were several in which he seemed to be drawing into the surface of the stone. Having been tutored by the potter Ann Stokes in 1974, he made a series of coil, pinch and squeeze pots; some bronzes of the early 1980s were closely related to these. He had first worked with bronze as a student at Birmingham and in 1979 he began bronze casting at A&A Sculpture Casting, London: his first *Leaping Hare* was cast there on 7 November 1979. A single gilded gesso hare was exhibited along with stone sculpture at his first show at the Waddington Galleries, London, in 1980; many bronze hares, leaping, prancing and otherwise, were made in the following two years. In 1982 he was chosen to represent Britain at the Venice Biennale. The work shown there was exhibited again at the Whitechapel Art Gallery, London, in January 1983, and from March to May there was a major retrospective exhibition at the Centre Georges Pompidou, Paris. Some bronze horses cast in 1983 were inspired by the horses of San Marco in Venice, which he studied under restoration when he was in Venice in 1982.

G. W.

Barry Flanagan, Eindhoven, Van Abbemuseum, 1977
Barry Flanagan, Paris, Museé national d'art moderne, Centre Georges Pompidou, 1983
Barry Flanagan. Recent Sculpture, New York, Pace Gallery, 1983

Lucian Freud

was born in December 1922 in Berlin, son of Ernst Freud, the architect, and a grandson of Sigmund Freud. In 1932 he came to England with his parents and went to school at Dartington Hall; he was naturalized in 1939. He studied at the Central School of Art and at Goldsmiths' College, and spent a short period before the war at the art school run by Cedric Morris and Lett Haines in Suffolk. He returned there for several visits after he was invalided out of the Merchant Navy in 1942, at which time he began to work as a full-time artist; he had his first exhibition at the Lefevre Gallery in 1944 with Julian Trevelyan and Felix Kelly. His drawings and paintings of meticulous accuracy and pitiless observation drew the comment from Herbert Read, 'Lucian Freud – the Ingres of Existentialism'.

His early paintings of his first wife Kitty have an intensity which is in part due to the exaggeration of the facial features, especially the eyes, which stare fearfully out at the observer. A sense of unease and dislocation permeates all Freud's portraits. In 1952 he painted *Francis Bacon* (Tate Gallery), a small portrait definable as Magic Realist, in which every line on the sitter's face is visible and each strand of hair discernible. Throughout the 1950s Freud continued to paint in this delicate and probing manner.

A change in his style can be distinguished in the late 1950s when he started to use hog rather than sable brushes, resulting in a greater fullness. *Woman Smiling*, 1958-60, is the crucial painting in this development. He has said: 'I want paint to *work as flesh*.... I would wish my portraits to be *of* people, not *like* them.... As far as I am concerned the paint *is* the person. I want it to work for me as flesh does.'

The bulk of Freud's work is portraiture: self-portraits or portraits of people whom he knows well, primarily women. He works from the model, slowly, over a long period. 'I am never inhibited by working from life. On the contrary I feel more free. I can take liberties which the tyranny of memory would not allow.' His portraits of his mother from the late 1970s show a profundity of psychological insight into the well-worn face of an old woman which invites comparison with the late Rembrandt.

Freud's work was shown at the Venice Biennale in 1954 together with that of Ben Nicholson and Francis Bacon, and between 1958 and 1968 at the Marlborough Gallery, London. In 1974 the Arts Council arranged a retrospective exhibition at the Hayward Gallery. Freud continues to paint from people he knows, sometimes with Old Master references. His *Large Interior W. 11 (after Watteau)*, 1983, was inspired by a painting in the collection of Baron Thyssen, whose portrait he was painting. He also paints still-lifes of flowers and leaves, such as *Two Plants*, 1977-80 (Tate Gallery), which seem to reflect an almost pantheistic identification with nature.

M. R. B

Lucian Freud. Recent Work, London, Marlborough Fine Art, 1968
Lucian Freud, London, Arts Council, 1974
Lawrence Gowing, *Lucian Freud*, London and New York, Thames and Hudson, 1982

Henri Gaudier-Brzeska

was born Henri Gaudier at St Jean-de-Braye, near Orléans, on 4 October 1891, the son of a craftsman-carpenter. Educated at St Jean-de-Braye and at Orléans, he visited London for two months in

1906 on a travelling scholarship and in 1907 won a second scholarship to spend two years in Bristol and Cardiff studying English business methods. Sketchbooks from these years show painstaking studies of plant, bird and animal life, often from the zoo, and of architecture. In 1909 a further bursary enabled him to spend several months in Nuremberg and Munich. The drawings that he produced on his return to Paris reveal a new interest in the human form. Employed during the day in a variety of different jobs, he read about art in the evenings at the Ste Geneviève library, where in 1910 he met Sophie Brzeska, a Polish woman twenty years his senior, whose name he was soon to add to his own. In 1910, due to ill-health, he returned home to St Jean-de-Braye with Sophie but following the eruption of a family scandal over their relationship, the couple left for Paris. By early 1911 they were living in London, lonely and with little money to their names, although Gaudier-Brzeska continued to study art avidly in libraries and museums.

In 1912, however, he began to make important contacts in the London artistic and literary world, meeting Katherine Mansfield and Middleton Murry and making friends with Horace Brodzky, Wyndham Lewis, Ezra Pound and Epstein. Starting to model portraits and to work in clay (producing in the main small animal studies from his zoo drawings), he was inspired by Epstein's example to try his hand at stone carving. In 1913 he exhibited with the Allied Artists' Association and gave up his job as clerk with a shipping broker in order to devote himself 'entirely to my art'. Although briefly affiliated in 1913 with Fry's Omega Workshops, he soon allied himself with the Rebel Art Centre and the Vorticists, participating in their 1915 exhibition and contributing to both issues of *Blast*, while also exhibiting again with the AAA and with the London Group.

He left England in September 1914 to fight for France and on 5 June 1915 was killed during an infantry charge at Neuville-Saint-Vaast. His death at the age of twenty-four halted a sculptural career that already seemed one of the brightest in England. While eclectic in his choice of sources and ofen stylistically inconsistent from one work to another, he developed with extraordinary rapidity. His most characteristic work combines a profound admiration for primitive sculpture with an understanding of Cubism, an innate sense of 'truth to materials' and a fierce and restless energy that is very much his own. Sophie Brzeska devoted the three years following her lover's death to promoting his reputation, achieving her ambition of a memorial exhibition of his work at the Leicester Galleries in 1918.

M. B.-D.

Ezra Pound, *Gaudier-Brzeska. A Memoir*, London, John Lane/Bodley Head, 1916
Roger Cole, *Burning to Speak. The Life and Art of Henri Gaudier-Brzeska*, Oxford, Phaidon, 1978
Henri Gaudier-Brzeska. Sculptor 1891-1915, Cambridge, Kettle's Yard Gallery, 1983

Mark Gertler

was born on 9 December 1891 in Spitalfields of Jewish parents who had emigrated to East London from the Polish region of the Austro-Hungarian Empire. For financial reasons the family went back to Austria for three years, settling permanently in East London in 1896. After ten years at local schools the young Gertler, chancing upon Frith's

autobiography, determined to become an artist, though his experience of art had been only of advertisements and the work of pavement artists. He attended art classes at the Regent Street Polytechnic but in 1906-7 lack of money resulted in his apprenticeship at Bell's Stained Glass Works. Through the support of William Rothenstein, the Jewish Educational Aid Society arranged for him to attend the Slade School; there he won a scholarship and several prizes, with praise for his ability in drawing. He became friends with Nevinson, Stanley Spencer, Roberts, Wadsworth, Paul Nash and Dora Carrington, with whom he later had a traumatic love affair until she left him for Lytton Strachey in 1917. At this time his life revolved around the polarities of the enclosed world of his family and the wider one of his friends from the upper ranks of society. His social gifts made him the life and soul of many parties, yet he suffered from morbid depressions throughout his life.

His early portraits and still-lifes, painted in a traditional style, gave way to a tougher, more deliberately primitive approach, parallel to that of Stanley Spencer whom he visited at Cookham in 1915. That year he lived at the home of Gilbert Cannan, through whom he met D. H. and Frieda Lawrence, Middleton Murry, Katherine Mansfield and Lytton Strachey. Cannan's book *Mendel* (1916) is based on the life of Gertler, who painted a Neo-Primitive tribute to his friend, *Gilbert Cannan at his Mill*, in 1916. He turned to more lyrical paintings, often made on visits to Garsington, where he stayed regularly from 1917 to 1927. There he met Roger Fry, who invited him to work for Omega Workshops in 1918.

In 1920 tuberculosis was diagnosed and from then onwards Gertler had to spend periods in sanatoria. The seductive nudes and rich female portraits of the Twenties gained him fame as an acceptable 'modern' artist, somewhat indebted to Renoir. He became increasingly dissatisfied by the representation of figures and still-life with smooth paint and rounded modelling, and in the early Thirties he flattened the picture space and reactivated the picture surface by means of simplified forms rendered with increasingly tactile brushstrokes. This radical change, prompted by regular visits to France, lost him success and his exhibition at the Leicester Galleries in 1934 was a failure. By this time he had married Marjorie Hodgkinson, who had also studied at the Slade; their son was born in 1932. A student at the Westminster Tech-

nical Institute (where he had begun teaching evening classes in 1931) remembered him remarking: 'I think I could have been a good painter if I hadn't chosen to be a fashionable one.' He took his own life on 23 June 1939 in his London studio as a result of acute depression.

S. C.

Gilbert Cannan, *Mendel*, London, Fisher Unwin, 1916
Mark Gertler 1891-1939, Colchester, The Minories, 1971
Mark Gertler – the early and the late years, London, Ben Uri Art Gallery, 1982

Gilbert & George

were born, respectively, on 17 September 1943 in the Dolomites of Ladino stock, and on 8 January 1942 in Devon. Gilbert studied at the Wolkenstein School of Art in South Tyrol, Italy, the Hallein School of Art, Austria, and at the Academy of Art, Munich. George studied at Dartington Adult Education Centre and Dartington Hall College of Art, Devon, and at the Oxford School of Art. They met in 1967 when they were both studying sculpture at St Martin's School of Art, London. Their first collaborative exhibition was at Frank's Sandwich Bar in 1968, which comprised 'object-sculptures'. Soon, however, they were radically to broaden the definition of sculpture to include 'postal sculptures', 'magazine sculptures' and, most importantly, 'living sculptures' in which they used themselves, already neatly attired in suits and ties, their faces and hands metalized. The most famous of these was *Our New Sculpture* (1969), later retitled *Underneath the Arches*, 'sculpted' to a tape of the song by Flanagan and Allan.

If one, urban, side of their work involved an identification with tramps, another turned towards a rural idyll: time spent in the countryside in summer 1970 was celebrated in several series of 'charcoal on paper sculptures', where pieces of paper were joined together to form huge sheets, and in the six triptychs *The Paintings (with Us in the Nature)* (1971). The first photo-pieces, also of 'nature', date from 1971 and were shown at Art and Project, Amsterdam. From 1972 to 1974 a large part of the subject-matter of these photo-pieces was alcohol: drinking pieces led to the *Human Bondage* and *Dark Shadow* works of 1974. Then in *Cherry Blossom*, also of 1974, inspired by their interest in oriental martial arts, the first colour, red, made its appearance in their work. The first pre-

sentation of *The Red Sculpture*, in which their faces and hands were coated with bright red pigment, was at the Art Agency, Tokyo, in 1975. After its last presentation – at the Stedelijk Museum, Amsterdam, in 1977 – they gave up doing 'living sculpture presentations', although they themselves may still be considered 'living sculptures' in the sense that they see their whole life-style as a work of art. Following *Red Morning* (early 1977), their photo-pieces acquired a new strength. For some time they had tended to be symmetrical, mandalic and cruciform: to the symbolic connotations of this, the work of late 1977, incorporating graffiti, added remarkably original insights into connections between sex, violence and politics.

In 1980, while their photo-pieces of the Seventies were being shown in a touring retrospective, other colours, starting with yellow, began to enter; and their work of the Eighties is characterized, visually, by its vivid colour. Its look has also been considerably altered by the introduction of photograms and drawn images. In 1981 they made the film *The World of Gilbert & George*, which summarizes most of their principal concerns. A major exhibition toured the United States in 1984-5, and in May 1986 the exhibition 'Gilbert & George. The Charcoal on Paper Sculptures 1970-1974' with 'Pictures 1982 to 1985' opened in Bordeaux, the latter subsequently touring through Europe to finish at the Hayward Gallery, London, in July to September 1987. This is accompanied by the publication of a catalogue containing all their photo-pieces, or 'pictures' as they now more simply call them, from 1971 to 1985.

G. W.

Gilbert & George, Baltimore, Museum of Art, 1984
Gilbert & George. The Charcoal on Paper Sculptures 1970-1974, Bordeaux, CAPC Musée d'art contemporain de Bordeaux, 1986
Gilbert & George. The Complete Sculptures 1971-1985, London, Thames and Hudson, 1986

Eric Gill

was born in Brighton, Sussex, on 22 February 1882, the second of thirteen children born to a Nonconformist (later Church of England) clergyman and a former professional singer. In 1897 Gill became a student at Chichester Technical and Arts School and in 1899 attended Edward Johnston's lettering class at the Central School of Arts and Crafts, where he also learnt masonry and stone-cutting. From 1899 he worked in the architectural offices of the Ecclesiastical Commissioners but in 1903 he decided to become a professional stone-cutter. Three years later he was beginning to move in illustrious artistic circles and making his first attempts at wood engraving.

In 1907 the Gill family – he had married Ethel Moore in 1904 – moved to Ditchling, Sussex. His first figure in stone was carved in 1910 and at this time he began to concentrate on sculptural projects. He and his wife were received into the Roman Catholic Church in 1913 and he was exempted from military service in 1914 to work on the *Stations of the Cross* for Westminster Cathedral. By the middle of the war a number of Gill's London friends had moved to Sussex and the 'Ditchling Community' began to take shape. In 1918 the Gills were invested as novices in the Third Order of St Dominic, and Gill spent four months of non-active service in the RAF; after the war he received numerous commissions for war memorials. In

1921 the Ditchling Community formed itself into the Guild of St Joseph and St Dominic; but in 1924 Gill moved to Capel-y-ffin in the Welsh Black Mountains, where he was soon joined by other members of the Community. In 1925 he made a pilgrimage to Rome, via Paris, and in 1926-7 met Zadkine and Maillol. The Gills moved to 'Pigotts', near High Wycombe in Buckinghamshire, in 1928, and Gill began to execute sculpture for the London Underground Railway headquarters at St James's; a year later he was commissioned to carve sculptures for the façade of Broadcasting House. In 1933 he became a founder member of the Artists International founded to oppose Fascism and war, and in 1934 he visited Palestine. From the mid-Thirties onwards he received a large number of public honours, including being elected an ARA in 1937. His largest project, the panels for the League of Nations building in Geneva, was completed in 1938, and in 1939 he designed a church at Gorleston-on-Sea, near Yarmouth. Gill died, of lung cancer, in Uxbridge, on 17 November 1940.

As well as being a stone-carver, Gill worked as a printmaker and typographer. He was also a fierce if idiosyncratic polemicist, whose ideas owed much to Carlyle, Ruskin, Morris and Coomaraswamy. His sculptures reveal his great admiration for medieval and Indian art and culture, as well as his belief in a 'truth to materials' approach; like his work in all fields, they are part of his self-confessed attempt to reintegrate 'bed and board, the small farm and the workshop, the home and the school, earth and heaven'.

M. B.-D.

Eric Gill, *Autobiography*, London, Jonathan Cape, 1940
Robert Speaight, *The Life of Eric Gill*, London, Methuen, 1966
Malcolm Yorke, *Eric Gill: Man of Flesh and Spirit*, London, Constable, 1981

Harold Gilman

was born at Rode, Somerset, on 11 February 1876; his father was a Church of England parson. During eighteen months convalescence from a hip injury incurred at Tonbridge School, he first discovered his interest in art, and after spending 1894 at Oxford and 1895 in Odessa he attended Hastings School of Art and then the Slade (1897-1901).

There he established a lifelong friendship with Spencer Gore. In 1902-3 he spent a year in Spain, where he admired and copied the work of Velazquez with Grace Candy, a painter from Chicago, whom he married. On his return he exhibited at the New English Art Club (1904); afterwards he and his family paid an extended visit to Chicago where his father-in-law attempted to get him to work in his firm. However, he found it impossible not to paint and they returned to poverty in England. His early works are smoothly textured, low-keyed harmonies of greys and browns revealing a debt to Velazquez, Whistler and Manet. Following his marriage and the birth of two daughters, his paintings show greater intimacy and compositional sublety.

As a result of a chance encounter with Sickert in February 1907, he became a founder member of the Fitzroy Street Group. His work began to show Sickert's influence in its use of broken brushwork and, later, a choice of unglamorous subject-matter, although he was already using lighter tones and his touch was already more deliberate. Lucien Pissarro's influence was evident, too, in Gilman's admiration for the Impressionist approach to pure colour. Sickert lent the Gilmans his house outside Dieppe in 1907-8, and in 1908 Gilman helped to found and showed at the first exhibition of the Allied Artists' Association. The family then moved to Letchworth, Hertfordshire, but in 1909 his wife and children went on holiday to America where Grace became very ill and solely through Gilman's lack of money and her father's unwillingness to help she was unable to return.

Gilman had already been alerted to the work of the Post-Impressionists by Ginner and the first Post-Impressionist Exhibition of 1910, followed by a trip to Paris in late 1910 or 1911, proved crucial. In 1911 he became a founder member of the Camden Town Group; in 1913 he became the London Group's first president, and in 1914 he helped found the Cumberland Market Group and shared an exhibition with Ginner at the Goupil Gallery. He painted in Sweden in 1912, and in Norway in 1913. His 'mosaic style' of *c.* 1911-15, with its small broken brushstrokes, was modified soon after 1914 in favour of firmer outlines and flatter planes of colour.

Between 1914 and 1915 he taught at the Westminster School of Art (and met fellow painter Sylvia Hardy whom he married in 1917). In 1916 he established with Ginner an art school in Soho, which lasted until the end of 1917: his paintings had the intimacy of Vuillard's interiors – especially distinctive are those of his wife and son, with their

brilliant colouring. In 1918 he visited Nova Scotia, having received his first major commission from the Canadian government. He finished the painting (of Halifax Harbour for the War Memorial in Ottowa) at 33 Parliament Hill, Hampstead, where he died on 12 February 1919, a victim of the Spanish influenza epidemic.

M. B.-D.

Wyndham Lewis and L. Fergusson, *Harold Gilman: An Appreciation*, London, Chatto and Windus, 1919
Harold Gilman 1876-1919, London, Arts Council, 1954
Harold Gilman 1876-1919, London, Arts Council, 1981

Charles Ginner

was born in Cannes, France, the son of an English physician and a mother of Scottish descent, on 4 March 1878, and was educated at the Collège Stanislas in Cannes. Leaving for Paris in 1899, he worked in an architect's office until 1904 and then, finally overcoming parental opposition to his long-held artistic ambitions, studied painting at the Académie Vitti and at the Ecole des Beaux-Arts. He left the latter in 1908 and worked on his own in Paris, taking Van Gogh, Gauguin and Cézanne as his mentors, as opposed to the Impressionists favoured by his teachers. After a voyage to Buenos Aires in 1909, where an exhibition of his own work helped to introduce Post-Impressionism to the Argentine, he settled in London later that year, largely due to the persuasiveness of his friends Gilman and Gore whom he had first met in 1908 when exhibiting with the Allied Artists' Association. Ginner soon entered the 19 Fitzroy Street circle, and was a founder member of the Camden Town Group (1911), the London Group (1913) and the Cumberland Market Group (1914). In 1912 he painted murals for Mme Strindberg's Cave of the Golden Calf nightclub.

As a painter with direct personal knowledge of French Post-Impressionism, Ginner was much looked up to by his English contemporaries. In April 1914 he and Gilman held a joint exhibition at the Goupil Gallery and prefaced the catalogue with an article entitled 'Neo-Realism' written by Ginner and originally published in the *New Age* on 1 January. In it he dismissed Post-Impressionism in its English guise as 'the New Academicism' and insisted that 'the aim of Neo-Realism is the plastic interpretation of life through the intimate research into Nature'. Realism did not, however, Ginner

argued, rule out the possibility of decorativeness – a form of special pleading, since a preoccupation with texture and pattern remained with Ginner all his life. Street scenes formed his primary subject-matter at this period, painted in a lower key than in Gilman's work so as to achieve a greater richness of colour. Figures were observed at firsthand and drawn with heavy outlines. Ginner and Gilman shared a teaching studio in Soho between 1916 and 1917 but the latter's premature death in 1919, following on that of Gore in 1914, left Ginner both personally and artistically stranded.

Drafted into the Army in c. 1916, Ginner served first as a private in the Royal Army Ordnance Corps, then as a sergeant in the Intelligence Corps. Later, he was put to work for the Canadian War Records Office as an Official War Artist. In 1920 he joined the New English Art Club. In 1942 he was elected an ARA; in 1945 he was made a member of the Royal Watercolour Society and in 1950 a CBE. During the Second World War he again served as an Official War Artist, specializing in harbour scenes and bomb-damaged buildings in London. He died in London on 6 January 1952.

M. B.-D.

Charles Ginner: Paintings and Drawings, London, Arts Council, 1953
Charles Ginner, London, Piccadilly Gallery, 1969
Charles Ginner, London, Fine Art Society, 1985

Spencer Gore

was born on 26 May 1878 in Epsom, Surrey, the son of Spencer Walter Gore, Surveyor to the Ecclesiastical Commissioners and an early lawn tennis champion, and his wife, Amy Smith, a solicitor's daughter. His boyhood was spent at Holywell, his parents' home in Kent. At Harrow he won the Yates Thompson Prize for drawing, and between 1896 and 1899 studied at the Slade, forming a close friendship with fellow student Harold Gilman. In 1902 he visited Spain with another Slade contemporary, Wyndham Lewis. In 1904, together with Albert Rothenstein (later Rutherston), he visited Sickert in Dieppe. For Gore this marked the beginning of a more intimate knowledge of recent French painting, while Sickert was encouraged by the enthusiasm of the two younger men to focus his thoughts on a return to London. This first trip to France was followed by two others, in 1905 and 1906, when Sickert lent Gore his house at Neuville, near Dieppe, for several months. Later summers were spent painting in Yorkshire, Hertingfordbury in Hertfordshire – his mother's home after his father's death, Somerset and Letchworth.

In 1905 Gore became a member of the 19 Fitzroy Street circle and there came into close contact with Lucien Pissarro, from whom he gained a greater insight into Impressionist and Neo-Impressionist working methods. Up to this point Gore was painting primarily landscapes influenced initially by Steer and then by Corot and Sisley. Partly under the influence of Sickert, but already with a greater concern for colour and a tendency to decorativeness, he embarked in 1906 on a series of music hall and ballet scenes as well as a number of landscapes indebted in part to both Pissarros, all of which, however, reveal a far more personal assimilation of French Impressionism than was previously the case. In 1908 Gore with Gilman helped to found the Allied Artists' Association and in 1909 he joined the New English Art Club. In 1911 he

became a founder member and first president of the Camden Town Group, and in 1913 he joined the London Group.

Under the impact of the 1910 and 1912 Post Impressionist exhibitions (the latter featured Gore's work in its English section), Gore's paintings show a Gauguinesque interest in pattern-making combined with an awareness of Matisse; this was soon replaced by a greater concern for the structures underlying the natural world, with the influence of Cézanne being uppermost and particularly evident in the late views of Richmond – where Gore moved, from Camden Town, in 1913. In 1912 he supervised a scheme for mural decorations in the Cave of the Golden Calf nightclub; a surviving design suggests affinities with early Kandinsky. On 25 March 1914 he got wet while out painting, contracted pneumonia and by 27 March, aged thirty-five, was dead. Wyndham Lewis, in an obituary, ranked his theatre paintings above those of Degas; while Sickert praised him (also posthumously) for his ability to 'take a flint and wring out attar of roses'.

M. B.-D.

Spencer Frederick Gore, 1878-1914, London, Arts Council, 1955
Spencer Frederick Gore 1878-1914, London, Anthony d'Offay Gallery, 1974
Spencer Frederick Gore 1878-1914, London, Anthony d'Offay Gallery, 1983

Lawrence Gowing

was born on 21 April 1918 in Stamford Hill, London. He was introduced to painting by Maurice Feild, who taught at a Quaker school in Herefordshire which Gowing attended from 1927 to 1932; the experience of painting in the open countryside made a lasting impression on him. In 1936 Feild's friend W. H. Auden sent him a letter of introduction to William Coldstream, who with Pasmore and Claude Rogers set up the School of Painting and Drawing in Fitzroy Street, later to move to Euston Road: Gowing enrolled as their student and followed Coldstream's example closely. In 1937 he met Adrian Stokes and in 1938 Stephen Spender and Julia Strachey, to whom he was later married (1952-66).

During the Second World War, excused active service on conscientious grounds, he painted in Wiltshire and Chelsea. From 1944 to 1947 he taught at Camberwell School of Art; from 1948 for

ten years he was Professor of Fine Art at Kings College in the University of Durham, Newcastle; in 1959 he became Principal of Chelsea School of Art; from 1965 to 1967 he was Keeper of British Art and Deputy Director of the Tate Gallery, before taking up the Professorship of Fine Art at Leeds University until 1975. His output included sensitive portraits, still-lifes and, especially, landscapes; his love of woodland scenes in particular was already evident in the paintings executed during the summers of 1946 and 1947 in Sutton, West Sussex. The handling of paint in some woodland scenes of the mid-1950s shows the influence not only of his mentor Coldstream but also of Cézanne, an exhibition of whose work (in Edinburgh and London) Gowing helped organize in 1954.

During the early 1960s he became ever more conscious of the space in his woodland pictures as essentially concave, seeing the image as a 'fabric of colour pulled towards me at the four corners of the canvas and bellying away into space in the centre'. This, together with what for him was the intensely sensual experience of painting in the woods – which enabled him to feel a Pan-like affinity between the natural world of vegetation and the sexually desiring human body – paved the way for an extreme change in his work, which occurred in 1976. Recognizing the whole human body as the paradigm of the unity that he had always sought from art, he began using his own body as a sort of template in front of the picture surface, the paint being applied by an assistant. Both the cosmic and the sexual implications of this direct body-painting were emphasized by his arms and legs being outstretched like Vitruvian man, the wrists and ankles secured to bondage equipment, simultaneously recalling masochism and martyrdom.

The move from somewhat conservative to extremely radical artistic practice may in part be connected with his understanding of the deeper implications of the ideas of Adrian Stokes, whose *Collected Writings* (1978) he edited. He has also written books on other artists, including Matisse (1979) and Freud (1982), as well as organizing several major exhibitions. For ten years until 1985 he was Slade Professor of Fine Art, University of London; he was elected an ARA in 1978; a touring retrospective was organized by the Arts Council in 1983, the year after he received a knighthood.

G.W.

Lawrence Gowing, London, Marlborough Fine Art, 1965
Lawrence Gowing, Studies from Nature, London, Waddington Galleries, 1982
Lawrence Gowing, London, Arts Council, 1983

Duncan Grant

was born on 21 January 1885 at Rothiemurchus, Inverness, but his early childhood was spent in India where his father's regiment was serving. After schooling as a day boy in the 'army' class at St Paul's School, he attended Westminster School of Art, encouraged by his relations, the Stracheys. The exceptional intellectual and artistic atmosphere of their home, where Grant was based for the whole of this period, ran counter to the formal art teaching that he was receiving, and he spent 1907 at La Palette in Paris. In London the following year, through his cousin Lytton Strachey, he became part of the Bloomsbury circle which revolved around the home of Vanessa and Clive Bell. In 1909 he became close friends with Roger Fry and was deeply affected by the Post-Impressionist exhibitions arranged by Fry in 1910 and 1912, for although he had visited Gertrude and Michael Stein's flat in Paris and had met Matisse and Picasso, he had continued to paint in a conventional manner until 1910. The impact of these London exhibitions was reinforced by a visit to Turkey, where he came under the spell of Byzantine mosaics.

In 1911 he exhibited with the Camden Town Group and, with Roger Fry and others, received a commission for two panels for the dining hall of the Borough Polytechnic. Work on decorative projects was then heralded as a way of enabling artists to live without teaching and, with this aim, in 1913 Grant was one of the founders of the Omega Workshops with Fry and Vanessa Bell. In the same year he was commissioned by Jacques Copeau to design costumes and sets for *Twelfth Night* at the Vieux Colombier theatre in Paris, which led to invitations to design for British theatres. As a pacifist Grant served as a farm labourer in the war years, first in Suffolk and then at the Sussex farmhouse, Charleston, bought by Maynard Keynes so that Grant and David Garnett could discharge their national service obligations by agricultural work. In 1918 Grant urged Keynes to persuade the British government to buy works from the sale of the Degas collection in Paris: as a result, pictures by Ingres, Delacroix, Corot and Manet were acquired by the National Gallery. After the Omega Workshops closed in 1919, Grant continued with Vanessa Bell to decorate town and country houses: as an easel painter his reputation between the two World Wars can be gauged by the title of an exhibition at Agnews in 1934, 'From Gainsborough to Grant'. He often travelled in France, in the summers painting at the Bells' house in Cassis.

As the outbreak of war began to seem inevitable he joined the Advisory Committee of the pacifist Artists International Association; thirty-nine of his works selected for the Venice Biennale of 1940 were shown in London instead. A retrospective was held at the Tate Gallery in 1959; four exhibitions simultaneously celebrated his ninetieth birthday in 1975. He died on 9 May 1978 and was buried in Firle churchyard near Charleston, next to his lifelong companion, Vanessa Bell.

S.C.

Paintings by Duncan Grant from 1910 to 1929, London, Paul Guillaume Gallery, 1929
Duncan Grant. A Retrospective Exhibition, London, Tate Gallery, 1959
Duncan Grant. A Ninetieth Birthday Exhibition of Paintings, Edinburgh, Scottish National Gallery of Modern Art, 1975

Richard Hamilton

was born on 24 February 1922 in London. He began attending art classes when he was twelve; on leaving school at fourteen, he worked in an advertising department, attending evening classes at St Martin's School of Art and Westminster Technical College, and then as a display assistant in a commercial studio which also provided a life class. In 1938 he became a student at the Royal Academy Schools, continuing until its wartime closure in 1940. After war service as an engineering draughtsman, he resumed his studies there in 1946, but under the new presidency of Sir Alfred Munnings the atmosphere was uncongenial and Hamilton was expelled, which made him liable for eighteen months' military service. In 1947 he married Terry O'Reilly, a marriage ended by her death in 1962. From 1948 to 1951 he was a student at the Slade School of Art, where his fellow student Nigel Henderson introduced him to d'Arcy Thompson's book *On Growth and Form* and Duchamp's *Green Box*. Hamilton devised the exhibition 'Growth and Form' at the Institute of Contemporary Arts in 1951, to be followed and complemented by the exhibition 'Man, Machine and Motion' which he organized in 1955 at the Hatton Gallery, Newcastle-upon-Tyne, helped by students at the University, where he had started teaching in 1953. His own paintings at this time were largely concerned with motion and perspective, taking up issues from Cézanne, Cubism, Futurism and chronophotography. He was a

founder member of the Independent Group at the ICA in 1952 and it was his contribution to the 'This Is Tomorrow.' exhibition at the Whitechapel Art Gallery in 1956 which acted virtually as a manifesto for the Pop Art movement, in which he was to play a major part. Ever since then, his paintings and prints have engaged with countless aspects of popular culture and styling, as well as investigating the borderline between hand-made and mechanically made imagery. In 1957 he began teaching interior design one day a week at the Royal College of Art, London, and in 1958 he designed a 'Gallery for a Collector of Brutalist and Tachiste Art' for the Ideal Home Exhibition at Olympia.

A typographic rendering of Duchamp's *Green Box*, which he had started in 1957, was published in 1960. Three years later he made his first visit to the United States in the company of Duchamp, and in 1965 he began reconstructing Duchamp's *Large Glass*, finished in time for the exhibition 'The Almost Complete Works of Marcel Duchamp' which he organized at the Tate Gallery, London, in 1966.

One of several joint ventures between Hamilton and Dieter Roth was the exhibition 'Collaborations' at the Galeria Cadaques, Spain (1976) and the ICA, London (1977), accompanied by the book *Collaborations of Ch. Rotham: a scatological element related this to a series of pictures executed during the 1970s, inspired by an advertisement, featuring toilet paper in a soft romantic landscape. Hamilton was also engaged throughout the 1970s on a project, initially instigated by the Japanese Lux Corporation in 1973, involving the physical inclusion of their latest hi-fi equipment within the work. A book of his writings, *Collected Words*, was published in 1982. In 1983 he collaborated with Rita Donagh on an exhibition at the Orchard Gallery, Londonderry, based on the Maze Prison. A retrospective of his prints, entitled 'Image and Process', was held at the Tate Gallery in 1983-4.

G.W.

Richard Hamilton, Paintings etc. '56-64, London, Hanover Gallery, 1964
Richard Hamilton, London, Tate Gallery, 1970
Richard Hamilton Image and Process. Studies, stage and final proofs from the graphic works, 1952-82, London, Hansjorg Mayer/Tate Gallery 1983

Barbara Hepworth

was born on 10 January 1903 in Wakefield, Yorkshire. She won a scholarship first to the Leeds School of Art (1920), where Henry Moore was a fellow student, and then to the Royal College of Art (1921), which she attended as a student of sculpture until 1924. In that year she received a West Riding award for foreign travel and went to Italy, living mainly in Florence. In 1925 she married fellow sculptor John Skeaping; they lived at the British School in Rome and both learned the traditional Italian technique of marble-carving. On their return to England they held a joint exhibition at their studio in St John's Wood, London. In 1928 she moved to Parkhill Road studios, Hampstead, where her neighbours were Henry Moore and Ben Nicholson. In 1932 and 1933 she and Nicholson, who became her second husband, travelled, visiting the Paris studios of Picasso, Braque, Brancusi, Arp and Mondrian. In 1933 she joined the group Abstraction-Création, which gave a vital impetus to her desire to carve pure geometrical forms. Her

early carvings were, like Moore's, inspired by the human figure, but by 1934 she had abandoned figuration; her sculptures, although abstract, were inspired by nature. In 1934 she wrote in *Unit One*: 'In the contemplation of Nature we are perpetually renewed, our sense of mystery and our imagination is kept alive and, rightly understood, it gives us the power to project into a plastic medium some universal or abstract vision of beauty.' For the rest of her life her work was guided by these principles.

During the 1930s Hepworth and Nicholson were in the forefront of the move towards abstraction in England, keeping in close touch with like-minded artists, such as Arp and Mondrian; the latter lived near them in Hampstead from 1938 to 1940. At the outbreak of the Second World War she and Nicholson with their triplet children, born in 1934, moved to St Ives, Cornwall, where, together with Naum Gabo, they formed the nucleus of an artistic colony. During the early part of the war, unable to obtain materials for carving, she drew and made small works in plaster but from 1943 she was able to carve again. Many of her pieces were inspired by the 'pagan landscape' between St Ives and Land's End: the rugged coastline, with its towering cliffs and curving inlets, and the neolithic standing stones which she discovered on the surrounding moors. She began to paint the interiors of her hollowed-out forms a delicate duck-egg or pale green to represent the sea, and she continued the practice of employing strings in her sculpture, first begun in 1938 in response to Gabo's and Moore's use of them, but now less for spatial reasons than to reflect the feeling of tension between herself, the wind and the sea. *Pelagos*, 1946 (Tate Gallery), is a typical example of her landscape-inspired sculpture.

In 1949 she bought Trewyn Studios, St Ives, where she lived permanently from 1951 after the dissolution of her marriage. Here she was able to work on a larger scale than before and received many international commissions, including the Dag Hammarskjöld Memorial, New York, 1962-3. She had two major retrospectives at the Whitechapel in 1954 and 1962 and at the Tate Gallery in 1968. After her tragic death in a fire in 1975 her studio was opened as a public museum.

M.R.B.

Barbara Hepworth. Retrospective Exhibition 1927-1954, London, Whitechapel Art Gallery, 1954
Barbara Hepworth. An Exhibition of Sculpture from 1952-1962, London, Whitechapel Art Gallery, 1962
Barbara Hepworth, London, Tate Gallery, 1968

Patrick Heron

was born on 30 January 1920 in Leeds; his father was a manufacturer who later founded Cresta Silks and the family lived in West Cornwall for periods during the 1920s, so that when Heron moved into Eagles Nest, Zennor, in 1956 he was returning to an area that he already knew. Between 1937 and 1939 he studied part-time at the Slade; during the Second World War, as a conscientious objector, he worked on a farm, 1940-4, and as assistant in the Bernard Leach Pottery at St Ives, 1944-5, where he met Nicholson and Hepworth. He had seen Matisse's *Red Studio* at the Redfern Gallery in 1943 which he later described as 'by far and away the most influential single picture in my entire career'. From 1945 to 1947 he wrote art criticism for the *New English Weekly*; he was art critic for the *New Statesman and Nation*, 1947-50, and London correspondent of the New York journal *Arts*, 1955-8. His early ideas about painting were summed up in his highly influential book *The Changing Forms of Art* (1955).

Until 1955 Heron worked in a figurative idiom derived from Braque and Matisse, painting still-lifes and interiors with figures which often have complex and ambiguous spatial relationships. He was extremely enthusiastic about the first exhibition of American Abstract Expressionism held in 1956 at the Tate Gallery, and from 1956 he became an abstract painter, although he continued to believe that 'there is no such thing as non-figuration. The best abstraction breathes reality; it is redolent of forms in space, of sunlight and air.' The change to abstraction coincided with his move to Zennor, where the garden was aglow with azaleas and camellias which he represented as coloured blobs and dashes. In 1957 he embarked on stripe paintings, both vertical and horizontal, which are suggestive of the view of sea and sky visible from Eagles Nest. In 1958 he moved into Ben Nicholson's former studio at Porthmeor and between 1958 and 1963 developed the paintings with 'soft-edged squares' and lozenges which became his 'formal vocabulary'.

In 1963 he began again to draw on the canvas before applying colour. The interlocking forms became increasingly complex as the series progressed; the sharp-edged shapes recall the rocky creeks and inlets of the Cornish coastline, and the rounded shapes are reminiscent of the granite boulders in his own garden. In the 1980s he has returned to a looser format with scumbled surfaces, still retaining the vibrancy of colour which is paramount in his work. In his Power lecture in Australia in 1973 he stated that 'the finished painting should also end in pure sensation of colour'.

Heron won the Grand Prize at the second John Moores exhibition in 1959 and a silver medal at the São Paulo Bienal in 1965. He has exhibited widely and frequently. He had a retrospective exhibition at the Whitechapel Art Gallery in 1972 and at the Barbican in 1985; seven paintings were included in the 'St Ives' exhibition at the Tate Gallery in 1985. In 1977 he was created a CBE and in 1980 he became a Trustee of the Tate Gallery.

M. R. B.

Patrick Heron, Wakefield, City Art Gallery, 1952
Patrick Heron 1953-72, London, Whitechapel Art Gallery, 1972
Patrick Heron, London, Barbican Art Gallery, 1985

Roger Hilton

was born on 23 March 1911 in Northwood, Middlesex, where his father was a general practitioner; his mother had trained as a painter at the Slade School and his father's cousin was the art historian Aby Warburg. The family name was originally Hildersheim – his paternal grandfather had emigrated from Hamburg in the 1850s and settled in Dundee – but it was changed to Hilton in 1916 because of anti-German feeling during the First World War. In 1929-31 and again in 1935-6 he attended the Slade School, and during the Thirties he spent about two and a half years in Paris attending the Académie Ranson under Roger Bissière. Hilton joined the Army in 1939, serving in the Commandos from 1940; he was captured in 1942 and remained a prisoner of war until 1945.

After the war he taught art in a boys' preparatory school and then at Bryanston School. He turned to abstract art about 1950; contemporary Parisian art was a strong influence on his work, including the new-found free calligraphic style adopted by Bissière from 1944 onwards. Hilton met a Dutch member of the Cobra Group, Constant (Nieuwenhuys, born in 1920), who was living in London in the early Fifties, and they travelled together to Paris and Amsterdam to look at painting by Mondrian; as a result, Hilton's work became simpler: he reduced his palette to the primaries with black and white and earth colours.

He taught at the Central School from 1954 to 1956, at which time he first visited St Ives to stay with Heron (who lived near Lanyon). In 1956 he rented a studio at Newlyn to which he returned for the next four summers, settling finally in Cornwall in 1965. His mature style dates from the period when he began visiting Cornwall, though his work had already been extensively shown in Europe.

In 1957 he took part in 'Statements', an exhibition organized by Alloway at the ICA: there were twenty abstract artists in the show and each published a statement. Hilton wrote: 'A creative artist is a man who is struggling with an idea. His works record his thought processes, his outlook . . .' His friends Adrian Heath, Terry Frost, Bryan Wynter and Heron formed one group in this wide survey, which also included British Constructivism. Hilton found this an alien mode, since the work was based on mathematical premises. His own freely painted abstracts suggest both landscape and the figure. Indeed, from 1961 some of his paintings show female figures with fluid outlines spread across the canvas in controlled abandon. His last works were gouaches, freely painted in a brighter range of colours on his sickbed, for he was bedridden for the last two and a half years of his life; he died on 23 February 1975 at his home in St Just, West Penwith. He had won the John Moores Prize in 1959 and again in 1963, and at the Venice Biennale in 1964 had been awarded the UNESCO prize.

S. C.

Roger Hilton, London, Institute of Contemporary Arts, 1958
Roger Hilton, Paintings and Drawings 1931-1973, London, Arts Council, 1974
Roger Hilton, London, Waddington Galleries, 1983

Ivon Hitchens

was born on 3 March 1893 in London, the son of an artist father; he grew up in Berkshire and in his late teens spent two years in New Zealand after a severe illness. On his return to England in 1911, he attended the St John's Wood School of Art before studying for four years at the Royal Academy Schools (1911-12, 1914-16, 1918-19). Towards the end of that time he acquired a studio in Primrose Hill where he lived until 1940. At the RA Schools he had gained a deep respect for Italian Quattrocento painting but Roger Fry's *Vision and Design* of 1920 led him to an interest in Cézanne. As a founder member of the Seven and Five Society (1920) he at first exhibited works in a style related to that of the Bloomsbury Group. He spent the summer of 1924 in Paris and, during the following year, visited Ben and Winifred Nicholson in Cumberland, both of whom exhibited regularly with the Seven and Five Society on his invitation. During the early Thirties Hitchens, like Nicholson, came under the influence of Braque. He contributed to 'Objective Abstractions', organized at the Zwemmer Gallery by Moynihan in 1934, and for a short

period he produced abstract pictures, for instance *Triangle to Beyond*, 1936. However, thereafter he used long horizontal canvases (the traditional 'seascape' format) for abstracted landscapes; at first he often used trees to divide the picture space into sections: 'I am always fascinated by the space left between the verticals of trees These divide up the area into separate movements which can be "read", "listened to" or "looked at"'

After his London house was bombed in 1940 he moved with his wife and their baby son to a gypsy caravan on a rural site in Sussex, where later he built the house which he occupied for the remainder of his life. There during the war he painted figures indoors and in the open air, but although he continued to paint nudes in landscapes, the majority of his pictures thereafter were abstracted landscapes in the long format he preferred. In 1942 the work of Hitchens together with that of Frances Hodgkins, Sutherland and Henry Moore was called 'Neo-Romantic' in an exhibition review by Raymond Mortimer, who found that these artists shared an identification with nature in their work. Neo-Romanticism has subsequently been applied more generally to landscape painting, especially if it includes a strong element of draughtsmanship. That is not a typical characteristic of Hitchens's work, in which the element of drawing lies in the brushstrokes themselves; in later years these were laid on a white ground which often shows through, giving an overall impression of brightness in spite of the gradations of tone in the individual sweeps of colour. Hitchens died on 29 August 1979. Murals by him are to be found in St Luke's Church, Maidstone, and in Cecil Sharp House, Regent's Park Road, London.

S. C.

Ivon Hitchens, London, Arts Council, 1963
Ivon Hitchens. Retrospective Exhibition, London, Waddington Galleries, 1973
Ivon Hitchens, A Retrospective Exhibition, London, Royal Academy of Arts, 1979

David Hockney

was born in Bradford, Yorkshire, on 9 July 1937; his working-class father was a pacifist. Between studying at Bradford School of Art (1953-7) and at the Royal College of Art, London (1959-62), he was allowed, as a conscientious objector, to work in a hospital in lieu of National Service; it was during this period that he saw and was inspired by an Alan Davie exhibition at Wakefield. With him at the Royal College were several artists whose names were to be associated with the emergence of Pop Art, including Caulfield and Jones; particularly influential was Kitaj, who encouraged his younger contemporaries not to be afraid of 'literary' subject-matter and to paint about the things that mattered to them most. In Hockney's case one of the most important of these was his homosexuality; he found a valuable precedent for the celebration of this in the poetry of Walt Whitman. He was deeply impressed by the Picasso exhibition at the Tate Gallery, London, in 1960, especially by Picasso's versatility: four of his own paintings exhibited at the 1962 Young Contemporaries show were called 'Demonstrations of Versatility', thus proclaiming his freedom not to be bound by any one style. In 1961 he visited New York and dyed his hair blond; on his return, he produced the series of etchings *A Rake's Progress*. He was awarded the Gold Medal on graduating from the Royal College in 1962, having already achieved a considerable measure of fame.

At the invitation of the *Sunday Times* he went to Egypt in September 1963, and at the end of that year he moved to Los Angeles, at the same time adopting acrylic instead of oil paint. The light, as well as the architecture, gardens and swimming pools of southern California, exerted an increasing influence on his paintings from the mid-1960s; both the flatness of acrylic and his growing interest in photography contributed to an immaculately hard-edged style which by 1968 came uncomfortably (for Hockney) close to photo-realism. This was not a problem with etching: in 1966 he produced *Illustrations for Fourteen Poems from C. P. Cavafy* and in 1968 he began work on a set of etchings illustrating *Six Fairy Tales from the Brothers Grimm*, which was published in 1970. That year also saw a major retrospective at the Whitechapel Art Gallery, London. Another major exhibition was held at the Musée des Arts Décoratifs, Palais du Louvre, Paris, in 1974.

In 1976-7 he made a series of etchings inspired by Wallace Stevens's poem *The Man with the Blue Guitar*, which in turn had been inspired by Picasso. Having designed Jarry's *Ubu Roi* for the Royal Court Theatre, London, in 1966, he designed Stravinsky's *Rake's Progress* and Mozart's *The Magic Flute* for the Glyndebourne Festival Opera, Sussex, in 1974-5 and 1977-8 respectively, and Satie's, Poulenc's and Ravel's *Parade* for the Metropolitan Opera, New York, in 1980, amongst other theatrical work. His work in the theatre may have contributed to the shift away from naturalism and towards a more open acknowledgment of artifice in his paintings in the late 1970s and the 1980s. At the same time he has produced a body of creative work in photography, exhibitions of which include one at the Centre Georges Pompidou, Paris, in 1982 and one at the Hayward Gallery, London, in 1985. He was elected an ARA in 1985.

G. W.

David Hockney. Paintings, prints and drawings 1960-1970, London, Whitechapel Art Gallery/Lund Humphries, 1970
David Hockney, Paris, Musée des Arts Décoratifs, Palais du Louvre, 1974
Hockney Paints the Stage, London, Arts Council/Thames and Hudson, 1985

Howard Hodgkin

was born in London on 6 August 1932. Soon after the outbreak of the Second World War he was evacuated to America, returning to England in 1943. He studied at the Camberwell School of Art 1949-50 and at the Bath Academy of Art, Corsham, 1950-4, after which he taught at Charterhouse School 1954-6, the Bath Academy of Art 1956-66 and Chelsea School of Art 1966-72. He was artist in residence at Brasenose College, Oxford, 1976-7 and made a CBE in 1977.

Hodgkin has evolved a style of painting which may at first sight appear to be abstract but which in fact always has a subject and is indeed subjective. He has said that the starting point for a painting is usually the specific memory of an encounter between people, 'one moment of time involving particular people in relation to each other and also to me'. Most of the paintings that he made from the 1950s to the early 1970s are based on an amalgam between a person or people and their surroundings; the setting is generally an interior containing works of art, Hodgkin's sitters usually being artists or collectors. Thus his picture is triggered off by other art as much as by the personalities of his subjects, who are always people well known to him; a dinner-party conversation or a visit to a museum may equally act as a catalyst.

Hodgkin has travelled extensively, making frequent visits to the United States as well as to Europe; over a period of many years he has found particular inspiration from his trips to India. He always paints on board rather than on canvas, liking the resistance of the material. The size and type of board are important, and he carries the paint up to and over the frames, which become an integral part of the painting. He works extremely slowly, sometimes taking years to bring a painting to a conclusion which satisfies him.

As well as a painter Hodgkin is an inventive and prolific printmaker; his vocabulary of form is similar to that of his paintings, and his etchings, aquatints and lithographs are executed in a very painterly fashion. In 1982 his prints, *Indian Leaves*, made on wet, hand-made paper in Ahmedabad, were exhibited at the Tate Gallery; Hodgkin has long been a keen collector of Mughal miniatures, which may be a contributory factor to the jewel-like brilliance of his colours. In 1984 he had an exhibition 'Forty Paintings 1973-84' in the British Pavilion at the Venice Biennale, which travelled to

America and Germany before returning to London to inaugurate the newly renovated Whitechapel Art Gallery. In 1985 he won the Turner Prize, having been a contender the previous year, and in 1986 he was awarded first prize in the Bradford Print Biennale for *David's Pool*. He has been a Trustee of the Tate Gallery and is at present a Trustee of the National Gallery.

M. R. B.

Howard Hodgkin. Forty-five paintings: 1949-75, London, Arts Council, 1976
Howard Hodgkin's Indian Leaves, London, Tate Gallery, 1982
Howard Hodgkin: Forty Paintings 1973-84, London, Whitechapel Art Gallery, 1984

John Hoyland

was born on 12 October 1934 in Sheffield. He studied at the Sheffield College of Art, 1951-6, and at the Royal Academy Schools, 1956-60. Afterwards he taught at the Croydon School of Art, 1962-3, and at Chelsea School of Art, 1962-70, where he became principal lecturer in 1965. His first visit to America was in 1964, when he travelled to New York on a Peter Stuyvesant bursary; in 1972 he was Charles A. Dana Professor of Fine Art at Colgate University, New York. In 1974 he began teaching at St Martin's School of Art, the Royal Academy Schools and the Slade School of Art. In 1979 he was artist in residence at Melbourne University, Australia, and in 1980 he selected the Hayward Annual.

During his frequent visits to New York Hoyland met Morris Louis and Kenneth Noland, Helen Frankenthaler and Robert Motherwell, as well as the critic Clement Greenberg. He later came under the influence of Hans Hofmann, an important teacher, who confirmed him in his belief in the expressive use of colour. Hofmann said: 'In symphonic painting colour is the real building medium.' In the 1960s Hoyland's paintings consisted of bands of interacting colour; in the early 1970s the paint was poured and splattered on to the canvas, veils of colour often being stabilized by a soft-edged rectangle of more solid impasto, which anchored the weight of the picture space. From the mid-1970s Hoyland's forms became more expansive and the brushstrokes more expressive: from being poured and brushed, the paint was now spread on with a palette knife, scumbled

and overlaid, so that the very thickness of the surface made the canvas three-dimensional; the rectangular shapes were joined by triangles and diagonals. In the early 1980s diamond-shaped clusters were the principal forms in the paintings; they either just touched edge to edge, or were overlaid in a space-expanding way. His most recent paintings have been composed of a circular shape within the pictorial rectangle; separate areas of activity are energized inside the circle, like satellites of a large planet, and the paint continues to be applied with bravura vitality, the colour as high-keyed as ever. Hoyland has said: 'Paintings are there to be experienced, they are events. They are also to be meditated on and to be enjoyed by the senses; to be felt through the eye.... They are not to be understood, they are to be recognized.'

Hoyland has always been interested in printmaking and has produced a steady flow of silkscreens, etchings and lithographs. An important addition to these is the monotype, which he has employed to great effect. He has exhibited widely and received many awards. In 1964 he won the International Young Artists Award, Tokyo, and in the same year he had his first one-man exhibition. In 1967 he had an exhibition at the Whitechapel Art Gallery and in 1979 at the Serpentine Gallery. He has shown consistently with the Waddington Galleries in London, besides many exhibitions in Europe, America and Australia. He was elected an ARA in 1983.

M. R. B.

John Hoyland. Paintings 1960-67, London, Whitechapel Art Gallery, 1967
John Hoyland. Paintings 1967-1979, London, Arts Council, 1979
John Hoyland, Australia, University of Melbourne, 1980

Gwen John

was born in Haverford, Wales, on 22 June 1876, the daughter of a solicitor. Her brother, Augustus John, was born two years later. Following the death of their mother in 1884, the family moved to Tenby, where Gwen John was educated. She attended the Slade School between 1895 and 1898, one of an outstanding group of women students which also included Ida Nettleship, Grace Westray, Edna Waugh, Gwen Salmond and Ursula Tyrwhitt. In 1898 she briefly attended Whistler's Académie Cormon in Paris. The little early work that survives reveals a debt to the subtle tonalities of Whistler, and to Ambrose McEvoy.

Gwen John exhibited at the New English Art Club for the first time in 1899, and in 1903 exhibited jointly with her brother at the Carfax Gallery. Later that year she left for France, and in early 1904 settled in Paris, earning her living by modelling. 1904 saw the beginning of her passion for Auguste Rodin and in 1906, through Rodin, she met and befriended the poet Rilke, who was then his secretary. In Paris she abandoned the warm red and brown tonalities and varnishes of her early works in favour of mauve, pink, blue and grey colour harmonies and a drier application of paint. In 1910 she tried her hand at etching, her first and only excursion into printmaking; the following year she moved to Meudon in order to be closer to Rodin's country house. In 1913 she was received into the Roman Catholic Church and one of her paintings was lent to the New York Armory Show by the American collector John Quinn who the year before had begun sending her a regular allowance in return for paintings.

She refused to return to England on the outbreak of war and from 1915 onwards she spent the summers in Brittany, which she continued to visit until 1921. She exhibited at the Salon d'Automne and the Salon des Tuileries in 1922 and 1923; and in 1922 her work was included in the 'Modern English Artists' exhibition at the Sculptors' Gallery, New York. Her only one-woman show in her own lifetime, which was also her first solo exhibition in London, took place at the New Chenil Galleries in 1926. In that year she met Jacques and Raïssa Maritain, and became attached to Raïssa's sister, though she continued to live as a recluse; her last years were spent in greater solitude than ever. She died in Dieppe on 1 September 1939.

Gwen John's subject-matter was restricted in the extreme, consisting mainly of portraits and interiors, and her style changed relatively little. Never confident of her own abilities, she worked very slowly and would repeatedly re-work the same compositions. Lyrical understatement and a strong sense of empathy for other women are the hallmarks of her art. Since her memorial exhibition of 1946 (held at the Matthiesen Gallery, London), her reputation has been rising steadily and a major retrospective was held at the Barbican Art Gallery in 1985.

M. B.-D.

Gwen John. A Retrospective Exhibition, London, Arts Council, 1968
Gwen John, Cardiff, National Museum of Wales, 1976
Gwen John; An Interior Life, London, Barbican Art Gallery, 1985

Allen Jones

was born in Southampton on 1 September 1937 of Welsh parents. Between 1955 and 1959 he studied painting and lithography at Hornsey College of Art, London, during which time he travelled to Paris, where he was especially impressed by Delaunay, and to Provence. Entering the Royal College of Art in 1959, he was the contemporary of Caulfield, Hockney and Kitaj. Doubtless a difficult student, he was asked to leave at the end of his first year but had already made a considerable impact. From 1960 to 1961 he attended a teacher training course back at Hornsey College of Art: in his teaching practice, his method was based largely on Klee's *Pedagogical Sketchbook*. He taught lithography at Croydon College of Art between 1961 and 1963, and drawing at Chelsea School of Art in 1964. His work of the early 1960s shows a strong psychological orientation, related to his reading of Nietzsche, Freud and Jung. He was especially interested in the idea of artistic creativity coming from dreams and other unconscious forces – much of his work has automatist origins – as well as involving a fusion of masculine and feminine elements: this latter interest is clearly evident in such paintings as *Hermaphrodite* (1963) and *Male and Female Diptych* (1965), which also reveal a quest for sexual identity.

In 1963 he won the Prix des Jeunes Artistes at the Paris Biennale. In 1964, having married Janet Bowen, the couple moved to New York, where they lived at the Chelsea Hotel, before undertaking a major tour of the United States; returning to London, they lived together in Chelsea until their divorce in 1978. It was in New York that Hockney drew Jones's attention to commercial fetishist imagery, which was to be a factor in bringing about a shift in his work away from the modernist insistence on flatness towards an open acceptance of three-dimensional illusionism and towards an eroticism which was far more explicit than previously. The new direction was announced in the painting *Wet Seal* (1966). An extreme both of illusionism and of explicit eroticism was reached in his hyperrealistic sculptures such as *Table Sculpture* and *Hat Stand* (both 1969), which because of their overt borrowing from the world of commercialized sex imagery have often been reductively misinterpreted as misogynistic. His first book, *Figures*, was published in 1968; it was followed by *Projects* and *Waitress* in 1971 and 1972. In 1970 he designed the sets and costumes for *O Calcutta* in London and for the West German television spectacular *Männer Wir Kommen*; in 1972 he designed garments for *The Body Show* at the ICA and the Theatre Royal, Stratford East, London; in 1976 he designed the poster for American distribution of the film *La Maîtresse*; and in 1978 he designed a mural overlooking Basel Railway Station, Switzerland, advertising 'Fogal' hosiery.

His principal work, however, has continued to be in painting and printmaking. A major exhibition opened at the Walker Art Gallery, Liverpool, in 1979, subsequently touring to London (Serpentine Gallery), Sunderland, Baden-Baden and Bielefeld. In 1981 he was elected an ARA, and in 1982-3 he was Guest Professor at the Hochschule der Künste, West Berlin.

G. W.

Allen Jones, Tokyo, Seibu Museum, 1974
Allen Jones, Edinburgh, Fruit Market, Scottish Arts Council, 1975
Allen Jones. Retrospective of Paintings, 1957-1978, Liverpool, Walker Art Gallery/Baden-Baden, Staatliche Kunsthalle, 1979

Phillip King

was born on 1 May 1934 at Kheredine, near Carthage, in Tunisia. It has been claimed that his childhood experience of the bright North African sun was to exert a considerable influence on his sculptural sensibility. He came to England in 1946 and attended Mill Hill School, London, from 1947 to 1952. Towards the end of his period of National Service (1952-4) he spent a year in Paris, where he made drawings from sculptures in the Louvre. From 1954 to 1957 he read modern languages at Christ's College, Cambridge – the same college where Caro had studied engineering twelve years previously – at the same time making sculpture influenced by Picasso, Matisse, Laurens and Maillol. In 1957 he married Lilian Odelle. He spent the year 1957-8 studying sculpture at St Martin's School of Art, London, because Caro was teaching there, and made small sculptures which he describes as being of a Brutalist/Surrealist type; in 1959 he began teaching at St Martin's. He worked in 1959-60 as an assistant to Henry Moore, thereby gaining confidence working on a larger scale.

In 1960 he was awarded a Boise scholarship, with the help of which he travelled to Greece, where his perception of the relationship between man and nature had a profound effect upon his thinking and practice. On his return to England, he cleared his studio of all previous work and began making a series of drawings, from which the sculptures *Window Piece* (1960-1) and *Declaration* (1961) were made. In 1962 he began using fibreglass, and colour also became an important ingredient for the first time, in *Rosebud*: its irreverently optimistic tone may be connected with the recent American painting that King had seen and admired at Documenta II in 1959.

He taught for one term in 1964 at Bennington College, Vermont; that year also saw his first solo exhibition at the Rowan Gallery, London. In 1967 he taught at the Slade School of Fine Art, London, and was appointed a Trustee of the Tate Gallery. Together with Bridget Riley, he represented the United Kingdom at the Venice Biennale in 1968. In 1969 he set up a studio at Clay Hall Farm, near Dunstable, Bedfordshire, equipping it for working on large-scale steel sculpture; the large steel piece *Sky*, for the Symposium of Sculptors organized for Expo '70, was completed during three months in Japan in the same year, and it was in 1969 too that King won first prize at Socha Piestanskych Parkov, Czechoslovakia. In 1972 he built a studio in the garden of his house in London, suitable for

executing smaller works, but his principal studio remained that at Clay Hall Farm. He received a CBE in 1974 and in 1977 was elected an ARA. During 1979-80 he was a Professor at the Hochschule der Künste, West Berlin, and in 1980 he was appointed Professor of Sculpture at the Royal College of Art, London. There was a major retrospective exhibition of his work at the Hayward Gallery, London, in 1981.

G. W.

Phillip King. Sculpture 1960-68, London, Whitechapel Art Gallery, 1968
Phillip King, Otterlo, Kröller-Müller National Museum, 1974
Phillip King, London, Arts Council, 1981

R. B. Kitaj

was born Ronald Brooks on 29 October 1932 in Cleveland, Ohio. He was brought up by his mother Jeanne Brooks, of Russian-Jewish descent, who in 1941 married a Jewish research chemist from Vienna, Dr Walter Kitaj. On leaving high school, he signed on as a merchant seaman in New York and made several voyages to the Caribbean and South America, between which he received formal art training at the Cooper Union, New York, where the influence of Abstract Expressionism was then paramount, and at the Akademie, Vienna. There he met Elsi Roessler, also from Cleveland, whom he later married and with whom he travelled extensively in Europe and North Africa. After service with the US Army in 1956-7, he took advantage of provisions in the GI Bill to continue his art education in England, firstly at the Ruskin School, Oxford, and then at the Royal College of Art, London (1960-2).

His greater experience of life and broader cultural horizons made him a considerable influence on his fellow students at the College, including Caulfield, Jones and especially Hockney, with whom he established a close and enduring friendship. In particular, his own preference for figuration provided an example of a rival modernism to that of prevailing abstraction, and encouraged other artists to include their extra-artistic interests in their art. His own interests, then as now, were exceptionally wide and embraced history, politics,

sociology, psychology, iconography and literature, especially poetry. He was also interested in ready-made visual material and in 1962 he met the screenprinter Chris Prater, with whom he made collage prints for many years.

In 1963 he had his first, highly successful one-man exhibition at the Marlborough New London Gallery and the Tate bought his *Isaac Babel Riding with Budyonny* (1962). His second one-man show, in New York, from which the Museum of Modern Art purchased *The Ohio Gang*, was in February 1965; later that year came his first one-man museum exhibition, at the Los Angeles County Museum of Art, followed by another at the Stedelijk, Amsterdam, in 1967. Having taught between 1961 and 1967 at various London art colleges, he accepted a one-year Guest Professorship at the University of California, Berkeley, in 1967-8, during which time he became close friends with the Black Mountain poets Robert Creeley and Robert Duncan. His wife died in 1969, after their return to London; with the children, he went back to California, taking up another year's Guest Professorship, this time at UCLA, in 1970. In Los Angeles and then again in London, he met the American painter Sandra Fisher, whom he married in 1983. The value of Fisher's use of pastel in her work remained incomprehensible to Kitaj until in 1975, on a visit to Paris, he was inspired by Degas's use of that medium, which he was to adopt for a significant proportion of his own work.

His recent paintings and drawings have increasingly returned to issues brought up in late nineteenth-century French art, which he has come to see as possessing a much deeper and more lasting significance than such later developments as 'Duchampism' and 'collagism'. In his work he has also shown an increasing preoccupation with his own Jewish origins and with the whole question of what a Jewish identity means in the twentieth century: 'I took it into my cosmopolitan head that I should attempt to do Cézanne and Degas and Kafka over again, after Auschwitz.' In 1976 he organized the exhibition of figurative painting 'The Human Clay' at the Hayward Gallery, London, and in 1980 selected pictures for 'The Artist's Eye' at the National Gallery. A major retrospective of his work was held in Washington, Cleveland and Düsseldorf in 1981. He was elected an ARA in 1984.

G. W.

R. B. Kitaj: Paintings, New York, Marlborough-Gerson Gallery, 1965
R. B. Kitaj, Hanover, Kestner-Gesellschaft, 1970
R. B. Kitaj, Washington DC, Smithsonian Institution, Hirshorn Museum and Sculpture Garden, 1981 with Kunsthalle, Düsseldorf, 1982

Leon Kossoff

was born in London on 7 December 1926, one of seven children of Russian-Jewish immigrant parents who ran a bakery in the East End. He has drawn and painted London obsessively since the age of twelve; in a statement of 1974 he wrote: 'I have worked from Bethnal Green, the City, Willesden Junction, York Way and Dalston. I have painted its bomb sites, building sites, excavations, railways and recently a children's swimming pool in Willesden. The strange ever-changing light, the endless streets and the shuddering feel of the sprawling city lingers in my mind like a faintly glimmering memory of a long forgotten, perhaps never experienced childhood, which if discovered

and illuminated, would ameliorate the pain of the present.' He lives and works in London to this day.

Between 1938 and 1942 Kossoff attended the Grocers School, Hackney Downs, and from 1945 to 1948 served with the Jewish Brigade and the Royal Fusiliers in Italy, the Netherlands and Germany. He then attended St Martin's School of Art during the day (1949-53) and Bomberg's classes at the Borough Polytechnic in the evenings (1950-2). In 1953-6 he studied at the Royal College of Art, and went on to teach for a period of five years at Chelsea School of Art and the Regent Street Polytechnic (1959-64). His first one-man show took place at the Beaux-Arts Gallery, London, in 1957. In 1962 he became a member of the London Group, and between 1966 and 1969 taught at St Martin's School of Art.

Like Auerbach's work, which has affinities with his own, Kossoff's paintings are characterized by a heavily impastoed surface, although recently the paint has a softer, chalkier quality and is applied less thickly, giving the forms in his paintings a greater visibility. Drawing and painting are almost indistinguishable and colour has a relatively small part to play, although in recent years his palette has become lighter and brighter. Again like Auerbach, Kossoff's repertory of motifs is extremely limited: essentially, either people very close to him in familiar interiors or anonymous passers-by in anonymous public spaces. On the whole, people in his paintings appear isolated, alienated from one another, whether through over-claustrophobic domestic relationships or through fear of contact in everyday urban existence. In spite of this, they retain a certain inner dignity, even a monumentality, which certain commentators on Kossoff's work (notably Helen Lessore) have seen as deriving, in part at least, from the artist's Jewish heritage. Equally, though, Kossoff's rootedness in his London environment, his choice of subject-matter and his essentially tonal approach to paint ally him with Sickert and a very British urban realist tradition.

M. B.-D.

Leon Kossoff – Recent Paintings, London, Whitechapel Art
 Gallery, 1972
Leon Kossoff: Paintings from a Decade 1970-1980, Oxford,
 Museum of Modern Art, 1981
Leon Kossoff, London, Fischer Fine Art, 1984

Peter Lanyon

was born on 18 February 1918 in St Ives, Cornwall. In 1936 he received tuition from Borlase Smart, a local landscape painter, and in 1937 studied at the Penzance School of Art. In the same year he met Adrian Stokes, who advised him to go to the Euston Road School, which he attended for a few months. In 1939 he met Ben Nicholson, Barbara Hepworth and Naum Gabo, who had moved to St Ives on the outbreak of war. Lanyon was immediately influenced by them and the character of his work changed completely. He stopped painting landscape studies and began to make constructions, many of which were intended as preparatory ideas for paintings. From 1940 to 1945 he served in the Royal Air Force.

Throughout the 1940s the influence of Gabo and Nicholson was paramount. Lanyon made linear free-standing sculptures and 'built' his paintings as if from a three-dimensional model. His paintings became progressively freer and he evolved a kind of lyrical abstraction based on landscape. He wanted to find a new way of organizing the space in a picture, so that a landscape could be viewed from all angles – above, below, and from the sides – as if the spectator were walking about in the picture space. The breakthrough paintings were *St Just*, 1953, and *Porthleven*, 1951 (Tate Gallery); the latter was commissioned by the Arts Council for the Festival of Britain exhibition. Both these paintings, although primarily landscapes, have figurative connotations: Lanyon saw *St Just* as also a crucifixion, and two residual standing figures can be discerned in *Porthleven* (which was developed with the help of constructions).

Lanyon was aware, earlier than his compatriots, of American Abstract Expressionism. He was included in a mixed exhibition in New York in 1951 and in 1957 had a one-man show there; his work was well received and he felt himself to be more successful in New York than in London. He made friends with American painters – Kline, Motherwell and Gottlieb – and in particular with Rothko, for whom he tried unsuccessfully to find a studio in St Ives.

In 1959 he took up gliding, primarily as a way of getting to know the landscape better. He said: 'The pictures now combine the elements of land, sea and sky – earth, air and water.' Into these gliding paintings he began to introduce more colour, which he laid in flat planes; the handling became broader and the areas of paint were more clearly defined. He died following a gliding accident on 31 August 1964.

During the last years of his life Lanyon travelled frequently abroad, having found the art world in Britain too provincial, although his own art was rooted firmly in the landscape of his native Cornwall. He exhibited during his lifetime at the Lefevre Gallery and at Gimpel Fils in London, at Catherine Viviano, New York, and in the 1961 São Paulo Bienal. In 1968 he had a posthumous retrospective at the Tate Gallery and in 1978 at the Whitworth Art Gallery, Manchester. Ten paintings were included in the 'St Ives' exhibition at the Tate Gallery in 1985.

M. R. B.

Peter Lanyon, London, Arts Council, 1968
Peter Lanyon. Paintings, drawings and constructions 1937-64,
 Manchester, Whitworth Art Gallery, 1978
Peter Lanyon, Stoke-on-Trent, City Museum and Art
 Gallery, 1981

John Latham

was born on 23 February 1921 on the Zambesi River, Northern Rhodesia. After his education in Bulawayo, Southern Rhodesia, and Winchester College, England, and service in the Navy during the Second World War, he became a student at Chelsea School of Art, London, from 1946 to 1950. His first exhibition was with John Berger at the Kingly Gallery, London, in 1948. In 1954, after discovering a way of painting which allowed images to arise from atomized paint propelled by an electrical paint-spraying apparatus, he became an honorary founder member of the Institute for the Study of Mental Images, set up with the scientists C. C. L. Gregory and Anita Kohsen, whose book *The O-Structure* was published in 1959. Their cross-referencing of physics with other disciplines such as psychology in a way that overcame the traditional thought-substance dichotomy, and their development of a radically time-based cosmology, were to be enormously important for Latham; in particular, their notion of the micro-event as the basic unit of the universe was close to that of the 'Least Event', one of the main sustaining principles of his art.

In 1958 he began using books as materials for sculpture, the first 'skoob' relief being *The Burial of Count Orgaz* (Tate Gallery): works called 'soft skoob' followed in 1960. Another of Latham's many reversals of spelling, 'noit' for the abstract-making suffix '-tion', was coined in 1960, as was

'Truth to material' was a potent rallying cry during those years; in reaction to Rodin's love of modelling, the return to direct carving by Epstein, Eric Gill and Dobson inspired younger sculptors to have an active relationship with their material and not to try to falsify a hard and concentrated material such as stone to look like soft flesh.

In 1928 Moore received his first public commission to carve a relief for the new Underground Railway headquarters, causing considerable controversy. In the same year he had his first one-man exhibition at the Warren Gallery. In 1930 he became a member of the Seven and Five Society and in 1933 with Nash he helped to form the avant-garde group Unit One. He and his wife Irina went to live in the Parkhill Road studios, Hampstead, adjoining those of Barbara Hepworth and Ben Nicholson. In 1932 he carved *Composition* in dark African wood, the first sculpture with a hole through it, which was bought by Kenneth Clark. Moore said: 'The hole connects one side to the other, making it immediately more three-dimensional.' In 1936 he took part in the International Surrealist Exhibition at the New Burlington Galleries, and in 1938 in the Exhibition of Abstract Art at the Stedelijk Museum, Amsterdam. Although he experimented with quasi-geometrical abstraction during these years his abiding concern has been with humanity and the human figure.

After the outbreak of the Second World War Moore was asked to join the War Artists' Scheme, achieving national recognition with his 'Shelter' drawings, inspired by the scenes in the underground stations where people took refuge from the Blitz. In 1943 he was commissioned to carve a *Madonna and Child* for St Matthew's Church, Northampton, for which he executed a hieratic composition dependent in its antecedents on both Masaccio and archaic Greek seated figures.

In 1948 Moore won the International Prize for Sculpture at the Venice Biennale. By then a sculptor of international renown, he received many commissions and as a result turned more and more to modelling and bronze casting. In 1948-9 he modelled a *Family Group*, the first time he had sculpted a male figure, and in 1951 a *Reclining Figure* for the Festival of Britain. He found it necessary to employ assistants, among whom were Caro and King; thus his studio became a training ground for younger British sculptors. In 1957 he carved in Italy the great *Reclining Figure* in Roman Travertine marble for the UNESCO headquarters in Paris, and in 1963-5 he executed a large bronze two-part sculpture for the Lincoln Center in New York.

Throughout his life Moore drew continuously, from early figure drawings and ideas for sculpture to the recent *Sheep Album*, which is complemented by the large bronze *Sheep Piece*, 1972. He was made a Companion of Honour in 1953 and received the Order of Merit in 1963. He has had many retrospective exhibitions, including two at the Tate Gallery in 1951 and 1968 respectively. An eightieth birthday exhibition was held at the Serpentine Gallery and in Kensington Gardens in 1978; in the same year he gave a major donation of sculpture to the Tate Gallery. He died on 31 August 1986.

M. R. B.

Henry Moore, London, Arts Council, 1968
The Drawings of Henry Moore, London, Tate Gallery/ Toronto, Art Gallery of Ontario, 1977
Henry Moore. 80th Birthday exhibition, Bradford Art Galleries and Museums, 1978

Malcolm Morley

was born in Highgate, London, in 1931. He never knew his father and from the age of six when his mother remarried until his emigration to the United States in 1958, he used his stepfather's name, Evans. His childhood fascination with boats and the sea led to him working on a transatlantic tug and on several North Sea barges; a year in Borstal was followed by three in prison, where he developed an interest in painting and took a correspondence course in art. From 1952 to 1953 he studied at Camberwell School of Arts and Crafts, London, and from 1954 to 1957 at the Royal College of Art; although a contemporary there of, amongst others, Joe Tilson and Richard Smith, his work in no way related to the emergence of Pop. Rather, he was so impressed by the Abstract Expressionists in the Tate Gallery's 1956 exhibition 'Modern Art in the United States' that he immediately visited New York and, after completing his diploma, moved there permanently in 1958, initially supporting himself by working evenings and weekends as a waiter: it was by waiting on him at a restaurant that he met his hero, Barnett Newman, who was to give him both advice and encouragement.

His paintings of the early 1960s showed a preoccupation with the picture surface and the painted mark: abstract and mainly black and white, they consisted typically of horizontal bands, the paint applied with such unconventional instruments as a pastry gun. His first solo exhibition was in 1964. There followed a series of paintings of warships in grey, like the ships themselves. Then, after trying unsuccessfully to paint a large passenger ship from life, he turned to using postcards and travel brochures as models. Most of the paintings of that period are surrounded by a wide white border, enhancing their two-dimensionality, a particularly successful example being *SS Amsterdam in Front of Rotterdam* (1966). Although superficially close to the work of the Super Realists – a term which Morley invented – his own work was developing along different lines. The first overt break was made in *Race Track* (1970), where a large red cross is painted across the photo-realist image; a further stage is marked by *Los Angeles Yellow Pages* (1971), where the image seems to be ripped through. Since then, this work has tended to become increasingly painterly, occasionally, as in *The General* (1974), incorporating elements of three-dimensional collage.

Having taught at the State University of Ohio, Columbus, in 1965-6 at the instigation of Roy Lichtenstein, he went on to teach at the School of Visual Arts in New York from 1967 to 1969 and at the State University of New York, Stonybrook, from 1972 to 1974; in 1977 he spent seven months in Berlin through the German Academic Exchange Programme. A major exhibition of his work toured Europe and the United States in 1983-4, one of its venues being the Whitechapel Art Gallery, London, in 1983. In 1984 he was the first recipient of the Turner Prize awarded by the Patrons of New Art of the Tate Gallery.

G. W.

Malcolm Morley, New York, The Clocktower, Institute for Art and Urban Resources, 1976
Malcolm Morley, Hartford, Connecticut, Wadsworth Atheneum, 1980
Malcolm Morley: Paintings 1965-82, London, Whitechapel Art Gallery, 1983

Rodrigo Moynihan

was born on 17 October 1910 in Santa Cruz, Tenerife. His father was a fruit-broker from London and his mother was from a cultured Spanish family with an interest in art. He had a varied schooling, first in London, at University College

School from 1918 to 1922, then in the United States at High School in Madison, New Jersey, from 1922 to 1925. He then spent two years at the American School in Rome where he began to study art, painting in Florence and Cannes before entering the Slade School in September 1928. He studied there until 1931 and, in the next year, began exhibiting with the London Group; he was elected a member in 1933, the year he married a fellow student, Elinor Bellingham Smith.

In 1934 he organized 'Objective Abstraction' at the Zwemmer Gallery, where he and Graham Bell showed pictures in which, he has said, 'the elimination of the object came out of the use of paint'. His dedication to the paint marks themselves (derived from study of specific pictures by Monet and Turner in the Tate Gallery) proved very hard to sustain in the face of hostility on the one hand from abstractionists like Ben Nicholson and on the other from realists like Coldstream. Moynihan had known Coldstream at the Slade and he was associated with the Euston Road School from its inception in 1937. But, although he had reverted to a figurative style the previous year, his aims differed from those of Coldstream and Graham Bell, who were advocating a socially relevant modern art characterized by a systematically observed relationship between the subject and their marks on the canvas. In contrast, Moynihan attempted to paint his objects in an impersonal and unpremeditated way.

He had a one-man exhibition at the Redfern Gallery in 1940 and then in October he was called up after producing two paintings on RAF subjects for the Ministry of Information. In spite of the intervention of Kenneth Clark and others, he did not become an Official War Artist until 1943, when he had been invalided out of the Army. The resulting figurative paintings convey his powers of recording the essence of a scene. In 1944 he was elected an ARA; he was raised to RA in 1954, having been appointed Professor of Painting at the Royal College of Art in 1950. There he did not dictate but encouraged his students to have confidence in themselves. At the College in 1951 he painted a large group portrait based on a film he took of the editors of Penguin Books.

In summer 1956 he again turned to abstract painting. His new work was included in 'Statements' organized by Lawrence Alloway at the ICA; in his catalogue introduction Alloway saluted Moynihan's early experiments: 'This, before London was ready to tolerate it, was painterly abstraction anticipating post-war styles.' In 1957 he resigned from the RA and from the Royal College and went to live in France. He remarried in 1960 and settled in Provence, though he had a studio in New York from 1968 to 1971; a major retrospective was held at the Royal Academy in 1978, when he resumed the position of RA. In recent years he has again taken up painting portraits and simplified still-lifes.

S. C.

Rodrigo Moynihan: Still Life Paintings, London, Fischer Fine Art, 1973

Rodrigo Moynihan. A Retrospective Exhibition, London, Royal Academy of Arts, 1978

Rodrigo Moynihan, New York, Robert Miller [Gallery], 1983

Paul Nash

was born in London on 11 May 1889; his father was a barrister and when he was twelve, the family moved to the country in Buckinghamshire, near the family home, Langley Rectory, where several Nash generations had farmed the land. This gave him the identity of a countryman, which proved a decisive contribution to his maturity as an artist. He left St Paul's School with no formal qualifications and decided to become an illustrator and draughtsman. He studied first at Chelsea Polytechnic, then at an LCC technical school before entering the Slade School in 1910. There he made friends with Ben Nicholson and they exchanged visits, both as students and later on in the Twenties when they were both practising artists. Nash found figure drawing extremely difficult and left the Slade in December 1911; during the following year his originality as a landscapist was recognized and by the time war broke out in 1914, he had received praise for his landscape drawings. He shared an exhibition with his artist brother, John Nash (1893–1977), in December 1913, where Roger Fry admired his work, inviting him to join Omega Workshops. In 1914 he worked with Fry on the restoration of Mantegna's cartoons at Hampton Court Palace. His friends at the time included the writers Siegfried Sassoon, W. H. Davies and Rupert Brooke; he also married Margaret Odeh, a scholar and suffragette.

After the declaration of war, he enlisted in the Artists' Rifles and, in 1916, took a commission in the Hampshire Regiment. He saw active service in France in February 1917 at Ypres, where he dislocated a rib, so missing the battle for Hill 60 in which most of his fellow officers were killed. He found the war-torn landscape inspiring and his watercolours painted on the battlefield won praise when shown at the Goupil Gallery in June 1917. In October he returned to the front as an Official War Artist, working for six months for the Department of Information and then for the Ministry of Information until February 1919. This paid employment as an artist enabled him to produce a series of haunting oils and watercolours in response to battle-scarred landscapes; his gift for recreating the spirit of a place remained his artistic strength for the rest of his life.

For a short period in 1920-1 he designed theatre sets, picking up an enthusiasm of his childhood when he had made models, scenery and costumes for amateur theatrical productions; in 1921 a friendship with Claude Lovat Fraser ended with the latter's death. The following year Nash was invited by T. E. Lawrence to make designs from photographs for a private edition of *The Seven Pil-*

lars of Wisdom. A Triumph (1926). He began using photographs for some of his paintings in 1929 and two years later, on a visit to the USA, his wife gave him a camera, which thereafter became an important tool and he often based pictures on his own photographs; his wife published these posthumously as *Fertile Images* (London, Faber, 1951).

Although Nash had visited Brittany and Normandy in 1911, his first visit to Paris probably did not take place until 1922. Thereafter he travelled regularly in France, including a trip with Burra in 1930. Many of his rather bleak landscapes of the Twenties were based on Kent beaches accessible from his home near Rye. From 1927 onwards he began experimenting with interior scenes with ambiguous forms, more in the spirit of Metaphysical Painting than Surrealism. However, in 1936 he was on the Committee of the International Surrealist Exhibition in London; he exhibited there and also at the major Surrealist shows in Tokyo (1937), Amsterdam (1938) and Paris (1938).

From 1930 he supplemented his income by writing art criticism and his articles reveal an appreciation of recent developments in European art. By 1933 he had arranged for the formation of Unit One, including Moore, Hepworth, Ben Nicholson, Burra and Wadsworth. The Mayor Gallery became showroom and office for the members and Nash publicized the aims of the group, which embraced the polarities of abstraction and Surrealism, and which are often married in his own work of the time. A visit to Avebury in 1933 opened up a fresh landscape transformed by ancient man, which he fruitfully exploited in new canvases. The visit took place on his convalescence from a vicious attack of bronchitis which weakened his health and shortened his life. None the less, he was appointed an Official War Artist in 1940 and painted major landscapes recording the impact of aeroplanes in the Second World War. He died of pneumonia on 11 July 1946; he had been working on apocalyptic renderings of sunflowers, conceived as modern mythologies inspired by reading *The Golden Bough* by Sir James Frazer. As in all his work, literary reference was transformed into pictorial terms.

S. C.

Paul Nash. A Memorial Exhibition, London, Tate Gallery/ Arts Council, 1948

Paul Nash 1889-1946, Edinburgh, Scottish National Gallery of Modern Art, 1974

Paul Nash. Paintings and Watercolours, London, Tate Gallery, 1975

Christopher Nevinson

was born on 13 August 1889 in Hampstead, London, son of H. W. Nevinson, author and war correspondent, and Margaret Wynne Jones, writer and suffragette. Educated at University College School, London, and Uppingham, he attended St John's Wood School of Art in London 1907-8, followed by the Slade School 1908-12. Between 1910 and 1912 he exhibited at the Friday Club and with the Allied Artists' Association, and in the winter of 1912-13 went to Paris, where he worked at the Académie Julian and the Cercle Russe, sharing a studio with Modigliani and mingling with the Italian Futurists and the French avant-garde. In 1913 his work was included in the 'Post-Impressionists and Futurists' exhibition at the Doré Gallery, London, and in November, together with Wyndham Lewis, he organized a banquet in honour of Marinetti's visit to London. He was a found-

er member of the London Group and an active member of the Rebel Art Centre. In June 1914 the *Observer* published 'Vital English Art: A Futurist Manifesto', a co-production of Nevinson and Marinetti in which Nevinson associated the Vorticists with Italian Futurism, an association the former vigorously denied.

In 1914 Nevinson volunteered as a motor mechanic and Red Cross ambulance driver. In 1915, the year he married, he joined the Royal Army Medical Corps; in March his first war paintings were shown at the London Group and in June/July he exhibited as a Futurist at the Vorticist exhibition and contributed to the second and last issue of *Blast*. His first one-man show, primarily of war paintings, held at the Leicester Galleries in September 1916, proved extremely successful; in July 1917 he was appointed an Official War Artist and was soon to be the first artist to draw from the air. A second exhibition followed in March 1918.

Nevinson was one of the first artists to use the fragmenting techniques of early twentieth-century art to depict literally shattering events. His prints, with their bold contrasts and jagged forms, marked a complete break with the still dominant tradition of Whistler and his followers. Although best known for those works which feature dynamic geometricizing elements, Nevinson worked in a variety of styles, refusing to be associated with any particular movement – an attitude he continued to adhere to in the post-war period.

In 1919 Nevinson visited Paris and New York, and was to visit New York again in 1920. He was elected a member of the New English Art Club in 1929, of the Royal Society of British Artists in 1932 and an ARA in 1939. Most of his later, less stylistically radical works treat urban subjects partly inspired by New York City, although there are also uncharacteristically gentle landscapes and flower pieces. He died in London on 7 October 1946.

M. B.-D.

Osbert Sitwell, *C. R. W. Nevinson*, London, Ernest Benn, 1925
C. R. W. Nevinson, *Paint and Prejudice*, London, Methuen, 1937
C. R. W. Nevinson: The Great War and After, London, Maclean Gallery, 1980

Ben Nicholson

was born on 10 April 1894 in Denham, Buckinghamshire, the son of William Nicholson and Mabel Pryde, both painters. Apart from a brief period at the Slade School in 1910-11 where he made friends with Paul Nash, he was without formal training. Between 1912 and 1918 he spent considerable time abroad and did not apply himself seriously to painting until 1920, the year of his marriage to fellow painter Winifred Dacre; in 1921 he was in Paris and saw works by Picasso and Braque. During the 1920s he painted still-lifes and Cornish and Cumbrian landscapes in a deliberately naive style. In 1924 he joined the Seven and Five Society, becoming its chairman in 1926.

In 1932 he and Barbara Hepworth, his second wife, went to France and made direct contact with Picasso, Braque, Arp and Brancusi. They joined the group Abstraction-Création and became members of Nash's Unit One. Nicholson's *Au Chat Botté*, 1932, demonstrates a genuine understanding of Cubist methods and by 1933 he was making paintings that combined geometrical abstract shapes with sinuous wandering lines which he incised on to board. His first all-white relief was shown with the Seven and Five Society in 1934, the same year in which he visited Mondrian's studio in Paris, a formative experience for him. In 1937 he was co-editor with Naum Gabo of the Constructivist book *Circle* and in the same year he painted *Painting 1937* (Tate Gallery), which reflects his admiration for Mondrian who lived in the same road in Hampstead from 1938 to 1940.

When the Second World War broke out he, Hepworth and their triplet children moved to St Ives, Cornwall, where they formed the nucleus of an artists' community. During the war years Nicholson's work became more figurative, introducing elements of the harbour and town of St Ives. After the war his reputation grew rapidly, reaching international proportions. He was commissioned to paint a mural for the Festival of Britain in 1951 and won the first Prize at the Carnegie International in 1952, the First Guggenheim International Prize in 1956 and in 1957 the international Prize for Painting at the São Paulo Bienal. He had a retrospective exhibition in the British Pavilion at the Venice Biennale in 1954 and major retrospectives at the Tate Gallery in 1955 and 1968. Also in 1968 he was awarded the Order of Merit.

He left St Ives in 1958, his marriage to Hepworth having been dissolved in 1951, and moved

to Ticino in Switzerland. At this time he was preoccupied with making abstract reliefs, in oil on carved board. The colour was worked into the relief surface during the carving process, the artist adjusting the colours and shapes as he worked. He continued to draw from architectural and still-life motifs, both drawings and reliefs being notable for the elegance and refinement of their execution; Nicholson's eye for line and colour was of the utmost delicacy. He died in London on 6 February 1982. His style was formed in the early 1930s and although he never completely abandoned figurative work, he is most admired for the originality of his geometrical abstracts, which were dependent on a basically Cubist pictorial structure.

M. R. B.

Ben Nicholson. Retrospective, Dallas, Museum of Fine Art, 1964
Ben Nicholson, London, Tate Gallery, 1969
Ben Nicholson: the years of experiment 1919-39, Cambridge, Kettle's Yard Gallery, 1983

Eduardo Paolozzi

was born on 7 March 1924 in Leith, Edinburgh, of Italian parents who owned an ice-cream parlour. After studying at the Edinburgh College of Art and at the Slade, he went in 1947 to live in Paris, where he met several modern masters, including Giacometti whose studio he often visited. He was considerably influenced by Dada and Surrealism, as well as by Dubuffet's contemporary *Art Brut*. Specific inspiration for his early sculptures ranged from Paris street fairs to natural history; he was fascinated by detail and his approach was already that of a collagist, both in two and three dimensions. He returned to London in 1949 and began teaching textile design at the Central School of Art and Design. In 1951 he married Freda Elliot and was commissioned to make a fountain for the Festival of Britain. The following year he founded, with Lawrence Alloway, Reyner Banham, Richard Hamilton and others, the Independent Group, whose discussions were to range over a wide variety of topics including the relevance for art of recent developments in science and technology but especially of the mass media. At the first meeting at the ICA, Paolozzi projected numerous images of advertisements, comic strips, horror film imagery, etc., in random order and with no verbal commentary – a 'lecture' which became a landmark in the prehistory of British Pop Art. He also took part in the 1956 exhibition 'This Is Tomorrow' at the Whitechapel Art Gallery.

Following his eccentric-looking robotic bronze sculptures of the 1950s, with their blend of the mechanical, biological and magical-totemic, his sculptures during the 1960s took direct advantage of modern industrial techniques; most were made of aluminium, sometimes brightly painted and sometimes polished, or of chromed steel. Parallel with his sculptures went collage-based prints: three important series, all realized with the help of the Kelpra Studio, London, were *As Is When* (1965), based on the life and work of Ludwig Wittgenstein, with whose ideas on language Paolozzi felt considerable affinity, *Moonstrip Empire News* and *Universal Electronic Vacuum* (both 1967), which engaged in a largely critical investigation of modern mass society, not least its military aspects. He was appointed Lecturer in Ceramics at the Royal College of Art, London, in 1968. In 1971 he was given a retrospective at the Tate Gallery, followed by another at the Nationalgalerie, West Berlin, in 1975.

Always interested in the architectural and environmental scale, he received during the late 1970s and early 1980s a number of commissions for large works in public spaces, both in West Germany and Britain. In 1979 he was commissioned to decorate Tottenham Court Road underground station: the work, in brightly coloured mosaic, was installed between 1983 and 1985; in the following year an exhibition on the theme was held at the Royal Academy, of which he had been elected an Associate in 1972 and a full member in 1979. He was elected to the Council of the Architectural Association in 1984. In 1985 he arranged the exhibition 'Lost Magic Kingdoms' at the Museum of Mankind, London, which replaced conventional ethnographic exposition with a documentation of bizarre cross-fertilizations between modern Western and 'primitive' cultures, recreating that sense of the magical unexpectedly contained within the apparently trivial, which has always been a major source of his artistic inspiration.

G. W.

Eduardo Paolozzi, London, Tate Gallery, 1971
Eduardo Paolozzi. Sculpture, Drawings, Collages and Graphics, London, Arts Council, 1976
Eduardo Paolozzi Underground, London, Royal Academy of Arts/Weidenfeld and Nicolson, 1986

Victor Pasmore

was born in Warlingham, Surrey, on 3 December 1908. He began to paint at Harrow School (1923-6) but the death of his doctor father in 1927 obliged him to earn his living. A clerical post in the Health

Department of the London County Council allowed time for evening classes at the Central School of Art; in 1932 he joined the London Artists' Association through which he met William Coldstream and Claude Rogers. He was elected a member of the London Group in 1934 and contributed freely handled, Fauve-influenced pictures to 'Objective Abstractions' at the Zwemmer Gallery, where fellow exhibitors Moynihan and Graham Bell showed fully abstract work. Pasmore destroyed the experiments in abstraction which he made after this show and, in 1936, took Sickert, Degas and late Manet as his mentors.

In 1937, with financial help from Kenneth Clark, he gave up his job as a clerk and with Rogers and Coldstream set up the School of Drawing and Painting which became known as the Euston Road School the following year when it moved to premises in Euston Road. The teaching staff included Graham Bell and also, for 1938, Vanessa Bell. Pasmore preferred teaching to the political and social concerns of Coldstream and Graham Bell, though he continued to teach with them at Camberwell School of Art from 1943 to 1949. Following his marriage to Wendy Blood in 1940 he painted naturalistic landscapes, often views of the Thames, which he showed at the Redfern Gallery in 1947. Then he turned to abstract art, contributory factors being an exhibition of the work of Picasso and Matisse at the Victoria and Albert Museum in 1945 and subsequent discussions with his colleagues Kenneth Martin, Adrian Heath and Terry Frost. His 1950 mural for Kingston bus depot reveals a debt to Ben Nicholson whom he came to know that summer in St Ives, where he joined the Penwith Society. In 1951 Pasmore contributed to *Broadsheet No. 1* devoted to abstract art and began to exhibit black and white constructed reliefs influenced by the book *Art as the Evolution of Visual Knowledge* by Charles Biederman, with whom he corresponded until 1955. From 1949 Pasmore was a pioneer of Bauhaus-derived teaching methods, introducing a Basic Form course at the Central School of Art and developing it as an abstract foundation course from 1954 in Newcastle with Richard Hamilton. They held summer schools in Scarborough from 1955 to 1957 and Pasmore organized 'Developing Process' at the ICA in London in 1959 to show the new teaching methods.

From 1955 to 1977 Pasmore was Consulting Director of Urban Design for the south-west housing area of Peterlee New Town, where he designed the Pavilion; in 1956 he contributed to 'This is Tomorrow' at the Whitechapel Art Gallery; in 1960 his work was selected for the British Pavilion at the Venice Biennale. This marked the beginning of his participation in many international exhibitions and from 1961 he gave up teaching for full-time studio work and has since then executed many commissions for mural decorations. In 1966 he acquired a house in Malta; he reintroduced colour and freer forms into paintings rather than reliefs and his later work, while remaining abstract, has taken on a strongly metamorphic character. He was elected an RA in 1983.

S. C.

Victor Pasmore, Newcastle upon Tyne, Hatton Gallery, 1960
Victor Pasmore. Retrospective Exhibition 1925-65, London, Tate Gallery, 1965
Victor Pasmore, London, Arts Council, 1980

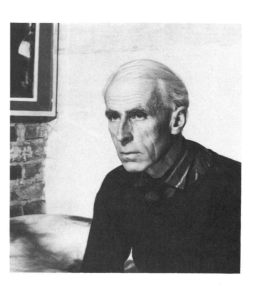

John Piper

was born on 13 December 1903 in Epsom; his father was a London solicitor and against his wishes he was an articled clerk in his father's firm between 1921 and 1926. He privately published two books of poetry – *Wind in the Trees* (1921) and *The Gaudy Saint and Other Poems* (1924) – but on the death of his father in 1926 he went to the Richmond School of Art, followed in 1927 by the Royal College of Art. He started making abstract constructions in 1934, exhibiting them with the Seven and Five Society of which he became secretary. He was associated with the pioneer review of abstract art, *Axis*, edited by Myfanwy Evans, who became his second wife after his divorce in 1937. Parallel with the abstract paintings, Piper was making collages from bits of cut or torn paper which he says was his 'way of keeping in touch with natural appearances'. In an anthology called *The Painter's Object* (1937), edited by Myfanwy Piper, he wrote an essay entitled 'Lost, a Valuable Object' in which he calls for a return to nature.

From an early age Piper had been interested in topography and architecture, especially church architecture. This tendency was strengthened in 1937 when he started work on his first *Shell Guide* edited by himself and John Betjeman, who said of him: 'He made regular tours to various parts of England and Wales, looking for stained glass, churches with box-pews in a Cotman state of picturesque decay, ruins, early industrial scenery, Welsh lakes and waterfalls, country houses, Yorkshire caves.' These were to constitute his principal subjects throughout the succeeding years.

With the outbreak of the Second World War he was invited to join the War Artists' Scheme and he recorded many bomb-devastated buildings in a highly romantic style. In 1941 he was commissioned by the Queen to make two series of watercolours of Windsor Castle and by Sir Osbert Sitwell to make paintings and watercolours of Renishaw Hall, both commissions being ideally suited to his love of historic buildings. In 1942 he wrote *British Romantic Artists* (London, Collins) tracing the Romantic impulse in British art, which clearly reflected his concept of his own artistic purpose.

Piper's output has been extraordinarily versatile, including book illustration, theatrical design, ceramics, stained-glass windows and textiles, as well as many writings. He did his first stage design in 1937 for Stephen Spender's *Trial of a Judge*; in 1942 he produced a Front Cloth for the ballet *Façade* from Edith Sitwell's poem set to William

Walton's music. In 1946 he designed the scenery and costumes for Benjamin Britten's *The Rape of Lucretia* at Glyndebourne, and collaborated with Britten throughout the next twenty-five years, ending with *Death in Venice* in 1973. He has made stained glass for Eton College Chapel (1959-64) and Coventry and Llandaff Cathedrals (1962) and, fittingly, a memorial window for Benjamin Britten in Aldeburgh parish church (1979); he also designed a large tapestry for Chichester Cathedral, 1965-6. Piper is perhaps chiefly recognized for his paintings, watercolours and prints of landscapes and buildings in Italy, France, England and North Wales. He has exhibited frequently and widely, since 1963 at the Marlborough Gallery. In 1979 he had a retrospective at the Museum of Modern Art, Oxford, and in 1983-4 at the Tate Gallery.

M. R. B.

John Piper. Retrospective Exhibition, Cambridge, Arts Council Gallery, 1953
John Piper Retrospective, Belfast, Ulster Museum, 1967
John Piper, London, Tate Gallery, 1983

Bridget Riley

was born on 25 April 1931 in London. She spent the war years with her mother, sister and aunt in Cornwall. After a spasmodic start to her education, she attended Cheltenham Ladies' College, then returned to London to study at Goldsmiths' College of Art (1949-52), where she acquired a deep admiration for the drawings of Ingres, and afterwards at the Royal College of Art (1952-5). One of the main starting points for her independent development was Neo-Impressionism: in 1960 she made a copy of Seurat's *Pont de Courbevoie*, while in her *Pink Landscape* of later that year, the dots of pointillism are so enlarged as to become autonomous units. The specific inspiration for this painting was an intense heat-haze experienced while travelling in Italy, where she was greatly impressed by the work of the Futurists, especially Balla, and by the Piero della Francesca frescoes at Arezzo. Her first solo exhibition was at Gallery One, London, in 1962. In 1963 she met Anton Ehrenzweig, who wrote the foreword for her second show at Gallery One as well as preparing a major critical essay on her work for *Art International*. By now Riley had evolved her characteristic style, to be dubbed 'Op' Art, making any fixed

image impossible for the spectator and substituting instead a constantly shifting perceptual experience of dazzlingly direct physical intensity. All her paintings of the early 1960s were exclusively in black and white – even if, as Ehrenzweig noted, 'strangely irridescent disembodied colours, like St Elmo's fires' might begin to be hallucinated. She had, however, been making colour studies on paper and actual colours entered her paintings on canvas from 1966 onwards, first as warmer and cooler greys, then as colours at full intensity, often in contrasting pairs such as red and turquoise.

In 1965 she was included in the 'Responsive Eye' exhibition at the Museum of Modern Art, New York; her solo exhibition at the Richard Feigen Gallery, New York, was sold out on the day of the opening. Her dramatic success was soured only by a New York clothing firm manufacturing dresses based directly on one of her paintings, owned by a director of the firm; Riley strongly protested against this commercialization. She won the International Prize for Painting at the 34th Biennale in Venice in 1968 and in the same year, with Peter Sedgeley, worked on the setting up of SPACE, a scheme for organizing artists' studios, which became operational in January 1969.

A retrospective travelled from Hanover to Berne, Düsseldorf and Prague in 1970-71, and there was also a major solo show at the Hayward Gallery, London, in 1971. During the late 1970s and early 1980s there have been numerous exhibitions in Australia and Japan, and Riley has travelled extensively in the Far East, as well as to India and to Egypt, where the underground tomb paintings in Luxor inspired, amongst other works, her decorative scheme for the Royal Liverpool Hospital in 1983. Also in 1983 she designed *Colour Moves* for the Ballet Rambert, first performed at that year's Edinburgh Festival.

G. W.

Bridget Riley. Paintings and Drawings 1951-71, London, Arts Council, 1971
Working with Colour: Recent Paintings and Studies by Bridget Riley, Arts Council Touring Exhibition, 1984
Bridget Riley, Selected Works 1963-1984, London, Goldsmiths' College Gallery, 1985

William Roberts

was born in Hackney, London, on 5 June 1895, the son of a carpenter. In 1909 he was apprenticed to the advertising firm of Sir Joseph Causton Ltd and attended classes at St Martin's School of Art in the evenings. In 1910 he won a scholarship to the Slade School, which he attended until 1913, making friends with his fellow student Jacob Kramer, whose sister Sarah he was later to marry. After travels in France and Italy in 1913, he produced his first Cubist compositions – although his interest in Cubism pre-dated his travels. He was briefly associated with Fry's Omega Workshops and exhibited at the New English Art Club. In 1914, however, he joined the Vorticists, appearing as one of the signatories of their manifesto in the first issue of *Blast* and participating in the Vorticist Exhibition of 1915. In that year he also exhibited with the London Group.

In 1916 Roberts joined the Royal Field Artillery and soon afterwards went to France. Two years later he returned to England as an Official War Artist for the Canadian War Records Office and the Ministry of Information. In 1920 he took part in the 'Group X' exhibition at the Mansard

Gallery; his first one-man show took place at the Chenil Gallery in 1923. In 1925 he began teaching part-time at the Central School of Arts and Crafts, a post he was to retain with the exception of the war years until 1960. Between 1927 and 1934 he was a member of the London Artists' Association. The outbreak of the Second World War prompted him to move from London to Oxford, where he lived until 1945, teaching one day a week at the Oxford Technical School. Returning to London, he began to exhibit at the Royal Academy, and continued to do so every year until his death. He was elected an ARA in 1958 and an RA in 1966; in 1965 a major retrospective exhibition was held at the Tate Gallery. He published *The Vortex Pamphlets 1956-1958*, an attempt to put the influence of Wyndham Lewis into proper perspective.

Roberts died in London on 20 January 1980: he drew and painted up to (and including) the very last day of his life. He preferred figure subjects taken from everyday life and, occasionally, literary sources. At first he developed a schematic and angular style and some early images are almost abstract, but his experience as an Official War Artist and as a soldier seems to have prompted him to adopt a more humanist approach. The angularity of the Twenties' works tends to give way later to a more sculptural approach to form, akin to that found in Classical reliefs; nearly all his post-1945 works consist of stylized renderings of people in everyday situations.

M. B.-D.

William Roberts ARA. Retrospective Exhibition, London, Tate Gallery, 1965
Paintings and Drawings by William Roberts RA, London, Royal Academy, 1976.
William Roberts. An artist and his family, London, National Portrait Gallery, 1984

Walter Richard Sickert

was born in Munich on 31 May 1860, the eldest son of an Anglo-Irish mother and Oswald Adalbert Sickert, an artist of Danish descent whose own father, Johann Jurgen Sickert, was also a painter. The family moved to England, via Dieppe, in 1868. After receiving a classical education at King's College School, London (1875-8), and a brief career as an actor in repertory companies (1878-81), he attended the Slade School between 1881 and 1882 as a student of Legros, and shortly after worked with Whistler as his assistant and pupil. It was from Whistler that Sickert learnt the art of etching, as well as the subtle tonal approach to painting that he was to draw on throughout his life. Degas, whom he first met in Paris in

1883 and again, in Dieppe, in 1885, was to prove a more crucial influence still. In Paris he also encountered Monet, Pissarro, Gauguin, Signac, Bonnard and Vuillard, thereby acquiring a far more modern and cosmopolitan education than was the norm in England at that time.

In 1888 Sickert joined the New English Art Club and with Wilson Steer led the 'rebel' group who in 1889 put on their own exhibition 'The London Impressionists' at the Goupil Gallery. His subject-matter at this time (c. 1888-95) was essentially urban, with particular emphasis on the music hall. From 1885, the year of his first marriage, to Ellen Cobden, which ended in divorce in 1899, Sickert spent part of each year in Dieppe and from 1895 wintered in Venice; between 1898 and 1905 he lived mainly in Dieppe with visits to Venice, where architectural views formed his staple subject-matter, although there are some figure compositions and portraits. Stylistic maturity was achieved soon after 1900, following a transitional phase in which his technique veered between a painterly 'impressionist' approach for *plein air* paintings and a more premeditated approach that involved transferring squared-up drawings on to canvas. The Dieppe and Venice works of c. 1900-5 have been described as 'essentially drawings in paint'; with their subdued tones, lightly applied paint and emphatic outlines, they mark a resolution of that earlier tension between careful draughtsmanship and painterly enthusiasm.

Returning to London late in 1905 and turning his attention to a new class of subject matter — the unglamorous inhabitants of seedy urban interiors (although he continued to paint theatre and vaudeville scenes), Sickert soon became the leader of the group of urban realist painters who gathered in his studio at 19 Fitzroy Street; in 1907 they became formally known as the Fitzroy Street Group. In 1908 Sickert was a founder member of the Allied Artists' Association and in 1911 the more advanced nucleus of the Fitzroy Street Group broke away to form the Camden Town Group with Sickert once again at its centre. Female nudes on metal bedsteads and couples in bedrooms or front parlours dominate Sickert's output at this period, giving, in the artist's own words, 'the sensation of a page torn from the book of life'. The 1908-10 series of works painted in response to the real-life 'Camden Town murder' of 1907, caused a considerable moral outcry. Colours are dark but rich; compositions are tauter and surfaces increasingly impastoed, although they begin to lighten again after about 1911.

Sickert moved to Bath in 1916, and between 1919 and 1922 was based in Dieppe. In 1926 after his third marriage, to the painter Thérèse Lessore (his second marriage, to Christine Angus, had taken place in 1911 and ended with her death in 1920), he settled in England for good. He left London in 1934 to live in Thanet (until 1938) and then in Bathampton; he died there on 22 January 1942. The 1920s saw an increasing number of public honours bestowed on him, among them the presidentship of the Royal Society of British Artists (1927-9) and associate membership of the Royal Academy in 1924, followed by full membership in 1934 from which, however, he resigned in 1935. The work of this last period, much of it based on Victorian illustrations or press photographs, drily painted and with a certain 'coarseness' of touch, was for a long time regarded as marking a decline; more recently, however, it has undergone considerable re-evaluation, while his earlier 'Camden Town' paintings proved a major influence on the Euston Road School of the late 1930s. Sickert was an important teacher and a stimulating, if unsystematic, art critic. His writings were published posthumously in 1947 as *A Free House!*, edited by Osbert Sitwell.

M. B.-D.

Sickert, London, National Gallery, 1941
Paintings, Drawings and Prints of Walter Richard Sickert, 1860-1942, London, Arts Council, 1977
Late Sickert, Paintings 1927 to 1942, London, Arts Council, 1981

Matthew Smith

was born on 22 October 1879 in Halifax. After his schooling there he worked in industry at the insistence of his father, who was a manufacturer, but in 1901 he was allowed to enter the Art Department of the Manchester School of Technology. From 1905 to 1908 he studied at the Slade School of Art in London, paying a memorable visit to Pont-Aven in his final year. Afterwards he lived in France, attending Matisse's school in Paris for a few weeks before it closed. He exhibited at the Salon des Indépendants in 1911 and 1912, returning to England to marry Gwendolin Salmond, a student at the Slade whom he had first met in 1907; they settled at Grez-sur-Loing. At this time he studied the work of Ingres in the Museum at Montaubon. The death of his father in August 1914 left him financially independent but war was declared while Smith was still in England and he was unable to return to France. He took a studio in Fitzroy Street and in 1916 met his neighbour Sickert, with whom he spent a holiday in Devon; he also met Epstein, who became a lifelong friend.

In 1916 he enlisted in the Army and served in France, where he was severely wounded. He was not discharged from the Army until 1919, when he returned to Grez with his wife and two sons, born in 1915 and 1916. His meeting with Roderic O'Conor in Paris that year was crucial for the development of the high-keyed landscapes that he painted on holiday in Cornwall in 1920 and 1921; O'Conor had been a close friend of Gauguin and Smith later saluted him as a precursor of the Fauves. Smith spent part of 1922 at a sanatorium in Switzerland, suffering from the first of recurring nervous diseases, and from this time did not live regularly with his wife. He met the painter Vera Cuningham in Paris, who became the model for his series of nudes of the 1920s, and exhibited regularly with the London Group, which he had

joined in 1920. He lived part of the year in London and part in Paris until 1930, after which he remained almost entirely in France, returning permanently to England only in 1940.

During the Second World War both his sons were killed and Smith lived a lonely life, moving often from one small hotel to another, sometimes staying with his friends Dorelia and Augustus John; he continued to travel after the end of the war. He shared a retrospective exhibition with Epstein at Temple Newsam House, Leeds, in 1942; in 1950 twenty-six of his pictures were shown at the Venice Biennale; in 1953 a retrospective was held at the Tate Gallery in London. He was knighted in 1954 and died in London in September 1959. Although throughout his life he was somewhat apart from mainstream modern art, inspired as much by Rubens as the Post-Impressionists, his gifts as a colourist were saluted in 1953 by the younger artists, Francis Bacon and Patrick Heron.

S. C.

A Memorial Exhibition of Works by Sir Matthew Smith CBE 1879-1959, London, Royal Academy of Arts, 1960
Matthew Smith 1879-1959. Paintings from the Artist's Studio, London, Arts Council, 1972
Matthew Smith, London, Barbican Art Gallery, 1983

Richard Smith

was born in Letchworth, Hertfordshire, on 27 October 1931 and studied at Luton School of Art (1948-50) and, after two years with the RAF in Hong Kong, at St Albans School of Art (1952-4) and the Royal College of Art, London (1954-7). In 1957 he spent a short time in Italy, and from 1957 to 1958 he taught mural decoration at Hammersmith College of Art. He had first visited New York in 1957, and in 1959 a Harkness Fellowship enabled him to live there until 1961, the year of his first one-man show (at the Green Gallery, New York).

Although he taught at St Martin's School of Art, London, in the early Sixties (making a short film, *Trailer*, exploring his preoccupation with cinematic distortion, in 1962), support for his art came from the USA rather than London, and he moved back to New York in 1963. After his marriage in 1964 he returned to England but still spent prolonged periods in the United States.

From his first work done at the Royal College, Smith has shown himself to be a gifted colourist. He was a fellow student with Peter Blake and was on the close fringes of the Pop Art movement. But

though he was preoccupied with the textures and shapes of commercial packaging, having read Marshall McLuhan's *Mechanical Bride* (1951) he was always more interested in the perceptual effects of the mass media than in the message of its images. At his large one-man exhibition at the Whitechapel Art Gallery in 1966 he showed very large, shaped canvases which almost took painting into the realm of sculpture. In the 'kite' paintings which followed in the early Seventies, the canvas was detached from its stretcher and supported by other means – threads, string, tape, ropes, metal rods – which became an integral part of the imagery.

In 1966 Smith won the Robert C. Scull Prize at the Venice Biennale and in 1967 was awarded the Grand Prix at the São Paulo Bienal; he was made a CBE in 1972. Although he has not had a retrospective in London since he settled in New York in 1976, by then he had achieved the distinction of two major exhibitions before the age of forty-five: nine years after the one at the Whitechapel, a second was held at the Tate Gallery (1975). He conceived this himself as a series of reconstructions of the six one-man shows he had had since 1961. The character of each section was dictated by that of the exhibition it commemorated, thus emphasizing the serial nature of his work. His method is to make a decision about format and then adapt to the structure and relationships which follow as a direct consequence.

M. B.-D.

Richard Smith. Paintings 1958-1966, London, Whitechapel Art Gallery, 1966
Richard Smith. Seven Exhibitions 1961-75, London, Tate Gallery, 1975
Richard Smith: Recent Work 1972-1977: Paintings, Drawings and Graphics, Cambridge, Mass., Hayden Gallery, MIT, 1978

Stanley Spencer

was born on 30 June 1891 at Cookham on Thames, Berkshire. After a scanty early education, he studied at the Slade School from 1908 to 1912, gaining a scholarship and other awards. Among his contemporaries were Mark Gertler, Nevinson, Bomberg, Paul Nash and Wadsworth. In 1912 he exhibited at the Second Post-Impressionist Exhibition organized by Roger Fry. During the First World War he served as an orderly in the Royal Medical Corps and later as an infantryman in Macedonia, experiences that provided themes for subsequent compositions. He was a member of the New English Art Club 1919-27 and had his first

one-man show at the Goupil Gallery in 1927, where he exhibited the enormous *Resurrection* (Tate Gallery) whose setting is the churchyard at Cookham. For him the events in the New Testament were a living and present reality, and through his imagination he transformed his home village into the Celestial City, the 'holy suburb of Heaven'.

In 1923-4 he worked on a series of designs for mural decorations based on his experiences during the war. These were seen by Mr and Mrs J. L. Behrend, who decided to build a memorial chapel at Burghclere. Spencer completed the murals in 1932: the nineteen canvases represent the daily round of a foot soldier during wartime, such as *Scrubbing the Floor* and *Map Reading*. The apotheosis of the series is *The Resurrection of Soldiers* on the east wall, one of Spencer's most powerful and moving compositions.

During the 1930s he painted a series called *The Beatitudes of Love*, an expression of his own joy in heavenly love and in sex, which he regarded as indivisible. Some of the figures in the paintings of this decade are very mannered, almost grotesque, and two paintings were rejected by the hanging committee of the Royal Academy in 1935. Spencer, who had been elected an ARA in 1932, resigned in protest and was not re-elected until 1950. Concurrent with his narrative and figurative paintings are freshly and directly painted landscapes and gardens in and around Cookham.

Early in the Second World War he was commissioned by the War Artists Advisory Committee to paint shipyards at Glasgow and he worked on this cycle, *Shipbuilding on the Clyde*, for six years. Again the paintings depict workmen going about their laborious daily tasks but the mannered style of the 1930s had by now been subsumed into a heroic distortion. Spencer followed the shipbuilding paintings with the Port Glasgow Resurrection series, 1945-50, in which the figures seem to be imbued with a fanatical religious fervour. After the war Spencer returned to Cookham and continued to paint religious pictures. He was working on a large painting of *Christ Preaching at Cookham Regatta* when he died on 14 December 1959.

In 1932 and 1938 Spencer was represented at the Venice Biennale. In 1947 he had a retrospective exhibition at Temple Newsam, Leeds; in 1955 at the Tate Gallery; and in 1980 at the Royal Academy. He was knighted in 1958. His visionary attitude has been compared to that of William Blake and his minuteness of observation to that of the Pre-Raphaelites, but he remains a true original of twentieth-century art.

M. R. B.

Stanley Spencer. War Artist on Clydeside, Edinburgh, Scottish Arts Council, 1975
Stanley Spencer 1891-1959, London, Arts Council, 1976
Stanley Spencer RA, London, Royal Academy of Arts/Weidenfeld and Nicolson, 1980

Graham Sutherland

was born in London on 24 August 1903. His father was a lawyer and he went to preparatory school at Sutton in Surrey, where the family had moved in 1910, and then to Epsom College. He became an engineering apprentice at the Midland Railway Works at Derby at the age of seventeen but he quickly found that engineering was not his *métier* and he enrolled at Goldsmiths' College School of Art in 1921, specializing in etching. His early drypoints and etchings were influenced by Dürer, Rembrandt, Millet and Whistler. In the late 1920s he discovered Samuel Palmer and developed a dreamlike pastoral romanticism which is indebted to Palmer's 'visionary' years. Following the Wall Street crash in 1929 the print market collapsed and Sutherland became a commercial designer of glassware, ceramics, postage stamps and especially posters. He also began to paint.

In 1934 he and his wife Kathleen made their first visit to Pembrokeshire, which from then on was a constant source of inspiration. Sutherland emphasized the drama and mystery of the landscape, and often anthropomorphized natural forms, to bring out, he said, 'the anonymous personality of these things'. In 1936 he exhibited in the International Surrealist Exhibition, although he was not really sympathetic to the movement and took little interest in the work of European artists, with the possible exception of Picasso.

In 1940 Kenneth Clark invited him to take part in the War Artists' Scheme. He responded to the devastation caused by bomb damage, which he rendered in a highly theatrical manner, as well as to scenes of human endeavour such as the Cornish tin miners and foundry workers whose uncomfortable labours he recorded. In 1944 he was commissioned to paint an *Agony in the Garden* for St Matthew's Church, Northampton, but the Dean accepted his preference for a *Crucifixion*, which was motivated by the horrific photographs then coming out of the concentration camps, as well as by the spiky image of the crown of thorns, which to Sutherland was the ultimate cruelty.

He visited the south of France first in 1947 and bought a house there in 1955. The effect of painting in bright sunlight made his work more dramat-

ic, more emotionally charged and high-keyed in colour. By then he acknowledged the influence of Matisse. During this period he painted his first portrait commission – of Somerset Maugham – which proved to be such a success that he received many more commissions, usually from the rich and famous, whom he enjoyed portraying. However, in the case of Winston Churchill, the portrait was so disliked that it was destroyed.

In 1952 he was asked to design a tapestry for the newly built Coventry Cathedral. The subject was Christ the Redeemer enthroned in glory: inspired by Byzantine art, it is an imposing image on a massive scale. From the cartoons for the tapestry Sutherland extrapolated the studies of animals which became the source-material for his first *Bestiary* in 1968 (twenty-six colour lithographs) and continued in his second *Bestiary* in 1979 based on poems by Apollinaire. He died in London on 17 February 1980.

<div align="right">M. R. B.</div>

Graham Sutherland, London, Institute of Contemporary Arts, 1951
Graham Sutherland, London, Tate Gallery, 1953
Graham Sutherland, London, Tate Gallery, 1982

William Turnbull

was born in Dundee, Scotland, on 11 January 1922, the son of a shipyard engineer. At an early age he decided to become an artist and, through evening classes, became proficient enough in drawing to find work illustrating detective and love stories for a local magazine publisher. From 1941 he served in Canada, India and Ceylon as a pilot in the RAF, and he was already twenty-four when he finally began two years of study at the Slade School of Art. There he made friends with fellow Scotsman Paolozzi, with whom in 1947 he visited the Musée de l'homme and Dubuffet's '*Foyer de l'art brut*' in Paris: Turnbull's art has always been fed by his reading about other and past societies. He lived in Paris for two years from 1948, meeting Hélion, Léger, Giacometti and Tzara, and making a brief visit to Brancusi in his studio.

When he returned to London he belonged to the Independent Group, which at first comprised informal talks among friends (including Reyner Banham, Hamilton and Paolozzi) and then meetings at the ICA, where Turnbull gave a talk on 'New Concepts of Space'. He shared his first exhibition with Paolozzi in London in 1950, and their work was shown with that of Moore and Armitage amongst others in 'New Aspects of British Sculpture' at the Venice Biennale of 1952. At that time he was already painting his sculpture as well as working on canvas. From the mid-1950s he did away with a conventional base for his sculptures and gave up depicting movement in favour of conveying stillness, at first making masks as well as paintings of heads, which were followed by standing figures, some of them named 'Idol'. He then began to combine elements from separate sculptures and to form freely imagined totemic pieces which could sometimes be arranged according to the spectator's own choice; titles such as *Oedipus* added a menacing note to these works. In 1956 he was greatly impressed by American Abstract Expressionist paintings shown at the Tate Gallery: on a visit to New York the following year he admired the work of Rothko and Still. He described his subsequent paintings as 'large environmental shields changing our lives . . . provocations to con-

templation and order'. His visits to the Far East, especially from the early Sixties, have reinforced his love of Eastern philosophy: in 1969 he produced a book of *haiku* poems by the Japanese poet Basho, designed to complement the special quality of the poetry.

In his single-minded explorations of modes of sculpture and painting he has continued to approach the problem of ritual in contemporary art, often in the Seventies using modular units. Recently he has returned to his own earlier mode, making figure-like sculptures which convey something of the mystery of Cycladic art. He is married to the sculptor Kim Lim and taught at the Central School of Art from 1952 to 1961 and from 1964 to 1972.

<div align="right">S. C.</div>

William Turnbull. Sculpture, Detroit, Art Institute, 1963
William Turnbull. Paintings, Vermont, Bennington College, 1965
William Turnbull. Sculpture and Painting, London, Tate Gallery, 1973

Edward Wadsworth

was born in Cleckheaton, Yorkshire, on 29 October 1889. After schooling at Edinburgh at Fettes College, he studied engineering for one year in Munich (1906-7), spending his spare time at the Knirr art school. He then returned to his native Yorkshire to attend Bradford School of Art and won a scholarship in 1908 to the Slade School, where he was awarded first prizes for landscape in 1910 and figure painting in 1911. Roger Fry invited him to participate in the Omega Workshops after he had taken part in the Second Post-Impressionist Exhibition when it was rearranged for tour in 1913. However, with Wyndham Lewis he soon broke from Omega and Bloomsbury, exhibiting first at the Post-Impressionist and Futurist show at the Doré Galleries and then in 1914 at the Rebel Art Centre as a founder member of the London Group.

Wadsworth's studies in Germany enabled him to contribute his own translations with illustrations from Kandinsky's *Über das Geistige in der Kunst* (Munich, Piper, 1912) to *Blast No. 1* (June 1914), in which he signed the Vorticist manifesto; he showed pioneering abstract works in the Vorticist Exhibition of 1915. He had continued to travel in Europe and was in Rotterdam on the outbreak of

the First World War in 1914. He served as an intelligence officer in the Mediterranean until he was invalided out of the Navy in 1917, when he spent a year working on dazzle camouflage for ships in Liverpool and Bristol. This experience provided the subject for a monumental war painting (National Gallery of Canada) which marks a transition between his abstract Vorticist paintings of 1915 and his modernist landscapes of the 1920s. Early in this decade he pioneered a revival of tempera as a medium and corresponded with de Chirico about the technique. During the Twenties he was one of the most European of British artists: a legacy enabled him to travel and he lived in Paris during 1929. His work was shown there in 1930 and at the International Exhibition in Brussels in 1935. *Editions Sélection* of Antwerp devoted a monograph to him in 1933 with essays by Zadkine and Waldemar George; in this and the year following Wadsworth contributed to the Parisian periodical *Abstraction-Création*. In London he was a founder member of Unit One, a group instigated by Paul Nash and including Moore, Ben Nicholson, Hepworth and Burra, uniting artists with very different approaches. In 1940 his work was selected for the Venice Biennale and in 1943 he was elected an ARA.

The element of fantasy in Wadsworth's paintings derives more from unexpected juxtapositions of scale and calculated precision closer to Metaphysical Painting than Surrealism. He remained always in control of style, re-exploring Futurist multiple viewpoints and Cubist compositional devices; in abstract compositions made in the last few years of his life he revived the optical effects characteristic of his studies with camouflage. He died in London on 21 June 1949.

<div align="right">S. C.</div>

Edward Wadsworth. Memorial Exhibition, London, Tate Gallery, 1951
Edward Wadsworth 1889-1949. Paintings, drawings, prints, London, P. & D. Colnaghi, 1974
Edward Wadsworth 1889-1949. Paintings from the 1920s, London, Mayor Gallery/Mark Glazebrook, 1982

John Walker

was born in Birmingham on 12 November 1939, and studied at Birmingham College of Art 1956-60 and at the Académie de la Grande Chaumière, Paris, 1961-3. He lived in London from 1964 to 1970, after which he moved to New York. His first one-man show took place at the Axiom Gallery, London, in 1967. He has been Professor of Painting and Drawing at the Cooper Union, New York (1974-5); Visiting Professor, Yale University (1975-7); Artist in Residence, St Catherine's College, Oxford (1977-8); Painting Tutor, Royal College of Art, London, and Visiting Artist, Columbia University, New York (1974-8); Visiting Artist, Monash University, Melbourne (1979); Artist in Residence, Prahran College of Advanced Education, Melbourne (1980), and Dean of the Victoria College of the Arts, Melbourne (1982). He has been the recipient of numerous awards and prizes since 1960, and represented Britain at the 1972 Venice Biennale.

Walker's works of the mid- to late-Sixties, the period in which he achieved stylistic maturity, were shaped canvases, usually trapezoidal, with smokey, suggestive surfaces, containing within them other shapes, ambiguous but substantial, located at the base of the paintings so as to suggest illusionistic pictorial space. In the mid-Seventies he embarked on a series of three-metre-tall abstractions, stretching a basically Cubist collage idiom to its limits. His method of throwing chalk dust into wet paint and his use of gels to achieve intermittent depths gave evidence of his technical ingenuity as well as his continuing concern with spatial ambiguities. Since the late Seventies, his paintings have increasingly evoked other paintings, both his own earlier works and those of previous masters, above all, Goya's *Duchess of Alba*. While his concern is still, in his own words, to stay 'just this side of abstraction', the forms in his paintings have become increasingly figurative and illusionistic, and dramatic, even theatrical, in their juxtaposition and lighting. Colours tend to be rich and layered, surfaces heavily encrusted and combined with translucent glazes; the overall mood tends to be epic and sombre. In the paintings done since Walker's first encounter with Australia and Oceania in 1979 and their alien culture, vegetation and light conditions, there is a new emphasis on heat and fertility and an obsession with primitive ritual in confrontation (not always resolved) with Western culture. Japanese Kabuki theatre, with its strong sense of ritual and pattern-making, also attracted his attention at this time. Words feature in his paintings not merely to emphasize spatial ambiguities but as pointers to their meaning, more allusive and complex than ever.

M. B.-D.

Projects, New York, Museum of Modern Art, 1974
John Walker, Washington DC, Phillips Collection, 1978
John Walker. Paintings from the Alba and Oceania Series 1979-84, London, Arts Council, 1985

Selected Bibliography

Compiled by Krzysztof Z. Cieszkowski

Alley, Ronald, and Sir John Rothenstein, *Francis Bacon*, London, Thames and Hudson, 1964.

Alley, Ronald, *British Painting since 1945*, London, Tate Gallery, 1966.

Alley, Ronald, 'Patrick Heron: the Development of a Painter', *Studio International*, vol. 174, no. 891, July-August 1967, pp. 18-25.

Alloway, Lawrence, *Nine Abstract Artists: their Work and Theory*, London, Alex Tiranti, 1954.

Andrews, Michael, and Victor Willing, 'Morality and the Model', *Art and Literature*, 2, Summer 1964, pp. 49-64.

Artscribe, nos. 34-36, *The Fifties* [articles by Adrian Lewis, David Nicholson, etc.], March, June and August 1982.

Ashcroft, T., *English Art and English Society*, London, Peter Davies, 1936.

Attwater, Donald, *A Cell of Good Living: the Life, Works and Opinions of Eric Gill*, London, Geoffrey Chapman, 1969.

Auerbach, Frank, 'Fragments from a Conversation', *X, a Quarterly Review*, vol. 1, no. 1, November 1959, pp. 31-4.

Baker, Denys Val, *Britain's Art Colony by the Sea*, London, George Ronald, 1959.

Baker, Denys Val, *The Timeless Land: the Creative Spirit in Cornwall*, Bath, Adams & Dart, 1973.

Baron, Wendy, *Sickert*, London, Phaidon, 1973.

Baron, Wendy, *The Camden Town Group*, London, Scolar Press, 1979.

Baxandall, David, *Ben Nicholson*, London, Methuen, 1962.

Beattie, Susan, *The New Sculpture*, New Haven and London, Yale University Press, for the Paul Mellon Center for Studies in British Art, 1983.

Bell, Clive, *Art*, London, Chatto and Windus, 1914.

Bell, Clive, *Since Cézanne*, London, Chatto and Windus, 1928.

Bell, Clive, *Old Friends: Personal Recollections*, London, Chatto and Windus, 1956.

Bell, Graham, *The Artist and his Public*, London, Hogarth Press, 1939.

Bell, Quentin, 'The Camden Town Group, 1: Sickert and Post Impressionism', *Motif*, 10, Winter 1962/3, pp. 36-51.

Bell, Quentin, 'The Camden Town Group, 2: Opposition and Composition', *Motif*, 11, Winter 1963/4, pp. 68-85.

Bell, Quentin, *Bloomsbury*, London, Weidenfeld and Nicolson, 1968.

Berger, John, 'The Weight' [on Leon Kossoff], *The New Statesman*, vol. 58, no. 1488, 19 September 1959, pp. 353-4.

Berger, John, *Permanent Red: Essays in Seeing*, London, Methuen, 1960.

Berger, John, *Ways of Seeing: based on the BBC Television Series*, London, British Broadcasting Corporation, and Harmondsworth, Middx, Penguin Books, 1972.

Berger, John, *About Looking*, London, Writers & Readers, 1980.

Berthoud, Roger, *Graham Sutherland: a Biography*, London, Faber and Faber, 1982.

Bertram, Anthony, *A Century of British Painting, 1851-1951*, London, Studio Publications, 1951.

Bertram, Anthony, *Paul Nash: the Portrait of an Artist*, London, Faber and Faber, 1955.

Blast: *Review of the Great English Vortex*, London, John Lane, The Bodley Head; New York, John Lane; Toronto, Bell and Cockburn, 1914-1915 (No. 1: June 1914; No. 2: July 1915); facsimile reprint, New York, Kraus, 1967.

Blume, Dieter, *Anthony Caro: Catalogue Raisonné*, 5 vols, Cologne, Galerie Wentzel, 1981 (vols I-IV), 1985 (vol. V).

Bomberg, David, 'The Bomberg Papers', *X, a Quarterly Review*, vol. 1, no. 3, June 1960, pp. 183-90.

Bowness, Alan, 'Kenneth Armitage: his Recent Sculpture', *Motif*, 11, Winter 1963/4, pp. 56-67.

Bowness, Alan (ed.), *Alan Davie*, London, Lund Humphries, 1967.

Bowness, Alan (ed.), *The Complete Sculpture of Barbara Hepworth 1960-69*, London, Lund Humphries, 1971.

Bowness, Alan, and Luigi Lambertini, *Victor Pasmore, with a Catalogue Raisonné of the Paintings, Constructions and Graphics 1926-1979*, London, Thames and Hudson, 1980.

Brach, Paul, 'John Walker's Multivalent Monolith', *Art in America*, vol. 71, no. 6, Summer 1983, pp. 137-9.

Brighton, Andrew, 'Consensus Painting and the Royal Academy since 1945', *Studio International*, vol. 188, no. 971, November 1974, pp. 174-6.

Brighton, Andrew, and Lynda Morris (eds), *Towards Another Picture: an Anthology of Writings by Artists Working in Britain, 1945-1977*, Nottingham, Midland Group, 1977.

Browse, Lillian, *Sickert*, London, Rupert Hart-Davis, 1960.

Buckle, Richard, *Jacob Epstein, Sculptor*, London, Faber and Faber, 1963.

Burgin, Victor, *Work and Commentary*, ed. Elizabeth Glazebrook, London, Latimer New Dimensions, 1973.

Cambridge, Kettle's Yard Gallery, *Artists at War 1914-1918* (exhibition catalogue, introd. Robert Cumming, October-November 1974).

Cambridge, Kettle's Yard Gallery, *Circle: Constructive Art in Britain, 1934-40* (exhibition catalogue, ed. Jeremy Lewison, February-March 1982).

Cambridge, Kettle's Yard Gallery, *1965 to 1972: When Attitudes Became Form* (exhibition catalogue, ed. Hilary Gresty, July-September 1984).

Cambridge Opinion, no. 37, *Modern Art in Britain*, ed. Michael Peppiatt, 1964.

Cambridge, Kettle's Yard Gallery of Art, *Surrealism in England, 1936 and After: an Exhibition to Celebrate the 50th Anniversary of the First International Surrealist Exhibition in London in June 1936* (exhibition catalogue, text by Toni del Renzio and Duncan Scott, May 1986).

Cardiff, Welsh Arts Council, *British Art the Modern Movement, 1930-40* (exhibition catalogue, introd. Alan Bowness; National Museum of Wales, Cardiff, October-November 1962).

Casson, Stanley (ed.), *Artists at Work*, London, George G. Harrap, 1933.

Catto, Mike, *Art in Ulster, 2: a History of Painting, Sculpture and Printmaking 1957-1977*, Belfast, Blackstaff Press, 1977.

Causey, Andrew, *Peter Lanyon: his Painting*, Henley-on-Thames, Aidan Lewis, 1971.

Causey, Andrew, *Paul Nash*, Oxford, Oxford University Press, 1980.

Causey, Andrew, *Edward Burra: Complete Catalogue*, Oxford, Phaidon, 1985.

Chamot, Mary, *Modern Painting in England*, London, Country Life, and New York, Charles Scribner's Sons, 1937.

Chappell, William (ed.), *Edward Burra . . . by his Friends*, London, André Deutsch, 1982.

Chitty, Susan, *Gwen John, 1876-1939*, London, Hodder & Stoughton, 1981.

Clark, Kenneth (introd.), *Paintings of Graham Bell*, London, Lund Humphries, 1947.

Clark, Kenneth, *Another Part of the Wood: a Self Portrait*, London, John Murray, 1974.

Clark, Kenneth, *The Other Half: a Self Portrait*, London, John Murray, 1977.

Cohen, Bernard, 'William Turnbull – Painter and Sculptor', *Studio International*, vol. 186, no. 957, July-August 1973, pp. 9-16.

Colchester, The Minories, *A Salute to British Surrealism, 1930-1950* (exhibition catalogue, introd. George Melly, Michel Remy and Louisa Buck; April-May 1985; travelling to London, Blond Fine Art, and Hull).

Collins, Judith, *The Omega Workshops*, London, Secker & Warburg, 1984.

Collis, Maurice, *Stanley Spencer: a Biography*, London, Harvill, 1962.

Compton, Michael, *Some Notes on the Work of Richard Long* (publ. on the occasion of his exhibition at the Venice Biennale, 1976), London, Lund Humphries, 1976.

Cork, Richard, *Vorticism and Abstract Art in the First Machine Age*, 2 vols, London, Gordon Fraser, 1976.

Cork, Richard, *Art Beyond the Gallery in Early 20th Century England*, New Haven and London, Yale University Press, 1985.

Cork, Richard, *David Bomberg*, New Haven and London, Yale University Press, 1987.

Cross, Tom, *Painting the Warmth of the Sun: St. Ives Artists 1939-1975*, Penzance, Alison Hodge, and Guildford, Lutterworth Press, 1984.

Dasenbrock, Reed Way, *The Literary Vorticism of Ezra Pound and Wyndham Lewis: Towards the Condition of Painting*, Baltimore and London, John Hopkins University Press, 1985.

Davies, Hugh, and Sally Yard, *Francis Bacon*, New York, Abbeville Press, 1986.

Davies, Peter, and Tony Knipe (eds), *A Sense of Place: Sculpture in Landscape*, Sunderland, Ceolfrith Press, 1984.

Digby, George Wingfield, *Meaning and Symbol in three Modern Artists: Edvard Munch, Henry Moore, Paul Nash*, London, Faber and Faber, 1955.

Dunlop, Ian, *The Shock of the New: Seven Historic Exhibitions of Modern Art*, London, Weidenfeld and Nicolson, 1972.

Duveen, Sir Joseph, *Thirty Years of British Art*, London, The Studio, 1930.

Eates, Margot, *Paul Nash: the Master of the Image, 1889-1946*, London, John Murray, 1973.

Ede, H. S., *Savage Messiah* [biography of Henri Gaudier-Brzeska], London, William Heinemann, 1931.

Epstein, Jacob, *Let There Be Sculpture: an Autobiography*, London, Michael Joseph, 1940; rev. ed., London, Hulton Press, 1955.

Evans, Myfanwy (ed.), *The Painter's Object*, London, Gerald Howe, 1937.

Evans, Myfanwy (ed.), *The Pavilion: a Contemporary Collection of British Art and Architecture*, London, I. T. Publication, 1946.

Falkenheim, Jacqueline V., *Roger Fry and the Beginnings of Formalist Art Criticism*, Ann Arbor (Mass.), UMI Research Press, 1980.

Farr, Dennis, *British Sculpture since 1945*, London, Tate Gallery, 1965.

Farr, Dennis, *English Art 1870-1940*, Oxford, Oxford University Press, 1978.

Ferguson, John, *The Arts in Britain in World War I*, London, Stainer and Bell, 1980.

Finch, Christopher, *Patrick Caulfield*, Harmondsworth, Middx, Penguin Books, 1971.

Forma, Warren, *5 British Sculptors (Work and Talk)*, New York, Grossman, 1964.

Fry, Roger, *Vision and Design*, London, Chatto and Windus, 1925.

Fry, Roger, *Letters of Roger Fry*, ed. Denys Sutton, 2 vols, London, Chatto and Windus, 1972.

Fuller, Peter, 'Leon Kossoff', *Art Monthly*, 26, May 1979, pp. 11-13.

Fuller, Peter, *Beyond the Crisis in Art*, London, Writers & Readers, 1980.

Fuller, Peter, *Images of God: the Consolations of Lost Illusions*, London, Chatto and Windus, 1985.

Fuller, Peter, 'Auerbach's Vision', *Art Monthly*, 98, July-August 1986, pp. 3-6.

Gage, Edward, *The Eye in the Wind: Scottish Painting since 1945*, London, Collins, 1977.

Gertler, Mark, *Selected Letters*, ed. Noel Carrington, London, Rupert Hart-Davis, 1965.

Gill, Eric, *Art and a Changing Civilization*, London, John Lane, The Bodley Head, 1934.

Gowing, Lawrence, 'Painter and Apple', *The Arts*, no. 1 [1946], pp. 70-8; republ. as a monograph, London, Arts Council of Great Britain, 1983.

Grigson, Geoffrey, 'Painting and Sculpture', in Geoffrey Grigson (ed.), *The Arts To-day*, London, John Lane, The Bodley Head, 1935, pp. 71-109.

Hall, Fairfax, *Paintings and Drawings by Harold Gilman and Charles Ginner in the Collection of Edward le Bas*, London, Fairfax Hall, 1965.

Hamilton, Richard, *Collected Words, 1953-1982*, London, Thames and Hudson, 1982.

Hammacher, A. M., *Modern English Sculpture*, London, Thames and Hudson, 1967.

Hammacher, A. M., *Barbara Hepworth*, London, Thames and Hudson, 1968.

Harries, Meirion and Susan, *The War Artists: British Official War Art of the Twentieth Century*, London, Michael Joseph (in assoc. with Imperial War Museum and Tate Gallery), 1983.

Harrison, Charles, 'Abstract Painting in Britain in the Early 1930s', *Studio International*, vol. 173, no. 888, April 1967, pp. 180-91.

Harrison, Charles, 'The Origins of Modernism in England', *Studio International*, vol. 188, no. 969, September 1974, pp. 75-82.

Harrison, Charles, *English Art and Modernism 1900-1939*, London, Allen Lane, and Bloomington (Ind.), Indiana University Press, 1981.

Harrison, Charles, and Fred Orton, *A Provisional History of Art & Language*, Paris, E. Fabre, 1982.

Harrison, Charles, *English Art and Modernism*, Milton Keynes, Open University Press, 1983 [course-unit for A315 third level course, *Modern Art and Modernism: Manet to Pollock*].

Hayes, John, *The Art of Graham Sutherland*, Oxford, Phaidon, 1980.

Hebdige, Dick, 'Towards a Cartography of Taste 1935-1962', *Block* (Middlesex Polytechnic), 4, 1981.

Hebdige, Dick, 'In Poor Taste: Notes on Pop', *Block* (Middlesex Polytechnic), 8, 1983.

Hendy, Philip, Francis Halliday and John Russell, *Matthew Smith*, London, George Allen & Unwin, 1962.

Hepworth, Barbara, *A Pictorial Autobiography*, Bath, 1970; rev. ed. Bradford-on-Avon, Wilts., Moonraker Press, 1978.

Heron, Patrick, *The Changing Forms of Art*, London, Routledge & Kegan Paul, 1955.

Heron, Patrick, *Ivon Hitchens*, Harmondsworth, Middx, Penguin Books, 1955.

Heron, Patrick, 'The Shape of Colour', *Studio International*, vol. 187, no. 963, February 1974, pp. 65-76.

Heron, Patrick, [interview with Patrick Heron, March 1980], London, Arts Video, 1980.

Hilton, Roger, *Night Letters, and Selected Drawings*, introd. Michael Canney, Penzance, Newlyn Orion Galleries, 1980.

Hockney, David, *David Hockney by David Hockney*, ed. Nikos Stangos, London, Thames and Hudson, 1976.

Hodin, J. P., 'Cornish Renaissance', *Penguin New Writing*, no. 39, 1950, pp. 113-24.

Hodin, J. P., *Barbara Hepworth* (with catalogue by Alan Bowness), London, Lund Humphries, 1961.

Horovitz, Michael, *Alan Davie*, London, Methuen, 1963.

Hull, University of Hull, *Art in Britain 1890-1940* (exhibition catalogue, text by Malcolm Easton, February-March 1967).

Hulme, T. E., *Speculations: Essays on Humanism and the Philosophy of Art*, ed. Herbert Read, London, Kegan, Paul, Trench, Trubner, and New York, Harcourt, Brace, 1924.

Humphreys, Richard (ed.), *Pound's Artists: Ezra Pound and the Visual Arts in London, Paris and Italy*, London, Tate Gallery, 1985.

Hyman, Timothy, 'Howard Hodgkin: Making a Riddle out of the Solution', *Art & Design*, vol. 1, no. 8, September 1985, pp. 6-11.

Ironside, Robin, *Painting since 1939*, London, Longmans, Green (for The British Council), 1947.

Joel, Mike von, 'Hoyland at Home: Interview', *Art Line*, no. 4, February 1983, pp. 10-11.

Johnson, J., and A. Greutzner, *The Dictionary of British Artists 1880-1940*, Woodbridge, Suffolk, Antique Collectors' Club, 1976.

Kent, Sarah, 'Abstract Relief' [interview with Gillian Ayres], *Time Out*, no. 697, 29 December 1983-4 January 1984, p. 69.

King, Phillip, 'One Feels a Bit More at Ease', *Retina*, no. 1, June 1982, pp. 70-83.

Kirkpatrick, Diane, *Eduardo Paolozzi*, London, Studio Vista, 1970.

Klingender, F. D., *Marxism and Modern Art: an Approach to Social Realism*, London, Lawrence and Wishart, 1943; repr. 1975.

Knowles, Rodney (ed.), *Contemporary Irish Art*, Dublin, Wolfhound Press, 1982.

Lambert, R. S. (ed.), *Art in England*, Harmondsworth, Middx, Penguin Books, 1938.

Latham, John, *Event Structure: Approach to Basic Contradiction*, Bracknell, Berks.; South Hill Park; and Calgary, Syntax, 1981.

Latham, John, *Report of a Surveyor*, Stuttgart, Hansjorg Mayer, and London, Tate Gallery, 1984.

Laughton, Bruce, *The Euston Road School: a Study in Objective Painting*, London, Scolar Press, 1986.

Lewis, Wyndham, *Blasting and Bombadiering*, London, Eyre and Spottiswoode, 1937.

Lewis, Wyndham, *Wyndham Lewis the Artist: from Blast to Burlington House*, London, Laidlaw & Laidlaw, 1939.

Lewis, Wyndham, *Rude Assignment: a Narrative of my Career up-to-date*, London, Hutchinson, 1950.

Lewis, Wyndham, *Wyndham Lewis on Art: Collected Writings 1913-1956*, ed. Walter Michel and C. J. Fox, London, Thames and Hudson, 1969.

Lewis, Wyndham, and Louis F. Fergusson, *Harold Gilman: an Appreciation*, London, Chatto and Windus, 1919.

Lilly, Marjorie, *Sickert: the Painter and his Circle*, London, Elek, 1971.

Lipke, William, *David Bomberg: a Critical Study of his Life and Work*, London, Evelyn, Adams & Mackay, 1967.

Livingstone, Marco, *Allen Jones: Sheer Magic*, London, Thames and Hudson, 1979.

Livingstone, Marco, *David Hockney*, London, Thames and Hudson, 1981.

Livingstone, Marco, *R. B. Kitaj*, Oxford, Phaidon, 1985.

London, Artists International Association, *A.I.A. 25: an Exhibition to celebrate the Twenty-Fifth Anniversary of the Foundation in 1933 of the Artists International Association* (exhibition catalogue, London, R.B.A. Galleries, introd. Adrian Heath and Andrew Forge, March-April 1958).

London, Arts Council, *The Euston Road School* (exhibition catalogue, 1948).

London, Arts Council, *Sixty Paintings for '51* (exhibition catalogue, for Festival of Britain, 1951).

London, Arts Council, *Decade 1910-20* (exhibition catalogue, introd. Alan Bowness; opening in Leeds, May-September 1965).

London, Arts Council, *Decade 1920-30* (exhibition catalogue, introd. Alan Bowness: opening in Leicester, February-August 1970).

London, Arts Council, *The New Art* (exhibition catalogue, introd. Anne Seymour, August-September 1972).

London, Arts Council, *Decade '40s: Painting, Sculpture and Drawing in Britain 1940-49* (exhibition catalogue, introd. Alan Bowness; opening in London, Whitechapel Art Gallery, November 1972-June 1973).

London, Arts Council, *Vorticism and its Allies* (exhibition catalogue, introd. Richard Cork, March-June 1974).

London, Arts Council, *British Painting '74* (exhibition catalogue, text by Andrew Forge, September-November 1974).

London, Arts Council, *The Human Clay* (exhibition catalogue, text by R. B. Kitaj, August 1976).

London, Arts Council, *Hayward Annual* (catalogues of annual series of exhibitions, from 1977).

London, Arts Council, *Arts Council Collection* [works purchased 1942-1978], London, Arts Council of Great Britain, 1979; supplement, *Arts Council Collection: Acquisitions 1979-83*, 1984.

London, Arts Council, *Thirties: British Art and Design before the War* (exhibition catalogue, October 1979-January 1980).

London, Arts Council, *Landscape in Britain 1850-1950* (exhibition catalogue, February-April 1983).

London, Arts Council, *The British Art Show: Old Allegiances and New Directions 1979-84* (exhibition catalogue, opening in Birmingham, November-December 1984).

London, British Council, *The British Council Collection 1938-1984*, London, British Council, 1984.

London, British Council, *The Proper Study: Contemporary Figurative Painting from Britain* (exhibition catalogue, New Delhi, Lalit Kala Akademi, December 1984).

London, Camden Arts Centre, *Hampstead in the Thirties: a Committed Decade* (exhibition catalogue, November 1974-January 1975).

London, Camden Arts Centre, *Hampstead Artists 1946-1986: an Exhibition to Celebrate the 40th Birthday of the Hampstead Artists' Council* (exhibition catalogue, April-May 1986).

London, Christie's, *The New English Art Club Centenary Exhibition* (exhibition catalogue, introd. Anna Robbins, August-September 1986).

London, Fine Art Society, *Camden Town Recalled* (exhibition catalogue, introd. Wendy Baron, October-November 1976).

London, Fine Art Society, *Sculpture in Britain between the Wars* (exhibition catalogue, introd. Benedict Read and Peyton Skipwith, June-August 1986).

London, Fischer Fine Art, *The British Neo-Romantics, 1935-1950* (exhibition catalogue, June-August 1983).

London, Grafton Galleries, *Manet and the Post-Impressionists* (exhibition catalogue, introd. Roger Fry, November 1910-January 1911).

London, Grafton Galleries, *Second Post-Impressionist Exhibition: British, French and Russian Artists* (exhibition catalogue, introd. Roger Fry, Clive Bell and Boris Anrep, October-December 1912).

London, Imperial War Museum, *British War Art of the 20th Century: the Official War Artists' Record of Two World Wars*, London, Mindata (microfiche publication), 1982.

London, Institute of Contemporary Arts, *When Attitudes Become Form* (exhibition catalogue, September-October 1969).

London, Marlborough Fine Art, *Art in Britain 1930-40 Centred round Axis, Circle, Unit One* (exhibition catalogue, March-April 1965).

London, Mayor Gallery, *Unit One: Spirit of the '30s* (exhibition catalogue, May-June 1984).

London, Mayor Gallery, *British Surrealism Fifty Years on: an Exhibition to Celebrate the Half Century of the International Surrealist Exhibition held at the New Burlington Galleries in Burlington Gardens, June 11th to July 4th, 1936* (exhibition catalogue, March-April 1986).

London, New Burlington Galleries, *London Group Retrospective Exhibition 1914-1928* (exhibition catalogue, introd. Alfred Thornton and Roger Fry, April-May 1928).

London, Parkin Gallery, *The Seven and Five Society 1920-35* (exhibition catalogue, introd. Mark Glazebrook; Southport, Cardiff and Colchester, from August 1979; London, January-February 1980).

London, Royal Academy of Arts, *A New Spirit in Painting* (exhibition catalogue, January-March 1981).

London, Tate Gallery, *Modern British Pictures from the Tate Gallery Exhibited under the Auspices of the British Council* (catalogue of exhibition touring nine European capitals, 1946-7).

London, Tate Gallery, *Annual and Biennial Reports and Catalogues of Acquisitions* (from 1954).

London, Tate Gallery, *The Modern British Paintings, Drawings and Sculpture*, by Mary Chamot, Dennis Farr and Martin Butlin, London, Oldbourne Press, 1964.

London, Tate Gallery, *London Group 1914-64, Jubilee Exhibition: Fifty Years of British Art* (exhibition catalogue, introd. Dennis Farr and Alan Bowness; July-August 1964; travelling to Cardiff and Doncaster).

London, Tate Gallery, *Recent British Painting: Peter Stuyvesant Foundation Collection* (exhibition catalogue, introd. Alan Bowness, November-December 1967).

London, Tate Gallery, *Henry Moore to Gilbert & George: Modern British Art from the Tate Gallery (Europalia 73 Great Britain)* (exhibition catalogue, Brussels, Palais des Beaux-Arts, September-November 1973).

London, Tate Gallery, *The Tate Gallery: an Illustrated Companion to the National Collections of British & Modern Foreign Art*, London, Tate Gallery, 1979.

London, Tate Gallery, *The Hard-Won Image: Traditional Method and Subject in Recent English Art* (exhibition catalogue, text by Richard Morphet, July-September 1984).

London, Tate Gallery, *St. Ives 1939-64: Twenty Five Years of Painting, Sculpture and Pottery* (exhibition catalogue, ed. David Brown, February-April 1985).

London, Whitechapel Art Gallery, *This is Tomorrow* (exhibition catalogue, August-September 1956).

Long, Richard, *Works 1966-1977*, Eindhoven, Van Abbemuseum, 1979.

Lucie-Smith, Edward, *Movements in Art since 1945*, London, Thames and Hudson, 1969; rev. eds 1975 and 1984.

Lucie-Smith, Edward, and Patricia White, *Art in Britain 1969-70*, London, J. M. Dent, 1970.

Lynton, Norbert, *Kenneth Armitage*, London, Methuen, 1962.

Lynton, Norbert, 'A Unique Venture: the Achievement of Ben Nicholson', *Studio International*, vol. 173, no. 890, June 1967, pp. 296-303.

MacColl, D. S., *Confessions of a Keeper, and Other Papers*, London, Alex. Maclehose, 1931.

Maenz, Paul, and Gerd de Vries (eds), *Art & Language: Texte zum Phänomen Kunst und Sprache*, Cologne, DuMont Schauberg, 1972 (parallel English/German text).

Martin, Barry, 'Phillip King', *Studio International*, vol. 187, no. 967, June 1974, pp. 277-80.

Martin, J. L., Ben Nicholson and Naum Gabo (eds), *Circle: International Survey of Constructive Art*, London, Faber and Faber, 1937; repr. 1971.

Melly, George, *Revolt into Style: the Pop Arts in Britain*, London, Allen Lane, Penguin Press, 1970.

Melville, Robert, 'The Durable Expendables of Peter Blake', *Motif*, 10, Winter 1962/3, pp. 14-35.

Meyers, Jeffrey, *The Enemy: a Biography of Wyndham Lewis*, London, Routledge & Kegan Paul, 1980.

Michel, Walter, *Wyndham Lewis: Paintings and Drawings*, London, Thames and Hudson, 1971.

Middleton, Michael, *Eduardo Paolozzi*, London, Methuen, 1963.

Milan, Palazzo Reale, *Arte Inglese Oggi: 1960-76* (exhibition catalogue, organized by The British Council, February-March 1976; Milan, Electa, 1976).

Moore, Henry, *Henry Moore: Sculpture and Drawings*, 5 vols, introd. Herbert Read, vol. 1 ed. David Sylvester, vols 2-5 ed. Alan Bowness, London, Lund Humphries and A. Zwemmer, 1944, 1955, 1965, 1977, 1983.

Morley, Malcolm, 'Malcolm Morley Talking on the Occasion of his Retrospective Exhibition at the Whitechapel Art Gallery (22 June-21 August 1983)', *Audio Arts*, vol. 7, no. 3, side 1 (1983) [audio recording].

Morphet, Richard, *British Painting 1910-1945*, London, Tate Gallery, 1967.

Morphet, Richard, 'John Walker's Work since 1965', *Studio International*, vol. 176, no. 903, September 1968, pp. 80-5.

Morphet, Richard, 'Le Réalisme Anglais entre les 2 Guerres', *Cahiers du Musée National d'Art Moderne* (Centre Pompidou), 7/8, 1981, pp. 322-45.

Morris, Lynda, 'What made the Sixties Art so Successful, so Shallow?', *Art Monthly*, nos. 1-2, October/November 1976.

Nairne, Sandy, and Nicholas Serota (eds), *British Sculpture of the Twentieth Century*, London, Whitechapel Art Gallery, 1981.

Nash, Paul, *Room and Book*, London, Soncino Press, 1932.

Nash, Paul, *Outline: an Autobiography, and Other Writings*, London, Faber and Faber, 1951.

New Haven, Yale Center for British Art, *The Camden Town Group* (exhibition catalogue, text by Wendy Baron and Malcolm Cormack, April-June 1980).

New York, Solomon R. Guggenheim Museum, *British Art Now: an American Perspective* (exhibition catalogue, January-March 1980; travelling to London, Royal Academy of Arts, October-December 1980).

New York, Jewish Museum, *The Immigrant Generations: Jewish Artists in Britain, 1900-1945* (exhibition catalogue, May-September 1983).

Nottingham, University Art Gallery, *Vision and Design: the Life, Work and Influence of Roger Fry, 1866-1934* (exhibition catalogue, text by Quentin Bell and Philip Troutman; London, Arts Council Gallery, March-April 1966; travelling to Nottingham, Leeds, Newcastle and Manchester).

Oxford, Museum of Modern Art, *The Story of the A.I.A.: Artists International Association, 1933-1953* (exhibition catalogue, text by Lynda Morris and Robert Radford, April-May 1983).

Oxlade, Roy, *David Bomberg, 1890-1957*, London, Royal College of Art (RCA Papers No. 3), 1977.

Paris, Musée d'Art Moderne de la Ville de Paris, *Un Certain Art Anglais...: Sélection d'Artistes Britanniques 1970-1979* (exhibition catalogue, text by Michael Compton, Richard Cork and Sandy Nairne; January-March 1979).

Parry-Crooke, Charlotte, *Contemporary British Artists, with Photographs by Walia*, London, Bergstrom + Boyle Books, 1979.

Penrose, Roland, *Scrapbook 1900-1981*, London, Thames and Hudson, 1981.

Portsmouth, City Museum and Art Gallery, *Unit 1* (exhibition catalogue, May-July 1978).

Ratcliff, Carter (introd.), *Gilbert & George 1968-1980*, Eindhoven, Van Abbemuseum, 1980.

Ray, Paul C., *The Surrealist Movement in England*, Ithaca (N. Y.) and London, Cornell University Press, 1971.

Read, Herbert, *The Meaning of Art*, London, Faber and Faber, 1931.

Photographic Acknowledgments

The exhibition organizers would like to thank the following for making photographs available.

Catalogue Illustrations

Barbican Art Gallery, City of London Cat. 155
The Bridgeman Art Library, London Cat. 154
Brian Coxall Cat. 194
Prudence Cuming Associates Ltd Cat. 10, 15, 22, 28, 51, 65, 78, 80, 81, 85, 86, 87, 90, 93, 111, 132, 133, 134, 140, 141, 142, 160, 163, 166, 167, 171, 173, 184, 197, 214, 237, 239, 240, 266, 269, 270, 271, 276, 282, 289
Anthony d'Offay Gallery Cat. 9, 76
Fitzwilliam Museum, Cambridge Cat. 2, 186, 250, 264
Derek Greaves Cat. 112, 179, 180
Sean Hudson Cat. 231, 236
Studio Lourmel, Paris Cat. 148
Marlborough Fine Art, London Cat. 136, 244, 294
Jessie Ann Matthew Cat. 268
Herbert Michael Fotograf, Zurich Cat. 158
Richmond & Rigg Photography, Hull Cat. 223
Peter Rumley Esq. Cat. 161
The Tate Gallery, London Cat. 150, 151
Waddington Galleries, London Cat. 177, 222, 252, 254, 306
John Webb Cat. 31, 34, 79, 130

All other photographs were provided by the owners of the works of art reproduced.

Text Illustrations

The Arts Council of Great Britain pp. 40/13, 41/16, 51/32
City of Birmingham Museums and Art Gallery p. 34/5
Conway Library, Courtauld Institute of Art, London p. 32/1
Prudence Cuming Associates Ltd pp. 71/16, 80/7
Anthony d'Offay Gallery, London pp. 33/3, 48/29, 64/2, 65/6
Fine Art Society, London pp. 36/7, 37/9
Fischer Fine Art, London p. 43/20
Elisabeth Frink p. 42/19
Carl Giles, Courtesy of the Daily Express p. 85/3
John Goldblatt pp. 44/21, 46/25, 48/28
Richard Hamilton p. 27/12 and 13

Mr and Mrs William Hardie p. 66/7
Imperial War Museum, London p. 96/7
Errol Jackson p. 89/1
Provost and Fellows of King's College, Cambridge p. 20/5
Peter Kinnear, Courtesy of the Tate Gallery Press Office p. 38/10
Courtesy of Leon Kossoff p. 80/8
Jorge Lewinski p. 50/30
Richard Long p. 47/27
Manchester City Art Galleries pp. 37/8, 94/5
Marlborough Fine Art, London p. 79/6
Mayor Gallery, London p. 39/12
National Gallery of Canada, Ottawa pp. 68/11, 70/14
The National Trust p. 21/6
Palazzo Grassi, Venice p. 68/10
Eduardo Paolozzi p. 26/10 and 11
Peter Peri Estate p. 78/5
Andrew Putler p. 88/5
Alex. Reid and Lefevre Ltd, London p. 22/7
Juda Rowan Gallery, London p. 45/24
Royal Holloway and Bedford New College, London p. 95/6
Anthony Stokes, Courtesy of Anthony d'Offay Gallery p. 84/1
The Tate Gallery, London pp. 17/2, 20/4, 24/8, 25/9, 29/14, 34/4, 39/11, 40/14, 41/15, 42/18, 44/22, 45/23, 47/26, 50/31, 52/33, 63/1, 69/12, 73/1, 74/2, 78/4, 91/2 and 3, 92/4, 97/9, 98/10 and 11
Thyssen-Bornemisza Collection, Lugano, Switzerland p. 77/3
Ulster Museum, Belfast p. 16/1
John Webb p. 87/4

All uncredited illustrations are taken from the publishers' and authors' archives.

Photographs of the Artists

Michael Andrews: Tessa Traeger, Courtesy of *Vogue* magazine
Kenneth Armitage, Victor Pasmore: Roger Mayne
Art & Language: Gareth Winters
Frank Auerbach: Mark Trivier
Gillian Ayres, Peter Blake, Anthony Caro, Patrick Caulfield, William Coldstream, Patrick Heron, David Hockney, John Hoyland, Allen Jones, R.B. Kitaj, Leon Kossoff, Peter Lanyon, Henry Moore, Eduardo Paolozzi, John Piper, Richard Smith, John Walker: Jorge Lewinski
Francis Bacon: Jane Bown

Graham Bell, Vanessa Bell, Duncan Grant: Courtesy of the Tate Gallery Archive
David Bomberg: Courtesy of Mrs Dinora Davies Rees
Mark Boyle: John Cooper
Stuart Brisley, Victor Burgin, John Latham, Bob Law, Rodrigo Moynihan: Saranjeet Walia
Edward Burra: Courtesy of Lady Ritchie
Alan Davie: David Ware
Frank Dobson, Christopher Nevinson: Howard Coster, Courtesy of the National Portrait Gallery Archive
Malcolm Drummond: Courtesy of Mrs Margaret Drummond
Jacob Epstein: G.C. Beresford, Courtesy of the National Portrait Gallery Archive
Barry Flanagan: Nic Barlow
Lucian Freud: Courtesy of James Kirkman
Henri Gaudier-Brzeska: Walter Benington, Courtesy of Christopher Hurst
Mark Gertler: Courtesy of Luke Gertler
Gilbert & George: Ian McKell
Eric Gill: Courtesy of Leeds City Art Galleries
Harold Gilman: Courtesy of Mrs Barbara Duce
Charles Ginner: Courtesy of Dr Wendy Baron
Spencer Gore: Courtesy of Frederick Gore
Lawrence Gowing: Roland S. Haupt
Richard Hamilton: Mary Webb
Barbara Hepworth: Courtesy of the Barbara Hepworth Museum
Roger Hilton: Adrian Flowers
Ivon Hitchens: Ida Kar
Howard Hodgkin: Nick Tucker
Phillip King: Graham Kirk
Gwen John: Courtesy of Mary Taubman
Wyndham Lewis, Edward Wadsworth: A.L. Coburn, Courtesy of the National Portrait Gallery Archive
Richard Long: Denny Long
Bruce McLean: Bernd Jansen
Malcolm Morley: Harry Diamond
Paul Nash: Felix H. Man
Ben Nicholson: Humphrey Spender, Courtesy of the National Portrait Gallery Archive
Bridget Riley: John Goldblatt
William Roberts: Courtesy of Mrs William Roberts
Walter Sickert: E. Drummond Young, Courtesy of the National Portrait Gallery Archive
Matthew Smith: Courtesy of Alice Kadel
Stanley Spencer: John Hedgecoe, Courtesy of the National Portrait Gallery Archive
Graham Sutherland: Courtesy of the British Council Archive
William Turnbull: Courtesy of Waddington Galleries

Index of Names